In his new book, Professor Martin Robertson – author of *A History of Greek Art* (1975) and *A Shorter History of Greek Art* (1981) – draws together the results of a life-time's study of Greek vase-painting, tracing the history of figure-drawing on Athenian pottery from the invention of the 'red-figure' technique in the later archaic period to the abandonment of figured vase-decoration two hundred years later. The book covers red-figure and also work produced over the same period in the same workshops in black-figure and other techniques, especially that of drawing in outline on a white ground.

Professor Robertson sees his book as filling the gap left by the classical art-historian Sir John Beazley, who wrote a *Development of Attic Black-figure* but no corresponding summation of his work in red-figure. The book has a secondary purpose: Beazley's work has in recent years been subjected to serious attacks which question both the validity of his method and the value of his approach. This book takes account of the cogency of some criticisms while demonstrating the essential rightness and importance of what Beazley did.

This is a major contribution to the history of Greek vase-painting. Anyone seriously interested in the subject – whether scholar, student, curator, collector or amateur – will find it essential reading.

The art of vase-painting in
classical Athens

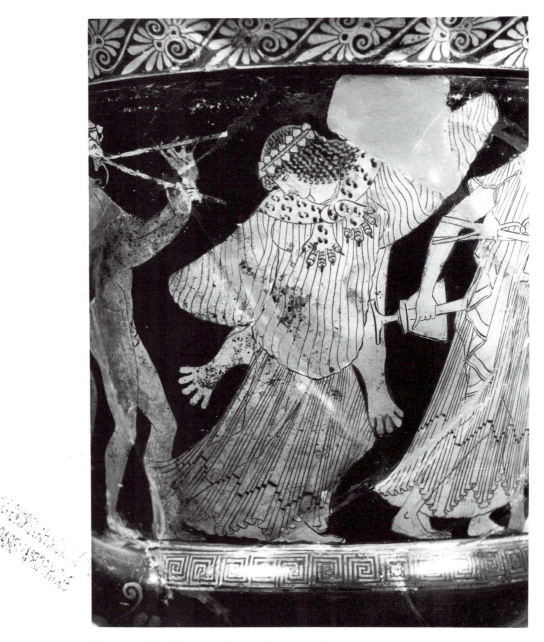

The return of Hephaistos (detail, maenad). Kleophrades
Painter.

The art of vase-painting in classical Athens

MARTIN ROBERTSON

CAMBRIDGE
UNIVERSITY PRESS

Published by the Press Syndicate of the University of Cambridge
The Pitt Building, Trumpington Street, Cambridge CB2 1RP
40 West 20th Street, New York, NY 10011-4211, USA
10 Stamford Road, Oakleigh, Victoria 3166, Australia

First published 1992
Reprinted 1996

Printed in Great Britain at the University Press,
Cambridge

*A cataloguing in publication record for this book is
available from the British Library*

Library of Congress cataloguing in publication data
Robertson, Martin.
The art of vase-painting in classical Athens/
Martin Robertson.
 p. cm.
Includes bibliographical references and index.
ISBN 0 521 33010 6
1. Vase-painting, Greek – Greece – Athens.
1. Title.
NK 4645. R7 1992
738.3′82′09385 – dc20 91-21355 CIP

ISBN 0 521 33010 6 hardback
ISBN 0 521 33881 6 paperback

FOR LOUISE

CONTENTS

Contents

Preface

This book is mainly a history of Attic red-figure. I have chosen a more general title because it treats also of vases decorated in other techniques, especially white-ground and black-figure, which were produced in Athens at the same time as red-figure vessels, probably generally in the same workshops and often painted by the same hands. I am further moved by the fact that I hope the book will appeal not only to specialists; and to non-specialists the time-honoured but awkward and inaccurate designations 'black-figure' and 'red-figure' do not say much. The reason for including the word 'art' in the title will appear in the Introduction. The title I have chosen has its own awkwardness. The 'classical', opposed to the 'archaic' period is generally taken to begin after the repulse of the Persian invasion, with the return of the Athenians to their sacked city in 479 B.C. On the conventional chronological framework we use, and which (with some hesitation and reservations voiced below) I accept, the invention of red-figure falls some forty or fifty years before that, and my earlier chapters are concerned with the work of those last decades of the archaic age. They were, however, a time of ferment in the arts, when a new approach, which ends by taking 'classical' shape, was breaking the cocoon of the archaic tradition. On the political and social side, too, it would be hard to begin a history of classical Athens later than the expulsion of Peisistratos's sons and the establishment of a kind of democracy in 510.

The other end of the story comes somewhere in the later fourth century B.C., when red-figure, and with it almost all attempt at painted figure-decoration on pottery, comes to an end in Athens. This point cannot be precisely fixed in time, but it cannot be far from (and surely not unconnected with) the suppression by Macedon of the city's last bid for freedom after Alexander's death, and the establishment, in 317, of government through a puppet dictator: the end of classical Athens.

It is impossible to illustrate more than a small proportion of the vases I mention individually. For every vase which is listed in Beazley's *ARV²* or *ABV* I give that reference, and that leads to references to illustra-

tion. I have also given where possible one direct reference to a picture. For this purpose I have made particular use of Boardman's three handbooks, *Athenian Black Figure Vases*, *Athenian Red Figure Vases: the Archaic Period* and *Athenian Red Figure Vases: the Classical Period*. These have a great many small pictures of vases arranged by painters according to Beazley's lists, and they and my book can be usefully used together. In some cases I have added further references to fuller or better illustration. For every vase illustrated I give one measurement in metres, as indication of scale, but many of these measurements are only approximate.

Though this book is essentially about drawing, I have chosen many pictures of complete vases. I have a great deal to say about shapes; and the relation of the picture to the pot is an important determinant of style. On the other hand I have also a good many pictures of fragments, since in these the detailed character of the drawing is often most clearly apparent.

I have been greatly helped by many people. I would particularly name John Boardman, Dietrich von Bothmer, Donna Kurtz, Ian McPhee and Dyfri Williams, the last by no means only for his invaluable assistance over photographs from the British Museum. Other people who have been particularly helpful in the matter of photographs are Olga Alexandri-Tachou, Hansjorg Bloesch, Nancy Bookidis, A.E. Fischer, David Gill, Mary Greuel, Th. Karagiorga-Stathakopoulou, Ursula Knigge, Glenn Markos, Joan Mertens, Francesco Nicosia, B.B. Rasmussen, Michael Vickers, Irma Wehgartner, Florence Wolsky, K. Zimmermann. Much of the book was written under the happy condition of being a Guest Scholar of the Getty Foundation at the J. Paul Getty Museum. I am deeply indebted to the Foundation and to Marion True at the Museum, with her staff: Ken Hamma, Karen Manchester, Karol Wight, and the endlessly helpful secretary Dorothy Osaki.

It has been a pleasure to collaborate again with Pauline Hire at the Cambridge University Press. My daughter, Lucy Pollard, provided the index, and my wife Louise much more than I can say.

Introduction

I. Vase-painting in Athens before the invention of red-figure

The adornment of pottery with more or less elaborate painted decoration is an old and tenacious tradition in Greece. Many regions have large deposits of very good potters' clay, and local potteries tended to develop styles of their own. In the later, Mycenaean, phase of the Bronze Age there was a common idiom of vase-painting with slight local variations over much of mainland and island Greece, in which an Attic version can be distinguished, technically accomplished but not outstanding.[1] The collapse of this culture involved movements of population and a period of impoverishment and regression, one feature of which seems to be a total cessation in the major arts: monumental architecture, sculpture, painting. There is a continuous craft tradition, including painted pottery, but this loses much in technical quality, and its decorative motifs, naturalistic (floral or marine) in origin, become more and more stylised towards abstract forms.[2]

It is in the phase which succeeds this 'Submycenaean' that Athenian potters first appear as leaders of the craft in Greece. It is a time of revival. Iron working has been mastered and the quality of craftwork, at least as illustrated in painted pottery, improves again. Besides technical improvement the new pottery shows a new range of shapes and decoration. The conventionalised natural motifs of Submycenaean are abandoned in favour of abstract geometrical forms. The new fashion lasts for centuries, and the style, and by extension the period, are known as Geometric, and this first phase, in which the patterns are simple and few, as Protogeometric.[3] From this point an unbroken development can be traced in Attic pottery into the archaic and classical periods.[4]

The dating in these years of transition between the Bronze and Iron Ages is particularly imprecise. There are connections in the Mycenaean period with the better documented history of Egypt, and on the basis of these it seems that the decline of the old order in Greece came in the later centuries of the second millennium B.C., and the Protogeometric revival probably before 1000.

Protogeometric pottery is found in several centres, but from the beginning the best, for quality of clay and colour, tautness of shapes and precision in the execution of the simple motifs (chiefly concentric circles and semicircles drawn with compass and multiple brush), is Attic. The Attic potters maintain this supremacy throughout the Geometric period (taken on our chronological scheme to cover the tenth and ninth centuries and most of the eighth), when the principle of decoration in now mainly rectilinear 'geometric' designs is elaborated into a highly distinctive and sophisticated style. In the mature phases of this style figurework is introduced, the figures partly assimilated to geometrical forms, notably the triangular torso with matchstick arms, evincing the power of the abstract tradition.

Figure-scenes are found on many types of vase but in Athens especially on huge pots, not designed for use but to stand on graves as monumental markers. At the same time in the sanctuaries of Greece a fashion begins for dedicating big tripod-cauldrons of bronze, likewise with abstract decoration on legs and handles and also added figurines of horses and men, highly stylised towards geometric shapes.[5] After the cessation for centuries of figurative and monumental art in the land, a new artistic beginning is marked by these inventions: a simple traditional cooking-pot recreated in decorative bronze as a gift for the gods; a common clay vessel for storage or mixing monumentalised as a marker for an honoured grave. The significance of these phenomena for the study of later phases of Attic vase-painting is that they show the craft of painted pottery assuming at Athens in this early period, through historical circumstances, an artistic importance which it has rarely held in other cultures. The phenomenon of 'vase-painting as a fine art' which we find in sixth- and fifth-century Athens needs accounting for; and this early history may help to explain how it came about.

In late Geometric the style becomes looser, the ornament less complex, figures fuller. This phase merges into the next style, known as 'Orientalising' because one evident feature of it is its borrowings from eastern art, especially floral ornaments and a new variety of animals

1

and monsters. The principal eastern source seems to have been Phoenicia, itself much influenced by the arts of Egypt and Assyria; and it is clear that Greek vase-painters did not derive the new motifs from painted pottery (a craft which had no significant tradition of figurework in any eastern country) but from other media, especially textiles and metalwork.

Differences already present in the Geometric styles of different regions become more significant in Orientalising. Attic vase-painters, with their strong tradition of figure-drawing, continue the modification, begun in late Geometric, of the angular silhouette with curvier, fuller figures and increasing use of outline and internal drawing. A generation later new colours are added, a purple-red, and in particular white, which is often laid on in large areas, generally over black underpainting. Some of the figurework is on a very large scale, on large pots in the tradition of the Geometric grave-marker, a use probably served by some of these also. Many pieces of this large 'black-and-white style' have been found on the neighbouring island of Aigina. On this and other grounds a good case has been made for their having been made there; but even if this is true, which is unproven, they have links both backwards and forwards to Attic tradition, and it is hard to trace the history of Attic vase-painting without them. In this style faces are often drawn in outline, sometimes filled with white, bodies in black silhouette sometimes covered in white, and detail is put in on the black with thin lines of white or with incision, that is, lines cut in the newly applied colour with a sharp instrument.[6]

For Attic potters this last way of enlivening the silhouette is one among many; in Corinth it becomes the rule. Corinthian Geometric was technically fine, with a more limited range and restricted use of ornament than Attic and no tradition of large vases or of figurework. In the orientalising period Corinthian vase-painters develop an exquisite miniature style, especially on tiny scent-bottles which are widely exported, whereas contemporary Attic is scarcely found outside Attica and Aigina. The favourite Corinthian technique is black silhouette with incision and added colour: 'black-figure'; and towards the end of the seventh century this becomes, under Corinthian influence, the norm in Attic also, and remains so through most of the sixth.[7]

The making of huge vases, no doubt as grave-markers, is still found in the first phase of Attic black-figure, but not thereafter; and in the next phase, approximately dated in the early sixth century, other changes too are apparent. Attic makers of Protogeometric vases had achieved a fine black, but on most Geometric and Orientalising pots it is thinner and paler. Now they master the production of a glossy black which remains typical of archaic and classical Greek pottery. At the same time they deliberately heighten the naturally ruddy colour of Attic clay to a strong orange, and the contrast of these two, with the added white and red, makes the character of Attic black-figure. All these colours are clay-based, and the contrast of orange and black is reached by a complex process of firing which never reaches temperatures to produce vitrification; so the term 'glaze' often used for the black is inaccurate.[8]

This improvement in technique is accompanied by some decline in artistry. The best drawing on the first black-figure pots of Attica is superb, and nothing like it is found in the next generation when, though there is good work, there is much repetitive drawing of animals verging on mass-production. The situation in Corinth is similar, and for the first time much Attic pottery is found alongside Corinthian in Italy. It looks like a trade war fought on a basis of quantity and of technical rather than artistic quality (won by Athens, since Corinthian figured pottery dies out around the mid century).

Another change is in the shapes and uses of Attic vases. Earlier most careful figured pottery in Athens seems to have been made to put in or on graves. Now the symposium seems to become the principal focus: among large pots, amphorae to store wine and kraters to mix it with water; among the smaller, jugs to dispense it and various forms of cup for drinking. Work for the grave goes on; and, most interestingly, the monumental grave-pots find successors in clay plaques, decorated by leading vase-painters, used to face a type of tomb down to after the middle of the century; but the emphasis is different.

Looking at Attic black-figure of this time one might think the craft likely to lose its peculiar status and drop into the humbler position it holds in most cultures, but this did not happen. Somewhere it seems in the second quarter of the sixth century there is an astonishing revival. The best craftsmen over the middle decades show not only an exquisitely refined technique but draughtsmanship of a very high order indeed. Among the earlier are Kleitias, Nearchos and the nameless Painter of Acropolis 606; among the younger, Lydos and Exekias (both of whom painted sets of tomb-plaques) and the painter who worked with the potter Amasis. These, among whose pupils were the inventors of red-figure, were artists; but of the use of this word there will be more to say in the next section.[9]

II. The study of red-figure vase-painting

The notion of 'art' distinct from craft has been expressed verbally only in comparatively recent times, perhaps not before Dürer who early in the sixteenth century distinguished *Kunst* from what was taught in the guilds. Certainly Greeks and Romans made no such distinction: *ars* and *techne* mean 'skill' in a very wide

sense (*ars longa, vita brevis*, which translates a Greek tag with *techne*, refers to the art of healing). However, late mediaeval and early Renaissance painters and sculptors before Dürer surely thought of themselves, and were thought of, as artists in the same way as those after him; and the same is clearly true, from the way they are spoken of in the literary record, of painters and sculptors in Greece. Vase-painting, though, is another matter. Ancient statues and pictures, like those of the Middle Ages and the Renaissance were not made primarily as 'works of art' but to serve some other purpose, generally religious. They produce their effect, however, by being what they are: paintings or sculptures, works of art; they have no other existence. A vessel exists primarily for a utilitarian end, as a container. It need not be decorated at all, and any decoration it may have need not aspire to much artistry. I see the best Greek vase-painters as artists; but the majority were craftsmen producing pottery vessels with more or less mechanical decoration; and even the artists spent much of their time doing just that; they too were primarily workers in a utilitarian craft. It appears to me that a failure fully to recognise this has sometimes confused the study of the subject.

Vase-artists are first of all pot-decorators; and the decorative scheme of black-figure is an exceedingly formalised one. The shiny black silhouette on the orange ground certainly has a powerful decorative effect, but lends itself only in a very limited way to the expression of feeling or to any concern with naturalism. Some discontent with this convention seems to have been felt by some artists, notably the Amasis Painter who sometimes, with very lively effect, draws women in outline instead of white silhouette (fig. 1). Then, probably towards the end of the third quarter of the century, a great innovation was made, among painters who are clearly pupils of Exekias, Lydos and the Amasis Painter, the last of whom at least was certainly still active: the invention of red-figure. Basically this is a simple reversal of the earlier technique: figures left in the colour of the clay, background blacked in. An account of the technique will be given later; here we need only notice that, since detail is then put in with brush instead of graver, it lends itself, while preserving the silhouette-principle so dear to the Greek pot-decorator, to a kind of drawing which must come far closer to the lost drawings of the time on panel and wall.

When, in the later eighteenth and early nineteenth centuries, Greek vases were first noticed by scholars, they were valued chiefly for their mythological subject-matter and the light it might throw on the literature of Greece and Rome. At the same time, however, they became collectors' items, and as such appreciated as works of beauty. Attempts to order them by time and place of production comes more slowly; and when that does happen there comes with it, based on the presence of inscribed craftsmen's names, the notion of attributing the drawings on them to individual hands.[10]

Collections of signatures, and tentative groupings around them, were made by Klein and others in the second half of the nineteenth century; and a much more substantial effort on these lines is Paul Hartwig's *Meisterschalen* of 1893. Hauser and Furtwängler followed;[11] but the basis of the study of vase-painting in this century has been the work of Beazley. Starting from the 'Morellian' approach to the study of Italian painting in the Renaissance, Beazley made it his life-work to present the whole field of Attic red-figure (later of black-figure too) in terms of individual artists influencing and influenced by one another. Others have applied the method to other classes of vase, and it has become accepted as a main approach to the study of Greek vase-painting. Recently, however, there have been strong attacks on both the validity of the method and the value of the approach. I believe in both, and this book is structured around Beazley's findings; but I see real substance in much of the criticism in both its arms, and the following pages are devoted to reviewing Beazley's approach and method in their light.

First a note on 'signatures'. I put inverted commas because, though these certainly give (or purport to give) the names of people concerned in the production of the vessel, we cannot be sure that the person named wrote the message. These inscriptions take two forms: 'so-and-so *egrapsen*' or 'so-and-so *epoiesen*'. The meaning of *egrapsen* can be either 'wrote' or 'drew', and here surely refers to the drawing on the vase, though a different interpretation will be considered later. The meaning of *epoiesen* is 'made', in a very wide application of the word (our 'poet' is *poietes* in one of its commonest uses, paralleled in old Scottish 'makar'). Its meaning on the vases is much disputed. That it does not mean the same as *egrapsen* is proved by inscriptions in the form *Euphronios egrapsen: Kachrylion epoiesen*, where different men are credited with the two activities, or *Myson egrapsen kapoiesen*, where the man is the same but the activities are distinguished. There are two main opinions on the meaning of *epoiesen* on vases: that it refers to the potter who made the vessel with his own hands; or to the owner of the shop from which the vessel issued. I have argued the first view. It is certain that the word was sometimes used in this sense by craftsmen, for instance sculptors; and the man (his name lost) who dedicated a fine early black-figure vase on the Acropolis to Athena with the words *autos poi[esas]*, 'having made it himself', surely meant 'with his own hands'. In other cases (for instance Nikosthenes and Pamphaios) the incidence of the inscription does seem to point rather to a workshop owner. My present view is that the word probably means one thing in some places, another in

others. It is convenient to assume that the people we study were consistent in their usages, but observation of our contemporaries and ourselves makes it most unlikely. I shall therefore refer to 'epoiesen inscriptions', not 'potter signatures', and to the person so named as *poietes* rather than potter; clumsy, but it leaves the question open as I believe it to be. Beazley rejected two tendencies which colour the work of earlier scholars. One was to assume that a vase with an *epoiesen* inscription and no *egrapsen* was painted by the person named; the other to work outward from signed vases in building a picture of the artist. Beazley was firm that the first position was mistaken. As to the meaning of *epoiesen* he finally accepted, with some hesitation and reserves, the view that it generally meant 'made with his hands'. On the other question he started from style. If an *egrapsen* inscription, or several, gave an artist a name, that was fine, but if such an inscription conflicted with stylistic judgement, style prevailed.[12]

Beazley's critics find two main faults. The first, that he has made it seem that the most important thing about any vase is who painted it, and so has sadly narrowed the study, has I think some force (though it is perhaps less Beazley's fault than his followers'), and I shall come back to it. The other argument is that his method is invalid; that the features of drawing which Beazley took for evidence of an individual's touch are, to a great extent, common formulae of a period, so that his painters are not to be believed in or believed in only in a very limited degree. Thus Stähler, in his book on the Eucharides Painter, himself attributed one red-figure vase to the Painter of the Eucharides stamnos, but from Beazley's list of over ninety allowed the artist only two certain others, with two more possible early works and two related (from the same workshop).[13] Here I simply disagree. The features which define Beazley's Eucharides Painter seem to me evidences of a distinct artistic personality, if a minor one, who was responsible for most of the vases in the list (give or take a few; there are always doubtful cases and it would be ridiculous to suppose that Beazley never made mistakes). A minor artist: this is something which will need more discussion; but pots ascribed to the Berlin Painter or the Pan Painter (figures entirely unrecognised before Beazley) are to my eye as distinctive and, at their best, as fine as woodcuts by Dürer or Utamaro. It is also true, however, that the worst work of both these vase-decorators reaches a level to which neither of the wood-engravers would ever have allowed himself to sink. This is another fact which will need further consideration, as will the question how far it is valid to make comparisons with work in other times, places and media.

First, however, we have to look at the most recent and most comprehensive attack on Beazley's approach, one which puts forward a totally new concept of the nature of Attic black-figure and red-figure. A few years ago Michael Vickers and E.D. Francis offered a radically new chronology for archaic and early classical Greek art.[14] On this view the fine black-figure of Kleitias and his successors was not produced before the second decade of the fifth century, and red-figure not invented until after the return to Athens following the defeat of the Persians at Salamis in 479. This work is full of new insights and valuable observations, and it is good to be reminded how flimsy the evidence is on which our conventional chronology is based; but it appears to me that the foundations of the new time-scale are even less firm, while the picture given of the development of Greek art is bizarre to the point of incredibility, requiring us as it does to fit all vase-painting from Kleitias to Hermonax, all sculpture from the Siphnian Treasury to Olympia into a span of twenty-five or thirty years.

The chief relevance of this theory here is that it is linked by Vickers to another about the nature of Attic vase-painting.[15] We know that the fifth century was a time of wealth in Athens, from the silver-mines at Laurion, loot from the Persian wars, and revenues of empire. There is literary evidence for the use of silver and gold plate, and a few pieces survive. In Vickers's view black-figure and red-figure pots are closely imitated from such vessels in precious metal, and made to look as like them as possible. The shiny black is an attempt to imitate silver (there is some evidence for a taste for tarnish), the orange of the clay gold, the purple-red copper, the white ivory. Black-figure represents gold, or more probably bronze, vessels with applied silver figures; red-figure silver vessels with figures applied in gold.

Such 'gold-figured' silver vessels do exist and do have some resemblance to red-figure;[16] and once again I am grateful to Vickers for reminding us of an important craft from which so little remains that we are too inclined to forget it, and for insisting on the importance for Attic potters of metal models, something he documents with many illuminating details. In this case too, however, he carries his case to a point where I am quite unable to follow him.

Vickers believes that from the time of Kleitias onwards the potteries of Attica were taken over by, and entirely subordinated to, the silver and goldsmiths. Black-figured and red-figured vases were copied directly from designs made for vessels in silver and gold, even to the inscriptions; so that the 'signatures' on vases give the names not of ceramists but of workers in the precious-metal industry. A name with *egrapsen* is that of a designer, one with *epoiesen* that of the man who actually made the vessel in silver and gold (both perfectly correct usages). Because the executant handled the precious stuff himself he was the more important person; and this accounts for the name Euphronios appearing on

earlier vases with *egrapsen*, on later with *epoiesen*: he was promoted. This is an attractive solution of a puzzle; and there is similar charm in the explanation for the cessation of red-figure in Athens in the later fourth century. In 317 the Macedonian-backed dictator Demetrios of Phaleron brought in a severe programme of anti-luxury laws. This will have put the goldsmiths out of business, and without their models the vase-painters were unable to continue. Other considerations, however, tell no less strongly against the theory. Some of these have been set out elsewhere by others and myself,[17] and we shall be coming back to the question in the course of the book, but a few points must be made here.

Some of the finest vase-pictures have complicated *pentimenti*, changes in design in the preliminary sketch or between the sketch and the finished drawing, or both.[18] These cannot possibly be explained as corrections of errors in copying; they show us an original artist at work perfecting his design. Then, the names Bakchios and Kittos, which are found with *epoiesen* on black-figure panathenaic amphorae of the fourth century, appear also, in two inscriptions on marble of the same period, as members of a family of potters.[19] More generally, the resemblance between the clay and metal vessels, though it is there and may have been intended, is surely far less than Vickers implies. The black, even granting tarnish, does not really look like silver, still less the orange clay like gold; and the application on some specially careful vases, early and late, of actual gold leaf for details[20] must rule out the idea that the clay was intended, in any significant way, to 'stand for' gold, while it brings into question the assumption that the finest pottery was a humble and despised product. Most important is the intrinsic improbability of the picture Vickers presents. Painted pottery had been a flourishing craft in Athens from Geometric on, and it does not seem to me the way things work that such a craft should suddenly be totally taken over by another.

Vickers starts from some evident truths: that there are great likenesses between metal vessels and pottery; that vessels in gold and silver were very dear and those in bronze, while much cheaper, still very much more expensive than pots; and that fifth-century Athenians had a high regard for wealth and property; but his further assumption, that influence can only work from a more expensive craft on a humbler one, never the other way, seems to me quite arbitrary and demonstrably false. A craftsman works in his own craft and looks with interest at work in others. Attic potters certainly borrowed a lot from metal-workers, but they adapted their borrowings to the traditions of their own craft; and we shall meet cases where they borrowed forms from yet humbler work and probably transmitted their borrowings to the metal-worker.[21]

On the other side the picture Beazley paints convinces me. I do not see how a style like that of the Berlin Painter, expressed consistently over many vases in composition, detailed drawing and feeling, could be transmitted by hacks copying supplied designs; still less the demonstrable influences between painters, including clear master–pupil relationships over several generations (e.g. Berlin Painter, Achilles Painter, Phiale Painter).

So, I accept the validity of Beazley's method. I am no less sure of the value of his approach. At the same time I have a sense that these varied expressions of discontent with the state of the study of vases in the post-Beazley era are based on a feeling of something being wrong which cannot be dismissed as nonsense. I think one root of the trouble is the failure to hold the distinction, noted earlier, between crafts which, like sculpture and painting, produce works that (irrespective of both their purpose and their quality) make their effect simply by being works of art, and those which, like pottery (and indeed gold and silver plate), exist to produce objects of use to which art is a dispensable adjunct. Most black-figure and red-figure vase-painters seldom or never achieved artistry; and those that did (even the best of them, and they were fine artists) remained workers in a utilitarian craft and often produced work that is no more than that.

Beazley learned both approach and method from students of Italian Renaissance painting, and his terminology in his early articles suggests that he thought of his field as not essentially different from theirs: the use of 'Master' where he later used 'Painter', and terms like 'school-piece'. He found that Morellian technique (recognition that each artist has a habitual way of rendering detail – ears, hands, drapery-folds) could be applied peculiarly well to the linear drawing on vases; no less well in bad than in good work, and he applied it all across the field.

Since in Renaissance Italy, as in all times and places, there were both good and bad artists, and good artists sometimes did bad work, it may be felt that the distinction I am insisting on between non-utilitarian and utilitarian crafts is not significant, but I believe that it really is. I am convinced that the finest Attic vase-painting earns a place in the history of Greek art on its own merits, even if it were not the best thing we have to guide us through the largely lost story of Greek painting which is of such immense importance for the history of European art; and in that connection Beazley's recognition of the major vase-painters and their relationships is of great intrinsic value. Nevertheless I do believe that there has been an unfortunate side-effect.

There are, and have always been, plenty of good reasons for studying vases and vase-paintings of all ranges of quality: for their iconography, their prov-

enance, what they can tell us about Greek life and craft and trade; but it is fair to say that before Beazley only the *better* vases were given much consideration as part of the history of *art*. By the influence of Beazley's emphasis on attribution, in combination with his application of the method to good and bad work alike, the whole of Attic vase-painting has been lifted into a position of importance in the history of Greek art which only a small part of it really merits. It is primarily this, I think, which leads some scholars to dismiss Beazley's work as a blind alley, or at best as a now worked-out vein.

I believe that both these views are wrong. The picture of the field he has left us, Attic vase-painting as the work of interacting craftsmen, is far more alive and real than what we had before and makes the study of vases for the light they throw on other things far more interesting; but I am sure it is also important to continue work on the vase-painters. A turning away from attribution to consider art in a wider social view is now, I think, a general tendency in art-history. This is surely good, in our field no less than elsewhere; but it is still important to keep up the study of art in terms of individual artists and their styles. This is the groundwork of art-history; and there are special reasons for continued work on it in the study of Greek vases. The almost total lack of documentation means not only that the study of it as a social phenomenon is that much more difficult; it also makes the definition of individual artists a dif-

ferent problem. In a better documented time like the Renaissance the artists are, so to speak, a given. They are there, however much dispute may arise around them. The Attic vase-painters are Beazley's discovery; not, I am sure, his invention, but he did invent the field, and it is most important that other scholars should work it over. There is no place for a Bible in scholarship.

This book, however, is not a revision or critical study of Beazley's work, though on occasion I find myself in disagreement with him; rather an attempt to fill a gap in its presentation. If Beazley had left us a *Development of Attic Red-figure* to go with his *Development of Attic Black-figure* I should probably not have written this, but this is not the book Beazley's would have been. It is my view of the field Beazley opened, looked at for its importance in the history of Greek art; hence the form of my title. I aim at the same time to indicate the range and variety of production in the Kerameikos over these years, but mainly as a background to the work of the better artists. The majority of Painters and Groups listed by Beazley get no mention, nor am I more than incidentally concerned with iconography and other aspects of the study. They interest me greatly, as they did Beazley, but my aim here is to give a clearer picture than exists at present of the development of fine Attic vase-painting in the red-figure period; and one of my hopes is that such a picture will facilitate these wider studies.

I

The beginning of red-figure

I. The invention

Black-figure is in essence a technique developed by vase-decorators for its decorative values. It can be used for quite complex narrative; even, by exceptional artists, to express some degree of emotion (Exekias) or wit (the Amasis Painter); but these are not its natural function. The dominance of the decorative is emphasised by a notable tendency to symmetrical composition: a mythological scene framed by onlookers who have little or nothing to do with the story or are positively intrusive, there only to make a formal, balanced design.[1] At the early stage of the archaic style when the technique was evolved, decorative values were generally dominant; and it remained essentially unchanged through the middle decades of the sixth century when art was changing character. Sculptors (and no doubt painters too, but what remains of their work is too scant to tell us much) were always pressing towards a greater understanding of natural forms, and at the same time towards command of complex action and grouping. One sees the first tendency in the developing anatomy of kouroi, the increasing complexity of the kore's drapery; both tendencies together in relief and pedimental sculpture. Attic vase-painters were debarred by the limitations of the black-figure technique from full participation in this movement. Yet it became less and less possible for any artist to ignore it, and by the end of the sixth century it had engendered the ferment which led to the abandonment of conventions which archaic art had inherited from earlier arts of the near east, and eventually to the establishment of the Greek, classical style.

We noticed in the black-figure of the early sixth century a moment when it seemed that the special character of the best Athenian vase-painting might wither away, and the craft revert to its more usual situation of supplying useful articles with unambitious decoration. Instead we got the brilliant revival epitomised for us in Kleitias and Ergotimos's François vase and carried on through several generations. Exekias and the Amasis Painter, however, seem only just able to

manipulate the technique to express what they want; and looking at the work of their followers one again feels the likelihood that the craft will lose its peculiar status. Once more, though, that was averted; this time by the invention of a new technique which allowed, within the craft, an *art* of vase-painting to continue.

The Amasis Painter, we saw, liked sometimes to draw in outline (fig. 1), using it chiefly for women's skin instead of the usual white silhouette.[2] Outline drawing has far greater possibilities for an artist interested in how to render bodily forms and drapery than does the shiny black silhouette with its engraved detail; but reliance on the decorative effect of silhouette was evidently deep-seated among Attic ceramists. The inspired solution was to reverse black-figure, using the shiny black for background, leaving the figures in the orange colour of the clay. Detail is then put in with a brush (or some other instrument giving a fluid line) as in outline drawing, but the silhouette principle is preserved; only light on dark instead of dark on light.

This 'red-figure' is a more laborious technique than black-figure. Before you put in the background you must know exactly where you want it to go, erasure being difficult with these materials; and you cannot simply draw the figures in outline and then put the background in. If you do that, the figures appear strangely etiolated. In an outline drawing the figure which the eye takes in is defined by the outline, which has a thickness of its own. If such an outline figure is drawn, and the artist then darkens the background up to the edge of the figure, then the outline vanishes in the background and the observer's eye sees only the space within the original outline, and this has not the full value of the figure originally drawn. The Amasis Painter was aware of this. When he shows the naked body of a nymph in outline against the black silhouette of a satyr's he stops the black just short of the outline (fig. 2). Once, on a small black jug with the main (black-figure) picture in a reserved panel on the front, he draws at the base of the handle a panther-mask in outline (fig. 3). It is completely surrounded by black; but again he does

not bring the black quite up to the edge of the outline, so this is not true red-figure though it looks forward to it.[3]

There are interesting experiments on seventh-century Cretan pots from Arkhades. Animals are drawn in outline, and the background filled in round them. The outline is generally left visible within the background, as the Amasis Painter leaves it, but once the background is brought right up to the outline, absorbing it, with the effect that the figures are unnaturally thin.[4]

Fig. 3. Oinochoe; Amasis Painter. Vignette at handle-base: panther-mask. H. of mask *c.* 0.025.

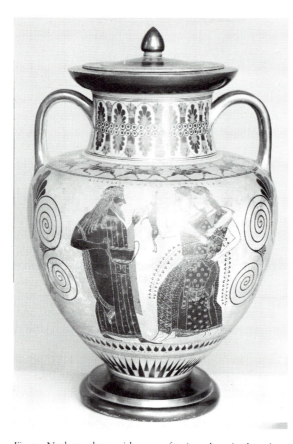

Fig. 1. Neck-amphora with name of *poietes* Amasis; Amasis Painter. Dionysos and nymphs. H. without lid (which does not belong) *c.* 0.33.

Fig. 2. Detail of 1. Nymphs

The solution found by the inventors of Attic red-figure is, after putting in a careful preliminary sketch, to begin by outlining all figures with a band of black, the so-called 'eighth-of-an-inch strip'. This strip is broad enough to suggest to the draughtsman's eye a background rather than an outline, and so allows him to realise the full presence of the figure within it. It can be seen on unfinished pieces, and generally on finished ones, where it stands up perceptibly against the surrounding black. It is not, however, intended for the observer's eye; only to help the artist to remain aware, while he is drawing the figure, of how it will look against the black of the completed vase.

Vases were thrown on the wheel in several sections, mouth and foot separately from the body, which itself was not always one. They were then joined, and the rolled handles added; and the pot was left to dry to a leather-hard state, when the decoration was put on. Preliminary sketch, visible on some black-figure and much red-figure (both in reserved areas and under the black) appears as slight indentations along the lines of the figures and sometimes diverging from them. The blunt instrument used was probably of charcoal or lead, and the colour left will have burned off in the firing. The black is a solution of the same clay as the pot, and when painted on was probably not very different in colour. The final contrast was achieved by a three-fold firing in the kiln. In a simplified summary, the first phase, in a dry heat, oxidised the whole pot red; the second, in a damp heat, reduced it all to black; in the third, dry again, the reserved clay surface reoxidised to red while the solution, which had partly sintered, resisted reoxidisation and remained black. Not infrequently accidents caused this too to go red or reddish brown.[5]

The free use of additional white and red makes black-

figure essentially a four-colour style. Red-figure, after the earliest experiments, employs these far less, so the effect is very different. In particular white is no longer used for women's skin. The black-and-white contrast of black-figure is only an extreme form of an ancient convention, found in Egyptian painting and elsewhere: man is ideally tanned, woman ideally pale; and the idea continues long after this. In late fifth and fourth-century red-figure it becomes common again to whiten women's skin; and when, about the same time, painters on panel and wall tentatively introduced shading, they seem to have used it first on inanimate objects and men's bodies, only later on women's.[6] Even in Roman painting the sex-contrast of brown and pale is often marked. No change of social attitude is reflected in the red-figure practice. Among upper-class fifth-century Athenians the rule that men (athletes, fighters, social beings) belong in the sun, women in the shuttered house, was probably more absolute than at any other time or place in antiquity. The abandonment of the colour-contrast is a technical development, arising perhaps from the fact that in black-figure white is almost always laid over black underpainting; but to our eyes the abandonment adds to the natural effect; and it allowed developments in drawing the human face and form to be carried on in figures of both sexes, though the athletic male body is always the main focus.

The reasons put forward here for the invention of red-figure seem to me sufficient: an internal necessity of the craft/art; but other sources have been sought. In archaic reliefs the figures were comparatively lightly painted and stood out mainly white against the blue or red background, and it has been conjectured that the inventor of red-figure was a marble-carver who moved into vase-painting.[7] The observation is just and relevant, but I doubt if the conjecture is necessary. Liking for light-on-dark is often found in Greek art. For instance, when about a hundred years after this mosaic floors begin to be laid in Greece, this decorative principle is almost invariably followed. I see red-figure as another case of the preference. For Vickers the change was forced on Attic ceramists by their having to copy designs for a new style of metal vessel, a reflection of increased wealth: bronze with silver figures gives place to silver with gold figures.[8] To the reasons I have given for rejecting this whole construct I will add here that red-figure does not seem to me a likely response to the challenge of finding a ceramic version of gold-figure. Gold-figure is achieved by incising the design in the silver and pressing gold leaf into it. A ceramic technique which is both much less trouble than red-figure and makes an effect more like gold-figure is found in Athens at this time. In this the vase is completely blacked, figures and ornament added on top in a light colour, with incision for details. This, known as 'Six's technique' from the scholar who first

studied it, was never very popular in Athens, probably because it was no better than black-figure for the new interests of the draughtsmen. A version of it, however, became regular in Etruria, as an easy way of producing vases that give something of the effect of Attic red-figure if not looked at too closely.[9]

In this Etruscan form it is perhaps better called 'pseudo red-figure', and some of the Attic examples, relatively large vases, have the same character, a single pink-brown colour being used.[10] More typically, Six's technique is employed by Athenian craftsmen (mainly minor black-figure painters, but there are pieces by Psiax) on small vessels, especially lekythoi; and other colours are added, giving a very different effect from red-figure. In this form the technique may well be more directly influenced by metal models than any other. I have no doubt the ceramists were constantly interested in what the metal-workers were doing and borrowed from them freely, but only ideas which they could adapt to their own strong tradition. It was a period of lively experimentation in the Kerameikos; and the experiment which took firmest hold and became the norm, red-figure, seems to me the least closely related to metal-work, looks more towards drawing. Another technique begins to be developed a little later than this by red-figure artists in certain special contexts, and becomes of the first importance: drawing in outline on a white ground, with steadily increasing polychrome additions. This takes off from the style of red-figure and becomes closer and closer to panel-painting. Attempts to associate this also with the industry in precious metals depend on the assumption that the white ground must be meant to suggest ivory. Perhaps it sometimes is so meant, probably sometimes to suggest alabaster; certainly in some special cases at the end of the fifth century, marble; but it seems to me probable that most often, if the craftsman had in mind anything beyond his own craft, it will have been the white priming of a wooden panel.

A word more on gold-figure and 'silver-figure'. Examples of gold-figure exist, none as early as the first red-figure. The technique may have begun as early, but such resemblance as there is between these two products of different crafts does not make me feel that one has to postulate the existence of gold-figure before red-figure could be invented. 'Silver-figure' is only a hypothesis. If it existed it must have been made in quite a different way from gold-figure, since silver cannot be beaten leaf-thin.

II. The inventors

The point in the development of black-figure at which red-figure was invented is given by a number of vases which bear pictures in both techniques. Such 'bilinguals'

of various shapes were evidently produced over a considerable period, but there is a group of large amphorae ('amphora Type A', the favourite shape at this time for elaborate work in black-figure) on which the red-figure picture is in a 'primitive' style, the painter evidently feeling his way in a new technique. Several vases of the same shape with both pictures in red-figure were evidently decorated by the same hand as most of the bilinguals. Two of the amphorae entirely in red-figure have the name of a *poietes* Andokides incised on the foot, and the artist is known as the Andokides Painter. His drawing shows a progression from a very hesitant manner to a much more assured one, without ever moving away from the decorative ideals of black-figure or seeming to realise the potential of the new technique. The black-figure pictures on these bilinguals (on none of which the Andokides Painter's red-figure is as primitive as on some of the purely red-figure amphorae) are by one hand which can be seen to have decorated also many purely black-figure vases (fig. 4). He is indeed one of the leading black-figure vase-painters of the time, and demonstrably a pupil of Exekias. He is known as

the Lysippides Painter; and the question is endlessly disputed whether the Lysippides and the Andokides Painter were one man or two (fig. 5).[11]

The black-figure and red-figure compositions on one vase, while sometimes quite different and sometimes the same scene with variations, are in other cases all but identical; and a peculiar rendering of Herakles squatting to tempt Cerberus to come on the lead is found in red-figure on an amphora in the Louvre by the Andokides Painter, and on an all black-figured one in Moscow by the Lysippides. There is also a cup in Palermo with the name of Andokides as *poietes* and bilingual decoration: an 'eye-cup', the most popular cup-form in black-figure of this time and soon taken over into red-figure. In this form of cup the short, stout stem is sharply set off from the broad, rather deep bowl, which is decorated with a huge pair of eyes on either side, a fantasy taken over from earlier cups produced in other centres than Athens and, like the gorgoneion (gorgon-mask) favoured for the interior, thought to have an apotropaic, protective, intent. Much of the gorgoneion is always drawn in outline, so that it adapts easily from black-figure to red-

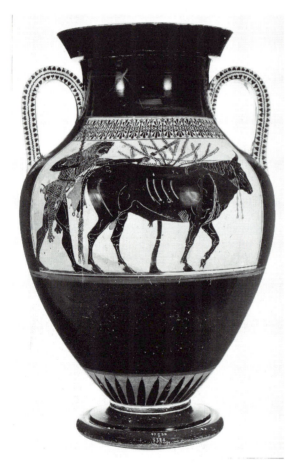

Fig. 4. Amphora Type A; Lysippides Painter. Herakles driving bull. H. *c.* 0.53.

Fig. 5. Other side of 4. Andokides Painter. Herakles driving bull.

figure. The stem of the Andokides cup is lost, taking most of the gorgoneion with it, but the bowl is largely preserved (fig. 6). It is dimidiated under the handles, one face reserved with a pair of archers between the eyes in black-figure attributable to the Lysippides Painter, the other black with a trumpeter in the same position in the Andokides Painter's red-figure. At each handle is a fight, a black-figure against a red-figure rank, and in each case a black-figure warrior fallen under the handle stretches his shield-arm forward so that it is drawn in red-figure.[12]

If this is the work of two men it shows very close collaboration of an unusual kind, and it is easier to think it the work of one. Against this is the fact that the Andokidean and Lysippidean styles look different, the black-figure being markedly stronger. That could be because black-figure was the technique in which the single artist got his training, in the other he was feeling his way. I have argued in the past for this, but I am not happy with it. The difference in style seems deeper, a matter of character, and it was this I suppose which led Beazley, after several changes of opinion, to come down firmly in favour of separating the artists.[13]

The Andokides Painter must, however, have been trained in black-figure, unless, as one theory has it, he was not originally a vase-painter at all but came in from another art. It has been noticed that his style is in some points very close to that of some of the reliefs on the Siphnian Treasury at Delphi.[14] Much of the design on these reliefs is carried through in paint; the sculptor must have been a painter too. The Delphic legend of the theft of Apollo's tripod by Herakles (represented in the gable of the Siphnian building) becomes popular at this time in Attic vase-painting, and two examples are by the Andokides Painter, one among his earliest work. The suggestion is that the Andokides Painter was originally a stone-carver and painter who worked on the Siphnian Treasury and later turned vase-painter in Athens.[15] I find this theory charming but difficult to accept. In ancient Greece as in Renaissance Italy the same man could often be painter and sculptor; but the craft of pottery seems to me on a different footing, even though Attic vase-painting had a fine-art side. I think it unlikely that anyone would become a vase-painter who had not been through the shop from boyhood, turning the wheel, working the clay, learning to pot and paint before he specialised. This type of general argument, though in our lack of documentation we have to use it, may not really apply here, but I find support for the conclusion in two different points. One is that the style of the Andokides Painter's red-figure, though not much like the black-figure of the Lysippides Painter, seems a pure product of the black-figure tradition in its decora-

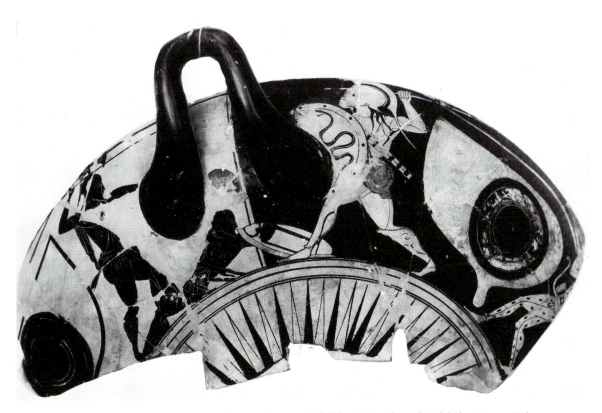

Fig. 6. Cup with name of *poietes* Andokides; Lysippides and Andokides Painters. Fight. H. of picture *c.* 0.10.

tive character; the other that the invention of red-figure seems to arise so naturally out of the needs of Attic vase-painting at the time that there is no need to bring in an inventor from outside. The relation between vase-painting and other crafts is something we shall come back to in a later chapter in connection with finer artists.[16]

The likeness of the Andokides Painter's style to that of the Siphnian Treasury reliefs is real, and significant, I believe, for date. A passage in Herodotus has generally been held to show that the treasury was set up not long before 525 B.C. Francis and Vickers have reasoned that the conclusion is unsound,[17] but to my mind have failed to prove their point. I conclude that the Andokides Painter's earliest work, and so the invention of red-figure, are to be dated around the end of the third quarter of the sixth century.

It is by no means certain that the Andokides Painter was the 'inventor' of the new technique. There are many more pots in primitive red-figure, some obviously imitations by incompetents but others good work; and there is one other strong artistic personality who evidently was in at the beginning. The only bilingual amphora with the name of the *poietes* Andokides, in Madrid, has pictures by neither the Lysippides nor the Andokides Painter. Black-figure and red-figure panels alike are in a distinctive style, surely the work of one artist. The red-figure picture is certainly by the same painter as two, both in the same technique, on an amphora with the name of a *poietes* Menon, and the painter was long known as the Menon Painter. A resemblance in style, however, to pictures on two small red-figured alabastra, in Carlsruhe and Odessa, which bear the names of Hilinos as *poietes* and Psiax as painter was early noted.[18] Other red-figured pieces are intermediate in scale and elaboration between the amphorae and the alabastra, and it is now accepted that the Menon Painter's name is Psiax.[19]

More black-figure than red-figure is ascribed to Psiax, and he is closely related ('brother', as Beazley puts it) to a black-figure artist, the Antimenes Painter. This fine and prolific craftsman, centre of a large group, shares with the Lysippides Painter the domination of black-figure painting in this generation. Both groups were bulk producers of standard neck-amphorae, the Antimeneans similarly of hydriai. A feature of these hydriai is the

Fig. 7. Hydria; Antimenes Painter. Women at fountain. H. of main picture *c.* 0.17.

narrow 'predella' under the main picture (fig. 7), generally with animals, in a delicate miniature style derived from that of the black-figure Little Master cups.[20] Psiax, a precise, even finicky, draughtsman, is at his best in miniature, or at least on a small scale. A neck-amphora in London which he decorated for the *poietes* Andokides is of idiosyncratic shape and the body is black, the pictures small black-figure panels on the neck; and some of his best work is on red-figure cups and on black-figure kyathoi (a kind of ladle with a tall handle). On these he often uses a white slip. Shape and decorative scheme of the neck-amphora (found also on two ascribed to the Antimenes Painter) are probably a case of direct imitation of metal-work.[21]

Though not at his best in large-scale compositions, Psiax is a finer and more boldly experimental draughtsman than the Andokides Painter. One of his red-figure cups (fig. 8) shows figures in foreshortened poses of a complex kind which one associates with the 'Pioneers' of the next generation.[22] I used to suppose this late work under Pioneer influence, but now wonder if Psiax was not rather the innovator. True, he can well have lived to be influenced by the later artists; the Andokides Painter certainly did so. Two of that painter's red-figure amphorae with the name of Andokides have Herakles stealing Apollo's tripod. One, in New York, with a Dionysiac scene on the other side (fig. 9), very hesitant in style and technique, is certainly among the painter's earliest work.[23] It has black-figure decoration also, but subordinate: a little picture on either face of the lip with

Herakles and the lion. These are on a white slip which has flaked, and it is hard to say if the small, damaged figures are by the Lysippides Painter. The other amphora with the tripod story, in Berlin, is very much more accomplished. On the reverse are athletes.[24] The complexity of a wrestling group suggests Pioneer influence, and the late date seems proved by the form of a neck-amphora which the painter shows standing on the ground (fig. 10). The standard black-figure neck-amphora is a broad stocky vessel. It is not one of the limited number of shapes used by the first painters in red-figure. The Pioneers are the first to adapt it to the new technique, and they remodel it, tall and slender, exactly as this pot pictured by the Andokides Painter.[25] The figure-drawing on this vase, however, in spite of evident influence, has far less of true 'Pioneer' character than that on Psiax's cup, and it is possible that Psiax had from the start more feeling for the possibilities inherent in the new technique than did the Andokides Painter.

Beazley noted that 'there are indications that Psiax may have been a pupil of the Amasis Painter'.[26] The Lysippides Painter certainly learned his style in the rival tradition of Exekias. If the Amasis Painter's experiments with outline had any direct influence in the creation of red-figure it was surely through Psiax. A scenario which makes sense (I claim no more for it) has Psiax inspired by the Amasis Painter's use of outline to invent the technique of red-figure, and by his own inventiveness to push it in the direction of its greatest stylistic potential; while the Lysippides/Andokides partnership, or painter,

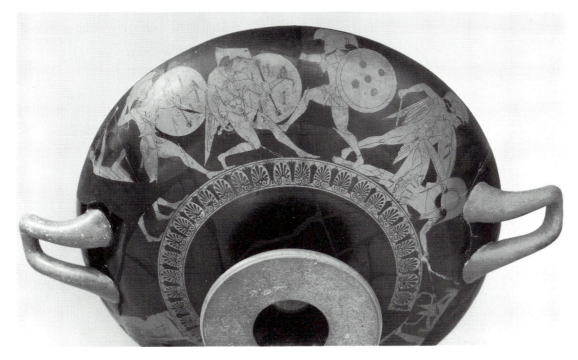

Fig. 8. Cup; Psiax. Fight. H. of picture *c.* 0.08.

Fig. 9. Amphora Type A with name of *poietes* Andokides; Andokides Painter. Dionysos with satyr and maenad. H. *c.* 0.57.

takes it up and exploits it as a pleasing decorative variation on black-figure.

It is interesting that both groups worked at one time or other with Andokides, whatever role the *poietes* played in this instance.

Fig. 10. Amphora Type A with name of *poietes* Andokides; Andokides Painter. Athletes. H. of picture *c*. 0.17.

III. The second phase

The styles of Psiax and the Andokides Painter still carry an aura of black-figure. Though white is rare there is much use of red, and Psiax even tries incision on the reserved figures, where it works to little effect. More importantly the thin black brush-lines, which on the reserved figures normally take the place of incised ones on the black, have in these painters' work as little variation as those. Soon, however, other artists appear who, though on early pieces (which cannot have been painted long after the invention) they still make some use of black-figure, seem from the beginning more at ease in the new technique.

Black-figure vases show two principles of decoration, favoured on different shapes: light vases and dark vases. On dark vases most of the surface is covered with black and the pictures are in reserved panels. On light vases the all-black surfaces are limited (often mouth, handles and foot) and the areas not occupied by the pictures have pattern-work, dark on light. Red-figure was easily accommodated to a dark vase like the one-piece amphora, the black surround simply extended into the background of the picture-panel. The neck-amphora

is a light vase, the black-figure pictures framed by lotus-and-palmette designs and the vessel circled below with graded bands of ornament. This may be the reason that the neck-amphora is only used for red-figure in a remodelled form. Rare early attempts to set a red-figure panel on it are the work of inferior craftsmen and very unsatisfactory. However, the same is true of early red-figure hydriai, yet the black-figure hydria is a dark vase, the pictures in panels on the front and the shoulder, which seems easily adaptable to the new technique.[27]

After the amphora the most important shape in early red-figure is the eye-cup. These cups in black-figure have the whole interior black, except for a tiny reserved disc or a gorgoneion at the centre; outside only foot, stem and the lower part of the bowl, the eyes and figures being in the broad reserved areas between the handles. Psiax decorates whole eye-cups in red-figure: not only the eyes and figures between or beside them on the exterior, but a tondo in the centre of the bowl. Within a narrow reserved circle he draws a single figure or an elaborate floral. We looked at the peculiar bilingual with the name of Andokides. What becomes regular is a bilingual on a different pattern: an exterior entirely in red-figure; within, a black-figure tondo, never more

15

than a single figure, surrounded by the broad black bowl.[28]

Many painters specialised in these cups, and the two most distinguished have left us their names: Epiktetos and Oltos. The first signs many of these early eye-cups as well as maturer works, but the name of Oltos is found only on two larger cups, from later in his career and of different form. The attribution to him of the early pieces is made by stylistic association. I have no doubt it is correct, but the distinction should be noticed.

In bilingual eye-cups the black-figure is normally by the same hand as the red-figure, but the artist seems less interested in it; and while a great many vases decorated in red-figure only are signed by or assigned to Epiktetos and Oltos, they have none in black-figure alone. The drawing on the early eye-cups is often simple: the back view of a satyr on a cup by the young Epiktetos in London has gone wrong, but in this figure and his fellow on the other side the craftsman seems as *technically* at home as in the charming but slight horseman who occupies the black-figure tondo (fig. 11).[29]

As the styles of these painters develop we see the potential of red-figure beginning to be realised. The simple black brush-lines of the beginning are modified in two ways. First, more and more use is made of the so-called 'relief-line', a black line which does actually stand up in relief and is used for the main demarcations of the body, for drapery-folds, and often to give sharper definition to the contour. Then, the brush-line is modified by the use of a thinned version of the black. This comes out a golden-brown, capable of considerable modulation. It is used for drawing musculature and many other features, and also as a wash. These developments, tentatively explored by Oltos and Epiktetos

Fig. 11. Cup with name of *poietes* Hischylos and signed by Epiktetos as painter. Horseman. D. *c*. 0.11.

and their colleagues, were ready to hand for the new movement in the next generation.

The relief-line was known earlier. It is used, for instance, to separate the tongues in the pattern round the tondos of black-figure cups before the invention of red-figure, but it was painters in the new technique who first used it in figure-drawing. It is not certain how it was made. A syringe has been suggested; and more recently convincing imitations have been produced by dipping a hair in the black, then laying it on the clay surface and lifting it off.[30] It is supposed that the painter had a stock of hairs of suitable lengths by him, but I find it hard to think that such drawing as we see in red-figure could be produced by these means. Also, though a good relief-line has a perfectly distinct character, there are cases in which I am not sure whether a line is a relief-line or not, and others in which what starts as a clear relief-line seems by the end an ordinary brush-stroke. Perhaps the special effect was produced by a special brush, or a special way of handling the brush.

The London satyr-cup has Epiktetos's signature on the red-figure exterior and in the black-figure tondo a second inscription: *Hischylos epoiesen*,[31] found also on two other eye-cups signed by Epiktetos and a dozen more, bilingual or red-figure, decorated by other hands, as well as two black-figure band-cups. There are many such *poietes* inscriptions on early red-figure cups by many different painters. Whatever the meaning of the word *epoiesen* this suggests a fluid workshop organisation at the time. Among these names are two (both found on vases with Epiktetos's signature and on others attributed to Oltos) which show a usage particularly suggestive of the workshop-owner interpretation: Nikosthenes and Pamphaios.[32] A great many vases, black-figure and red-figure, decorated in a variety of styles with a great range of quality, bear one or other of these names, and they are found almost exclusively in Etruria. Among black-figure works with the name of Nikosthenes are a large number of bulk-produced neck-amphorae and kyathoi, the former of a special design based on an Etruscan model. These are evidently intended for a particular market, and the inscription looks like a trade-mark. The name of Pamphaios is found over a similar range. Among the vases with it are three specimens of a refined version of the Nicosthenic neck-amphora, with fine red-figure decoration attributable to Oltos.[33] Analogous is the distribution of another *poietes*-name, Kachrylion, but this appears only on red-figure and (except for one plate-fragment) only on cups, some of these too by Oltos, others by a great painter of the next generation, Euphronios; associations to which we shall return in the next chapter.[34]

A special feature of Oltos's neck-amphorae with the name of Pamphaios is the elaborate floral ornament in red-figure. On the amphorae by Psiax and the

Andokides Painter the ornament is still in the black-figure technique. The early bilingual eye-cups have generally a red-figure palmette at the handle. At first this is of a very simple kind, the so-called 'closed palmette' in which the leaves are drawn in relief-line on a single reserved mass, but as painters become surer of the technique they outline each leaf separately against the black. From this beginning stem the complex floral ornaments, mainly around the handles of cups or pots, which are one of the beauties of red-figure. Artists vary greatly in how interested they show themselves in this aspect of vase-decoration. We shall be noticing others who are, and Oltos is certainly first in line. No great development is found on eye-cups, but there are examples on cups which follow on not much later. The best of Oltos's work in this kind, however, is on the neck-amphorae and especially on a stamnos (fig. 12) (the first, uncanonical, example of a new shape of which

there will be more to say), which also has Pamphaios's name.[35] These pots too belong relatively early in his career though not to its start. On the stamnos the big palmette-complexes are different at the two handles, showing that they are not designed as framing for the figure-scenes but each as a piece of decoration on its own ('four-sided decoration', found often on later examples of the shape).[36]

Though Oltos worked chiefly on cups he decorated many other shapes and some of his best work is on large pots. Epiktetos is almost exclusively a painter of drinking vessels, mainly cups, except for a line in plates which include some of his best pieces. Rather surprisingly one of his earliest vases is a calyx-krater, in the Villa Giulia. He signed it, but his style is not yet formed and it strongly recalls Psiax, who was surely his teacher. A foot originally thought to belong to it bears the name of Andokides as *poietes*. The association would be

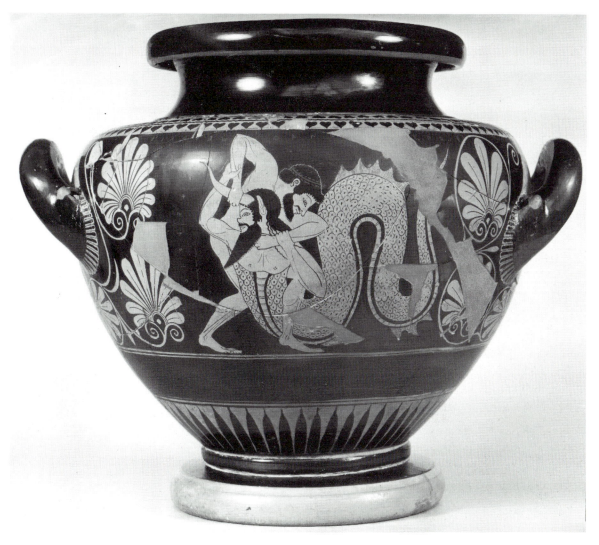

Fig. 12. Stamnos with name of *poietes* Pamphaios; Oltos. *Herakles and Acheloos.* H. *c.* 0.27.

17

unsurprising, but it is now said that the foot does not belong to this vase.[37]

The majority of eye-cups (apart from some early oddities and a later revival which we shall mention in another chapter)[38] are bilinguals with palmettes at the handles and a figure between the eyes, but there are variations. Some have a red-figure tondo; on some the eyes are set next the handles and the palmettes brought to flank the figure between them. Not far into the careers of Oltos and Epiktetos a new remodelling of the cup-shape takes place, and the old form gives way to it. The wide bowl is shallower, and instead of the sharp offset of the stout stem, the contour is a continuous S-curve from lip through slender stem to spreading foot: the kylix, which through much of the fifth century was to carry some of the greatest Greek vase-painting, and which remained in use to the end of the story. Cups of this kind are decorated in black-figure; there are plain black examples; and it becomes the first great vehicle for white-ground; but it is above all a red-figure shape. The exterior decoration is normally a many-figured scene between the handles, which may or may not have palmette-decoration round them. Small cups often, and sometimes larger ones, have a picture only in the tondo. Most of the best cup-work of Oltos and Epiktetos is on this form.

Oltos moved with the times, and there will be more to say of his style in the next chapter.[39] There is evidence that Epiktetos lived even longer, and we shall find more than one occasion to come back to him,[40] but once his style was formed he did not essentially change it. He is the first artist to show the full quality of red-figure, and his work has wonderful grace and charm.

Some of Epiktetos's best pieces are plates, tondos larger than his cup-interiors, with one or two figures perfectly disposed within a plain black rim and exquisitely drawn (fig. 13). It is rare in this phase of the art for cup-tondos to have more than one figure. Of Epiktetos's dozen surviving plates (almost all signed), all but one are from early in his career though later than the bilingual cups. The exception is interesting. A very fragmentary piece from the Acropolis bore a picture of Athena, certainly from Epiktetos's hand and once signed; the end of the word *egrapsen* survives. Of a second inscription all but the first letter of the name Epiktetos remains, followed by the beginning of *epoiesen*; the only *poietes* inscription with this name. The rim bears a pretty palmette and lotus chain (the lotus is an important adjunct to the palmette in red-figure ornament from Oltos on) and the form of rim and foot are quite different from those of the painter's other plates, much closer to examples decorated by younger painters.[41]

We noticed beautiful early black-figure fragments dedicated to Athena on the Acropolis by the maker: *autos poiesas*, 'having made it himself', where we felt the meaning must be 'made with his hands'.[42] A rather later red-figure painter, Myson, who specialised in column-kraters, signed one dedicated on the Acropolis with the formula: *Myson egrapsen kapoiesen*, 'Myson drew and made'.[43] Like Epiktetos's plate, this krater is on a different model from those the painter normally decorates. We cannot be sure in either of these cases that the dedicator was the painter himself, but it is a probable hypothesis, and the representations on Myson's vase (discussed in a later chapter)[44] seem to support it. I think it a further reasonable conjecture that it was customary at a certain stage for a vase-painter to dedicate a vase to Athena on the Acropolis, and when he did so to make it himself as well as decorate it, even though he normally adorned pots fashioned by others.

I have concentrated here on Epiktetos and Oltos because they are fine draughtsmen with an important place in the development of red-figure, leading on to the great innovators who are the main subject of the next chapter. In one section of that chapter, however, we shall have something to say of their many colleagues, and of the relation of cup-painting and pot-painting in this phase.

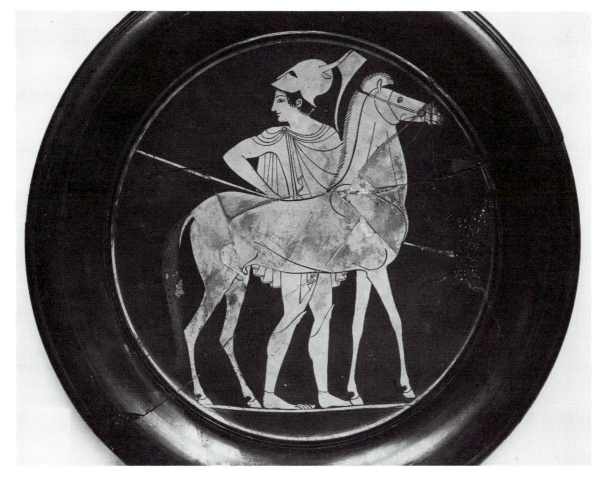

Fig. 13. Plate signed by Epiktetos. Warrior with horse. D. *c.* 0.19

2

A time of ferment: the red-figure Pioneers and their contemporaries

I. The red-figure Pioneers

The change from archaic to classical is marked by a climactic moment when sculptors made the momentous choice of relaxing the formal four-square pose without turn or shift of weight, which 'statue' had meant until then, in favour of a more natural stance, the weight unevenly distributed, slight turns in torso and neck. The first such new statue for us is the 'Kritian boy', a marble dedicated on the Acropolis probably (in my view) just before the Persian sack of 480. That it cannot be much earlier or later is shown by its resemblances to Roman copies of the bronze tyrant-slayers by Kritios and Nesiotes set up in 477.[1] This moment marks the explicit acceptance of a change in the approach to art, the seeds of which had perhaps always been present in Greek sculpture and painting, from their beginnings before 600, and which had been felt with increasing force (as we can see particularly in architectural sculpture) in the last fifty years or so before Xerxes's invasion. The friezes of the Siphnian Treasury at Delphi, which we noticed as giving an approximate date in the 520s for the invention of red-figure, are the work of two sculptors, of equal skill and art, one a formalist in the archaic tradition, the other revolutionary in the way he defies the surface-plane with three-quarterings and fore-shortenings.[2] The formal tradition does not die quickly (witness the draperies of late sixth-century korai), but the other becomes ever more powerful and intrusive; and when its full force is felt in Attic vase-painting it spells the triumph of red-figure over black-figure.

The new style is suddenly apparent in the work of a group of painters, the best of whom have left us their names: Euphronios, Euthymides, Phintias. Beazley called them 'Pioneers', I think, because, though they did not invent red-figure, it was they who showed its full potential. I think he felt (and I am with him) that the finest of all Greek vase-painting is found in the works of the next generation (his favourites were the Kleophrades Painter and Onesimos); and he saw the earlier group rather in terms of those who made that achievement possible.

That the Pioneers formed a group not only in our eyes but in their own is indicated by the way they put each other's names on their vases in various contexts. Most inscriptions painted on vases before firing are names, in four categories: with *egrapsen*, with *epoiesen*, with *kalos*, or beside a figure. The Pioneers are not alone in having a wider range, but they write on their vases more freely and with more variety than most.

A word about *kalos*-inscriptions. Some of Exekias's vases are inscribed *Onetorides kalos*, 'Onetorides is beautiful'; and from the later sixth through much of the fifth century the practice of praising youths in this way becomes exceedingly popular. Many of the artificial appellations we give painters are taken from these names: Lysippides Painter, Eucharides Painter. A woman's name with *kale* is found much less commonly. Sometimes two or more names are found on one vase. Often we meet a generalised form: *ho pais kalos*, *he pais kale*, 'the boy (or girl) is beautiful'; or simply *kalos*, *kale*. It is probably idle to seek a reason for this last practice. Equally pointless seems *epoiesen* by itself on many rough late cups of Epiktetos. Perhaps the painter (or someone else in the shop) just liked practising letters or doodling. Nonsense inscriptions, jumbles of letters, are found too, sometimes in the work of painters who elsewhere have sense, even on the same vase. But to return to the names with *kalos*; the practice is reported in other contexts. Aristophanes has a joke about *kalos*-graffiti on walls, and Pheidias is said to have written *Pantarkes kalos* (praise of his favourite Elean boy) on the ivory thumb of his great Zeus at Olympia. That was a personal choice, and so it surely was sometimes with the vase-painters. *Memnon kalos* occurs on many of the earlier cups by Oltos and nowhere else. Memnon must have been Oltos's friend, but in other cases the names seem to be those of popular favourites. Euaion son of Aeschylus, praised by several artists in the mid fifth century, has to be the tragic poet's son (himself a *tragikos*, tragic poet or actor), and there are many other such public figures widely praised.[3] A special case is Leagros.

This name is immensely popular with most of the Pioneers and some of their red-figure contemporaries, as

well as occurring on early pieces by some of their pupils. It is found too on half a dozen black-figure vases of the Leagros Group, to which it gives the name. This is important in confirming the contemporaneity of this group with the Pioneers, but much more chronology than that has been built on it. Leagros was a historical figure. And an attempt has been made to use his career to establish absolute dates for the vases.[4] However, it is impossible to establish the date of his birth at all closely, nor do we really know the ages between which a youth would be likely to receive this kind of homage. A *kalos*-name can be useful in establishing relative dates of different painters and groups, but for absolute dating it can only be taken along with other evidence to suggest a period in wide terms. We will put off a consideration of absolute chronology to the end of the chapter.

Of the three major Pioneers it seems that Euphronios was active before Euthymides and Phintias before Euphronios. Given the tiny proportion that survives of vases made, such a conclusion can easily be overturned by new finds, but it fits the evidence we have. First there is a cup with Phintias's signature and the name of a *poietes* Deiniades, not otherwise known.[5] The style of this piece is, as Beazley puts it, 'pre-Pioneer' (fig. 14). I doubt if without the signature it would have been ascribed to Phintias, though there is no reason at all

to doubt that it is his. Though not an eye-cup it is of eye-cup shape, all in red-figure; in the tondo a satyr, on one side the struggle for the tripod, on the other Herakles approaching the sleeping giant Alkyoneus. It is stylistically no more advanced than early work of Epiktetos and Oltos, and has technical features which suggest that Phintias was learning his craft from Psiax. The next works associable with Phintias are in fully developed Pioneer style, and we will come back to them after looking at Euphronios.

For long the earliest-seeming piece signed by this painter was a cup in Munich[6] (where the Phintias/ Deiniades cup is also). This is a large kylix of the new form. The signature is on the foot-edge, which bears a further inscription, naming the *poietes* Kachrylion. On the interior is shown a young horseman, perhaps Leagros whose praise is written beside him. Outside is a superb rendering of Herakles's fight with the three-bodied Geryon. There are many subordinate figures and, on the second face of the cup, Geryon's herd of cattle guarded by warriors. Under one handle the giant's ox-herd, Eurytion, lies dying; under the other a palm-tree indicates foreign parts. There is no handle-ornament, but a beautiful palmette-chain circles the cup under the figures' feet.

This has not the extreme emphasis on musculature

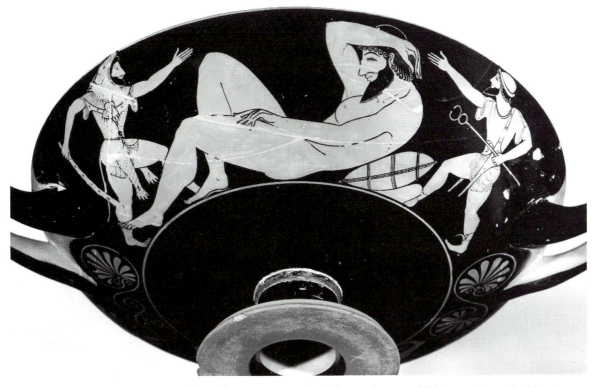

Fig. 14. Cup with name of *poietes* Deiniades and signature of Phintias as painter. Herakles and Alkyoneus. H. of picture, *c.* 0.11.

21

and foreshortening that we shall find in the full Pioneer style, but the interest is already there. It is a grand composition carried out with mastery, complex and vivid, unlike any cup-decoration attempted before.

Kachrylion's name is found on many other red-figure cups by many hands, including several ascribed to Oltos;[7] and with these (though it does not bear Kachrylion's name) goes a recently found second cup with the signature of Euphronios.[8] This, like those with Kachrylion's name and decorated by Oltos, is smaller than the Munich cup, and the style of drawing looks earlier; but in boldness of conception the main picture looks forward even more vividly to the artist's mature style. The tondo here has a complex floral (fig. 15), a feature found also in cups by Psiax and Oltos. On one side of the exterior is a *genre* scene: a man in armour dancing to a piper (the Pyrrhic), a boy and girl with flowers looking on. The principal picture is a story from the Iliad: Sleep and Death carrying the body of Sarpedon from the field before Troy (fig. 16). Euphronios returned to this in a major work of his maturity,[9] but the little early picture has to my eyes more tragic force. The huge torso of the dead hero, who has a black beard but golden hair (a wash of dilute black) is propped face up on the stooping back of Thanatos (Death), whose brother Hypnos (Sleep) behind holds the legs, while a Trojan warrior walks sadly in front. The attempt to show both feeling and physical effort is new.

This cup takes with it two others as certain early works of Euphronios, though neither is signed. One in Malibu, another recent discovery, is terribly ruined but small areas still reveal the quality.[10] This too has a floral in the tondo. On one side of the exterior is a chariot-harnessing, and the main picture is of Odysseus and Ajax bringing the body of Achilles to the Greek camp. This and the Sarpedon cup might have been designed as a pair. The other cup, long known, is in the British Museum (fig. 17). It has the name of Kachrylion as *poietes*. The tondo is figured, Theseus and Ariadne; and Theseus figures again on the exterior, in the main picture lifting the Amazon Antiope into his chariot.[11] Beazley ascribed this to Oltos. I think it certain that the new pieces prove it to be by the young Euphronios, and it becomes clear that at this period the two artists, both working with Kachrylion, came very close to one another.[12] The younger painter than went on to create the Pioneer style. Oltos never quite followed him into that, but the two late cups on which he put his name are big, elaborate pieces evidently inspired by such work as the Geryon cup, though without specifically Pioneer features.[13] To the same period belong splendid fragments of an amphora Type A by Oltos which have the same character.[14] Oltos's signed cups bear also the name of a *poietes* Euxitheos, and this is further found on an amphora Type C (smaller and simpler than Type A) decorated by the same painter with a single figure on either side;[15] and most interestingly on two very large pots with the signature of Euphronios as painter, masterpieces of his maturity. The incidence of Kachrylion's name, like that of Nikosthenes or of Pamphaios, perhaps suggests a trade-mark, owner rather than potter. One might have thought that Euxitheos succeeded him, but in this case the few appearances, linked to only two painters, seem more suggestive of the other usage.[16]

One cannot say that Euphronios was a pupil of Oltos. I see them rather as companions for a time and feel that Oltos, though surely the elder, was more influenced by Euphronios than an influence on him. Phintias, another

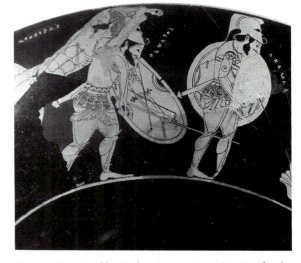

Fig. 15. Cup signed by Euphronios as painter. Interior: floral. D. *c.* 0.13. Fig. 16. Exterior of 15: Sarpedon's body borne from the field. H. of picture *c.* 0.13.

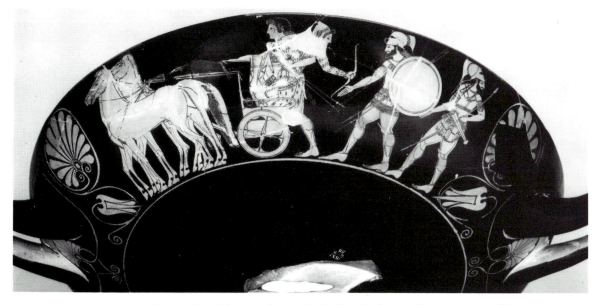

Fig. 17. Cup with name of *poietes* Kachrylion; Euphronios. Theseus carrying off Antiope. H. of picture *c*. 0.14.

older man, was won over completely to the new style. Of course new finds might show Phintias creatively working his way to it, as we see Euphronios do in the early cups, but I doubt it. The style of his early signed cup with Deiniades is unadventurous, and even in his mature 'Pioneer' work Phintias is a much less strong draughtsman than Euphronios. I see him as eager follower, Euphronios as pathfinder.

Phintias's major surviving works in his Pioneer phase are amphorae Type A, and this is true also of Euthymides, but not of Euphronios. We cannot of course say that he did not paint amphorae, but on the surviving evidence the big shape he preferred for his major works in the new manner was other: the calyx-krater. The amphora is a store-jar for wine; the krater a wide-mouthed bowl for mixing it with water (the Greeks rarely drank wine neat). Kraters take many forms, as we shall see. The earliest calyx-kraters we have (and they are almost certainly among the first made) are a fragmentary black-figure vase from the Agora at Athens ascribed to Exekias as a late work, and two complete ones which are at least very near him.[17] These probably antedate the invention of red-figure. There are more black-figure pieces from the circle of the Antimenes Painter,[18] and others contemporary with the Pioneers;[19] but Euphronios is the first to leave us examples in red-figure.

Complete or fragments, we have a dozen pieces from his hand, all very large. The most important feature of the shape from the decorator's point of view is the straight wall, sloping up and slightly out to a strong moulding at the top, from the shallow bowl on which the handles are set and which rises on a narrow stem

from the stout foot. This wall offers a particularly good field for figure-compositions. A complete vase in the Louvre, signed, has been long known and is the foundation on which the artist's modern reputation rests.[20] The principal face shows Herakles wrestling with Antaios, and the two huge bodies, locked in a grip on the ground, stretch from handle to handle (fig. 18). One of the giant's legs is doubled under him, the foot appearing foreshortened behind the buttock, and the musculature of both athletic figures is drawn in such detail as has prompted the suggestion that the artist had

Fig. 18. Calyx-krater, signed by Euphronios as painter. Herakles and Antaios. H. *c*. 0.45.

dissected cadavers. The elaboration, however, does not detract from the power of the design. One feels the struggle; and the outcome is hinted in the set face of Herakles, while his shaggy opponent bares his teeth in the frantic effort. Fragments of another such krater, signed by the painter, likewise in the Louvre,[21] show the same hero wrestling with the lion of Nemea in the same schema, stretched along the ground. This is a traditional design for the struggle with the lion in Attic vase-painting; and a unique composition by the Andokides Painter, on an amphora in London,[22] shows the next moment. The hero has risen to his knees and swung the beast up into the air over his head. The same end is surely implied for the giant Antaios, who took his strength from his mother Ge, Earth, and lost it when he was held away from her.

This picture is a programme piece of the new style, but the artist has put everything into the two principals. The little figures of women running in the background, local nymphs perhaps, disturbed by the attack on Antaios, are quite traditional in treatment; and the charming picture on the back, a musician mounting the platform, his audience sitting round, puts little emphasis on the new concerns.

None of these has the name of Euxitheos as *poietes*, but that appears on a third calyx-krater in the Louvre, very fragmentary, with Dionysiac scenes, certainly from Euphronios's hand though his signature is not preserved.[23] Some years ago a second virtually complete krater on the same scale and model appeared, and is now in New York.[24] This bears both Euphronios's signature and the name of Euxitheos as *poietes*. Here the painter returns to the theme of the early cup: Sleep and Death with Sarpedon's body (fig. 69),[25] but he treats it in a new way. Hermes in the centre directs the operation on Zeus's behalf. Thanatos bends to lift the shoulders while Hypnos takes the legs, and the composition is dominated by the huge naked corpse. Sarpedon here is a beardless youth, fair-haired. Death too is fair, his brother dark (one might have expected the reverse, but this is how the names are placed). Both are bearded warriors, as on the cup, but there (both dark) they are wingless, here winged. The group is flanked by standing warriors in profile, and more like them are shown on the back; well drawn, but as on the Antaios krater the painter has put all his art into the protagonists. The attempt to suggest the weight of the body and the effort of lifting is impressive but not entirely successful. Hypnos looks almost hump-backed, and I find the picture less effective than the Herakles and Antaios, as well as less moving than the little early cup.

The names beside the figures on that cup are put in letter by letter in the red-figure technique. This laborious process is found very occasionally in early red-figure,[26] but from the start the normal medium for inscriptions in the field of a red-figure picture is the purple-red used for wreaths, baldrics and the like. This is rather blobby and does not make for the fine lettering found sometimes when inscriptions are written in black on a reserved area, as regularly in black-figure and for craftsmen's names on handle or foot in red-figure. On the Sarpedon cup Euphronios put his signature in black round the edge of the foot, as he put the name of the *poietes* Kachrylion on the Geryon cup. The lettering is often good too when such names are incised in the black. Many of the *poietes*-inscriptions of Andokides are cut in the black of an amphora foot, as later those of the *poietes* Hieron in the black of a kylix handle.[27]

Purple-red is now used only for details like these. This restriction, with the mastery of relief-line and dilute black (though Euphronios often uses relief-line for anatomical detail where a later artist would employ dilute) makes the effect of these pictures quite other than the Andokides Painter's, even apart from the different style of drawing. Another very significant feature of the change is the rich use in Euphronios's work of red-figure florals. Black-figure calyx-kraters normally have animal groups or small figure-scenes on the bowl, and we shall meet this practice later carried into red-figure by some painters with a black-figure connection.[28] Euphronios puts complex florals in red-figure here, as well as in the area above the handles and round the rim. We saw fine experiments in this kind by Oltos on vases with the name of Pamphaios, before his association with Kachrylion and Euphronios. This seems to be an area in which the younger painter did learn from the older. None of the other Pioneers shows such great interest in florals, and we shall find the same division among the great painters of the next generation.

With these two great mythological scenes go several more on calyx-kraters: the signed fragments in the Louvre with Herakles and the lion already mentioned; a fragment in Milan with Herakles's head, and one in Malibu with an exquisite Athena.[29] Very fragmentary but much more substantially preserved is a vase in private hands.[30] The front shows Herakles's fight with the brigand Kyknos, son of the war-god Ares (fig. 19). Herakles has struck Kyknos down. He falls, bearded face turned full towards us; but the hero has to face another attack, from the divine father, who comes in, spear raised. Herakles is still concerned with the son, but his own divine patron, Athena, comes to the rescue, pressing past him, spear likewise raised, to confront the god. Behind Ares stands his consort Aphrodite, and at the other end was a figure, now almost entirely lost, wearing a long chiton and moving up behind Athena, probably Zeus who, in the legend, had to intervene with his thunderbolt to prevent the strife spreading among the gods. The way the powerful figures are massed in a complex composition, together with the extraordinary

Fig. 19. Calyx-krater signed by Euphronios as painter. Herakles and Kyknos. H. of picture *c.* 0.18.

refinement of detail, make this for me the finest and most interesting of all Euphronios's pictures.

The picture on the back of this vase, of which only fragments survive, showed athletes practising to the pipe, and will have given the artist more scope for his anatomical interests than the armoured figures of the obverse, though Kyknos, falling, bares himself from the hips down and has one leg doubled back like Antaios. A well-preserved calyx-krater in Berlin, ascribed to Euphronios, has athletes on both sides, but this is a slighter, quieter work.[31] A very fragmentary but very fine unsigned piece in Munich, with a symposium, will be considered later in another connection.[32]

With the calyx-krater goes another new shape, the

25

psykter or wine-cooler. A device for keeping wine cool by giving a pot double walls is found occasionally in black-figure, Chalcidian and Attic, amphorae or neck-amphorae with a spout on the shoulder to reach the cavity; and an early fifth-century red-figure column-krater on the same design has recently appeared.[33] The spreading form of the calyx-krater must have suggested the idea of designing a pot to stand in it and serve the same purpose: a mushroom-shaped vessel, hollow down to the flat bottom of the stalk. Many pictures show one standing in a calyx-krater at the symposium, and the way ladles are used show that the wine was in the psykter, the coolant round it. The first psykters, and pictures of psykters, are later than the first calyx-kraters, and the fashion is brief, while the calyx-krater remains popular to the end of Attic vase-painting and has a long history after that. There are black-figure psykters, but none need be as early as the first red-figure ones, and though two red-figure examples are attributed to Oltos these need not (though they may) antedate the first by the Pioneers.[34] Certainly it is among the Pioneers that the shape is first popular, which accords well with Euphronios's choice of the calyx-krater as the vehicle for his best work. He signs one psykter (as does Euthymides) and another, fragmentary and rather poor, is attributed to him; while others are given to Phintias, to Euphronios's imitator Smikros, to Euthymides's imitator, known as the Dikaios Painter, and as very early works to his great follower in the next generation, the Kleophrades Painter; or anonymously to the Pioneer circle. After that, though for a while very fine pieces are made, these seem special orders; and vases in this form, as well as representations of it, cease to appear within a couple of generations. On the conventional dating the whole series lies within the last quarter of the sixth century and the first half of the fifth.

Smikros, imitator of Euphronios: the relation has always been evident from the style, but its closeness has recently been more precisely documented. The best piece signed by Smikros (a nickname type of name, 'Tiny') is a stamnos in Brussels with a symposium on the front, slaves busy with the wine on the back.[35] The most lovingly drawn figure, a young banqueter, has the name Smikros witten by him: a 'self-portrait'. Some years ago fragments of a very fine calyx-krater with similar scenes, certainly attributable to Euphronios, began to appear. They are now in Munich and have been built up into a great part of the vessel.[36] It is clear that the pictures on Smikros's stamnos are reduced and simplified versions of those on the krater. Moreover, the beautiful young Smikros, his name beside him, is on the krater too: 'portrait of a colleague'.

The Pioneers, fond of the written word, make a good deal of allusion to one another. Euphronios 'represents' Smikros; Phintias 'represents' Euthymides and has a character greet him; Euthymides names Euphronios.[37]

One can deduce from this that they were interested in one another; possibly even that there was a 'Pioneer workshop' in which they all sat; but the practice raises other problems. Symposium and palaistra (athletes' exercising ground) were, with war and the training for it, the most constant features in the life of an upper-class Athenian youth. It is generally accepted (surely right) that the pictures of these themes on vases show people of that kind. This is confirmed by names like Leagros written by such figures. Phayllos, written beside an athlete in pictures by Phintias and Euthymides, was a famous athlete who became so rich that he could fit out a ship in the fleet which defeated the Persians at Salamis in 479.[38] How then does one explain the naming of vase-painters in such company? Smikros is shown at feast, Euthymides by Phintias as a youth taking a music-lesson and toasted by a hetaira in the way another hetaira, on a vase by Euphronios, toasts Leagros.[39] Even more explicit is a scene on a rough psykter with youths exercising and courting: one couple is given the names of Leagros and Euphronios. Some have taken these cases, especially the last, as evidence that vase-painters actually did mix on the most familiar terms in good society; but this I cannot credit. Vickers, believing that the names on vases are not those of ceramists but of silversmiths and goldsmiths whose designs, inscriptions and all, the vase-painters reproduced, sees no difficulty in the notion that these prestigious craftsmen rubbed shoulders with the *jeunesse dorée*. I find his whole theory untenable; but that aside I should find it very hard to believe that a craftsman, even one who worked with precious metals and so was better remunerated, would have been admitted as companion and lover by a young dandy.

To me the simplest supposition is that (as Keuls has suggested)[40] in these inscriptions the vase-painters are indulging in fantasy, putting themselves among the rich and high; and I see no reason to suppose that in most cases such joking would have been offensive to their customers. The portrayal of Euphronios as Leagros's lover might be an exception, and here it is important to establish the status of the vase. This, and a pair to it which has an interesting but obscure picture of youths at work with nets or packages, has been ascribed to Smikros, but I cannot see this.[41] On the evidence of the signed pieces, Smikros was not a draughtsman comparable to Euphronios or Euthymides, but he obviously appreciated Euphronios's style and tried hard to imitate it. In these two psykters (neither known to Beazley), the choice of shape, the inscriptions, and elements in the style show clear awareness of Pioneer work. The drawing, however, is not just lacking in care; it is grossly inept. An athlete in back view is a travesty of Pioneer style. I see these two vases as the work of an artist contemporary with the Pioneers but outside the circle, clumsily imitating, or perhaps rather rudely parodying,

their approach. If that is so, the pairing of Euphronios and Leagros could be different in intention from the Pioneers' pictures of each other.

Euphronios's signed psykter, in Leningrad,[42] shows four naked women reclining at a symposium. One pipes, and the other three hold each two large cups of varied forms. The symposium was a male institution. The wives and daughters of citizens in this most macho of societies led very cloistered lives, and female company for the drinkers was given by hetairai, courtesans. These provided sex and music, and no doubt conversation (Pericles's Aspasia came from this milieu). Whether hetairai really laid on their own symposia on the male model, as shown here and on a vase by Phintias, we do not know. It seems very likely; but a suggestion has been made that this is another vase-painters' joke.[43] This joke might have had more appeal to the customer than the other, and I do not think the idea is to be ruled out. One might possibly seek support for it in the fact that one of the women looks straight towards us. Frontal faces in this time tend to be grotesque, like satyrs, or distressed, like the dying Kyknos, and they are often bearded.

Artists hesitated to risk attempting a young and beautiful face in this difficult aspect. However, Euphronios was an innovator, and he has guarded himself by concealing all the lower face behind the cup.[44]

These women are of massy build, like many of the painter's men; but there is very little anatomical detail, and his mastery of the basic structure of the female form is much more hesitant than of the male. The naked man had been from the beginning the favourite subject of Greek artists. There are occasional naked women: ivory statuettes from a Geometric tomb marvellously transformed from an oriental model; sixth-century bronze mirror-handles; and from time to time in black-figure vase-painting;[45] but there is no tradition of how to treat the female nude, and it is long before one is established. Early examples tend to be narrow-hipped boys transmuted into girls by omitting the sex and applying small breasts. Euphronios here makes an effort at something different, and in the next generation other painters carry it further, but they are not very successful.[46]

Phintias's hetaira-symposiasts (fig. 20) are playing kottabos.[47] There are fuller pictures of this game, in

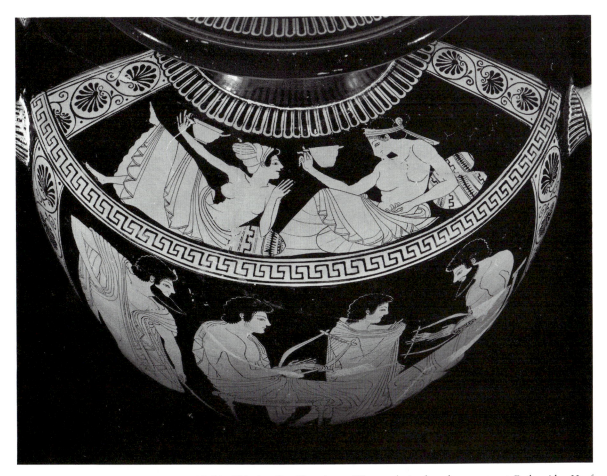

Fig. 20. Hydria; Phintias. Shoulder-picture. Women playing kottabos; one toasts Euthymides. H. of shoulder-picture *c*. 0.06.

which, when the cup was drunk nearly dry, the drinker would swing it by the handle on the fore and middle fingers and send the last drop out, aimed to land on and displace a small saucer on a stand. The drop could be dedicated to someone, and one of these women offers hers to Euthymides. On Euphronios's psykter Smikra (another Tiny) tosses hers for Leagros, and uses a Doric, not an Attic phrase; whether because it was a formula of the symposium, or that the vase-painter intended a real Smikra who was a Dorian. Phintias's women have mantles, but they are wrapped round the legs only, leaving the upper body bare, normally a male fashion. The painter has put in more musculature, in the tradition of the male nude, than Euphronios does on his women, and there seems here even less of an attempt at a different ideal, but the breasts are drawn with some care. On a later vase we shall see Phintias showing unexpected interest in the aging female form.

These women are on a smaller scale than Euphronios's and form a subordinate picture on the vase: the shoulder of a hydria, the main picture on which occupies the front of the body.[48] We shall come back to the history of the hydria in red-figure at the end of this section. The principal picture on this vase, in Munich, shows a youth, the name Euthymides written beside him, seated with a lyre opposite an older man also holding a lyre, evidently a teacher. Another pupil stands by, and a man watches, leaning on his stick. From now on there are a good many pictures of master and pupil, the subjects being music (generally the lyre) and poetry, represented by a scroll, sometimes inscribed with snatches of verse.[49] They parallel the palaistra, the training of the mind alongside that of the body. This is one of the most pleasing of Phintias's vases, but the quiet figures in the main picture, wrapped in their mantles, do not give much opportunity for Pioneer experiment. There is more in the women on the shoulder; more still on a second hydria, in London,[50] which Phintias signed (the Munich vase is an attribution).

The London vase shows three naked youths with hydriai at a lion-head water-spout, a bearded man wrapped in his himation leaning on his stick to watch them (fig. 21). Two more such recline on the shoulder, mantles round their legs, one holding two cups, the

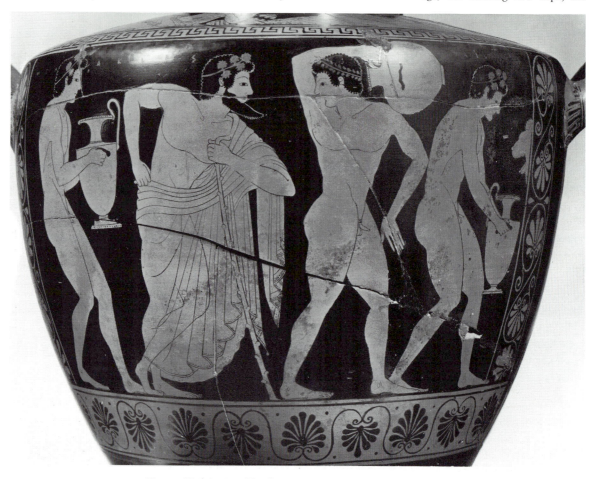

Fig. 21. Hydria, signed by Phintias as painter. Main picture: youths at fountain and man. H. of picture *c*. 0.18.

other a lyre: a normal symposium. Dozens of black-figure hydriai and a few red-figure show women with their pots at a fountain. From literature and art alike it is clear that in Greece, as in most contemporary and earlier cultures of the near east, drawing water for the household was strictly woman's work, and slave-woman's at that.[51] These youths so employed are not unique: a late black-figure lekythos found in the Agora at Athens has a similar scene, but the boys are wearing himatia;[52] and there are youths in himatia carrying hydriai on the Parthenon frieze.[53] These last are in a religious procession, and the action must have a ritual meaning. The same may be true of the youths on the vases. If not, they are drawing water for use in the palaistra, certainly not for domestic purposes.

The youths' bare bodies give scope for study of muscular action. One lifting a full jar shows a real feeling of weight and strain. The anatomical detail with which they are loaded is just like Euphronios's in general character, though details are Phintias's own. Closely similar are athletes on the reverse of an amphora Type A in the Louvre, unsigned but inseparable from the London hydria and from a signed amphora, the painter's most ambitious work, in Tarquinia.[54]

The athletes on the Paris vase are balanced, like those on Euphronios's Kyknos krater, by a mythological scene on the front: Apollo and Artemis coming to the rescue of their mother Leto abducted by the Giant Tityos. Here one feels the artist's weakness compared to Euphronios, but on the signed vase in Tarquinia he does better. On one side is shown the struggle for the tripod, reduced here to the two principals, Herakles and Apollo, alone. This is not unusual on certain shapes of vase, but is very surprising in an amphora panel, where many-figured composition had hitherto been the rule. It looks forward to developments we shall meet in the next generation. Phintias's composition and drawing are not, I feel, quite strong enough to make the two naked figures fill the wide space in an entirely satisfying way, but it is an interesting experiment. Another surprise is the way Herakles (the more effective of the two figures) is shown without a beard, though he has a fine growth of whisker. Soon after this it becomes the rule to show him so in his encounter with the lion, traditionally the first of his labours. By some accounts at least his anger with Apollo, which led him to snatch the tripod, was due to the god's refusal to purify him after he had killed the bard Linos, who was trying to teach the unruly boy the lyre;[55] so another episode from the start of his career. Phintias may have had this in mind, but we cannot be sure since there is a general tendency from about this time for gods and heroes, bearded in earlier archaic art, to be shown young. Euphronios drew dead Sarpedon first bearded, then a beautiful youth.

The picture on the other side is quite different: a five-figure composition centred on Dionysos. The god stands isolated on the black field over which his vine-branch spreads, on either side of him a compact group, of satyr and maenad. One satyr, embracing his girl, turns his face full to us. The detail, down to eyelashes and fingernails, is as finely drawn as in Euphronios, and if the figures are not so surely articulated the composition is still effective. There is a remarkable anticipation of this composition on a smaller black-figure amphora by the Amasis Painter;[56] one of those in which his drawing in outline of the maenads' naked bodies (in Phintias they are fully clad) looks forward to red-figure. It has been demonstrated that the Amasis Painter worked long enough to be influenced by the Pioneers, perhaps specifically by Euphronios.[57] This vase does not belong to that late phase of his work, and must have been painted long before Phintias's; but Phintias was active in pre-Pioneer days and his early cup shows links with Psiax, who has links with the Amasis Painter. There is no reason why Phintias should not have known such a composition of the older artist and have adapted it to a larger scale and to the new interests of Pioneer red-figure.

Among other works by Phintias are a number of cups, some signed. They are not big special pieces like Euphronios's Geryon ('parade-cups' those have been called; we shall meet others),[58] but one of them is of peculiar interest.[59] The painter has not made much of the satyr in the tondo, but on either face of the exterior he has taken some care over an unappealing picture of a young man in dalliance with a naked hetaira. She has a double chin and a heavy, wrinkled body drawn with surprising realism. The double chin recurs on a clothed hetaira shown by Euphronios piping at the feast on his Munich krater.[60] Her name is by her, Syko. Perhaps Syko was a well-known figure of the town and her portrait has been left us by Phintias too.

The last of the major Pioneers, Euthymides, seems to stand to Euphronios and Phintias rather as Oltos and Epiktetos to Psiax and the Andokides Painter. If Euphronios can be seen creating the Pioneer style and Phintias, having started as a draughtsman in an older tradition, enthusiastically taking up the challenge, Euthymides seems one brought up to think in the new style. At least there is a fluidity, an assurance in his mastery of it which the other two seem to obtain with a struggle. Of course the relations I am postulating between these artists cannot be proved to be factually correct. New evidence could easily upset it; but I believe that it gives a true picture of the kind of way the craft of pottery and the art of vase-painting developed in Athens in this critical time, and that is more important than details of priority between individuals.

Euthymides's signature survives, as we noticed, on a psykter; also on a plate and a 'parade-cup', both very

fragmentary,[61] and on two amphorae type A. Two more are certainly by the same hand as these. No calyx-krater is known by him and it seems that for him, as for Phintias, the amphora was the natural vehicle for major work.

Each signed amphora (both in Munich) has an arming-scene on the front; and in both the central figure, a young warrior, stands frontal, head bent and one foot turned to the side, and fastens his corslet. On one[62] he is flanked by his family, a woman holding helmet and spear, an old man wrapped in his cloak. In such scenes the old man is always the father, the woman may be mother or wife. Here we can be sure: the artist has written names: Priamos, Hektor, Hekabe. They are Hector, hope of Troy, with his father Priam and his mother Hecuba. In earlier work Priam's age is indicated by white hair and perhaps a bent stance. Euthymides makes him bald, with stubble on chin and sunken cheeks. There is evidence that later the mask for Priam in Attic tragedy was traditionally stubbly, and there may be a connection, but not necessarily. Euthymides loves to write on his vases, and the names are sometimes mythological, but he does not seem to have had as strong an interest in legend and narrative as some of his colleagues. The warrior's departure is a genre scene, and the near-replica, on the second signed vase,[63] of the Hector-figure has the name Thorykion, not known from mythology (*thorax* is corslet). His companions are not his parents but two squires, bowmen in Scythian costume. Such figures are shown in mythological contexts. They have been interestingly argued to have a special connection with Achilles,[64] and at times their costume is given to archer-heroes, Trojan Paris or Greek Teucer. However, they often appear in scenes which have no evident legendary allusion, and we know that the Athenians employed a kind of police-force of Scythian mercenaries.[65]

On the backs of both vases are genre-scenes: a *komos* (revel) on Hector's, athletes on the second, among them Phayllos.[66] Euthymides's signed psykter[67] shows athletes too, and there the young wrestlers on the front are named Theseus and Kl[yt]os. Theseus, legendary king of Athens and unifier of Attica, was being promoted at this time by Athenian propaganda as companion and equal of the great Herakles. He was sometimes claimed as the inventor of scientific wrestling, which may account for Euthymides's choice of name here, but this is in no real sense a scene of legend. Theseus is shown throwing the brigand Kerkyon, often in serial pictures of his adventures, structured on Herakles's, but Klytos (or however we restore the young partner's name) is not from legend, and the scene is as simple a picture of life in the contemporary palaistra as the fragmentary picture on the reverse. There one of the two is Phayllos again, and the picks that athletes used to loosen the hard ground with are lying around.

Theseus does appear in a genuinely legendary context in Euthymides's work. On a third amphora in Munich,[68] as fine as the signed two, he carries off a girl (fig. 22) with the help of his friend and constant companion Perithoos. The figures are named. Young *Theseus* lifts *Korone* high (her head overlaps the frame) and she plays with his hair, while he looks back at *Helene* who tries to restrain him; *Perithous*, bearded, walks behind with spear and sword and looks back, evidently at the figures shown on the reverse: two more of the victim's companions running in pursuit and an older man gesturing. Theseus is the Don Juan of Greek legend, but no Korone is named in the stories. A famous tale, however, was his abduction, with Perithoos's help, of the girl Helen from her father's house before she married Menelaos. It looks as though the vase-painter had put the names by the wrong figures. One of the women on the back has the name Antiopeia, an Amazon queen with whom Theseus was involved but who is certainly not meant here. There are other inscriptions on both sides, some words of doubtful relevance, some seemingly jumbled letters. This vase, in fact, is a good illustration not only of Euthymides's cheerful indifference to niceties of legend, but of another characteristic, his pleasure in writing whether or not he has anything to say.

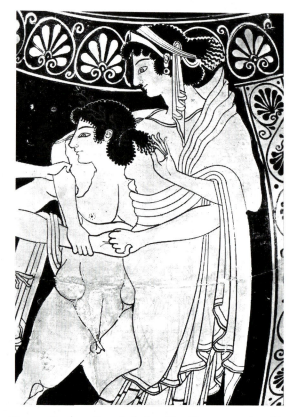

Fig. 22. Amphora Type A; Euthymides. Theseus carrying off a woman. H. of detail *c.* 0.16.

The picture on the front has a wonderful vitality and brilliance, and Theseus's naked body is splendidly drawn. Phintias makes more use than Euphronios of dilute black for anatomical markings; Euthymides does too, and in his work observed detail is simplified, clarified, subordinated better to the general effect. In such a scene as Herakles and Kyknos, Euphronios justifies his intricate detail by the power and complexity of the narrative composition. Euthymides has left us nothing like that, but his individual figures are better realised wholes.

Of the six pictures on these three amphorae, five are three-figure compositions, and in the one four-figure scene Theseus and the girl make a single element. On a fourth vase, in Paris,[69] the obverse is different, a warrior mounting his chariot, but on the back are three figures again. The simple alignment of these weighty people makes fine decoration, and the best of them are remarkable studies in form and movement. Particularly im-

pressive are the komasts on the back of the Hector vase, especially one in a back-view contrapposto of surprising sophistication (fig. 23).

We looked at the names on the front of this vase. It bears other inscriptions both front and back which need our attention. On the front is the artist's signature in a form he often uses: *egrapsen Euthymides ho Polio*, 'Euthymides drew, son of Polios (or Polias)'. We shall come back to the implications of this, and look first at what is written on the other side. One figure is labelled *komarchos*. This could be a name, but is perhaps more likely a title, 'leader of the revel'. He carries a kantharos, a metal shape, not very regularly copied in pottery, and when shown in pictures generally (but not always) in the hands of Dionysos or his followers or (often in a different form) of Herakles.[70] It seems to have had ritual use, and its representation here in the hands of *komarchos* might imply that this is more than an ordinary revel. There are also letters grouped and scattered

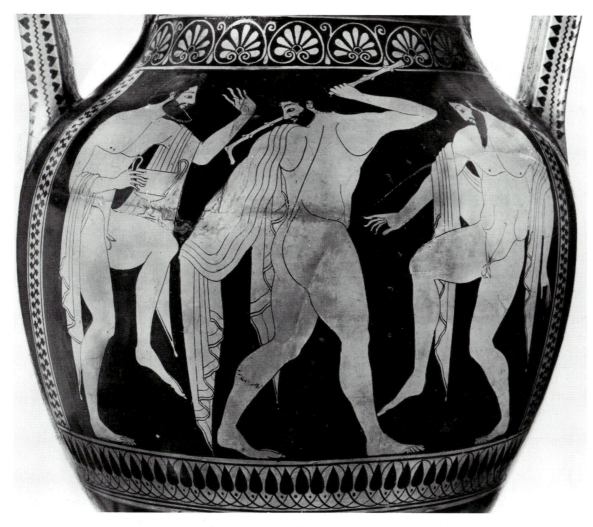

Fig. 23. Amphora Type A, signed by Euthymides as painter. Revel. H. of picture *c.* 0.25.

31

between the figures, and between two of them a complete phrase, *hos oudepote Euphronios*, 'as never Euphronios'. This has generally been interpreted as a boast by Euthymides: 'Euphronios never did anything so good'. Recently a scholar has read in the other letters a conversation between the komasts which leads up to the phrase with the meaning: 'Euphronios was never such a revel-leader as you are'.[71] There are things in favour of this interpretation. One might expect the painter's boast to follow directly on his signature; but I do not think this has much force. The boast applies best to the reverse-figures, while the signature is naturally placed on the front. The involvement, however, of a colleague in the action of the picture is very much in the Pioneer spirit. I do not, though, feel very happy with the other phrases read. On the whole I prefer the old interpretation, but the question remains open.

The appearance of the father's name in the signature raises another interesting question. The practice is found in *epoiesen*-inscriptions both of sculptors and of ceramists, and in several cases the father's name too is known in the craft. On black-figure vases we have inscriptions naming Ergotimos as *poietes*, Nearchos both as *poietes* and painter, and on Little Master cups the *poietai* Tleson and Ergoteles name Nearchos as their father, Eucheiros names Ergotimos. On red-figure cups a *poietes* Kleophrades names his father Amasis.[72] It has been suggested, and though this evidence is not proof it makes the idea plausible, that it was customary for a craftsman to record his father's name only if the father was a craftsman too.[73]

We have no record of a ceramist Polios or Polias, but the name Pollias occurs with *epoiesen* on several statue-bases from the Acropolis which can be dated by the lettering to about this time.[74] Polias is found as the dedicator's name in a painted inscription on a very fine, large clay plaque decorated in a modification of the black-figure technique with a picture of Athena to whom it was offered. The style is sufficiently like Euthymides's red-figure to make the attribution to him plausible. Another even larger plaque from the Acropolis is likewise of fired clay but different in intention, much thicker and probably architectural. It has a running warrior in a range of colours different from those of vase-painting: red-brown for the skin, outlined in black on a light ground, outline drawing for helmet and shield; only a garment round the waist is black with incised folds. On the three-quartered shield is a satyr, running and turning. Precisely the same figure, in reverse, is shown on the profile shield of Thorykion on Euthymides's amphora. It has been argued, with great plausibility, that these two plaques were painted by Euthymides, the first for his father Polias to dedicate.[75]

The use of the patronymic by the vase-painter son makes it probable, but no more, that the father too was a craftsman, and it is tempting to identify him with the sculptor. The spelling is no problem: it is a regular but not consistent practice in early inscriptions (till well after this time) to write a single letter to represent a double. The identification could never possibly be proved. What is interesting is the question whether the craft of vase-painting was close enough in character and status to that of sculpture to make such a transition in one family plausible. External evidence about the status of either craft, or that of panel- or wall-painting in this period is virtually non-existent, but we can surely deduce something from the character of the works themselves.

Part of the frieze of the Siphnian treasury at Delphi is completed in paint in a way which shows the sculptor either working in the very closest collaboration with a painter, or (which seems to me perhaps more probable) a competent painter himself.[76] With the statue-bases found in the wall of Athens hastily thrown up by Themistocles in 479 was one which had been decorated in paint alone. It bore an obliterated signature which has been read as that of Endoios, a known sculptor; it was in any case probably that of the sculptor of the statue which stood on the base.[77] The reliefs on the bases found with it (they all probably originally formed a connected group) are very pictorial and very strikingly like red-figure Pioneer drawing. When I speak of Euphronios 'creating' the Pioneer style I mean creating it as a vase-painting style. In a wider view it is part of the whole artistic movement of the time, which finds extraordinarily similar expression in different media.

Earlier I stressed that even the finest vase-painting is subservient to the needs of a craft the business of which is to produce containers which need not, to serve their purpose, have any artistic character at all. It is important to remember this to account for the extreme range of quality in even a good vase-painter's work; but in the present context it is of little significance. The fact that a sculptor's work can serve its purpose only by being a work of art does not prevent much sculpture being very poor and lacking in artistic quality, while the best vase-painting, though the purpose it serves is the adornment of a utilitarian pot, does in fact reach a high level of art. The vase-painters too were surely aware of their quality. Even if Euthymides's remark about Euphronios is not the artist's boast it is generally thought, the practice of signing is sufficient proof of pride in work, as indeed is the skill and care put into it. 'Art' existed, but was not yet distinctly conceived as separable from craft; and I see no impossibility in a sculptor's son opting for vase-painting. That will have meant, in the first instance, opting for pottery, for surely any apprentice, even though his ambition were painting, will have gone through the mill.

The craft is the basic thing, whether pottery, stone-

working or another, and this makes me doubt the likelihood of an individual often moving from one craft to another, as we saw was suggested for the Andokides Painter, conceived of as starting in sculpture.[78] It has similarly been thought that the peculiar quality of the great Pioneers should be explained by supposing them panel-painters moved to vases; but apart from the general doubt we can trace early stages in the development on vases of Euphronios and Phintias.

Euthymides and Phintias use red-figure florals, but without the imaginative interest in their potential that is shown by Oltos and Euphronios. Much of the pattern-work framing the panels on their amphorae is in black silhouette on reserved bands. This may be partly because the amphora was a shape of a traditional prestige in black-figure which in red-figure it never quite attains. Phintias, and especially Euthymides, by making the figures fewer and larger and spreading them further over the surface, do much to give the shape a new character. Their successors go further, abandoning the panel-system; but by then it is very much a minority taste and soon goes out of the repertory. The abandonment or rethinking of old shapes and the creation of new ones is an important feature of this phase.

We saw how Euphronios made the calyx-krater into a major red-figure shape and developed red-figure ornament on it as something with an importance of its own alongside figurework, much as in black-figure picture and ornament had been developed together on the 'light' neck-amphora. Another new shape on which pattern and figures are combined in the same way is the stamnos. The piece with the name of Pamphaios as *poietes* and painted by Oltos before his close association with Euphronios[79] has already this character but differs in contour and proportions from the canonical form, first found in examples painted by Euphronios and Smikros. Only fragments survive by Euphronios, but two exist with the signature of Smikros.[80] There are black-figure stamnoi, but none earlier than these. The black-figure ones are decorated on different principles, most making little play with ornament. In fifth-century red-figure there are many different approaches to stamnos-decoration, but one strong tradition keeps up the idea of making the ornament-complex at the handles of equal weight with the figure-scenes. Interesting are two large stamnoi in 'pseudo red-figure' (Six's technique) in which attractive floral designs are spread over the whole vase.[81]

Another shape which appears to be a Pioneer creation is the pelike.[82] This is a variant of the amphora, closest to the simple Type C, but with the distinction that the widest point is below the centre, something very unusual in Greek ceramics, especially in a large vase; the little alabastron is an example on a small scale,[83] and there is a type of oinochoe, the olpe, with the same charac-

teristic. There are black-figure pelikai, but all seem later than the earliest red-figure examples.[84] The shape has two forms, the norm being a 'one-piece' vase, the wall running in a continuous double curve from lip to foot; the other, much less common, has a separately articulated neck and is known as a neck-pelike.[85] Two ascribed to Euphronios are neck-pelikai, one to Euthymides not. There are a few black-figure neck-pelikai, and a very few red-figure from the next generation, and that is all; whereas the ordinary pelike remains among the most popular shapes to the end of vase-painting. That the neck-pelike was the first form is suggested by the existence of two vases in which the neck is not articulated but there is palmette-decoration in that position exactly as though it were. A hundred years earlier, when the first one-piece amphorae were produced in Athens, some of the earliest examples had separate decoration on the neck,[86] clearly because the tradition of the neck-amphora was so strong; and this may be a parallel case.

Of these two vases, one in Leningrad, long known, has on the back a rather formally disposed pair of wrestlers, on the front a charming scene: two seated men and a boy standing, pointing to the first swallow and discussing it – the Pioneer liking for the written word. This used to be ascribed to Euphronios as an early work but is now detached from his oeuvre, surely rightly. The other, in Boston, almost identical in shape and decorative layout, is certainly by another hand. Morellian detail is consistently different, and the drawing, though not careful, is far livelier. On either side two boys leap high in the air to the strains of a pipe (fig. 24). One pair is seen from the front, the other from behind. Names are written by some figures, and *Leagros kalos*. This too is very near Euphronios but cannot be his. I incline to think it a very early work

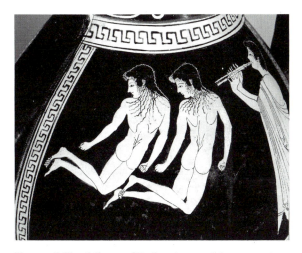

Fig. 24. Pelike; follower of Euphronios, possibly young Euthymides. Boys jumping to pipes. H. of detail *c.* 0.11.

of Euythymides. In any case I suppose both pelikai were produced about the same time in Euphronios's workshop.[87]

The neck-amphora is one of the oldest forms in Greek ceramics, but some of its remodellings are so drastic as to make it almost a new shape. Such was the short, broad, sharp-shouldered, light-ground vase, created in the mid-sixth century, which remained the norm for black-figure but was ignored by the early red-figure painters; and such the vase created for red-figure by the Pioneers.[88] This is a tall, slender vase with longer neck, and it retains this basic character, though with great variations, especially in size, handle-form and decorative scheme, throughout red-figure. It is always, however, a black vase, and the original Pioneer pieces are very black indeed. Other ornament is often entirely suppressed, and the decorative effect achieved entirely by silhouetting a single reserved figure against the black on either side. One such was originally signed by Euphronios (only *egrapsen* remains, but it is his drawing), one is signed by Smikros, others are from that immediate circle, and three are given to Euthymides.

A few show variations. One ascribed to Euthymides has a narrow band of maeander on the neck; two from Euphronios's circle have palmettes there; and one of his own has the body completely black and on each side of the neck a reclining komast.[89] The finest of all is perhaps one by Euthymides in Warsaw, all black but the figures. On one side a youth pours wine from an amphora (fig. 25); on the other a satyr tests a pipe. The wine-pourer (labelled so in true Pioneer fashion) is beautifully drawn in front view, except that the artist has shirked the foreshortening of the left foot, with awkward effect. The back view of the satyr, however, is perfectly carried through to his foreshortened right foot.[90]

The fine effect of a single figure isolated on the black may have been suggested by early red-figure cup-

Fig. 26. Plate; Psiax. Trumpeter. D. *c.* 0.12.

interiors. An amphora Type C by Oltos has Achilles and Briseis so placed on either side, but it has the name of Euxitheos as *poietes* and need not be earlier than the Pioneer neck-amphorae.[91] Epiktetos had applied it in his black-rimmed plates. How foreign the idea is to black-figure may be seen in plates which Psiax painted, in the old technique but the new manner (fig. 26). The little black figures isolated in the centre of the light disc have a charm, but the effect is totally different from that of any traditional black-figure and surely less effective than Epiktetos's red-figure. The only other artist of the time to specialise in the plate, Paseas, is related to Psiax and worked in both techniques, but for his plates chose red-figure.[92]

The scheme of Euphronios's neck-amphora with completely black body and figures on the neck (like a black-figure one we noticed earlier by Psiax) relates it to other shapes. Some black-figured neck-pelikai, and two very fine red-figured ones by a painter of the next generation are on the same design; but the only shape regularly so decorated is the volute-krater. This too now makes its first appearance in red-figure, but its earlier ceramic history is curious. Most Greek vase-shapes are more or less closely related to metal and many are surely of metal derivation, but those which are in regular ceramic use are developed by potters in their own way. For others, only from time to time borrowed into ceramics, the potter probably looked each time afresh at his metal model. Such are the phiale and the kantharos, both vases with a ritual use.[93] The volute-krater is a symposium vase; but, for whatever reason, it appears only irregularly in Attic black-figure. Perhaps the metal vessel, which seems to have a connection with Laconia (the Greeks may have called it 'Laconian krater' as they

Fig. 25. Neck-amphora; Euthymides. Youth pouring wine. H. of detail *c.* 0.10.

called the column-krater 'Corinthian'), was not popular in Athens.

The first and greatest Attic black-figure volute-krater is the François vase, in the second quarter of the sixth century. Next, thirty or forty years later, are a couple from the circle of the Antimenes Painter and one with the name of the *poietes* Nikosthenes.[94] The François vase is decorated with frieze on frieze of exquisite small figures: two on the neck, three on the body, one on the foot, and figures on the handles too. The others have black body and figures on the neck, generally on the lower register with florals above. That this was a decorative scheme employed on archaic volute-kraters in bronze we know from a number of surviving examples. The huge and splendid vessel found in the tomb of a Gaulish princess at Vix on the upper Seine has on the neck, below patterned mouldings, a frieze of chariots and warriors, cast and applied as relief decoration. There are gorgons, snakes and lions on the handles, but below neck level only a lightly engraved tongue-pattern on the shoulder and similar designs on the cast foot.[95]

Around the time of the Pioneers the shape begins to be regularly employed in Attic pottery, red-figure and black-figure. The black-figure examples, and many red-figure, have all black body and figures confined to the lower register of the neck, with florals above. In the main they are the work of hacks, but one fragmentary red-figure piece is by Euthymides.[96] One by Euphronios (certainly a very late work; we shall return to it in the next chapter) is different.[97] It has small figures on the lower register of the neck, a fine palmette and lotus frieze on the upper; but the body, instead of being black, has a composition of big figures (Herakles and Telamon against Amazons) and florals below the handles. From this point on the shape becomes regular in the repertory of Attic potters and is often the vehicle for major work. Both types of decoration continue, and variations develop in the disposition of figures, florals or black on the two registers of the neck. There is no longer any need to postulate direct reference to metal models. I suspect, though it cannot be demonstrated, that, while the scheme of plain body and figured neck is certainly derived directly from the metal vessels, the idea of using the body for large figure compositions is a vase-painters' innovation.

The hydria is a water-pot with three handles, one vertical at the back from lip to shoulder, to carry the empty vessel and to use in pouring, two horizontal at the sides for lifting when full. Such a pot was regular in Attic Geometric alongside the neck-amphora, and the two shapes were then of almost identical basic form. They develop in their own ways with much variety. The late black-figure hydria is as consistent in shape and decoration as the late black-figure neck-amphora, and

produced in the same vast quantity, but it is of totally different character. It is a black vase, with flaring lip and tall neck rising almost vertically from a narrow almost horizontal shoulder, itself sharply angled from the body. The principal picture is in a panel on the front of the body, and there is a subordinate one on the shoulder.

This model was devised later than the canonical neck-amphora, about the period of the invention of red-figure. The first craftsmen to specialise in its decoration are the Antimenes Painter and his circle, though there are also a good number by or near the Lysippides Painter.[98] Black-figure hydriai continued to be produced in very large numbers through the Pioneer period, as we shall see in the next section.[99] Very early red-figure pieces are few and seem 'amateur' efforts by black-figure painters,[100] but some of the Pioneers take it over. We noticed the London vase signed by Phintias and one in Munich attributed to him, and there is another in the same collection.[101] None are given to Euphronios or his immediate circle; none to Euthymides, but his weak companion Hypsis signed one. Half a dozen are placed more loosely in the Pioneer Group.[102] There are also some in the very early work of artists who issue immediately from the Group and whom we shall consider in the next chapter. After that we find only occasional pieces, no regular production.[103]

Of the three pots shown in the picture on Phintias's London hydria two are of this form, the other quite different: a round pot with a continuous double curve from lip to foot. Actual examples of this shape are first found in the Pioneer Group. The very few black-figure examples are no older. There is one by Euphronios, a fragment by Phintias, and half-a-dozen by Euthymides (one signed) or in his manner. The second of Hypsis's two signed vases is also of this form, and several are assigned simply to the Group.[104]

This shape (sometimes called kalpis to distinguish it from the other) remains, with much variation of proportion and detail, the hydria-form of red-figure throughout its history. The manner of applying the decoration also varies greatly, but all these early pieces follow a consistent scheme. A band of ornament joins the two side-handles across the front of the vase, and on the shoulder above this is the figured scene, heavily framed in pattern-bands.

II. Black-figure in the time of the Pioneers: the Leagros Group and others

In the period from the invention of red-figure up to the later stages of the Pioneer revolution, the new technique was employed by a relatively small number of artists responsible for only a tiny proportion of the decorated pottery produced in the Kerameikos. This is true at least of pots; the history of the cup is different and will be

treated in the next section. Small pots like the lekythos (important in funeral rites) and the oinochoe (wine-jug) are rare in early red-figure, and many of such as there are belong to the class of casual experiments by black-figure painters.[105] Even among larger pots the great bulk of production, especially of neck-amphorae and hydriai, continues in black-figure. In the generation immediately following the Pioneers the picture changes entirely. Black-figure soon comes to be used almost exclusively for bulk-produced hackwork and the special case of the prize oil-amphorae at the Panathenaic games. Even in the Pioneer time it seems clear that the very finest talents (along with others not so good) are drawn to red-figure, but excellent work is still done in the old technique.

Good examples of red-figure produced as a sideline by a black-figure painter are some oinochoai, decorated with a single figure, which are ascribed to a Goluchow Painter. Because of their very primitive technique, Beazley placed them with the earliest red-figure, but others have felt, I think rightly, that the poses and anatomical treatment of athletes on two jugs in Warsaw (ex-Goluchow) imply awareness of Pioneer developments. These figures somewhat resemble athletes on reverses of panathenaic amphorae by the Euphiletos Painter, a competent craftsman in black-figure. He is the first to specialise in panathenaics, and also decorated two hydriai with the name of the *poietes* Pamphaios. The Goluchow Painter, whether or no he is identical with the Euphiletos, was unquestionably at home only in black-figure.[106]

One important reason for the eventual triumph of red-figure must surely be that the fluidity and variability of its line adapts it far better than black-figure to express the athletic ideal that dominates classical art. There are works in which the artist, varying the pressure on the graver, manages to bring the incised line near to the same subtlety, but the unnatural effect of the shiny black makes this only a limited success. We shall look at a piece of this kind in the next chapter, but it is work of a red-figure painter. In general the best late black-figure painters adopt a different strategy.

The name of Leagros, so popular on Pioneer vases as well as on vases by some of their red-figure contemporaries and on early pieces by their immediate successors, is further found on five black-figure hydriai, once with *kalos*, the other times alone. These give its name (Leagros Group) to a large body of vases more or less closely related stylistically, which include much of the best black-figure of this time.[107] The name shows that they are approximately contemporary with Pioneer red-figure; and the artists' approach to composition and drawing makes a comparable break with tradition. The Group has been partly broken down into painters, but

most of them show much less pronounced individuality than the Pioneers, and none of them has left us a name. They are far less addicted to the written word. It is thought that the two Groups might have sat in the same workshop. Graffiti under the feet of many vases show at least that they were sometimes handled by the same traders; but we know so little about the organisation of the Kerameikos that the concept of 'workshop' has to be used with caution. I am not even sure that a 'Pioneer workshop' is a demonstrable entity.

Be that as it may, the painters of the Leagros Group were certainly aware of what the red-figure painters were doing, and the 'new look' of their black-figure seems a reflection of that knowledge. They seem to wish to give the effect of weight and bulk found in Euphronios and Euthymides, and often achieve it less in the individual figure than by massing figures together, overlapping them, so that much of the picture-surface is black. Pioneer figures often overlap the border, giving the feeling that these people are too big and active to be contained in the narrow bounds of the panel. Artists of the Leagros Group do the same sometimes, but more often they get this effect by the opposite means, cutting the drawing off. The front of a chariot-team will be shown galloping in from the left, or the rear of one departing to the right. They like more violent, spread movement than the red-figure painters, and their handling is quite different. They are not concerned to record observed forms of anatomy or drapery, but dash in a quick impression, so that their incision is as different from the inner detail of contemporary red-figure as it is from the precision traditional in black-figure.

Leagran iconography overlaps that of the Pioneers but has its own emphases. Like Euphronios, these painters have a favourite hero in Herakles. His new rival Theseus does not appear often, but on a splendid amphora in Naples, by an outlier of the Group known from this vase as the Antiope Painter, the Athenian hero is shown carrying off the Amazon queen.[108] This subject, new at this time, is found, probably under Athenian influence, in the pediment of the temple of Apollo at Eretria[109] and on several red-figure vases. One is a cup ascribed to Oltos,[110] another the London Kachrylion cup once given the same attribution but now recognised as an early work of Euphronios.[111] The war at Troy is a source more favoured by the black-figure than the red-figure painters, though Euphronios has left us the dead Sarpedon and the dead Achilles. On Leagran hydriai we meet moments from its early stages: Achilles in ambush at the fountain for the boy Troilos or slaughtering him on the altar of Apollo,[112] or Ajax and Achilles at dice;[113] and later: Achilles dragging Hector's corpse at his chariot-tall,[114] or carrying Penthesilea's from the field (fig. 27);[115] Ajax carrying the dead Achilles;[116]

Fig. 27. Hydria; Leagros Group. Warrior carrying dead Amazon (Achilles and Penthesilea? Theseus and Antiope?). H. of picture *c.* 0.17.

and finally scenes from the sack and its aftermath: Neoptolemos, Achilles's no less savage son, putting Priam to the sword on the altar of Zeus,[117] or leading Priam's daughter Polyxene to sacrifice her on his father Achilles's tomb;[118] Aeneas escaping with his father and his son.[119]

Priam standing by his chariot gives his name to a Priam painter, who does not fit into the Leagros Group but shares their liking for Trojan stories and for Herakles, and is another example of a good black-figure artist working in the shadow of the red-figure Pioneers.[120] Many of his hydriai have the genre subject, women at the fountain-house (fig. 28), found in the Leagros Group too. This is the theme of dozens of older or more old-fashioned hydriai, particularly among the Antimeneans; but the younger painters, by setting the women one in front of a column, another half hidden by one, open quite a new world of space.[121]

One calyx-krater is given to the Priam Painter, two to a related painter of some quality, the Rycroft Painter.[122] None of these have the secondary pictures on the lower bowl of the earlier black-figure examples. Euphronios

puts florals there, but here the area is black, which becomes the norm in later red-figure.

In the Leagros Group are also found a fair number of smaller vases, oinochoai and particularly lekythoi, and we will touch on these in the next chapter.[123]

III. The course of cup-painting

Over a long period of Attic vase-painting certain crafts-men specialise in the decoration of cups. This seems to begin with the Siana cups of the C Painter and others[124] before the middle of the sixth century, and continues with the Little Masters.[125] Both types are also decorated by non-specialists, and the cup-decorators do not always confine themselves to cups, but the distinction is marked. In the black-figure cups of Type A, to which the eye-cups belong, the specialisation is less clear, but it becomes so again in early red-figure. We looked only at Oltos and Epiktetos, because we were concerned to trace the development of red-figure drawing, and these two are artists important in the formation of the style; but they had a host of companions and competitors of

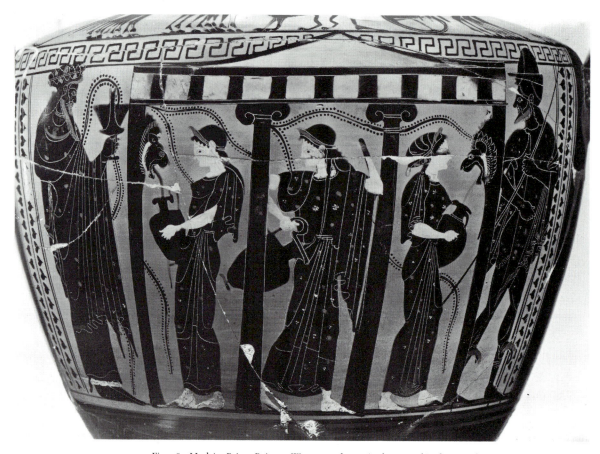

Fig. 28. Hydria; Priam Painter. Women at fountain, between big figures of Hermes and Dionysos (symbolising sanctuaries?). H. of picture *c.* 0.19.

every degree of competence or incompetence. We have seen that up to the time of the Pioneers the bulk of pot-production continued in black-figure, and most red-figure on pots is the work either of a small number of artists mostly with some artistic pretension, or of black-figure painters making an occasional foray. The picture in cup-painting is different. Black-figure continued to be used for cups, in quality declining from dull to dreadful,[126] but the great bulk of production, over the whole range of quality, is in the new technique.

Both Oltos and Epiktetos produce much run-of-the-mill work, some of it really poor, especially in their later periods, in Oltos's case contemporary with the Pioneers, in Epiktetos's probably later still; but both to the end can still rise to heights. Among the cup-painters of this phase are several of real merit whom we shall touch on in a moment, but the majority are bulk producers who seldom rise above competence and often sink below it. Pheidippos (to cite one of some fifty identified) seems a mere imitator of young Epiktetos.[127] The Euergides Painter, named for a *poietes* with whom he alone seems to work, is a collaborator with Epiktetos who shows himself on occasion capable of pretty drawing in an

individual style, but is for the most part mechanically repetitive. It is of interest that a big amphora Type A, evidently emulating the productions of Euthymides and Phintias, a rather careful if not very successful work, is thought on Morellian grounds to be probably from his hand.[128]

A painter Skythes is a neat and lively draughtsman (fig. 29).[129] His little figures have sometimes a comic look to us, but it is doubtful if that was intended. On the other hand the old man taking his dog for a walk (fig. 30) in the tondo of a related cup, with the name (which we shall meet again) of the *poietes* Hegesiboulos, really does look like an intended caricature.[130] That such an idea was not foreign to the time is shown by the grotesques on two tiny tondos, one a pyxis-lid, the other a disc of uncertain use from the Acropolis.[131] To huge heads with exaggerated features are attached tiny bodies. The naked man on the Acropolis disc is defecating; possibly also the clothed one on the little pyxis-lid in Boston. A similar dwarf attends a woman on a small cup from the Agora which I believe to be an early work of the great post-Pioneer Kleophrades Painter.[132]

Of the many red-figure cups with the name of the

Fig. 29. Cup; Skythes. Youth running with armour. D. *c.* 0.10.

Fig. 30. Cup with name of *poietes* Hegesiboulos. Old man walking dog. D. of cup *c.* 0.18.

poietes Pamphaios a number are assigned to a prolific painter who also decorated a few other shapes including a kantharos, a kind of skyphos and a tall pyxis all with the name of Nikosthenes. He is known as the Nikosthenes Painter.[133] He started among the eye-cup painters, and moved on to be a major bulk-producer of kylikes. His general level is low, but a cup in Melbourne[134] with Herakles approaching the sleeping Alkyoneus has life, and the painter's masterpiece is of real merit. Beazley, who originally made this the painter's name-piece (Master of the London Sleep and Death), then removed it from his *oeuvre*, but later still replaced it; and it hardly seems possible to separate it.[135] The ruined tondo (a satyr) can never have been more than a scrawl in the painter's usual manner, and the Amazons arming on one side, though unusually careful, are nothing special; but the main picture is another matter. Sleep and Death are lifting the body of Sarpedon, directed by Iris acting for Zeus and in the presence of a woman who must be the hero's mother, Europa (fig. 31). Comparison with Euphronios is inevitable; and though the picture has neither the power of that painter's early cup nor the monumentality and finesse of his krater,[136] it is in its own right a touching and beautiful composition. Here the *daimones* (both winged warriors, one dark, one fair, as they are on the pot, but both here beardless youths) lift the corpse by shoulders and legs, more or less as they do in that picture, but the bearded hero with his face to the sky is more like the figure on Euphronios's cup. Before the greater artist's pictures of the subject were known Beazley had suggested that the Nikosthenes Painter

might have been inspired beyond his usual capability by some other work.[137] It could indeed be that Euphronios provided the inspiration, but the minor craftsman shows himself capable of being inspired.

Beazley lists the Nikosthenes Painter under a very wide heading, 'The Coarser Wing' (of cup-painters);[138] and bad as his worst is, far greater depths are plumbed by others. The Birth of Athena daubed round a cup by the Poseidon Painter might have been suggested by the treatment of the theme on a big 'parade cup' signed by Euthymides of which magnificent fragments survive, but here there can be no talk of inspiration.[139] Likewise the Pithos Painter's repeated tondo-design of a reclining drinker in back view starts from a Pioneer idea, but what this scrawler gives us is an almost unintelligible hieroglyph with no compensating quality of formal design.[140] There are many many more as bad as these or nearly, but we need not look more closely. Their interest to us here is the demonstration that in this period, while red-figure painters of pots are still an elite, those on the cup side have already taken over the whole qualitative range of black-figure, anticipating a situation which becomes general a generation later. The coarse tradition continues into that time, and is a strand we shall meet in considering the complexity of the cup-painting situation in the great flowering after the Pioneers.[141]

We saw the name of a *poietes* Kachrylion on cups decorated by Oltos and Euphronios.[142] It recurs on many others by different painters, some down towards the level we have just been sounding, others excellent. One of these, the Hermaios Painter, takes his appellation from a second *poietes*; and the name of a third,

Fig. 31. Cup with name of *poietes* Pamphaios; Nikosthenes Painter. Sleep and Death lifting
Sarpedon's body, with Iris and the hero's mother, Europa. H. of picture *c.* 0.10.

Chelis, is found on cups of the same circle on one of
which a 'Chelis Painter' collaborates with Oltos. The
Hermaios Painter is a charming, delicate draughtsman
who stands close to young Euphronios. Indeed it is
possible that, like Oltos, he has been credited with
pieces which are really Euphronios's own. Another who
puts Kachrylion's name on his cups, the Thalia Painter,
though the general run of his work is rather poor, shows
on a cup in Berlin with erotic scenes that he can draw
very well indeed. These artists are important as showing
a strand of really good work contemporary with the
Pioneers but of generally rather different character.[143]

That the Pioneers began as an offshoot of this group is
suggested by the appearance of Kachrylion's name on
cups by the young Euphronios when he was closest to
Oltos, and even on his Geryon cup which, though still
relatively early, shows the painter near his full power.
The Geryon cup has coral red for the lower part of the
stem and the foot and for the whole interior of the
bowl except the red-figure tondo. This is found on a
good many cups with the name of Kachrylion or by
painters associated with him, rather rarely on other
contemporary work, though the cup with the name of
Hegesiboulos as *poietes* has it. In later periods, too, we
shall find it largely confined to a few painters' work. It
has been convincingly suggested that this is because
only a few craftsmen (or workshops) were prepared to
specialise in the complicated process of producing this
colour.[144] It appears on the interiors of the few surviv-
ing fragments of the signed cup by Euthymides with the

Birth of Athena;[145] and it would be no surprise if the
name of Kachrylion were to be found on that too. When
Beazley first noticed fragments of this he thought of
Euphronios for style,[146] and I take it to come early in
Euthymides's *oeuvre*.

In the circle of the better painters around Kachrylion
seems to belong Peithinos. This painter's name was long
known only on one cup, in Berlin, on which the linear
detail is perhaps more elaborately drawn than on any
other surviving piece of red-figure. Much later a tondo-
fragment with the same signature appeared: a satyr,
drawn in an everyday style which suggests the neigh-
bourhood of the Thalia Painter. As Beazley noted,
without the signatures no one would have thought of
connecting the two.[147] There is, however, no reason to
question that they are the same man's work; no artist
could often have drawn in the manner of the Berlin cup.
This shows on the interior Peleus wrestling with Thetis;
on one face of the outside youths with girls, on the other
youths making up more enthusiastically to boys. The
excessive elaboration of the drawing perhaps induced an
extreme degree of mannerism. Some of Euphronios's
detail is nearly as complex, but that is supported by a
strong sense of form and a vigour of draughtsmanship
both lacking here. An inscription *Athenodotos kalos*,
which appears on this cup, is common on early works of
the post-Pioneer generation, and features of the decora-
tion confirm such a date. Maeander-strips are drawn
round the tondo and under the exterior pictures; and
both figured areas extend over the bowl-surface to a

point where they overlap each other. These characteristics are normal in post-Pioneer cups but not earlier. The artist's style, however, was surely formed earlier. The overlapping of pre-Pioneer, Pioneer and post-Pioneer is particularly evident in cup-painting.

IV. A note on absolute dating

My reluctance to say much about the actual years covered by the development traced in these chapters will have been noticed. I did express the belief that a passage in Herodotus dates the treasury of the Siphnians at Delphi to before but not much before 525 B.C., and that stylistic comparisons show that the first red-figure must belong to about the same time. There are a few other possible links to actual dates, which we will look at in a moment, and on the basis of these a conventional scheme of dating has been evolved which, in its broad outlines, I find presents a convincing picture and which I provisionally accept. As generally used now, however, the system takes the form of assigning a date within a decade to any individual work, and this I find dangerous. Greek art does indeed certainly exhibit a very steady stylistic development, but no less certainly it goes beyond the evidence to suppose that every piece which shows a given stage of development is contemporary with every other piece which shows the same. We noticed, for example, that the character of the Andokides Painter's style suggests that it was formed around the time that the friezes of the Siphnian Treasury were carved. His early work, on technical grounds clearly among the earliest red-figure, should then belong not very far either side of 525. Other pieces attributable to him, however, technically far more assured and so later, present an unchanged *style* (concept of drawing and decorative character), and one such vase has features which show it to postdate the Pioneer revolution. Surely in innumerable cases works must have been produced well outside their immediate stylistic context but do not betray this to us. We shall come back to this in later chapters in connection with Epiktetos.[148]

It can be argued that this is hair-splitting; that these variations do not affect the truth of the overall picture, and that decade-dating is too convenient a way of ordering the material to be abandoned. This might, perhaps, be acceptable if we could always remember that we are using a convention; but that seems to me impossible, and I find it an insuperable objection to stylistic dating by decades that a decade inevitably brings historical events to mind. If we date a vase 520–510, it should have been painted in the last years of Peisistratid rule; 510–500, in the first years of democracy; 500–490, against the background of the Ionian revolt and its disastrous failure, with the sack of Miletus in 494; 490–480, between Marathon and

Salamis, in the dangerous lull between the two Persian invasions; and so on. It would be wonderful if we could relate art so closely to historical happenings, but in general in archaic Greece we cannot; and we should try to avoid giving the impression that we can. Dating by quarter-centuries, which I have used in my summary account of earlier black-figure, is of course open to the same objections, but it has the advantages of appearing less precise and of not evoking so immediately historical events. I shall continue in my narrative to avoid dates as far as possible, but shall pause from time to time, as here, to look at what evidence there may be.

Two imagined bases for absolute dating at the end of the sixth and beginning of the fifth century will not take the weight put on them. The supposed *floruit* of Leagros as a beautiful youth we have already discussed and dismissed.[149] The Persian sack of Athens in 480 is more complicated. This took place, and it certainly involved much destruction of monuments on the Acropolis and in the lower city. The difficulty is to know what surviving remains can be associated with the event. On the Acropolis a great deal of sculpture in late archaic style was found, broken but often with a very fresh surface, as though buried soon after being put up. The latest looking in the series pass beyond the archaic and approximate in style to the copies of the bronze Tyrannicides put up in 477. Only a few pieces found on the site belong in style between this phase and that of work on the Parthenon after the middle of the century. I find it perverse not to suppose that the end of the archaic series corresponds to the Persian sack.

The case of painted pottery dedications is different. There is an unbroken stylistic series from archaic to high classical, and a claim that fragments which show traces of burning belong to the sack will not do. Accidental fires are too common for that. I find nothing surprising in the difference. Pottery is an essential craft, and the reestablishment of potteries as soon as citizens returned will have been inevitable; indeed some may have continued working for the invader. Besides immediately useful material, they could soon have produced fine decorated ware, and this will have served people, busy rebuilding their ruined city, to give the goddess, more expensive offerings put off till easier times.

In the lower city too it is very hard to feel any certainty about levels which might represent the sack and so date the pottery found in them. However, as with the Siphnian treasury earlier, parallels with sculpture are a real help. One monument in the lower city which has yielded sculptures is the surest fixed date we have: the wall hastily thrown up by Themistocles after the return in 479. We have noticed that the reliefs on statue-bases found in it are extraordinarily close to the Pioneer vase-painting of the mature Euphronios, Phintias and Euthymides. The style of the reliefs is certainly not as

developed as that of the latest looking sculptures from the Acropolis. This does not prove that they are actually earlier; but it is likely, and that they and the Pioneer vases were produced some years before the invasion is confirmed by the character of the one piece of red-figure from the mound raised over the dead at Marathon in 490. Apart from an early black-figure vase, no doubt incorporated because the builders of the mound disturbed an earlier grave, the offerings are late black-figure lekythoi, of a kind glanced at in the next chapter. The one red-figure piece, of which only scraps remain, was a kylix with a maeander-border to the tondo. The remains of the figurework have allowed Williams to ascribe it convincingly to Onesimos in his Panaetian phase.[150]

If we suppose that Psiax and the Andokides Painter created red-figure not very far from 525 and that pupils of the Pioneers were already active by 490, the development we have covered in these chapters takes a reasonable time. The latest pieces in some levels of excavation in the lower city, which have been thought to represent the Persian sack, show the style of Pioneers' followers in a developed phase, as do burnt sherds from the Acropolis. The scheme is fragile but coherent, and it makes a reasonable working hypothesis.

There is some confirmation from a different source, iconography. A legend that an Attic princess, Oreithyia, had been carried off by the lord of the North Wind, Boreas, to be his bride in his Thracian wastes, is not illustrated in archaic art but becomes suddenly fashionable in early classical red-figure. Herodotus records that the Athenians felt gratitude to Boreas for scattering the Persian fleet off Cape Artemision in 480. That Athenian artists should then begin to illustrate a story which linked the benefactor with their legendary royal house is entirely probable. Among the earliest looking examples is a stamnos assigned as a late work to a distinctive artist, the Berlin Painter, whose earliest recognisable pieces were plainly painted under the eyes of the Pioneers. His style shows considerable development (and in the end decline), and it is reasonable to see his career as running from somewhere around 500 to after 480. In another chapter we shall consider other reasons for supposing that his last works (which include the Oreithyia vase) run even later.[151]

This seems to me a case where the appearance of new subject-matter can be linked with real probability to a historical event. It would be nice if one could make the connection more often, and indeed it is frequently attempted (we shall notice cases in the next chapter);[152] but, except in the most generalised way (battles against Amazons and Centaurs popular after the Persian wars) I find most such connections very doubtful.

3

After the Pioneers: red-figure mastery;
the beginning of white-ground

I. Cup-painters and pot-painters

Red-figure in the phase we have now reached is dominated for a generation by some half-dozen draughtsmen. Two, the nameless artists known as the Kleophrades Painter and the Berlin Painter,[1] specialise in pots, while others (more of them) concentrate on the kylix: Onesimos (the Panaitios Painter), Douris, the Brygos Painter (after a *poietes* whose name appears on a dozen of his cups) and Makron who collaborated regularly with a *poietes* Hieron.[2] Other cup-painters come near to these in quality and influence: the Foundry Painter, who stands between Onesimos and the Brygos Painter; the Antiphon Painter, near Onesimos; the Triptolemos Painter.[3] This artist has contacts with the Brygos and Foundry Painters, and more remotely with Douris, whose signature appears awkwardly on one cup attributable on style to the Triptolemos Painter, a matter to be considered later.[4] There is also a sequence of painters who lead up to (or are perhaps early phases of) Apollodoros.[5] No other pot-painter of the time comes so close to the leaders, though there is fine work among them. The division is not absolute: the Kleophrades Painter produced splendid cups, and some of the Triptolemos Painter's best work is on pots; but it is nevertheless marked. Many cup-painters but seemingly no pot-painters work also from time to time in developing the new technique of white-ground.

I have used the word 'draughtsmen' not 'painters' because, though 'vase-painting', 'the Brygos Painter' are accepted usage in the study, what one finds on vases is draughtsmanship rather than painting; though even then, the drawings on Greek vases do not correspond closely, in technique or character, to any other manifestation of the art of drawing familiar to us. When I speak of a generation dominated by a few major figures, I am thinking of the fine art I believe the best vase-painting in Athens at this time to be, an art the history of which is best traced in terms of artistic personalities; but it is constantly necessary to remind ourselves that this art

is a special case in a utilitarian craft in which these artist-artisans are engaged with very many others in work where much of the time artistry is hardly a consideration.

In this generation black-figure becomes used almost exclusively for low-level work (apart from panathenaic amphorae), while red-figure takes over all shapes at all levels of quality. There is certainly continuity in cup-production from earlier specialists in the shape at all levels; but the 'great' late archaic cup-painters, like the 'great' pot-painters, stem rather from the Pioneers.

The connection is documented for the cup-painter who seems to begin earliest and who is perhaps the finest of all: Onesimos (the Panaitios Painter). Many of his cups bear the inscription *Euphronios epoiesen*, and the earliest phase of his style is hard to separate from that of a group of cups which in turn are very like work that seems to be a late phase of Euphronios's own.[6] Onesimos's own mature work falls into two periods, and the name is found only on a late cup. Beazley at first distinguished these two phases as work of two artists, calling the earlier the Panaitios Painter.[7] Early scholars, accepting *epoiesen* unaccompanied by an *egrapsen*-signature as itself equivalent to *egrapsen*, had assumed that the cups with *Euphronios epoiesen* were late works of the painter Euphronios. Furtwängler first rejected this, but later came to believe that it was so. There has lately been a revival of this notion, together with an idea, also postulated by earlier scholars, that the Kleophrades Painter was not a pupil of Euthymides but his later phase; and a new suggestion that the Berlin Painter is Phintias.[8] I cannot myself accept any of these identifications; but they are serious suggestions and have to be seriously considered. It does the study no good to assume that all Beazley's final opinions are necessarily right; and it is essential to remind ourselves that the reconstruction of an artistic personality on purely stylistic evidence *must* have a subjective element which rules out certainty.

43

II. The Pioneers' direct successors

a. Euphronios, the 'Panaitios Painter', Onesimos

Among vases painted by Euphronios, two seem to show his style at a later stage than any which we looked at. One is signed: a fragmentary cup from the Acropolis.[9] Almost all the tondo is lost, but round the outside much is preserved of a processional scene: Peleus on foot, leading his bride the sea-nymph Thetis, the gods in their chariots attending the wedding. The figures are drawn with the care and elaboration of those on the great kraters, but the composition is formal, suiting the subject, quite unlike the dramatic force of the action-scenes on those and the early cups, the drawing even a little mannered: a 'Parade Cup'. Perhaps it is worth noting that there is no coral red, as there is on the great Geryon cup in Munich with Kachrylion's name and on Euthymides's cup with the Birth of Athena.[10]

The other piece is not signed but cannot have been painted by anyone else. It is a volute-krater, and we noticed it as the first of the shape which has big figures on the body as well as little ones on the neck. It has been at Arezzo[11] since at least the early eighteenth century, when drawings were made of it and engraved for Thomas Cook's sumptuous posthumous production of Thomas Dempster's *De Etruria Regali* (Florence, 1723–4). The main picture shows the artist's old favourite, Herakles, and his companion Telamon against a company of Amazons, while on the back, beyond big florals below the handles, more Amazons run up. The composition is somewhat reminiscent of the death of Kyknos, and the drawing almost as elaborate, but the whole rather more smoothly integrated and less powerful. Telamon's action is like that of Harmodios in the Tyrannicide group by Kritios and Nesiotes set up in 477, and Herakles is not unlike Aristogeiton from the same group. The vase can hardly be so late, and this has been taken as evidence that the composition of the bronze group was modelled on that of its predecessor by Antenor, carried off by Xerxes. However, experimental poses were in the air, and the Harmodios movement may well have been worked out by draughtsmen before Kritios adapted it to statuary.

In the eighteenth century the figures on the body of the vase were largely obscured (evidence perhaps that it had been around a long time), and the engraver could give only hesitant sketches of them, concentrating on the little figures on the neck. These are in a totally different manner: a company of more than twenty merry komasts, young and old, drinking, music-making and dancing. They are drawn quickly, with none of the elaboration of the big figures on the body or of those on the Acropolis cup. One can see them as descendants of the nymphs on the Antaios krater, or of the rather hastily drawn figures on a fragmentary psykter in Boston with the death of Pentheus;[12] but they have perhaps nearer kin elsewhere.

Figures with some resemblance to those on the volute-krater are found on a number of cups, mostly quite small, many of which Beazley originally ascribed to the Panaitios Painter[13] but later detached. Some he gave to an Eleusis Painter,[14] classing the rest as a 'Proto-Panaetian Group' (fig. 32) of which he thought that some might really be early work of the Panaitios painter himself.[15] The affinity of some figures on these cups with the Arezzo komasts is one of the grounds for considering the possibility that the 'Panaitios Painter' is not early Onesimos but late Euphronios (the division between Euphronios and Onesimos is of course a given). Another is that in his most monumental work, especially the Theseus cup in the Louvre[16] which we shall shortly be considering, the 'Panaitios Painter' displays a combination of elaboration and power which make it a worthy, perhaps a greater, successor to such pieces as the Kyknos krater.

There is a further link in some very fine fragments (divided between Berlin and the Vatican) of a cup with the Iliupersis (sack of Troy) on which the name Euphronios appears, the verb lost.[17] Beazley recognised the possibility that these were painted by Euphronios, but found the idea hard, and he saw that they were related also to the Proto-Panaetian Group. A recent study by Williams has recovered more of the composition, and he makes a good case for this cup, and several from the Proto-Panaetian Group, being indeed early works of the 'Panaitios Painter' (Onesimos).

Fig. 32. Cup; Proto-Panaetian Group. Youth starting hare. D. of cup *c.* 0.23.

However, there will be more to say on this in the next section. Relevant is a recent discovery: a huge and splendid Iliupersis cup in Malibu which cannot be other than early work by the 'Panaitios Painter' himself, yet is closely akin to the earlier fragments.[18]

The late cup in Athens signed by Euphronios has the kalos-name Leagros, as have many of the cups assigned to the Eleusis Painter and the Proto-Panaetian Group and one left by Beazley in the Panaitios Painter/Onesimos list. Many in both Proto-Panaetian and Panaetian lists have other names, including Panaitios, which are not found on Pioneer vases. On the volute-krater are two which appear nowhere else: Philiades and Xenon.

An area which Beazley found so difficult let none think to find easy. For what my opinion is worth, I feel (as Beazley came to) that the sequence 'Panaitios Painter' – Onesimos makes a convincing artistic personality developing over time, while (as he always thought) the sequence Euphronios – 'Panaitios Painter' does not; but I am anything but certain. We shall return to this troubled region in the next section, in discussing some early white-ground cups of superlative quality.[19] In considering the series of red-figure cups, I shall accept Beazley's final Onesimos, who includes the Panaitios Painter, but distinguish his earlier phase as Panaetian.

It has been suggested that the komasts on the neck of the Arezzo krater may not be Euphronios's own work but an assistant's. This is possible, certainly;[20] but they are not quite Proto-Panaetian and are not, I think, of much help on the really interesting question: are the Panaetian vases late works of Euphronios, early works of Onesimos or, as they appeared in Beazley's work for more than forty years, work of a third artist whose name we do not happen to know? My point in stressing that we cannot be sure is twofold: to remind ourselves yet again that there is no biblical authority in Beazley's last opinion; and to remember the limitations imposed on our knowledge by the nature of the evidence. I am convinced that putting vase-drawings together on stylistic grounds as works of one man is sound procedure, but we can never be sure that it gives us the whole man and must often feel it unlikely that it does. Sometimes, as with Douris, who has left us more than forty signatures over an evidently considerable period, or even without that help, as with the Berlin Painter whose Morellian traits are found on such a large range of vases, we can get an impression of some roundness of personality; but the edges will always be blurred, and there is always the possibility of breaks in style which our perceptions cannot leap. We shall come back often to this problem.

That, style apart, there was some practical association between Euphronios, the 'Panaitios Painter' and Onesimos is documented in the occurrences of the in-

scription *Euphronios epoiesen*. The earliest looking cups on which this is found are stylistically later than the latest with *Euphronios egrapsen* (the Acropolis cup). If one does not accept that the Berlin/Vatican cup with the name of Euphronios was painted by him, the name there was presumably followed by *epoiesen*. None of the cups assigned by Beazley to the Eleusis Painter or placed in the Proto-Panaetian Group bear that inscription, but the great new Iliupersis cup in Malibu has it, and it occurs on seven or eight in Beazley's Panaitios Painter/Onesimos lists, including the one with Onesimos's signature. A still later appearance does not concern us at the moment.[21]

One cannot of course be absolutely certain that the painter Euphronios and the *poietes* Euphronios were the same man, but it is far more likely than not. There is an inscription *Phintias epoiesen* on a cup which differs in style from the vases with Phintias's signature as painter but seems to follow on them chronologically. Euthymides is probably in the same case, and possibly Smikros also.[22] Accepting it as probable that the same man is meant, what can one suppose actually happened when a painter became a *poietes*? For Vickers Euphronios was a designer of silver and gold vessels and their decoration, now promoted to carrying out the designs. It is promotion because a man who actually handled the bullion would be paid more than one who only provided designs. This, like the rest of the theory, strikes me as an intellectually ingenious solution which has little relation to how craftsmen really function. Accepting the name as that of a ceramist, the two usual explanations are offered: either Euphronios became a potter, throwing and constructing vessels with his own hands; or he became owner of the workshop. Another suggestion, that he became a designer, supplying ideas for vases and their decoration to be carried out by others, seems to me to run into the same snags as the theory that potters and vase-painters were carrying out metal-workers' designs.[23] The *pentimenti*, the appearance of spontaneity, the quality of the actual drawing on the cups, all speak against it.

That an *epoiesen*-inscription gives the name of a potter who made the vessel with his own hands has received support from Bloesch's work.[24] Bloesch has shown, by most carefully studying, measuring, drawing and photographing under special conditions very large numbers of cups, that those with one *epoiesen*-name – Euphronios, Brygos, Hieron, Python – share common characteristics of detail which set them off from others, and round each name a large number of uninscribed cups can be grouped. This was long taken by proponents of the *poietes* = potter school (to which I have adhered) as virtually proving their case, but others have argued with cogency that it really does not do so; that this kind of homogeneity can be a matter rather of 'house style' in one pottery than of a single craftsman's turn of hand.

It is hard to know when one is imposing on ancient Athens ways of thinking from one's own very differently constituted world, but I do find it strange to think that the painter Euphronios became simply a potter. For a modern 'art potter' great originality is possible, but the variations on the accepted form of kylix at any one period in Athenian ceramics are minimal. The opposition, however, between the two possibilities may not really be so sharp. I suppose anyone working in a pottery started with the humblest tasks and was expected to master all the skills. A vase-painter will have learnt to throw a pot before he began to specialise in decoration, and the man who became head of the workshop will have already been a master potter.[25]

We noticed changes of decorative principle in the cups of this time: both inside and out, expanded areas of figure-decoration and the use of a maeander border. The maeander, in large and sometimes complex forms, was the favourite motif of Attic geometric. In vase-painting of the intermediate ages it is rather rare (no doubt there was continuity in other crafts). In its new guise, a narrow linear border often incorporating panels of other linear designs, it becomes ubiquitous in fifth-century red-figure, not on cups only but on every type of vessel.

The Proto-Panaetian cups and those of the Eleusis Painter are transitional and show various experiments. The very early Iliupersis fragments in Berlin and the Vatican[26] have a tondo-picture which occupies almost the whole cup interior within a palmette-border below the rim. The same scheme is found on one Proto-Panaetian cup[27] and, in a modified form on the great Panaetian Theseus cup.[28] This idea of occupying most of the tondo with a big picture recurs from time to time in red-figure.[29] In white-ground cups, a much smaller series of consistently high quality which begins in just this transitional time, it is the rule rather than the exception.[30]

The huge Iliupersis cup in Malibu inscribed *Euphronios epoiesen* is also unusual, perhaps innovative, in shape and decoration.[31] Beazley distinguished three basic forms of red-figure cup: Type A, to which most eye-cups belong, with a stout stem sharply set off from the bowl; Type B, the kylix *par excellence*, of which most of the cups discussed in this and the following chapters are members, with its continuous double curve from lip through slender stem to wide foot; and the rarer Type C. This has the continuous curve from bowl into stem, but the stem is stouter and set off from the wide foot by a heavy moulding; the foot-edge is set off from the flat upper surface and is reserved, as it is in the other types but it is deeper here; and the cup has an offset rim, broad and slightly concave. The whole seems deliberately designed for an effect other than the elegance of Type B. The Malibu Iliupersis is among the earliest examples of Type C to

survive, and it seems possible that the form was devised to suit an exceptionally large scale, though later it was used for normal pieces. The only earlier cup we have of such great size is one in black-figure, ascribed to the Lysippides Painter.[32] This is of the form regular at that time, Type A. A convincing scenario has the designer of the Iliupersis cup, feeling the slender stem of Type B inappropriate to such a large piece, invent a new form which in this respect looks back to the old Type A. Since we possess only a tiny proportion of the fine pottery actually produced in Athens at this time, it would be over bold to claim that this is the cup in which the innovation was made; but it is legitimate to use it to reconstruct a probable process.

The *poietes*-inscription on the Malibu cup runs along the reserved foot-rim, and this practice is repeated on at least one later example of the type,[33] but is not particular to it. Euphronios signed his Sarpedon cup so, and put both his signature and the *epoiesen*-inscription of Kachrylion in this position on the Geryon cup. Both these are Type B, and we shall meet other examples later.[34]

In decoration too the cup in Malibu is unusual. The outside pictures are deep, the tondo wide, and they overlap considerably; and there is also a zone of action scenes on the interior, round the tondo, the maeander frame of which forms their ground-line while above they are bounded only by a reserved line below the offset rim. Below the outside pictures is a maeander, and below that a palmette-scroll rings the root of the cup-stem. The exterior pictures illustrate events described in the Iliad: Briseis taken from Achilles at Agamemnon's behest, the act which set the whole tragedy in motion; and Ajax in combat with Hector. These events belong to the tenth year of the ten-year siege, but the Greeks were able to capture Troy only after Achilles had himself been killed, an arrow, loosed by Paris from the wall, in his vulnerable heel.

The interior of the cup is devoted to the sack. In the tondo, the climactic moment: Priam, who has taken refuge at an altar, is struck down by Achilles's young son Neoptolemos, the weapon not sword or spear but, horribly, the corpse of the old king's grandson, dead Hector's child Astyanax, whom the savage Greek has already killed. Beside the altar stands a woman. There was one in the same position on the earlier Iliupersis cup in Berlin and the Vatican, but there only a trace of her remains. In other red-figure pictures of the scene no such figure appears, but a woman is often shown in black-figure versions, and is sometimes characterised as old, so she is Priam's wife, Hecuba (Hekabe). On this cup the woman is young and her name is by her, Polyxene, the royal couple's daughter, whom Neoptolemos later sacrificed at his father's tomb,[35] to appease the angry ghost and secure a fair wind.

The altar on the earlier fragments carries an in-

scription: *Dios hieron*, 'of Zeus, sacred'; that on this cup, *herkeiou*. Zeus Herkeios, Zeus of the hearth, had an altar in the courtyard of every Greek house, and this shows that the setting is not a public sanctuary but the palace. On the Berlin/Vatican cup there are traces of a dead Trojan at the feet of Neoptolemos. This area is largely missing from the Malibu picture, but fingers reach up towards Astyanax's, and beside them is a name, . . . *aiphonos* (?Daiphonos).

The figured zone round the tondo (much lost) shows other episodes from the sack, following on one another without frames, as often in pictures of this story. In the top centre is another favourite excerpt from this night of horrors. A second royal daughter, Cassandra, has taken refuge at the statue of Athena, but the lesser Ajax seizes her (fig. 33). We know that he dragged her off and raped her, that clinging to the image she pulled it to the ground, and that the goddess avenged this sacrilege by raising a storm against the fair wind bought by Polyxene's blood, drowning the miscreant and scattering the Greek fleet. As in other pictures of the episode,

the nature of the assault is only hinted at in the princess's nakedness. Vase-painters of this time show men with erections and in many postures of love-making with hetairai. Satyrs too are often ithyphallic though they seldom achieve their object except with animals. Heroes and gods, though their pursuit of women and boys is a constant theme, never reveal their full carnality.

Flanking this are less particularised scenes: Trojan men and women cut down or resisting armoured Greeks with snatched-up weapons. A woman attacking a Greek with a great wooden pestle is a recurrent figure, and she is once named Andromache, Hector's widow, Astyanax's mother, but it is not clear that she was generally so thought of.[36] Beyond on the left comes the rescue of Aithra. After Theseus had abducted the girl Helen, her brothers Kastor and Polydeukes attacked Athens in his absence and rescued her, and they carried off Theseus's mother, Aithra, to be her slave. During the sack her grandsons, Akamas and Demophon, found and saved her. This, like the fates of Priam and Cassandra, is often portrayed on its own. Here it is balanced by a

Fig. 33. Cup with name of *poietes* Euphronios; Onesimos ('Panaitios Painter'). Detail of interior: (Iliupersis), Ajax and Cassandra. H. of detail *c.* 0.15.

47

much rarer story: Odysseus arranging the departure of old Antenor and his wife Theano who had compounded with the Greeks.[37] It is possible that in one of the missing areas a related episode was shown which we shall meet in other pictures of the sack: Aeneas's escape.[38] At the bottom, opposite Cassandra, part of another popular episode is preserved. Menelaos, setting eyes again at last on his wife Helen, in the heat of the carnage rushes at her to kill, but Aphrodite and Eros intervene and the sword drops from his fingers.[39]

The terrible theme of the sack of Troy is a favourite at this time and for long. The scene or excerpts from it had often been portrayed before; but the great conspectuses of it in this generation (we shall look at two more archaic masterpieces) have an urgency which suggests some contemporary relevance. Probably none of the archaic examples postdates the sack of Athens by the Persians in 480 and 479, but that was the last in a grim series. Every Athenian between 500 and 480 would have been aware of such events drawing nearer and nearer home. About 498 the Greek cities of Ionia rebelled against their Persian masters. In an early success, with help from Athens and the Euboean city of Eretria, they sacked Sardis, once capital of Lydia, now seat of a Persian satrap. The tide soon turned, and in 494 the Persians burned the rich and powerful Ionian city of Miletos, and the revolt was at an end. Four years later King Darius sent a punitive expedition against Athens and Eretria, and before the Persians were repulsed by the Athenians at Marathon they had destroyed the Euboean city. After the sack of Miletos an Athenian dramatist, Phrynichos, had staged a play on the subject. It was suppressed, and the author fined a huge sum for what, in Britain in 1940, was called 'spreading alarm and despondency'. Eretria was far closer to Athens; a Persian force had set foot in Attic territory at Marathon; and, great as was the euphoria at that victory, few can have supposed that it was the last word.[40]

The Malibu Iliupersis shows the tradition of Euphronios in the power of the compositions and the emotional force. The drawing, careful and extremely effective, does not attempt the elaboration of detail he likes in his best pieces. There is little of the male nude here to offer comparisons with the older master's anatomical explorations (the naked Cassandra is a charming but still primitive essay at rendering a woman's body[41]). When one does meet the naked male in Panaetian work it shows a changed approach. On the basis of the observations recorded with obsessive care by Euphronios, the body here is mapped out on simpler lines, designed to suggest athletic muscularity, but less particularised and used to construct a more formal pattern. Simplification is already present in Euthymides's style, but in the work of the younger generation the artistic control through the imposition of formal pattern

is more insistently felt. Big divisions are marked by black relief-lines: collar-bones, breast muscles, hips and hip-furrows, shins and ankles; and on the back the spinal furrow, shoulder-blades, hips; other features by dilute brush-lines of golden-brown. Splendid Panaetian examples are figures of Theseus at his labours, on the outside of the great cup in the Louvre already mentioned.[42]

Theseus in sixth-century art appears, not only in Athens, as the slayer of the Cretan Minotaur. Stories of him as an abductor of women also seem to be early; but his frequent appearance on early red-figure cups in a series of struggles with miscreants or monsters reminiscent of Herakles's labours is new. It is thought to be part of an Athenian attempt (perhaps expressed in an epic poem) to build their own great hero into a Panhellenic figure comparable to Herakles, in some of whose adventures he is associated. Later phases in this process are the bringing home of his supposed skeleton from Skyros by Cimon around 470 and the building or rebuilding over it of a shrine, of the paintings in which we shall have much to say later;[43] and his introduction at the end of so many Attic tragedies as the good king who resolves stories with which he probably had no original connection.

On early Theseus-cups the adventures occupy the exterior, abutting on one another without frames, like the episodes from the sack of Troy in the cup-zone we have just looked at. The difference is that those are events taking place on one occasion in which different people take part, so the whole can be read as a single action episodically set out. The Theseus-cups show the same principal actor performing a chronologically extended series of actions; and so the design anticipates the notion, so popular in late antiquity and the middle ages, of 'continuous narrative': a single setting in which a cast of characters plays out the successive scenes of their story. Here, however, the presence of the black background, in place of a unified spatial setting, allows one rather to read the actions as separate though unframed pictures.

On the Louvre cup we are shown four selected adventures, two on either front. Three, the overcoming of the tyrannous brigands Skiron, Procrustes and Kerkyon, are episodes on Theseus's youthful journey to Athens, from his mother Aithra in Troezen, to claim his inheritance from his father King Aigeus. The fourth is his capture of the bull of Marathon, the final proof of his birth and worth (fig. 34). The figures of the hero and his opponents, unhappily much damaged, are magnificent examples of post-Pioneer athleticism: complex postures shown with an easy mastery learned from the struggles of the earlier artists, anatomy simplified and subdued to the overall design.

The big picture in the tondo is different, and a

masterpiece: no athletic nudes here, but beautiful play with complex drapery subdued to a grand design (fig. 35). The story is one we read in a poem by Bacchylides, but unless our chronological scheme is very wrong the picture must be earlier than that. The child Theseus is shown at the bottom of the sea (dolphins swin around), supported by a fish-tailed Triton and presented to Queen Amphitrite, while Athena, patron of heroes, stands by.

In Bacchylides this episode takes place on a voyage to Crete. Theseus had volunteered to go with the youths and girls sent as a tribute to King Minos to be devoured by the Minotaur. Minos was on board himself, and when he spoke of his father Zeus, Theseus countered with a claim to be son of the sea-god Poseidon. Minos drew a ring from his finger and threw it into the waves, challenging Theseus to prove his claim by fetching it back. Theseus went overboard after it, and was kindly received by Poseidon's consort Amphitrite. This part of Theseus's story normally follows on his recognition as son by Aegeus. The double paternity seemingly presented no problem to a Greek. These mortal sons of gods are regularly presented at the same time as mem-

Fig. 34. Cup with name of *poietes* Euphronios; Onesimos ('Panaitios Painter'). Detail of exterior: Theseus and the bull of Marathon. H. of picture *c*. 0.13.

bers of a family, accepted by and honouring a mortal father. The Christian concept of the Holy Family is related to this tradition.

In the pictures on the Panaetian cup, the long-haired little boy received by Amphitrite is manifestly younger

Fig. 35. Interior of 34: Theseus received by Amphitrite, Athena present. D. of cup *c*. 0.40.

49

than the athletic youth of the exterior scenes; but I doubt if this means that the painter had a different version in mind. Varied versions of Greek myths abound, but it would be hard to fit the underwater adventure into an earlier stage of Theseus's life, and I suppose the painter was more concerned to make attractive and effective pictures than to keep details of the whole story consistent. Besides, the wreath which Amphitrite holds, in applied clay and once conspicuous through being covered in gold, is probably a present to Theseus to guide him through the labyrinth. Such a magic shining wreath is an old part of the story, though more often associated with Ariadne than with Amphitrite; indeed it ends in the heavens as the constellation Ariadne's crown.[44]

The use of applied clay for gold-leaf additions is not infrequently found on very fine cups of this time. On Euphronios's Acropolis cup with the gods at the wedding of Peleus and Thetis, Hephaistos carries a bowl of this character; and, on a beautiful Brygan cup we shall look at later, the gold is preserved on a similar bowl and on ear-rings, bracelets and other ornaments.[45]

Work that can be grouped closely round another cup in the Louvre, on which *Euphronios epoiesen* is accompanied by *Onesimos egrapsen*,[46] is, as we have noted, so close in style to the Panaetian cups we have been looking at as to make it highly probable that the 'Panaitios Painter' is only an earlier phase of Onesimos. The later work loses nothing in quality of drawing, but it is less vigorous, gentler in mood. There are big pieces like the signed cup, but perhaps the nicest work is on small cups with a picture inside only (a type found also among Panaetian cups and in the *oeuvre* of most cup-painters): in Brussels, a naked girl carrying clothes and a pot of water to a cauldron (fig. 36); or a fisher-boy, in Copenhagen.[47] If the same man drew the Brussels girl and the Cassandra on the Malibu cup he has come some way in the interval, but I see no difficulty in that. There are splendid intermediate examples in Panaetian work. Some are in erotic scenes with revellers or satyrs; but one, on the interior of a small fragmentary cup in Bowdoin, with no outside decoration, is a single quiet

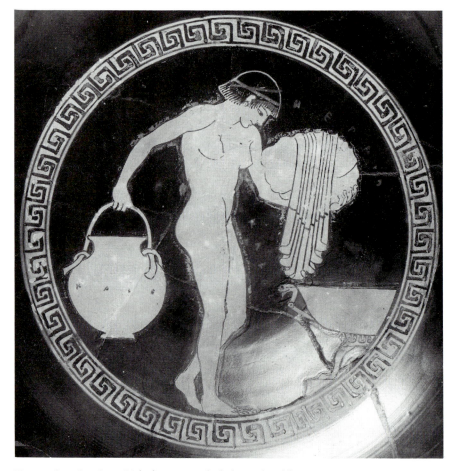

Fig. 36. Cup; Onesimos. Naked woman with clothes and cauldron. D. *c.* 0.15.

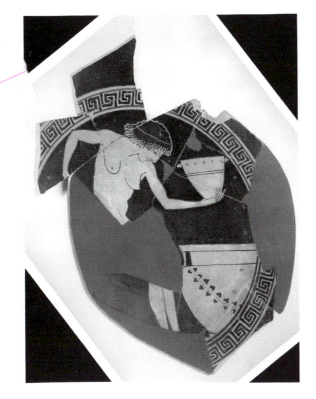

Fig. 37. Cup; Onesimos ('Panaitios Painter'). Naked woman drawing wine. D. *c.* 0.15.

figure, standing at a krater with a cup to fill (fig. 37).[48] The beautiful drawing is more assured than in the Cassandra, less tender than in the Brussels girl.

The Bowdoin cup offers another little feature of interest. The vessel the woman holds (a skyphos; a type of drinking vessel we shall consider later[49]) is inscribed with the name of Douris, an important contemporary cup-painter. It is nice to see the Pioneer practice of greeting colleagues carried on by their successors.

Whether the principal cups we have been looking at in this section are the work of one man or two, they form a closely knit series. Moreover they exhibit draughtsmanship of an order which, by itself, justifies the consideration of red-figure vase-painting as a branch of fine art.

b. *The white cup, and the origins of white-ground decoration*

In many early archaic Greek wares a white slip is habitually laid on the surface of a vase to take the decoration. The fine Attic clay was evidently not felt, as a rule, to need this; and from early in the sixth century the contrast of bright orange and glossy black is the basic determinant of black-figure decoration. Later, however, around the time of the invention of red-figure, a fashion develops for painting black-figure on a creamy white slip[50] (not the same as the purer white used in black-figure for women's skin and other elements). The white slip is found mainly on smaller vases: oinochoai (some with the name of Nikosthenes), kyathoi and mastoi (some decorated by Psiax and his circle, often fine, and he has left us a good white-ground plate) and lekythoi.[51] Areas of large vases, however, are also treated in this way. We noticed that an early red-figure amphora by the Andokides Painter had a white lip with black-figure pictures.[52] The same artist has left us an experiment in 'white-figure'. On a small amphora in the Louvre, with the name of Andokides as *poietes*, he white-slipped the picture areas and then painted in the background black, as in red-figure but leaving the figures white.[53] He chose scenes with women only: Amazons arming on one side; on the other women (perhaps the Amazons again) swimming; and the adjuncts too are things that might have been painted white on a black-figure vase: a horse, a column. Paseas (an elegant draughtsman in both techniques related to Psiax) made more sophisticated play with the same idea. Fragments survive of a fine red-figure plaque with scenes of love-making (fig. 38), on which he white-slipped only those areas of the surface on which women's skin would appear in the finished drawing.[54]

The popularity of the white slip, at just the time when artists were developing the new freedom in drawing which red-figure allowed, forms the background against which a new art arises, of outline drawing and polychromy on a white ground. The basic appeal of red-figure surely lay in the way it combined the silhouette principle so dear to the vase-decorator with a style of drawing comparable to that of painters on panel or wall. The white slip cannot but have reminded vase-painters of the white priming of wooden panels on which artists drew in a number of colours (as we see in the rather earlier Corinthian panels from Pitsa[55]); and some now yielded on occasion to the temptation to reject silhouette and work with the freedom of panel-painters. It is important to note, though, that this new

Fig. 38. Plaque; Paseas. Love-making. H. of larger fragment *c.* 0.07.

mode never posed a challenge to red-figure in the way red-figure had to black-figure. White-ground vases with outline and polychrome decoration are never more than a tiny proportion of the output of figured vases from the Kerameikos; they cease to be produced around the end of the fifth century; and (except in the case of later fifth-century white lekythoi) they are almost entirely a side-line of painters whose normal work is in red-figure.

The term 'white-ground' is ambiguous. It can denote any vase which has a white slip; thus the mass-produced little black-figure grave-lekythoi of the fifth century are distinguished as 'white-ground' or 'red-ground' according to whether they have a slip or no. By an accepted convention, however, 'white-ground' is also in regular use to define a class as specific as 'red-figure' or 'black-figure': the white vases which are decorated with outline drawing and polychromy. This is how the term is used regularly in this book.

In its first phase, with which we are now concerned, outline drawing on a white ground appears on some oil and scent-bottles (lekythoi and alabastra), on a calyx-krater, and especially on cups. The reason for discussing this technique at this point is that the white cup, the vehicle for some of the masterpieces of Athenian vase-painting, appears to have been the creation of the artists we studied in the last section. Later, when the technique is applied to a good many shapes, and the lekythos becomes of the first importance, the white cup goes out of fashion, but at the beginning it is paramount. Cups are the main subject of this section, but we will glance at other shapes first.

A white lekythos fragment from Athens has the signature *Pasiades egrapsen*; and three white alabastra have the same name with *epoiesen*. One of these has only palmette decoration, and takes three others with it. The other two have figurework of good quality, apparently not by the same hand as the signed lekythos.[56] The alabastron, a round-bottomed scent-bottle with its widest point (as we noticed in connection with the pelike) below the mid height of the vase, is of eastern origin, borrowed in Crete in the mid-seventh century, and from a little later immensely popular in Corinthian pottery right through the archaic age. Attic examples begin after the mid-sixth century and become at all common only towards its end. Their shape is different from the Corinthian, a re-borrowing from another eastern model. Oriental specimens, commonly found on Greek sites, are of alabaster; hence the Greek name, and hence surely also a liking for a white slip on clay alabastra.[57]

The white alabastra with the name of Pasiades as *poietes* are associated with a number of other white-ground and more red-figure examples, all more or less close to the Euergides Painter (one with the name of a *poietes* Paidikos[58]); but the two figured Pasiades pieces

are of very superior quality. One, in Athens from Delphi, has an Amazon on one side, a maenad on the other (two-figure decoration is the norm for the shape). The other, in London,[59] shows a maenad and an uncharacterised woman, but in this case their gestures suggest that they are meant to be associated in one picture (figs. 39 and 40). This is interesting for the nature of maenadism, a question we shall touch on in a later section.[60] The attractive drawing is in black relief-lines like those used in red-figure, and the style is not essentially different from that of the red-figure work in the same group. A bird in black silhouette between the women on the London vase, however, reminds one of the black-figure tradition in white-ground, while the free use of colour wash, though not totally unparalleled in red-figure, points the way to a new pictorialism.

The white lekythos as a field for outline drawing is rather rare in this early stage of the technique. We noticed a fragment from the Agora signed by Pasiades as painter. Later are three large, elaborate pieces certainly decorated by the cup-painter Douris, quite early in his career but not right at the start. These are important, but they are isolated, not part of a coherent tradition in the development of the white lekythos, and we will do better to look at them when we come to consider the painter's *oeuvre*.[61]

Of exceptional interest are fragments in Taranto of a large calyx-krater with satyrs and maenads in 'Pioneer' style but drawn in outline and colour on a white ground (a rim-fragment in Oxford, also from Taranto, has an ivy-band on a white ground and might belong to the same vase). White calyx-kraters are known later, but this is unique in its time.[62]

Turning to the white cup, we may glance first at one white-slipped cup decorated in black-figure. There is a class of poor black-figure eye-cups with red-ground gorgoneion in the tondo on which the exterior has a white slip. On one, not an eye-cup and of better quality, the whole interior too, within a black rim, is white, and bears a picture of a horseman in black-figure, with the name of the *poietes* Pamphaios. A picture which fills the whole cup-interior is found earlier in black-figure, in Exekias's great cup in Munich with the ship of Dionysos, where the background is coral red.[63] We noticed such enlarged tondos in red-figure, in two early Panaetian cups. A little later is a ruined cup in London with Apollo and Daphne, by a pupil of Euthymides, the Ashby Painter.[64] We shall meet important examples later still, but in red-figure it is always the exception.[65] In the white cup it is rather the rule.

The white cup which seems to come next exists in fragments only (part of the Bareiss Collection, now in Malibu[66]), but it is a piece of peculiar interest. The shape is a variety of Type A which keeps the unmodulated lip on the outside, but inside has a sharply

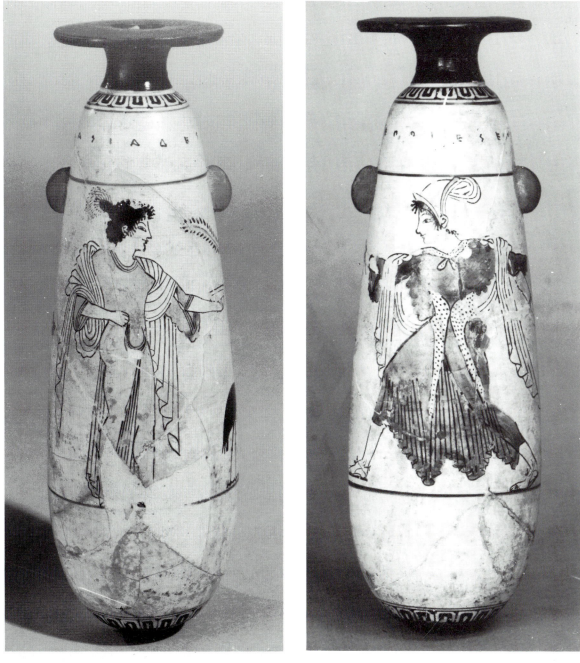

Figs. 39 and 40. Alabastron with name of *poietes* Pasiades; Pasiades Painter. Woman and maenad. H. *c.* 0.16.

offset rim. It was rather small, and the exterior is black, together with the interior of the rim. Below this the interior is slipped white, and the picture occupied the whole field, about 20 cm across. The whole centre is lost, with the cup-stem and foot, but enough of the picture remains to show that it consisted of two figures (fig. 41). Dionysos holds kantharos and vine-stock, and a piping satyr faces him; and, while the god is drawn in outline and thinned wash, the piper is in black-figure.

This combination has long been known, but in a strictly limited context: lekythoi, certainly later than this cup and of far lower artistic quality. The mode is conventionally known as 'semi-outline'. At the time such lekythoi were being made, probably during the first quarter of the fifth century, there is an immense production of the shape for funeral use, in red-figure, black-figure on a red ground, black-figure on a white ground, semi-outline and outline on a white ground, probably often from the same workshops and ranging from the coarsest bulk-production to decent craftsmanship. The semi-outline examples, most of which are associated with a Diosphos Painter whose main work is in black-figure, are near the upper end, but have little pretension to artistry (fig. 134).[67]

The Bareiss cup is quite a different matter. The black-figure drawing is of extraordinary technical refinement: a delicate, nervous use of the graver for anatomical markings (and, over thinned wash, for the hairs of the tail) in clear emulation of the more sensitive and varied lines of red-figure. Such lines are splendidly used in the outline figure; and the black silhouette of the big kantharos and of the heavy clusters which hang among the more lightly drawn vine-leaves, and on which the grapes are raised in relief, all help to merge the two modes of drawing in a satisfying unity.

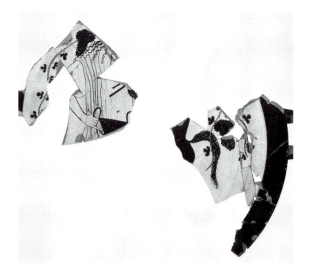

Fig. 41. Cup; Euphronios? Dionysos and piping satyr. Original d. *c.* 0.22.

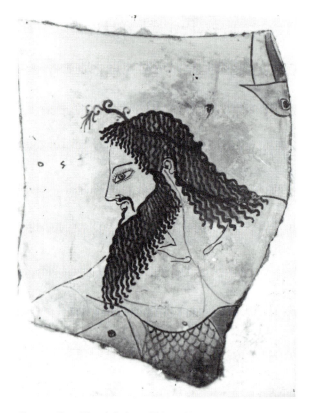

Fig. 42. Cup; Eleusis Painter. Triton. H. *c.* 0.11.

I do not suppose there is any direct connection between this experiment and the semi-outline lekythoi. There the mixture arose from the variety of techniques in simultaneous use in the workshop. On the cup I see rather the tentative move towards the freedom of outline drawing by a highly conscious artist convinced of the value of silhouette in vase-decoration.

Both heads are entirely lost, and attribution is not easy. However, the god's beautifully drawn hand with its extended little finger and exquisitely traced sinews is closely paralleled on Euphronios's late cup from the Acropolis, and the Bareiss cup is ascribed by Mertens to Euphronios, an attractive but doubtful attribution. There is a fluidity and suppleness of drawing which I do not see in any other piece certainly painted by Euphronios; if it is his, it enlarges him, but I do not find this impossible. It does not seem Panaetian, or Proto-Panaetian; and though the cups which give his name to the Eleusis Painter are the closest things we have to it in character, the hand does not seem the same to me.[68]

The two cups from Eleusis are likewise very fragmentary, but again enough remains to show that they were of no great size, black outside, and decorated on the white interior with a picture which filled the bowl. The rims in both cases are entirely lost. One shows a Triton, dolphins around him (fig. 42), and is of great beauty. The drawing of hair and beard, in strong black

curls over a wash of dilute black, is anticipated on Euphronios's Kyknos krater; but the thicker, bolder line and the light background make the effect here much more pictorial. The other, with Athena killing a giant, is very fine too, but there is some clumsiness of construction which is noticeable also in the red-figure cups ascribed to the same hand.[69]

The history of the two white cups' attribution is of interest. The great Greek scholar Semni Karouzou (then Papaspyridi), publishing fragments from Eleusis in 1925, ascribed them to Euphronios, citing the late cup from the Acropolis. In the same year Beazley listed them as very early works of the Panaitios Painter (nos. 1 and 2 in the list); but by 1942 he had grouped them with five red-figure pieces as the Eleusis Painter, a position he did not change. Karouzou's comparison is good; but I cannot see these white cups as late works of Euphronios. Williams puts them, with some Proto-Panaetian pieces, especially the Cahn (ex-Ferrari) cup,[70] in his group round the Berlin/Vatican Iliupersis cup; and sees this as the earliest phase of Panaetian Onesimos. The grouping convinces me; but I incline to see the red-figure Beazley gave to the Eleusis Painter as inseparable from the rest, and to guess it all the work of a very talented young companion – an expanded Eleusis Painter. I feel, however, quite unsure.

As a general rule white-ground decoration on cups is confined to the interior (perhaps because the flat or slightly concave surface seemed more suitable to a more pictorial, less decorative, style of drawing); but there are interesting exceptions. A cup in Gotha (with rim offset outside as well as in, but otherwise rather of Type B than C), has a small red-figure tondo in the centre of the bowl, white-ground pictures on the exterior. The surface, inside and out, is severely damaged. Traces of inscriptions in the white pictures contain a name that might be Pasiades, but there is no stylistic connection with any of the other vases bearing this name. There are also remains that might possibly be restored as *Euphronios epoiesen*. Beazley placed this cup in his Pioneer chapter, saying that 'it shows the influence of artists like Euphronios and the Sosias Painter'[71] (on the latter see the next section). The massive reclining drinkers, one stretched over each face of the white exterior, one of them looking out at us over his cup, recall Euphronios's red-figure revellers, those on the Munich krater, or the hetairai of the Leningrad psykter. The charming red-figure tondo has a youth putting his arm round a boy who lifts his face to be kissed, while the youth's dog shows equal if different interest in a hare hanging in a cage. The drawing in both techniques gives me the same feeling as the Eleusis Painter's: ambitious but untrained talent. Indeed I should have no difficulty in seeing this as the first preserved essay by the Eleusis Painter himself.

A number of cups are white-slipped inside and out. The earliest we have (fragments in London, from Naucratis)[72] is ascribed to the very young Douris, before the phase at which he painted his white lekythoi. In this first stage of his career his style shows affinities with the Proto-Panaetian and Panaetian, and some of the cups he decorates go with those inscribed *Euphronios epoiesen*. Interestingly, Bloesch connected the potting of the Naucratis fragments with that of the Eleusis Athena cup. In the tondo, which filled the bowl, the Naucratis cup has a unique rendering (reconstructible from the scant fragments) of Europa taking her seat on the bull, which kneels for her. Both steer and princess are drawn in outline, but she has a black himation over her shoulders. On the outside were a fight and the struggle for the tripod, but even less of them remains. A fragment with Apollo's head, formerly incorporated, has been seen to be too thin for this cup-wall, so proves the existence of another with white inside and out.

A rim-fragment in Cambridge,[73] probably a little later than this, has a helmeted head on the white exterior (fig. 43). The interior is black, but within the rim is likely to have been white. Beazley thought this piece probably by Myson. I see a likeness, but feel it superficial. The miniature scale is entirely unparalleled in that artist's work, and nothing there suggests that he was capable of it. Berge, in her study of Myson, rejects the cup-fragment, which she is inclined to connect with Epiktetos. I believe it to be a late work of that artist, of whose extended career we shall have more to say.[74]

Of about twenty white cups of which fragments were found on the Acropolis, five were all white.[75] The most important we shall discuss in a later chapter. It is by a

Fig. 43. Cup-fragment; Epiktetos. Outside, warrior. L. *c.* 0.025.

great early classical artist, the Pistoxenos Painter, one of three white cups by him with fragmentary *epoiesen*-inscriptions. On one of the other two (both have red-figure exteriors) the name survives: Euphronios; his last appearance.[76] Another of the five all-white Acropolis pieces, a small fragment, earlier, has on the interior the letters . . *ro* . ., which might be from *Euphronios epoiesen*, and on the outside, exquisitely drawn, the back of Dionysos's wreathed head and part of his vine-branch. Of this Beazley remarks that 'the style of what little remains is not remote from Onesimos'.[77]

It is interesting, however, that Beazley did not ascribe with certainty a single white-ground cup to the Panaitios Painter/Onesimos himself, though some red-figure pieces which he did give him have a zone of plain white round the red-figure tondo,[78] a decorative device found also in other painters' work and akin to the use of coral red. Since it is clear that the white cup is a creation of the circle around Euphronios at the close of his painting career, the circle from which the Panaitios Painter/Onesimos issued as Euphronios's clear successor, it is perhaps a surprise not to find him interested in this line. Other scholars, indeed, have given him several white cups, and Beazley listed as in his manner two from the Acropolis and a fragment in Berlin, saying of the last, 'May be by the painter himself'.[79] Of one of the Acropolis pieces he remarks that the red-figure outside is near the painter, the white-ground inside (a single figure of Athena) 'not definitely so'. It is possible that the painter had a different manner in white-ground, and that Beazley was too nice in keeping apart these works, and others which he does not list but which are certainly not far from these. On the other hand, perhaps Onesimos (the Panaitios Painter) did not care for the outline technique, and these pieces are the work of a companion or companions. It would be pleasing if one could find mature work of the Eleusis Painter here.

Many unattributed white cups are of outstanding quality, for instance one in the Louvre[80] (this, surely, from the immediate circle of Onesimos) on which Tydeus puts Ismene to the sword (fig. 44). This vase is from the Campana Collection and was no doubt found in an Etruscan tomb. The same is true of the early classical cup in Berlin, the latest to preserve the inscription *Euphronios epoiesen*.[81] Graves in Greece too have yielded them. A lovely little late archaic cup in Delphi with Apollo, unascribed, comes not from the sanctuary but from a grave.[82] A grave at Camiros on Rhodes held the most beautiful of early classical white cups, the Pistoxenos Painter's Aphrodite on a goose;[83] and the three marvellous little masterpieces of the Sotades Painter came, with other white cups and vases with white slip, from a grave in Athens.[84] Nevertheless, a remarkably high proportion of white cups are, as Mertens has noted, from sanctuaries: Athena on the

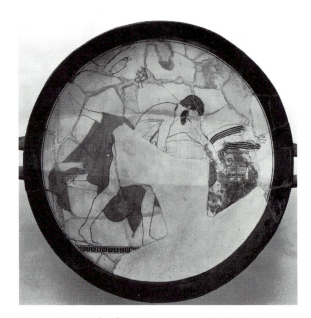

Fig. 44. Cup; circle of Onesimos. Ismene killed by Tydeus. D. *c.* 0.32.

Acropolis, Demeter and Persephone at Eleusis, Aphaia on Aigina, and Apollo there too; and the Naucratis fragments are from sanctuaries also.[85]

The early classical piece from the Aphaia temple, to which we shall return in a later chapter, has on its red-figure exterior only a single figure on either side, an Eros. The same 'short' decoration is found on the red-figure exterior of the Athena-cup from the Acropolis, placed by Beazley in the manner of Onesimos; here on either face a man pouring a libation, his prayer inscribed. This decorative scheme is not unknown on cups entirely in red-figure; but it is rare, and it is interesting that several of the much smaller number of cups with white-ground interiors should show it.[86]

c. Euthymides and the Kleophrades Painter

The inscription *Kleophrades epoiesen* is found on the foot-rim of three fragmentary cups. On one, a recent find of which no other fragments have been identified, this is followed by the words *Amasidos huus*, 'son of Amasis', no doubt the famous earlier *poietes*.[87] A second originally bore the same sequel, but it is incomplete and Hartwig restored it as *Amasis egrapsen* (though the remains do not really allow that), and postulated a younger Amasis, the painter of the cup, to whom he ascribed five other vases: a second fragmentary cup, a pair to the inscribed one; a calyx-krater; and three large amphorae Type A which stand very close in style to Euthymides.[88] Six restored the inscription correctly (except that he made the genitive of the name *Amasios*);[89] and Hauser, accepting Hartwig's attribu-

tions and adding three more, supposed them all late works of Euthymides.[90]

Beazley took this group of vases for his first study of a vase-painter.[91] While recognising the close dependence of the amphorae on Euthymides, he absolutely rejected the idea that they could be that painter's work. He greatly enlarged the *oeuvre* of this young pupil of Euthymides, the Kleophrades Painter (whom he first loosely called 'Kleophrades'), and saw his career as extending on over several decades. I have myself no doubt that the separation is correct, but the identity of Euthymides and the Kleophrades Painter, like that of Euphronios and the Panaitios Painter, is now powerfully argued again by Ohly-Dumm.[92]

The inscription *Euphronios epoiesen* makes a link outside the stylistic one between Euphronios and the Panaitios Painter, but in the case of Euthymides and the Kleophrades Painter there is no such documentation. We shall glance later at a single jug with an incised inscription *Euthymides epoiesen*,[93] but that was certainly decorated neither by Euthymides nor the Kleophrades Painter. The very early amphorae on which the Kleophrades Painter's drawing is so close to Euthymides's have been shown by Bloesch to be like the older painter's amphorae in potting also. All are placed in one class (the Eukleo Class), though in different subdivisions of it.[94] In the Kleophrades Painter's amphora-pictures (fig. 45) the grouping and structure of the massive figures, three to a scene, is very Euthymidean.[95] So is much of the detailed drawing, but the male anatomy is more formally patterned (the same difference we noted between Panaetian and Euphronian) and the lips are often outlined, a recurring practice in the Kleophrades Painter's work. Such differences are not in themselves a reason for doubting single authorship; they could easily be developments in the style of one artist. What rules the idea out for me is that I see the mastery of figure-drawing manifest on

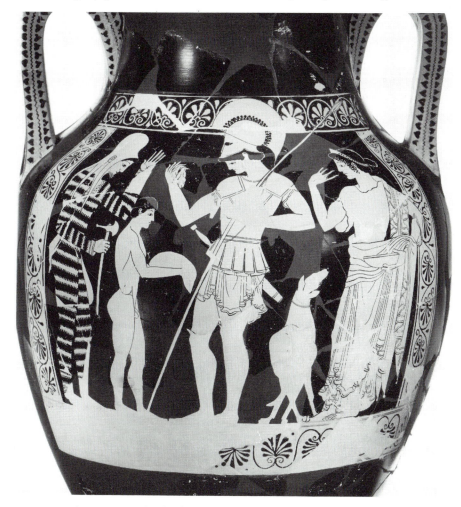

Fig. 45. Amphora Type A; Kleophrades Painter. Warrior leaving home. H. of picture *c.* 0.25.

Euthymides's amphorae replaced on the others by a painstaking emulation. Euthymides can be careless, but he is not clumsy or laborious as work on the Kleophradean amphorae sometimes is. These are linked to the mature work of the Kleophrades Painter (which is not second to Euthymides or anyone else in mastery) in ways which few could doubt as the development of a single draughtsman. In their close links back to Euthymides I see rather a young talent trying hard to do as well as his master.

There are vases of other shapes, notably two psykters with Dionysiac scenes,[96] which Beazley first gave to Euthymides, later, at Miss Richter's suggestion, to the young Kleophrades Painter.[97] These I feel to be Kleophradean, but they are slighter work. For me it is the careful efforts on the big amphorae, where the artist is evidently doing his best, which decide the matter.

The character of the pattern-work on the early amphorae is perhaps significant. The enthusiasm in developing the red-figure floral, evinced earlier by Oltos and Euphronios, later by the Berlin Painter, seems hardly shared by Euthymides, who often uses a palmette-chain in black silhouette on the reverses of his amphorae. On the front, however, the band above the picture is always in red-figure. In this position on the Kleophradean amphorae appears neither a red-figure floral nor the palmette-chain in black silhouette but a double lotus and palmette-chain in black-figure (silhouette with incision and added colour). This pattern regularly occupies this position on black-figure amphorae Type A, and was taken over into red-figure by the Andokides Painter. We have seen that the latest Andokidean amphorae are not much earlier than this, but it is a surprise to find a younger artist now employing the old (and old-fashioned) formula. That Euthymides, at an advanced stage of his career, should suddenly have taken it up would be very odd indeed. The running chain of palmettes in black silhouette is a time-saver and is plainly used as such by many red-figure artists, for instance the Kleophrades Painter himself above the reverses of some calyx-kraters, where he has a red-figure chain above the front picture.[98] The double lotus-and-palmette chain in black-figure is finicky to draw and must be a deliberate choice. The lip of one of the early Kleophradean amphorae, and the lids of that and another, are decorated with black-figure pictures.[99] The Kleophrades Painter is responsible later for an important series of black-figure panathenaic amphorae, and for a few other pots in the same technique.[100] One might wonder whether he could have got his first training in a black-figure workshop (perhaps of the Leagros Group) before moving over to red-figure.

Relevant in this context is a small group of vases, some of fine quality, which Beazley put together as a 'Pezzino Group'. He placed them within the Pioneer

circle and remarked that they were 'somewhat akin to the earliest work of the Kleophrades Painter'.[101] They do not appear to be by either Euthymides or the Kleophrades Painter, and do nothing to my mind to advance the notion of the single artist. The masterpiece of the Group, a calyx-krater from Agrigento, shows a hero's body lifted from the field, and plainly owes much to Euphronios's Sarpedon krater; a point we shall come back to in discussing the great series of calyx-kraters by the Kleophrades Painter. First, however, we must look at two more masterpieces of this transitional phase.

One, not known to Beazley, is fragments of a magnificent volute-krater with a battle of Greeks and Amazons on the body (the neck is not preserved).[102] The splendid drawing can be seen either as Euthymides's at a stage later than anything else we have from his hand, or as exceptional work by the young Kleophrades Painter. Such a doubt might seem a strong argument for the identity of the two artists, but this I think would be a wrong deduction. The break in style between the assured drawing on Euthymides's amphorae and the hesitations on those ascribed to the Kleophrades Painter remains a fact unaffected by this new evidence. The fragments must, whoever painted them, be later than the amphorae. If they are by the young Kleophrades Painter they show him the closest we ever see him to his master; if by Euthymides, he is here developing alongside his talented pupil and under some influence from him. The second scenario seems to me the more plausible, and I judge these wonderful fragments to be by Euthymides.

The second piece for consideration here is one of the best known achievements of Greek vase-painting: a big kylix in Berlin, bearing on the foot the name of a *poietes* Sosias.[103] It is a 'Parade Cup', like Euphronios's Wedding of Peleus and Thetis or Euthymides's Birth of Athena, and is drawn with the greatest elaboration and also great power. The exterior, partly lost, has a crowded assembly of seated deities receiving Herakles into Olympus; the famous and beautiful interior a group of two big figures (fig. 46). A bearded warrior sits on his shield, head turned over his shoulder, teeth bared in pain, while his young friend binds the arm from which he has drawn an arrow. The wounded man is named Patroklos, the helper Achilles, and this picture is our only evidence for this particular story. Unique in its time is the drawing of the eyes of these two figures. In early Greek art the eye, even when shown (as it normally is) in a profile face, is given its full frontal development. A generation or two after the time of this cup, when archaic conventions are breaking, this tradition is abandoned and the eye begins to be given the form it actually presents when seen in profile. On the exterior of the Sosias cup the old convention is maintained, but in the exceptional figures of the tondo the artist has allowed himself actually to draw the eye as it really

appeared when he looked carefully at a profile face. In the effort of so rendering them he has made them unnaturally large, but the effect is to add astonishingly to the strongly felt pathos of the scene.

Beazley was unable to place this piece, ascribing to the 'Sosias Painter' only fragments of a kantharos from the Acropolis with another divine assembly, no less elaborately drawn than that on the cup.[104] Ohly-Dumm has had the inspired thought that the Sosias cup is the work of Euthymides.[105] She sees the attribution as reinforcing her theory of the artist's identity with the Kleophrades Painter. While I cannot follow her in this I am sure the placing is essentially right; only I see the cup as very early work of the Kleophrades Painter. I think too she does well to detach the Acropolis kantharos as having only a superficial resemblance to the cup. She sees it as a possible very early work of Douris, and this seems to me probably right.[106]

The name of Sosias as *poietes* is found once again, on a small 'stand' (a doubtful identification of the use of the shape), the little tondo of the upper surface decorated with the figure of a satyr in red-figure, a slight work which has not found an attribution.[107] It is of interest that a Sosias, most probably the same man, is named in greetings on two vases by Euthymides and one by Phintias.[108]

We noticed that one vase bears the name of Euthymides as *poietes*. The inscription is on the foot of a fragmentary oinochoe in New York,[109] incised in the black of the upper surface. It is at present difficult, if not impossible, to decide on technical grounds whether an inscription incised in the black after firing was put there in ancient or modern times. It may be proved genuine by the circumstances of finding, or false by, for example, the use of letter forms inconsistent with the date of the vase. Here the writer has left a space between the name and the verb, which is most unusual in this period (unless the inscription is in two lines) and raises a doubt. The jug, with its red-figure picture, is certainly genuine. It shows a procession of deities drawn in a very elaborate manner which has reminded some of the Sosias cup, but to me the resemblance appears superficial.

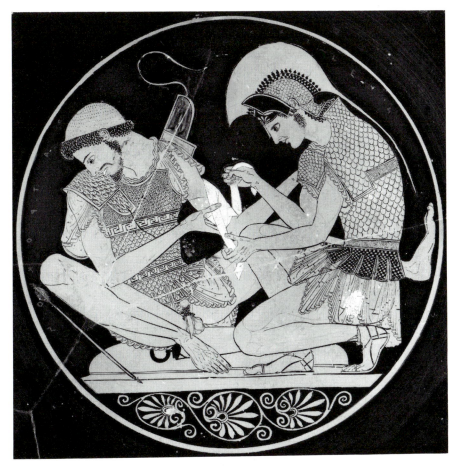

Fig. 46. Cup with name of *poietes* Sosias. Given by Ohly-Dumm to Euthymides, by me to the Kleophrades Painter. Achilles binding Patroklos's wound. D. *c.* 0.18.

59

Fig. 47. Cup; Kleophrades Painter. Fragment of outside: Theseus and the bull. L. *c.* 0.12.

The construction of the figures is heavy and clumsy, the drawing laboured, neither Euthymidean nor Kleophradean.

The Kleophrades Painter shows a marked preference for big pots as vehicles for his painting, but throughout his life he did decorate cups, and the one with the name of Sosias, if it be his, is not his only masterpiece in this field. The pair of big cups in the Cabinet des Médailles, of which one has the name of Kleophrades on the foot, are both terribly fragmented, but they stand among his best works and among the greatest Attic kylikes. They belong later in his *oeuvre* than anything we have yet looked at, but surely very little later; indeed in the third of the early amphorae (in Munich), where the draughtsman appears rather more assured than in the other two, he comes very close to the style of the cups. Their superb drawing I see as the kind of thing that made Euthymides look to his laurels in the volute-krater fragments. Like those, the exterior of one cup showed an Amazonomachy, a warrior donning a greave in the tondo.[110] The whole of the other is given over to deeds of Theseus.[111] This reminds one of the great Panaetian cup in the Louvre, and some groups on the exteriors of the two cups are similarly composed, both following traditional models. The way the Kleophradean hero, though, lies under the hooves of the bull to rope it (fig. 47) is a bold and original departure. In the drawing the two share much that is the style of the time, but to compare them is a good way of demonstrating the validity of Beazley's distinction of artistic personalities among these ceramists. Both are strong draughtsmen; but the wiry elegance of Onesimos's handling makes a quite other effect than the Kleophrades Painter's thick black line defining massive forms. The contrast is underlined by the choice of subject for the tondo. In place of the other's beguiling fairy-tale, the child under the sea, the Kleophrades Painter gives us the young hero wrestling with Kerkyon

and treats it as a match in the contemporary palaistra between two trained and powerful athletes of all but equal strength.

Other masterpieces from this relatively early time include a pointed amphora (a not common shape in fine pottery of which we shall have more to say in a later chapter),[112] and two big volute-kraters. The beautifully preserved pointed amphora, in Munich,[113] has slight little figures of athletes on the neck, and round the body a splendid rout of maenads and satyrs attendant on Dionysos, one of the most often illustrated of Greek vases, not without reason. Of the fragmentary volute-kraters one has a big picture on the body (the neck is lost) of the Psychostasia: Hermes weighing for Zeus the lives of Achilles and Memnon (an armed manikin in each scale-pan) to determine which is fated to kill the other in combat, the mothers on either side each interceding for her son.[114] Massive figures like these and the maenads of the pointed amphora are most characteristic of the artist, but the other volute-krater, now almost complete, shows another manner.[115] The body of this vase is black, the pictures confined to the neck, small figures, hastily but brilliantly drawn. The upper register does not have the floral ornament most often found there but Herakles in battle with Amazons, on the back Amazons arming and coming up to help; the lower back, Peleus snatching Thetis for his bride from among her sister nymphs; the front, more deeds of Herakles.

A special place in the artist's work is taken by a series of calyx-kraters, running from the very beginning to far down in his career. A perfectly preserved piece in Harvard,[116] with the return of Hephaistos (fig. 48), was attributed by Miss Richter, and was the occasion of her detaching some pieces given previously by Beazley to Euthymides and ascribing them too to the Kleophrades Painter; a change accepted by Beazley and surely right. The figures on the Harvard vase owe much to Euthymides, but the choice of shape points another way. Such a small number of vases is attributed to any of the Pioneers that one must be cautious in speaking of preferences among them for certain shapes; but it still might be significant that Euthymides is credited with five amphorae Type A, two of them signed, and no calyx-kraters, while Euphronios has many calyx-kraters, at least four of them signed, and no amphorae. We noticed that the painter of the calyx-krater from Agrigento, who shows some affinities with the young Kleophrades Painter, seems to have looked at Euphronios's Sarpedon calyx or one just like it; and in the next section we shall see the very young Berlin Painter, whose stylistic contacts are mainly with Phintias and Euthymides, showing on one calyx-krater a similar relation to the Sarpedon vase, and on another to another calyx by Euphronios.[117]

All these craftsmen were surely sitting not far from

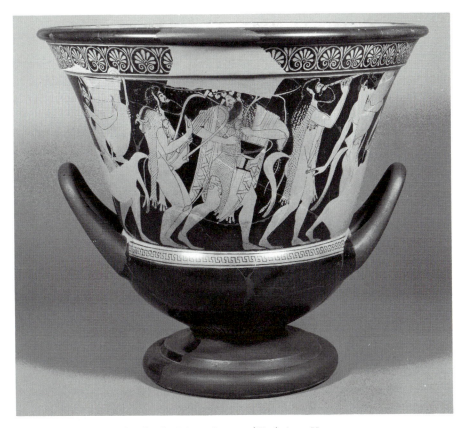

Fig. 48. Calyx-krater; Kleophrades Painter. Return of Hephaistos. H. *c.* 0.44.

one another, and were aware of each other's work; and I find it entirely reasonable to picture a young painter, when he undertook the decoration of an amphora looking to Euthymides, of a calyx rather to Euphronios. The young Kleophrades Painter appears primarily a Euthymidean; but he liked the calyx-krater (there are some twenty in his list, against five amphorae Type A) and so looked to Euphronios as well. The Harvard vase is ringed by the processional figures, with no interruption above the handles. Several of the painter's later pieces of this shape are decorated on the same principle, others quite differently: a simple composition of two massy figures on either side, separated by wide black areas over the handles. There are, however, two other very early pieces (both fragmentary) which show a third system: many-figured scenes on either side, separated by florals over the handles, the scheme preferred by Euphronios. One of these, in the Louvre,[118] has heroes quarrelling on the front, an arming scene on the back. The other, in Copenhagen,[119] drawn with great elaboration, has on one side a komos (Anacreon named among the revellers), on the other a symposium (reclining revellers and a girl piper standing). I do not think it is only the subject-matter here that recalls the piece in

Munich on which Euphronios pictured Smikros and Syko;[120] there is influence in the drawing too.

To the immediately succeeding period, the time of the Kleophrades cup and its pair and the pointed amphora in Munich, belong two calyx-kraters with two-figure pictures. One, in Tarquinia, has athletes, the other, in New York, warriors; powerful, rather stark works.[121] The artist's penchant for the shape continues into the next phase in which, without losing any of his strength, he seems to become a little gentler. On one calyx-krater of that time, in the Louvre,[122] he returns to the Harvard vase's procession ringing the vase: Dionysos with satyrs and maenads bringing Hephaistos home to Olympus (fig. 49). This is a work of great beauty; but the masterpiece of this period is on another shape: a hydria in Naples[123] of the new round-bodied form (kalpis), with the picture on the shoulder.

The painter had used the shape before. Among his earliest pieces are a hydria of the old angular form and one of the new. The decoration of the latter (in Rouen) follows the pattern set by the Pioneers: a short picture on the front of the shoulder heavily framed in bands of ornament. The Kleophrades Painter continues to employ this scheme on several works of his maturity,[124]

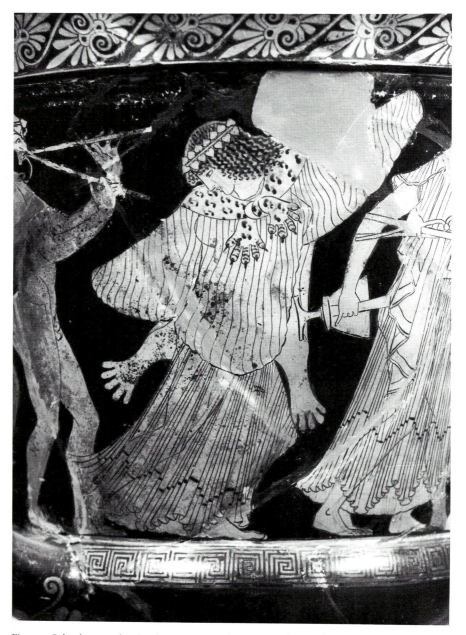

Fig. 49. Calyx-krater; Kleophrades Painter. Return of Hephaistos; detail: maenad. H. *c.* 0.20.

but the Naples vase is different. It shows the Iliupersis in a many-figured composition carried right round the shoulder of the pot, above the side-handles, to begin and end at either side of the vertical handle from lip to shoulder at the back.

We considered the subject in its very full treatment on the huge early Panaetian cup,[125] which must have been painted considerably before the hydria. On the cup the climax, the death of Priam, was isolated in the tondo, the other scenes ringing it. On the hydria there is no

tondo, and the death of Priam is incorporated with the rest, taking the central position on the front of the shoulder (fig. 50). The almost circular field is like that of the cup-zone, but with a difference. In the zone round the cup-tondo (and on a wonderful cup-exterior with the same scene by the Brygos Painter, which we shall consider later[126]), the feet rest on the narrow inner circle, and this encourages the painter to use wide, spreading gestures and movements in the figures. On the kalpis shoulder the ground-line is the wide outer circle,

which leads rather to compact, pyramidal compositions. This fact seems to be used by the Kleophrades Painter to emphasise a different approach, a different feeling.

No woman (Polyxene or Hecuba) is shown in the central scene. Neoptolemos has thrown the mangled body of the child into his grandfather's lap, and is about to deal the death-blow with his sword. Old Priam sits on the altar, clasping his bloody head in his hands, his face largely hidden by the left arm of the Greek who reaches forward to grip his shoulder. The two figures make a triangle enclosing the dead Astyanax and the head of a Trojan who lies dead at Neoptolemos's feet (perhaps the 'Daiphonos' of the Panaetian cup). Neoptolemos's right arm, back with the *machaira* (hacking sword), reaches over the heads of the group behind him (the Trojan woman who has brought a Greek to his knees with her pestle) and is the only 'spread' element in this composition of compact groups. The last scene in this direction is the rescue of Aithra. She sits on a low block, and her elder grandson stoops to raise her while the younger stands guard. Under his shield, in the corner of the picture, a little Trojan girl sits on broken ground, head on hand, awaiting the slavery from which Aithra is being saved. Two more such nameless images of despair appear in the other half of the picture. Behind the altar

grows a palm-tree, its tufted top bent and twisted, an extraordinarily powerful symbol of ruin. A woman sits with her back to it, beating her head. Another, who faces her, is in part concealed by a statue of Athena, beyond which are seen Cassandra, clasping its skirt, and her ravisher, gripping her head and threatening her with drawn sword. A dead young Trojan lies under his feet. The last scene at this end is the escape of Aeneas, leading his son, the child Askanios, and carrying his father Anchises on his shoulder. The old man, like Priam, is wrinkled, stubbly and bald, and his arm almost completely conceals the hero's face.

The naked Cassandra, another brave but still rather primitive attempt to construct a female nude, has one leg doubled under her, the foreshortened foot appearing behind. Such renderings carry on the tradition of the Pioneers; and in concealing faces the Kleophrades Painter goes beyond them: a truly archaic artist could not hide the face of an important character. In other pictures he, like a few other artists of this generation (Panaetian Onesimos, young Douris), attempts three-quarter faces, which we do not find in Pioneer work. There are even one or two faces shown tilted back and sharply foreshortened from below (fig. 136), as well as the odd attempt at *profil perdu*. The three-quarter faces are

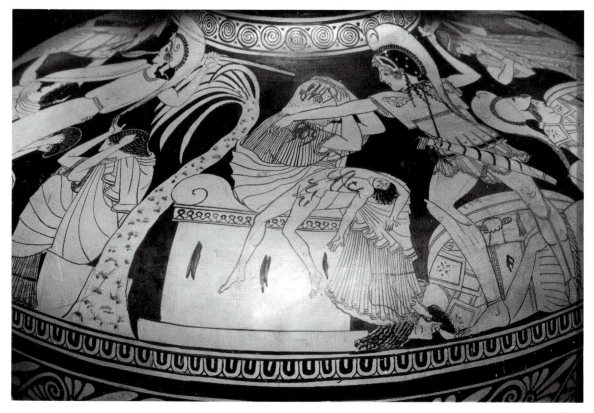

Fig. 50. Hydria (kalpis); Kleophrades Painter. Iliupersis. H. of picture *c.* 0.17.

always bearded and generally helmeted; an attempt at a beautiful young face in this view comes only in the next, early classical, phase of Greek art, and is not successfully achieved until quite late in the century.[127]

An even more significant anticipation of classical feeling in this picture is its gravity, the sadness of the dead and the mourners, not identified as heroic figures. Exekias more than half a century before had put similar feeling into his picture of Ajax preparing his end,[128] but Ajax is the tragic hero. These mourners look forward to the different world of the tragic chorus, a world also expressed in the wall-painting of Polygnotos of Thasos, as it appears to us filtered through Pausanias's descriptions and echoes in contemporary vase-painting. This degree of feeling is rare in the Kleophrades Painter's work, though it is found in the tondo of the Sosias cup; but his figures often have a serious air, a *gravitas*, which sets them off from those by other painters of this generation.

Most of the compositions we have so far looked at from his hand show several figures. The cup-tondos have only one or two, and some of the calyx-kraters only two on each side, but the painter also uses single-figure decoration. We looked at the new type of neck-amphora introduced by the Pioneers: a slender black vase with one figure on each side; and there are a number of these by the Kleophrades Painter. One in Vienna, in his earliest style, has athletes very like those on the early amphora in Munich, but it may be by an imitator rather than the artist himself.[129] A beautiful one in Harrow,[130] from the time of the Iliupersis vase, has on each side a satyr holding pieces of armour (fig. 51). These look odd in the hands of the wine-god's jolly companions. Dionysos, however, took part with the other gods in the battle against the Giants. He is sometimes shown in it accompanied by satyrs and maenads, sometimes before it, being armed by satyr-squires; and that is certainly the context in which these figures should be read. An interesting feature of both pictures is the clear trace under the black of preliminary sketch, which shows substantial differences from the finished work. Arms and hands were sketched at different levels, and where one satyr now holds a spear he earlier held a corslet. Such changes are found in the work of many painters but this artist's are particularly striking. Clearly he was a careful draughtsman who worked hard on his designs, and the nature of the changes is powerful evidence against the notion that vase-painters habitually copied given models.[131]

The neck-amphora is by no means the only large vessel in this period to bear single-figure decoration. The Kleophrades Painter employs it, for example, as a different way of decorating the kalpis. An alternative to putting the picture on the shoulder is to set it lower down the body, only the figures' heads reaching up on to

the shoulder. Later this becomes the most popular method, generally with several figures. On a small late kalpis in the British Museum the Kleophrades Painter has an unframed picture of two naked women at a laver; but on another of the same period in Munich he makes it a black vase with a single figure: Iris carrying the infant Hermes.[132] These pieces are slighter, less powerful, than the painter's earlier work, but have great charm. An earlier kalpis, also in Munich, with the same scheme, another quick but attractive work, shows a satyr weighed down by a wine-skin, amphora, food-basket, *barbitos* and flute-case – all the paraphernalia for a party (fig. 52). This was once attributed by Beazley to Euthymides, later withdrawn.[133] If it is not his it certainly belongs in the area of his late work and of the earliest pieces by the Kleophrades Painter.

Another shape on which the painter employs single-figure decoration is a new type of krater, the bell-krater; but we will discuss these in the next section, in connection with similar pieces by the Berlin Painter, who seems to have introduced the shape into fine pottery and is certainly the great master of the one-figure decorative scheme.[134] The Berlin Painter's favourite shape for

Fig. 51. Neck-amphora; Kleophrades Painter. Satyr with spear and shield. H. *c.* 0.48.

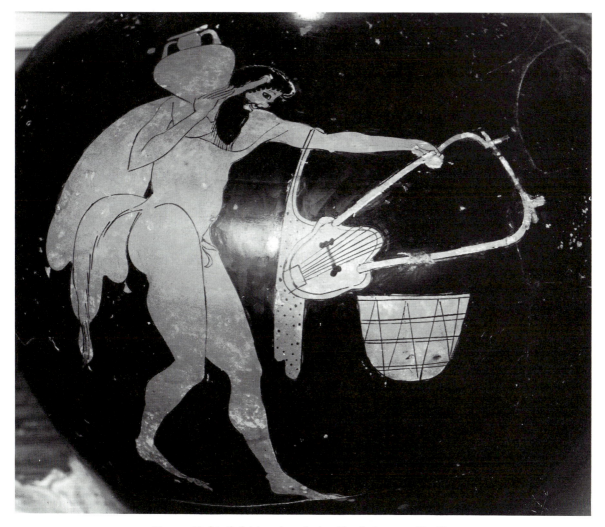

Fig. 52. Hydria (kalpis); perhaps Euthymides. Laden satyr. H. of figure *c*. o.16.

the scheme is a variant of the neck-amphora, the so-called 'amphora of panathenaic shape' or, for short, panathenaic amphora; and the Kleophrades Painter has left a few of these, decorated in red-figure in the same way.[135] This egg-shaped vessel, narrowing to neck and foot, is adapted from the black-figure vase used for the prize oil given to winners of events in the four-yearly Panathenaic games; and this in turn had been adapted (like the pointed amphora) from a storage and trade vessel in coarse pottery.

The first black-figure prize vases appear around the middle of the sixth century, probably after a reorganisation of the Panathenaic festival ascribed to Peisistratos and dated 566 B.C., though the authority for this is poor. After an experimental period the decorative scheme of these vases becomes stereotyped. On the front Athena, wearing the snake-fringed aegis over her long

chiton, strides with shield and raised spear between columns on which fighting cocks stand, and beside the column in front of her runs an inscription: *ton athenethen athlon*, 'one of the prizes from Athens'. On the back is a picture of the event for which the prize was given.[136] There are also uninscribed vases on the same design, which presumably were not given as prizes. When black-figure gives way to red-figure for large-scale and careful work, the panathenaic prize-vase remains an exception, continuing to be painted in black-figure throughout the whole red-figure period and beyond. These black-figure vases are often attributable to red-figure painters, and some of the finest of this time are by the Kleophrades Painter (figs. 53 and 54). We noticed that he had a black-figure side, and while most of his work in that technique is slight and hasty the panathenaics are good.[137] From this period (but not

Figs. 53 and 54. Panathenaic prize-amphora; Kleophrades Painter. Athena; athletes in *pankration*.
H. *c.* 0.64.

before), for about a century Athena's shield-device on vases of this class ascribed to one painter is always the same: for the Kleophrades Painter a winged horse (Pegasos). This has been supposed the choice of the vase-painter or workshop owner. A more likely explanation seems to me that the state commissioned prize-vases for each festival from one workshop or more, and laid down what Athena's device should be; but on this hypothesis problems arise, and we shall have to come back to the question more than once.[138]

Two other shapes the artist favours are the stamnos and the pelike, many of both coming from his late period, when his work tends to be rather hastier and more conventional. A careful stamnos, not late, in London, has not the usual many-figured stamnos decoration, but a group of two on each side of a black vase: Theseus with the Minotaur and with Procrustes. The unkempt brigand's face is in three-quarter view.[139] One late pelike, in Berlin, a big pot with a single quiet figure of a goddess on either side, bears the inscription, twice over, *Epiktetos egrapsen*. The same inscription was once read on the very early neck-amphora in Vienna which is either from the Kleophrades Painter's hand or by a close imitator. The faint letters on the

Vienna vase, however, are now said to be meaningless, while the inscriptions on the pelike are certainly modern and apparently not laid over the traces of genuine letters. 'Epiktetos II' (as the Kleophrades Painter is sometimes known) seems therefore a misnomer. It was never possible to identify him with the older Epiktetos, who was probably still active at this time.[140]

One or two other vases by the painter will come to our attention later, in particular an amphora Type A, one of the last of its kind, in Würzburg (which also has one of his earliest).[141]

d. The Berlin Painter and his origins

Beazley began his programmatic series of articles on individual vase-painters with 'Kleophrades' in the *Journal of Hellenic Studies* for 1910, and followed this in the next year's volume with 'The Master of the Berlin Amphora'.[142] A nucleus of works by the Kleophrades Painter had already been put together by others. The artistic personality of the Berlin Painter was totally unrecognised, and now forms the classic justification of Beazley's method.

The beauty of the elaborate drawing on the amphora

in Berlin had caught the attention of scholars before. One had ascribed it to Euphronios, another to the Kleophrades Painter; but these were pot-shots at attribution.[143] The validity of Beazley's work depends on the way he looked closely at the whole field of Attic pottery of the time, in so far as it was known to him, and perceived how the vases grouped themselves by style, rather than picking out a fine piece here and there and looking for a name with which it might be associated. The vases that grouped themselves to form the *oeuvre* of the Berlin Painter show a very elaborate and consistent system for rendering the anatomy on the male nude, and a no less constant way of drawing drapery. The artist chooses, in general, a limited number of shapes to decorate, and seldom deviates from a consistent way of decorating each shape. His beautiful florals and distinctive maeanders are as much his own as the figurework; and so is the sparing way in which he uses them. He names figures on some elaborate pieces, and sometimes praises the beauty of a youth: Sokrates, Alkmeon (praised also by the Brygos Painter) and Nikostratos (praised by the Antiphon, Triptolemos and Hephaisteion Painters);[144] but has not chosen to leave us his own name or that of a *poietes*. I find it impossible not, myself, to see him as a person, and hard to understand how anyone can not do so. A no less consistent artistic personality of the time, Douris, is documented by more than forty signatures, on works which show some variety in style and evidently cover a long time.[145] It is good to have such a demonstration that a vase-painter was a conscious artist; but the name is not necessary to establish his existence.

In Beazley's first article on the Berlin Painter the thirty-eight vases listed as from his hand are followed by twenty-nine which are called 'school-pieces'. Later he came to see that most of these must be in fact the painter's own, showing a development and in the end a marked decline. Beazley continued, however, to use the term 'school-piece' in relation to this and other artists. It defines a real phenomenon: work which resembles the painter's, is imitated from him, but cannot be by him; but it is perhaps better avoided. Beazley took it over from the study of Italian painting. There it has a precise meaning: work on a master's design, executed in his studio by assistants or apprentices; and this is not, surely, a situation one can envisage in a Greek potter's workshop, primarily geared to the production of useful vessels. The Berlin Painter must have been for long the leading decorator in a shop where others will have learned from him and imitated his manner; but 'school' seems to me a misleading word.[146]

Besides pieces which have little character beyond evident emulation of the Berlin Painter's style, are others which can clearly be seen as the work of distinctive painters who learned to draw from him and became themselves leading figures in later generations, most notably the Achilles Painter. These we shall consider in subsequent chapters.[147] It is also possible to say something of where the Berlin Painter himself learned his art; but before we come to this, which involves yet unresolved problems, we should look at the character established in the mainstream of his work.

The Berlin vase from which he takes his name is a very large amphora Type A. In black-figure the one-piece amphora (whether Type B or the more elaborate Type A) is a black vase, the picture on each side a light 'window'. Red-figure, by extending the black into the background of the pictures, did more to integrate these with the pot, but painters continued to frame the figure-scenes in bands of pattern. This is still the scheme in the early amphorae of the Kleophrades Painter, but one from his full maturity, in Würzburg,[148] shows a totally new approach to the decoration of the shape. The same is true of the Berlin amphora and of three others by the Berlin Painter, while a fifth by the same is quite different again. These half-dozen, and about the same number more by minor contemporaries, are the last amphorae Type A we have; and though the simpler Type B continues long, it becomes a rarity. Clearly the new decorative schemes devised for it by the Berlin and Kleophrades Painters are designed to make the old favourite shape for special work acceptable in a new age; but splendid as their creations are the attempt did not succeed.

On the Kleophrades Painter's vase two massive figures on each side make the whole decoration; like the two he puts on some calyx-kraters, but more closely knit than those. In each picture a fully armed warrior is restrained by an old man in chiton and himation: on the back (fig. 55), Hector held by Priam; on the front Ajax by Phoenix (an episode from the Iliad). One speaks of front and back of the vase here because Ajax is drawn in front view, Hector in back; and though much of the Greek is lost enough remains to show that the figures corresponded exactly: one model pose drawn from opposite sides. One may compare the bowmen in Pollaiuolo's St Sebastian in the National Gallery, London. The device is not unparalleled in vase-painting but is rather rare.[149] It chimes with the Kleophrades Painter's interest in foreshortening and careful observation.

The only pattern preserved on the Kleophrades Painter's vase is a deep maeander-strip below each group. Probably there was never more, but one cannot be sure. The upper part of the vase is missing; and on the Berlin Painter's name-vase (though not on the other three amphorae on which he used this general decorative scheme) the upper junctions of the handles are joined by a delicate ivy-wreath in red-figure, a rare pattern which picks up the traditional simple ivy-strand

Fig. 55. Amphora Type A; Kleophrades Painter. Hector restrained by Priam. H. of picture *c*. 0.29.

in black silhouette which still decorates the handle-flanges.

I do not know if the Berlin vase was painted before or after the Kleophrades Painter's, but the way figures are used to decorate the shape is even more revolutionary in the Berlin Painter's work. The Kleophrades Painter's two thickset figures spread wide across the pot, and consequently so does the strip of pattern below them. On the front of the Berlin amphora[150] also two figures are shown, and an animal with them, but all three long-limbed, elegant creatures are superimposed, contained within one contour and occupying no more of the vase-breadth than a single figure (fig. 56); while on the back of the vase only one figure is shown.

The pattern-band below the feet of the figures on both sides is shallower as well as shorter than that on the Kleophrades Painter's vase, and is a pattern rare in vase-painting, a running spiral. The linear pattern-band used

to define the groundline under figures on pots of this period is normally some form of maeander, which we have noticed already as regular on interiors and exteriors of cups. The running spiral one might say is a curvilinear version of the rectilinear maeander. Its rarity in vase-painting may well be due to the fact that to make a neat maeander needs only a steady hand, and with practice could surely be done quickly; while to keep the hand steady in drawing a running spiral must call for great concentration as well as skill. It appears to have been a relatively popular pattern in metal-work, and no doubt its occasional appearance in red-figure reflects the vase-painter's awareness of the decoration of metal vessels. We will consider this question in more detail in a later section, in connection with a phiale by Douris.[151]

On the back of the Berlin amphora a satyr stands, or moves slowly, to the right, carrying a *barbitos* in his left hand, and raising in his right a full kantharos which he

bends his head to sip. On the front a similar satyr stands, his body three-quartered to our right, bent head turned back the other way. He too holds a *barbitos* in his left hand, but up, ready to play, his fingers on the strings and in his right hand the *plektron* with which to strike them. Immediately behind him, body almost completely overlapped by the satyr's, young Hermes moves swiftly to the right, head in winged cap forward, feet in winged boots seen to either side of the satyr's. His arms reach out too, the left far forward with the *kerykeion* (herald's wand) and a kantharos, the right

back with a wine-jug, both vessels, from the way they are carried, evidently empty. Overlapping the god, overlapped by the satyr, a fawn steps delicately to the right, its nose lifted towards the kantharos.

The *barbitos* is a sophisticated form of the simple lyre (the infant Hermes's invention), still like that with a natural tortoise-shell as sound-box, unlike the elaborate wood-built *kithara*. The musical instrument most commonly played by satyrs is the double pipe. Of pictures showing them with a stringed instrument (lyre, *barbitos* or *kithara*), several illustrate the story

Fig. 56. Amphora Type A; Berlin Painter. Satyr, fawn and Hermes. H. with lid *c.* 0.81.

of Hephaistos brought back drunk to Olympus by Dionysos. Hermes plays a part there, and his rare association here with the wine-god's vessels fits that context.[152] It was surely in the painter's mind; but one does not feel that telling a story was his chief concern. Rather he wants to make, from the carefully studied human form, exquisite decorative compositions for a vase-surface; and this is his great achievement.

In his early article Beazley does little but list the artist's *oeuvre* as he sees it, note the main Morellian details of anatomical and drapery drawing, and very briefly characterise his style. Writing later, however, he gives a fuller characterisation of the Berlin Painter, and concludes that his peculiar gift is a wonderful care and feeling for harmonious contour, picked up in the sure calligraphy of a complex and consistent system of inner markings.[153] Such preoccupations are most clearly expressed on a black vase with a single figure on each side, and much of the painter's best work takes this form. More than a dozen vases survive by him of the shape taken from the panathenaic prize amphora:[154] completely black, mouth, handles and foot as well as the whole body, the sole decoration a single figure on either side, often without even a pattern-strip under the feet. Such are one in Munich with *barbitos*-playing satyrs exceedingly like those on the Berlin amphora, and one in Würzburg with Herakles brandishing the tripod on one side pursued on the other by Apollo.[155] There is an effective contrast here between the two naked figures. The hero is seen frontally (fig. 57), legs wide in an arrested stride, emphasising his powerful torso as he swings the tripod over his head, the club across his body, and glares back, the scalp of the lion-skin slipping from his head, at his pursuer. The elegant, fierce young god moves with a long step like Hermes's on the Berlin amphora, and his arms reach out, the left forward, a cloak over it, a bow in the hand, the right back with an arrow. The artist often spreads a figure in this way, to occupy more of the black pot-surface and make an interesting contour.

Some of these panathenaic-type amphorae do have a pattern-strip below the figures. On the four amphorae Type A which he adapts to single-figure decoration the artist puts in such a band, but in two of them it is of special character. We noticed the spiral on the Berlin amphora. On one in Basel,[156] the strip is an exquisitely drawn lotus and palmette chain, unique in this position though regular decoration for a krater-rim. On a smaller vase in New York, a recent discovery, on which the drawing is oddly stiff and weak, and on one in the Louvre, he uses a maeander.[157] On these amphorae, a larger and broader shape than the panathenaic type, he modifies the extreme blackness, keeping the traditional reserved handle-flanges with silhouette ivy, and on the Berlin vase the reserved area above the foot with black

rays. The Basel, New York and Louvre vases have no pattern-band above the figures.

The amphora in Basel shows on one side Herakles (fig. 58), on the other Athena. Both are in their full panoply, but they stand quietly in profile. He holds out a kantharos, of a special form often associated with him, and she raises a jug to fill it. Such a relation between the goddess and her mortal protégé is a surprise, but it is fairly often illustrated at this time and is certainly connected with the legend of the hero's assumption to Olympus as a god. The drawing in detail is as exquisite as on the Berlin vase; and Athena's shield-device is the finest piece of heraldry in Greek art: a gorgoneion, surrounded by three lion-protomes alternating with winged protomes of griffin, horse and goat. The effect of the figures, however, particularly that of Athena, is stiffer; and this is still more marked in the Dionysos and satyr of the Louvre amphora, and there the handling too is duller.

This difference in character is most noticeable when one compares the series of panathenaic-type amphorae with a series of neck-amphorae,[158] also decorated with

Fig. 57. Panathenaic-type amphora; Berlin Painter. Herakles with Apollo's tripod. H. *c.* 0.52.

a single figure on each side, like those of the Pioneers and the Kleophrades Painter. In his first article on the Berlin Painter, Beazley classed these as 'school-pieces', but he soon came to see that they must be from the painter's own hand, and placed them in a 'middle period', when the painter is still a careful, painstaking craftsman, but the spring has gone out of the year and convention set in. The amphora Type A in the Louvre stands on the edge of this phase, and I feel it foretold even in the one in Basel. The transition is gradual, and some of the neck-amphorae have the grace of the early work. The 'middle period' declines into a 'late period' of mainly mechanical repetiton and bulk production. We shall touch on this in later chapters, in connection with the Berlin Painter's followers.[159] There is more to say here about the vases of his prime; and also about his relation to contemporary black-figure, and about his own origins in the circle of the Pioneers.

Only small fragments exist of a fifth amphora Type A by the Berlin Painter, with a totally different decorative scheme.[160] As on the Berlin amphora a band of pattern joined the upper handle-roots; not, as there, an ivy-wreath, but a spiral. On the Berlin vase a spiral runs below the figures' feet, and that was its function here too. The whole body of the vase below this level was black, and the exquisitely drawn little Dionysiac figures occupied the narrow space below the lip. We possess one complete amphora with this scheme by a different painter. The pot has been ascribed to the same potter as the Berlin Painter's complete pieces of this shape,[161] but the decoration is by a clumsier hand, that of the Eucharides Painter, who shows other points of contact with the Berlin Painter.[162]

The Berlin Painter has left us no amphora Type B, but one of the smaller, slighter and less popular Type C. This, in New York,[163] a masterpiece of his prime, has no ornament at all. On one side a young citharode flings back his head and sings to his instrument (fig. 59). On the other his trainer, a bearded man in a himation, his forked wand of office in one hand, beats time with the other. Such 'mantle-figures', bearded or more often youthful, are found on many of the Berlin Painter's reverses, not always having any clear association, as this trainer has, with the figure on the front.[164] In his good time he draws these men or youths with the same loving care as the principals, but they foreshadow a tendency to skimp the backs of vases. Their descendants, the mantle-youths of late fifth- and fourth-century red-figure mark the nadir of the craft.[165]

The black vase with only one figure on each side and not even a maeander-strip under their feet is not unique to the Berlin Painter, but he shows himself fonder of it than any other painter. At the same time he is one of the masters of ornament. The lotus and palmette bands, which he puts especially on the upper register of a

volute-krater neck or on the rim of a calyx-krater,[166] but often elsewhere too, carry on the interest shown in red-figure florals by Oltos and Euphronios. The execution is more consistently fine in his than in theirs, and he varies the detail of the traditional designs with real originality. Even his maeander is special.

The maeander can be drawn without interruption or with intercalated squares of pattern. The spacing of these squares can be regular or irregular. The Berlin Painter sets the pattern-square (his preferred one is a saltire with dots between the arms) alternately against the upper and lower border and draws the maeander symmetrically on either side of it. Many painters have a recognisable way of drawing the maeander and pattern-squares, but this is a particularly attractive as well as distinctive design, and it is found almost exclusively on vases attributable on other grounds to the Berlin Painter or to some painter who learned his style of figure-drawing from that master. His late pupil the Achilles

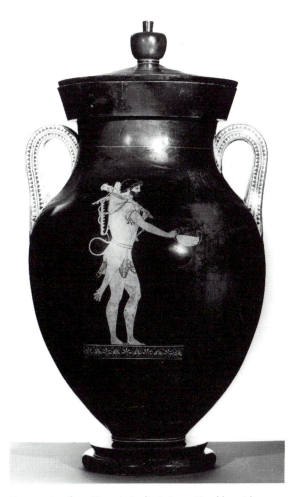

Fig. 58. Amphora Type A; Berlin Painter. Herakles with kantharos. H. with lid *c.* 0.79.

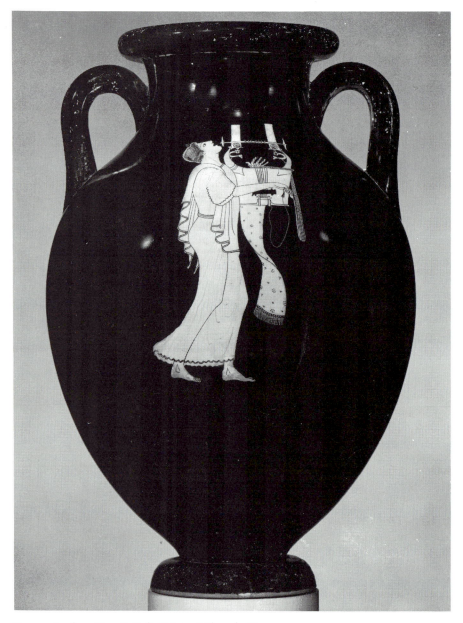

Fig. 59. Amphora Type C; Berlin Painter. Citharode. H. *c.* 0.41.

Painter carries the tradition into the time of the Parthenon, and *his* pupil the Phiale Painter even farther down the century. Beazley nicknamed this system ULFA (upper, lower, facing alternately) and we shall notice it again.[167]

More than half a dozen volute-kraters by the Berlin Painter are preserved in whole or in part. Three are linked to the amphorae by having a single big figure on either face of the body. These have also a picture on the lower register of the neck and florals on the upper.[168] One of the others has two figures on each side of the

body and the lower register of the neck black; the upper has a floral.[169] A fragment has a picture on the upper register, but in this case we do not know how the rest of the vase was treated.[170] The artist's masterpiece in this kind, in London,[171] is in the old tradition: black body, picture on the lower register of the neck, floral on the upper. The floral is the most usual in this position: a double chain of alternate lotus and palmette. Euphronios used the same basic pattern in the same place on his Arezzo vase,[172] but the treatment is totally different. The Berlin Painter repeats his version, with

subtle variations, on two of his other volute-kraters[173] and on one calyx-krater rim;[174] the single chain, similarly varied, on several calyx-krater rims and under the feet of the figures on the Basel amphora.[175] On two very early volute-kraters he has a chain of large palmettes; and on one, in the Villa Giulia, a unique and much more elaborate complex of palmette and lotus.[176]

On the lower neck of the Villa Giulia krater the pictures (athletes on the back, on the front the fight of Herakles and Kyknos interrupted by Zeus's thunderbolt) fill the field with many figures. The other figured necks are similarly treated, except for that in London. Here both sides show combats: Achilles against Hector, each backed by his patron deity, Athena and Apollo (fig. 60); Achilles against Memnon, their goddess-mothers, Thetis and Eos, behind them. In both pictures the four figures are evenly spaced with plenty of black around them: an adaptation of single-figure decoration, but they are vividly linked by action and character. Achilles in both advances with spear and shield, steadily against Memnon who flings himself wildly at his adversary, shield forward, sword-arm far back for the stroke (fig. 61). His mother, one hand to her head, the other stretched out palm up, anticipates disaster and prays for mercy, while Thetis's gesture seems to urge her son on. On the other side Achilles moves in more swiftly for the death-blow while Hector, wounded already in breast and thigh, falls back, letting spear and shield slip. Athena echoes Achilles's forward movement. Apollo, who cannot remain by the pollution of death, hurries away, but turns as he goes. Bow in left hand, quiver on shoulder, he has pulled an arrow and stretches his right hand back with it: an allusion to the death that he will bring to Achilles.

In these small figures, as surely drawn as the large ones, the painter slightly simplifies in some points his system of internal markings, but not in essentials. Across Apollo's himation, for instance, long folds sweeping from the right do not quite reach the left-hand contour, from which short folds come out between them. Exactly so he draws his big mantle-figures. It is a scheme which vividly suggests the volume of the figure, but no other artist uses it. Apollo is blond, his hair in thinned colour, something of which this painter is especially fond.

The pretty fragment from the figured upper register of a volute-krater neck, in the Astarita Collection in the Vatican, is interesting for its treatment of the subject, the Return of Hephaistos. In early pictures of the drunken rout the smith-god is always mounted on a donkey. So he is on the Kleophrades Painter's calyx-kraters, the second of which must be roughly contemporary with this piece. So often later, too; but this is among the first to show a new scheme, Hephaistos on foot with the rest.[177] Part of a satyr remains, then

Dionysos. He advances, vine-branch in hand, and turns to watch, perhaps to guide, the faltering dance-steps of his companion, who has put on an animal-pelt over his short chiton. The new version was probably created under the influence of a satyr-play.

These neck-figures are among the smallest in the painter's work; but he has a large output of middle-sized and small vases: some oinochoai; many lekythoi; many small neck-amphorae with various handle-forms, the most popular the 'Nolan amphora' with three-reeded handles and the 'doubleen' (two-reeded).[178] The quality is often excellent, and this side of his work is of further interest for other reasons.

We have noticed various points at which red-figure painters took over further areas of production from black-figure. Up to this time these smaller pots had been almost entirely in the old technique. One can point to the odd earlier oinochoe or lekythos in red-figure, but the Berlin Painter is the first major red-figure artist to take them over and popularise them. Only one Nolan and one lekythos are attributed to the Kleophrades Painter, and no oinochoe.[179] After this time, though black-figure production continues, these vases become an important side of red-figure. Some contemporary black-figure craftsmen, the Gela and Edinburgh Painters for instance, who specialise in small neck-amphorae and lekythoi, issue from the Leagros Group,[180] as the Kleophrades and Berlin Painters issue from the Pioneers. It would be no surprise to find that black-figure and red-figure specialists sometimes sat in the same workshop. The Berlin Painter, however, does not seem, like the Kleophrades Painter, to have had a black-figure side. A group of panathenaic prize-vases is associable with his style, but the red-figure work they are close to is from the end of his career and it is doubtful if any are from his hand. They share Athena's shield-device (a gorgoneion) with a group of related style attributable to the Achilles Painter, and we will discuss the two groups together in a later chapter.[181]

The Berlin Painter's small neck-amphorae are normally black vases without florals, sometimes with single-figure decoration, sometimes with two on the front. The doubleens are often particularly nice: we may cite one in Boulogne with a blond Eros bowling a hoop.[182] Most of the painter's early lekythoi are likewise black vases: one figure on the front and the shoulder black; but one, from Corinth, has a floral on the shoulder, and on the body two figures, Athena and Herakles.[183] I should guess this exquisite piece to be among the first lekythoi the painter decorated, though it is not in his earliest style. Two with black body and a picture on the shoulder will be mentioned later. In his late period he retains single-figure decoration for the body, but often has a floral or little subordinate figure on the shoulder. Among many listed as 'early' or 'late'

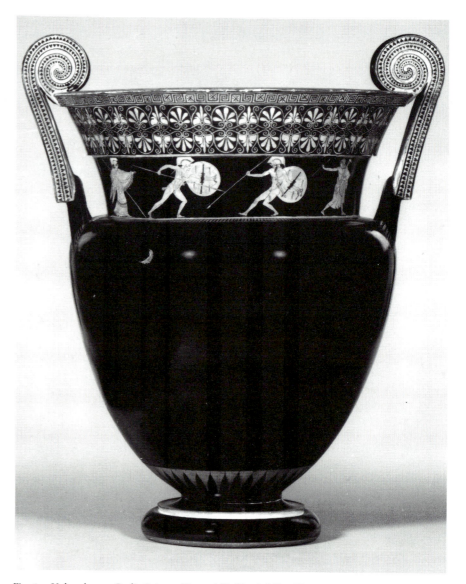

Fig. 60. Volute-krater; Berlin Painter. Hector killed by Achilles. H. *c.* 0.65.

Fig. 61. Detail from back of 60: Memnon attacking Achilles.

Beazley gives to only two small neck-amphorae and one lekythos the label 'middle'. I feel it more likely that some called early are in fact contemporary with middle-period work; that in these slighter pieces the artist kept much of his early grace and charm at a time when, on a grander scale, he was emulating, generally without great success, the more solemn spirit of a new age.

There is, though, one big elaborate vase already of this middle phase which does seem to achieve this solemnity: a dinos in Basel.[184] The dinos or lebes, a round-bottomed bowl with no handles, which required a separate stand often (as here) lost, is another shape which was regular in metal and which, though adopted quite often in Attic pottery, shows no steady ceramic development. There are splendid examples in early

black-figure which have a big figure-scene all round the body.[185] From the second half of the sixth century comes a series of black dinoi, with only a silhouette pattern on the top and outer edge of the reserved rim, and within the rim a black-figure picture of ships which, when the bowl was full, would seem to float on wine.[186] Fragments of a vase by the Kleophrades Painter derive from this tradition. The body of the bowl is black and the outer edge of the rim reserved with the usual ivy-wreath in black silhouette; but the upper and inner surfaces of the rim are decorated in red-figure: a palmette-chain within, and on top youths reclining at a banquet.[187] This is probably the earliest example of the shape we have in red-figure, but the Berlin Painter's follows close. The shape remains rare, and those that there are revert to the early black-figure system of decoration: a big figure-frieze round the bowl. Such is the Berlin Painter's.[188]

There are exquisite floral bands on rim and shoulder and below the figures' feet. Zeus mounts his chariot, amid a great array of deities (fig. 62): Athena, Apollo playing the *kithara* and accompanied by a fawn, Artemis, Dionysos, Poseidon, Hermes. At a point opposite the figure of Zeus two sceptred goddesses stand, facing outward, and between them a bearded man in a himation holding a knotted staff (fig. 63). This is no deity, and has been interpreted as a mortal worshipper. The artist, however, has given him the facial type, in particular the large round eye, which he and others at this time regularly reserve for Herakles.[189] Herakles was claimed as the first initiate in the Mysteries at Eleusis, and I suspect that that is what is meant here. The gear associated with his mortal labours (lion-skin, club, bow and arrows) put aside, he stands in civil garb between his sponsors, Demeter and Persephone; and Zeus and the Olympians come out to welcome him to Olympus.

Whatever the subject, the rendering has true solemnity. As we see most clearly in sculpture, there is a marked change of mood between late archaic and early classical. Many late archaic artists anticipate this spirit and help to create the new style. The Kleophrades Painter is one such in vase-painting. The Berlin Painter is a pure child of the archaic, and this accounts for the failure of his later work; but occasionally, and especially in this vase, he does achieve sympathy with the new spirit.

The dinos is a mixing-bowl for wine and water, a krater. Many other forms of krater were current in the Kerameikos at this time, and the Berlin Painter decorated examples of all. We have looked at his volute-kraters. He has not left us a series of big calyx-kraters comparable to the Kleophrades Painter's, but his use of the shape is interesting. One very large and beautiful piece is in fragments, scattered between London and Athens, where it was dedicated on the Acropolis.[190] In

this, which seems transitional from his early to his middle phase, he comes closer than anywhere else to the inspired solemnity of the dinos; and the subject is at least formally similar. On the front Athena mounts her chariot, Zeus standing by, Hermes at the horses' heads; on the back are Dionysos, and Apollo playing the *kithara* between his sister and his mother. The pictures are separated by palmette and lotus complexes, and there is a single palmette and lotus chain on the bowl below them as well as a double one on the rim above. There are similarly big, elaborate calyx-kraters from the very beginning of the painter's career, and we shall return to these when we discuss his origins,[191] but others from his prime are of different character.

A lovely scrap of calyx-krater with the head of a winged goddess[192] tells us nothing of the decorative scheme; but two, from the Athenian Acropolis and Sicily,[193] are smaller pots with black rim and bowl and few figures: Dionysos and a satyr on the front of the vase in Syracuse, a single maenad on the back; perhaps two figures on each side of the Athens vase, which had an Eleusinian theme; no ornament above the handles. Single-figure decoration on the calyx-krater is extremely rare, but the Berlin Painter, on a dull piece of his middle period in Oxford,[194] puts not only a mantle-youth on the back but a single Nike on the front; true, a massively 'spread' figure, with her wings and the phiale and big tripod she carries.

Single-figure decoration is equally rare on a related shape (another wide-mouthed bowl), the bell-krater; but all four pieces by the Berlin Painter have it, except that in one picture Europa runs beside the bull.[195] However, the form of this vessel which the Berlin Painter uses is very different from the shape as it becomes popular later. Indeed in this first form it departs in some respects from the normal conventions of Attic fine pottery. The handles are not the attached rolls of clay almost universal on fine pots but unpierced lugs; the broad, thick rim is only just set off from the body; and the vessel has no distinct foot, simply a flat bottom from which the wall rises direct. This last feature is found on some small jugs but on no other large pot. All this changes soon. First a simple foot is added, later enlarged and the pot-walls brought in to a relatively narrow stem above it. The rim is more elaborately modulated, and the lugs are replaced by rolled handles. In this developed form the bell-krater conforms to the metal-oriented look of most fine Attic pottery; but its derivation from the simple form is clear, and this is a strong argument against the supposition that all Attic pottery shapes of a vaguely metallising character are actually copied from metal models. Looking the other way, we can trace the origin of the simple shape. Cups of late sixth-century style, by or near the Euergides Painter, show a youth standing in a huge vessel of

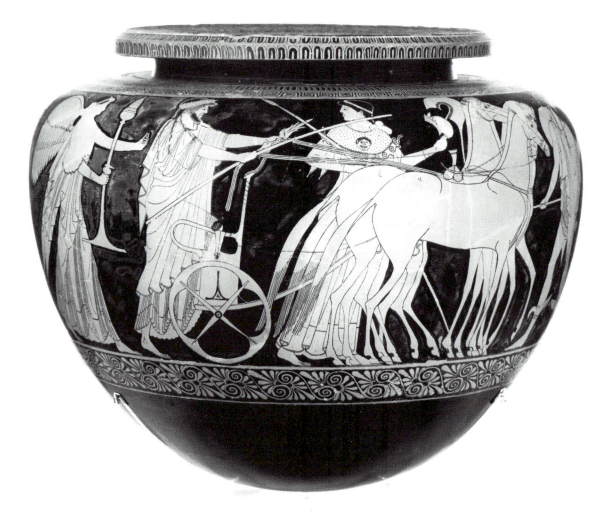

Fig. 62. Dinos; Berlin Painter. Zeus mounting his chariot. H. *c.* 0.33.

exactly this form. He is probably treading grapes;[196] and the vat for that purpose is amusingly taken as a model for the fine-ware mixing-bowl. The object depicted on the cups is plainly a utilitarian, undecorated vessel, in coarse pottery or less probably in wood.

The Berlin Painter (or the 'Berlin Potter' or workshop owner) may not have been the first to adapt this shape to fine pottery. Fragments survive of two vases in earlier styles, which seem to have been of this form. One[197] is ascribed to the Dikaios Painter, a name given to the decorator of a few vases in the manner of Euthymides. This could have been produced as late as the Berlin Painter's, but there is no reason to suppose that it was; and that is hardly a possibility for the other fragment,[198] which is in early red-figure style. It is ascribed to a

Hischylos Painter, named after a *poietes* with whom the young Epiktetos worked. Both these fragments are from vases with many-figured scenes. The lower part of neither is preserved, nor are the handles, but the beginning of the lip on the Hischylos Painter's is set off by a band of pattern. I see no connection between these and the Berlin Painter's beyond the fact that they look to the same model in coarse ware.

The case of the Kleophrades Painter is different. We have one complete vase by him of this shape, and a fragment of another.[199] The complete pot has one figure on each side, and the shape is very like the Berlin Painter's without being quite the same model. One difference seems significant. Instead of the flat bottom from which the wall rises direct, the Kleophrades

Fig. 63. Another view of 62: Herakles between Demeter and Kore?

Painter's potter has added a tiny base-ring: surely a concession to the general practice in fine-pottery shapes of articulating the foot. This suggests to me that he took the shape from the Berlin Painter's potter and modified that craftsman's direct reproduction of the coarse-ware form.

These fine pots include one of the Berlin Painter's masterpieces.[200] On one side golden-haired Ganymede, a cock (a love-gift) in his outstretched left hand, trundles his hoop (fig. 64); like the little Eros on the Boulogne doubleen, but a far more monumental figure. On the other side Zeus, wrapped in his mantle, sceptre horizontal in his left, leans in a forward stride, not so much pursuing as, with an imperious gesture of his extended right hand, bidding the boy come to him.

The column-krater (known to the Greeks as 'Corinthian krater' and probably invented at Corinth in

the later seventh century) was popular in Athens from about the same period. Some are very fine, but in the second half of the sixth century it is rarely a vehicle for good drawing. There are a few early red-figure examples by black-figure painters (one bilingual),[201] but we have none by any Pioneer or by the Kleophrades Painter. The Berlin Painter has left us a few slight pieces, black vases with single-figure decoration; and one fine fragment of a rim with palmettes and part of a lion.[202] We can be certain that this is the Berlin Painter's because he has a constant and distinctive rendering of the lion, whether as lion-head fountain-spout, scalp and skin worn by Herakles, or as the living creature. No other painter draws them so. The lion-protomes on Athena's shield on the Basel amphora are exactly the same, and the painter has left us several pictures of lions and lionesses on their own. A black-bodied lekythos in Munich has a lion on

Fig. 64. Bell-krater; Berlin Painter. Ganymede. H. of figure *c.* 0.21.

the shoulder (fig. 65); another, fragmentary, from Adria, a lioness against a floral background. Finest of all are two neck-pelikai from Spina. They are replicas, though one is even more lovingly detailed than the other: black vase; on one face of the neck a lion, on the other a lioness.[203]

A lion accompanies maenads tearing Pentheus on a stamnos in Oxford. The Berlin Painter has left us more than twenty stamnoi, running from his mature early style to the very end.[204] He puts no florals on this shape, and in his early work normally has three figures on each side. A very attractive example, formerly in Castle Ashby,[205] has Athena, standing between seated Zeus and Hera and pouring wine for her father. On the Oxford vase[206] the lion is under one handle and the six maenads, rushing round the pot (fig. 66), reach into the handle-areas. This looks forward to the composition he prefers for this shape in his late work: many figures circling the pot, the handles ignored as though they were applied over the finished drawing (a fiction as old as the François vase). The drawing on these late stamnoi (like the Boreas vase mentioned in an earlier section)[207] is

Fig. 65. Lekythos; Berlin Painter. Lion. H. of picture *c.* 0.04.

often very poor, and it is hard to know which are from his hand, which imitations. The early pieces are never very elaborate but lively and pleasing.

The Berlin Painter uses the fiction of the handles applied over the figure-drawing on one earlier vase, not a stamnos: a highly finished hydria (kalpis) with an assembly of deities drawn in the heavy style of his middle period.[208] The many-figured picture is on the body of the vase; and two hasty but rather pleasant pieces from his late period are black vases with two figures on the body.[209] His favourite scheme of decoration for the shape, however, is different.[210] The Kleophrades Painter carried on the Pioneer tradition of a picture on the shoulder heavily framed in pattern-bands. The Berlin Painter likewise puts the picture on the front of the shoulder, but the only pattern is a band below the figures' feet. His favourite design in this position has two figures confronted over an object: Ajax and Achilles seated at the dicing table (fig. 67);[211] Dionysos beating time while a maenad dances, a lion-cub (more simply drawn than usual) between

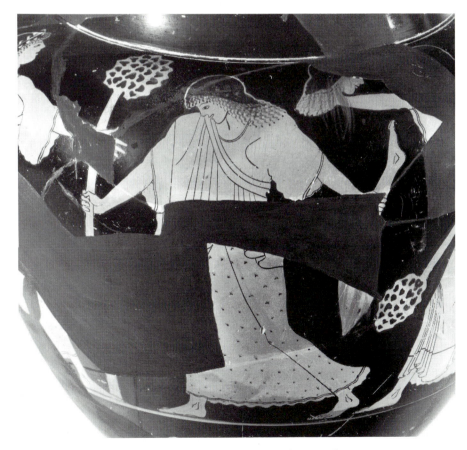

Fig. 66. Stamnos; Berlin Painter. Maenads with limbs of Pentheus. H. of picture *c.* 0.17.

Fig. 67. Hydria (kalpis); Berlin Painter. Ajax and Achilles dicing. H. of picture *c.* 0.12.

them;[212] Apollo and Artemis at an altar;[213] and, especially fine, Achilles crouched behind the fountain to ambush Troilos, sees the boy's sister Polyxene come to fill her pitcher.[214] The dicing scene is one of the latest renderings of a subject immensely popular in black-figure. The Troilos story too is going out of fashion; the Berlin Painter often takes a backward look. The spout of the fountain is the painter's regular lion-head; and a lost vase had another old theme adapted to this shape: Herakles and the lion (our painter's lion) wrestling on the ground.[215]

Another such lion-head spout is found on one of the Berlin Painter's few hydriai of the old black-figure shape.[216] This slight but pretty vase in Madrid[217] adapts another favourite black-figure theme rare in red-figure: a woman and a girl drawing water at a fountain; on the shoulder an Eros between palmettes. The artist's most important piece of this shape (in the Vatican)[218] is quite different: a black vessel with a version of single-figure decoration. On the front of the body is a great tripod, reaching from near the bottom to near the shoulder-edge, and extended across the breadth by two spread wings. It is flying over sea: a leaping dolphin in red-figure under either wing and a reserved strip at the bottom with wavy top, on it in black silhouette an octopus and fishes. At Delphi the Pythia, Apollo's priestess, sat in the bowl of the tripod to give out the god's oracles. Here Apollo himself sits so, golden-haired, in long chiton and himation, quiver and bow on shoulder, playing the lyre. His body is drawn across the sharp angle of the shoulder, his head where it begins to slope up to the neck. This is a splendid design exquisitely executed; but I cannot stomach the denial of the shape, in the way the picture is folded over the sharp shoulder-angle. It is, of course, only an extreme illus-

tration of a problem basic to Greek vase-decoration; and it is interesting that the Berlin Painter, perhaps the most perfect master of the harmonious adjustment of figure to pot, should not have found this arrangement offensive.

This vase belongs to the painter's prime. We may find the design awkward, but it is calculated. The awkwardness of a splendid picture on the shoulder of a kalpis in New York[219] is clearly due to its being extremely early work. A Greek strides forward and spears a fallen Amazon who reaches out her hand in a supplicating gesture; probably Achilles and Penthesilea. The drawing is extremely careful, as it is also in the maeander-band below, already ULFA but with a pattern-square not found elsewhere in the painter's work. One has the impression of a very young talent trying very hard. The same character is found on one panathenaic-style amphora, in Munich,[220] a discobolos on one side, on the other a jumper, and on a few more pieces; and it is time to look at the painter's origins.

That the Berlin Painter learned to draw among the Pioneers is obvious. The closest parallels in Morellian detail are with Phintias, and Phintias may have been the younger painter's first teacher; but Beazley, accepting this possibility, always felt the influence of Euthymides at least as important, and he was surely right. The resemblances between Phintias and the Berlin Painter have suggested to some (though I do not think this has been put in print) that they may have been the same man, but this I cannot believe. Signatures give us Phintias's development from the pre-Pioneer cup in Munich to the painstaking emulation of Euphronios and Euthymides on his big pots, and to the accomplished buffoonery of the later cups. At no point in this development do I see anything that could lead to the Berlin Painter's sensitivity to contour and mastery of line. The two appear to me totally different personalities.

Among works in the Berlin Painter's earliest style are fragments of three big calyx-kraters, very carefully and grandly drawn. One is from Corinth.[221] The five fragments (surely from one vase) give parts of a combat (much of a dying warrior) and Athena; there were big black areas over the handles, separating two pictures. Another, in Malibu,[222] of which much more is preserved, was not known to Beazley. It has a many-figured scene going all round the vase: the battle over the body of Achilles, Ajax lifting it in the presence of Athena. The drawing here is of an elaboration comparable to Euphronios's, and Achilles's blond head (fig. 68) is, in effect and in detail, quite extraordinarily like Sarpedon's on Euphronios's New York krater (fig. 69).[223] Clearly, like the young Kleophrades Painter, the young Berlin Painter, when he undertook a calyx-krater, looked to Euphronios. The third (fragments scattered in various collections)[224] is Dionysiac in theme and much recalls a

Fig. 68. Calyx-krater fragments; Berlin Painter (very early). Detail: Achilles's corpse carried by Ajax. H. of fragment *c.* 0.18.

Fig. 69. Calyx-krater; Euphronios. Detail: Thanatos bending to lift Sarpedon's body. H. of picture *c.* 0.19.

Dionysiac calyx-krater by Euphronios in the Louvre.[225] In some details, however, the exceptionally elaborate

drawing is very near to Phintias. In particular the partly preserved frontal face of a satyr seems closely modelled on the type used by Phintias on his amphora in Tarquinia.[226]

A very similar stylisation is used by the Berlin Painter for the gorgoneion in the centre of Athena's shield on the Basel amphora and the face of a Gorgon chasing Perseus on a panathenaic-type amphora in Munich.[227] The same mask, much enlarged but identical in detail, is found as the sole decoration of a kalpis in London[228] (on the front of the body). This likeness led me once to attribute the London vase to the Berlin Painter, but Beazley rejected it as not having the painter's quality of line, and I am now sure that this judgement is correct. It must be by an imitator.

All the pieces we have been considering as very early work of the Berlin Painter have already his full system of anatomical detail, and there is to my mind no question that they are his. A number of other vases have been attributed to his beginnings, some of them by me, which do not have this 'signature', and these attributions must remain at the best doubtful. Most important are two very fine pelikai, certainly by one hand: in Vienna, the death of Aigisthos (fig. 70); in Florence, deeds of Theseus.[229] Furtwängler attributed them to Euthymides,[230] and Beazley first accepted this, though noting them as in some ways untypical. Later he detached them (a 'Vienna Painter') and observed that they seem to lead on to the Berlin Painter.[231] In conversation he adumbrated the idea that they might be very early work of the Berlin Painter himself; and when I tried to demonstrate that this was the case he accepted it, though with some hesitation. There is, however, real difficulty in knowing where to place them in relation to the pieces just discussed, and no help is given in this by the discovery of the Malibu krater with Ajax and Achilles, unknown to Beazley. I still feel that the Berlin Painter could have painted these pelikai, but not that he certainly did.

The pelike was never a favourite shape of this artist's. Besides the neck-pelikai from Spina, we have two of the normal shape, one from his early, one from his middle period, with single-figure decoration,[232] and one (early) with many-figured framed pictures in the tradition of the Vienna and Florence vases. This, in the Villa Giulia,[233] shows Herakles and Apollo struggling for the tripod, Athena intervening, and on the back a man and a youth, rivals for a boy. It is of interest as being surely from the painter's hand, yet quite untypical in design.

Of similar character to the Vienna and Florence pelikai is a beautiful cup-tondo with a warrior disarming (fig. 71). This is in a small cup in Athens,[234] black outside, which is inscribed *Phintias epoiesen*. It is universally agreed that it was not painted by Phintias. Beazley never ascribed it; Hoppin gave it to Euthymides;

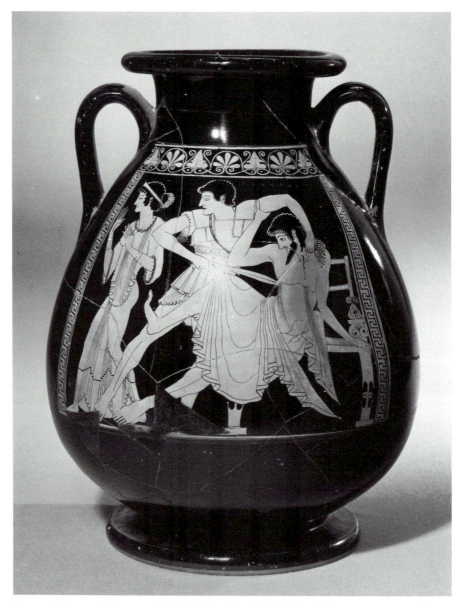

Fig. 70. Pelike; possibly very early Berlin Painter. Death of Aigisthos. H. *c.* 0.35.

I to the young Berlin Painter. Here too I now feel the attribution a possibility but no more. It is a significant fact that among the very large number of vases assigned with certainty to the Berlin Painter there is not a single cup. A very small cup from the Agora[235] has the name of a *poietes* Gorgos, not otherwise known, and praise of a youth Krates, named also on cups by Skythes and from the Proto-Panaetian Group. It has in the tondo a youth with a hare, outside the combat of Achilles and Memnon, with their mothers (fig. 72), and a Dionysiac scene. This is in a lively style which certainly has points of contact with the Berlin Painter's. Lucy Talcott

ascribed it to him, and I argued for the attribution, concluding that it was the painter's earliest work. Beazley accepted this, with even more hesitation than over the pelikai. I now feel, with the majority of scholars, that it is hardly possible. There are links to a small group, mainly of small cups, collected by Beazley round a 'Salting Painter' and a 'Carpenter Painter'. All this forms a *terrain vague*, which may be set in the neighbourhood of late Phintias and the early Berlin Painter, but it is probably a mistake to ascribe any of these vases to either artist.

I have dwelt on this because it is a good example of

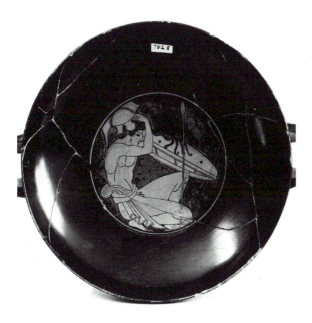

the fuzzy edges necessarily found in a field which depends entirely on stylistic judgement. Beazley, after his doubtful acceptance of the Gorgos cup, did ascribe one other cup to the Berlin Painter, a small fragment from the Agora,[236] but that seems to me, and I think to most scholars, to have been an aberration. It should, however, be noted that fragments from the Acropolis of two plates[237] are certainly from the Berlin Painter's hand; and three or four uncouth plates (grouped as a 'Bryn Mawr Painter')[238] show his influence. The plate is a shape generally favoured by cup-painters. One of the Acropolis pieces, in red-figure, showed Herakles; the other, very beautifully drawn on a white ground, Athena. This is the artist's only known experiment in that technique, unless a small piece of a second white-ground plate with a maenad, from the same site, is also (as it may be) his.[239] We have noticed that the white-ground technique is, at this period, of interest primarily to cup-painters.

Fig. 71. Cup with name of *poietes* Phintias. Warrior disarming. D. *c.* 0.25.

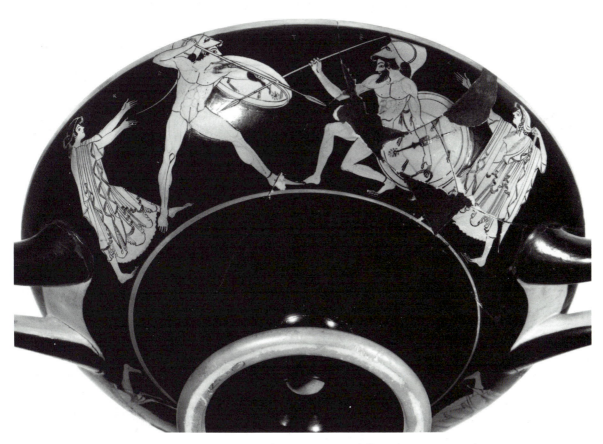

Fig. 72. Cup with name of *poietes* Gorgos. Achilles and Memnon in combat. D. *c.* 0.18.

III. Three leading cup-painters

a. Douris

The Attic red-figured kylix is typically (there is much variation) a wide, shallow bowl with an unbroken double curve from unmodulated lip through low, narrow stem to a relatively wide, almost flat foot with an offset edge. This near-vertical edge is reserved, the upper surface of the foot, stem and lower part of bowl black. In most small and many larger examples the whole exterior of the bowl is black, reserved only a patch under each handle and the interior of the handles themselves. Within the rim is a narrow reserved line; and there are many unfigured cups in which the rest of the inner bowl is black too, but these do not concern us. The two handles are set just below the rim and curve up to its level, so that, when hung by one handle on a nail or peg, the rim rests flat against the wall. On the underside of the foot, then visible, the resting surface is reserved, the interior of the hollow stem black. Cups are often so shown in pictures of drinking parties (e.g. fig. 79), which also indicate that the cup, when full, was normally held by the foot, empty could be carried by one handle or swung on the fingers in the game of kottabos. The tondo-picture occupies the centre of the bowl, only rarely (except when it is white-ground) extending over most of the interior. Pictures outside are normally many-figured, occupying the space between the handles on either side, with or without florals at the handles. Circling the tondo and under the exterior pictures is normally some form of maeander, though ocasionally a floral band is substituted. Fully decorated examples are generally between about 20 and about 40 cm in diameter, but bigger and smaller are found. The shape had metal analogues and may sometimes have had metal models; but it is a regular potters' form with its own ceramic development, and there is no reason to imagine models in metal-work for the decoration.

Of the artists of this time who specialise in the kylix we have already considered perhaps the greatest, Onesimos (the Panaitios Painter), to whom almost no other shape has been attributed. Most of the other leading cup-painters were less exclusive (as few major pot-painters abjure the cup with the consistency of the Berlin Painter), but in most cases their preference for the kylix is extremely marked.

Douris we have already noticed for the important fact that in his case the ascription of works in a distinctive style to one painter is confirmed by more than forty signatures. Most of these are on cups, but two are on other forms of drinking vessel, kantharos and phiale, one on a small round aryballos, and one on a relatively large pot, a psykter.[240] The name also occurs twice as

poietes, once on the signed kantharos, once on a larger aryballos of different form, not signed with his name as painter but the picture certainly his.[241] Other *poietes*-inscriptions are found in his work: on a cup of his middle period, Kalliades (not otherwise known); on one of his early period, Kleophrades (interestingly one of a pair, like the pair by the Kleophrades Painter, one of those bearing the same inscription);[242] on the phiale (fig. 74), which belongs to his 'early middle' period, a name ending in . . . kros, or . . . chros, unknown unless it be the minor Pioneer painter Smikros.

The Kleophrades inscription, like others with the name, is placed on the foot-edge, a position favoured for *epoiesen*-inscriptions and sometimes for *egrapsen*. On three cups with the signature of Douris in the tondo, one among his very earliest, one from the beginning of the 'early middle' period, one from the middle, the name Python is inscribed without a verb on the edge of the foot.[243] The same name occurs with *epoiesen* on a cup of special shape which also has the signature of Epiktetos as painter (the inscriptions there in the two outside pictures), of which we shall have more to say.[244] All three cups by Douris with Python's name have the same potting, and it seems safe to suppose that the name here is equivalent to an *epoiesen*-inscription. The importance of this is that the same potting characteristics are found in the majority of cups signed by Douris or attributed to him (though not in those with the names of other *poietai*) including those of his late period, when signatures and *epoiesen*-inscriptions are alike lacking. It seems that Douris and Python had a long association (whatever its nature) like that we shall meet between Makron and Hieron or the Brygos Painter and Brygos. Bloesch, however, has observed that a few of the early ascribed cups have the potting characteristics of those inscribed *Euphronios epoiesen*,[245] which suggests that the artist may have got his first training in the Panaetian circle. Long before Bloesch's work, Beazley had noticed a connection between the styles of the young 'Panaitios Painter' and the young Douris.[246]

Beazley divided Douris's work into four periods: 1, 'very early and early'; 2, 'early middle'; 3, 'middle'; 4, 'late'. The basis of the division is stylistic development, but there is also some supporting evidence. In the first two periods the inscription *Chairestratos kalos* appears fairly often. Interestingly it is once combined (on the cup with the name of Kleophrades as *poietes*) with Panaitios. Near the beginning of period 3 Chairestratos ceases to appear and Hippodamas begins, but he appears less frequently than Chairestratos before him. While Chairestratos's name seems to occur seldom or never except on cups by young Douris or in his neighbourhood, Makron too praises Hippodamas and after him Hiketes, who appears in Douris's work in period 4. There is also a change in letter-form. In period

1, and into period 2, Douris begins his name with the form of delta most regular in Attic writing, a simple triangle, Δ. On most of the signed pieces in period 2, however, and all those of period 3 (there are no signatures from period 4) he employs a different form, like a lambda with a dot, Λ.

I stress these details because they seem to me to add up to a degree of documentation, scanty but more than we often find in this field, which helps to justify the method in cases where even so much as this is lacking. There is, however, one document which does not support but runs against stylistic attribution. One cup, in Berlin, with the signature *Douris egrapsen* (dotted delta), finds no place stylistically at any point in Douris's development as envisaged above.[247] Moiseev and Buschor ascribed three pots (not cups) to the same hand as the Berlin cup, and supposed them to be the work of Douris. Beazley added many more, cups and pots, but saw them as work of an important painter, impossible to identify with Douris, whom he called the Triptolemos Painter.[248] We shall discuss this artist in a later section, and glance at possible explanations of the signature (none is very satisfactory). Here I will only say that I am convinced that the separation from Douris is right; and that, if forty signatures arrange themselves to give a picture of a single artist's development, and one sticks out like a sore thumb, that (whatever the explanation) seems to me to confirm rather than undermine the validity of the method.

Douris's development seems clear and consistent. The earliest signed pieces (three cups, one in Vienna[249] with Python's name on the foot, which has scenes of arming and departure; the round aryballos in Athens with a youth and a woman (fig. 73)[250]), have elongated, attenuated figures, at times rather awkwardly or hesitantly drawn; and one or two of the attributed cups look even more like prentice work. The artist shows his full power in the phiale[251] and in a second signed cup in Vienna[252] with Python's name, which shows the story of the arms of Achilles. Beazley placed this cup at the beginning of period 2, and the phiale (which he did not know) goes closely with it, though the signature there has the old delta, that on the cup the new. The very early aryballos and the phiale have elaborate florals, and the two Vienna cups a palmette-chain round the tondo and maeander under the outside pictures; but in general there is little ornament in period 1, and in 2 the artist settles to a very bare mode: no palmettes, and single-line borders. In period 3 his figure-drawing is fully assured, and he relaxes the austerity, putting elaborate and distinctive palmette-complexes at the handles and developing an individual maeander: a rather black pattern-square between single maeander-hooks or a pair. Period 3 merges gradually into period 4, the artist's drawing tending to become more conventional.

Towards the end it is often hard to distinguish his own work from imitations.

The bare cups of period 2 correspond in spirit to the black pot with single-figure decoration, favoured at this time, particularly by the Berlin Painter; and there seem to be points of contact between the two artists. Beazley, in his first article on the Berlin Painter, noted that the silens of Douris's psykter (period 2) show that artist's influence, and that 'the cup-painter who most resembles him in temperament is Douris'.[253] Features of the signed phiale, a most unusual piece, and of two other phialai which have been associated with the Berlin Painter, suggest a possible link between the two artists at the beginning of Douris's period 2. This may, however, be illusory.

The phiale is a ritual vessel, primarily for pouring libations though it can be drunk from. It came into Greek religion from the east in the seventh century; and both in the east and in Greece it is a metal form: gold, silver, bronze. There are a good many clay examples made in Attica in the sixth and fifth centuries, but it never becomes a regular ceramic form with its own development. It is a wide, shallow bowl, handleless, with a knob in the centre; and, as countless representations show, it was held for pouring with the thumb over the rim and the middle fingers reaching into the hollow under the knob. This determines its size. Surviving examples in all materials vary little in this respect and are hardly ever more than about 25 cm in diameter. The very fragmentary piece signed by Douris was about 42 cm, far too large for the human hand; and three or four others on the same scale, of approximately

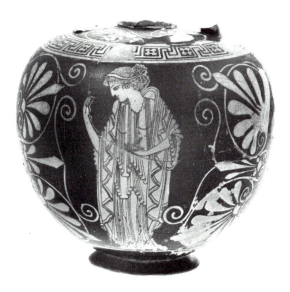

Fig. 73. Aryballos signed by Douris as painter. Woman. H. *c.* 0.09.

the same date, have come to light in recent years. One is from a sanctuary at Caere in Etruria, and it is likely that the others have similar provenances. The size was surely intended to demonstrate that they were for the use not of men but of heroes or gods.[254]

Douris's phiale is decorated outside and in with figure-scenes and patternwork. Outside are two pictures from the story of Herakles and Eurytos; inside three scenes: a combat from the Trojan war, an assembly of deities (fig. 74) and a pursuit. On the outside of the rim is an elaborate ovolo, inside a narrow palmette-frieze. Round the black omphalos, outside a broad and a narrow palmette-frieze, inside a narrow palmette-frieze and a running spiral. The same collection (the J. Paul Getty Museum) had earlier acquired two more phialai, a pair, slightly smaller (about 33 and 32 cm) but still outsize.[255] They have no figurework and are decorated on a different system: outside black; inside, within a narrow black rim, coral red; but round the omphaloi (both missing) on the inside are bands of pattern of exactly the same character as those on the Douris. The smaller has a narrow palmette-band surrounded by an elaborate ovolo; the other a narrow but more elaborate lotus and palmette band surrounded by a running spiral.

The palmettes and the ovolo are of a character common to much contemporary red-figure, but the lotuses are closely paralleled only in work of the Berlin

Fig. 74. Phiale with name of *poietes* ... kros or ... chros and signed by Douris as painter. Detail of interior: seated deities. H. of fragment *c.* 0.12.

Painter, whose florals are more varied and imaginative than most. The spiral is, as we noticed, an extremely rare pattern on painted pottery but is favoured, in a form very like indeed to this, by the Berlin Painter. The phiale with these two patterns has therefore been attributed to the Berlin Painter, and presumed to take the pair with it. The appearance now of an identical form of spiral on the phiale signed by Douris suggests a connection between the two artists. I have tended to this view in publishing the Douris, but I become doubtful of its validity. The spiral was certainly a metal-workers' pattern. It is found on the handles of bronze volute-kraters, and on one of the two occasions when the Kleophrades Painter uses it, it is in that position.[256] The big clay phialai are certainly modelled very closely on the metal form of the shape; and I suspect that when Douris or the Berlin Painter (if the other phiale is his) uses the spiral to decorate that shape he is borrowing the pattern from a metal model. I do not, however, conclude that this implies any model for the figurework on Douris's phiale; or that when the Berlin Painter uses the pattern on an amphora[257] or the Kleophrades Painter on a hydria[258] he is making a copy of a metal vessel. Rather they have taken the pattern into their repertory as a variant for special occasions from the common maeander.

There is a great number of golden heads on Douris's phiale, and several also on the related cup in Vienna. This is not generally very common in the artist's work but is, as we noticed, in the Berlin Painter's. I doubt, though, if this is evidence for influence.

Both phiale and cup are among the artist's most elaborate but also most attractive and effective works. To the same period belong three large and elaborate lekythoi decorated with outline and colour on a white ground. We looked at the earlier white cup with Europa, and one of the earliest of the painter's red-figure cups has a white zone round the tondo.[259] The white lekythoi are ambitious pieces and a most interesting anticipation of a later fashion. One, in Palermo, shows Iphigeneia led to sacrifice;[260] one, in Cleveland, Atalanta running, accompanied by three flying Erotes who hold complex floral sprays;[261] the third, in Malibu, young warriors arming.[262] The first two are interesting subjects interestingly treated, and all are very serious work; but I find them over-wrought and heavy, without grace or charm.

I do not feel in Douris the mastery of line which gives such harmony to the best figures by the Berlin Painter, such sensitive strength to Onesimos's; but he is one of the great masters of tondo composition. Early is a fragmentary cup in the Cabinet des Médailles[263] with a very impressive Ajax (three-quarter faced) lifting the body of Achilles; and from the middle period comes a splendid series of mythological pictures: Eos lifting the

body of her dead son Memnon;[264] Zeus striding, a muffled figure sleeping in his arms, probably the boy Ganymede;[265] a heraldic dragon spewing out the body of Jason, behind it a tree, the golden fleece hanging in its branches, Athena standing by, head bent, holding her owl[266] – a version of the story we do not know from any other source (fig. 75). No less beautiful are some scenes from daily life, of the same period, notably a pair of revellers on a cup in the British Museum,[267] moving together, the leader turning back to the other (fig. 76).

Very similarly composed is a picture of a dancing girl and boy piper in the tondo of another cup in London,[268] this one signed by Epiktetos (fig. 77). On one side of the exterior of this cup (the other side has Herakles at the altar, turning on Busiris's Egyptians) is a symposium: two couches viewed in the usual way from the front, a third seen end on, the drinker foreshortened in back view (fig. 78). This is an unlikely design before the Pioneers; and the same scene is treated in a closely similar way on a third London cup,[269] this one again by Douris in his middle period (fig. 79). Epiktetos's cup is the one which bears not only his own signature (in the symposium scene) but also (in the Busiris picture) the name as *poietes* of Python, who as we saw has a regular association with Douris. I take all this as evidence that in the time of Douris's middle period Epiktetos was still active, and drawing in essentially the style he had developed long before; and that, in this collaboration with Python, he chose to imitate Douris's compositions. Long ago Furtwängler noted the likeness between the two symposium pictures, and he too concluded that Epiktetos was the imitator;[270] but he was not trammelled by the rigid chronological framework within which we work. I have little doubt that this chronology is in its general lines right, but I am sure it should be applied loosely, with a wide allowance for overlap of careers and styles. In my view, as we shall see, Epiktetos surfaces again even later.[271]

The Epiktetos/Python cup is of a special shape, in which there is no stem and the bowl rests directly on a tall foot with reserved edge. The type is known as 'Chalcidising' because it is certainly imitated from eye-cups produced in the black-figure ware known as Chalcidian but actually made by Greek settlers in Italy.[272] Chalcidian runs roughly through the second half of the sixth century and the cups belong to its latest phase. There are some twenty Attic imitations in black-figure (likewise eye-cups), one of which has the name of the *poietes* Pamphaios. All these are likely to be still sixth-century, but I do not think they necessarily date our cup. It has distinctive potterwork unlike any of the black-figure pieces, and is not an eye-cup. In a later section we shall find a contemporary of Douris producing a new version of the eye-cup;[273] and I take this Chalcidising piece to be a similar throwback to an out-dated form.

The cup-exterior, the area between the handles, is an awkward picture-space, and Douris does not always seem such a consummate master of it as some painters are, or as he himself is of the tondo, but he has left us some splendid examples. The compositions on the second Vienna Python cup[274] are particularly grand; they also pose an interesting problem. They illustrate the dispute of Ajax and Odysseus over the arms of the dead

Fig. 75. Cup; Douris. Jason disgorged by the dragon for Athena. D. *c.* 0.20.

Fig. 76. Cup; Douris. Two revellers. D. *c.* 0.20.

87

Fig. 77. Cup with name of *poietes* Python and signed by Epiktetos as painter. Dancer and piper. D. *c.* 0.14.

Achilles. Ajax had borne the unstripped body from the field, while Odysseus protected his rear. It was agreed that one of them had earned the dead hero's famous armour, but both claimed it. When a vote gave it to Odysseus, Ajax drew his sword on him. Odysseus responded, but they were separated. Ajax retired to his tent and, overcome by madness, slaughtered sheep and cattle in the belief that he was killing the Greek princes; then, recovering his senses, fell on his sword. On this cup Douris shows in one picture the vote (fig. 80): Athena in the centre, behind a low block on which pebbles are being piled by heroes queuing on either side.

At the back of each queue stands one of the rivals, Odysseus gesturing pleasure at his growing heap of votes, Ajax veiling his head. In the other picture (fig. 81), Ajax, in armour and with drawn sword, is restrained by two comrades from attacking Odysseus, in himation, who is drawing a sword from a scabbard he has snatched up. Two heroes hold him back also, while Agamemnon, arms outstretched, rushes between them, dominating this picture as Athena dominates the other.

Aside from their splendid quality, the particular interest of these pictures lies in the fact that the same two scenes are paired, with closely similar compositions, on a number of other cups. Three of these are by Douris himself, one earlier, two later than the cup in Vienna, but all are very fragmentary and one at least of the later ones has a rather different treatment of the vote. One, however, by the Brygos Painter, in London (fig. 82), is virtually complete and very close indeed to the Vienna Douris; but in a second example by the same painter the voting-picture is again varied. There are also two fragmentary cups by Makron, one of which has a canonical quarrel but the other side seems different; while of the second only the voting is preserved, on the regular design.[275]

We shall return to some of these in other sections. Here we need only note that the interiors of all these cups have different subjects, some connected with the exterior story, some not. The tondo in Douris's Vienna cup has Odysseus handing the armour over to Achilles's young son Neoptolemos, brought to Troy for the final scene. In spite of the variations I have the impression that the common inspiration behind the paired pictures of voting and quarrel must have been visual rather than literary. Since it was taken up by different painters who are not likely to have been sitting in the same shop, the

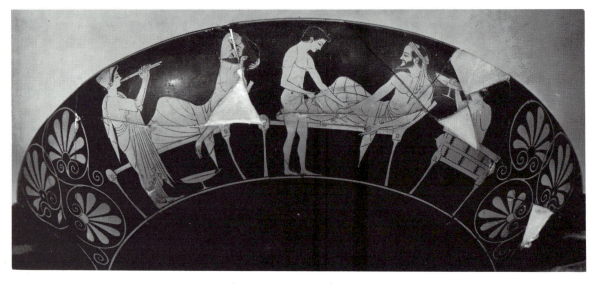

Fig. 78. Exterior of 77: symposium. H. of picture *c.* 0.08.

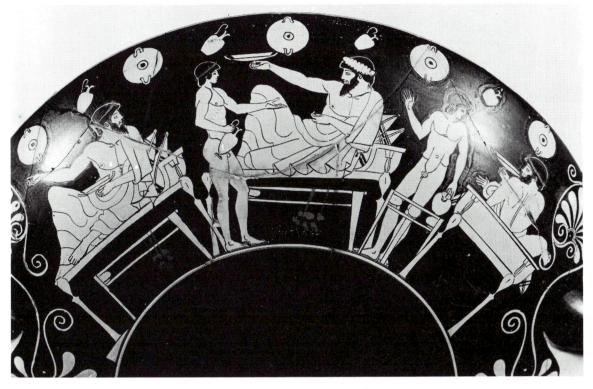

Fig. 79. Cup signed by Douris. Symposium. H. of picture *c*. 0.10.

source is less likely to have been in vase-painting than in wall-painting. Sculpture is a possible alternative, but a pair of wall-paintings appears to me most likely.

We glanced at some of the lovely tondos of Douris's middle period, mythological and other. One of the most pleasing exteriors of this phase is on a signed cup in Berlin,[276] with praise of the beautiful Hippodamas, and pictures from contemporary life. In the fragmentary tondo an athlete is putting on or taking off a sandal, his other gear around him. Both sides of the exterior show a school-scene, or at least a series of vignettes of boys at their lessons (fig. 83). At one end of one side a bearded man sits on a stool, fingering a lyre, plectrum in hand. On a lower stool facing him a small boy sits, also with a lyre, and imitates his action. Back to back with this boy sits another bearded man, who holds a scroll inscribed with a hexameter verse. He seems to be checking the recitation of a boy who stands in front of him. The hexameter (in which there are mis-spellings) reads like a conflation of tags meant to suggest the opening of an epic poem about Troy. At the right-hand end a bearded man sits frontally on a stool, feet crossed. He holds a staff and surveys the scene. A similar figure sits in the same position in the second scene, only his knees are away from the action and he looks back at it over his shoulder. Back to him stands a boy, facing a beardless

teacher on a stool, who holds tablets and stylus poised above them, as though he were correcting the boy's exercise. The last group on the left consists of a second youthful teacher who sits on a stool playing the pipes, and a boy standing in front of him who lifts his face, evidently to sing to the music. All wear the himation, the standing boys wrapped close. The seated boy with the lyre and all the teachers have it round the lower body only, so that the arms are free. The seated men with sticks, probably *paidagogoi* who have brought boys to school and are waiting to take them home, have it pulled up over the left shoulder, the usual wear for walking around. On the wall in the second scene are a scroll, a writing-case, a lyre, and a puzzling object in the form of a cross which appears quite often in this context; in the first scene two more lyres and a pipe-case, but also provision for break: two cups and a three-footed food-basket. Under each handle is a hanging palmette from which tendrils curl up to enclose a palmette at either side: the simplest form of a design regular on the artist's middle-period cups.

There are a good many such school-pictures, for instance on fragments by Onesimos from Naucratis in Oxford, where a scroll is similarly inscribed with verse-tags. We shall meet other inscribed scrolls later.[277]

The kantharos is defined by its high-swung handles;

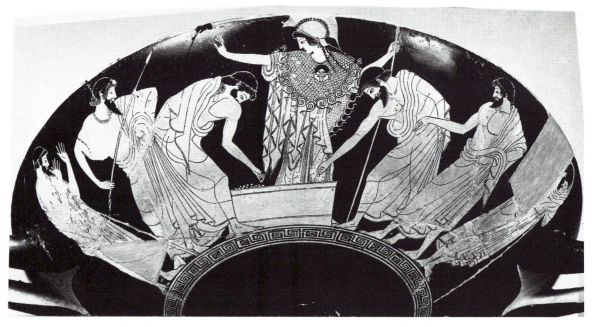

Fig. 80. Cup with name of *poietes* Python and signed by Douris as painter. Voting for arms of Achilles. H. of picture *c*. 0.11.

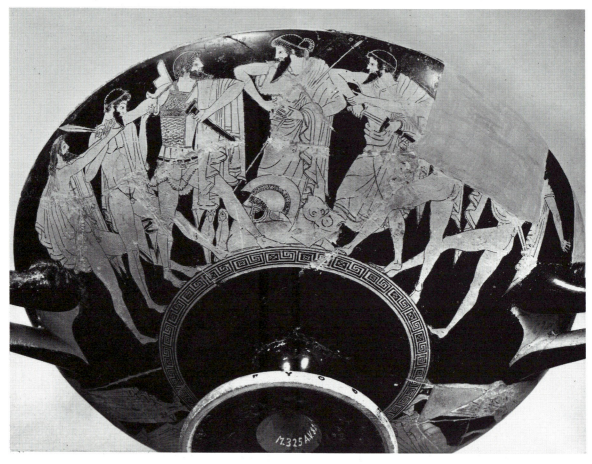

Fig. 81. Other side of 80: quarrel of Ajax and Odysseus.

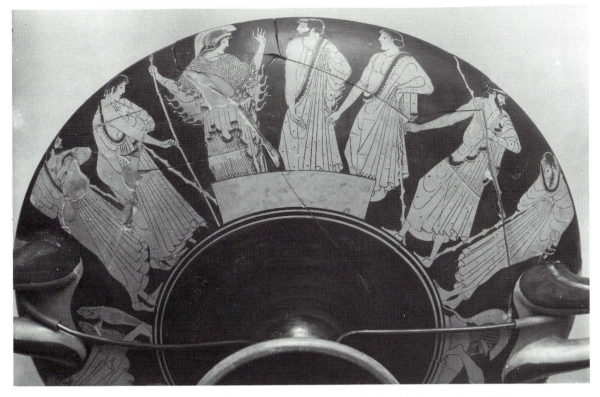

Fig. 82. Cup; Brygos Painter. Voting for arms of Achilles. H. of picture *c.* 0.11.

Fig. 83. Cup signed by Douris. School. H. of picture *c.* 0.10.

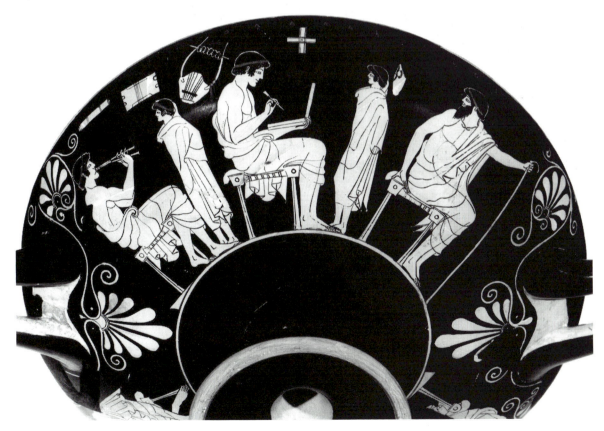

but the one signed by Douris, in Brussels,[278] is not of the most usual form, with a tall, slender stem and tall straight sides. We saw good pictures of that on the Berlin Painter's name-vase, and it is constant in Dionysiac scenes, especially in the god's own hand. Douris's has a low, rounded bowl on a low stem. Precisely the same form is held by Herakles, served with wine by Athena, in a very charming cup-tondo in Munich,[279] which used to be thought late work of Douris but is now given to a follower, the Oedipus Painter. A form in which the same round bowl is set without stem direct on a low ring foot is regularly held by Herakles, for instance on the Berlin Painter's Basel amphora.[280] This and the Dourian seem variations on a single basic type which has been neatly associated with literary references to a 'Heraclean cup'.[281] Douris's vase, a fine work of his early-middle period, is appropriately decorated with pictures of Herakles (fig. 84) and Telamon fighting Amazons. No type of kantharos has a steady ceramic development, and this is probably a case where any potter who needed to make a vase of this type would look directly to a metal model.

On the face of the kantharos where Herakles appears Douris set his signature as painter, and with it a second inscription, *Douris ep[oiesen]*. This appears again (complete) on a second aryballos in Athens,[282] of a different shape from the very early one. Here there is no painter-signature, but another inscription, painted before firing: *Asopodorou he lekythos*, 'the lekythos belongs to Asopodoros' (there is plenty of evidence that *lekythos* was used for any form of oil-flask). This was evidently a special order, by or for Asopodoros; and the Athenian grave in which it was found was no doubt Asopodoros's. The dotted delta is used here in the owner's name as well as Douris's, as it is also in Hippodamas's when it appears on Douris's cups, and in

Skamandros (the river of Troy) in the quotation on the scroll in the school-scene. The picture on the aryballos, certainly from Douris's hand in his middle period, shows a boy fleeing from an Eros who pursues him with a ship, while another opens his arms as though to protect him (fig. 85). There is some formal resemblance to the larger and more elaborate picture on the earlier white lekythos with Atalanta running among Erotes;[283] but the little red-figure picture has all the charm I feel lacking there.

Douris painted a few red-figure lekythoi and small neck-amphorae (doubleens). Some of them are black vases with single-figure decoration: a doubleen in Leningrad with Nike and a victor; a nice lekythos in Vienna University, with Eros kneeling and blowing a trumpet.[284] These might point to some link with the Berlin Painter, who, as we saw, was the first red-figure painter to specialise in these shapes, but I do not see any clear stylistic resemblance. In the fine signed psykter of the early-middle period, however, I do feel force in Beazley's early observation that the satyrs show the Berlin Painter's influence.[285] It is an engaging as well as a careful work, and the revelling satyrs (one dressed up as Hermes) display some pleasing inventions (fig. 86). The ornament is restrained. Under the picture runs a delicate and unusual maeander which, with distinctive Dourian pattern-squares, adopts the principle of ULFA, confirming that the artist has been looking at the Berlin Painter. Then in a narrow reserved groove at the top of the hollow stem, where the mushroom shape spreads out, he has put an exquisite tiny chain of palmette and

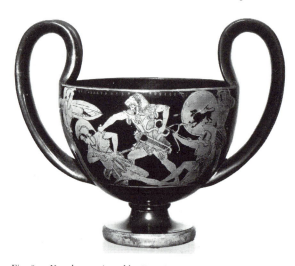

Fig. 84. Kantharos signed by Douris as painter and *poietes*. Herakles fighting Amazons. H. with handles *c.* 0.18.

Fig. 85. Aryballos signed by Douris as *poietes*; Douris. Boy between Erotes. H. *c.* 0.10.

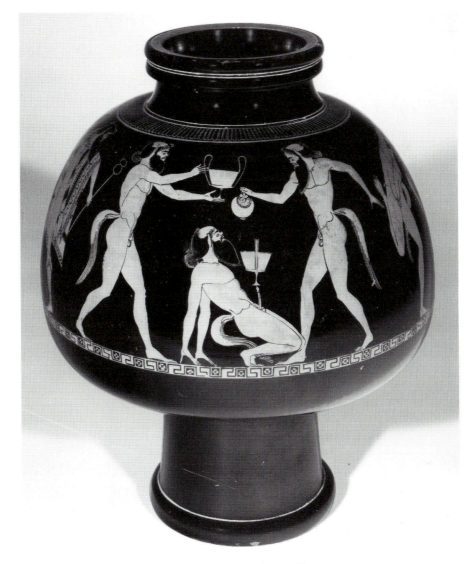

Fig. 86. Psykter signed by Douris as painter. *Komos* of satyrs. H. *c.* 0.29.

lotus in black silhouette. I can think of no normal circumstance in which this would be likely to be seen. The artist put it there for his own pleasure.

In his late period Douris also decorated a few rhyta: vases with moulded animal-heads, based on metal vessels of ritual character. We will discuss this phenomenon (with the related one of vases in the form of human heads) in the following section.[286]

b. The Brygos Painter

There are some sixteen cups or cup-fragments with the inscription (complete or in part) *Brygos epoiesen*, always written in black on a reserved surface: twice on the foot-edge, the rest on the interior of a handle. Of the cups from which drawing survives, the five finest are by

one outstanding painter, to whom many more cups and a number of vessels of other shapes have been ascribed, and whom we know as the Brygos Painter. Four more were painted under this master's direct influence, but another two are unconnected with him in style. Many of the cups ascribed to the painter or his circle are connected by their potting to those with the *poietes*-name of Brygos.[287] Since there is no *egrapsen*-signature, we cannot be sure that the Brygos Painter is not Brygos himself; but the number of cups with the name which were decorated by other hands speaks against that, though it is not conclusive. More probably it was a regular partnership, like those of Douris and Python, Makron and Hieron, whatever the role of the *poietes*.

One of the two cup-feet with *Brygos epoiesen* is on a cup by the Brygos Painter;[288] the other on a frag-

mentary piece not connected with him. On this (in the Cabinet des Médailles[289]) only Bry . . . survives, but the restoration is no doubt correct. Beazley described the fragments as 'much earlier' than the other signed pieces, but the 'much' seems an exaggeration. They are from a large, elaborate cup. He could not ascribe it to a hand, but associated it in general character with some other cups, and describes them and it as 'the end of a mode, the last of the "Parade Cups"'. The Parade Cups, we saw, were a Pioneer fashion, and the last of them can hardly be earlier than the Proto-Panaetian. The Brygos Painter is certainly an approximate contemporary of the other painters discussed in this chapter, though not among the older of them. He seems to have achieved his very individual style early, and his work, until his late phase, does not show the degree of change that Douris's does. There is development, though, and the earliest-seeming pieces look later than early Douris. Beazley remarks that 'the earlier work of the Brygos Painter runs parallel with the work of Onesimos in that artist's later – post-Panaetian – phase'.[290] With the Brygos Painter we seem for the first time to be out of direct contact with the Pioneers.

We saw that Douris was at his best in tondo-compositions. There are many beautiful tondos by the Brygos Painter too, but he loves also more complex massings, swift movement, swinging draperies, and he is perhaps the greatest master of the cup-exterior. On a cup in the Louvre[291] he has left us an Iliupersis to compare with the roughly contemporary kalpis by the Kleophrades Painter and the earlier Proto-Panaetian and Panaetian cups.[292] On the huge fragmentary cup in Malibu, Onesimos (the Panaitios Painter) put the climactic episode, the death of Priam, in the tondo and the other scenes, exceptionally, in a circle round that. On the kalpis the continuous circle is broken by the back handle, and the death of Priam occupies the centre front. The Brygos Painter sets his picture on the outside of a cup, so the handles separate it into two sections.

The painter has indicated continuity by having a Trojan cut down by a Greek fall under one handle, his sword-arm above his head reaching into the other picture (fig. 87). Hung on the wall by this handle, the cup presents a continuous action, beginning and end marked by a palmette within the handle opposite; but the two sides make each a self-contained composition, and the altar on which Priam sits is at the centre of one. The structure of the picture on the kalpis, with the feet on the wide outer circle, leads to compact pyramidal groups. On the cup the feet are on the narrow inner circle and the figures reach up in spreading movements. There is a corresponding contrast in mood. The Kleophrades Painter's tone is given by still figures, mourners and the dead; with the Brygos Painter all is

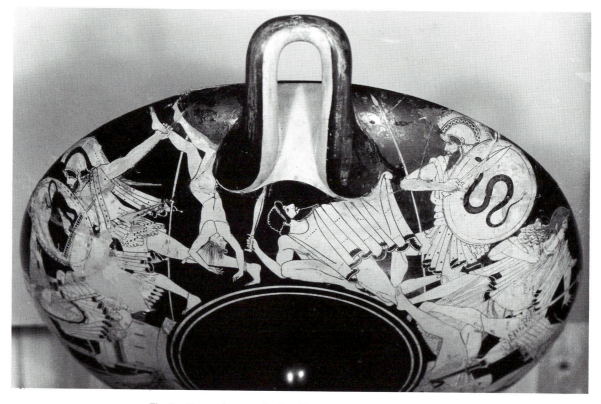

Fig. 87. Cup with name of *poietes* Brygos; Brygos Painter. Iliupersis. H. of picture, *c.* 0.12.

action. The difference is stressed in the indication of setting. Behind the altar, where the Kleophrades Painter has a ruined palm-tree, the Brygos Painter puts a huge tripod, standing proud. The old king on the kalpis sits still, head in hands, the dead child on his knee. The Brygos Painter, like the Panaetians, has Neoptolemos (here, exceptionally, bearded) brandish Astyanax's corpse as a weapon, while the old man has drawn his feet up on the altar and sits, knees splayed, reaching both hands out in supplication.

The Greek's rear heel and the arm of the dead boy all but touch the hand and sword of the Trojan fallen under the handle from the other side. This figure, almost horizontal, has his right leg doubled under him and fights back, left arm, wrapped in a cloak, reaching out towards a Greek who has dropped his spear (as Neoptolemos has) and comes in for the death-blow with a hacking-sword. Behind the Greek a Trojan woman, hair loose, skirt pulled above her knee, rushes by in the same direction but looks back, mouth open in a cry. This wonderful figure divides the centre of this side with a Greek in the foreground. He leans forward to the right, shield-arm stretched out, right hand far back with a thrusting-sword to finish off a Trojan who sprawls along the groundline, head thrown back, beard pointing at the sky. Behind him a Trojan woman swings a pestle to club the Greek, and at her back a boy makes off, his foot overlapping the bounding-palmette under the handle. On the other side of the handle the only quiet group closes the Priam picture. A Greek warrior marches off, leading a Trojan woman who looks back past the tripod to the terrible scene at the altar. In the Kleophrades Painter's picture the men on both sides are fully armed. Here, with greater dramatic effect, Greeks alone are so. Trojans have only cloaks and the swords they have snatched up.

A good many of the figures have names, some unexpected. The woman led away is Polyxene, her captor Akamas; Astyanax is not only the dead child but the live one running away; and the woman with the pestle is only here identified as his mother Andromache. Other names used here are not elsewhere recorded for figures in this story. The double appearance of Astyanax is very unusual. Akamas and Demophon are sometimes shown leading away their grandmother Aithra, but the single warrior leading a woman in this context is normally Menelaos with the recovered Helen. These oddities have led to the suggestion that it was not the painter who put in the names on this cup but an assistant who picked them rather haphazardly.[293] This I doubt; they have too good a rationale. Only here is the woman's heroic action with the pestle associated with protection of a child, and for that Andromache and Astyanax are the obvious candidates.[294] Polyxene was taken alive at the sack, and the great new Panaetian cup

shows her in direct association with her father's death on the altar.[295] I think the artist put the names and meant them. A figure he did not name is the woman rushing wildly by, mouth open, on the second side. One would love to see her as Cassandra. Another moment is regularly chosen, as we have seen, for Cassandra at the sack.[296] The painter here omitted that scene, and I could believe that, in this very personal Iliupersis, it was she he had in mind when he drew this tremendous figure.

Priam's hair and beard are white, and the garments have heavy black borders and dotted decoration. The Brygos Painter likes this kind of restless surface more than most of his time. It recurs in the tondo, where another white elder sits and holds out a phiale into which a standing woman pours wine. They are named Phoenix and Briseis, Achilles's old tutor and his mistress, and the arms which hang conspicuously on the wall must be his. Thus it forms a prologue to the action of the exterior, like the epilogue in Douris's cup with the story of the arms.[297] One of the Brygos Painter's versions of that story has a different epilogue: Ajax dead, the sword in his body, and Tekmessa laying a cloth over him (fig. 88) as she does in Sophocles's play of a little later.[298] In the most complete of the Brygos Painter's arms cups (fig. 82), in London,[299] which is also the one closest to Douris's, the tondo has yet another scene. A bearded man in chiton and himation and wearing a travelling hat, leads a woman by the wrist and holds a spear over her. These unnamed figures are certainly from legend, and one would expect them to be more or less closely associated with the story, but one cannot be sure. A variant of the Phoenix and Briseis,

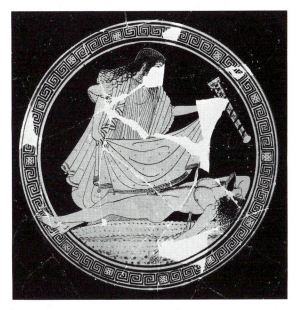

Fig. 88. Cup; Brygos Painter. Tekmessa covering dead Ajax. D. *c.* 0.15.

even more elegantly and strongly drawn, is in the tondo of a cup in Tarquinia.[300] Here one half of the exterior has the combat of Achilles and Memnon. On the other is a much rarer Trojan scene: Paris, who had been exposed as a child, recognised and received home; and here the woman who looks towards us with a gesture of distress is certainly Cassandra, the unregarded prophet of woe.

There are other splendid mythologies: a Gigantomachy in Berlin, Selene in the tondo driving her two-horse chariot straight at us (fig. 159);[301] a fragmentary but superb Circe and Odysseus from the Acropolis;[302] and many more. The artist was also a master of daily life, in particular the symposium and the komos. One of his most beautiful cups, in Würzburg,[303] the name of Brygos on the handle, has a procession of revellers, dancing along to pipes and a *barbitos*, nearly a dozen men and youths, and on one side a couple of hetairai. In the tondo the aftermath: a young man stands and vomits while a girl (with a slave's short hair) tenderly holds his temples (fig. 89). I quite often feel in this artist's work, though it is hard to say how far it was meant, a touch of tenderness, of feeling, rather rare in the art of this macho world.

As well as the effects of wine on men, the painter was fond of the wine-god and his company. A splendid cup in the Cabinet des Médailles[304] has in the tondo an exceptional design: Dionysos plays the *barbitos*, head flung back till his beard points at the sky, mouth open in song, while on either side of him a smaller satyr dances with castanets, one also holding a vine-stock with leafy branches which fill the background. On the outside a wild procession of satyrs and maenads dances to music,

like the revellers of the Würzburg cup. Two of the satyrs play the *barbitos*, and the god himself walks beside a donkey: surely they are on their way to pick up Hephaistos and carry him home to Olympus. We saw that a fragment by the Berlin Painter illustrates a new version of that old story, in which the mount is dispensed with, the god brought home on foot.[305] That is perhaps influenced by a satyr-play; and another such surely suggested the scenes on the exterior of a cup by the Brygos Painter in London.[306] This is the second piece in which the name of Brygos is written on the foot-edge. It is a cup Type C, with offset rim and stout stem set off from the foot by a moulding. On one side Iris, the gods' winged messenger, has been seized at an altar by a band of satyrs intent on rape. Dionysos stands by, showing no disposition to intervene. On the other side another band threatens the queen of heaven herself, Hera, but she has found protectors (fig. 90). Between her and the gang stands Hermes, who gestures as he addresses them; and behind her strides in Herakles, bow and arrow held out threateningly in his left hand, club ready in his right. From under the lion-skin appear the striped sleeves and trousers of a Scythian archer, the police of Athens.

The tondo-picture of this cup can hardly be linked in any way to these scenes. A standing girl pours wine into a seated man's phiale; as Briseis for Phoenix, but here she has a ladle, not a jug. Further, the man is not old but a warrior in his prime, with helmet and full armour and his spear in his other hand; and with her left hand the girl supports his shield. The warrior wears a himation over his armour, which is uncommon: Oltos and Douris show Ares so in divine assemblies.[307] It perhaps indicates that he is committed to war but here engaged in offices of peace. We should expect the two in the Brygos Painter's tondo to be characters from legend, but they are named Chrysippos and Zeuxo and cannot be identified in any known story. (He sometimes names figures in contemporary scenes, as *Kallisto* dancing for *Pilipos* in another London cup-tondo (fig. 91).) In both interior and exterior pictures tiny details are added in gold on raised dots of clay.[308]

On a cup in Munich with Dionysiac revels outside the painter carries the theme into the tondo but changes the technique.[309] The snake-wreathed maenad who rushes with thyrsos in one hand, in the other a panther-cub, is drawn in outline on a white-ground (fig. 92). There is a band of white within the rim, but the picture-field, unusually for a white cup, is confined to the central tondo, surrounded by black with no intervening pattern-band. The drawing is in relief line and dilute black (golden) brush-lines, with some dilute washes, and is just like the artist's red-figure in character.

A damaged white lekythos in Gela[310] is also attributed to the Brygos Painter. It shows an episode he

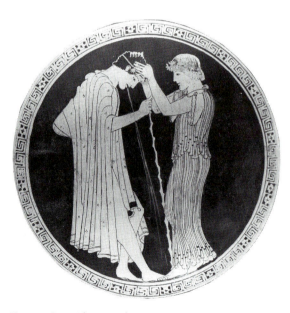

Fig. 89. Cup with name of *poietes* Brygos; Brygos Painter. Slave-girl helping youth vomit. D. *c.* 0.15.

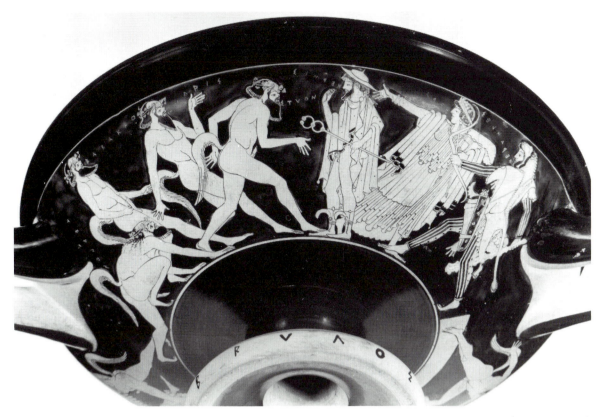

Fig. 90. Cup with name of *poietes* Brygos. Hermes and Herakles protecting Hera from satyrs. H. of picture *c.* 0.09.

Fig. 91. Cup; Brygos Painter. Youth at feast; girl dancing. D. *c.* 0.16.

FIG. 92. Cup; Brygos Painter. Maenad. D. *c.* 0.14.

omitted from his Iliupersis, Aeneas leading away his father Anchises. This has a technical feature we shall meet commonly in one phase of development of the white lekythos, as well as on other shapes with white-ground decoration: the addition of a second, purer white for details, most often for women's skin, here for much of the hero's armour and for his father's himation. An exquisite white oinochoe (fig. 93) in the British Museum[311] (a shape rarely so decorated), with a woman spinning (no second white), was given by Beazley to a fine companion of the Brygos Painter whom we shall treat in another section, the Foundry Painter.[312] Williams, however, has shown good reason for thinking it by the Brygos Painter himself.[313] He argues convincingly too for other white-ground pieces as the Brygos Painter's. One is a fragmentary cup from the Acropolis not listed by Beazley but associated by Langlotz with the Panaitios Painter.[314] It shows Athena

with a boy, probably Erichthonios, a huge snake and a tree. Athena's chiton is in added white, something very rare on white cups. Another is the fragment in Berlin with Eros which Beazley called Manner of Onesimos.[315]

There are also a good many red-figured lekythoi and Nolan amphorae from the Brygos Painter's hand (more than by Douris).[316] He seems among the first to standardise a red-figure shoulder-decoration for lekythoi of palmettes and lotus-buds (he put it also on the shoulder of his white lekythos). Like several painters who did not normally decorate plates (Onesimos, the Berlin Painter, the Harrow Painter), as well as others who did, he has left us a fine fragment dedicated on the Acropolis:[317] a singing reveller. This is one of the burnt pieces which have been thought to antedate the Persian destruction.

The painter's most important work on shapes other than cups is on drinking vessels of different forms:

Fig. 93. Oinochoe; Brygos Painter (rather than Foundry Painter). Woman spinning. H. of picture *c.* 0.09.

98

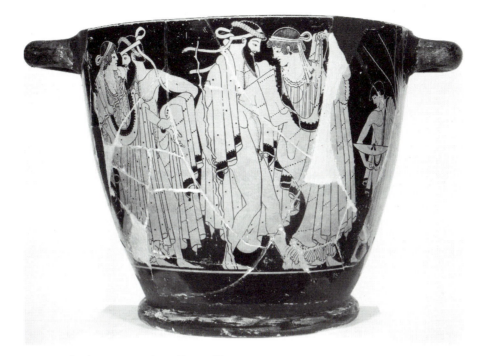

Fig. 94. Skyphos; Brygos Painter. *Komos*. H. *c*. 0.29.

skyphoi, kantharoi and animal-head rhyta. One of his most pleasing revels (fig. 94) is on a big skyphos in the Louvre,[318] and on a still larger one in Vienna[319] he adapts his symposium scenes to legend. Young Achilles reclines at dinner, and turns his head over his shoulder to address the pretty little boy serving, while old Priam stands at the foot of the couch patiently waiting. Slaves behind him are loaded with the gifts with which he hopes to ransom his son's body – Hector, who lies twisted and bloody under the Greek's couch. This is, clearly with intention, a heavy vase: straight walls rising almost vertically from the heavy roll of the foot; thick horizontal handles at the rim. The elaborate fine drawing of the still scene is heavy too. It is a *tour de force*, but does not seem perfectly suited to the painter's genius. The group of unnamed heroes in conversation on the back is livelier. We shall find in the next section that Makron, another cup-painter who favours the big skyphos for special pieces, makes something very different of the shape.[320]

One of the best examples of the painter's work on a shape other than a cup is on a kantharos in Boston;[321] not of the Heraclean type like Douris's but the tall-stemmed, straight-walled Dionysiac kind. The pictures, however, are not related to the wine-god; at least not directly so. On either side a sceptred Zeus pursues one of his loves: a youth with a hoop, who can only be Ganymede; and a woman. Ganymede was to become Zeus's cup-bearer; and if the woman were Semele, on

whom he begot Dionysos in Thebes (where this vase was found), a Dionysiac association would be established for the whole. In two of the many pictures in which Zeus pursues a woman she is named Aigina, and that is the identification usually made here,[322] but it is not sure. On a later vase the pursued is shown to be Thetis by the naming of her father (to whom her sisters are running with the news) as Nereus.[323] The setting of this scene on the kantharos is a sanctuary (altar and palm behind Zeus), but that does not help. Given the association of the shape I incline to Semele. Like Cassandra in the Louvre Iliupersis, this woman pulls her skirt above her knee to help her run faster, and she turns back with a gesture of supplication.

The painter also decorated kantharoi of a different type, where the high-handled drinking-vessel is supported on a base in the form of two moulded heads, back to back. Such 'head-vases' begin to be made in the Kerameikos a generation or two before, and continue through the century. Beazley classified them by the sculptural style of the heads which are of many types: woman, Herakles, Dionysos, satyr, negro, later Persian; singly or in almost any possible janiform combination.[324] There are also animal-heads, which we will speak of in a moment in connection with rhyta; also complete figures, human or animal, and groups. The supported vessel may be kantharos, 'one-handled kantharos' (mug), oinochoe or aryballos.

The rhyton is related but essentially different, though

the difference becomes blurred. Like the phiale the rhyton is originally a metal vessel of oriental origin and religious use. It is a cup, ending below in an animal's head. It has no base, and when empty has to be laid down or stood upside-down on its rim. This is a case where the clay vases are surely directly copied from metal originals, even moulded from them; but they differ in one important respect. An essential element in the ritual use of the metal vessel is the piercing of the bottom (the animal-mouth) for the wine to jet. Clay examples invariably lack this feature; and this surely means (like the great size of some phialai) that they are marked as not meant for mortal use but made to dedicate in sanctuaries or bury in graves. The kantharoi in the form of animal-heads on stands, mentioned above, are an adaptation of the rhyton, removed one step further still from the original design.[325]

Rhyta come in the form of heads of many animals. Douris has left us lion, donkey and eagle;[326] the Brygos Painter donkey and dog, as well as two mugs with a ram's head mounted on a stand.[327] One of these, now lost, had a magnificent picture of two sleeping maenads approached by satyrs; and, at the back of the head,

below the handle, an ivied altar, on one side Dionysos standing, on the other a satyr piping to him.[328] The other has a symposium; and symposia (mortal men or satyrs) are found also on the two women's-head kantharoi and one of the rhyta proper. The other rhyta show a variety of subjects: satyr and maenad, komos, Eros and boys, pygmies fighting cranes. We shall return to this last not very common subject in a later chapter in connection with a related type of vase.[329]

The Brygos Painter had a very large circle of imitators and companions, several of whom have distinct characters of their own. We shall treat in later sections of the two most interesting, the Foundry Painter[330] and the Dokimasia Painter.[331] The artist's own fire fails in later life, and much work that seems to be his is weak and not certainly distinguishable from imitation. This phenomenon, which we meet so often in painters of this generation, is surely a function of the time. The classical style, forged in the new world that comes into being through the Persian wars, leaves some artists stranded in the past. However, there is charm in many of these late Brygan pieces, especially among small cups, with picture inside only, and lekythoi. A lekythos from Paestum[332] shows a young girl carrying sprigs, and walking behind her a woman who holds a parasol over the girl's head. This is perhaps an excerpt from the Panathenaic procession in which, we are told, daughters of *metics* (non-Athenian traders settled in the city, who had certain privileges) were allowed to walk in the procession with parasols to shade the daughters of citizens.

One other piece associated with this phase of the Brygos Painter's activity should be mentioned. It is in Munich,[333] a large cylinder, double-walled, with a spout at the bottom, a type of wine-cooler. On each side are two figures: Dionysos and a maenad; and a man and woman with *barbitoi*, named as Alcaeus and Sappho (fig. 95), the great poets of Lesbos a century before. This was long ago given to the Brygos Painter by Furtwängler. After long hesitation Beazley finally accepted it as a very late work. The figures are far larger than any others we can associate with the painter, and Sappho's face is drawn in three-quarter view, something he normally avoids (unlike some of his contemporaries) even for bearded and ugly faces. The rather tame drawing is nevertheless at least very close to the late Brygos Painter. We will come back to the question of this attribution in a later section.[334]

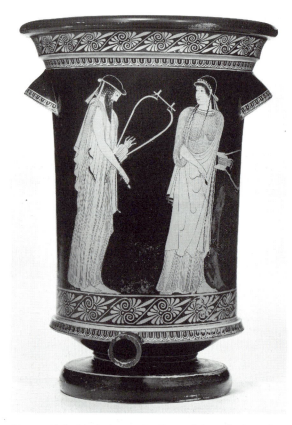

Fig. 95. Cylindrical wine-cooler; Brygos Painter. Sapho and Alkaios (Sappho and Alcaeus). H. 0.52.

c. Makron

The inscription *Hieron epoiesen* is found, complete or in part, on some forty vases and fragments, the great majority cups but there are three skyphoi and a kantharos.[335] It is painted on the edge of one cup-foot

(the bowl missing), and incised in the black upper surface of the kantharos-foot. In all other cases it appears on the handle; sometimes painted on the reserved area, in black (like the Brygos inscriptions) or in red, but much more often incised in the black. Incised inscriptions are, as we have noticed, inevitably suspect. A few of Hieron's have been thought, but not proved, false. The great majority, however, are surely genuine. Among the suspects are the kantharos-foot, where the name is spelt without the aspirate, Ieron, and a father's name, Medon, is given. To this we shall return.[336]

One of the skyphoi bears also a painter's signature, in red on the black ground, in the usual way: *Makron egrapsen*.[337] The other two skyphoi and all but two of the near thirty cups with Hieron's name on which figure-work is preserved are certainly attributable to the same hand. More than three hundred other cups have been given to Makron, and a few small vases of different shapes,[338] including a pyxis, with women, dedicated on the Acropolis.[339] Names are inscribed, some with the addition of *kale*; and *Makr…* running upwards by a skirt is probably from such a name, but could be a second signature. Most of the women's names are similarly placed; but it is worth noting that Makron's signature on the skyphos runs just so, from near the bottom up along the edge of a skirt. The two other cups with Hieron's name are in a different and later style. Some fifty pieces, mainly cups, share their distinctive character. Their author, the Telephos Painter,[340] was evidently a pupil of Makron. It is not easy to trace such a connection in the work of the Amphitrite Painter, whose fifty-odd vases, more than half of them cups, include the Ieron kantharos.[341]

The cups with the inscription *Hieron epoiesen* have in common consistent details of potting, as is normal in cups bearing the name of one *poietes*, and many of those ascribed to Makron have the same. This was evidently a steady collaboration, like those of Douris with Python and the Brygos Painter with Brygos. The difference among these craftsmen in inscriptional usage is interesting. All three have in common that most vases in the group bear neither painter's signature nor *poietes*'s name. The Brygos Painter puts the name of Brygos on a fair number but never, on present evidence, his own. Makron puts Hieron's on many more, his own only very rarely. Douris puts his own on many, Python's on only a few. It is not easy to find a rationale in this, and I see no reason to expect one. I would suppose it a matter of whim. Hieron liked his name to appear, and Makron obliged but was not much interested in advertising his own. Douris, on the other hand, liked to see his own while Python was rather indifferent. A better explanation may be forthcoming; but the tiny proportion of vases with such inscriptions to those without makes it

most unlikely, or so it seems to me, that it was a matter to which painter, *poietes* or public attached great significance.

The practice of regularly putting an *epoiesen*-inscription on a handle, shared by the Brygos and Hieron vases, and the difference in the way it is written, suggest that craftsmen in one workshop may have taken the idea from the other but decided to apply it in a style of their own. Elsewhere it is rather rare, though one cup with *Euphronios epoiesen* has it incised in the handle-black[342] like most of the Hieron vases. We saw that Douris in his earliest phase decorated some cups that go with those that have the name of Euphronios as *poietes*. His style at that time is linked to early Panaetian work, while the Brygos Painter has affinities with post-Panaetian Onesimos. One of three cups put together by Beazley as probable early work of Makron is Euphronian in potting.[343] Makron shares the *kalos*-name Hippodamas with Douris (in the latter's middle period), and once puts Hiketes, whom old Douris favours. It is hard, though, to trace any stylistic connections. Perhaps, like some other cup-painters we shall meet in a later section, he stemmed from a tradition which by-passed the Pioneers; or rather (since their influence was pervasive) had no direct connection with any one of them or of their immediate followers. We shall touch on his possible origins again after looking at his work.[344]

Like the Brygos Painter, Makron is a master of movement, especially of the massing of draped figures in movement. There are attractive tondos (fig. 96), especially some with a single figure, but far his most memorable work is on cup-exteriors and big skyphoi. His two

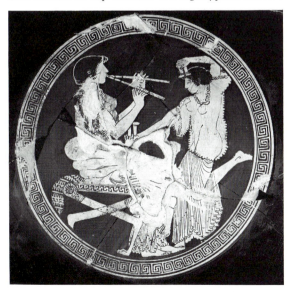

Fig. 96. Cup with name of *poietes* Hieron; Makron. Girl dancing to woman's piping. D. *c.* 0.16.

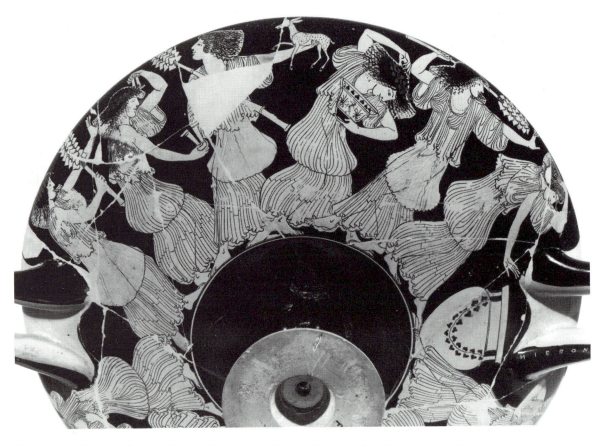

Fig. 97. Cup with name of *poietes* Hieron; Makron. Maenads at image of Dionysos. H. of picture *c*. 0.12.

Fig. 98. Other side of 97: maenads.

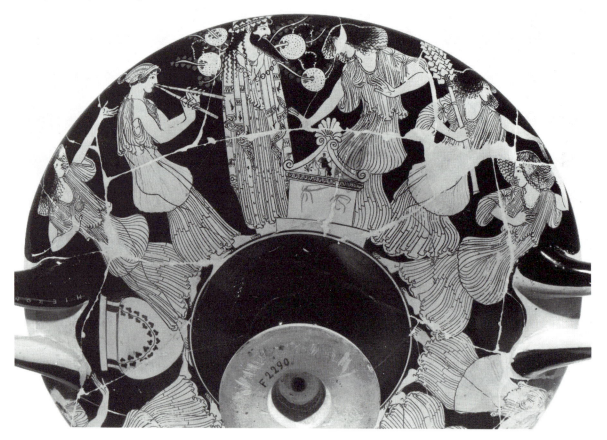

finest cups are both in Berlin, one with a Trojan theme, the other Dionysiac.[345]

The outside of the second shows maenads celebrating a feast of the god. At the centre of one side is his altar, and beside it his primitive image (fig. 97): a bearded mask fastened to a post, ivy-wreathed and draped. Behind this a woman, hair snooded, pipes; and all across the rest of the exterior (there are no palmettes at the handles, only a wine-bowl under one) cavort the other woman-votaries (fig. 98), hair loose under the ivy-wreath, chiton worn without himation, swirling in the dance. They may carry a cup, a thyrsos, an animal, but they are lost in the rapture. There is no finer rendering of Dionysian possession. These are ordinary mortals. No satyrs are present, and the god only in his image. On later vases we shall see quieter pictures of such women at an earlier stage, making ready the image for a festival.[346] Here they are on the edge of passing over into the other world, in which vase-painters more often show them, when the god himself and his satyrs are present to them; and he is here in the tondo, with thyrsos and vine-stock, attended by a piping satyr.

Here the whole cup has one theme, but Makron is generally less devoted to this principle than Douris or the Brygos Painter. The other Berlin cup[347] has in the tondo a picture of a man making up to a boy named Hippodamas, so a 'portrait' of the beauty praised elsewhere by this artist and Douris. The outside pictures are independent scenes from one story, that of Paris (given here, as almost always in vase-painting of this period, his other name, Alexandros). In one (fig. 99) the young goatherd, not yet recognised as prince, sits on a rock, lyre in hand, his flock beside him and behind him under the handle. In front of him stands Hermes, who gestures as he explains to the youth that he has been chosen to judge which is loveliest of the three goddesses who follow: armed Athena, Hera, and at the back, sure of victory, Aphrodite with four winged Loves flitting about her. Behind her, at this handle, a beautiful palmette-complex separates off the second scene. The Trojan prince, now recognised, has come to Sparta and, in Menelaos's absence, is leading off his wife Helen, the most beautiful woman in the world, the bride-bribe promised to Paris by Aphrodite at the Judgement. The goddess has been as good as her word. She has made Helen unable to resist the seducer. Veiled as a bride, Helen follows submissively, and Paris leads her by the wrist and looks back at her, while the two spears he carries in his other hand slope above her. Following the couple, the groom's cousin and companion Aeneas,

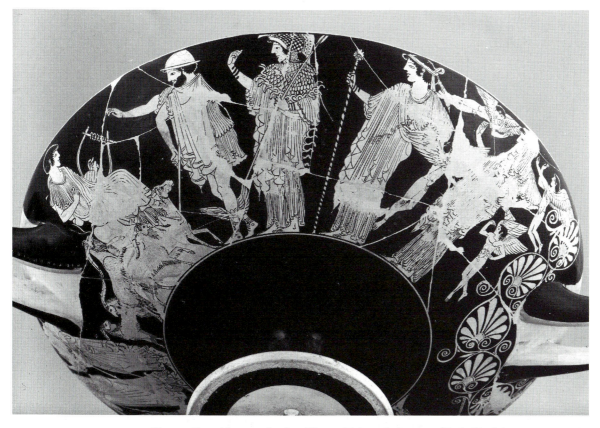

Fig. 99. Cup with name of *poietes* Hieron; Makron. Judgement of Paris. H. of picture *c*. 0.12.

103

likewise carrying two spears, turns to gesture away the protesting women and elders behind.

This is a good piece, parts of it exquisite (Paris and his goats, Aphrodite and her Erotes), but I do not feel in it the power of the Dionysian cup. When, however, Makron takes up the story of Helen another time, on the skyphos in Boston[348] on which he put his own name as well as Hieron's, he reaches perhaps his greatest heights. The two sides of the skyphos, as of the cup, present a unified theme; only the flight from Sparta is the first, not the second, scene on the skyphos, and the recurrent figure is not Paris but Helen; or rather there are two key figures, Helen and Aphrodite.

On the cup the figures are strung out in a row. This is the basic principle of archaic composition, and allows for subtle variation in spacing and overlap. Makron does not neglect these subtleties here, but exploits them on the skyphos in a far more individual and striking way. The abduction scene (fig. 100) seems to be at a later moment. There are no protesting Spartans at the back. The groom, still leading his bride by the wrist, is bringing her home. Aeneas (dark and bearded on the cup, here young and fair) leads the procession. He and Paris still carry each their pair of spears, and Aeneas has a shield and Paris a helmet pushed up on his hair. Both look back at Helen, and so does a little Eros who hovers between the lovers and adjusts the circlet on her bent fair head. Behind her Aphrodite is lifting Helen's himation to cover the back of her hair; and behind the goddess is her handmaid, Peitho (Persuasion, whose power has just been so fatally shown). These three are standing still, Helen perhaps just taking a small step.

Their feet are close together, and they occupy almost exactly the same space as the two men stepping out in the other half. Aeneas's shield just overlaps Paris's cloak, but a bit of black background appears between them, and a bit between Paris and Helen. Between the three women, from shoulder to ankle, there is almost none; and this light effect, obliteration of the background by draperies, is even more striking in the picture on the other side.

This shows a later moment in Helen's story. Menelaos, her Greek husband, setting eyes on her again in Troy, draws his sword on her, and she flees to Aphrodite's protecting arms. Behind Aphrodite a woman, and at the end an old man, look on. Between this man and the rest is a strip of black background. Elsewhere it is obliterated completely by the draperies of the three female figures, and only a sliver appears at waist level between Helen and armoured Menelaos, making in all an extraordinarily light picture.

In the low space under the handle between the old man and Peitho is a boy, looking and moving towards Peitho, so part of that scene. Makron's signature runs up between them. No doubt the boy is the *pais amphithales*, boy with both parents living, who was an essential participant in an Attic wedding. Under the other handle a man with black beard but thin grey hair and bald crown sits on a lordly stool and watches Menelaos's attack. He is named Priam. This story is normally associated with the Iliupersis; but if Makron really intended this elderly but not aged and not much troubled person for Priam at the sack he has made a strange job of it. There is a story, attested in art and by

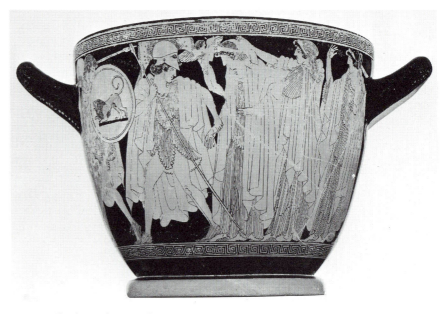

Fig. 100. Skyphos with name of *poietes* Hieron and signed by Makron as painter. Paris bringing Helen to Troy. H. *c.* 0.21.

allusions in surviving literature, but nowhere fully told, of an embassy to Troy ten years before to try to get Helen back by negotiation.[349] Menelaos was one of the ambassadors, and I have little doubt that in some account the attack on Helen took place then, and that is what Makron is illustrating here.

That Makron was sometimes an ignorant or careless mythographer has been suggested in connection with one of his most effective tondos. On the exterior of a cup in Leningrad[350] is a not very commonly illustrated story from the siege of Troy. On one side are princes in the Greek camp. On the other Odysseus and Diomedes have made their way into the city by night to steal the Palladion: a holy image of Athena, one of many charms on which the safety of Troy was held to depend. They are shown quarrelling over which has got the right figure. The tondo has no Trojan connection. A youth draws his sword on a frightened woman, and they are named: Theseus and Aithra. We know of no story that Theseus attacked his mother; and it has been suggested that the vase-painter wrote Aithra in mistake for Medea, the young hero's wicked stepmother who traduced and tried to poison him when he came to Athens claiming to be the son of Aigeus.[351] The idea is plausible and well argued, and may be right, but I am not certain. The mistake seems an odd one, and there is so much we do not know. One could imagine such a twist as this in some version of the story of Aithra and her young son in Troezen after he had lifted the stone and found the sword and other tokens left by his father.

Makron does sometimes unite all three cup-pictures in a single theme, and the two sides of the exterior are generally linked. So are the two sides on all three big skyphoi. We have looked at the story of Helen in Boston. One in the Louvre[352] has episodes from the story of Achilles; one in London,[353] in the main picture, Triptolemos sent by Persephone to bring grain to the world, and round the sides and back deities more or less closely associated with Eleusis.

The choice by a cup-painter of an outsize skyphos for special work recalls the Brygos Painter; and Makron's London vase is of the same basic design as the Brygos Painter's, but the Boston and Louvre vases are different. The red-figure skyphos in this period is generally a small or smallish vessel. It takes various forms, but 'Type A' is the basic model for the large ones.[354] One usual feature of Type A is that the handles are horizontal and set on the lip (so it could be hung on the wall like the kylix). This is reproduced in the Brygos Painter's big pieces and Makron's Triptolemos vase, as well as in a powerful fragment by the Kleophrades Painter in Florence,[355] with Centaurs besetting Iris. On Makron's other two the handles are set well below the rim and slope up diagonally towards its level without quite reaching it. Also the walls are less straight,

curve in to a slightly narrower base above the stout ring-foot. These features are very rare in red-figure skyphoi, though they recur on a very fine piece we shall discuss later by the Triptolemos Painter, which is related to Makron's Helen skyphos in subject too.[356] A very similar character, however, is found in a long series of big late black-figure skyphoi of the Heron Class, by the Theseus Painter and others,[357] though in these the rim is slightly offset (fig. 101). The light effect produced by Makron's spread drapery, obliterating background, is, in reverse, like the dark effect produced by the same kind of means in so much work of the late black-figure Leagros Group.[358] On some cup-fragments from the Acropolis Makron puts in hillsides and trees, a degree of landscape more easily paralleled in black-figure than in red-figure.[359] It seems to me possible that this painter got his first training in a black-figure workshop.

The winged Erotes attendant on Aphrodite and Helen on the cup and skyphos are among Makron's most delightful and individual creations. They recur in his work, some in similar scenes, others on their own. A pair of them forms the sole decoration on each of two askoi (fig. 102).[360] The shape we call 'askos' is a small, low vase with a slightly domed top, near one edge of which a round spout rises at an angle. There are various forms, but the commonest, Type 1, to which these belong has an arched handle going back from the spout to the opposite edge, dividing the circular field (generally around 10 cm in diameter) into two, each of which is normally occupied by one figure. Askoi first appear about this time, become extremely common in the late fifth century,[361] when we shall have more to say of them, and continue far down the fourth. The later ones have mostly quick daubs of animals, but earlier there are interesting pieces, a few by good artists. The rarer Type 2 (there are yet other forms which need not concern us here) stands higher and the vessel is tubular (there is a vertical passage below the handle through to the base). Makron has left us one of these too, with a

Fig. 101. Skyphos; Heron Class, Theseus Painter. Lion and bull at tree. H. *c*. 0.17.

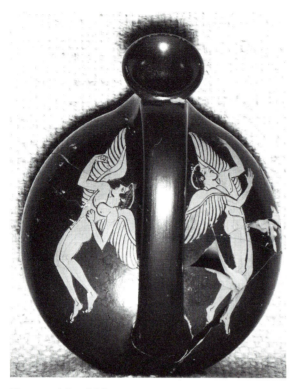

Fig. 102. Askos; Makron. Erotes. D. *c.* 0.08.

reclining maenad on each side, seemingly early in his *oeuvre*.[362]

A more pedestrian follower in the next generation painted a pair of Erotes disposed in the same way on a similar field: the shoulder of a round aryballos.[363] Makron himself may well have done the same, but the only aryballos we have from his hand, in Oxford,[364] has a pair of panthers in this position. The body has an amusing picture of boys playing with toy chariots. It is important to note that this exquisite little vase is above reproach and has never been questioned, since Bothmer has been unhappily misquoted as calling it a forgery.

Makron seldom rises to the heights of the Helen skyphos or the maenad cup, but he never sinks below a decent level and is often much better than that. The general run of his cups show men and boys, and especially men and women, and these scenes have often charm and rarely or never the brutality which vase-painters of this time so often display in depicting the relation of man to woman.

IV. Other cup-painters

a. The Antiphon Painter and his group

Among cups associated by their potting with those which bear the name of Euphronios as *poietes* are some ascribed to an Antiphon Painter. He takes his name

from a youth described as *kalos* on a very pretty stand with athletes in Berlin, his masterpiece. Apart from this and a fragment thought to be from a mug, nothing is given him but cups (nearly one hundred, many of them fragments).[365] With a rather larger number of cups and fragments described by Beazley as in the painter's manner, there are of other shapes only one skyphos (possibly the painter's own) and one pyxis.[366] We noticed a similarly marked preference for the cup over any other shape in the work of Onesimos; and Beazley notes that the Antiphon Painter's style 'derives from the earlier ("Panaetian") style of Onesimos, and runs parallel to the later style of the master',[367] adding that the two artists are sometimes rather close to one another; and indeed there are cases in which a fragment assigned by him to one artist has later been found to join one which he had placed in the other list. They surely sat in one workshop.

The Antiphon Painter shows almost no interest in gods or heroes and among his scenes of contemporary life has a marked preference for palaistra, a race in armour (*hoplitodromia*) and *komos*. He is a good craftsman, but only a few of his best cups have the quality of the Berlin stand. Many are no more than competent, and it is hard to draw a line between his own weaker work and that of his imitators. The painter's own style, however, when he is being careful, has one really interesting feature which Williams, who has made a study of the group, has drawn attention to.[368] Most painters of this phase, whether of pots or cups, are content, after the anatomical experiments of the Pioneers, to adopt and adhere to a schematic anatomy which, based on observation, makes also a pattern they find satisfying. The Antiphon Painter can be traced continually experimenting with slightly varied renderings, working towards a more effective suggestion, with the linear means at his disposal, of the three-dimensional male body in movement. This gives him a place in the story.

The group has another importance too. Some of the later cups in the Antiphon Painter's manner come extremely close in character to some of the more humdrum works in the Pistoxenos Painter's group. The Pistoxenos Painter, one of the first leading vase-painters whose style can be called classical, is also the last to put on at least one of his early cups the name of Euphronios as *poietes*.[369] The Pistoxenos Painter's style, and that of his group, lead on directly to the work of the Penthesilea Painter and his very large circle of collaborators,[370] who dominate early classical cup-production. Cautious as we need to be in using the concept of a 'workshop', it does here look as though we can see one long-lived establishment with which Euphronios was long associated as *poietes*, and in which the leading painters are first Onesimos, beginning in his Panaetian phase

and later accompanied by, perhaps outlived by, the Antiphon Painter; then the Pistoxenos Painter; finally the Penthesilea Painter.

We noted that there was a surprising late 'revival' of the red-figure eye-cup.[371] All eighteen examples known are given to the Antiphon Painter and his imitator (at this period) the Colmar Painter, on whom we shall touch again in a later section.[372] The shape is not that of the early eye-cups, but the contemporary kylix, and the artist does not modify his figure-style (fig. 103). The choice of a pair of large eyes, a figure between, to decorate the exteriors can only be deliberate imitation of a fashion which had passed hardly less than a quarter of a century before; but the model for these eyes, as Williams has shown, is found on black-figure kyathoi which were still in production. Williams argues convincingly that the fashion must have been in response to a particular demand, probably from Etruria.[373]

The Antiphon Painter and his group make much use of *kalos*-names, and this is a good place to note how the same name is used by a variety of artists. Antiphon occurs only on the Berlin stand, Laches only on cups attributed to the Antiphon Painter or his manner. Aristarchos, on the other hand, is found on two cups given to the Antiphon Painter and one to Onesimos; Lykos on eight cups placed in the Antiphon group, ten attributed to Onesimos, one of them from his Panaetian period, one to the Foundry Painter, and one to the manner of the Tarquinia Painter, a leading artist of the Pistoxenos group. Lysis is found a dozen times in the Antiphon group, on six cups attributed to the Colmar Painter, and once on a cup ascribed to the Pistoxenos

Painter. Nikostratos, who is named on one cup attributed to the Antiphon Painter, appears elsewhere only on pots: two given to the Berlin Painter, one to the Triptolemos Painter, one to the Hephaisteion Painter (a minor figure connected with the Dokimasia Painter);[374] one (no *kalos*) to the early classical Copenhagen Painter. Diogenes is named on two cups ascribed to the Antiphon Painter and one to the Foundry Painter, and on pots given to Douris, the Diogenes Painter and the early classical Syriskos Painter, companion of the Copenhagen Painter. The Foundry, Triptolemos, Dokimasia and Diogenes Painters are discussed in later sections, the Pistoxenos, Tarquinia, Copenhagen and Syriskos Painters in the next chapter.[375]

A loose contemporaneity must be implied, and the most interesting appearances of these names are those on vases by painters working in an early classical style. These painters are certainly of a younger generation than those we are treating in this chapter, but generations naturally overlap. It is surprising that Lykos should appear on one cup ascribed to Panaetian Onesimos and one to the manner of the Tarquinia Painter. One may wonder if the early dating of the first cup[376] is correct, if it might not rather find a place with the other nine dated to Onesimos's post-Panaetian phase.

b. The Foundry Painter

The Brygos Painter had a large circle of imitators.[377] There will be more to say of some of them in the section on the Dokimasia Painter who, for much of his career at least, was a very close associate indeed.[378] Beazley

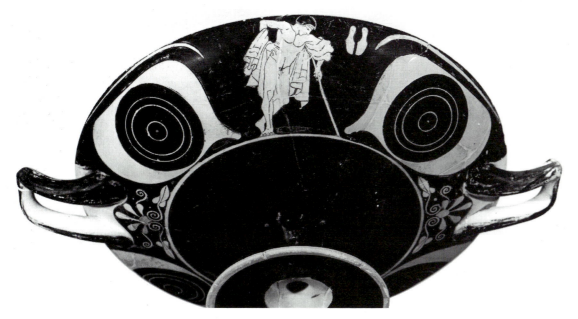

Fig. 103. Cup; Antiphon Painter. Youth between eyes. D. *c.* 0.25.

always counted the Foundry Painter as one of these, and noted that 'with his forceful, sometimes even brutal style he often equals the Brygos Painter'.[379] He certainly deserves independent consideration; and there are indications that his relation to the Brygos Painter (though he does sometimes come very close to him) was looser than that of other members of the circle. At least one of the cups assigned to him (almost all his forty-odd pieces are cups or cup-fragments) shows the details of potter-work that characterise those which bear the name of the *poietes* Brygos.[380] Half a dozen, however, go with those that have the name of Euphronios as *poietes*;[381] and the realism of his style (sometimes, as Beazley noted, brutal) finds nearer parallels in the work of Onesimos than in that of the Brygos Painter. There seems also a stylistic link between the Foundry Painter and the Triptolemos Painter,[382] an artist treated in a later section, who similarly shows potting and stylistic connections with both the Euphronian and the Brygan circles, as well as with Douris and the *poietes* Python. One gets the impression that, while some painters sat for most of their careers in one workshop, others habitually moved around.

The Foundry Painter takes his name from a very fine cup in Berlin.[383] In the tondo the sea-nymph Thetis takes from the smith-god Hephaistos the armour he has made for her to give to her son Achilles. Both sides of the exterior have pictures of Hephaistos's mortal votaries, workers in bronze: on one a furnace and men engaged in fitting together newly cast parts of a statue (fig. 104); on the other a complete statue being cleaned and polished. These are perhaps the best pictures we have of Athenian craftsmen at work.

This is one of the cups which have potting links with the Euphronian; and though there is much in the drawing to recall the Brygos Painter, it also looks to Onesimos. A fine Panaetian cup by that painter in London, with the name of Euphronios as *poietes*, has on the outside a chariot and Herakles bringing the Erymanthian boar live to Eurystheus who, terrified, takes refuge in a store-jar; in the tondo an old man bargaining with a hetaira.[384] In the faces of this old man and of Eurystheus's old father, Onesimos has produced vivid images of bald and wrinkled age, and these recur in his work. The Brygos Painter and his circle avoid or soften such particularities, but the Foundry Painter takes them up and carries them further. One of the workmen on the foundry cup does not look old, but his

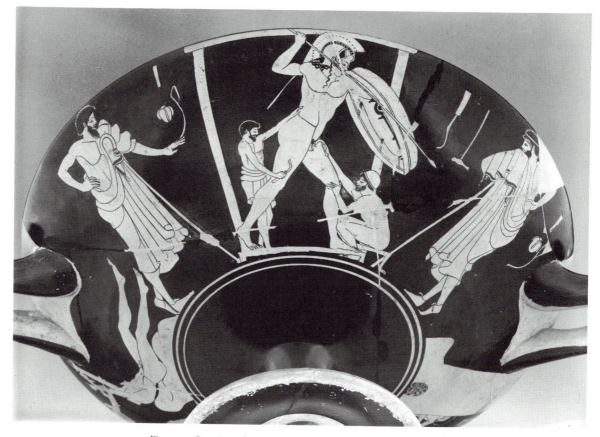

Fig. 104. Cup; Foundry Painter. Work on a bronze statue. H. of picture *c.* 0.11.

108

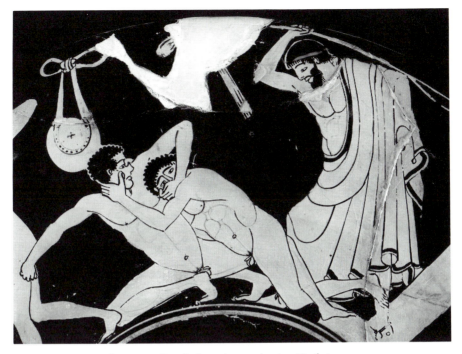

Fig. 105. Cup; Foundry Painter. Detail of exterior: *pankration*. H. of picture *c.* 0.11.

face is a carefully observed and forcefully rendered study in individuality, nothing to do with the ideal.

Other such heads appear in the painter's work; and it is not only in faces and figures (a bent back, a pot belly) that he shows himself unusually uninhibited by the conventions of his time, but in actions too. Wrestlers and boxers forget the rules and get really rough (fig. 105); revellers not only throw up but pee; and in the approach of men to women there is no trace of the tenderness we sometimes feel in the Brygos Painter's work. All these features can be found in the work of other artists of this time, but they seem central to the Foundry Painter's vision.[385]

We saw that Beazley ascribed to the Foundry Painter 'in his most Brygan mood' a white-ground oinochoe with a woman spinning, but that Williams has shown good grounds for thinking it the Brygos Painter's own.[386] There are also two very fine cups of which Beazley wrote that 'they are close to the Brygos Painter at his height, but hardly from his hand. They might be by the Foundry Painter at the point in his career when he was closest to the Brygos Painter'.[387] One, in Tarquinia, has scenes of legend. In the tondo a hero leads a woman: surely the same subject as in the tondo of the Brygos Painter's cup in London with the arms of Achilles;[388] but the exterior scenes on the Tarquinia cup are disparate and do nothing to help the identification of the pair. One shows Menelaos pursuing Helen, the other a rare story: Theseus, sandals in hand, led by Hermes,

steals silently away from Ariadne, asleep under a tree on Naxos.

The second cup, in London,[389] has scenes of contemporary life. A good deal is missing. In the rather large tondo is a composition still, in spite of an ugly lacuna near the middle, effective and attractive. A youth stands playing the pipes, leaning a little back, and a man sits listening (fig. 106). He leans back too, and clasps his knee, a well caught glimpse of a natural pose. On the fragmentary exterior is an orgy. One well-preserved figure is another boy piping. Absorbed in the music and the effort he has drawn one foot back, the toes curled under (fig. 107). These touches of vivid observation, unusual posture or movement caught and noted, lead me to believe that Beazley's thought about these two cups (they surely go together) is right. Unlike the white oinochoe, these do seem to me to be by the Foundry Painter; but, as so often, there can be no certainty.

c. Apollodoros and others

In this chapter we are mainly concerned with the influence of the Pioneers, which determined the course of vase-painting in Athens as an art. However, while most of the major figures in this phase were actual pupils of Pioneers or learned directly from such pupils, in others the influence seems less direct: Makron for example.[390] In this connection the Colmar Painter, mentioned earlier,[391] is worth a glance. He is not a

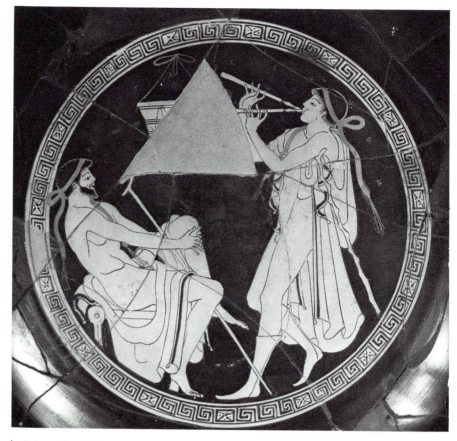

Fig. 106. Cup; probably Foundry Painter. Boy piping to singing man. D. *c.* 0.18.

Fig. 107. Detail from outside of 106: youth piping. H. of picture *c.* 0.11.

serious artist, though a cup in Oxford[392] (a long-haired boy running with a hoop and a tray of food, fig. 108) has charm, but his career is interesting. We saw that he probably sat at one time with Onesimos and the Antiphon Painter, though working at a lower level, but his origins are not there. Some of these later cups have the features of those with the *poietes*-inscription of Euphronios,[393] but some earlier ones go with those of Kachrylion.[394] There is a small group of coarse cups which Beazley put together as the work of a Bonn Painter.[395] These he traced to the low-level production of the 'coarser wing', in particular the wider circle of the Nikosthenes Painter and the Pithos Painter;[396] but he also noted that they were so close to the earliest Colmar Painter that it might be that the 'Bonn Painter' was actually that craftsman's first phase. I do not know (or greatly care) if this is so. The interest of these figures is not as individual artists but in the way they document how one tradition can merge with another, and how indissoluble are the links between vase-painting as a fine art and the basic commercial production of pottery.

When considering the course of cheap cup-production we noticed also that there is a tradition of fine, sometimes very elaborate cup-painting which runs through the time of the Pioneers but is little influenced by

110

them. Oltos is at times on the fringe of the Pioneer Group; Epiktetos occasionally acknowledges them; but Peithinos and those painters around the *poietes* Kachrylion who produce sometimes really elegant work seem to follow an almost totally independent line.[397] There is another fine sequence which starts in the time of the Pioneers but remote from them and keeps its independence in the phase we are now considering.

The name of Apollodoros as painter occurs on a few cups and cup-fragments, and Beazley and others have attributed twenty or thirty more.[398] The technique is very fine, the drawing neat and elegant, the style very distinctive and, as Beazley notes, mannered and precious. It is not ineffective, though, with its strangely elongated figures. Beazley also put together three much smaller groups, which he saw as closely connected together and leading directly to Apollodoros, all or some of them perhaps early works of his own: the Epidromos Painter, the Kleomelos Painter and the Elpinikos Painter.[399] All of these have been enlarged, though not greatly, by others. These 'painters' are called after *kalos*-names which occur in their work. Apollodoros, on signed and attributed works, calls Euryptolemos *kalos*, and on two attributed cups Pammachos.[400] Pammachos is so named again on two cups unknown to Beazley. One, with a crouching warrior, is surely by Apollodoros.[401] The other, in Basel,[402] of singular charm (fig. 109), is attributed by Schefold to a companion. I see it as close to the Elpinikos cups. A boy stands shyly hugging himself in front of a seated man with tablets on his knees, his stylus raised meditatively towards his mouth, surely considering what the boy has written.

Cups attributed to Apollodoros and to all the other three have potting characteristics in common and are grouped as an Apollodoros Class;[403] but one given to the Epidromos Painter is associated with those which bear the name of the *poietes* Hieron.[404] Most of the *kalos*-names are found only in these groups, but Epidromos occurs on a few others, including a Proto-Panaetian cup and another where it is interestingly combined with Leagros.[405] One of the cups given to the Epidromos Painter is noted by Beazley as influenced by Douris in his early-middle period.[406] An Apollodoros is called *kalos* on an unattributed cup-fragment from Adria,[407] and the writer uses the dotted delta favoured by Douris though not confined to him.

It seems to me exceedingly likely that all four groups are the work of one man, though Ohly-Dumm argues interestingly for separating the Kleomelos–Elpinikos cups from the Epidromos–Apollodoros series.[408] I see those rather as particularly fine pieces from the artist's prime, about the time that the early Epidromos phase merges in the late phase which includes the signed cups.

Very few shapes other than cups are associated with the group: a stemmed plate, two aryballoi.[409] A fragmentary oinochoe from the Acropolis[410] with the struggle for the tripod has the name of Kleomelos and is given to the 'Kleomelos Painter'. Its interest is that it shows already something of the mannered character of the late phase.

Many of the cups in all phases are small and decorated inside only. Among these are an astonishing composition with the *kalos*-name Kleomelos and two masterpieces with Elpinikos. The Kleomelos cup, in Malibu,[411] shows a wall with defenders on the ramparts

Fig. 108. Cup; Colmar Painter. Boy running with hoop and food. D. of cup *c*. 0.20.

Fig. 109. Cup; possibly by the Elpinikos Painter. Boy and teacher. D. of cup *c*. 0.20.

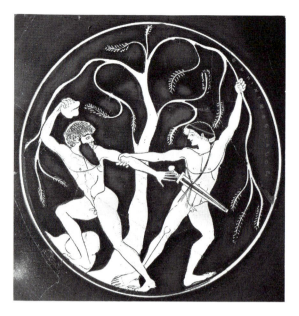

Fig. 110. Cup; Elpinikos Painter. Theseus and Sinis. D. *c.* 0.13.

them spring upright again; till Theseus passed and served him the same way. Here Theseus seizes Sinis by the left arm and with his own left hand pulls on a high bough of a tree which grows near the centre and spreads its branches over the background. Sinis struggles to pull away and heaves up a rock in his right hand. The two figures' feet cross at the foot of the tree, and they lean outwards and look back at one another. This is one of the earliest examples we have of a formula for strife which recurs constantly in classical art. Herakles and the bull on one of the metopes from the temple of Zeus at Olympia, Athena and Poseidon in the west gable of the Parthenon, are major examples.[414]

It is sad to see vigour like this lost in the elegant affectation of the later works (fig. 111), but I see nothing implausible in postulating such a development. One might wonder if it happens more easily to a talented artist working a little outside the mainstream of development, as we have suggested for Apollodoros; but I should hesitate to press that as a general principle. We shall think about this question again in connection with a later and greater artist, the Pan Painter.[415]

V. Two cup-painters with a strong pot side

a. The Triptolemos Painter

We noticed that one of the forty-odd inscriptions *Douris egrapsen* is on a cup in Berlin, the style of which is quite different from that of any other piece with this signature, but is found on a large number of unsigned cups and pots.[416] The other works with this painter-signature show a considerable variety, but those and the many more which are stylistically linked to them can be arranged to build up a clear picture of one artist's development in time. The Berlin cup and the other pieces in the same style (more than a hundred) find no place in that scheme. A distinct artistic personality is clearly presented, and we know him by Beazley's appellation: the Triptolemos Painter.[417]

As we noted, the case does nothing to discredit Beazley's method, rather confirms it. There must be some explanation for the puzzle, and we need not be too bothered if we cannot find it. Douris could have been the Triptolemos Painter's name; but the fact that the rare dotted delta is used here too is against that. The potting of the Berlin cup[418] conforms to that of cups associated with the name of Python as *poietes*, as do most of the cups with the Douris signature, so the two painters were probably sitting in the same workshop when it was made and decorated. The inscription could have been added as a deliberate fake, or by a third party in spite or fun or error; or there is some other explanation. The question has to be considered for its bearing on method, but the answer does not greatly matter.

and attackers below (fig. 137). We shall return to it when we come to consider the development of wall-painting and its influence on vase-painting. One of those with Elpinikos, in Bonn,[412] has only the head of a girl, drawn in outline on the reserved disc, the *kalos*-name neatly circling it. This is attractively interpreted as Selene, the Moon. The other cup, in Munich,[413] has Theseus and the brigand Sinis (fig. 110). Sinis, of enormous strength, destroyed travellers by bending down two pine-trees, binding the victim to them, and letting

Fig. 111. Cup; Apollodoros. Satyr. D. *c.* 0.14.

Another cup by the Triptolemos Painter (stylistically early in his *oeuvre*, which the Berlin cup is not) is Pythonic;[419] five other early ones are Euphronian;[420] one, not early, Brygan.[421] Beazley noted elements in his ornament which associate him with Douris,[422] and I see elements in his figure-style which suggest the Brygos Painter and, more strongly, the Foundry Painter. We noticed that a fragment which Beazley originally gave to the Triptolemos Painter turned out to join one certainly by the Foundry Painter; and the Triptolemos Painter's masterpiece, a calyx-krater in Leningrad, he originally thought of as the Foundry Painter's.[423] We shall be noticing collaboration with other pot-painters, and a possible link with the Makron–Hieron workshop. He seems one of the wanderers of the Kerameikos, but he is always a clearly distinct personality.

The Triptolemos Painter is a good artist, and there are other reasons for giving him attention. One is his bridging of the gap between cup-painter and pot-painter. Beazley places him among cup-painters because of the large number of his cups, but adds that he 'has an important pot side, and much of his finest work is on pots'.[424] There are sixty-odd cups in the list against forty-odd pots, ten of those skyphoi, which is in general a cup-painter's shape. Seventeen of the cups form a group which Beazley first listed as in the Painter's manner, adding however that he thought they must in fact be early works from his own hand (fig. 112).[425] Later, surely rightly, he included them as such. None of the pots goes with these, so it appears that he started as a cup-painter, and we shall see that the same seems to be true of the Dokimasia Painter. I can cite no case of a pot-painter developing such a strong line in

cups, though there are very good cups by pot-painters, the Kleophrades Painter for example. Many of the Triptolemos Painter's cups are excellent, but in his best pots he achieves a monumentality one would not, from those, have guessed him capable of.

After the early group of cups it is hard to see any development in the painter's mature style. Indeed (and this is another reason why this artist's work merits particular attention) it seems that he kept a very pure archaic style in a period when most artists of his quality had moved into a new mode. The evidence for this is collaboration with other painters, the clearest instance being a pelike in Mykonos.[426] The picture on the front, a man making love to a boy, is the Triptolemos Painter's, the *komos* on the back by an inferior though not worthless craftsman known as the Flying-angel Painter. That painter's work can be seen to progress from an archaic to an early classical phase.[427] The rough picture on the pelike shows this later character, while the Triptolemos Painter's drawing on the other side is pure archaic.

There is possible confirmation of this sustained archaism in a relationship between the Triptolemos Painter and the Pan Painter, but here the evidence is more difficult to evaluate. Working on stamnos-fragments in the Louvre, Beazley 'seemed to notice a distinct resemblance . . . in technique and finish of the potter-work'[428] between pieces which belonged to a vase by the Triptolemos Painter and others from one by the Pan Painter. The Triptolemos Painter's piece showed the story of Marpessa's choice of her mortal suitor Idas over the god Apollo;[429] the Pan Painter has Priam come to ransom Hector's body.[430] The Pan Painter's piece had also elements in common with fragments of a second stamnos by the Triptolemos Painter: 'the floral designs at the handles are much alike . . . and the curiously poor maeanders under the pictures appear to be by the same man – neither of our painters, but an unskilful assistant in the workshop'.[431] This is evidence that the two painters sat for a time in the same workshop, and the Pan Painter belongs essentially to the early classical age. However, the highly personal, sometimes mannered style of this great artist (whom we shall treat in a later chapter) makes his development hard to trace. His earliest work certainly belongs to the latest archaic. One such piece is a very large pelike in Malibu of a distinctive class all of which were surely produced at one time.[432] Most of the class are decorated by minor late archaic painters, but one, in Copenhagen, is a mature work of the Triptolemos Painter.[433] It is possible that the Pan Painter's Louvre stamnos-fragments are also from this early phase, when the Triptolemos Painter's archaic style was still to be expected, as it was not when he came to collaborate with the Flying-angel Painter. It is of interest that the rare subject of Marpessa's choice is

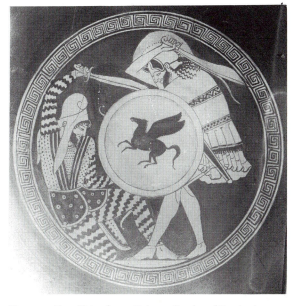

Fig. 112. Cup: Triptolemos Painter. Greek and Persian in combat. D. *c.* 0.12.

treated also by the Pan Painter in a certainly very early work, a psykter in Munich.[434]

The Triptolemos Painter's most impressive work is on stamnoi (his name-vase, for instance, in the Louvre),[435] pelikai (the piece in Copenhagen, on which Triptolemos again figures, fig. 113) and the calyx-krater in Leningrad which Beazley first attributed to the Foundry Painter.[436] This has the story of Danae. On one side she stands, baby Perseus in her arms, between her father Akrisios and the man making the chest in which she and the child are to be set adrift; a popular subject at this time. On the other side is a much rarer scene: the child's conception. Danae sits alone on a couch and leans back to receive in her lap the golden rain which is Zeus. The drapery, and the rich ornamentation of the couch with its mattress and cushions, are strikingly Brygan; but the effect of the monumental figure, isolated on the black vase without ornament above the handles or on the rim, is quite other. As a cup-painter turning to pots the artist would naturally look to the Kleophrades Painter and the Berlin Painter.

We may end with another fine vase which raises questions of method in a different context: the identification

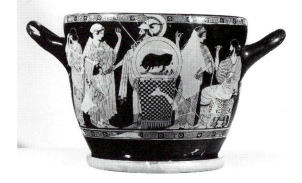

Fig. 114. Skyphos; Triptolemos Painter. Warrior's departure. H. *c.* 0.22.

of scenes of legend. This is a smaller pot, related to cups but still allowing figures on a rather larger scale: a big skyphos such as we saw decorated by the Brygos Painter and Makron.[437] It is interesting that this vase (in Berlin)[438] is of the rare form found in two of the three Hieron/Makron skyphoi: handles set well below the rim, which is adorned with a pattern-band, and sloping up towards it. A good deal is missing. On one side, evidently the back, is a warrior's departure (fig. 114), a generic scene though it may have a particular application. An altar is shown under each handle, and on the front is a picture of a clearly specific event.

A warrior advances, sword drawn, on a fleeing woman; and one thinks naturally of the picture on the similar skyphos by Makron: Menelaos attacking Helen in Troy. So this was first interpreted, perhaps rightly, but there are differences which give pause. No deity appears to protect the woman, but behind the warrior is Athena, apparently urging him on. In front of the woman flees a young man in a himation, his long hair looped up under a patterned diadem. A sword-belt is hung round his neck as though he had snatched it up, and as he runs he draws the sword, looking back. A shield, no doubt his, leans against one of the columns which mark the action as indoors. If the woman is Helen this is one of her Trojan husbands: Deiphobos if the setting is the sack, if the embassy Paris (whom the figure on the vase well suits). However, there is a different story which Hampe well argued to be better suited to this picture overall.[439]

The archaic poet Mimnermos[440] is reported as telling how, at Athena's behest, Tydeus killed Ismene because she had slept with Theoklymenos. A mid-sixth-century Corinthian amphora[441] with named figures shows Tydeus, drawn sword ready, seizing the arm of a half-naked woman on a couch, Hysmena, while behind him a naked man, Periklymemnos, flees looking back; evidently a slightly varied version of the story told by

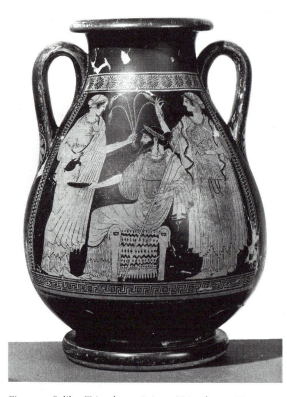

Fig. 113. Pelike; Triptolemos Painter. Triptolemos. H. *c.* 0.50.

Mimnermos. The Attic dramatists made something quite different of Ismene, but there is evidence that the old story was still current in early fifth-century Athens: a fine white cup in the Louvre which we noticed as from the circle of Onesimos (fig. 44).[442] It is very hard to suppose that an artist would show Athena encouraging Menelaos to kill Helen, but her presence is perfectly accounted for in Mimnermos's story. An objection, however, has been raised. The Corinthian amphora and the Attic cup share a very distinctive iconography: the lover is omitted from the second, but that is a function of the cup-tondo format, and in both the victim is caught by the avenger naked in bed, which underlines the nature of the offence. To suppose, without the evidence of inscribed names, that a painter has abandoned this tradition and made use of a new iconography derived from Menelaos and Helen is bad method. This is a good argument. The iconography of vase-painting tends to be consistent and long-lasting. Nevertheless, from time to time an old theme is radically rethought, and I incline to believe that the Triptolemos Painter's skyphos illustrates the story of Tydeus and Ismene.

I have treated the subject at greater length elsewhere.[443] I dwell on it here, not because it is so important to reach the correct answer in one particular case, but because the case illustrates so well the problems and methods of interpreting legendary scenes in vase-painting, and that is such an important part of the study.

There is another approach to these images, both more esoteric and more general, which aims to elucidate their meaning for artist and patron at a level beyond that of the illustration of a particular story. There is value in that method I am sure; but I do not think the recognition of those remoter meanings makes it any less important to define the pictures on vases as literal illustrations of particular stories, relating this fragmentary tradition to the independent and even more fragmentary tradition in surviving literature; trying to establish what stories were told in what forms at what times.

Another notion, that often these vase-pictures do not illustrate stories the vase-painter knew but are drawn from his free fancy I believe to be simply mistaken. The vast majority evidently refer to legends we can identify, and the painter often names the figures. It is an arrogance to suppose that where we cannot make the identification there is none to be made.

b. The Dokimasia Painter

In the large Brygan circle Beazley isolated a group of four painters as 'Mild Brygan', having 'less fire than the Brygos Painter'.[444] The two principals are the Briseis and Dokimasia Painters. The Briseis Painter decorated two of the cups with the name of the *poietes* Brygos. He is far below the master in quality, though his Theseus at the bottom of the sea, on a cup in New York (fig. 115), the arms of a huge Triton protectively about him, has great charm.[445] The contrast in design between this and Onesimos's tondo-picture of the scene[446] (fig. 35) is a good example of how different artists, working on different fields, create very varied iconographies for an uncommon subject.

The Dokimasia Painter[447] is the closer to the Brygos Painter. Indeed Beazley ended by recognising as his two fine cups and a fragment of another long given to the Brygos Painter himself;[448] and it is possible that there are other such adjustments to be made. The painter's name-cup, in Berlin (fig. 116), has young Athenian cavalrymen presenting their mounts for official inspection, a subject illustrated on a number of cups of this general period, but seldom so clearly and fully.[449]

We saw that a good many pots are attributed to the Brygos Painter, all (with one exception to which we shall return) relatively small: Nolan amphorae, lekythoi, oinochoai. To the Briseis Painter are given several such, and also two larger pieces, a column-krater and an amphora of panathenaic shape;[450] to the Dokimasia Painter three stamnoi (fig. 117) and a calyx-krater.[451] This may seem a small tally to justify calling the artist 'a cup-painter with a strong pot side'. The calyx-krater, however, which is in Boston,[452] is a very large, monumental vase, quite exceptional in a cup-painter's work; and there are features in this painter's pot-production which suggest a change of direction rather than a side-line.

The calyx-krater is of particular interest for its subject-matter. Two columns, one at each handle, support an entablature all round the pot under the rim, and the figures circle it in a continuous frieze; but they form two different pictures. On one side is the death of Aigisthos at the hands of Orestes, Clytemnestra rushing, axe in hand, to her lover's help; a favourite theme. On the other, at present unique in Attic vase-painting, the deed for which that death is revenge (fig. 118): Agamemnon, trapped in the shirt without neck- or sleeve-holes, is put to the sword by Aigisthos, backed by Clytemnestra with her axe. Women run hither and thither in both. The drawing throughout is good, and Agamemnon is a really memorable figure.

It has been thought that the trap-shirt was an invention of Aeschylus; but unless our dating is badly out it is hard to suppose that this vase was painted as late as 456 when his *Agamemnon* was produced; and it seems better to take it as evidence that in this detail Aeschylus was using an old story, perhaps from Stesichoros. It would not be the first time that a work of art has proved a story older than had been supposed from surviving literature. On the other hand our dating is so schematic,

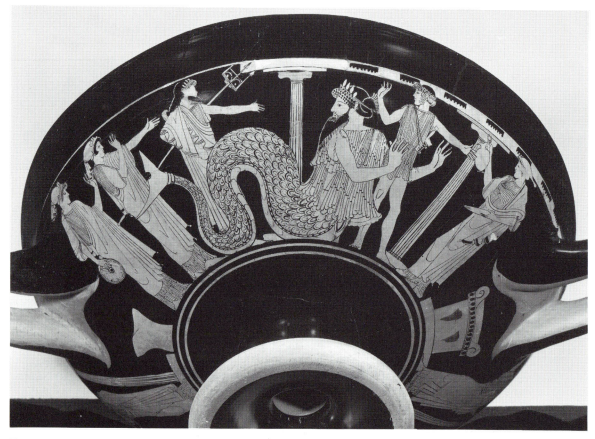

Fig. 115. Cup; Briseis Painter. Theseus at the bottom of the sea. H. of picture *c.* 0.09.

Fig. 116. Cup; Dokimasia Painter. Youths having their mounts inspected. H. of picture *c.* 0.10.

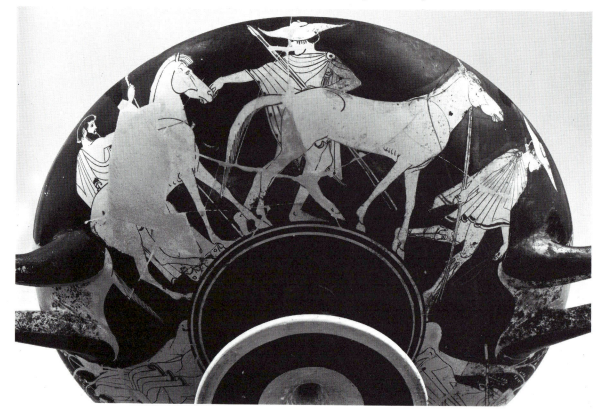

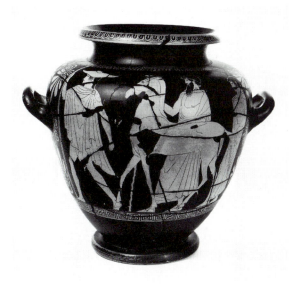

Fig. 117. Stamnos; Dokimasia Painter. Youth leading horse. H. *c.* 0.33.

the allowance to be made for individual styles lagging behind the trend so unsure, and the gap between the round date we should naturally put on this vase and the date of the play not so enormous, that a grain of doubt does not remain.

We have seen reason to think that the earliest work of the Pioneers' pupils falls before 500, and that a late work of the Berlin Painter is to be dated on iconographic grounds after 480. As we shall see in another chapter, his late work is probably later still.[453] The earliest pieces of his pupil the Achilles Painter are hard to distinguish from it; and that artist's mature work is so close in spirit to the Parthenon sculptures that it must be dated to the forties and thirties. It would be reasonable to place the overlap between his earliest and the Berlin Painter's latest in the decade 470–460. Douris's career seems to cover much the same range as the Berlin Painter's, from about 500 to the 460s. Onesimos, whose Panaetian phase begins about the same time, does not seem to have gone on so long, perhaps not much after 480. The Brygos Painter must have been younger, his career, as

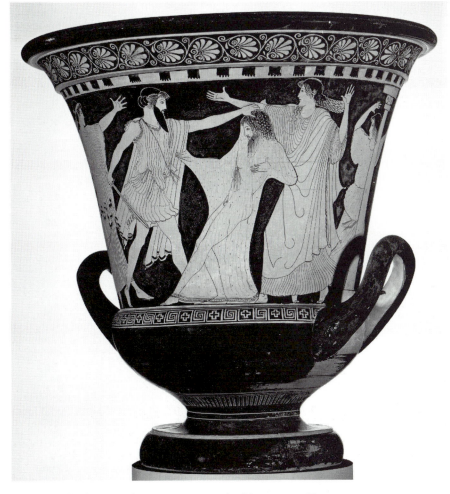

Fig. 118. Calyx-krater; Dokimasia Painter. Death of Agamemnon. H. *c.* 0.51.

117

Beazley says, running parallel with Onesimos's post-Panaetian phase; and his tired later work surely goes at least into the 470s. The Dokimasia Painter evidently learned from him in his prime, and his most Brygan cups are not likely to be much later than 480. On the other hand two of his stamnoi, both decorated with a death of Orpheus[454] related in composition to the death of Aigisthos on the calyx-krater, are linked by their potting to a class of stamnos decorated by the old Berlin Painter and his imitators; and one of these bears a related death of Aigisthos.[455] A plausible scenario would have the Dokimasia Painter, in the later seventies or sixties, leaving the Brygan workshop for the Berlin Painter's. There he worked on larger pots in a more monumental manner, while never losing the essentially Brygan character of his drawing. However, I cannot stress too strongly how far from established any of this is.

One more vase seems to me to need looking at again in this context: the large cylindrical wine-cooler in Munich with Alcaeus and Sappho (fig. 95).[456] We saw that Beazley ended by accepting Furtwängler's attribution to the Brygos Painter, calling it 'very late'. It is a stately piece, but it certainly lacks Brygan fire. The figures too are on a far larger scale than any others from the Brygos Painter's hand. In the light of the Dokimasia Painter's late development, I wonder if this is not another candidate for transfer, with the fine early cups, from the master's list to the pupil's.

VI. Other pot-painters

a. The Nikoxenos and Eucharides Painters

We have seen how many really good cup-painters there are in this period. It is curious that in pot-painting the Kleophrades and Berlin Painters (with the younger Pan Painter) stand out far above the rest. Good drawing is quite often found in the work of some painters we shall look at in these sections, even the occasional masterpiece, but the general standard is more humdrum. Cup-painting seems to attract more of the finest talent; and when a good cup-painter like the Triptolemos Painter turns to pots, he produces work above the common standard.

I begin with the Nikoxenos Painter and the Eucharides Painter, because the first takes us back to the time of the Pioneers, and the Eucharides Painter is inseparable from him. The Nikoxenos Painter worked also regularly in black-figure, and his black-figure belongs to the Leagros Group,[457] probably late in it. We saw that the Leagros Group seems to stand in some relation beyond mere contemporaneity to the red-figure Pioneers; but the Nikoxenos Painter's red-figure[458] is not at all closely related to Pioneer work (fig. 119). His black-figure is of decent standard; his red-figure the often barely com-

petent hackwork of a black-figure painter who never achieved sympathy with the newer technique. Beazley, who did not come to the attribution of black-figure until after he had worked for many years on red-figure, published early articles on these two as red-figure artists, seeing the Eucharides Painter as a more competent and talented pupil and follower of the Nikoxenos.[459] From the first he envisaged the possibility that they were really phases of one man's development, but decided against the idea then[460] and maintained the distinction to the end. After attributing black-figure to both, however, he remarked: 'The black-figure vases of the two groups are so much alike that judging by them only I should probably have counted the two artists the same. The red-figure vases, however, speak for difference'.[461] I have suggested the possibility of dividing the work in another way: the Nikoxenos Painter, having trained a pupil who developed a decent mastery of red-figure, handed over that side of production to him while continuing himself to produce the black-figure. That is: the black-figure Beazley ascribed to the Eucharides Painter should be regarded as late work of the Nikoxenos.[462] There is no proving such a theory, but I incline to think that it best saves the phenomena. In any case I cannot believe that the red-figure is the work of one man. The Eucharides Painter's earliest pieces are crude and like his master's, but there are always Morellian differences, and I sense two distinct personalities.

Each takes his appellation from a *kalos*-name not certainly found in the work of any other painter. *Nikoxenos* is written round the shield of Athena on a red-figure amphora of panathenaic shape, in Mississippi,[463] and *kalos* in the field. The goddess appears again on the other side, and on both sides of a

Fig. 119. Hydria (kalpis)-fragment; Nikoxenos Painter. Athletes. Gr. d. *c.* 0.065.

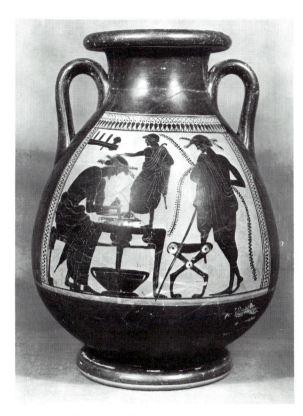

Fig. 120. Pelike; Eucharides Painter, or perhaps rather Nikoxenos Painter. Cobbler's shop. H. *c.* 0.40.

The Eucharides Painter has no hydriai of the old form and no plaque, but he adds to the repertory neck-amphorae (large and small), stamnoi, column-kraters, an oinochoe, lekythoi, skyphoi and a dozen cups, all but one small with picture inside only. He has not left so many of any one pot-shape, but all his major work is on pots, his favourite shapes being stamnos and calyx-krater. Among his best pieces are a stamnos, inscribed *Eucharides kalos*, in Copenhagen,[470] with youths and women, an Eros over each handle; and a calyx-krater in the Louvre with pictures from the Iliad:[471] the mission to Achilles, and a moving version of Sleep and Death lifting the body of Sarpedon.

This vase, and at least one other of his calyx-kraters (most are fragmentary) share a feature with at least one of the two ascribed to the Nikoxenos Painter.[472] Below the main pictures, on the cul (the shallow bowl from which the handles spring) are small independent pictures. Such additional pictures, we saw, are found on most of the few black-figure examples of the shape but on no other red-figure.[473]

Many red-figure pots of this period show some influence from or affinity with the styles of the Kleophrades Painter or the Berlin Painter. The Eucharides Painter's lekythoi are clearly influenced by the Berlin Painter's;[474] and there is evidence for direct contacts between these two artists. We looked at fragments of an amphora Type A by the Berlin Painter where the decoration is confined to the neck, between the handles, separated from the black body by a pattern-strip. The only other piece like this we have is a complete vase in Hamburg,[475] decorated by the Eucharides Painter (fig. 121); and the potting of this amphora is in all details like that of the Berlin Painter's name-vase and his amphora in Basel. When the Eucharides Painter decorated the Hamburg vase he must have been sitting in the Berlin Painter's workshop.

The drawing in the Hamburg pictures is in the Eucharides Painter's early style, rather primitive and close to the Nikoxenos Painter's. The Berlin and Basel amphorae belong to the Berlin Painter's mature early style, and this suggests that the Eucharides Painter was the younger man. There is further evidence for contact between the two artists at a slightly later stage; and in this case it seems to be the Berlin Painter who is sitting for the moment in the other workshop. A fine but rather untypical work by the Berlin Painter is a neck-amphora in Basel,[476] seemingly transitional from his early to his middle period. Instead of the single-figure decoration he prefers on this shape he has circled the vase with an Amazonomachy (fig. 122) in the tradition of the composition put by Euphronios on his volute-krater in Arezzo.[477] There is also an exceptional amount of floral ornament; and Beazley noted that the neck-floral and also the potter-work connect the vase with a neck-

second vase of the same shape, in Boston,[464] and of two more in the Louvre.[465] None of these figures is in the Panathenaic pose, but those on the name-vase are flanked by columns with cocks, and on another, in a Swiss private collection,[466] Hermes on either side is similarly placed. Beazley's list of black-figure vases by this painter consists largely of neck-amphorae, with also pelikai and hydriai, but contains no panathenaics. To the Eucharides Painter he assigns a number. Many are fragments, but four complete ones are inscribed prize-vases, and these have a snake for shield-device.[467]

The most attractive of the black-figure pieces is in the Eucharides Painter's list: a pelike in Oxford.[468] On one side is an unexplained picture of Hermes and two satyrs in a rocky landscape. On the other a cobbler is cutting the leather sole round the foot of a child standing on a table (fig. 120): a pretty picture, but it is a rather summary version of an earlier one by a better painter;[469] and there is that feel about late black-figure in general.

The Nikoxenos Painter's red-figure includes, besides the amphorae of panathenaic shape, amphorae Types A and B, pelikai, hydriai of both forms (with a marked preference for the kalpis with picture on the shoulder) (fig. 119), volute-kraters with picture on the neck only, calyx-kraters and one plaque dedicated on the Acropolis.

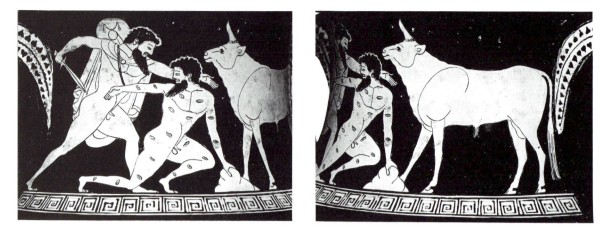

Fig. 121. a and b. Amphora Type A; Eucharides Painter. Death of Argos. H. of picture *c*. 0.12.

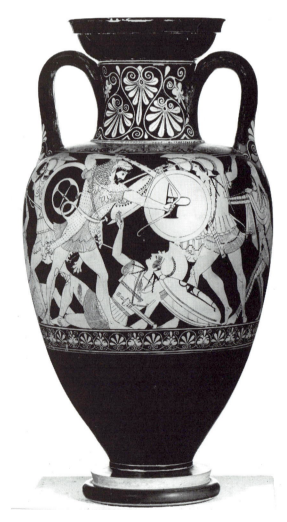

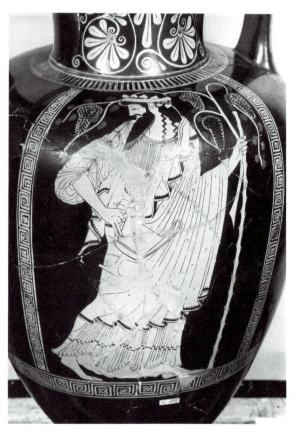

amphora in London by the Eucharides Painter.[478] This, one of the painter's most careful and elaborate works, and one of his best, has Dionysos on one side (fig. 123), Ariadne on the other, with a rich surround of pattern. Of the same character and quality, though not a pair to

Fig. 122. Neck-amphora; Berlin Painter. Amazonomachy. H. *c*. 0.55.

Fig. 123. Neck-amphora; Eucharides Painter. Dionysos. H. of figure *c*. 0.20.

this vase, is a second neck-amphora by the Eucharides Painter in London.[479] On one side Tityos assaults Leto, and on the other her son Apollo draws his bow against the rapist. The side-frames on these two vases are maeanders. This pattern is rather rare as a vertical strip, but another example is its use to frame figures of Athena and Hermes on an amphora of panathenaic shape in the Vatican by the Berlin Painter.[480] This is the only vase of this favourite shape on which he frames the figures; and (again uniquely) he here adds a floral on the neck. This pot belongs to the same stage in the Berlin Painter's development as the Amazonomachy in Basel, while the London neck-amphorae belong to the maturity of the Eucharides Painter.

This is perhaps the place to mention a group of small vases (Nolan amphorae, oinochoai, lekythoi) with purely floral decoration.[481] The pretty designs correspond, with varying degrees of closeness, to those found on vases with figurework by the Berlin Painter, and Beazley lists them at the end of his chapter on that artist. He notes, however, that florals identical to some of these are found on an oinochoe by the Dutuit Painter.[482] This charming miniaturist seems connected with a late black-figure workshop, but Beazley once remarked that in his figure-style he 'may be said to face towards the Eucharides Painter'.[483]

One can scarcely doubt that the Berlin Painter normally sat in one big workshop, the Nikoxenos and Eucharides Painters in another, but it seems clear that there was a lot of coming and going between workshops in the Kerameikos. This is a natural situation in a craftsmen's quarter of a Mediterranean city, where so much goes on in the open air.

Beazley notes that the Eucharides Painter's 'latest works, poor in quality, already belong to the early classic period';[484] something we have noticed in other late archaic artists. Before we leave him we may glance back at the subject-matter of the pictures on his early amphora in Hamburg.[485] One shows the death of Actaeon, and we will come back to it in considering the work of a greater artist.[486] The other has thousand-eyed Argos, set by Hera to guard Io in her metamorphosis, killed by Zeus's emissary Hermes. This subject is found fairly often in red-figure vase-painting, and almost always, as here, the transformed heroine is clearly represented not as heifer but as bull. It seems to happen too regularly to be dismissed as a vase-painter's error, but what the explanation is I do not know.

b. The Syleus Sequence

Nikoxenos Painter and Eucharides Painter may have been one, but I think not. The same question arises with the artists treated in this section; and here, though some of the links are less immediately obvious, I am much more inclined to believe that the several groups are phases or aspects of one artist. The case is parallel to that of Apollodoros and the cup-groups which lead up to him.[487]

The history of attribution is interesting. In his 1918 book Beazley gave eighteen vases to a Painter fo the Syleus Stamnos, and in an earlier chapter four to a Painter of the Diogenes Amphora.[488] He does not note any connection between the two. In the German lists of 1925 he added to both groups. The Syleus Painter has thirty-three,[489] the Diogenes Painter six;[490] but he has lost one of the old ones. This, a hydria in Boston with Danae and the chest, Beazley notes as related to the work of the Painter of the Munich Amphora, a newly defined personality to whom he gives eleven pieces.[491] Another new name is the Painter of the Würzburg Athena, given ten pieces and placed immediately after the Diogenes Painter, though no connection is specified.[492] The Syleus Painter is here defined by his relation to the Copenhagen, Syriskos and Oreithyia Painters, whom we treat in the next chapter.[493] In the 1942 *ARV* Beazley establishes the sequence. Under the Painter of the Munich Amphora (who here has twelve attributions, one of the old set aside as 'near the painter...and possibly a late work of his'), he writes: 'The line beginning here runs on to the Syleus Painter'.[494] Next comes a Gallatin Painter, author of the Boston Danae vase and two others: 'Very like the Diogenes Painter, and perhaps, after all, the same in an early phase. Also related to the Painter of the Munich Amphora'.[495] The Diogenes Painter is next, with seven or eight pieces: 'Like the Gallatin Painter. Leads on to the Syleus Painter'.[496] Lastly the Syleus Painter, who 'continues the Diogenes Painter'. His fifty-one vases include, as early work, those formerly given to the Painter of the Würzburg Athena.[497] In *ARV*² (1963) the Syleus Sequence is given a chapter:[498] Painter of the Munich Amphora (list unchanged except for one possible addition); Gallatin Painter (unchanged, but one fragment added as 'near both the Gallatin Painter and the Diogenes'; Diogenes Painter (seven attributions and three possibles); Syleus Painter (sixty-two pieces, and five or six more in the Addenda); and 'it is very likely that the Diogenes Painter is an earlier phase of the Syleus, the Gallatin a still earlier; and even the Painter of the Munich Amphora might be the nonage of the Syleus'.[499] The only change in Paralipomena is the addition of one vase to the Diogenes Painter's list.[500]

I have traced this progress in detail because it is such a beautiful example of the flexibility and openness of Beazley's mind, an encouragement to us too not to be afraid of questioning his judgement in particular cases. It shows how, starting from cores of closely knit pieces, he worked out to larger groupings, new finds and new observations pointing new connections; also how he

could leave a question open, did not feel the necessity of giving a definite answer.

These painters (I prefer to think 'this painter', but let us keep the plural), though not the equal of the Kleophrades Painter or the Berlin Painter, are serious artists who produce, alongside much humdrum work, pieces of great merit. Most of the best comes from the last phase; but the masterpiece of the 'Diogenes Painter', a very large column-krater in Leningrad, from Kerch, is a work of real beauty.[501] On the damaged back are two satyrs. On the front Zeus, thunderbolt held high, pours a libation from a phiale Athena has filled from a jug she holds (fig. 124). She is bare-headed, holding her helmet in her other hand. A lovely group.

The Diogenes Painter is so called from a name written on an amphora in London.[502] It is followed by *kalos*, but seems also to refer to a figure of a young boy courted by three youths (two of them also named) (fig. 125). The *kalos*-name is found also, as we noticed,[503] in the work of three cup-painters (Douris, the Antiphon Painter, the Foundry Painter) and one other pot-painter,

the Syriskos Painter. This artist, with his companion the Copenhagen Painter, will be considered in the next chapter in connection with the transition from archaic to classical.[504] The mature Syleus Painter has some affinity with this group, as Beazley noted in *AV*.[505] The Diogenes Painter's amphora looks earlier than any other piece on which the name appears, and this is consistent with the representation of Diogenes here as a young boy. This vase is an amphora Type B. A second is attributed to the same hand, others to the Gallatin and Syleus Painters. The latter has also at least one of Type A, as is the name-vase of the Painter of the Munich Amphora. All have many-figured framed pictures in the tradition of the Pioneers, and it seems possible that the first painter, or the painter in his first phase, got his training in the circle of Phintias.

The workshop, on present evidence, produced only large pots: amphorae Types A, B and C; amphorae of panathenaic shape; one important pointed amphora;[506] hydriai of both forms; pelikai, stamnoi, volute-kraters and loutrophoroi. We mentioned the Diogenes Painter's

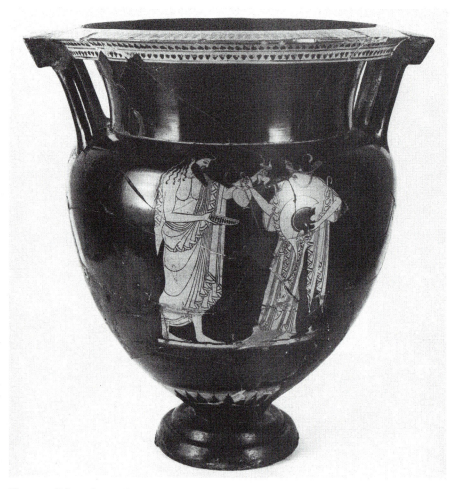

Fig. 124. Column-krater; Diogenes Painter. Zeus served with wine by Athena. H. *c.* 0.51.

Fig. 125. Amphora, Type B; Diogenes Painter. Young men making up to boy. H. of picture *c.* 0.25.

great column-krater, and two more ordinary ones are ascribed to the Painter of the Munich Amphora, but it is not a regular shape in the workshop. We have already mentioned the generally rather humble character of the column-krater, and shall have more to say of it soon.[507] There are no Nolan amphorae, lekythoi or oinochoai, nor any form of drinking vessel. Rather surprisingly there are no large neck-amphorae. Fourteen of the seventeen pelikai are placed in the 'Syleus Painter' list, but four of them are called 'early', and these belong to a special class of very large pieces (the Class of Cabinet des Médailles 390),[508] the pictures framed by consistent bands of pattern but the figure-work by different hands. We met one by the Triptolemos Painter, and will consider the class further in connection with an early work by the Pan Painter.[509]

Many of the pots with framed pictures are early. Alongside from the beginning are also black vases with no ornament and one or two figures on each side. The Painter of the Munich Amphora has an amphora Type C with Zeus on one side, on the other Europa on the bull.[510] The Diogenes Painter's column-krater is of this kind, and there is much in the Syleus Painter's list, amphorae of panathenaic shape and others. The figures in the mature work of the Syleus Painter have a massive character which looks forward to one tendency in early classical red-figure, best represented, perhaps, by the Oreithyia Painter; a connection noted by Beazley.[511] An impressive example in the Syleus Painter's work is a kalpis in Berlin with an unframed picture on the body (fig. 126). The four large figures show an unusual subject: Athena and Dionysos hurrying Theseus and Ariadne away from one another.[512] Similarly massive are the figures on a fine pelike in the Louvre,[513] likewise with unframed pictures, on the front Eos carrying Memnon's body. A beautiful fragment from Al Mina in Syria has the head of Ganymede pursued by Zeus. It is from a volute-krater with pictures on both body and

neck, of which other substantial fragments survive.[514] It must have been among the artist's best works.

Black-figure prize-amphorae for the Panathenaic games are attributable to several red-figure painters of this time: the Kleophrades Painter; the Eucharides (or perhaps rather the Nikoxenos) Painter; the Berlin Painter in old age, or at least his school.[515] We may note in passing that some of these amphorae lack the inscriptions, so were presumably not actual prizes. There are pieces in the manner of these painters but not apparently from their own hands, and these have the same shield-device for Athena (the Kleophrades Painter's Pegasos, the Eucharides Painter's snake) as those attributable to the painters themselves. Occasionally the same device appears on a vase not associable with the usual painter's style. This might indicate that, to complete a special commission, one workshop might borrow a painter from another.[516] An example is Athena with Pegasus on a handsome prize-vase in Naples, wrestlers on the reverse, the style of which is not Kleophradean.[517] It is exceptional in having, besides the usual inscription, a second, incised down the black of one column: a painter's signature, *Sikelos egrapsen*. I have suggested that this piece, and two fragments of panathenaic reverses from the Acropolis which Beazley ascribed to the same hand, may be by the Syleus Painter, and so give us his name.[518]

Sikelos is in origin an ethnic slave-name, Sicel. Two branches of the native population of Sicily were known to the Greeks as Sikeloi and Sikanoi. An early red-figure plate with a figure of Artemis, lost but known in an old drawing which shows that it was near, if not by, the painter Oltos, bore the inscription *Sikanos epoiesen*.[519] We shall have more to say in the next chapter about such ethnic names in the Kerameikos.[520]

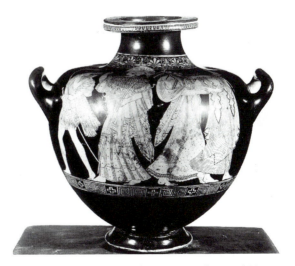

Fig. 126. Hydria (kalpis); Syleus Painter. Athena and Dionysos separating Theseus and Ariadne. H. *c.* 0.35.

c. Myson and the painters of column-kraters

The column-krater is a popular shape in late archaic red-figure, but we have noticed few examples. The Diogenes Painter's carries drawing of great beauty, but this is exceptional. Of the artists whose work we have considered only the Eucharides Painter decorates the shape more than occasionally. Most column-kraters are the work of low-grade craftsmen who specialise in this production to the exclusion of almost anything else. Many remain unattributed, but Beazley isolated two related hacks, the Goettingen and the Chairippos Painter, and allotted to them or their circle some fifty of the earlier examples.[521] More interesting than these is Myson.

In his first article, in the *JHS* for 1908, Beazley published three vases in the Ashmolean. One was the black-figure pelike with the cobbler's shop, later ascribed to the Eucharides Painter,[522] another a red-figure column-krater, a black vase without pattern-work, a single athlete on either side. Beazley here was almost exclusively concerned with subject-matter, but in a note at the end he grouped this vase with several others as being in one style.[523] In the 1918 book he repeated this list of column-kraters, slightly modified and considerably enlarged, and made important extensions to it in two directions: two large elaborate vases of other shapes, certainly by one hand; and a small untypical column-krater, fragmentary, from the Acropolis, inscribed *Myson egrapsen kapoiesen*, giving the painter a name and at the same time defining him as *poietes*.[524] Neither association has gone unchallenged; but both find support from a study in depth of 'Beazley's Myson'.[525] In this (which has wide application for the validity of Beazley's work in general) Berge analyses the evidence on which he bases his associations and the way he builds up his picture of the artist's personality. A fascinating finding is that pieces which, in the earlier lists, seem to a less sharp eye to have little to link them, are often brought together through common likenesses to another piece only later known to Beazley.

We considered the signed vase in connection with a similar signature of Epiktetos, also on a piece from the Acropolis (a plate, different in potting from the others he decorated, and seemingly later), and concluded that it was probably a custom for a vase-painter at some stage to dedicate a work of his to Athena on the Acropolis and to make with his own hands the vase he was going to decorate for this purpose.[526] Myson's column-krater is smaller than his normal ones and on a different model, and the style of the pictures belongs to a fairly advanced stage in his development. Their subject-matter is at least compatible with a personal interpretation.

The inscription is written, in the usual red but in very large letters, on the black neck of the vase (fig. 127):

a most unusual disposition and surely evidence in it-self that this is a dedication by the painter-*poietes*. Epiktetos's plate showed Athena alone, in the *promachos* position of the goddess on the panathenaic amphorae. She appears on both sides of Myson's pot, but differently. On one she sits, reaching out a phiale, and a youth in himation bends his head and reaches out a bunch of twigs towards her. On the other the goddess stands by an altar, a column behind it supporting entablature. Beyond it a male (upper part missing) reaches out his hand (with something in it?) across the altar on which twigs lie. This side is more elaborately drawn and was probably the front. The neck, largely lost, could have had a lotus-bud pattern (often found on the front of column-kraters, the neck at the back being black), and this would account for the inscription being put on the back. Pottier suggested that both the worshippers represented Myson. We will return at the end of the section to an attractive modification of that idea.[527]

The two ambitious vases which stand apart from the artist's usual work (a few others of similar character figure in Beazley's last lists and will be discussed later) are an amphora Type A in the Louvre and a calyx-krater in London. The krater[528] has on one side Apollo and Herakles struggling for the tripod and the fawn, on the other (fig. 128) old Aithra led from the sack of Troy by her grandsons. On one side of the amphora[529] Theseus, accompanied by Perithoos, carries off Antiope; on the other, a unique representation, King Croesus of Lydia sits on a throne raised on a pyre. He pours a libation while a slave puts a torch to the logs. This is a legendary story about a historical character, the wealthy and powerful ruler of Lydia, suzerain of many Greek cities and patron of Delphi, who lost his kingdom to the Persians in 546 B.C. Herodotus, writing a hundred years or so after the event and some fifty after this vase

Fig. 127. Column-krater with signature of Myson as painter and *poietes*. Youth before Athena. H. of part shown *c.* 0.09.

Fig. 128. Calyx-krater; Myson. Rescue of Aithra. H. *c.* 0.40.

was painted, tells the story of the Persian monarch Cyrus setting Croesus on a pyre to burn him; but a miraculous storm extinguished the flames, and the deposed king became Cyrus's favourite counsellor.

Almost all Greek narrative art illustrates stories of gods or heroes. Certainly the Greeks did not make the sharp distinction we do between legend and history. To them the men who fought at Thebes and Troy had really lived and fought and were their ancestors; but still a distinction was evidently felt. The men of Hesiod's heroic age were different from the men of today; perhaps because the gods intervened so much more often and directly in their lives, and for many of them, as Aeschylus says, the blood of *daimones* was still not thin in their veins. The saving of Croesus on the pyre was the act of Apollo; and the notion of divine intervention may lie behind the introduction of another historical event into Attic vase-painting about this time. Fights between Greeks and Persians begin to be shown on vases. Such pictures, unlike Croesus on the pyre, are *contemporary* history; but, equally unlike that, they are always general, never personalised: it is a generation or more later that the battle of Marathon is painted, with named

participants, on the wall of the Stoa Poikile. Later still it is admitted to temple-sculpture. Herakles, Theseus and other *daimones* had fought beside the Athenians and Plataeans at Marathon, and there was surely a feeling that there was something miraculous about the defeat of the Persian host.

The compositions on Myson's amphora and calyx-krater are ambitious and the drawing elaborate. The artist is vying with the best. He does not do badly, but not, one feels, quite well enough. The detail is often sloppy, and this is not compensated by much natural verve. The most effective of the four pictures seems to me the rescue of Aithra on the krater. The old woman, wrinkled, bent and grey, is well realised, and the play of light and dark in the armour is effective. The treatment of the warriors in the Antiope picture on the amphora is so similar that the two vases have been stylistically associated for more than a century.[530] Beazley's linking of them to the other vases in his Myson list (about ninety in all, some seventy of them column-kraters) is less evident and has been argued against, but it stands up to Berge's close analysis, as does the association of the signed vase. The two special pieces must be

from early in his career, and take with them a good panathenaic in Florence with Herakles and Apollo which Beazley originally gave to the Pan Painter but later, surely rightly, to Myson.[531] The difficult question of the relation between Myson and the Pan Painter we will consider when we come to that artist.[532]

The Antiope picture must be among the latest of the group of Attic vase-pictures of the subject which seem to cluster round the monumental rendering in the pediment of the temple of Apollo at Eretria.[533] Besides those we have already noticed, by Oltos, young Euphronios, and the black-figure Antiope Painter (Leagros Group), there is one scrawled on a volute-krater neck by a companion of the Nikoxenos Painter[534] and one on a fragment of a Panaetian cup by Onesimos.[535] The subject is also found on a fragmentary psykter in the Astarita Collection in the Vatican, which Beazley ascribed to Myson.[536] If this fine work is his it must be even earlier than the amphora and the calyx-krater; but it is one of the few pieces which Berge's analysis fails to tie in with the rest. The same goes for good cup-fragments in Florence:[537] inside, satyr and maenad and the name Leagros; outside, warriors. The only other cup in the list ('probably by Myson') is the tiny white scrap in Cambridge with a warrior's head, already mentioned as being in my view a late work of Epiktetos.[538]

It looks as though Myson had set out with the ambition of being among the producers of fine work, but could not quite make it. Beazley thought Phintias might have been his master,[539] and it is probable at least that he learned in the Pioneer workshop. The amphora belongs to the latest version of Type A, with unframed

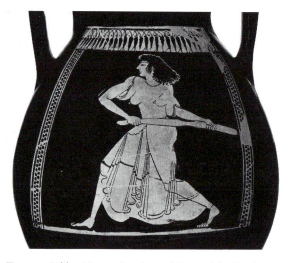

Fig. 130. Pelike; Myson. Daughter of Nereus defending house against Herakles. H. of picture *c.* 0.14.

pictures, so goes with the Berlin Painter's and the later of the two in Würzburg by the Kleophrades Painter. Myson seems to have settled gradually into the mainly down-market production of column-kraters and pelikai. These were to become (with the kalpis, of which he has left us no example) the staple products of the Mannerist Workshop, the early painters in which were Myson's pupils.[540] Myson, however, keeps in general a better standard than either his Mannerist pupils or his contemporaries the Goettingen and Chairippos Painters and their circle.

A good fragment in Adria,[541] which might be from a volute-krater rather than a column-krater, with the return of Hephaistos, has still some of the character and quality of the early pieces. Some of the column-kraters with framed pictures, a Centauromachy in Naples, for instance, or a Herakles and the lion in the Villa Giulia,[542] have compositions which seem rather painful attempts to keep up the grand manner. Most of the column-kraters of the Goettingen and Chairippos circle have framed pictures, and this is the rule in later generations, but the shape is also adapted to the favourite late archaic mode of a black vase with little or no ornament and one or two figures on each side (fig. 129). Myson uses both methods, but many more of the second, and these tend to be more attractive. The Oxford athlete vase is a good example.[543] The pelike too comes in both styles, but of more than a dozen ascribed to Myson only one has unframed pictures. One of his liveliest works is a pelike in Munich[544] with framed pictures: Herakles breaking up the house of Nereus, and a Nereid stoutly facing up to him, like a Trojan woman at the sack, with a huge pestle (fig. 130).

Very few vessels of other shapes are listed, and several of these fit with difficulty into Berge's analysis. Of three

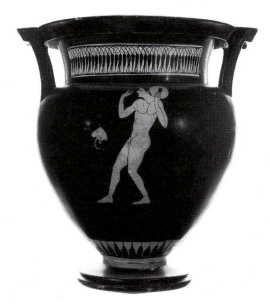

Fig. 129. Column-krater; Myson. Discus-thrower. H. (including foot which does not belong) 0.38.

oinochoai one, in Boston, is an uncontroversial late work, but a lively fragment from the Agora seems to have only a superficial resemblance to the artist's drawing. One in Salonica finds better parallels in the work of the Eucharides Painter,[545] and the same is true of a psykter in Berlin.[546]

The leading painter in the Mannerist Workshop in its early phase is known as the Pig Painter. Of him Beazley says: '[He] is especially close to [Myson], continues his style in fact; and it is not easy to say where Myson ends and the Pig Painter begins'.[547] He does not, in this late judgement, repeat an observation made earlier in connection with a column-krater attributed to Myson as a late work, that the Pig Painter 'might even be Myson in his later years'.[548] Such an idea receives no support from Berge's analysis; but that the Pig Painter was a close follower, who ultimately took over Myson's position in the shop, seems clear. In view of this, and of the youth of the figure whose head is preserved on Myson's signed Acropolis vase, Berge has suggested that the occasion of the dedication might have been the formal association of the Pig Painter in the business. Myson would then have shown himself before the goddess on one side of the vase, on the other his young pupil; very probably, given the way trades and crafts ran in families, a son or nephew.[549]

d. Some other painters of large pots

The most important remaining pot-painters of this period are the Copenhagen and Syriskos Painters. They, as already noted, will be treated in the next chapter because of their importance in the transition from archaic to classical. There are many more: the corresponding chapter in *ARV*[2] has seventeen names. Many, however, are very small groupings, none of very high quality, and only a few need, for one reason or another, mention in this survey.

The Troilos Painter[550] is of interest for his relation to the Kleophrades Painter. On at least one occasion he decorated a stamnos which was a companion piece to one by that artist;[551] and Beazley remarks that shapes and patterns point to a workshop connection. He adds: 'As to figure-work, the artist may have thought that he came closer to the Kleophrades Painter than he did'.[552] Certainly he imitates specific renderings like the outlining of lips, but he is a very crude draughtsman though with a certain vigour. His best work is, suitably, on a calyx-krater (a chariot with deities; athletes) in Copenhagen.[553] One or two black-figure neck-amphorae are also ascribed to him.[554]

The Harrow Painter[555] looks towards the Berlin Painter, but the relation is a different one. The Troilos Painter certainly sat in the same workshop as the Kleophrades Painter, and one may guess that putting figurework on pots was not his principal occupation there. Between the Harrow and Berlin Painters there is no evidence for a workshop connection. The attributed *oeuvre* of the Harrow Painter is much larger than the Troilos Painter's (nearly a hundred pieces against twenty-odd) and one would guess that he was the principal painter in an independent workshop. His main production is of column-kraters and large neck-amphorae, the pictures drawn with little care; but the same hand is clearly traceable on small oinochoai, each with a single figure, on which he is evidently trying for something better. He is never an assured draughtsman, but in these smaller figures he takes trouble, and a charm comes through which is only occasionally to be felt in his larger, everyday work.

While *ARV*[2] was in press a pair of small jugs was acquired for the Noble Collection. On one is a boy cup-bearer (fig. 131), on the other a boy running with a hoop and a tray of food (the same subject as in the Colmar Painter's prettiest cup). In the first Addenda Beazley entered these under 'Manner of the Berlin Painter', writing: 'The drawing is extremely close to the Berlin Painter himself, and has much of his χάρις. These are not mere imitations of the Berlin Painter's style, but careful copies of two vases by the Berlin Painter himself. Bothmer and Shefton have both suggested that the hand may be that of the Harrow Painter. For the pattern-band compare his oinochoe in Harrow'.[556] In Addenda III he added them to the Harrow Painter's list.[557] Later, in conversation, he suggested that he had at first exaggerated the closeness of these pieces to the Berlin Painter, but I hardly think so. One cannot perhaps absolutely claim that they are direct copies of works by the master; but I do feel that, particularly here and in general when he was trying to do his best, the Harrow Painter did consciously look for inspiration to drawings by the Berlin Painter. The boy on one of the Noble jugs has golden hair, as does the boy with a hoop on the name-jug in Harrow.[558] There are other fair heads in the painter's work, and we have noticed the Berlin Painter's predilection for this colouring. I see something of the Berlin Painter in all the figures on the small oinochoai, and at moments in the larger, coarser work too.

On a big, ruined column-krater in Vienna, as to the attribution of which Beazley evidently had doubts but which seems to me certainly the Harrow Painter's,[559] the beautiful design of Clytemnestra restrained by Talthybios (extract from a death of Aigisthos) surely goes back to the Berlin Painter. Another column-krater, in Berlin,[560] like the last with unframed pictures, has a very charming scene of a winged goddess comforting a sulking boy (presumably Achilles with his mother Thetis). Here, though, I see very little to remind me of the Berlin Painter, and would give the artist himself full

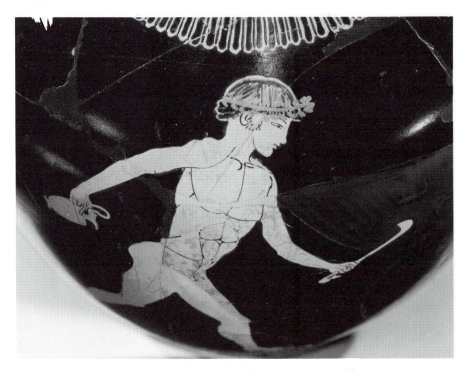

Fig. 131. Oinochoe; Harrow Painter. Boy running with jug and ladle. H. of figure *c*. 0.11.

credit. So also for the amusing picture on a column-krater with framed pictures in Caltanisetta, from the Sicel site of Sabucina:[561] Hephaistos squatting at his forge, surrounded by satyr-workmen. The inspiration for this is surely from a satyr-play. In a later chapter we shall look at a strange vase probably from the Harrow Painter's hand, in which the artist is copying quite a different model.[562]

Another painter with a considerable *oeuvre* (some ninety attributed pieces), again one would think principal painter in an independent workshop, is the Tyskiewicz Painter.[563] He takes his name from an early owner of his masterpiece, a big calyx-krater in Boston. He decorated most of the large shapes, but in considerable numbers only column-kraters, stamnoi and especially pelikai. In detail he is a coarse, clumsy draughtsman, but his figures have weight and force. The calyx-krater shows Trojan combats, a deity behind each hero, big florals over the handles. The effect is crowded but powerful. The florals derive from the Berlin Painter, the figures are nearer the Kleophrades, but there seems no close connection with either.

The late work of the Tyskiewicz Painter is early classical in character. No doubt most of these painters worked on into that time, but some adapt more than others. We noticed a late drawing by the Flying-angel Painter, early classical in style, on the reverse of a pelike the front of which is decorated by the Triptolemos

Painter in a still purely archaic idiom.[564] The Flying-angel Painter[565] is called after an amphora Type C in Boston. On one side a satyr holds a little boy satyr on his shoulders, 'flying-angel' (fig. 132); on the other a second satyr brandishes a huge phallus. The artist is one of the few who favour this shape: eleven are ascribed to him, more than any other shape in his not very large output except for seventeen column-kraters. The amphorae are black vases with single-figure decoration, often slightly out-of-the-way themes. On another with satyrs, in Leningrad, one dances, while the other carries a pantheress which he seems about to violate. On either side of one in the Petit Palais is a naked woman, one holding a phallus, the other a phallus-bird, and she is uncovering a basket full of phalli. On one side of a piece in the Villa Giulia a youth throws a stone at a hawk which has picked up a hare.[566] The drawing is not fine but conveys a distinct, odd personality.

To this painter are also attributed two or three red-figure lekythoi, and he is probably responsible as well for a few with white-ground decoration.[567] Beazley describes a small group of pelikai, by 'the Painter of Louvre G 238',[568] as near him, and as linked by the maeander with the Geras Painter and his follower the Argos Painter. This uncouth couple again like odd subjects, often with phallic emphasis, satyrs and Herms. Small pelikai by the Geras Painter form a class which is related to a class of small pelikai by the Pan Painter,

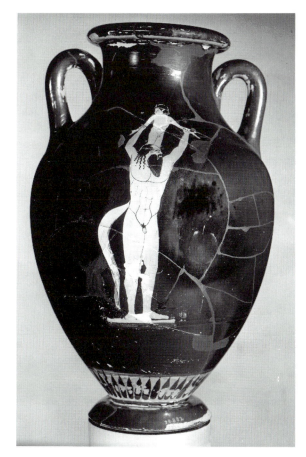

Fig. 132. Amphora Type C; Flying-angel Painter. Satyr holding boy-satyr 'flying-angel'. H. *c.* 0.40.

who favours similar subjects. We shall come back to this.[569]

In the same general area belong a few vases in curious style, evidently the work of one hand, the Siren Painter.[570] One is a very large pelike of the class mentioned in connection with the Triptolemos Painter and with the Syleus Painter. Another pelike of the class is near the Argos Painter, another by the Pan Painter, and to these too we shall return.[571] The Siren Painter's other three vases are stamnoi, of a distinctive shape with ribbed handles set low, and with framed pictures. To the same class belong some early pieces by the Syleus Painter, and the Tyskiewicz Painter's are related.[572] The name-piece, in London, has on one side three Erotes flying over the sea, on the other Odysseus bound to the mast rowed by his crew past the Siren's island (fig. 138). In both pictures, especially the second, the painter seems to be attempting to realise space in a new way, and we shall look at this picture again in that connection in the next chapter.[573] As a draughtsman he shows here no great mastery of the human figure, still less of the human face, but in another stamnos, in

Malibu,[574] not known to Beazley, he does better. This splendid picture shows the blinded ogre, Polyphemus, at the mouth of his cave, letting his flock out unaware that Odysseus and his companions are bound under the beasts' bellies.

Two other small groups deserve mention as illustrating, with the Triptolemos and Dokimasia Painters, how craftsmen trained by cup-painters sometimes take up pot-painting. Half a dozen stamnoi and kraters are ascribed to a Hephaisteion Painter,[575] whom Beazley characterises as having 'some kinship with such members of the Brygan circle as the Dokimasia Painter'. We have noticed him as sharing the *kalos*-name Nikostratos with the Berlin, Antiphon, Triptolemos and Copenhagen Painters.[576] One of the vases given him is a calyx-krater with single-figure decoration, another a stamnos with the same; both unusual, and a second such stamnos is at least close.[577] To a 'Painter of Palermo 1108' are attributed a calyx-krater, an amphora of panathenaic shape, a kalpis with picture on the body and a cup. He is a follower of Makron; and it is interesting that, though no big pots are given to that master himself, one of his early classical followers, the Syracuse Painter, is almost exclusively a pot-painter.[578]

e. Painters of small pots in various techniques

Many of the red-figure artists we have looked at in this chapter, pot-painters and cup-painters alike, decorate small pots, in particular lekythoi and small neck-amphorae, but only the Berlin Painter seems to have taken over from black-figure the production of these lines in quantity. In the next generation, as black-figure declines further, more and more red-figure craftsmen begin to specialise in them, and already in this period there are a few who do so. We have already noticed one, the Dutuit Painter,[579] and it is interesting that he has black-figure connections. His charming miniaturist style (fig. 133) is in a black-figure tradition, going back to Little Master cups and the predelle of Antimenean hydriai (fig. 7); and Beazley has connected his work with that of the Diosphos workshop,[580] one of the better producers in this period of lekythoi and other small vases in black-figure and mixed techniques (fig. 134). We shall come back to this in a moment.

Another craftsman of this time who decorates, to our knowledge, only Nolan amphorae and lekythoi, all in red-figure, is the Tithonos Painter.[581] In his 1918 book Beazley spoke of the Dutuit and Tithonos Painters together, and suggested that the first might be said to face towards the Eucharides Painter, the second towards the Berlin Painter.[582] He never repeated the first suggestion, but we have seen that there were links in the use of florals between the Berlin, Eucharides and Dutuit Painters.[583] The debt of the Tithonos Painter to the

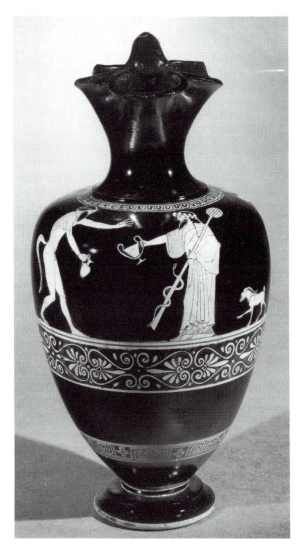

Fig. 133. Oinochoe; Dutuit Painter. Dionysos and satyr. H. *c.* 0.28.

on the master is more consistent than the Harrow Painter's[587] and his recognised *oeuvre* much smaller.

Panathenaic amphorae apart (big pots, the work now of red-figure artists), black-figure from this time on has little place in the history of art; but it is important to remember that a large part of the decorated pottery produced in the Kerameikos was still in the old technique; especially lekythoi, small neck-amphorae, oinochoai, skyphoi and cups. Much of this late black-figure is mechanical daubing of no aesthetic interest; indeed black-figure drawing of this period at its worst rivals the most degraded productions of fourth-century red-figure. As a sample we may cite the neck-amphorae of the Red-line Painter, most cups of the Leafless Group, and a high proportion of the lekythos production, especially those of the Haimon Group and the Class of Athens 581.[588]

There are better painters of black-figure lekythoi. At the beginning of this phase the Gela and Edinburgh Painters seem to issue from the Leagros Group, and retain some of its quality.[589] Later there is relatively decent work in some productions of the Theseus Painter and his companion the Athena Painter,[590] and of another pair, the Diosphos and Sappho Painters.[591] The main interest, however, of the works in this technique at this time, is rather in the fact that it survived so long beside red-figure, and in the interrelations between practitioners of the two techniques.

The black-figure lekythoi of this time, at all levels, have as often as not a white slip. Alongside them there is a considerable production of more or less hasty red-figure lekythoi, and the painters of these also work on a white slip, but in outline; and there is a good deal of contact between the two lines of production. Details of potting show that a single workshop put out the lekythoi of the Athena Painter, who worked in black-figure, and of the Bowdoin Painter[592] who worked in red-figure and outline on a white ground. It has been suggested, and may be true, that these painters were one man.[593] The Diosphos and Sappho Painters produced not only black-figure lekythoi but others, on a white-ground, which combine black-figure with outline drawing: 'semi-outline' (fig. 134). We met this combination in a beautiful fragmentary cup which may have been painted by Euphronios,[594] but that is both earlier and far finer and there is probably no connection. The importance of these white-slipped lekythoi (black-figure, semi-outline and outline) is that it is from this humble tradition that spring the great outline and polychrome funeral lekythoi of the classical age. It is clear that the mass-produced small lekythoi of this time were almost entirely for funeral use though there is as yet no specifically funereal iconography.

Semi-outline and outline lekythoi from the Diosphos–Sappho workshop normally have the picture framed by

Berlin Painter is palpable. Beazley in *ARV*[2] describes him as 'related to' that artist.[584] He never calls him a pupil, as he does three artists whom we shall consider later: the Providence Painter, Hermonax and the Achilles Painter.[585] At one time I thought this an unnecessary distinction, but I now see the point of it. A competent but unoriginal craftsman, the Tithonos Painter clearly modelled his figurework rather closely on the Berlin Painter's, but he ignores the very distinctive maeander-system (ULFA)[586] which seems a hallmark of the workshop and is faithfully reproduced by the Providence Painter, the Achilles Painter and the latter's pupil the Phiale Painter. It is true that Hermonax too rejects this, a question we shall have to consider when we come to that great early classical artist. I incline to suppose that the Tithonos Painter did not sit in the same workshop as the Berlin Painter, though his dependence

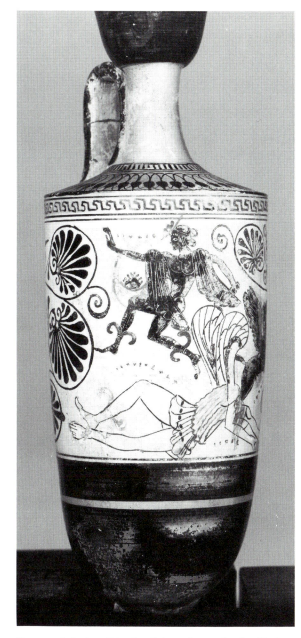

Fig. 134. Lekythos; Diosphos Painter. Perseus leaving Medusa dead. H. *c.* 0.25.

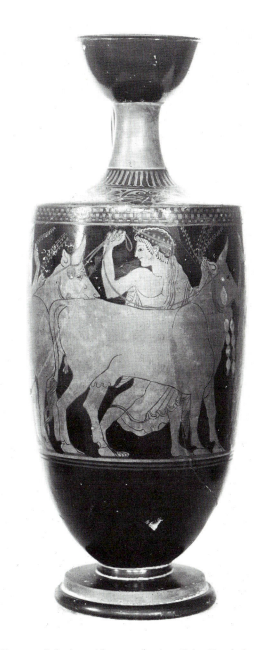

Fig. 135. Lekythos with name of *poietes* Gales. Youths leading cows to sacrifice. H. *c.* 0.31.

big black palmettes in a distinctive arrangement; and the scheme is also found on some black-figure lekythoi, for instance those of the Emporion Painter, whose bad drawing has more individuality than most.[595] Something like this scheme is found on two red-figure lekythoi of good quality, in Boston (procession to a sacrifice) (fig. 135) and Syracuse (Anacreon and boon-companions).[596] These are evidently the work of one man, and both bear the name of a *poietes* Gales. Beazley listed the 'Gales Painter' (one cup doubtfully associated

with the lekythoi) at the end of his Pioneer chapter, but not as a member of the Group. I would suppose these lekythoi roughly of the time of the Gela and Edinburgh Painters, work of a talented young artist in a black-figure workshop moving over to the other technique. Of similar character is a lekythos with a party including an old woman named Oinophile. Beazley put the drawing in the manner of Onesimos,[597] and reports Miss Haspels's observation that the potting is that of a black-figure workshop, the Marathon Painter's.[598] This artist,

131

a hack related to the Haimon Painter, is so called because a consignment of his lekythoi was buried in the mound raised over the dead from the battle of 490.

Much of the work we are concerned with in this section certainly runs later, several of the painters going on into the early classical phase. The late work of the Bowdoin Painter is certainly of that time: some pretty small squat lekythoi in red-figure, more interesting than his repeated designs on lekythoi (red-figure or white) of women or goddesses running, flying or standing at an altar, youths or Erotes piping.

Besides lekythoi these black-figure painters decorated other shapes. The Sappho Painter takes his name from a picture on a hydria in Warsaw,[599] in Six's technique, of a woman playing a lyre, her name inscribed. This technique is also practised by the Diosphos Painter. The Athena Painter likes oinochoai, and the Theseus Painter was the principal and best decorator of the big skyphoi of the Heron Class (fig. 101). We noticed that these probably provided a model for the shape used for red-figure by Makron and the Triptolemos Painter.[600] The best of them are attractive, with a lot of white and summary but not atrocious drawing.

There will still be black-figure lekythos-painters to glance at in the next generation, whose work is not without interest, but that is the end.[601]

4

Archaic into classical

I. A change of background: the revolution in wall-painting

I have spent a long time on the Pioneers and their successors, but I do not think it is disproportionate. It is of course a personal judgement (and even as a personal judgement a simplification) to say that this period marks the highest point of Greek vase-painting. The black-figure of Exekias and the Amasis Painter, a few generations earlier, is arguably the most accomplished work in all vase-painting; and the apogee of white-ground was reached, first on cups, then on lekythoi, in the generations following those charted in these chapters. Still, red-figure can be said to be the culmination in the search for a method which would most effectively integrate the decorative values, preeminent for a craftsman adorning a pot, with the interests of an artist using the human figure for narrative. Further, this precarious balance, once achieved, could be perfectly maintained only while narrative art was still mainly bound by traditional archaic conventions.

The revolution which broke these conventions was already taking place in the time we have been considering. The first statues to show the figure relaxed from the formal posture of the archaic *kouros* were made while these vase-painters were at work. This vital development seems to have taken place in the years immediately preceding the Persian invasion of Greece in 480; so that is a convenient point to mark the change in our art-historical sequence: Archaic, Classical. In reality, of course, the change was far more gradual; and a comparably radical and evident breach with tradition in drawing does not seem to have occurred till later. The essential character of archaic drawing, which it shares with the earlier drawing and painting of Egypt, is that the illusory world is kept entirely in the surface plane. The figures are flat; that is, their solidity is only implied, not represented by modelling; and there is no attempt to suggest the space in which they move.

Ways of suggesting solidity and depth were explored by Greek painters over the coming centuries, and they

thus created the concept of painting which dominated Europe from the Renaissance until the beginning of the twentieth century. The effect achieved, however, was deeply at variance with the traditional Greek concept of what constitutes suitable decoration for a pot. Some red-figure painters, as we shall see, do incorporate elements from the new approach; but the unmodulated glossy black background to the figures was profoundly hostile to it, and in general these craftsmen avoid it. In consequence their art gradually loses touch with the major arts, and in doing so begins itself to decline, though much of beauty as well as of interest goes on being produced.

Outline drawing and colour wash on a white ground accommodate the new much better. Some of the best classical vase-painting is in this form; but it is striking how resolutely this is maintained in the Kerameikos as a sideline, surely because it did not provide the sharply defined surface which was felt essential for pot-decoration.

Comparison of drawings by Euphronios and Euthymides with the fine low relief on the athlete-bases from the Themistoclean wall clearly shows the parity of the best vase-painting with the major arts;[1] but that is probably the last time one can make such a demonstration. The complex poses favoured by the Pioneers are already suggestive of the third dimension, but the suggestions are kept within strict limits. We see no three-quartered face in their surviving work, and when they foreshorten a limb they do it by implication rather than by actually drawing it. On Euphronios's krater Antaios's foot appears behind his buttock, suggesting the leg doubled back, but the thigh is drawn in full extension (fig. 18).[2] Five circles may indicate toes on a frontal foot, but the foot is not actually drawn in recession. The next generation goes a little further. Three-quarter faces are tried, and a three-quartered foot ocasionally drawn in recession, for instance the satyr's on the front of the Berlin Painter's name vase.[3] On at least one vase by or close to Panaetian Onesimos a *profil perdu* is essayed; and on one by the Kleophrades Painter a satyr fronting us looks straight up, so that his face is

seen in sharp foreshortening from the beard up (*di sotto in su*) (fig. 136).[4] These attempts are not a great success, but they are bold and interesting experiments, and it seems safe to assume that similar experiments were being made at this time in major painting, though perhaps one may guess that there too they were not carried very far.

A fragmentary psykter in the Villa Giulia[5] bears a picture of a battle of armoured Greeks against Centaurs, drawn by a not very accomplished hand but quite exceptional in design. In the appendix to his 1925 book Beazley noted that it seemed to him related to the Harrow Painter.[6] He never took this further, but I have little doubt myself that it is indeed that craftsman's work. It is full of the most violent action, with complicated poses and three-quartering, and whoever drew it was surely copying a big wall-painting. One interesting feature is a dark wash in the hollow of a foreshortened shield-interior. This must be meant to suggest shadow. There are also primitive attempts in the Brygos Painter's work to model by shading: hatching in dilute black round the bulge of a shield. This too no doubt reflects experiments in major painting; but there is reason to think that even there it was not carried far at this time. At least the literary tradition clearly associates the introduction of shading with two later painters: Apollodoros of Athens (not to be confused with the earlier vase-painter of that name); and his younger

Fig. 136. Hydria (kalpis)-fragments; Kleophrades Painter. Sleeping maenad between satyrs. (A third fragment has traces of second satyr, arm raised, by right-hand border.) H. of left-hand fragment *c.* 0.13.

contemporary, Zeuxis of Herakleia, who worked from the fifth into the fourth century. It is only in that period that such attempts reappear in vase-painting.[7]

In the intervening time major painters seem to have concentrated rather on the realisation of space: experiments of which we shall have much to say in connection with the ambivalent reaction to them of vase-painters. A nascent interest in the problem is already hinted at in late archaic vase-painting. A recently found small cup with a picture in the tondo only is inscribed *Kleomelos kalos* and can be ascribed to the Kleomelos Painter, who may well be a phase of the young vase-painter Apollodoros.[8] The picture (fig. 137) shows a city-wall, defenders thrusting spears down from the battlements at attackers thrusting up from below. The design, unparalleled in previously known vase-painting of the time, is surely inspired by a wall-painting; but my suspicion is that at this stage essays of this kind were still tentative and rare even in the major art. It seems to me that vase-painters in this phase are still working in the same frame of reference as their grander contemporaries; but that in the following generations this gradually ceases to be the case.

The innovations of the Pioneers seem to correspond to those credited in the literary tradition to Kimon of Kleonai, pupil of Eumaros of Athens.[9] If the vase-painters felt themselves innovators in their own right, working alongside other painters and sculptors in relief, this was possible because all accepted the dominant character of the surface they were decorating. From what we read about the wall-painters active in Athens and elsewhere in the decades after the Persian wars, Polygnotos of Thasos and the Athenian Mikon, they made the profound breach of trying to suggest depth beyond and around the figures, the space in which we move.[10] This tentative aproach to the dissolution of the picture-surface, the opening of a window on a feigned world, would not naturally occur to a vase-painter. Most vase-painters ignore it; and when they do attempt it their efforts have all the air of imitation.

We are lucky in having one set of small but fine wall-paintings which seem to date from the moment just before this crisis. They come from the Tomba del Tuffatore (Tomb of the Diver) at Paestum in South Italy.[11] They are painted on a light ground in a limited range of colours. The symposium-scenes round the walls are in drawing and composition essentially like the most exquisite examples of late archaic Attic vase-painting in red-figure or white-ground. The composition of the ceiling-picture is much more daring: a diver in mid-air, water below him, trees and a kind of quay from which he has leapt. Even this, though, does not really make the break: everything is still in the plane of the lower picture-edge. The composition of the Siren Painter's name-picture (fig. 138), or that of a black-figure picture by the Priam Painter with bathing women, are of essentially the same character.[12]

Many of the late archaic artists we considered in the last chapter worked on into the early classical time, but seem not to have felt at home there. Some, like Douris, become academically repetitive. Others sink into decline: most notably the Berlin Painter, but he is by no means alone. A few perhaps (the Triptolemos Painter seems one) manage to keep their late archaic vigour unalloyed. There are some, though, who begin like these as late archaic artists but change with the times, accepting or helping to create the new classical style. One such is the Syriskos Painter; and I thought it better to defer to this chapter consideration of him, and of his late archaic companion the Copenhagen Painter, though in that artist's work no classical phase can be traced. On these craftsmen there is some very interesting, and difficult, evidence from inscriptions on vases.

II. A question of names and dates

In *ARV*[2] Beazley describes the Copenhagen Painter as 'an academic artist, akin to the later phase of Douris', and the implication that he was a younger man is surely correct. The Syriskos Painter he calls '"brother" of the Copenhagen Painter', and he notes that their work is sometimes hard to distinguish. He adds, however, that vases which he earlier ascribed to a 'Kephalos Painter' he now sees as 'the late, the early classic, work of the Syriskos Painter'.[13] We will look in the next section at the works and styles of these artists, and at their relation to each other and to others. Only this basic information is necessary now, to help us evaluate some curious

Fig. 137. Cup; Kleomelos Painter. Siege. D. of cup *c.* 0.17.

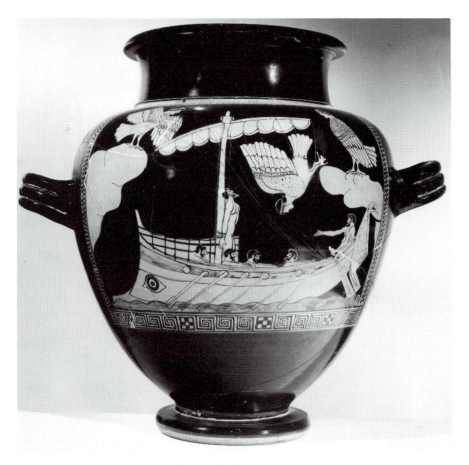

Fig. 138. Stamnos; Siren Painter. Odysseus and the sirens. H. *c.* 0.35.

inscriptional evidence, which needs to be discussed at the beginning of this chapter because of its chronological implications.[14]

The Syriskos Painter takes his name from the inscription *Syriskos epoiesen* on a vase he decorated. This, in the Villa Giulia,[15] is a container moulded in the form of an *astragalos* (knucklebone); something for which there seems to have been a fashion in this period. We will consider the type later in connection with another example.[16] This was long the only occurrence of the name Syriskos. In time for Beazley's *Paralipomena* two more vases appeared which bear the name in a unique formula. Before we consider these we will glance at a fourth apearance. This is on a calyx-krater, unknown to Beazley, and the inscription runs *Syriskos egrapsen*. I have not seen the vase or a photograph, but the scholar who is to publish it believes it to have been decorated by the Copenhagen Painter, and he is unlikely to be wrong. The 'Copenhagen Painter', then, was called Syriskos, and was the *poietes* whose name his colleague the Syriskos Painter put on a vase.

The other two vases with the name, in a private collection in England,[17] are a skyphos and a cup-skyphos, said to have been found together. The cup-skyphos is a shallower vessel than the skyphos, a wide bowl spreading out from a low foot, with cup-type handles below an offset rim; but like the skyphos it is a drinking-vessel decorated on the exterior only. The pictures on this one show two adventures of Theseus: Procrustes and Sinis; both treated very quietly, confrontation not conflict. The figures are much smaller than those on the skyphos (in each picture two women, a fruit-tree between them, fig. 139), but the style of drawing is identical as is that of the florals at the handles. Beazley wrote of these two vases that they 'might be exceptionally precise work by the Syriskos Painter. They also resemble the Copenhagen Painter. I have preferred to use a new name for the artist'.[18] The name he chose, 'the P.S. Painter', derives from an inscription, identical (give or take an obliterated letter or two) on the two vases: *Pistoxenos Syriskos epoiesen*; two names without a conjunction, followed by a verb in

the singular. I do not see how this peculiar formulation can mean anything but that Pistoxenos and Syriskos are the same man.

Syriskos is a common type of name of ethnic origin ('little Syrian'). Several names of painters or *poietai* on Attic vases are of this character: in black-figure Lydos (Lydian) and Sikelos (Sicel), both painters, and Thrax (Thracian), *poietes*; in red-figure Sikanos (Sican), *poietes*, Skythes (Scythian) and Mys (Mysian), painters.[19] The great black-figure painter Lydos uses the definite article before his name, *ho Lydos*, emphasising the ethnic character ('the Lydian'). Such names were often borne by slaves; and one black-figure vase[20] is actually signed: *Lydos egrapsen doulos on*, 'Lydos' (or 'Lydian') 'drew, being a slave'. The late, weak style has

no evident resemblance to that of the vases signed by the great Lydos, and this is probably the work of another man of the same ethnic origin. It is in any case unequivocal evidence for a vase-painter being a slave. Of course that these vase-painters and *poietai* were foreigners by blood does not make them a less integral part of the Attic ceramic tradition.

The first name in the inscription, Pistoxenos, means 'trusty stranger', and would be an eminently suitable Greek name for a foreign slave to take on being granted his freedom. I suppose that this is how Syriskos became Pistoxenos; and that these two vases originally formed part of a larger number similarly inscribed at the same time to mark the change.[21]

Since these pieces lie on the borderline of archaic and

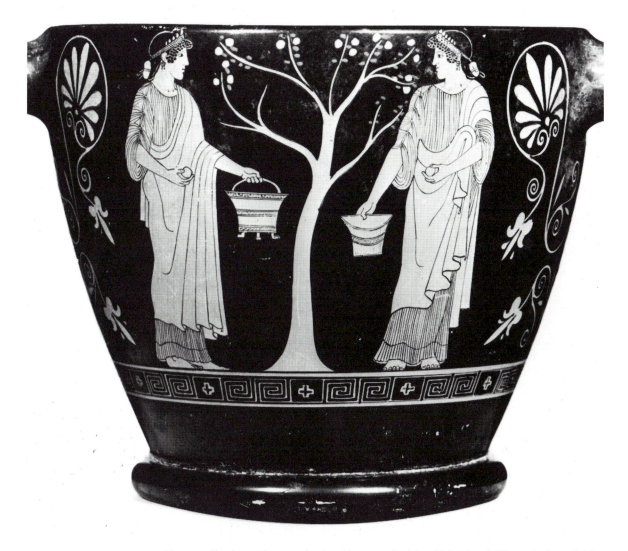

Fig. 139. Skyphos with name of *poietes* Pistoxenos/Syriskos; 'P.S. Painter'. Women (or Nymphs) in orchard. H. *c.* 0.14.

classical, and since that change certainly took place around the time of the Persian invasion, it would be nice to imagine that the little Syrian had earned his freedom by faithful service in that crisis. Alternatively (though not in contradiction to that fantasy) one might conjecture that the owner of the workshop wanted his slave to succeed him and freed him to that end.

The name of Pistoxenos appears, always with *epoiesen*, on six other vases. One, lost for more than a century and never illustrated or described, is said to have been a cup; the other five are forms of skyphos. Three of these are the Attic type (Type A), like the 'P.S.' skyphos; and of these two are decorated by the Syriskos Painter. The third gives his name, the Pistoxenos Painter, to the leading cup-painter of this transitional period. We shall have much to say of him,[22] but this collaboration with Pistoxenos is his only clear point of contact with the Copenhagen–Syriskos group.

There is no difficulty in supposing the *astragalos* with the name of Syriskos earlier than the two P.S. vases, or the three Type A skyphoi with the name of Pistoxenos later; but with one of the other two skyphoi inscribed *Pistoxenos epoiesen* a real problem arises. Of the second of these (among the Campana fragments in Florence) little but the inscribed foot remains, and nothing can be said about its relative date.[23] It was of Type B, the thin-walled form derived from Corinth. So is the other, in London,[24] only exceptionally here both handles are vertical. It has finely drawn pictures: on one side Dionysos and a satyr with donkey, on the other a satyr between donkeys (figs. 140 and 141). In the field of the latter picture is written the name of Pistoxenos as *poietes*; in the field of the other that of Epiktetos (incidentally another slave-type name: 'Purchased') as painter.

If Syriskos formally assumed the name of Pistoxenos somewhere around 480, then any vase with the second name should be as late as that. We have already considered evidence that Epiktetos, whose earliest work

cannot be much later than about 520 and whose style, though showing development and change, never lost its sixth-century character, actually worked on well into the fifth.[25] Many good scholars cannot accept the possibility that this skyphos belongs to the same time as the others with Pistoxenos's name; but I believe that it does. The style is certainly late in Epiktetos's development; and he has left two good cup-skyphoi (in Oxford and Naples),[26] in the same late manner, which I can easily see as going with the P.S. piece. In view of the contact already postulated between Douris in his middle period and Epiktetos, it is interesting that a cup-skyphos in Bologna ascribed to late Douris has a rather similar character.[27]

It is in this last phase of Epiktetos's work that I would seek to place the white cup-fragment in Cambridge which Beazley thought probably by Myson;[28] and there is a red-figure cup (once on the Basel market)[29] which might help confirm Epiktetos's activity at this late date. Like the cup-skyphoi it is unsigned, but is certainly by Epiktetos and late in his *oeuvre*. In the tondo a drinker reclines and plays kottabos. On one side of the exterior Herakles fights Centaurs. On the other a bearded man with long loose hair pursues a woman past an altar while two other women rush off. He wears a short chiton and is girt with a sword. The subject is not certain; but if the pursuer had wings we should have no hesitation in identifying Boreas and Oreithyia, a subject which, as we have seen, is not found in Attic art before 480. The wind-god is regularly shown with loose hair and short chiton, sometimes with Thracian cloak and cap but quite as often without; and the venue (like that of any abduction) is sometimes marked as a sanctuary. I know no example in which Boreas has a sword. A drawn sword in the hand would imply a different kind of subject, but I do not think the sheathed weapon at the pursuer's side is significant. The omission of wings is more surprising; but the subject is new and has as yet no established iconography. I think it is possible that this is

Fig. 140. Skyphos with name of *poietes* Pistoxenos and signed by Epiktetos as painter. Dionysos. H. *c.* 0.09. Fig. 141. Other side of 140: satyr with donkeys.

the subject the painter intended here. That the cup is fifth-century is suggested by the fact that the circle of the tondo is wide, well overlapping the circle below the pictures on the exterior.

We need to consider more closely the relation of the two vases with the Pistoxenos–Syriskos inscription to the Copenhagen Painter (Syriskos) and the Syriskos Painter; but before we can do that we must look at those artists' work.

III. Pot-painters

a. *The Copenhagen–Syriskos Group, the Oreithyia Painter and others*

The Copenhagen Painter[30] takes his conventional name (we will touch again on the question of his real name in a moment) from an amphora Type B in the National Museum: on one side an old man followed by a little black boy, no doubt a slave (fig. 142); on the other a

youth purchasing an amphora. The big black vase with hardly any adornment beyond the one or two figures on each side is reminiscent of the Berlin Painter's amphorae Type A, with the latest of which it must be more or less contemporary. The painter, however, has not the older artist's command of, nor surely his concern with, calligraphic beauty of contour and balancing elaboration of detail within the contour. The effect is plain, quiet, rather austere; and this is one frequent manifestation of the new, classical spirit which is taking over. It informs much of this painter's work, and that of his 'brother' the Syriskos Painter. It makes their weaker pieces dull in a way in which archaic drawing, though often summary or downright bad, seldom is; but their best has shades of feeling which were hardly within an archaic artist's grasp.

A favourite shape with the Copenhagen Painter is the stamnos. One, in a Swiss private collection,[31] has on the front a fairly conventional picture of Theseus killing the Minotaur, flanked by Ariadne and Minos. On the

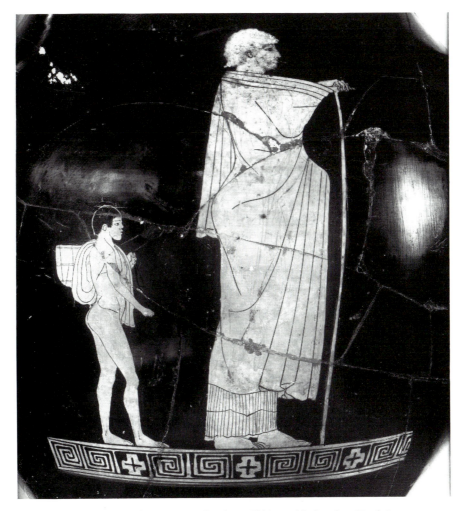

Fig. 142. Amphora; Copenhagen Painter (Syriskos). Old man with slave-boy. H. of picture *c*. 0.24.

139

back are women and children, wrapped in their cloaks, standing or moving quietly, heads bowed: the Athenian families of the boys and girls sent as a sacrificial tribute to the monster. This picture is sensitive and touching in a quite unarchaic way. There is something of the same character in a fragment from the Acropolis,[32] on which the Minotaur lies dead and a bearded man, in short chiton and girt with a sword (Minos?, Theseus?) gently lays a starry cloth over him.

The Syriskos Painter[33] is often a rather freer draughtsman, and one at least of his best works has a more mouvementé scene. This is a *lebes gamikos*, a standed bowl of special form made for use in wedding ritual. The piece in question was put in a grave on Delos, and transferred with other grave-furniture to a trench on the offshore islet of Rheneia when the Athenians purified the holy island in 426. The picture, which circles the vase without interruption, shows women (or Muses) dancing in two rings in opposite directions, to the music of the lyre played by Apollo (or an Apolline youth). The complexity of the movement portrayed is in line with the new interest developing among wall-painters in the realisation of space; but there is nothing in the way the design is laid on the pot that is outside the vase-decorator's tradition.

We have seen that Beazley hesitated between attributing the two vases inscribed *Pistoxenos Syriskos epoiesen* to the Syriskos Painter (as exceptionally precise work) or to the Copenhagen Painter (Syriskos), but opted to keep them separate.[34] I do not think this means that he believed in the 'P.S. Painter' as an independent artist; rather a holding operation. That at least is how I see him. Surely the P.S. vases were painted by one of the two other artists; and in view of the doubt we should consider the possibility that those two were really one: the painter-*poietes* Syriskos/Pistoxenos. Such conflations of two groups originally classed as separate painters were often made by Beazley himself (as with the Syriskos and Kephalos Painters) or considered but never positively accepted or rejected (as with the Syleus Sequence). On consideration, however, I am inclined in this case not to believe in fusion. I find it easier to see, as Beazley continued to do, the painters as two. If that is so, then Syriskos (the Copenhagen Painter) will, in his avatar as Pistoxenos, have given up painting and concentrated on his work as *poietes* (whether potter, workshop-owner or both). In this he collaborated not only with his long-time companion the Syriskos Painter, but with old Epiktetos and with the younger man we know as the Pistoxenos Painter. The incidence of his *epoiesen*-inscription suggests that he may have specialised in skyphoi and cup-skyphoi. Another figured cup-skyphos, in Zurich, has pictures of adventures of Herakles and Theseus composed very much like those on the P.S. vase of that shape. It is the work of a minor

early classical artist, the Painter of the Yale Lekythos, who seems to owe something to the Dutuit Painter.[35] It is unusual in having a patterned rim, a pretty band of lotus and palmette. Both skyphos and cup-skyphos are popular shapes in plain black ware, and it is likely that some of those come from Pistoxenos's workshop.

We noticed in the Kleophrades Painter's work two pointed amphorae,[36] an adaptation to fine ware of the coarse, unadorned vessel in which wine was transported. This never became a constant shape in Attic fine ware, but examples occur in black- and red-figure from about the end of the sixth century. A cluster of such vases was produced in the time and circle with which we are now concerned. Beazley ascribed one in London to the Copenhagen Painter and one in Brussels to the Syleus Painter at a late (though not the latest) phase of his development, when he draws close to the Copenhagen and Syriskos Painters.[37] Two more, in Munich (fig. 143) and Berlin, almost replicas of one another, have pictures of Boreas carrying off Oreithyia and give his name to the Oreithyia Painter.[38] This artist's work is listed by Beazley in an Early Classical, not a Late Archaic chapter, but he is close in character to the Copenhagen and Syriskos Painters though his figures tend to be heavier, more massive. Another

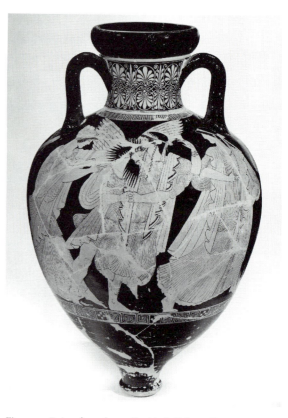

Fig. 143. Pointed amphora; Oreithyia Painter. Boreas abducting Oreithyia. H. *c.* 0.58.

example, now in Zurich, which Beazley seems to have known only in photographs of the fragments before the vase was made up, he gave to the Oreithyia Painter; but Isler-Kerenyi, in an exemplary publication, showed good reason for ascribing it rather to the Copenhagen Painter.[39]

The shape varies considerably. The Kleophrades Painter's two have a tall neck very sharply offset from the jutting shoulder, a form not far from that of some rough wine-jars.[40] The neck has small figures, a feature not found elsewhere. All other examples have a neck in varying degrees shorter, with floral decoration. The name-pieces of the Oreithyia Painter, and some earlier black-figure examples by the Acheloos Painter (Leagros Group),[41] are egg-shaped with a strongly sloping shoulder. One might think of influence from the panathenaic amphora, but the shape is not very far from that of the transport jar for Chian wine. The Syleus Painter's (fig. 144) is much broader in proportion, with flatter shoulder and short neck. The London vase by the Copenhagen Painter is similar, but the neck even shorter, the shoulder flatter; and the piece in Zurich is very close indeed to this. This type too is near to a rough-ware model.[42]

The placing of the pictures varies too, in ways which cut across the distinctions of form. The black-figure pieces, the Kleophrades Painter's two, the two with Boreas and Oreithyia and the Copenhagen Painter's London vase all have big figures which occupy the full height of the picture-space on the body of the vase. The Syleus Painter's has a maeander-band round the pot just above its broadest point. A single picture (Centauromachy) circles it below, and above, between the handles, are a Gigantomachy and Theseus roping the bull of Marathon. The figures in the shoulder pictures are a little larger than those in the Centauromachy, but the difference is hardly significant. The Zurich vase has a similar division but much higher up the vase, so that the shoulder-scenes (Centauromachies both) are small and there is no doubt that the relatively big figures below are the main focus. Here too these figures ring the vase, but they form two separate (though undivided and related) pictures on the two sides. Most of the figures in both are Nereids, but in one they are in attendance on Amphitrite as she receives Theseus (fig. 145), in the other on Thetis, bringing armour to her son Achilles.

The figures on this beautiful vase are less weighty than those on the Oreithyia amphorae as well as stiller. I am in no doubt that Isler-Kerenyi is right in attributing it to the Copenhagen Painter; and I have dwelt on it not only because of its quality but because this is a good example of the rare case where Beazley seems simply to have got it wrong. Another pointed amphora has turned up more recently which looks like a pair to the Zurich vase and is certainly by the same hand.[43] There is interest also in the varied forms given to the shape and the varied treatment of it as a surface for pictures, arising from the fact that it is not a regular part of the fine-ware repertory.

The weight of the Oreithyia Painter's figures is a feature of much early classical work. There are anticipations, for instance in the work of Euthymides and the Kleophrades Painter, but in their days it was an exceptional personal taste; now it seems part of the spirit of the time. A favourite vehicle for artists to display figure-work in this style is the volute-krater, now regularly adorned not only with small figures on the neck but with big scenes round the body. We have already noticed that the column-krater is rarely used for very good work. Now a clear distinction seems to become established between the column-krater for slight, no doubt cheap, production and the volute-krater for quality. The fashion for the big volute-krater reaches its acme in workshops considered in the next chapter, notably the group of the Niobid Painter,[44] but it begins among the craftsmen we are discussing.

Fragments of one volute-krater are attributed to the Copenhagen Painter and of several to the Syriskos Painter, as well as two to the Syleus Painter (we noticed the fine piece from Al Mina). Only one complete vase of

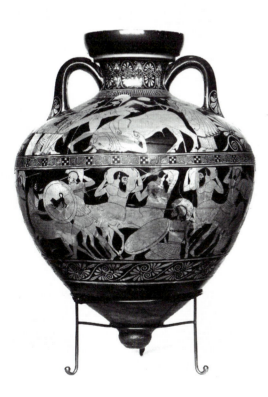

Fig. 144. Pointed amphora; Syleus Painter. Theseus and bull, Centauromachy. H. *c.* 0.52.

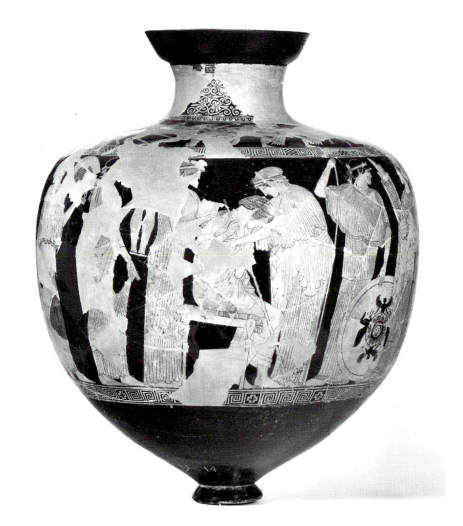

Fig. 145. Pointed amphora; Copenhagen Painter (Syriskos). Achilles and Thetis, H. *c.* 0.47.

the shape from the group survives, a late piece by the Syriskos Painter with Eos and Kephalos (once the name-piece of the 'Kephalos Painter');[45] but a handle in the Louvre, exceptionally decorated with figure-scenes (adventures of Theseus) comes from what must have been a grander vase by the same artist in his earlier phase.[46]

The Kephalos krater is in Bologna; and Bologna and Ferrara are the great repositories of this shape in its full flowering, just after this time. The Bologna vases come from the Etruscan site of Felsina; those in Ferrara from Spina, the great port in the Po delta which seems to have had both Etruscan and Greek inhabitants. Among volute-kraters in Bologna is the name-piece of the Boreas Painter (the subject is popular now), the principal artist in a group which produces mainly column-kraters of no great quality. When he occasionally rises above this level he chooses the volute-krater.[47]

A finer craftsman from the same general circle is

known as the Painter of Bologna 228.[48] This name-vase is a column-krater, but a work of care and quality, as is one by the same artist from Spina. Others are the usual run-of-the-mill; and, curiously, a small volute-krater from Spina is no better; but this unexpected contrast only points up the general truth that good work is put on volute-kraters, poor on column-kraters. This artist, however, has a wider range of shapes. He is possibly the decorator of a fine set of oinochoai, certainly of an exceptionally handsome funeral loutrophoros. This is an Athenian ritual vessel. It takes two forms, differentiated only by the handles; the thin, high body and thinner, higher neck are identical in both. In the 'loutrophoros-amphora' two curvy handles run from lip to shoulder, often attached by stays to the neck; in the 'loutrophoros-hydria' there is one such and two small loop-handles on the shoulder. The shapes derive from late Geometric neck-amphora and hydria, and the extreme elongation for the ritual use begins in early

142

black-figure. The Geometric shapes were used as grave-markers, amphora for a man, hydria for a woman, and that distinction is held on black-figure and red-figure loutrophoroi which show the prothesis. The painter's vase, in Athens, is of the hydria type and shows a woman's prothesis, while a neck-fragment by him in New York, with warriors, so for a man's funeral, is of the other kind. Later in the fifth century loutrophoroi of both forms are decorated with wedding scenes and appear in them. The shape was certainly used to bring water from the spring Kallirrhoe for the bride's bath; and in the late fifth and fourth centuries marble versions of the two types are used to mark graves, apparently of those who died unwed. There will be more to say of these in a later chapter.[49]

b. *The Pan Painter; the Mannerist workshop and others; the Alkimachos Painter*

There was evidently a very large demand for column-kraters in the latest archaic period and the following decades. The column-krater painters we have just glanced at look towards and sometimes emulate the masters of the new, serious, heavy style which is one aspect of early classical art. Another important group is that of the painters whom Beazley placed in a Mannerist workshop, and others who, though not in the workshop, seem to share some of its ideals. We saw that the earlier painters in the workshop were pupils of Myson;[50] but they also show powerful influence from a much greater artist, the Pan Painter.

Beazley first used the word 'mannerist' in his 1918 book, where one chapter is entitled 'The Pan Painter and other Mannerists', but already in his first article on the Pan Painter six years before he had spoken of 'strong and peculiar stylization, a deliberate archaism, retaining old forms but refining, refreshing and galvanizing them'.[51] In 1918 he says of the Artemis and Actaeon on the painter's name-vase: 'the lean, surprising, devilishly elegant figures carry the mind far away from Greece to some Renaissance bronze-worker, to Jean Goujon or Giovanni Bologna';[52] and in *Der Pan-Maler* (1931) he said that in using the word he had in mind the Antwerp Mannerists of the early sixteenth century; and added that he would be willing to qualify the term with 'archaising' or 'sub-archaic'.[53] The sense of his usage is evident, even if this style in Attic vase-painting does not have much in common with sixteenth-century Mannerism as it is understood now. Two other points need noting. First, there is a touch of the pejorative in his use of the word. In the 1931 book he says of the Pan Painter that he 'begins as a mannerist and ends as a mannerist. Between, he is more'.[54] Then, in 'the Mannerist workshop' or 'the Mannerists' the word is used simply to label a succession of painters who

evidently sat together and learned from one another over many decades, even though the later members retain little or nothing of the character originally defined as 'mannered'.

There are clear links between the earliest works of the Pan Painter and the best pieces by Myson; and also between the Pan Painter's mature style and Myson's later work; as well as strong influence from the Pan Painter on the styles of the first Mannerists (Pig Painter, Leningrad Painter), who certainly carried on Myson's workshop. Beazley thought that both of these were pupils of Myson; and the Pan Painter too, beginning his career in the shop with the others. It is not clear, however, that this is the nature of the relationship. Both Follmann, working on the Pan Painter, and Berge, working on Myson, came to question it.[55] Berge accepts that the Pan Painter learned something from the older Myson, but doubts that there was a direct workshop apprenticeship. She further notes a connection we have already touched on between the young Pan Painter and the Triptolemos Painter. We noticed that the latter was one of the wanderers of the Kerameikos, and the Pan Painter surely was so too.[56]

A beautiful early vase (not known to Beazley) illustrates this tendency, and is of importance too in helping to establish the painter's chronological relationship to some others. This fragmentary piece, a very large pelike in Malibu, we have alluded to several times already.[57] On one side is a scene popular at this time: Triptolemos despatched by Demeter and Persephone to carry through the world the gift of grain. The other picture (fig. 146) is unique. It concerns Dionysos, and appears to show him bringing the vine to man: a perfect counterpart to the other. The bearded head in this fragmentary picture (probably the mortal recipient of the divine largesse, Ikarios) has brothers in several other of the painter's early works; and it is in these that he stands closest to fine work by Myson like the krater in the British Museum. The little maenad and satyr behind Ikarios, gathering ivy from a dead tree, are less careful but delightfully vivid, and stand at the beginning of a special line in the artist's work which will concern us later. The beardless heads in the other picture (fig. 147), these too closely paralleled in other early work, at the same time point the way to the Artemis and Actaeon of his mature masterpiece; while the wonderful hands typify the elegant strength of his best drawing throughout his career. The ornament, on the other hand, and the way the pictures are disposed on the pot, are totally untypical.

The Pan Painter decorated several large or largeish pelikai, but on no other are the pictures framed. The patterns used to this end on the exceptionally large Getty vase are exactly those found on a number of other outsize pieces of this shape put together by Beazley

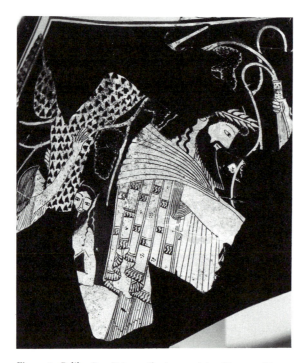

Fig. 146. Pelike; Pan Painter. Ikarios receiving Dionysos(?), detail. H. of detail *c.* 0.13.

Fig. 147. Other side of 146: Triptolemos and Demeter, detail.

as the Class of Cabinet des Médailles 390. 'Class' in Beazley's terminology signifies links in the potter-work, and corresponds to 'Group' for works linked by style of drawing but not necessarily attributable to a single painter. One cannot with absolute assurance ascribe so fragmentary a vase as the Getty pelike to a Class (all the lower part, with the foot, is lost); but in all observable particulars it corresponds to the Class of Cabinet des Médailles 390, and the pattern-work seems to me to make it virtually certain that it belongs.

Of the seven vases listed in the Class by Beazley four are attributed to the Syleus Painter as early work (originally the 'Painter of the Würzburg Athena'), and another is said to recall him. One of the remaining two is given to the Siren Painter, and the last said to recall the Argos Painter.[58] A small fragment of a pelike which Beazley lists as near the Syleus Painter has an upper border-pattern like those found in the Class and may come from an eighth.[59] One other complete pelike, in Copenhagen, is on the same large scale and has the same pattern-borders, not found elsewhere in the work of its decorator, the Triptolemos Painter.[60] Beazley did not put it in the Class, but like the Getty Pan Painter it appears to me to belong there. Becker, in her study of the pelike as a shape, does associate the Copenhagen vase with the Class, which she subsumes as the earliest pieces in a much larger grouping, her Workshop of the

Syleus Potter.[61] She sees this as dominating pelike-production from about 480.

I would suppose that the workshop in which the young Syleus Painter was sitting was called on to produce a matching set of exceptionally large pelikai; and that, to get the order completed on time, extra painters were hired. In any case the Pan Painter and the Syleus Painter appear to have begun work about the same time, unless indeed, as may well be, the Syleus Sequence is really the work of one man, in which case he can be traced back a good deal further. As to absolute dating, I would think it likely that this collaboration took place somewhere in the decade 490/480. The Triptolemos Painter seems to have begun earlier as a cup-painter (there are links with Douris in his earliest phase, which cannot begin much after 500). He went on into the early classical period; but his other link with the Pan Painter (witnessed by stamnos-fragments in the Louvre discussed earlier) need not be later than their collaboration on the Class of Cabinet des Médailles 390. The Pan Painter's psykter in Munich, which we noticed as having the same rare subject as one of the Triptolemos Painter's Louvre stamnoi, Marpessa choosing Idas in preference to Apollo, is in an immensely elaborate and mannered style which looks even earlier than the Getty vase.[62] On his Louvre stamnos[63] he showed Priam petitioning Achilles for Hector's body, a subject which

almost disappears in the classical period. The Pan Painter follows the traditional design, most familiar in the Brygos Painter's Vienna skyphos,[64] but his Priam is a more animated and moving figure than the older painter's.

The painter is seen at his superb best on the name-vase, a bell-krater in Boston.[65] We saw how the Berlin Painter took into fine pottery, unchanged, a shape in use for a vat or tub; and how the Kleophrades Painter imitated it, adding, in concession to fine-ware practice, a tiny ring-foot.[66] The two examples the Pan Painter has left us have a moulded foot, and the rim is given more definition by a narrow band of ovolo ringing the vase below it. This form, found also in the Oreithyia Painter's work and in that of some artists we shall meet in the next chapter, retains much of the simplicity of the original with greater elegance.[67]

On one side of the Boston vase the painter sets comedy (fig. 148): Pan, goat-headed, goat-hooved and ithyphallic, pursues a young shepherd (probably Daphnis) past a rock on which stands a rustic wooden image of a fertility god. The other face (fig. 149) shows tragedy: Artemis draws a bow on young Actaeon who falls, one arm flung up, eye rolling back, while four of his hounds set on him. The story is occasionally shown in Attic vase-painting from the mid-sixth century, but more often in this time.[68] After the repulse of the Persians, in seeming contrast to the great flowering of Greek culture, stories of the wanton unreliability of the gods towards mortals seem in the front of people's minds. In these pictures the goddess is never shown naked, and the version that the hunter was punished for seeing her so is almost certainly a later invention. An old story had Zeus send his daughter to destroy her votary because he had lusted after the god's beloved, Semele. (Both Semele and Actaeon were members of the ill-fated royal house of Thebes.)

Another element in the story of which there is no trace here is the transformation of the hunter into a stag; but that appears in vase-paintings only a generation or two later.[69] A variant in which the goddess deceives the hounds by casting a deer-pelt over Actaeon is illustrated by the Pan Painter himself in an early picture. There she does not draw her bow but stands still, reaching out an arm towards the victim, who is clad from wrist to knee in the dappled hide, its scalp pulled up over his hair. This was on one side of a volute-krater, now fragmentary, a dedication on the Acropolis.[70] The other side had a no less splendid and exquisite picture of a Giant, struck down in the Gigantomachy by Dionysos's spear, and overwhelmed by the god's aides: a lion, a pard, a snake and the coils of the ivy-branch in his other hand. Dionysos is the god not only of wine but of wild nature. Another beautiful fragment from the same early period,

in Boston, with Dionysos's vine and a bearded god's head, comes from a vase of the same shape,[71] but no complete one survives from the painter's hand. He has left one calyx-krater, in Cambridge,[72] with Achilles and Penthesilea, Herakles and Syleus; the surface ruined but the head of Achilles still beautiful. His second bell-krater, in Palermo,[73] has pictures of dance: on the front Dionysos and a maenad, on the back two revellers and a dog. There is life and charm in the drawing, especially in the second picture, but it is a much weaker piece than the Boston vase. It is thought, probably rightly, to be a late work. To the painter's column-kraters we will return.

The strikingly stylised rock in the Pan picture is found also in the early Actaeon and elsewhere in the painter's work. On an oinochoe in London,[74] Oreithyia's old father Erechtheus sits on one, grieving as the wild Thracian wind-god pursues his daughter (that theme again). Another is seen in a hastier but delightful little picture on a vase in Vienna[75] of a special class: very small pelikai of distinctive make and decorated with odd scenes, some at least of which seem to have a ritual significance. There are ten of them,[76] and Becker subsumes the Class in her larger Class of the small pelikai by the Geras Painter.[77] Beazley lists the Geras and Argos Painters in a Late Archaic chapter, the Pan Painter in an Early Classical, but there must have been a large overlap. The Geras Painter was a miserable draughts-man, but the scenes on his little pelikai often have a character not unlike that of the Pan Painter's (both have a thing about Herms); and I am sure it does not violate chronological probability to see him in these as a crude imitator of the Pan Painter.

The Vienna pelike (fig. 150) shows a man, wrapped in his himation and with a fur cap like the shepherd's on the name-vase, squatting on a rock. A basket held in one hand, rod and line in the other, he draws up a fish, while two more put up their faces to be caught. Opposite him stands a youth, in fur cap and short chiton off the right shoulder (workman's garb). He holds a stick over his shoulder, a basket on the end; and on the back of the vase he is seen running to market, a basket on each end of the pole, past a street-corner Herm. In general the best red-figure is careful, meticulously drawn. When the Berlin Painter or the Brygos Painter draws hastily he tends to draw poorly. The Pan Painter can be as elaborately careful as the others; but on the best of his little pelikai, like the one in Vienna, his quick sketches have all the charm and strength of his personality undiluted. Like everyone else he produces weak work, but that is as likely to be on careful as on careless pieces.

An example of careful weakness is a big pelike from Spina.[78] On one side, as on the early Getty pelike, Triptolemos is sent forth. It is a fuller picture of the

Fig. 148. Bell-krater; Pan Painter. Pan pursuing Daphnis(?). H. *c*. 0.37.

scene, but a sadly feeble one, and Thetis coming to Achilles on the other side is hardly better. However, another big pelike from his maturity, in Athens,[79] has a beautifully drawn picture of Herakles and Busiris's minions: a masterpiece in his black-comedy mood.

The Pan Painter decorated many other shapes, including some cups (one of which had a white interior, now largely lost).[80] There are kalpides and small neck-amphorae; alabastra and skyphoi; loutrophoroi and nuptial lebetes; an amphora of panathenaic shape; fragments of a dinos in the Vlasto Collection, with love-making, which was certainly one of the masterpieces of his prime.[81] In point of numbers his favourite shapes appear as the lekythos and the column-krater.

One scholar has argued interestingly that the Pan Painter's master was the Berlin Painter.[82] I do not think so; but in his liking for the lekythos and in the way he adorns it he surely shows the older artist's influence. He prefers a black vase (often including the shoulder, though on others he puts a floral there) with a single figure (two occasionally, as a very charming

piece in London with Apollo and Artemis[83]). One in Adolphseck[84] has, like the Berlin Painter's two lion-lekythoi, the body all black except for a maeander-strip at the top, the picture on the shoulder (fig. 151). Two Erotes fly towards one another, each holding ends of tendrils which wind to support a palmette in the centre between them and one behind each, flanking the handle. Together with this, his loveliest work on the shape is perhaps a black-shouldered vase in Boston[85] showing a hunter with his dog: perhaps Kephalos, since a replica of this figure, on a skyphos-fragment from the Acropolis,[86] has a hand laid on his shoulder – Eos, the Dawn, who loved him. We have two white lekythoi from his hand, one an early work, in Leningrad,[87] with a pretty picture of Artemis petting a swan. The goddess's skin and the bird's plumage are added in a purer white; a practice we shall discuss in a later chapter.

A beautiful column-krater in Bari[88] belongs to the Pan Painter's early period: on the back a flute-player, on the front Poseidon holding an *aphlaston*. This is the

Fig. 149. Other side of 148: death of Actaeon.

stern-ornament of a warship, carved with a grotesque face. The few other representations of it on Attic vases belong like this in the later years of the Persian wars or soon after.[89] Like the Bari vase, more than half the painter's column-kraters are black, with one figure on each side (occasionally two on the front). The rest have framed pictures. All except the Bari vase seem to show a mature or late stage of his style, and they are the side of his work which brings him closest to the early Mannerists.

The artist's second white lekythos is in Syracuse,[90] from Gela, as are many of the red-figure lekythoi: the column-krater we have just looked at from Bari; the name-vase from Cumae; the early psykter from Agrigento; and a higher proportion of his work comes from Sicily or South Italy, as against Etruria, than is usual with most painters of this time.

We saw that the Pig Painter was a pupil and close follower of Myson, and probably took over the shop from him.[91] Beazley names half a dozen others as Earlier Mannerists, some of them very small groupings, and classes some ninety vases more as 'Earlier

Mannerists: Undetermined'. He speaks of these painters in general as pupils of Myson,[92] but it appears to me, and this is confirmed by Berge's researches, that of the named artists only the Pig Painter was actually that. She has observed that on some late vases Myson had the collaboration of other assistants; but they, for the present, remain in the 'Undetermined' group. Beazley speaks of the Leningrad Painter as ' "Brother" of the Pig Painter, but less Mysonian';[93] perhaps he was rather a pupil of the Pig Painter, though near the beginning of that craftsman's career. The vases grouped as work of the Pig Painter Beazley originally gave to a 'See-saw Painter', after a fragmentary column-krater in Boston with two girls on a see-saw.[94] He afterwards saw that this was the Leningrad Painter's, and renamed the other the Pig Painter after a pelike in Cambridge (figs. 152 and 153) showing a man in company with a swineherd, perhaps Odysseus and Eumaios.[95] The see-saw picture is close in character to the Pig Painter's early work. Both painters develop under powerful influence from the Pan Painter.

The nature, in practical terms, of the Pan Painter's

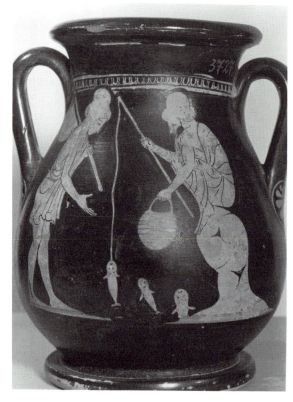

Fig. 150. Pelike; Pan Painter. Anglers. H. *c.* 0.17.

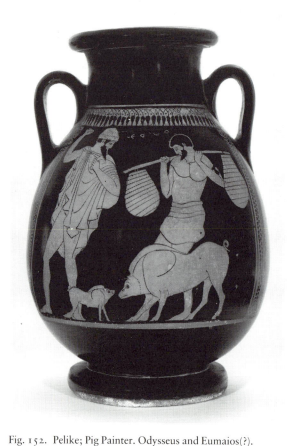

Fig. 152. Pelike; Pig Painter. Odysseus and Eumaios(?).
H. 0.35.

Fig. 151. Lekythos; Pan Painter. Two Erotes. H. of picture *c.*
0.04.

Fig. 153. Detail of 152: pig and piglet.

relationship to the Mannerists is puzzling to determine.
His stylistic influence on them is so pervasive that one
would think he was sitting in the shop. However, the
potting of Mannerist column-kraters has a distinctive
and unvarying character, and to this none of the Pan

Painter's conform. Perhaps he was his own potter – but
we are running into guesswork. The Mannerist work-
shop had a strong 'house style'. This is witnessed not
only by the difficulty in distinguishing hands (the large
'Undetermined' element) but, in a different way, in a

matter of pattern-work, charted by Berge. It is a custom for column-kraters, from whatever workshop, to be decorated on the neck (if it is not plain black) with a pattern in black silhouette on a reserved panel: long lotus-buds pendent from intersecting arcs with dots between, other arcs rounding the buds below. This mechanically conventional and rarely carefully drawn design (which, in a simplified form also decorates the lip, with palmettes on the handle-plates) is variously treated in detail by different painters. In this workshop, from the later work of Myson himself down to the last practitioners near the end of the fifth century, it has certain constant features: elongated dots, a distinctive shape to the buds, arcs below which do not intersect. The principal members of the group, however, have each a distinctive figure-style.

The Pig Painter is a dull draughtsman. When careful he can be quite competent but never fine. His hastier work is coarse. The name-picture,[96] which is of this kind, has a touch of life and charm, but that is rare. The Leningrad Painter is much more interesting. He never seems to aspire to great artistry, but he shows an appreciation of the art of the Pan Painter and at his best emulates it with a light, pretty touch. He also has a taste for odd subjects, which was taken up by younger members of the group, though none of them shows much care for decent drawing. With the column-krater the staple products of the workshop are pelikai and kalpides. Most of the latter have a long framed picture occupying the whole front half of the shoulder, and with a band of pattern on the front between the side-handles, often lotus-bud like those on the necks and lips of column-kraters.

One such vase by the Leningrad Painter shows, with a good deal of life, a scene in a workshop.[97] Craftsmen (and, unexpectedly, one craftswoman) are seen applying decoration to completed vessels: two volute-kraters and a large kantharos; while another large kantharos stands on the floor, a ribbed oinochoe standing in it, and a smaller kantharos and oinochoe hang on the wall. In the midst of this activity appear Athena and two winged victories, all carrying wreaths. The venue is normally taken for a pottery; but the very metallic character of the vessels has led to a well-argued suggestion that these are rather bronze-workers or silversmiths. The shapes in question, however, though certainly of metallic origin, were all reproduced in pottery, though none of them was a regular line in the humble Mannerist workshop. The rather sparse gear of the workers is most readily interpreted as paint-pots and brushes, and I suppose the old interpretation is still the most likely. Women are often shown at their 'own' crafts in which men take no part, spinning and weaving, but the appearance of one among men in a men's workshop is unique. The evident

element of fantasy makes this a slippery document for the history of craft or of social manners, but as a picture it has great charm.[98]

Another nice piece by the painter, of the same shape (fig. 154), has five satyrs, in the phallic drawers of the satyr-play, dancing in with pieces of a couch or throne which they are beginning to set up on the stage.[99] A piper in a long patterned robe provides their music, and a figure behind him must be the *choregos* (financer and presenter of the play) or the poet. This seems a safer document for the history of the stage than the other for craft.

The only other personality among the Earlier Mannerists with a large body of recognised work is the Agrigento Painter.[100] Beazley says that he 'takes off from the Pig Painter'. I should guess his beginnings to be later than the Leningrad Painter's, in the phase when the Pan Painter's influence was paramount, and he appears to have worked on well into the time of some of the Later Mannerists. He never shows the flair of the Leningrad Painter, and in his later work the mannered posing of the figures seems to become less a style than a mechanical habit. It is interesting that more than half the Pig Painter's column-kraters have unframed pictures, only about a fifth of the Leningrad Painter's, and only one among more than fifty ascribed to the Agrigento Painter.

Of the other individually identified earlier Mannerists, only the Perseus Painter[101] has more than a handful of vases (twenty) to his name. On one pelike[102] he puts a Herm-picture of the same character as those on small pelikai by the Pan Painter and the Geras Painter; but in general he looks forward to the style of the Later Mannerists. The same holds for the Oinanthe Painter,[103] who has less than half a dozen, some of those doubtful, but who deserves a mention because his drawing is less bad than some and he provides a link between the Leningrad Painter and the leader of the later group, the Nausicaa Painter.[104] Both the Perseus and Oinanthe Painters decorate kalpides with picture on the body, not the shoulder; a system which tends to predominate in later work. Only three of seventeen kalpides attributed to the Leningrad Painter are of this kind; and one at least of those, a pretty vase in Chicago[105] with a youth kissing a girl, is a late work close to the Oinanthe Painter.

The undetermined list contains pieces as good as any assigned to names. We may look at a column-krater in Chicago[106] with framed pictures. On the back a woman with long hair loose, wrapped in her himation, stands between two Victories. Both are closely wrapped, like the woman, and one of them, who faces away from the central figure, also has her hair down her back: an odd picture of unclear meaning. On the front (fig. 155) is

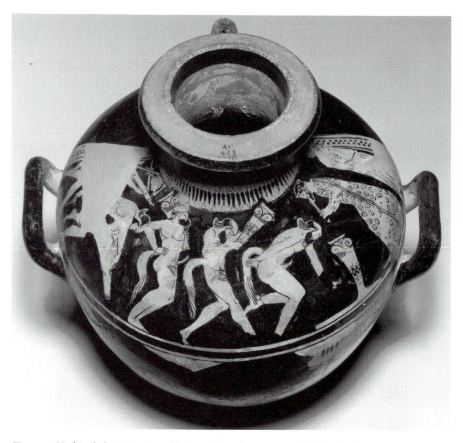

Fig. 154. Hydria (kalpis); Leningrad Painter. Scene from a satyr-play. H. of picture *c.* 0.10.

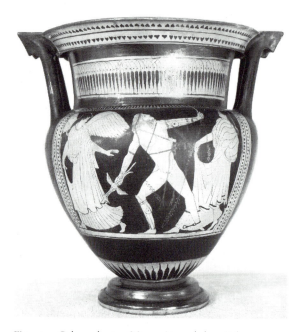

Fig. 155. Column-krater; Mannerist workshop. Salmoneus. H. *c.* 0.46.

a rare scene from legend: the madness of Salmoneus, King of Elis, who believed himself a greater Zeus and threatened the king of the gods with a simulacrum of his own weapon, the thunderbolt, before being struck dead with the real thing. In the picture he brandishes a sword in his left hand, his bolt in the right, hurling it heavenward. He wears a greave on his right leg but the other has got on to his left arm, and he is festooned with fillets, wreaths and chains. It is an interesting picture, better conceived than executed, and one can believe that the painter was not unfaithfully echoing something great. It is interesting that a Salmoneus is recorded by the wall-painter Polygnotos.

Another column-krater with framed pictures in Basel, which Beazley knew but did not attribute, may be mentioned here.[107] On the ruined reverse are two satyrs at a volute-krater. In the main picture three pairs of men, wearing oddly patterned corslets over short chitons and youthful masks, are dancing and singing in front of a structure covered with fillets, surely a tomb. From this, in response to their gestures and song, is rising, already half revealed, a bearded man in a himation, his mouth open to speak to them. The nearest parallels to the corslets are worn by bearded old men in

an equally obscure scene on an early hydria by the Pan Painter in Leningrad.[108] The Basel vase is not his work, but one could well believe the painter influenced by him. The drawing is neither careful nor very sensitive, but has life and character. Berge notes that, while the potting is perhaps compatible with the vase having been made in the Mannerist workshop, the drawing is not that of a Mannerist. She points to likenesses to an unattributed column-krater in Palermo: Herakles bringing the Erymanthian boar to Eurystheus; on the back a youth.[109]

Certainly several artists outside the Mannerist workshop felt the Pan Painter's influence. One of these is the Cleveland Painter[110] to whom, besides nine column-kraters with framed pictures, only one neck-amphora and two oinochoai are given. One of the oinochoai[111] is by the same potter as one by the Orchard Painter.[112] This craftsman was mainly a painter of column-kraters, and is related to the Boreas Painter, whom we have already noticed as belonging to quite a different milieu from the Pan Painter and the Mannerists.[113] In the chariot-scene on the front of his large and fine name-piece[114] the Cleveland Painter seems to look in that direction too, but the *komos* on the back, and much of his other work, is nearer the Mannerists. Before he recognised the Cleveland Painter, Beazley listed a column-krater in Vienna[115] which he later gave to him (a *komos* on either side) as 'Manner of the Pan Painter'; and the composition of the Cleveland Painter's picture in Harrow of Kaineus driven into the ground by Centaurs (his treatment of the same subject on a vase from Spina is different) links it directly to the same scene on a column-krater in London by the Pan Painter.[116]

Rather different is the case of the Alkimachos Painter.[117] He painted column-kraters, and other shapes including a few cups, but the greatest amount of his work is on small neck-amphorae, Nolans and the like. Elements in the drawing, especially the roughly daubed mantle-youths on his reverses, suggest that he may have been taught by the Harrow Painter; and his relation to the Pan Painter seems something like the Harrow Painter's to the Berlin Painter.[118] Pictures on a large neck-amphora in Leningrad,[119] with Hermes on one side pursuing Ganymede on Zeus's behalf, on the other in conversation with an older boy, possibly Paris (before the Judgement), look like direct copies of work by the Pan Painter. More successful are a very charming Athena and Hermes on a Nolan in London.[120] Beazley originally ascribed to him the Salmoneus krater in Chicago;[121] but though in his emulation of the Pan Painter this artist sometimes comes close to the Mannerists, he is not of them, and Beazley's second thought here was surely right.

Some of the Alkimachos Painter's best work is on big lekythoi. One, in Boston, has Zeus seated, giving birth to Dionysos from his thigh. On another, in Berlin, Perithoos sits in Hades and Herakles clasps his hand but cannot free him. Both these have real grandeur; and a third, in Basel (fig. 156), not known to Beazley but surely rightly ascribed to the painter, even more.[122]

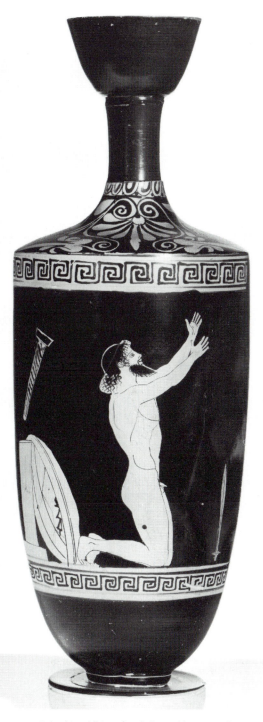

Fig. 156. Lekythos; Alkimachos Painter. Ajax preparing to die. H. *c.* 0.32.

Here Ajax, his shield and empty scabbard behind him, kneels and lifts hands and face to pray, before falling on his sword, upright in the ground before him.

Another big lekythos may be mentioned here. It is in Taranto,[123] and shows Ariadne lying asleep, wringing her hands in a bad dream, her face towards us. A little winged figure at her head is Hypnos, ensuring that she does not wake, while her faithless lover rises from her side, called by Athena who motions him to quiet. Beazley listed this as 'near the Pan Painter'. Some have thought it his own, but that can hardly be. It is surely not from the Mannerist workshop, nor I think by the Alkimachos Painter. It is an impressive composition and carefully drawn, but with an odd clumsiness. For the present, like the Basel krater, it remains isolated, though Beazley thought that a hydria on the market with Athena and a Giant,[124] unrelated to the Pan Painter, was probably by the same hand as the lekythos.

IV. Cup-painters

a. The following of Douris and Makron; and some others

Beazley noted that, among the large number of cups attributable to Douris's workshop in his late period, it is often hard to be sure which are from his own hand, which the work of close imitators. He distinguished an Oedipus Painter, called after a cup in the Vatican with Oedipus and the Sphinx, but gave him only a handful of pieces.[125] Other cups he listed as in Douris's manner, and by several of those in the artist's own list he put 'School-piece?'. More work has been done since, especially by Guy, enlarging the Oedipus Painter's *oeuvre* and distinguishing other personalities among the painter's imitators, beginning in his middle period. None of them, however, impresses his work with much originality. All this late production, Douris's own and that of his imitators, stands in very much the same position as that of the pot-painters in the Syriskos Group,[126] between archaic and classical; only those pot-painters were younger men, trained in the archaic tradition but bringing into it a new positive force for the creation of the classical. The only strong artistic personality in Douris's circle, Douris himself, could never really slough his archaic skin. A little later, though, this workshop did produce important classical cup-painters. We shall look at the Akestorides Painter in the next chapter. The Euaion Painter, a major figure, seems best treated even later.[127]

The case of Makron is analogous but not the same. The master's style shows less awareness of change than Douris's, remains always the purest archaic; and he may not have worked long into this transitional phase. We noticed that two of the forty-odd cups bearing the name of Hieron as *poietes* were not decorated by Makron.[128] Their style is later than his, and one might guess that he was no longer active when they were made. They were painted by one craftsman, known as the Telephos Painter[129] after the subject of one of them. He certainly learned from Makron, but his style differs from the master's not only in quality (he is a much less sure draughtsman) but in character. He still uses some archaic formulae, but the odd angularities and twisted posturings ('Anglo-Saxon attitudes'), analogous to but much harsher than the Pan Painter's mannerisms, seem like a deliberate send-up. The tell-tale eye in near-profile confirms a general feeling that this drawing belongs to the new age.

More than fifty pieces, mainly cups, are attributed to this painter. The inscribed cups, both in Boston,[130] illustrate his style best. One has scenes from the story of Telephos. In the tondo of the other Eos pursues Tithonos, while round the exterior (figs. 157 and 158) an extraordinary procession follows a warrior who seems to be trying to climb a crag: an unexplained and curious subject which seems well suited to the curious style.

Similarly post-archaic in feeling is a considerable body of material, mainly cups, some or all of it attributable to one hand, which again clearly stems from Makron. The principal craftsman is known as the Clinic Painter[131] from the unusual subject of a round aryballos in the Louvre. The shape is like that of Makron's piece in Oxford with the toy chariots. On the shoulder are two Erotes which recall Makron's on his askoi. They have a mild charm, but none of the master's brilliance.

There is also a group of early classical pots attributed to a Syracuse Painter,[132] who certainly was another pupil of Makron. The best of them is a stamnos in Boston with Hermes weighing the fates of Achilles and Memnon, the agitated mothers flanking him: big figures, covering the surface well, though the drawing lacks subtlety.

One other vase bears the name of Hieron as *poietes*. It is a kantharos with scenes from the Gigantomachy. The style, which is early classical with no trace of archaic, is found on some fifty other vases of many shapes, the majority cups. The artist is known as the Amphitrite Painter,[133] and I mention him here rather than in the next chapter because of the connection with Hieron. The inscription, like most of those with the name, is incised and therefore open to suspicion; and this has oddities, already mentioned, which have been held against it: the omission of the aspirate (Ieron) and the addition of the father's name, not mentioned elsewhere.[134] It also employs the imperfect, *epoi[ei]* (last letter, epsilon for epsilon iota, lost, but there is no room for more) instead of the aorist *epoiesen*, generally more usual and found in all other inscriptions with this name.

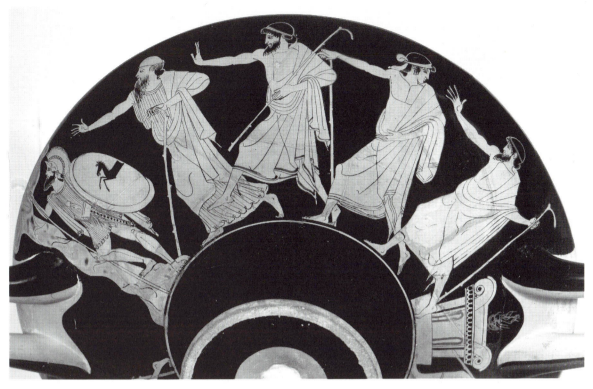

Figs. 157 and 158. Cup; Telephos Painter. Unexplained subject. H. of picture *c.* 0.11.

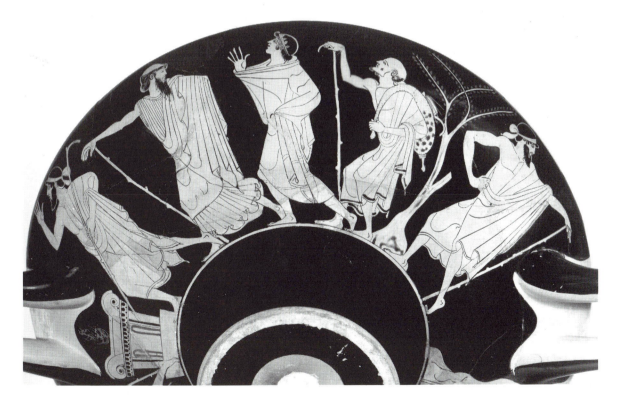

It can be argued, however, that such departures are unlikely in a forger. A definite answer, false or genuine, is hardly possible.

Two of the painter's cups have Amazonomachies,[135] and there are other subjects, but the majority have quiet groups of youths with boys or women, which might be seen as following on Makron's many similar compositions, but there is no evident stylistic link. The big profile eye gives character to the faces, and the drawing is strong if not very sensitive.

The Amphitrite Painter takes his name from a picture on a pyxis in Athens[136] of Poseidon pursuing his bride to be. Beazley first took the pursued for one of the god's mortal flames, Amymone, and for long called the artist the Amymone Painter, but later recognised a mistake and changed the name. The painter's most interesting pictures are on a kantharos in London:[137] on one side an assembly of gods with the great sinner Ixion about to be tied to the wheel; on the other, violent death in a sanctuary, a picture not satisfactorily interpreted.

The Brygos Painter's late work is sometimes weak, and hard to distinguish from that of imitators, but there is no clear development of the workshop into an early classical phase. However, an important early classical pot painter, treated in the next chapter, the Villa Giulia Painter,[138] whom Beazley connected with the following of Douris, is now seen, in some early white-ground cups, to have roots in the Brygan tradition.

One composition from the Brygos Painter's prime can be used to point the difference between pure archaic and this transitional phase. One of his great red-figure cups, in Berlin, has on the outside the battle of Gods and Giants, in the tondo (surely connected with that) Selene,

the Moon, driving her two-horse chariot straight towards us (fig. 159).[139] Her face is turned in profile, but the big moon-disc on her head is a full circle, drawn across the maeander-border. Her body, hands holding reins and goad, is frontal, as is the car in which she stands and which hides her lower part. There is a star on either side of her head, and the half-figure is framed by the wings of the horses, whose heads and forelegs appear over the sea, indicated by a string of small arcs along the edge of the circling border below.

A white-ground tondo (fig. 160) gives us a corresponding picture of Helios, the Sun.[140] The basic composition is the same, and details like the eye are hardly less purely archaic than in the figure of the goddess; but the effect is profoundly different. The artist has made the god (frontal but face in profile, like his sister) much smaller in relation to the field. The disc on his head is larger than hers but is entirely contained within the circle; and the winged steeds appear over a sea which occupies almost the bottom third of the picture, and is drawn in broad calligraphic swirls. This is not rendering of space in any naturalistic sense, but a window has been opened; we breathe a new air. One cannot point to any evident influence on this draughtsman from the work of wall-painters; but his composition is an

Fig. 160. 'Bobbin'; following of Brygos Painter(?). Helios. D. *c.* 0.11.

Fig. 159. Cup; Brygos Painter. Selene. D. *c.* 0.16.

expression of the same urge which led to their revolutionary experiments.

The painter's hand has not been recognised in any other piece, but I should be inclined to seek his origin among the later followers of the Brygos Painter. The tondo is not that of a cup-interior but the surface of a clay disc. It is plain on the back, with a broken projection at the centre. Complete examples exist: two such discs, joined back to back by a very short stem, making a kind of reel or bobbin. The use is not known, but the form is briefly popular in the early classical period (this is the earliest-looking; we shall meet others in this chapter and the next), both in white-ground and red-figure.[141]

Another white-ground piece stands, like the Helios bobbin, on the borders of archaic and classical: a small cup, decorated inside only, very pretty (fig. 161).[142] A boy in a himation stands tuning his lyre, a hare looking up at him. This was found in a well in the Agora of Athens, together with a small red-figure cup by one of the minor painters in the Brygan workshop, which looks late in that series.[143] The character of the fill, with traces of burning, suggested to the excavators that it might be detritus cast after the Persian sacks of 480 and 479. It has been questioned whether the style of the white cup can be so early. I see no reason why it should not be; but of course one must not go on from that to say that this *is* fill from the sack and so dates the style of the vases.

Another beautiful though fragmentary white-ground tondo of this transitional character is in a cup dedicated to Artemis in her sanctuary at Brauron in east Attica.[144] It shows a girl, possibly Amymone, bringing her pitcher to a lion-head fountain-spout. The remains of the red-figure exterior go with other cups given to a Stieglitz Painter, and it seems that he also drew the white-ground picture, but that is a great deal finer than anything in his surviving red-figure gives us warrant to expect. Beazley first spoke of this artist as 'early classical: still showing influence of Makron's school'; then as 'school of Makron'; but in *ARV*² he lists him not in the chapter 'Followers of Makron' but in the next, 'Other cup-painters'.[145]

Of the same phase and general character but a dull work is the white-ground tondo of a cup in Florence, with Aphrodite seated, Erotes fluttering round her. An athlete on the red-figure exterior is named Lyandros, and a very few other red-figure pieces are associated under the name of the Lyandros Painter.[146]

In this transitional phase one more minor painter of red-figure cups (one of these too has a white interior) needs a mention. His liking for naked women, washing or taking off or putting on boots, has earned him his name of Boot Painter.[147] Over the attribution of a cup in Warsaw[148] Beazley hesitated. He first compared it to a cup in the Vatican by the Telephos Painter, and seemed unsure in rejecting an attribution to that artist; but he finally gave it to the Boot Painter, who is not a Macronian but a close follower of the Kleophrades Painter. Beazley even suggests that the Boot Painter may be a late phase of that great artist.[149] I find this hard to believe; but the doubt is a good example of the problems that beset us in studying a very ill-documented field in which the practitioners are at one and the same time commercial pot-decorators and serious artists, working over a period of profound and rapid change in visual perceptions.

b. The Pistoxenos Painter and his companions

The Pistoxenos Painter is a perfect representative of this transitional phase. Among his earliest-looking works is the latest-looking cup to bear the name of Euphronios as *poietes*. The potting of this is like that of the other cups with the same inscription, and the drawing retains marked archaic elements. On the other hand, the artist's developed style brings him close to the Penthesilea Painter, most important of early classical cup-painters and leading figure in a very large workshop. The potting of the Pistoxenos Painter's later cups goes with that of the Penthesilea Painter's. Links can be traced in the work of minor craftsmen around the Pistoxenos Painter both forward to the Penthesileans and backward to the Antiphon Group. We have already noted these facts and concluded that we can trace here the history of a single workshop long associated with the *poietes* Euphronios, though in its Penthesilean phase it seems to have undergone enlargement and a change of character.[150] We observed that the Pistoxenos Painter takes

Fig. 161. Cup; following of Brygos Painter(?). Youth with lyre. D. of picture *c.* 0.11.

his name from another *poietes*: but his association with Pistoxenos seems to have been occasional only;[151] unless indeed Pistoxenos became *poietes* for Penthesilean cups.

The main production of painters in this circle is cups, and they work largely in red-figure; but, good as the Pistoxenos Painter's best red-figure is, his masterpieces are white-ground cup-interiors. Such is the cup with the name of Euphronios, in Berlin.[152] The vase is fragmentary and much of the surface in poor condition, but the faces of the two figures on the interior (fig. 162) are relatively well preserved. A youth sits, the shaft of a sceptre or spear leaning on his shoulder, and holds out a vessel for a standing woman to fill. Both jug and cup are lost, but this was surely the action. Part of the woman's name remains, . . *med* . . , and Furtwängler's suggestion is surely right that the picture shows Achilles served by his captive Diomede (with whom, Homer says, he slept after he had lost Briseis to Agamemnon).

The eyes are fringed all round with separately drawn lashes, something Euphronios the painter liked in his careful work but which gradually goes out among the Pioneers' successors. Here it has an old-fashioned effect, enhanced by the fact that the eyes are drawn almost in the fully frontal archaic tradition; only the artist has shifted iris and pupil a little towards the inner corner, more markedly in Diomede's than the other. The effect, however, is not archaic. The young man's head is strikingly like the blond boy in marble from the Acropolis, in which the execution retains an archaic brilliance but the spirit is already classical.[153]

Fragments survive from two other white cups, evidently by the same hand as this, but both more assured in drawing. Each, like the Euphronios cup, shows two figures, male and female, but in both there is more action. On one, in Taranto, a satyr assaults a maenad (fig. 163). On the other, from the Acropolis, the roles are reversed: a Thracian woman, axe in hand, prepares to despatch the wounded Orpheus, who lifts his lyre to defend himself.[154] The satyr's round eye and the maenad's long one are still frontal, but not fringed, though a golden line, in very diluted colour, along the maenad's upper lid suggests lashes. Both Orpheus and his slayer have an almost fully open profile eye. This, I suppose, suggests that the Acropolis cup is the later; but the sense that the artist has now mastered his medium and can do whatever he wants is perhaps even stronger in the masterpiece in Taranto. Orpheus's head is again

Fig. 162. Cup with name of *poietes* Euphronios; Pistoxenos Painter. Achilles and Diomede(?). D. as restored *c.* 0.21.

very like the blond boy, and there cannot be many years between the three cups. Part of the word *epoiesen* appears on both the Orpheus and the maenad cup. It is likely that the name was Euphronios, but not enough of either piece remains to assess the details of the potter-work.

Purple-red and a more scarlet matt colour are used for the two himatia on the Berlin cup; the purple again for Orpheus's himation, slipping from him as he collapses, and for the maenad's chiton. The satyr wears an animal skin with white markings on a ground that now at least is a matt black. This has not been found elsewhere, but the two reds now become a regular part of the polychromy of white-ground vase-painting. Clay is added in relief, for gilding now lost: the women's bracelets on all three cups, and features of the bard's lyre.

The exteriors of the Berlin and Taranto cups were in red-figure. Only scraps survive at Taranto, but the Berlin cup has a pretty picture of a horse-race, boys up. Boys and horses recur in the painter's work, a taste in which he looks back to Onesimos, forward to the Penthesilea Painter. The Acropolis cup is one of the relatively rare examples on which the white slip is applied to the exterior also.[155] There were palmette-complexes at the handles, and the pictures showed men with horses. The men are in outline, the beasts in black silhouette with incision: 'semi-outline' once again adopted by a fine artist.[156] The upper part of one of the men survives, bearded and wearing Thracian cap and cloak. These were a fashion among the knights of Athens; but here the wild beard and blunt features show that the artist meant a Thracian, so the outside picture is linked to the tondo. Another Thracian practice was tattooing, and the woman within is tattooed. On her left forearm, under the bracelet, are two long stripes joined by diagonal lines, and on her right upper arm a neat little 'Geometric' horse.

Tattooing appears again in the painter's work, on one

of the best of his red-figure pieces, the skyphos with the name of Pistoxenos, in Schwerin.[157] Orpheus's butcher is young and beautiful. On the skyphos it is a bent and wrinkled old slave-woman, and her tattoos are correspondingly less sophisticated. Thick, irregular bars run the length of her inner forearm, and others down her neck from her jaw, and surely mark her as from Thrace.

The painter no doubt based this figure on domestic slaves he had seen in Athens, but he has set her in a mythological context. On the front of the vase, where the Pistoxenos inscription is, a white-headed man, his beard still dark, sits on a chair and demonstrates lyre-playing to an attentive youth who sits with his instrument on a stool opposite the master. Such school-scenes are popular at this time. We noticed the most celebrated, on a middle-period cup by Douris.[158] The Pistoxenos Painter has transposed this scene from contemporary Athenian life into the heroic age. The master is named Linos, the pupil Iphikles. Iphikles was Herakles's twin brother, but whereas Herakles was begotten by Zeus, Iphikles was the seed of Alkmene's mortal husband, Amphitryon. The story was that Herakles was sent to the bard Linos to learn music and poetry. The role of student did not suit him, and one day, irked beyond endurance, he gave rein (not for the last time) to his ungovernable temper and picking up his stool brained the professor; the beginning of troubles which were to end only on the pyre at Oeta. There are several pictures of the murder, one on a cup by Douris in Munich,[159] later and weaker than the school-scene; but the Pistoxenos Painter has chosen to tell the story indirectly. While the good boy Iphikles is taking his lesson, Herakles (fig. 164) is on his way to school, wrapped in his mantle and using a staff in the form of a huge arrow. Behind him his old slave, named Geropso,

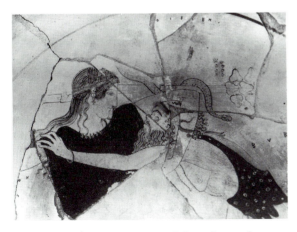

Fig. 163. Cup-fragment; Pistoxenos Painter. Satyr and maenad. L. of detail *c.* 0.18.

Fig. 164. Skyphos with name of *poietes* Pistoxenos; Pistoxenos Painter. Herakles on the way to school. H. *c.* 0.15.

carries his lyre and supports her steps on a crooked stick.

The ambience is of fifth-century Athens, but the artist has done more than write heroic names by the figures. He has given Herakles the traditional big, round eye;[160] and this, with his curly head and his proud carriage, sets him off against the foil of the smooth, conformist Iphikles. The staff in the form of an arrow seems to have been an Athenian fashion of the time; but here it is surely chosen for its suitability in the hand of the person portrayed.

The drawing of the eyes suggests that this vase is still rather early in the artist's work. The gap-toothed, wrinkled face of the old slave is a step in realism beyond anything we have seen.

Other red-figure pieces, besides cups, include a bobbin and a pyxis.[161] The pyxis is a box for toiletries, which takes a number of forms. We noticed one by Makron which he perhaps signed.[162] It often has scenes from women's life. so Makron's; also the Pistoxenos Painter's, only the lid of that has hares at play; a pleasing departure from custom.

A considerable body of cups is placed in the painter's neighbourhood, and as we have seen they are almost certainly products of a single workshop. Individual hands are distinguished, the best of them the Tarquinia Painter,[163] but he is of little distinction. His most important piece is a white-ground cup in London with the making of Anesidora; so the figure is named, but it is evidently a version of the Pandora myth. The style is a harsh version of the Pistoxenos Painter's. Other white-ground pieces are placed in the Pistoxenos Painter's neighbourhood. Magnificent fragments from the Heraion of Samos (with Herakles) and in Boston (with Odysseus and Diomedes) (fig. 165) must be by one hand and are called by Beazley 'akin to those of the Pistoxenos Painter.[164] I suppose they are probably his

Fig. 165. Cup-fragment; Pistoxenos Painter or very near him. L. of fragment *c.* 0.20. Odysseus and Diomedes.

own, and the style links back interestingly to the white cups around Onesimos. Another beautiful white cup, which we have already glanced at, was found in the temple of Aphaia on Aigina and is in Munich.[165] It shows Europa on the bull. Beazley did not attribute it, but Schefold suggested that it is the Pistoxenos Painter's, and Williams has supported the attribution with strong arguments.

One more white cup is undoubtedly his, and his masterpiece. It was found in a grave at Camiros on Rhodes and is in the British Museum.[166] It is rather smaller than the others, and its potting relates it not to those with the name of Euphronios but to some decorated by the Penthesilea Painter and his companions. It is plain black outside. As with the Taranto and Athens cups a ring not far within the rim circles the picture. This is omitted on the Berlin cup, but that has a short chord under the feet of the figures. We do not know if this feature was present on the other two; there is none on the London cup, where the single figure floats free in air: Aphrodite riding a goose (fig. 166). She carries a tendrilled flower, and her feet are sandalled. Goddess and bird are drawn in modulated golden lines of dilute black. Her himation, and the borders of her chiton at neck and ankle, are purple, and a maeander in yellow-white is added on the chiton-borders. This is one of the most exquisite pieces of coloured drawing on a white ground we have in vase-painting, and it must surely bring us very close indeed to contemporary painting on panel.

The eye is drawn as in the death of Orpheus, and the perfect classicality confirms that this is not among the painter's early works. Strong traces remain of preliminary sketch; and these show that the artist once meant to draw the face in three-quarter view.[167] We may be glad that he changed his mind, for it is some time yet before vase-painters master that; and without the serene profile this picture would not satisfy as it does.

The cup bears the inscription *Glaukon kalos*. This appears also on the early white-ground cup in Berlin as well as on a red-figure cup in the same collection, and probably was written also on the Taranto and Athens cups though only . . . *on* now remains (with the signa of *kalos* at Taranto). The name appears on a lekythos in the painter's manner and a cup by the Tarquinia Painter, as well as on pieces from other workshops: a dozen vases, most white lekythoi, by or near the Providence Painter; red-figure by the Nikon Painter and other minor figures of the time; a white lekythos by the Timokrates Painter;[168] other lekythoi unascribed. On several the name of Glaukon's father is given: Leagros.[169]

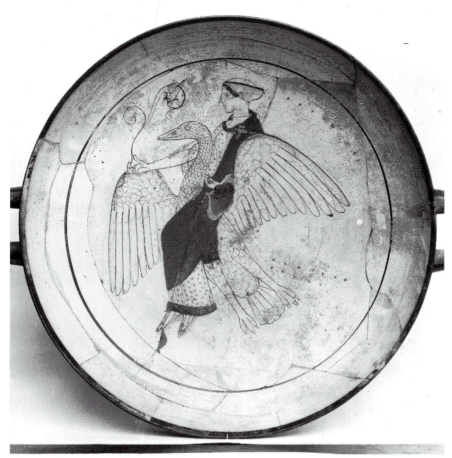

Fig. 166. Cup; Pistoxenos Painter. Aphrodite on a goose. D. *c.* 0.24.

5

Early classical

I. Cup-painters

a. The Penthesilea Painter and his workshop

The group of artists round the Pistoxenos Painter prob-
ably formed a single workshop, derived from one
dominated by the Antiphon Painter and leading on to
the Penthesilea Painter's. In this last case the inter-
relationships of different painters in the group make
it certain that some at least of them sat together in
one establishment; so the term 'workshop' here is at
last certainly justified. The styles of the Pistoxenos
and Penthesilea Painters are closely related. Indeed
Hartwig and Furtwängler believed that the *oeuvre* of the
'Pistoxenos Painter' was really the early work of the
Penthesilea. Beazley separated them; and Diepolder,
who wrote a monograph on the Penthesilea Painter
as Furtwängler conceived him, later came round to
Beazley's opinion.[1] In this case I have virtually no doubt
that Beazley's separation of the two personalities is
correct.

The Penthesilea Painter takes his name from the
tondo-picture of an exceptionally large cup, in Munich.[2]
A Greek is dealing the death-blow to a collapsing
Amazon (fig. 167). Another Amazon lies dead. A
second Greek storms past. Within a narrow ivy-strand
frame the picture occupies the whole big circle, so that
the figures are exceptionally large for a vase-painting,
especially a cup-painting. We have seen that to fill the
whole width of the bowl, uncommon in red-figure, is
rather the rule in white-ground. The artist here (he
works in white-ground too) has borrowed from that
technique the use of washes of added colour: different
shades of red for the Amazon's chiton and the Greek's
cloak. The colour-scheme of white-ground is certainly
nearer that of wall and panel painting than is red-figure.
In spite of that Attic vase-painters cling to the decorative
principle of silhouette embodied in red-figure. They
keep white-ground for special purposes, never on
a large scale, and it is in red-figure that the direct
influence of wall-painting is sometimes evident. Two

Amazonomachies painted on Athenian walls in these
years survived to be seen by Pausanias seven hundred
years later; and we shall be looking at designs on large
pots which seem directly imitated from those com-
positions. The picture on the Munich cup is clearly not
precisely that. The design is conceived for the circular
field, the figures twisted to fit the tondo. Nevertheless it
is not only the borrowing of some polychromy from the
white-ground palette that sets this off from the red-
figure norm. Though the dead Amazon lies curved along
the rim while the principal one, down on one knee,
presses her foot against it and her killer bends to keep
within its upper edge, still the figures have a bigness and
power quite exceptional in vase-painting. The painter
had surely looked at the new art and absorbed and made
his own something of its spirit.

After Hector's death, Queen Penthesilea brought her
Amazons to Troy to succour Priam. She too was killed
by Achilles, but as he felled her he loved her. Doubt has
sometimes been expressed whether this twist was pre-
sent in the early epic where this story was told, but
without reason. I feel sure that the notion of love in
death was in the mind of the artist who conceived this
picture. The identity of the figures, however, is still not
quite certain. An Attic story of the love of Theseus and
the Amazon Antiope existed in several versions, and one
seems to have taken a form like this.

A not much smaller cup, likewise in Munich,[3] again
has a picture which occupies the whole breadth of the
bowl: Apollo killing Tityos who has assaulted Leto. The
action has some of the force, the figures the bigness, of
the Penthesilea picture; but there is nothing here like the
complexity of Achilles's action, his shield-arm shifted
behind his back as he bends to thrust his sword down
into the Amazon's breast, which gives such concentra-
tion and power to the picture. That is beyond anything
attempted by the Pioneers or their successors. The
composition of the Tityos picture is simpler, and there is
no polychromy. By itself it would not lead one to look
for inspiration outside the tradition of vase-painting.

The pictures on the outsides of both these cups are

Fig. 167. Cup; Penthesilea Painter. Amazonomachy (probably Achilles and Penthesilea). D. *c.* 0.46.

clearly by the same hand as the tondos, but they are different in character from those, scenes from daily life, simply composed and drawn without much care. Both show youths: on the Penthesilea cup arming, with horses; on the other in conversation with boys. These derive very evidently from the everyday cups of the Pistoxenos Painter, as those do from Antiphontic and Onesiman cups. However, though we do seem to have before us successive phases of a workshop, it is also true that there is a change of character in this last phase. If one counts up the vases listed in Beazley's chapters on Onesimos and the Antiphon Painter, and throws in those in that on the Colmar Painter, one will hardly get to 500, and only about a dozen painters are distinguished (though more has been done since within the Antiphon Group). In that on the Pistoxenos Painter and his Group there are fewer than 250 vases and nine named painters. The chapter 'The Penthesilea Painter

and his workshop' contains some 1,500 vases and twenty named painters. It is true that this phase of the workshop seems to have lasted a long time, perhaps about as long as its previous history from the Eleusis Painter and the Proto-Panaetian Group to the Pistoxenos Painter and his companions. In absolute dates the earlier phases may be supposed to have lasted from around 500 into the sixties, the Penthesilean from the sixties till well down the third quarter of the century. In any case it looks as though production were stepped up,[4] and another new characteristic points the same way.

We have noticed cases of collaboration between two painters on one vase, but they are in general rare. In the Penthesilean workshop nearly forty examples have been observed, involving at least ten painters.[5] When Beazley first noticed the phenomenon, he knew of no case in which the Penthesilea Painter himself took part, but one

appeared later. In a cup from Spina the tondo has a picture of Zeus seizing Ganymede, big figures which fill the whole bowl.[6] This is certainly the master's work, though the drawing is exceptionally mannered. The youths and men with horses on the exterior, however, are by the most distinguished of his associates, known as the Splanchnopt Painter from a picture of a man inspecting sacrificial entrails for omens (*splanchnoptes*).[7] When this artist collaborates with another member of the shop he takes the tondo, the other the exterior. On several occasions this is the Painter of Brussels R 330; on another the Painter of Bologna 417, who on other occasions paints exteriors for tondos by the Painter of Brussels R 330.[8] Clearly the tondo is the most valued space (as also in the great cups in Munich, entirely by the Penthesilea Painter), and one can detect a pecking order among the painters. It does not seem to be applied quite consistently, but at the lower end of the scale of quality the Curtius Painter,[9] a peculiarly farouche hack, decorates exteriors for a good many others but nobody does an exterior for him.

In one case the collaboration is different. In a cup from the Agora the tondo (two women) and exterior (youths and women) are by the Painter of Bologna 417, while in a zone round the tondo the story of Eos and Kephalos is put in by the Painter of London E 777, who also does an exterior for the Painter of Brussels R 330 and has an exterior done for him by the Curtius Painter.[10] We noticed a figured zone circling the tondo on the great early Panaetian cup in the Getty with the Iliupersis. We shall meet other examples.[11] One of the Penthesilea Painter's own greatest cups has this feature; and on this, if there is any distinction of quality between the different areas, the pictures on the exterior seem the grandest.

This is a huge cup from Spina,[12] the largest kylix we have. Because of the surrounding zone the tondo is relatively small, though still bigger than most. The figures in the zone are smaller, and the largest are those on the exterior. The drawing throughout is superb. Within the rim is an olive-wreath; between zone and tondo a ring of palmettes. In the zone are the deeds of Theseus, shown in a continuous circle, more episodes than usual, seventeen human figures and Minotaur, bull and sow as well as trees and rocks. In the beautiful tondo are two youths, naked but for short cloaks and elaborate fillets tied round their heads, carrying each a pair of spears. They are approaching an altar, one on horseback and leading a second horse, the other walking at his side. One thinks of the Dioskouroi, but they and Theseus were no friends. Possible alternatives are Theseus himself with Perithoos, or the two sons of Theseus.

On the outside an area at the junction of bowl and stem is reserved with black rays, exceptional treatment for a cup of exceptional size. Not far above this comes the interrupted maeander below the pictures, leaving an unusual height for the figure-scenes and the palmette-complexes at the handles which divide them. The pictures are from the Trojan war. On one side (fig. 168)

Fig. 168. Cup; Penthesilea Painter. Quarrel of Ajax and Odysseus. H. of picture *c.* 0.20.

the quarrel for the arms of Achilles follows the lines of the archaic composition (Douris, the Brygos Painter[13]) but with a bigger, roomier effect. The two heroes are opposite views of one model-pose, something we noted in the heroes on an amphora by the Kleophrades Painter and the jumpers on a Pioneer pelike.[14] We are more often in this time reminded of the Pioneers than we are in the intervening period. The relation of the profile left leg and rear-view right leg of Ajax picks up Pioneer ideas; and the figure of a hero restraining Odysseus carries them further. He has his knees sharply bent, and the way the right buttock and receding thigh are drawn is a new attempt to master the third dimension. Further, his head is in back view, both ears seen but a trace of cheek below the left, an approach to a *profil perdu*.[15]

There are ten figures in this composition, eight on the other side (fig. 169), which is the most impressive of all. A victorious warrior moves to the left (the reverse of the usual direction, but there are other examples) and

thrusts his spear down at another, already on his knees, collapsing. Between them a winged goddess moves to the left, looking back at the victor but her hands seeking the victim. At either side, two behind the victor, three behind the other, are bearded men and youths in civil garb, looking on and showing (most markedly those on the left) signs of grief. They must be thought of as watching the fight from the wall of Troy. Alfieri, publishing the cup, sees the scene as Iris successfully intervening to save the wounded Hector from Ajax. This may be right (though in the Iliad it is Athena who steps in), but the despairing faces and gestures of the figures behind the stricken warrior suggest to me rather that his wound is mortal. With Simon and Beazley I see this as Eos come to her dying son, whose body she will carry away as we see in Douris's cup-tondo.[16]

The mourners are among the most moving figures in vase-painting. One thinks of the old seer in the west gable at Olympia, and of the figures Pausanias evokes

Fig. 169. Other side of 168: detail, Trojans mourning Memnon's fall.

163

for us from Polygnotos's Underworld: Hector, clasping his knee with an expression of sorrow; Memnon resting his hand on the shoulder of Sarpedon who sits with his face sunk on his hands. If we compare the figures of grief on the cup with the differently effective ones in the Kleophrades Painter's Iliupersis, we see what a world of expression is being opened. These are tragic in a new sense; and we remember that this is the time of Aeschylus in his prime and the young Sophocles.

Many of the painter's cups are hastily and conventionally drawn, the kind of thing turned out most of the time by most of his companions. The Pan Painter often draws no more carefully, but he seldom loses the spark, becomes mechanical, in the way the Penthesilea Painter does. I do not know if this is related to the fact that the Pan Painter seems a clear example of a free-lance decorator, the other the leading painter in a single workshop which was seemingly organised to facilitate a production line.

The painter adorned other shapes than cups in red-figure: skyphoi and cup-skyphoi, kantharoi, a bobbin, an askos in the shape of a lobster claw (a fancy of the time; there are others from the workshop);[17] one hydria. These are generally better than the poorer cups, but none is a masterpiece. A skyphos in Boston[18] is interesting. On the front (the back has satyrs and a maenad) two Pans start back as a goddess emerges from the ground (fig. 170). The birth of Aphrodite from the sea, and similar figures rising from the ground, become a frequent theme in this time. The identity of the goddess coming out of the ground varies. Sometimes it is certainly Persephone; but on a poor rough pelike in Rhodes

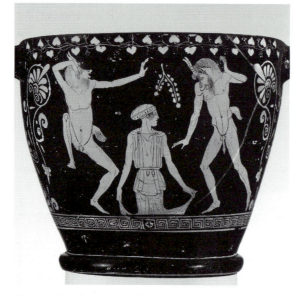

Fig. 170. Skyphos; Penthesilea Painter. Pans startled by rising goddess. H. *c.* 0.23.

she is named Aphrodite.[19] In a more complicated scene the rising figure is inscribed Pandora; and the same type of half-figure is used, on some pieces we shall meet later, for Ge, the Earth herself.[20]

On a ruined but attractive white-ground pyxis in Ancona[21] by the Splanchnopt Painter, Aphrodite does not confront us as she rises magically, but is shown in profile coming up to meet Eros who greets her on the shore, as he did on the base of Pheidias's Zeus at Olympia. An unusually pretty red-figure vase of the same shape, in New York, by another Penthesilean, the Wedding Painter (of whom Beazley writes, 'approaches the Splanchnopt Painter'), shows the goddess already emerged running to meet Eros, and here she is drawn on a smaller scale than the other figures, as though a child.[22]

The white-ground pyxis is a fashion of this time. Others are ascribed to the Splanchnopt Painter and further members of the workshop, with domestic or wedding-scenes;[23] and a fine one in New York[24] appears in the later versions of the Penthesilea Painter's own list. The history of its attribution is interesting. Swindler gave it to the artist in 1915, but Beazley first wrote that, though it certainly resembled his work, 'I cannot persuade myself that it is from his hand.'[25] He connected it with a white pyxis in London showing a wedding, and described them as 'akin to the work of the Sotades Painter'.[26] In *AV* he listed those two and a fragment from the Acropolis as by one hand and related to the London Anesidora cup (then called just 'manner of the Pistoxenos Painter', the Tarquinia Painter not yet being defined).[27] In *ARV*[1] he gives the New York pyxis to the Penthesilea Painter, and with it the Ancona pyxis, though he here first defines the Splanchnopt Painter from a core of pieces previously listed as 'manner of the Penthesilea Painter and very near him'.[28] He gives him the London wedding pyxis and the Acropolis fragment, and both of these remain his. These hesitations do not lead me to doubt the reality of either the Penthesilea Painter or the Penthesilea Workshop. They only underline the peculiar difficulties in the study of a large workshop, untypically organised and with a strong 'house style' imposed by the leading painter.

The New York pyxis (fig. 171) has the Judgement of Paris, and it is amusing to compare it to Makron's version.[29] The fairy-story atmosphere is dissipated; these are very down-to-earth people. Paris sits on a rock, a bearded man of uncertain identity behind him, and takes his instructions from Hermes. Hera and Athena confront one another, while Aphrodite stands apart, chatting with Eros. The rock on which Paris sits is interestingly modelled with some attempt at naturalism; contrast the calligraphic stylisation with which the Pan Painter likes to render such outcrops.

There are pretty white bobbins (fig. 172) by the

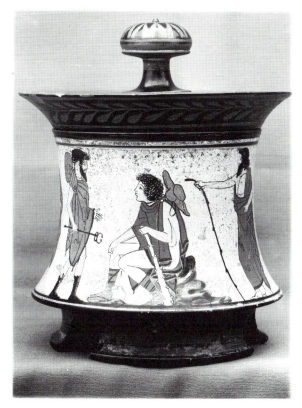

Fig. 171. Pyxis; Penthesilea Painter. Judgement of Paris. H. *c.* 0.17.

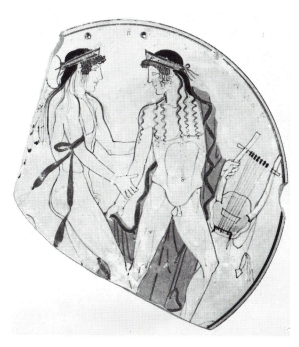

Fig. 172. Bobbin; Penthesilea Painter. Zephyros and Hyakinthos. D. *c.* 0.13.

Penthesilea Painter too, but no white cup. It would be no surprise to find one. There is a white covered cup (a shape we will discuss later) by the Splanchnopt Painter;[30] but the white cup is going out of fashion. The Pistoxenos Painter, its greatest master, seems to be the last to specialise in it.

Two splendid red-figure pieces need a mention, but their status is not clear. One, cup-fragments from the Acropolis,[31] had an arming-scene on the exterior, but little remains of it. In the tondo, within an olive-wreath, the picture occupied the whole field. In the centre, fronting us but with her face turned to her proper right, are the remains of a hieratic figure in a long chiton. She has no armour or aegis, on her long hair a stephane, not a helmet, and the top of the staff she holds is missing; but an olive-spray, an owl perched in it, grows from the frame on her proper left, so she can only be Athena. Below the olive a long-haired child, olive-wreathed and with a cloak over the shoulders, drinks from a phiale; a most unusual action. There must have been another figure on the other side towards whom Athena was looking. The child resembles the child on the central slab of the east frieze of the Parthenon; and there is surely here too some allusion to ritual.[32]

In *ARV*[1] Beazley listed this, with a cup in London, under the observation: 'The general character of these two cups is Penthesilean'; but he dropped it from later lists (the London cup, which has no close connection with the Athens fragments, he placed in 'Workshop of the Penthesilea Painter: Undetermined'). Others have given it to the painter himself. The drawing is extremely fine, unusually neat for the painter, nearest perhaps to the Spina Ganymede cup. The olive-wreath border is differently drawn in the two, but it is different again in the huge Spina cup, to which also the Athens fragments have some resemblance.

The second marginal piece is a big calyx-krater in Bologna[33] with an Amazonomachy (figs. 173 and 174). It is one of a good many large kraters with this subject which evidently reflect, in some degree and in varying ways, the influence of the contemporary wall-paintings in Athens. We shall be considering several of these vases later.[34] The Bologna calyx is one of the finest, and does not go closely with any of the others. Furtwängler attributed it to the Penthesilea Painter, and Bothmer listed detailed points of likeness. Beazley placed it by itself, after his Penthesilea Painter list, noting these facts but not making an attribution. Whereas many of the big pots with battle-scenes seem to take over directly elements conceived for wall-painting, the splendid composition circling this krater is kept, like that of the Penthesilea cup, strictly within the traditional bounds of vase-painting design. I should like to think Furtwängler was right.

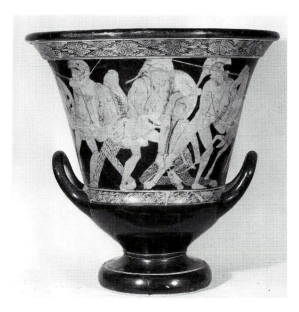

Figs. 173 and 174. Calyx-krater; perhaps Penthesilea Painter. Amazonomachy. H. *c.* 0.55.

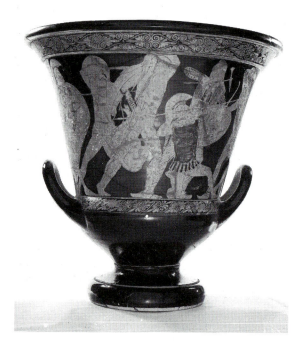

b. Various: the Akestorides Painter; the Sabouroff Painter

It seems clear that the Penthesilean workshop continued in production deep into the fully classical age. The later work of these craftsmen, however, is of no significance for the history of art: mechanical repetition of formulae established in the early classical. Another important workshop runs parallel with this, but its development is different. We noticed in the last chapter the followers of Douris in the phase of transition from archaic to classical.[35] The line continues (surely a single workshop, though less demonstrably so than the Penthesilean), and a major figure appears at its centre, the Euaion Painter. He seems to begin about the same time as the Penthesilea Painter, but his style develops as he works on into the fully classical age, and important later painters seem to take their start from him. He is indeed an essentially classical artist, and we will consider him in the next chapter.[36] Among the companions of his youth, however, one deserves mention here: the Akestorides Painter.[37]

Early and late the painters of this group tend to concentrate on scenes of daily life; and their drawing is often smooth to the point of dullness, academic. The Akestorides Painter endows the same subjects and the same quiet style of drawing with unusual life and charm. On a small cup in New York, decorated inside only (fig. 175), a boy sits by an altar, a haunch from the sacrifice hanging above it, and plays a lyre, lifting his face to sing. The name Akestorides, written beside him, is found with *kalos* on other vases of the time. Here it must identify the boy.[38]

The Akestorides Painter has left us two school-pictures, and in both of them a scroll held by a boy is inscribed. We noticed the hexameter inscribed on a scroll held by a teacher on Douris's cup in Berlin. Between that, which belongs to the painter's middle period, and the Akestorides Painter's pieces, comes a lekythos in a private collection, with a picture in a style

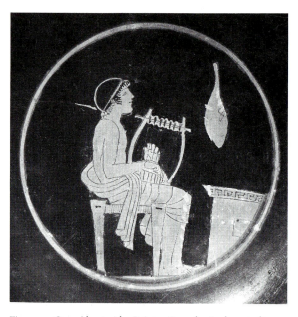

Fig. 175. Cup; Akestorides Painter. Boy playing lyre at altar. D. *c.* 0.08.

166

related to late Douris. Here a boy sits in a chair, his writing-case hanging on the wall, and holds on his knees a scroll inscribed with the beginning of a hymn to Hermes.[39] One of the Akestorides Painter's inscribed scrolls is on the exterior of a cup in Washington.[40] One of the schoolboys sits holding a scroll and bends his head to read it. It too is inscribed with the first words of a hexameter line. On the interior of a cup in the Getty (Bareiss Collection)[41] the upper part of a similar figure is preserved, and the scroll reads, in prose: 'The companions of Herakles: Iolaos'. There was not room for the last letter of the name; and in the actual text represented it must have been followed by others: Telamon, no doubt; probably Iphikles; perhaps Hyllos and Philoktetes; possibly Theseus. About six hundred years later the Latin treatise on mythology which goes under the name of Hyginus (itself thought to have been a school-book) is arranged under headings of just this kind. It is fascinating to glimpse an Athenian schoolboy of the fifth century B.C. already learning his mythology from such a handbook.

These two workshops, the Penthesilean and the Dourian, were perhaps the principal producers of cups in the early classical period, but there were others. The tiny white cups of Sotades and the Sotades Painter belong to this time, but we will look at them, with the other products of that extraordinary partnership (or person) in a separate section.[42] The followers of Makron cannot be traced far, but the Amphitrite Painter, whom we noticed in the last chapter because of his association with Hieron, belongs rather to the phase we are now considering. Beazley lists him in a miscellaneous chapter which includes also the Boot, Stieglitz and Lyandros Painters and a few hacks.[43] Of one of these, the Painter of Würzburg 487, he says that he is a follower of the late archaic Colmar Painter;[44] of another, the Painter of Louvre G 456, that his late cups (originally collected as work of a 'Painter of Naples 2610') are contemporary with the cups of the Eretria Painter.[45] That very good artist worked from the third into the last quarter of the fifth century: another reminder of how painters and workshops overlap periods.

A cup in Munich,[46] with unimportant pictures in red-figure on the outside, has a white tondo (fig. 176). The picture, in the usual way, occupies the whole interior: a single figure, carefully drawn and of great beauty. Hera, her name beside her, stands holding a knotted sceptre, a diadem on her fair hair, her mantle close-wrapped about her in the manner of the great early classical statue of Europa known as 'Amelung's goddess'.[47] This cup is of the same time and spirit as the Pistoxenos Painter's mature white cups, and of no less quality, but the hand is different. The artist, the Sabouroff Painter,[48] worked mainly in red-figure at a fairly low level. About sixty red-figure cups are ascribed to him, a high proportion of

them from early in his career, as the Hera is. A mention here of the white cup would suffice if this were all, but the artist produced also more than two hundred pots, in a variety of shapes. Of his many lekythoi the majority (more than a hundred) are white ground and, like the white cup, of much higher quality than his red-figure work. He is a figure of importance in the development of the classical white lekythos. He also provided subsidiary pictures for a red-figure loutrophoros, the main scene on which is the work of the Achilles Painter, one of the great vase-painters of the high classical age and himself another leader in the development of the white lekythos. We shall return to the Sabouroff Painter in these connections in the next chapter.[49]

The potting of the Hera cup, and of some of the artist's red-figured cups, has been ascribed by Bloesch to a follower of the potter who made the cups inscribed with the name of the *poietes* Brygos. In another section we shall meet other white cups which seem to have a Brygan connection.[50]

II. Skyphos-painters: the Lewis Painter and his circle

We have noticed skyphoi before, masterpieces among them,[51] but this is the first time we find ourselves defining a painter by his specialising in the shape. The skyphos became a popular drinking-vessel in Athens far back in the sixth century, and a number of black-figure practitioners, from the early Komast Group to the late Heron Class, make a speciality of the shape in one or other of its forms.[52] It is most extensively produced, however, in plain black,[53] and the use by red-figure painters in the archaic period of the skyphos (and of the cup-skyphos, which goes with it) is occasional. We saw that in the time of change from archaic to classical a *poietes* Pistoxenos, who had himself been active as a red-figure painter and continued to work with red-figure painters, seems to have specialised in the production of skyphoi and cup-skyphoi.[54] Whether or not there is any direct link between Pistoxenos the *poietes* and the Lewis Painter (a question which I do not think has been studied), both are examples of a new interest in the shape at this time. It never, though, became a popular form with red-figure painters. Aside from the hacks who turned out the little owl-skyphoi ('a present from Athens'),[55] the only specialists in it are the Lewis Painter, his follower in the high classical time the Penelope Painter,[56] and minor artists who worked with them. The Euaion Painter and his circle show some interest in the shape, and to an early member, the Euaichme Painter,[57] seven have been attributed; about half his small output. It is interesting that Beazley notes of one small group which he lists in the Lewis Painter's chapter that they are close to him but also to the Euaion Painter.[58]

Fig. 176. Cup; Sabouroff Painter. Hera. D. *c.* 0.27.

The Lewis Painter was named after an owner of one of his skyphoi; but after he had become known by this appellation vases from his hand appeared which bore signatures, first a fragmentary, then a complete one: *Polygnotos egrapsen*.[59] It is more convenient to keep the made-up name because the signature of Polygnotos has long been known on several vases by a leading pot-painter of the high classical age.[60] It is further found on one vase ascribed to a late Mannerist, known as the Nausicaa Painter.[61] It is often suggested that the vase-painters called themselves by the name of the great wall-painter, Polygnotos of Thasos, whose work in Athens may begin as early as the time of the Lewis Painter. We shall revert to this question when we come to the classical pot-painter.[62] In his case I find another explanation more plausible; but both the Nausicaa and Lewis Painters show an interest in subjects foreign to the red-figure tradition and perhaps inspired by wall-painting, so the suggestion may be true of them.

All the skyphoi ascribed to the Lewis Painter are of Type A, and there is no vase of any other shape in his list, but the skyphoi vary in size and elaboration. The smaller have a single figure on either side and often no handle-florals. Some of the larger also have one or both of these characteristics, but the more elaborate have two figures in each picture and a palmette-and-tendril complex at each handle. In this 'four-sided' decoration they resemble the Pistoxenos vase in Schwerin,[63] and the handle-complex of that vase is of the same general character as the Lewis Painter's.

Very occasionally the Lewis Painter puts more than two figures in a picture. A vase with ruined surface in Berlin,[64] which looks early, has no handle-floral. On one side Nike pours wine for seated Hera, and on the other a little girl stands between two standing women; an unexplained subject. On a closely related piece in Vienna,[65] one side of which shows Athena reaching an olive-spray towards Theseus who turns as he moves away, the other has two women and two children (fig. 177). One woman holds out a little boy, and both this

168

child and another slightly bigger boy who stands in front of her turn their faces and outstretched hands to another woman, named Nymphe, who reaches out her arms to them. This is interpreted, surely rightly, as Ariadne handing over her children by Theseus, Demophon and Akamas, to the care of a Nymph. The subject has not been recognised elsewhere in vase-painting, and the compositions are unusual. This could well be a case of influence from wall-painting.

The artist's drawing is neat but stiff, generally rather dull. He is more lively on some smaller pieces. Two, without handle-ornament, show basically the same scene: a winged girl in short chiton leaps out from behind a bare tree-stump rising from rough ground, to pursue a boy who, on the other side, runs away looking back. There are differences, however. On one in Schwerin[66] the evidently young boy is neat, a ribbon round his hair, wears his mantle over both shoulders and arms, and runs past a stele. His pursuer's hair too has a ribbon round it and lies on her neck. On the other, in Naples,[67] the youth looks older, has a short cloak slung over one arm and carries a pair of spears, out hunting or travelling. The winged girl has an unbound head of wild hair, bristling up and back.

The boy on the Schwerin vase has *kalos* beside him, the girl *kale* (on the Naples vase only *kal*.. remains by the girl). Ignoring this, and the breast which in neither case is very pronounced, some scholars have interpreted both pictures as Zephyros pursuing Hyakinthos; but it seems to me quite certain that a girl is intended on both vases. Smith suggested that both show Eos, in Naples pursuing Kephalos, in Schwerin Tithonos. This is attractive, but the short chiton would be very odd for Eos, the

rough head in Naples even odder. The hair of Boreas is commonly drawn in this way, and his sons are often shown winged like himself. Schefold brilliantly suggested his daughter Chione for the pursuer on both vases.[68] However, Boreas had another daughter (both by Oreithyia), Kleopatra, of whose tragic fate Sophocles has the chorus remind Antigone in a lovely song. They speak of her wild girlhood in Thrace: 'Boread, horse-like over the foot-steep crag, gods' child'. I should like to think that both the painter of the Naples vase and the poet had a wall-painting of the young Kleopatra in mind. The Schwerin vase perhaps does show Eos and Tithonos, the unusual elements being borrowed from the new treatment brought in with the new subject.

The subject of Zephyros and Hyakinthos (Hyakinthos, as often, riding a swan), is found, on a larger skyphos, with handle-florals, in Vienna. This Beazley first gave to the Lewis Painter. Smith detached it, with a few others, as work of a 'Zephyros Painter', and Beazley accepted this.[69] The style is perhaps a little harsher, more farouche, than the Lewis Painter's usual but, as both Smith and Beazley noted, very like and quite as good. It is not clear to me that these pieces are certainly the work of a different hand; possibly rather the same man in another mood.

Another member of the group, the Agathon Painter, takes his name from a vase in Berlin which he decorated, exceptionally not a skyphos but a pyxis.[70] This bears the name of a *poietes* Agathon, not recorded elsewhere. None of the others need concern us until we come to the Lewis Painter's more interesting pupil and successor in the high classical age, the Penelope Painter.

III. Pot-painters

a. The Villa Giulia Painter

A fragmentary calyx-krater in the Villa Giulia[71] is circled with a ring-dance of women holding hands. The composition is simpler than that of the Syriskos Painter's Mykonos lebes,[72] the movement slower; the whole effect quieter, less dynamic. The drawing, competent, careful but not stiff or dull, has a quiet charm, and the same character suffuses other work ascribed to the same artist. Beazley qualified him as 'academic' (a word he also applied on occasion to the Copenhagen and Syriskos Painters) and connected him with the followers of Douris. There is certainly a likeness of feeling; but such quiet 'academicism' is one expression of the classical spirit, and it is not necessary to postulate a close connection between all artists who conform to it. Recent research has suggested a different root for the Villa Giulia Painter's art.

Some good white cups, not known to Beazley but clearly attributable to this painter, have been con-

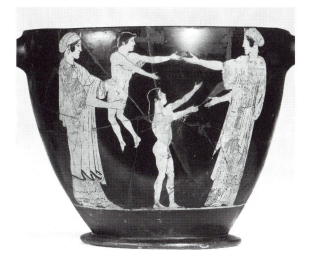

Fig. 177. Skyphos; Lewis Painter. Ariadne handing her sons by Theseus to a Nymph. H. *c.* 0.16.

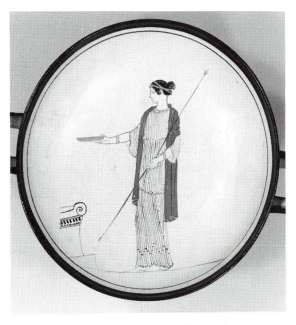

Fig. 178. Cup; Villa Giulia Painter. Goddess at altar. D. *c.* 0.25.

vincingly linked to the Brygan tradition;[73] and I do not find it difficult to suppose that the artist's red-figure work might derive from the 'mild Brygan' style exemplified in the work of the Dokimasia Painter. A good example of the Villa Giulia Painter's white cups is one in New York,[74] with a goddess at altar (fig. 178). The red-figure exterior, with a *komos*, is exactly as in a group of cups entirely in red-figure put together as this painter's work by Beazley.[75] He did know of one white piece, a dedication on the Acropolis;[76] but though attributable it is a tiny scrap which tells little of the painter's white-ground style.

It is conceivable that the little white cup from the Agora[77] with the lyre-playing boy might find a place early in this line; and another white-ground piece which Beazley found it difficult to place most probably belongs later in it. We will come back to this question after we have looked a little further at the Villa Giulia Painter's red-figure.[78] We noticed that the Sabouroff Painter seems to have put all his art into his white-ground drawing, content to remain just an artisan in red-figure.[79] The Villa Giulia Painter is not like that. He did work on other shapes in white-ground: lekythoi, alabastra, and there are fragments of two white calyx-kraters; but he is always first and foremost a red-figure painter.

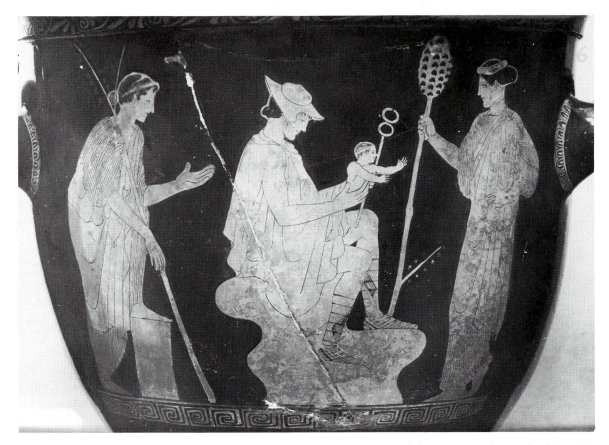

Fig. 179. Bell-krater; Villa Giulia Painter. Hermes giving baby Dionysos to the nymphs of Nysa. H. of picture *c.* 0.20.

He decorated many shapes, but his preference seems to be for calyx and bell-kraters and especially stamnoi. There are narrative scenes: Perseus prepares to kill Medusa on several bell-kraters,[80] but more often we find quiet assemblies (fig. 179). Several of the stamnoi have a subject found also on stamnoi by other painters now and later: a rustic image of Dionysos with women busy about it.[81] They are maenads; not maenads as we have seen them before, possessed by the divinity, but ordinary women still, making quiet preparation for the festival.

We may cite two pictures in Cambridge to illustrate the painter's range. One is a slight but lively piece of drawing on a kalpis.[82] The picture is on the body and is unframed: three figures, the witch Medea cozening the daughters of Pelias into killing their old father with the promise of raising him to life again in renewed youth (fig. 180). At one side Medea stands with drawn sword and gestures as she talks. One daughter, standing frontal to us, has a phiale balanced on her raised left hand. She looks at Medea and lifts her right hand to her face in a movement of distress. The other darts away, arms out in a gesture of alarm, and looks back towards the sorceress. Her face is in three-quarter view, better mastered than earlier but still clumsy. The shocking moment is vividly conveyed.

The other piece, much larger and more careful, shows the painter's style at its noblest. Fragmentary (it comes from Naucratis), it is a big cylinder, thick-walled and with only two bands of black inside, evidently the support for some very large vessel; lebes or dinos.[83] The picture shows an assembly of gods: Apollo with *kithara*, Artemis with bow, Hermes with *kerykeion*, Dionysos with thyrsos and ivy-branch, a goddess without emblem who is probably Leto. The two goddesses and Apollo hold also phialai; and between Apollo and Artemis stands a wreathed boy with a jug, surely Ganymede (fig. 181). The upper part is lost, with all the heads but the boy's; but the quality transcends the condition, and the tall still figures convey a powerful sense of occasion. This character is hardly found again in the artist's work, but is to be seen, together with a tenderness the older

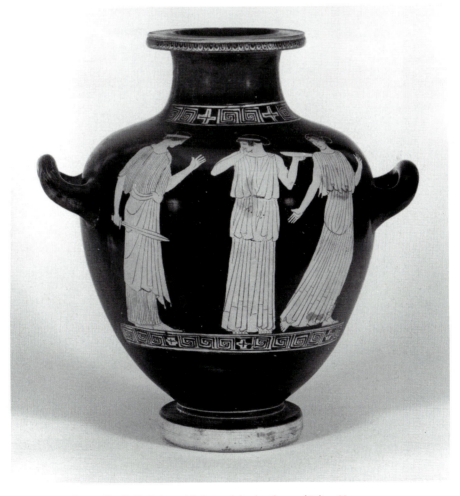

Fig. 180. Hydria; Villa Giulia Painter. Medea and the daughters of Pelias. H. *c.* 0.29.

Fig. 181. Stand; Villa Giulia Painter. Olympian assembly. H. as preserved *c.* 0.29.

artist does not show, in the style of his greater pupil the Chicago Painter.

Beazley listed the Chicago Painter's work in the same 'Early Classical' chapter as the Villa Giulia Painter, and elsewhere discusses them together. The close link indeed is evident; but I see the Chicago Painter as a central figure of the high classical, and put off discussion of him to the next chapter.[84] Beazley himself put two other painters, whom he describes as connected with this group, into a later chapter: the Eupolis and Danae Painters.[85] One more, however, he lists early: the Methyse Painter, to whom he ascribes a dozen pieces, with half a dozen more as probably his.[86] He calls him

'akin to the Chicago Painter', and it would not entirely surprise me if these attractive pieces turned out to be an early phase of that artist's work.

Among the vases 'probably' by the Methyse Painter are very beautiful fragments in Cincinnati[87] of a white calyx-krater with Helen and Paris (fig. 182); and the drawing on these reminds me of that on another white cup, in Boston.[88] The white picture-area on this is not the interior of the bowl but the slightly domed surface of a cover. A dozen or so such cups exist, with a cover which was no doubt thrown separately but then attached, so that it forms part of the finished vessel. A small orifice is left for drinking, sometimes as here

Fig. 182. Calyx-krater fragments; probably by the Methyse Painter. Aphrodite with Helen and Paris. H. of large fragment *c*. 0.13.

with a grating. Nearly half of these cups, which are all Attic, are white-ground or red-figure of roughly this time (there is a fragment of a red-figured example by the Pistoxenos Painter, of a white-ground by the Splanchnopt Painter).[89] The rest are black-figure, ranging over a considerable time but all earlier than this. The tondo of the Boston cup is surrounded by an olive-wreath in red-figure, and a summarily drawn running woman in red-figure occupies each exterior face of the bowl.

Beazley thought the red-figure pictures resembled the later work of the Carlsruhe Painter (a prolific hack who produced lekythoi in both techniques and whom we shall touch on in another section), and remarked that he

Fig. 183. Covered cup; circle of the Villa Giulia Painter. Apollo and Muse. D. of picture *c*. 0.11.

could not be sure that the tondo, though much finer, was not by the same hand as those.[90] Whoever painted the red-figure, I find it impossible to believe that the exquisite white-ground tondo (fig. 183) is the Carlsruhe Painter's. Apollo stands frontal, his naked body set off by a purple-red cloak, and looks down at a Muse, in a red-brown dress, who sits on a rock, a lyre in her left hand, right elbow on knee, hand to chin, looking up at the god. A narrow exergue below the figures is cut off by a band of running key, but their feet do not reach it. The Muse is up on her rock, indicated in lines of thinned glaze, and such a line runs irregularly under Apollo's feet: the first tentative attempt we have met at detaching the figures from the base-line and setting them in a landscape. From this time on we shall see more of the same thing, and it certainly reflects, sometimes in a more evident way, an interest of contemporary wall-painters.

The hand to the chin is a favourite gesture of the time, modified in various ways and with varied meanings. The quick movement of the Peliad on the Cambridge hydria marks distress. Often, especially when the elbow rests on the knee as the Muse's does it seems to imply deep contemplation: she is receiving the god's inspiration. At other times the contemplation is tinged with grief, or with foreboding as in the greatest rendering of the gesture: the old seer in the west gable at Olympia. This gesture is something we shall meet again.

b. Followers of the Berlin Painter: the Providence Painter; Hermonax

The Berlin Painter evidently exerted a wide general influence, but several artists can clearly be seen to model their style of drawing directly on his and can be supposed to have learnt it by sitting with him. The latest and greatest of these, the Achilles Painter, can be seen already at work in this early classical time; but he

is a central figure and formative power in high classical vase-painting and we will treat him in the next chapter.[91] Two other artists of quality belong entirely to the earlier phase: the Providence Painter, and Hermonax.

The Providence Painter takes his name from a handsome big neck-amphora with twisted handles in Providence, Rhode Island.[92] Apollo stands with *kithara* and phiale (fig. 184); on the other side a woman or goddess with phiale and oinochoe. This neck-amphora goes with the series decorated by the Berlin Painter in his middle period; and it must have been in that phase, perhaps in the decade after the repulse of Xerxes's invasion, that the Providence Painter learned from the Berlin Painter.

Fig. 184. Neck-amphora; Providence Painter. Apollo. H. *c.* 0.51.

We noticed that the Berlin Painter, though primarily a decorator of large pots, was the first important artist to popularise in red-figure the smaller neck-amphorae (Nolans and doubleens) and lekythoi. The Providence Painter, though a few large pots like the name-piece testify to his ability on this scale, evidently concentrated almost exclusively on the production of smaller vessels. In the next section we shall glance at some of the minor craftsmen who in this period specialised in small neck-amphorae in red-figure, lekythoi and alabastra in red-figure, white-ground and black-figure. It would have been quite proper to have treated the Providence Painter with these. He no doubt had an influence among them; but he is an artist in quite a different class. Moreover he has a place which needs defining in the important line which runs from the Pioneers through the Berlin Painter to the Achilles and Phiale Painters; and it is interesting to compare and contrast him with Hermonax.

Among the things which the Providence Painter derived from the Berlin Painter and adhered to throughout his career is a preference for the distinctive symmetrical maeander-design, ULFA.[93] This, with the unchanging closeness of his figure-drawing and composition to the Berlin Painter's, leads me to think that he remained in the workshop, keeping up the standard of production in smaller pots, against the decline in the master's own later work, until the Achilles Painter takes over. Unlike his master, but like most lekythos-painters of this younger generation, he sometimes uses white ground with outline drawing on his smaller lekythoi. He takes no part, however, in the evolution of the white-ground funeral lekythos, with distinctive iconography and technique. We shall find other painters of this time working towards it; and at a later date the Achilles Painter takes it over and makes it a major line in this workshop's production.

It is a surprise to find the Providence Painter decorating a number of cups, a shape which both the Berlin and Achilles Painters appear to have rejected utterly. There are more by Hermonax; but Hermonax appears in many ways a special case in this circle.[94]

Character of figurework and Morellian detail make it clear that Hermonax, no less than the Providence and Achilles Painters, was trained by the Berlin Painter; but there are other things which suggest that his relation to master and workshop was different from theirs. Hermonax does not use ULFA, nor does he show any special fondness for the dotted saltire which is the favourite pattern-square in that; nor does he draw his maeander-borders with the neatness which the Berlin Painter, and those who adopt ULFA from him, affect. He does produce many small neck-amphorae and lekythoi, and these, apart from the maeander borders, have a strong affinity with those of the others. However, he is primarily a painter of large vases; and all his

Fig. 185. Pelike signed by Hermonax as painter. Thebans round the Sphinx. H. *c.* 0.40.

signatures (with the exception of one on the white-ground interior of a tantalising cup-fragment from Brauron[95]) are on big pots of two shapes: stamnos and pelike. Of these the stamnos is favoured by both the Berlin Painter and the Achilles Painter (and there are half a dozen by the Providence Painter), but the pelike (especially the large pelike) is relatively rare in their work. Moreover, particularly on his large pelikai (fig. 185), Hermonax likes to add zones of pattern in a way quite foreign to the Berlin Painter's tradition, and to mass his figures so that spread drapery leaves little room for black background.

This last recalls Makron's practice on some vases.[96] Pfuhl postulated an influence from Makron on

Hermonax, and Beazley agreed.[97] It is interesting that Hermonax's individual way of drawing the profile eye, which gives his faces great charm, is most nearly paralleled in the work of the Amphitrite Painter who, as we saw, may have some connection with the tradition of Makron.[98] We have already noticed that Hermonax painted a good many cups; and his taste for writing his name (Beazley knew ten signatures and more have appeared since) further distances him from the Berlin/Achilles tradition and aligns him rather with the cup-painters. All this suggests to me that, once he had learned to draw from the Berlin Painter, Hermonax

left the shop and went his own way, absorbing other influences.

Hermonax is a good and individual draughtsman. His smaller work is often attractive and his larger has sometimes real power. He likes pursuit-scenes (Boreas and Oreithyia; Eos and one or other of her mortal loves; youth, perhaps Theseus, and woman), but quiet ones too, as the Theban elders and Oedipus around the Sphinx. One cup shows a surprising congress of sirens: one in the tondo, three each on either exterior face. Another cup of similar make and pattern-work has owls disposed in the same way, and is surely his too, though

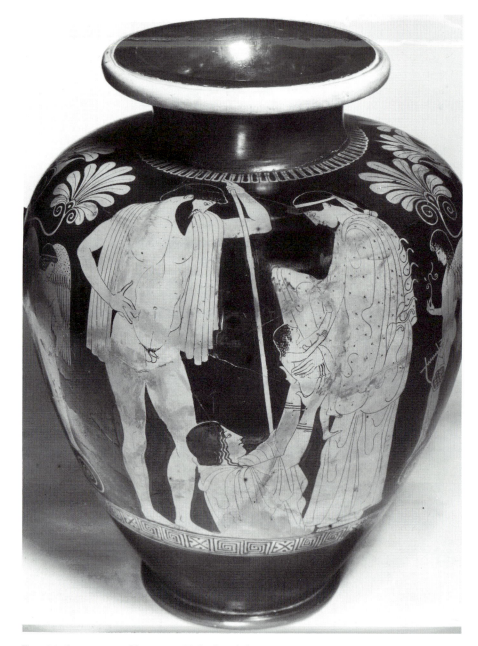

Fig. 186. Stamnos; near Hermonax. Birth of Erichthonios. H. *c.* 0.39.

Morellian parallels are lacking.[99] He had followers, and a group of a dozen or so large pelikai and stamnoi is evidently the work of one hand, the 'Painter of the Birth of Athena': graceless imitations of the master.[100]

Quite different is the case of a stamnos in Munich.[101] This used to be ascribed to Hermonax. If his, it is unquestionably his masterpiece; but Pallottino put forward strong arguments against the attribution and Beazley accepted them and withdrew it from the canon, together with a fragment from another stamnos which must be by the same hand.[102] The Munich vase is a stamnos of special form, rather high for its breadth, with a narrow tall neck (like two of the Berlin Painter's from his middle period, but less exaggerated than those[103]). Like many stamnoi it has 'four-sided' decoration: that is, the florals at the handle occupy as much of the pot-surface as the figure-pictures. In this case the effect is enhanced by the way that, at either side of each floral, under the outermost palmette, a winged boy stands on a tendril-curl. These four Erotes both belong to the floral and, at the same time, frame the figure-scenes.

On one side Zeus sits enthroned, his left hand up on his sceptre, his right holding out a phiale. Before him a winged goddess, Nike or Iris, stands frontally. Her left

Fig. 187. Detail of 186: Ge with Erichthonios.

arm and hand are muffled in her himation while the right hangs at her side and the hand, half hidden behind the god, can be thought of as holding a jug. The two figures form a single light block with very little background. Zeus may be thought of as here to approve the action in the picture on the other side (figs. 186 and 187) which concerns the birth of Erichthonios.

In this curious myth Hephaistos attempted to rape Athena, but she avoided him and his seed fell and impregnated Ge (Earth). Ge in due time gave birth to a boy. Athena acknowledged the divine child; and he, as Erichthonios, became king of Athens. The rendering on this vase is paralleled in other fifth-century Athenian works including, it seems, the marble relief-base in the temple of Hephaistos, which supported bronze statues by Alkamenes of Hephaistos and Athena and which is probably copied in two Roman reliefs.[104] On the vase Ge is a half-figure emerging from the ground; but not, like Persephone or Aphrodite, about to issue forth. She rises only far enough to reach the child up to Athena who, bare-headed and unarmed, stoops to take him and wrap him in her aegis. He stretches his arms out to her. Behind Ge Hephaistos stands three-quarter frontal and looks down at the child. His left hand is high on the staff on which he leans, his right on his hip. The hand on hip (a favourite early classical pose) is echoed in the Eros behind him, even to the extended forefinger. It is the boy's left hand, though; with his right he steadies himself on the tendril by holding a loop of it. The Eros behind the winged goddess on the other side does the same with his left, extending his open right. The other two keep their balance without hands. The one behind Zeus plays a lyre. The one behind Athena holds his lyre at his side and lifts a flower in his other hand to smell it.

The Erotes's faces, and Erichthonios's, are very much in Hermonax's style; those of the large figures less so, and the wavy, curling lines in the drapery are untypical. I do not think this vase is Hermonax's, but the artist must have been close to him in the circle of the Berlin Painter. In the next chapter we shall meet vases which have points of resemblance to this, and will consider the possibility that we have here an early work of a master of that time.[105]

In its combination of grandeur and charm, gravity and grace, this is perhaps the most perfect embodiment in vase-painting of the early classical spirit.

c. Small pots: red-figure, black-figure, outline

A number of artists in this time specialise in small neck-amphorae and lekythoi, like the Providence Painter, but none approach his quality. Among the better are the Oionokles, Nikon and Charmides Painters, all called after *kalos*-names they favour.[106] The Oionokles Painter certainly learned to draw from the Providence Painter. His style is harsher, coarser, but quite strong.

He does not use ULFA, and I should guess that he got his training in the Berlin Painter's workshop but did not stay there. For relative chronology the free use of *kalos*-names among these craftsmen is of some interest. Nikon, Charmides, Kallias, Kallikles, Hippon and Timoxenos appear on vases by the Providence, Oionokles, Nikon and Charmides Painters and those of a hack, the Dresden Painter;[107] not all are present on works by all, but it would be no surprise to find any combination. More interesting are a few contacts further afield. The Oionokles Painter praises Akestorides, whom we met in an earlier section and shall meet again in a moment.[108] Nikon appears also on a vase attributed to the Villa Giulia Painter and one said to recall the Alkimachos Painter;[109] Hippon on a lekythos classed as near the Pan Painter;[110] Charmides on a Nolan from the following of Douris and on a cup by the Cat-and-Dog Painter, a minor figure in the Pistoxenos Painter's circle.[111] Finally Glaukon, son of Leagros, whom we saw praised by the Pistoxenos Painter and others of his circle appears also on vases of the Providence and Nikon Painters and of two to be mentioned shortly, the Painter of the Yale Lekythos and the Timokrates Painter.

There are plenty more of these more or less indifferent craftsmen who produce the same range of shapes as well as sometimes oinochoai. A few venture from time to time on larger pots, the Painter of the Yale Lekythos, for instance, who decorates in addition some skyphoi and the odd cup-skyphos and cup.[112] We noticed his cup-skyphos in an earlier chapter. A large number of others concentrate almost exclusively on lekythoi and other oil-flasks or scent-bottles, especially alabastra but also squat lekythoi (the shape becomes popular at this time) and the occasional aryballos; the quality generally low. Some of the late archaic practitioners mentioned in an earlier chapter worked on into this time; so the Bowdoin Painter.[113]

One lekythos of the time may be mentioned as a curiosity. It has many more figures than are normal on the shape: Apollo, Artemis, Leto and Hermes on the body; on the shoulder two flying Nikai; a third on the neck; and it bears the signature of a painter Mys. This is one of those ethnic names we have spoken of. It was borne also by a famous engraver of metal-work who was active in Athens rather later.[114] The drawing is more careful than some, but nothing else by the same hand has been recognised.

I mentioned that the Bowdoin Painter may be identical with the black-figure Athena Painter, and some of the black-figure painters of the earlier phase certainly worked into this. The prolific Haimon Workshop[115] surely did so, and from it seems to have developed the last lekythos-workshop to produce figurework in a distinctive black-figure style, that of the Beldam Painter.[116] He takes his name from a very unpleasant picture on a

lekythos in Athens of satyrs torturing an old woman. He likes sadistic subjects (another lekythos in Athens shows bound prisoners being cast into the sea[117]), but he is a better draughtsman, when he bothers, than many of his red-figure contemporaries. Many of his lekythoi are white-slipped, and he occasionally drew on them in outline. One red-figure lekythos in Copenhagen was made in his workshop, and the drawing is thought to be his too.[118] The Carlsruhe Painter,[119] mentioned in an earlier section as a producer of lekythoi in red-figure and in outline on a white ground, is associated with the Beldam Workshop.

With the Beldam and Emporion Painters and other lingerers the bulk production of bad black-figure comes to an end. I have wondered if the apparent sudden expansion of the 'Euphronios Workshop' in the time of the Penthesilea Painter may reflect this change.[120] Did the workshop owner close down a previous line in black-figure and turn the potters and painters involved over to bulk production of bad red-figure kylikes?

The Beldam Painter favours a form of lekythos with a peculiar and ugly mouth-form, the so-called 'chimney lekythos' used also in the Haimon Workshop and by the Emporion Painter,[121] rarely elsewhere. The Beldam Painter's lekythoi often have false interiors, something found frequently later in the great funeral white lekythoi.[122] It was apparently so that an impressive show of big lekythoi, apparently full of oil, could be put on at a funeral with the minimum of actual expense. The iconography of some of these lekythoi by the Beldam Painter is funerary; and funerary iconography becomes regular at this time in the work of some decorators of lekythoi in outline on a white ground.

Of these the Tymbos Painter and his circle are producers of miserable hackwork,[123] but there are a few of better quality. The most significant is the Timokrates Painter (he uses also the *kalos*-names Akestorides, Alkimachos and Glaukon), whom Beazley saw as having a relation to the Pistoxenos Painter.[124] There are also small groups, the Vouni and Lupoli Painters,[125] the first at least related to the Timokrates; and others rather larger, the Painter of Athens 1826 and the Inscription Painter (put together by Buschor as one painter, separated by Beazley).[126] None of these is an interesting artist, except the Timokrates Painter, the best of whose figures are full of charm (fig. 188); but their work is quite careful and they stand at the beginning of a great tradition. Quite often figures are shown at a tomb; and, even when they are not, preparations for a visit to the tomb are perhaps implied; a question we shall come back to.

We noticed on white lekythoi by the Brygos and Pan Painters that a second white, purer than the creamy off-white of the ground, is used for a woman's skin and other elements.[127] This is found, for women's skin and

for stelai, on the vases we are now considering, and still on many that we shall meet in the next chapter. It is very rare on white cups or pyxides; and I have thought its presence on lekythoi due to their close dependence on black-figure tradition. It is, however, often found on the relatively rare white calyx-kraters (though not on the Methyse Painter's fragments),[128] where that explanation does not apply.

Fig. 188. Lekythos; Timokrates Painter. Mother and maid with baby. H. *c*. 0.38.

Fig. 189. Cup; Hesiod Painter. Muse tuning her *kithara*. D. *c*. 0.14.

The craftsmen considered in this section range from the decent journeyman down to the hack. There is one contemporary painter of small pots who is one of the greatest ever to work in the Kerameikos: the Sotades Painter; but he, and the moulder-potter with whom he worked (surely identical with the *poietes* Sotades whose name appears on many of their pieces) stand so much apart from any others that they must be given separate treatment.[129] We may close this section, though, with a glance at pleasanter work than the lekythoi: three little white vases grouped together under the name of the Hesiod Painter.[130] A pyxis in Boston shows a cowherd meeting the Muses. Hesiod describes how, while herding his cattle, he was met by the Muses on Mt Helikon. His name was therefore given to the painter; but since then a papyrus-fragment has turned up with an account by Archilochos of the same thing happening to him. There may have been others, and without an inscription we cannot be sure whom the painter meant. Clearly by the same hand are two delicate little cups in the Louvre, their surface better preserved than the pyxis. Each shows a Muse. One stands playing her *kithara*. The other sits, bending over hers to tune it (figs. 189 and 190). The artist has drawn the face of the standing Muse in three-quarter view, and succeeded better than some; but her sister, shown in profile, is still the prettier.

179

Fig. 190. Cup; Hesiod Painter. Muse with *kithara*. D. *c.* 0.14.

d. The Niobid Painter and his Group

The artists in this section are among the most important of the period, less for their drawing, which is often unsubtle, than because on some major pieces they unquestionably reflect, at times almost certainly copy, works with which the great wall-painters of the time were revolutionising the art of painting. In doing so they make apparent a crisis in the art of vase-painting. In the turbulence of the late sixth century, the revolution which swept away the conventions of archaic art seems to have been spear-headed by sculptors. The painters clearly went along with it, but their innovations were 'sculptural' rather than 'pictorial'; that is, they concerned almost exclusively the rendering of the individual figure in action or repose, hardly at all the organisation of figures in space. While draughtsmen looked no further than this, decorators of pots were at no particular disadvantage; and we saw how the Pioneers seemed to feel themselves a living part of the new movement. The isolation of figures silhouetted against shiny black raises no problem while the new interest in three-dimensionality is confined to the individual figure. When painters begin to be concerned to relate figures not simply as elements in the decoration of a surface but as representations of people having their being in a three-dimensional world, a problem does arise; and that change is certainly one which the great wall-painters of this time were making.

The above is a simplification. Miss Haspels long ago pointed to a 'pictorial' character in much late black-figure, from the Antimenes Painter, through the Leagros Group, to the Beldam Painter, contrasting with the 'sculptural' character of contemporary red-figure.[131] At times figures are made relatively small, elements of their setting enlarged and multiplied; at others they are massed together, so that great parts of individuals are not seen. No doubt these experiments reflect things in contemporary wall-painting (indeed we have an example in the Tomba del Tuffatore[132]), which red-figure artists for the most part ignored, though there are exceptions (the Siren Painter's name-vase, the Kleomelos Painter's siege-cup.[133]) When, however, Polygnotos and Mikon intellectualised the new interest in space by the specific device of setting figures at different levels up and down the surface of the wall to suggest recession, they opened a road which led on to shading, highlighting, perspective: European painting. Here a real conflict develops for the vase-painter, whose primary concern must remain the decoration of his pot-surface. For long a compromise remained possible. Much of the time many wall-painters, and particularly panel-painters, no doubt went on producing work which departed little from traditional character. Most vase-painters all the time, and all most of the time, did the same; and their work is often still of great beauty. From now on, however, the most experimental vase-painting no longer seems, as the work of the Pioneers did, a living part of art's progress but an imitation in an ill-adapted medium; and this leads to an ultimate decline in absolute quality.

The painters of the Niobid Group adhere most of the time to traditional methods of composition; but the Niobid Painter himself and some of his companions occasionally, in elaborate pieces, attempt to reproduce the new wall-painting. The classic example is a big calyx-krater in the Louvre (figs. 191 and 192), the Niobid Painter's name-vase.[134] The picture of Apollo and Artemis shooting down the children of Niobe was certainly meant by the painter as the back of the vase. The subject is taken for the painter's name because there is no agreement on what story he meant in the more elaborate and many-figured picture on the front. On both sides the figures are set up and down the field, and wavy lines added in white (now largely faded) indicate rising broken ground. Figures stand on these lines, and some are partly concealed behind them.

Six figures make up the Niobid picture. Apollo, the largest on the vase, high up in the centre, draws his bow, and Artemis, behind him, takes an arrow from her quiver. In front of Apollo, but higher up (further back) grows a tree. A girl and a boy lie dead, an arrow in the back, beneath the feet of goddess and god respectively; and to right and left another boy collapses, each clutching at an arrow. The dead son is partly hidden by the ground; and in front of him another arrow is shown,

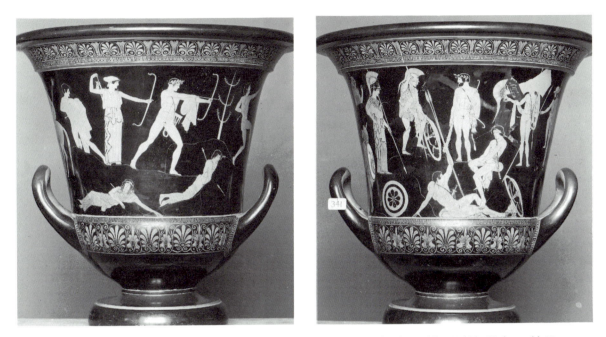

Figs. 191 and 192. Calyx-krater; Niobid painter. Slaughter of the Niobids; Underworld. H. *c.* 0.53.

cut by a fold of the hill. This surely indicates another dead child, completely hidden: one arrow only is shown in each victim; the divine marksmen cannot miss.

On the other side the picture extends above the handles and contains eleven divine or human figures, as well as a horse. Near the centre, corresponding to Apollo but on a slightly smaller scale, Herakles stands frontal, looking towards the taller figure of Athena who stands lower down but her helmet-crest reaches almost to the top border. She looks in the hero's direction, but between them a warrior stands on the uneven ground, at a slightly higher level than Herakles. His knees are bent, and he leans on his spear and bends forward, gazing earnestly in the hero's face. He wears a helmet (the cheek-piece makes it uncertain whether he is bearded), short chiton with a cloak wound round him, sword-belt over shoulder, and greaves, and holds his shield resting on the ground. The other eight figures are all warriors girt with swords. Most striking are two naked youths in the centre, below Herakles. One sits on his cloak, his right knee lifted and clasped by his right hand, his face in three-quarter view. His spear leans behind him, and on the base-line below are his shield and helmet. The other youth reclines on his cloak along the base-line, resting on his right hand reached back, left high on two spears, and looks up at his companion, who seems to gaze into the distance. The recliner has a travelling hat slung on his back, and his shield leans behind him. Beyond it a bearded warrior in helmet and cloak, shield on arm, spear on shoulder, turns his back on the scene and looks up at a naked youth on higher ground over

the handle. A round helmet is slung behind his shoulder. Between him and Athena the upper part of an armoured youth appears above a fold in the ground, on a slightly smaller scale, back to us but looking towards the centre, hand raised in a wondering gesture. Above and behind the seated youth another naked youth stands frontal, holding out an elaborate helmet. Behind him a bearded warrior in chiton and cloak stands with one foot up, and behind him, over the handle, a naked youth in a round helmet stands by his horse.

I will not go into the many interpretations suggested for this scene, since I believe that the correct answer was found some years ago by Barron.[135] He first observed that the six naked torsos all have an extra division in the musculature of the belly. This is not found in the Apollo on the other side, nor elsewhere in the painter's work; which strongly suggests that he is here copying a picture by another. Moreover the same feature is found in two pictures on a vase by one of the Niobid Painter's companions, the Painter of the Woolly Satyrs,[136] who again employs it only here. The vase is a volute-krater in New York (figs. 193 and 194), Amazonomachy on the body, Centauromachy on the neck; and in the case of the Centauromachy there is independent evidence for believing it copied from another work. Figures and groups which appear here are found again in vase-paintings by other artists and also in the west pediment of the temple of Zeus at Olympia (completed by 456 B.C.), a composition with strong pictorial elements. These are the first Centauromachies which show the fight as a brawl at the wedding-feast of Perithoos, and they surely all go

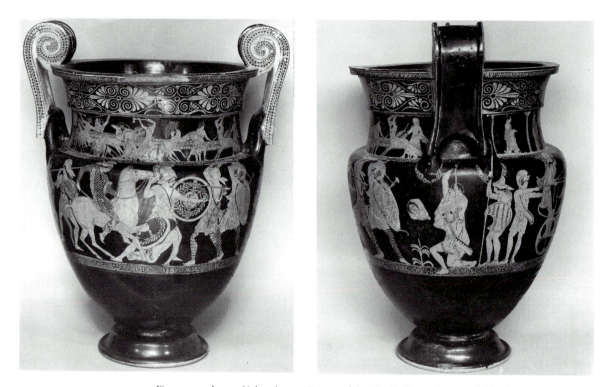

Figs. 193 and 194. Volute-krater; Painter of the Woolly Satyrs. Front and side views: Amazonomachy; Centauromachy on front of neck. H. *c.* 0.63.

back to one original. This is likely to have been a wall-painting in Athens, and we can probably identify it.

When Kimon conquered the island of Skyros in 474–3 B.C., a skeleton was found there which was identified as Theseus's. In accord with an oracle from Apollo in Delphi he brought the bones to Athens and built over them a shrine adorned with paintings. Pausanias[137] describes three, on three walls: Amazonomachy, Centauromachy, Theseus under the sea. He goes on to tell various tales of Theseus's end, without any clear relevance unless there was a picture related to that theme on the fourth wall. It is often supposed that there must be a lacuna in the text and that Pausanias described such a picture. A famous story, briefly alluded to by Pausanias at the beginning of his digression, told how Theseus accompanied his friend Perithoos into the Underworld to help him carry off its queen, Persephone; how they were caught, and remained there till Herakles came down to carry off Cerberus. Herakles was allowed to free Theseus, but not Perithoos.

That this is the subject of the Niobid Painter's picture is very plausible. Theseus will be the splendid figure at the bottom; Perithoos his seated companion. The rest are dead heroes, the two over the handles surely the Dioscuri. Athena should not properly set foot in Hades, but in archaic pictures of Herakles seizing Cerberus

he is commonly accompanied by Hermes or Athena or both.[138] The little half-figure behind her is surely conceived as glimpsing the Underworld from outside: probably Herakles's faithful companion Iolaos. In Polygnotos's many-figured Underworld at Delphi, as it appears to us in Pausanias's detailed description,[139] almost all the characters are dead, but Odysseus and two companions are living men looking in on it.

The presumption then is that figures and groups in this picture and in the Amazonomachy and Centauromachy on the vase by the Painter of the Woolly Satyrs are copied from pictures on three walls of the Theseion, shown by the anatomical oddity to have been all by one man. Pausanias refers to Mikon as author of the fourth scene, Theseus at the bottom of the sea;[140] but whether the others were his or Polygnotos's we cannot know. The groupings in the Niobid Painter's Underworld, and the mood which informs it, are extraordinarily like what Pausanias's description of Polygnotos's Underworld at Delphi evokes, but that was a vastly larger and more complex composition. The picture in the Theseion is likely to have been smaller and simpler than that, but the vase-painting surely does not give its whole composition. The way the main groups are placed between the handles while other figures are set above them shows how the vase-painter, not the

wall-painter, constructs his picture; but he nevertheless bases his design on the principles employed in the new wall-paintings.

The Centauromachies in the shallow fields of a volute-krater neck and a pediment are by the nature of their settings bound to a single base-line. The Amazonomachy on the body of the volute-krater does show broken ground, some figures partly hidden in its folds, but the feet of most are not far above the lower border and their heads reach to near the upper. The same is true of an Amazonomachy on a calyx-krater found with the volute-krater at Numana (near Ancona) and decorated by another companion of the Niobid Painter, the Painter of the Berlin Hydria;[141] also, seemingly, of a fragmentary volute-krater body with a Centauromachy by the Niobid Painter himself.[142] This treatment keeps the compositions closer to vase-painting tradition than those on the Niobid Painter's name-vase; but it may in fact also reflect the wall-painters' different approach to different subjects.

The two paintings of this time described in detail by Pausanias, Polygnotos's 'Troy Taken'[143] and 'Under-world' in the Lesche of the Cnidians at Delphi, both showed almost exclusively still figures, alone or in groups, set up and down the field. A taste for stillness is one aspect of early classical art; and, while figures in action can be interwoven interestingly in a surface plane (as countless archaic battles show) to make a large composition of still figures and groups exciting, there is immense advantage in setting them up and down the field, so that they interlock and glances can meet across heads (meeting looks are often referred to in the descriptions). What Pausanias says of the 'Battle of Marathon'[144] (of uncertain authorship) in the Stoa Poikile at Athens is compatible with its being a relatively traditional, frieze-like construction, like the battles on the vases. The slaughter of the Niobids is technically a scene of action, but in character far closer to the other type. The deities stand still to loose their shafts; the victims collapse dying or lie dead. Similar seems Pausanias's report of a picture by Polygnotos in a temple at Plataea as 'Odysseus having already made an end of the suitors'.[145]

Our craftsmen were of course ceramists working in a ceramic tradition, and what they take from wall-painting they adapt to their own purpose. The silhouetting shiny black ground is totally at odds with even this primitive approach to a surrounding space; and most of their work is traditional in composition too. No Morellian links, implying a master–pupil relation, have been observed with any late archaic or transitional group, but there are other connections. The potting of oinochoai decorated by the Berlin Painter and the Niobid Painter is similar;[146] and the florals on two

stamnoi by the Berlin Painter's late pupil the Achilles Painter are Niobidean.[147] In a more general way, the fact that all their most important work is on big kraters, bell, calyx and especially volute, shows them heirs to a tradition we noticed developing, perhaps from Kleophradean origins, in the circles of the Syriskos, Oreithyia and Boreas Painters.[148]

The oldest-seeming member of the group is the Altamura Painter, whom Beazley calls the Niobid Painter's 'elder brother'.[149] His quieter pieces have some charm, but more ambitious efforts (a Gigantomachy on a volute-krater in London from Altamura which gives him his name; an Iliupersis on a calyx-krater in Boston) tend to be heavy and empty. Good examples of his nicer style are a volute-krater and a bell-krater from Spina with related subjects.[150] On the first Zeus hands the infant Dionysos to the Nymphs of Nysa to nurture; on the other (fig. 195) a bearded Dionysos, enthroned, has his own son Oinopion on his knee, on either side a woman, one perhaps the child's mother Ariadne. Fragments of another bell-krater have heads of deities drawn with unusual finesse and of great beauty.[151]

Five of the artist's bell-kraters[152] are of the early type with lugs, moulded foot and simple black rim (it is interesting that there is just such another by the Oreithyia Painter[153]), but the Oinopion vase has handles instead of lugs and jutting mouldings with ovolo at top and bottom of the rim. The Niobid Painter has only one with lugs,[154] half a dozen with handles, and nearly as many more are ascribed to his manner.[155] One of his handled pieces, an early work in Bologna,[156] is just like the Altamura Painter's. The rest have out-turned rim with laurel-wreath and plain disc foot. There are several of just the same type by the Villa Giulia Painter, though sometimes he prefers on the rim a running palmette-chain which he uses also on rims of calyx-kraters.[157] The bell-krater in this form, laurel on lip, sometimes a moulding with ovolo below, becomes popular from now on, gradually the most popular krater-shape in the Attic repertory, a position it maintains to the end. The range of quality is great. We shall meet masterpieces; but the run of late fifth- and fourth-century bell-kraters are among the most charmless examples of hack production to survive from the ancient world.

The Niobid Painter's drawing is like the Altamura Painter's but in general better. He has not the sure command of expressive or harmonious line which seems the particular achievement of the best red-figure; but his early work often has a charm which his colleague only achieves rarely, and in his masterpiece, the Louvre krater, he rises to the challenge of making effective vase-decoration from the wall-painter's creation. The very complex pose of the warrior between Athena and Herakles was no doubt present in the model, but the

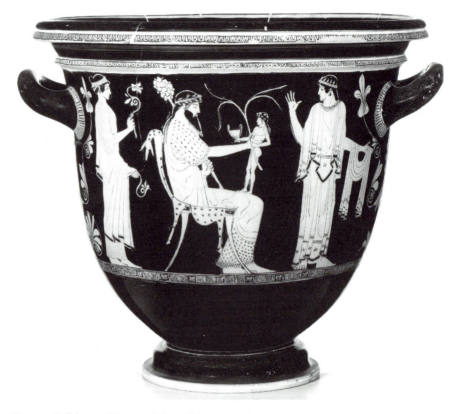

Fig. 195. Bell-krater; Altamura Painter. Dionysos with Oinopion on his knee. H. *c.* 0.45.

vase-painter has managed it well. It shows the same advance on Pioneer experiments that we noticed in the Achilles on the Penthesilea cup.

Three of the Niobid Painter's volute-kraters have Amazonomachies, big battles all round the body.[158] The Amazonomachy in the same position by the Painter of the Woolly Satyrs takes from its wall-painting model not only the irregular ground-line but some extra-ordinarily contorted poses: a fallen Greek seen from behind, twisted under his shield; an Amazon collapsing forward, speared from over her shoulder by a Greek who rises from behind a fold in the ground. The Niobid Painter in his battles avoids such things, adapting the wall-painters' concepts to vase-painting tradition. These are not his most successful efforts. Like the Altamura Painter he seems happier in quiet scenes. His battles and his sacks of Troy lack fire.[159] It is interesting that the two most effective and powerful of these battle vases, conceived in awareness of the wall-paintings, are not by members of the group and depart not at all from vase-conventions. Both are calyx-kraters with Amazonomachies. One in Bologna we have already noticed as being near, if not by, the Penthesilea Painter. The other, in Ferrara, is early work of the Achilles Painter.[160]

The figures on the volute-krater necks are of course on a small scale; and that these artists sometimes chose such a scale for preference is shown by a new fashion in calyx-krater decoration. Three or four of this shape, two complete, by the Niobid Painter,[161] and one by a follower, the Geneva Painter,[162] are girdled by a maeander-band; a picture circling the vase above, and below a separate picture on each side. There is a fragment of such a vase by the Villa Giulia Painter,[163] and a good many from various workshops later in the century. The Gigantomachy round one from Spina by the Niobid Painter is rather livelier than his larger-scale battles. The Geneva Painter has an Amazonomachy in this position. Figures like a mounted Amazon seen in foreshortening from the back show the influence of the wall-paintings, but he is a comically bad draughtsman; unless indeed to be funny was his intention.

The standard of draughtsmanship among the Niobid Painter's followers is uniformly low. The battle on the calyx-krater in New York by the Painter of the Berlin Hydria,[164] a mêlée round an Amazon on horseback seen directly from in front, suggests an interesting model but the handling is weak and dull. Two or three vases put together as a 'Painter of Bologna 279'[165] show the same mixture. The most interesting, a volute-krater from

184

Spina,[166], has on one side the last fight of the seven against Thebes. The six combats are set out in two overlapping tiers, and in the centre front Amphiaraos and his charioteer are swallowed in the earth with their team. On the other side, shown as the front by the way it embraces the areas under the handles, twenty male figures, mostly defined as warriors, are likewise arranged in two overlapping tiers, those in front being slightly smaller. Most stand in pairs, and most hold olive-sprays up to one another, but there is considerable variety. At the centre top sits Athena, a spray raised in each hand, and a warrior, travelling hat on neck, bare head wreathed, leans on his spear and looks at her. This is another subject which is hard to interpret, but it is very probable that it has to do with the Theban story.

Each of these two pictures suggests an interesting wall-composition clumsily cramped into an area of vase-surface. The contrast with the effectively adapted designs on the Niobid Painter's name-vase is most marked; and the drawing is correspondingly coarse and weak.

The best of the circle, after the Niobid Painter, is the Painter of the Woolly Satyrs.[167] His style is sometimes uncouth, but it has vigour. He likes odd subjects and treats them interestingly. A bell-krater (with handles) in Syracuse,[168] from which he takes his name, has Dionysos and a woman shooing two shaggy satyrs out of a building; a unique scene, perhaps from a satyr-play. A calyx-krater in Palermo[169] has another puzzle. Herakles sits naked and despondent-looking beside the corpse of the lion, while another figure, wearing the lion-skin, stands before a king (Eurystheus?). One thinks of the fairy-story in which the dragon-slayer is almost cheated of the princess's hand by an impostor who finds the carrion and brings the head to the king. There, if I remember, the true hero had cut out the tongue and so is able to prove his claim; but I know no such story in antiquity.

Nothing in outline on a white ground is ascribed to any of these painters. This seems odd in view of their concern with wall-painting, which must in colouring and effect have been much closer to white-ground than to red-figure. The answer perhaps lies in the kind of pot they choose to decorate; and one is again reminded that vase-painters are primarily men of their craft. No cup, bobbin, pyxis, lekythos or aryballos, the staples of white-ground production, is known in this group. Some of the painters decorate oinochoai, and white oinochoai exist;[170] but all those are small, while these craftsmen tend to monumentalise the shape. Similarly, even white calyx-kraters are never on the grand scale these artists favour.

IV. The Sotades Painter and Sotades

The name Sotades, or part of it, is found on nine vases, eight times followed by *epoiesen* or *epoiei*, once alone. Four of these vases were supported by moulded figures, the inscription incised on the black base, but only one of these survives complete: an Amazon on horseback, in Boston.[171] One of the fragmentary bases bore a horse (most likely ridden), another a sphinx,[172] the third a more complex group.[173] A human leg survives, and a hoof, not of a horse; and fragments which seem to go with it include a camel's head and a human head in Persian dress. Two appearances of the name are incised on the rims of small phialai, made with exceptional finesse: white interior with black omphalos and rim; outside fluted, the nine concentric flutes coloured black, white and red, the rim black. One of these is in London, the other in Boston,[174] identical with the first but for the presence of a modelled cicada perching on the omphalos. Two more appearances of the name are on tiny cups (likewise in London) of exquisite make. They have wishbone handles, something found from time to time on Attic cups of the sixth and fifth centuries. The exterior of one[175] (this has the name without a verb) is black; of the other[176] coral red; each with a band of the other colour. The interiors of both are white, with superlative miniature drawings, certainly both by one hand. The ninth appearance of the name is on a less exceptional vase, once in Goluchow,[177] a low-footed kantharos of the type often shown in Herakles's hand, decorated in red-figure with groups of satyrs and maenads. The drawing is by the same hand as that on the two white-ground cups, but, like the potting, it is more everyday work.

The two white cups and the two phialai were found in one tomb in Athens, together with five other vases. Two are mastoi, decorated like the phialai and of the same refinement.[178] The other three are stemless cups, of the same fine make as the stemmed cups with Sotades's name and with the same handles. One has a white interior with a picture by the same masterly hand as those.[179] The other two seem to be a pair. The outsides have the same colour-contrast as the two stemmed cups. The one with the mainly red exterior has red again within, surrounding a white tondo with outline drawing;[180] the other a white zone surrounding a red-figure tondo.[181] Neither of these pictures (pleasant but of no great quality) is by the same hand which decorated the other three; and the white-ground picture bears the name of a *poietes* Hegesiboulos.

Our chief concern is with the great draughtsman who decorated the Sotades cups and whom we call the Sotades Painter; but before we consider his works and style there is more to say about this background material. The nine vases (almost certainly originally ten:

185

five pairs, one Sotadean stemless having gone missing), found in one Athenian grave, must have been ordered as a set.[182] Without the inscriptions we should certainly have assigned them all to one workshop, almost certainly to one potter; but there are signatures of two *poietai*. If *epoiesen* or *epoiei* always indicates a workshop owner, then two workshops were employed; if it always means the man who made the vase himself, then two potters. If it can mean either, then one might argue that Sotades was the owner, Hegesiboulos the potter or vice versa. I find it impossible to suppose that these exquisite and faultlessly matched pieces were made in more than one workshop. I also feel that *epoiesen* or *epoiei* on the base of a finely modelled figure like the Boston Amazon must, like an inscription in the same form on the base of a bronze statue, give us the name of the actual modeller. I further feel it likely that when the same name, Sotades, appears on vessels of exceptionally fine make the implication is the same: Sotades made them with his hands.

We do not know who actually incised the inscriptions on the phialai from the grave (or on the figure-vase bases). On the white cups from the grave it was no doubt the painter who wrote them: the Sotades Painter the name of Sotades on the two stemmed cups; another the name of Hegesiboulos on one of the stemlesses. I think it likely that the potter (and modeller) Sotades made all the vessels for this grave in the workshop of Hegesiboulos.

Even if this scenario is correct, which is very far from sure, it does not follow that Sotades regularly worked in Hegesiboulos's establishment. He could have had a workshop of his own, and borrowed Hegesiboulos's on this occasion for a special reason. The inscripton *Hegesiboulos epoiesen* is found on one other cup, the red-figure decoration of which is near to the style of Skythes and which cannot be much less than forty years earlier.[183] That cup too has coral red; a usage which seems to be confined to certain workshops. That of Kachrylion is one; and it is not impossible that the Hegesiboulos of the red-figure cup took that over. Whether the Hegesiboulos named on the stemless is the same man or a younger member of the same family, maintaining the workshop, we cannot say.

No other white-ground work is attributed to the Sotades Painter, but a good deal more red-figure besides the kantharos with the name of Sotades. A dozen of his red-figured pieces are moulded vases or fragments from such. Some of these are figures or groups standing on bases, like the pieces with the name of Sotades, others animal-head rhyta; and there are more than thirty such vessels decorated in the painter's manner, some of which may be from his own hand. The models for these were surely the work of Sotades. There is a complete sphinx, in London, with pictures by the painter himself;[184] a

crocodile eating a black boy, three of the surviving examples decorated by the painter;[185] a pygmy dragging a dead crane[186]; and a grotesque head.[187] The rhyta are heads of hound, ram, donkey and boar, or combinations dimidiating two of these.[188]

The animal-head rhyton is, like the phiale, a ritual vessel, originally conceived for metal and with oriental connections. It was already established in Greece before this time,[189] but the Sotadean workshop shows other links to the east. The crocodile eating a black suggests the Nile. It was round the sources of the Nile that the land where pygmies fought cranes (the subject recurs as decoration of two animal-head rhyta) was traditionally laid. The sphinx, of course, though long at home in Hellas, was of eastern origin. The Amazons were easterners too, though from less far: their city Themiskyra was laid in northern Asia Minor. It was in Egypt that the fragments in the Louvre of a group including a camel and a Persian were found, and its red-figure decoration (in the Sotades Painter's manner) showed a fight apparently between Greeks and Persians. Another such fight, in which the orientals are winning, is shown on the Boston Amazon-vase with the name of Sotades, and that was found in Sudan, at Meroë. The lists of works by the Sotades Painter or in his manner include one fragment of a moulded vase from Ehnasa[190] in the Delta, and several from further east still, Babylon[191] and Susa.[192]

Apart from the eastern connection, the pattern of provenances is in general slightly unusual. There is relatively little from Etruria, one or two from Numana, more from Campania, South Italy and Sicily, or just 'Italy'. Cyprus and South Russia figure; and there is more than usual from the Aegean area: Lindos on Rhodes, the Cabeirion at Thebes, Aigina, Vari in Attica, Athens (the grave-group and others), 'Greece'.

Sotades appears as a most distinctive artist who found a patronage rather out of the usual line. The work of the Sotades Painter is as fine and as strikingly individual as Sotades's own. As with Amasis and the Amasis Painter, one cannot but feel it likely that they were one man, but of course a perfect partnership is equally possible.

In the three cups from the grave which the Sotades Painter decorated, the whole tondo, about 13 cm in diameter, is whitened within a narrow black rim, but the size of the picture varies. In the stemless (fig. 196)[193] it is contained in a circle about 11.5 cm across. In the centre a man with strikingly vivid unideal features, wearing a fur cap and an animal-skin knotted at his neck, a hunter's throwing-stick in his left hand, starts away, right hand raised with a stone, and looks back at a huge snake which rears behind a cluster of what might be rushes or wheat and vomits out a cloud of vapour. Most of the lower part is lost, with the man's feet and part of his legs, but the toes of his right foot are preserved on a

fragment with the legs of a woman in a chiton fallen against the border-line at the lower left. The snake is clearly no natural denizen of the countryside but a monster-snake, a dragon, so the picture gives some story from legend. A number of heroes encountered dragons, but the features and costume of the man seem to preclude his being a hero. I am convinced by a recent idea which sees him as Aristaios, the rustic *daimon* in flight from whom Eurydice roused the snake which killed her (leading to Orpheus's journey to the Underworld). She is shown here dead.[194]

The drawing is entirely in thinned black (golden) lines with no use of added colour. In spite of the tiny scale it has a subtlety and strength which stand indefinite enlargement. Throw a slide of this on the screen and you almost have a detail from a contemporary wall-painting. The way the thinned black is used in washes and hatching for the patterns along the snake's back and the pelt of the skin Aristaios wears suggests modelling by shading. It seems to have been only late in the century that this became a serious preoccupation of painters, and we shall then meet echoes in vase-painting, but a primitive attempt had been made in the latest archaic. We noticed the Brygos Painter's hatching to model the convexity of a shield.[195] There is something similar to that on the next cup we shall look at by the Sotades Painter. In the Aristaios picture there seems ambiguity, in the use of washes and hatching, between indicating the colours of the snake, the roughness of the pelt, and modelling the roundness of the forms by shading.

On the stemmed cup (fig. 197) which bears the name

of Sotades without a verb[196] there is no framing circle, but the figures are no larger than those on the stemless and more space, greater importance, is given to the setting. The story is not in doubt, since the figures are named: Polyeidos and Glaukos. Minos's little son Glaukos went missing. The seer Polyeidos traced him to a vat of honey in which he had drowned. Minos built the boy a tomb and shut Polyeidos up in it with the body: if he wished to live he must bring the child to life. A snake slipped in, and Polyeidos killed it. A second snake came with a leaf in its mouth and revived its mate. Polyeidos took the leaf and brought the boy too to life again.

The artist has drawn the tomb as a beehive dome, a tripod set on top. At the bottom is a deep strip of pebbles, the floor of the tomb, and the two figures are placed on this, as though the dome were drawn in section to show them within. Indeed, the dome's outline has a thin hatching on the inner side which can only be shading to model its concavity. Against the lower rim, far below the pebble-strip, the dead snake lies and the living glides towards it. Polyeidos kneels, cloak wrapped round his legs, and looks down at the snakes. He holds a stick vertically in both hands to strike down towards them. Glaukos, wrapped all but face and feet in his mantle, crouches, arms round knees, and looks down too. Thus the picture does not illustrate a single moment but almost every stage in the story between the entry of the first snake and the child brought to life. There is a corresponding ambiguity in the treatment of space. The pebble floor on which the figures rest and the hollow

Fig. 196. Stemless cup; Sotades Painter. Aristaios and the snake which killed Eurydice(?) D. *c.* 0.13.

Fig. 197. Cup with name of (*poietes*) Sotades; Sotades Painter. Polyeidos and Glaukos in the tomb. D. *c.* 0.13.

dome that covers them are a wonderfully bold breach with tradition; but the sectional opening of the tomb and the setting of the figures in no real spatial relation to it, with the use of the undefined space at the bottom for the snakes, show how partial and hesitant these first steps are.

I think that this vase-picture tells us a lot about the nature of the revolution in wall-painting. In the construction of the Niobid Painter's Underworld[197] the contradictions are less stark; but the ambiguity is there in the doubt how far the setting of figures at different levels represents recession, how far height. It can be rationalised as the slight recession of steeply climbing terrain (a common enough feature of Greek landscape), but I doubt if the Greek artists and their audience would have understood a need for such rationalisation.

The figure of Polyeidos, in spite of a considerable loss, shows as another example, with the Penthesilea Painter's Achilles and the Niobid Painter's hero between Athena and Herakles, of the renewed interest in the observation and recording of complicated poses. In this picture the painter uses two matt reds for the garments.

In the second stemmed cup (fig. 198),[198] as in the stemless, the drawing is carried out entirely in the dilute black. A dark circle defines an area a little bigger than that on the stemless, but within this an even smaller

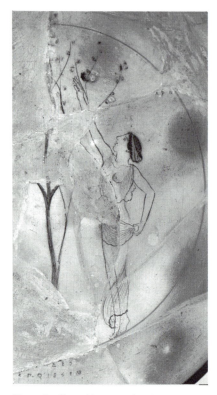

Fig. 198. Cup with name of *poietes* Sotades; Sotades Painter. Woman or nymph picking apples. H. of detail *c.* 0.08.

picture-field is bounded by a broader golden stripe. In the centre stands a tree on which fruits are indicated by application of a thick white pigment. The same is used on the other pieces: for the vapour belched by the dragon and for the pebbles of the tomb floor. On the pebbles it is coloured with dark dilute wash; in the other cases not; but it may (though it need not) once have carried gilding. On the right of the tree a young woman stands on tiptoe reaching for a high apple. The base of the tree is missing, with most of its left side and the area next it; but beyond the gap is preserved the back of a second woman, presumably crouching to pick up fallen apples. Her name is by her, Melissa; and letters are preserved from the other's name. Apple-picking is found quite often in fifth-century Attic art, sometimes in a funerary context (late black-figure lekythoi, a marble relief[199]). No doubt that is the implication on this grave-vase too.

The Sotades Painter's two other cups from the grave illustrate myths concerned with death. The white-ground picture in the stemless with the name of Hegesiboulos has a woman whipping a top; the red-figure tondo in the pair to it a seated woman with a baby in a high chair:[200] scenes of daily life, such as appear on funeral lekythoi. The apple-pickers have been called Hesperids or honey-nymphs or simply mortals. We cannot be sure. Hoffmann's fascinating study of these pictures explores their imagery at a deeper level.[201]

Whatever the subject the drawing is wonderful. The girl's face is upturned and her right arm reaches high, following her look. Her scarfed hair hangs down, and her left hand pulls the transparent dress against her legs. The hem curls prettily round her ankles; but her whole being, from her downward-pointing toes to the fingers stretching up, is concentrated in the action of reaching for the fruit beyond her grasp.

Thirteen figures of women, similar in scale and character to this, are shown in the best of the artist's works in red-figure: a vase in the form of a knucklebone (*astragalos*), found on Aigina and now, like the cups, in London.[202] We met earlier one vessel of this strange form, with the inscription *Syriskos epoiesen*.[203] That stands on the borders of archaic and classical and is no doubt a little earlier than the Sotades Painter's (which is surely another creation of the modeller Sotades). There are a few more of the same general time; perhaps there was a brief fashion for carrying gaming-pieces in a container made in their own image. The painter has cleverly and charmingly fitted his figure-subject (there is no ornament) to the complicated shape (figs. 199–202).

Of its six irregular surfaces the vase rests on one long side, and that and one short end are unadorned. The surface is covered with black, and the fourteen figures move without borders or ground-lines over the other four faces. At the left end of one long side is the orifice.

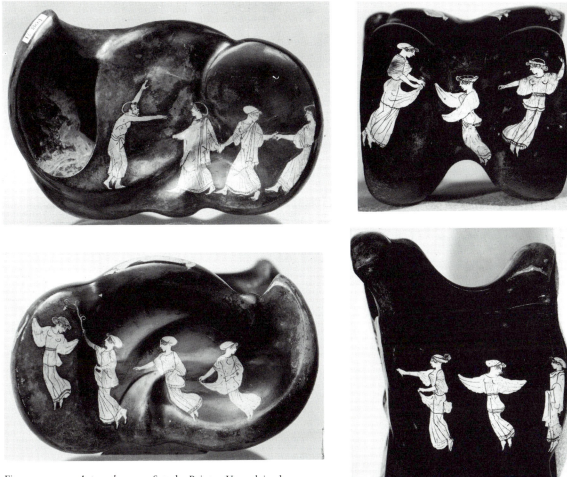

Figs. 199–202. *Astragalos*-vase; Sotades Painter. Unexplained subject (dance on earth and air). H. *c.* 0.12.

The picture begins next to this, and seems to give it the character of a cave-mouth. With his back to it stands a bearded man with unideal features of the same general cast as Aristaios's on the white stemless.[204] His himation is knotted round his waist, workmanlike, leaving the upper torso bare. He is in another of the well-observed awkward poses favoured by these vase-painters in touch with wall-painting. Weight on left foot, right drawn back and resting on the toes, knees slightly bent, he leans a little forward, face tilted a little up but his gaze straight ahead, right arm too pointing straight forward while the left is stretched straight up. He is directing the dance of three women. The foremost moves towards him, her left hand back clasping the right of the second woman, who turns and looks back, left hand reached out for the third to grasp as she hurries up to join the dance. The left half of her body is deemed to be hidden by a raised rim which curves along this edge of the vase-surface. The first two wear chiton and himation, the third chiton only. First and third are dark

and bare-headed; the middle one wears a sakkos over her fair hair. All these figures are moving or standing on irregular ground. When one turns the corner on to the short end the three women one finds there are airborne, floating, and the same goes for the seven on the other two faces. All have their feet close together, toes pointing down. Their hair, fair or dark, is variously dressed, but all except one wear only a chiton. The four on the other long side and three who float across the upper surface all move to the left like the dancers on the ground, two of them looking back. Of the three on the short end the two outer ones move the other way, one looking back. Three have their arms in their long sleeves. This 'wing-dance' is a regular feature of maenadism, coming in with the thyrsos early in the red-figure period (*frontispiece*). A maenad on the lost kantharos with the name of Sotades is so shown.[205]

189

Four of the women on the *astragalos* lift the lap of their dress, and one of these carries a long flowered tendril. Only the rearmost of the three crossing the top wears a himation over her chiton and floats rather stiffly, her arms and hands muffled in it.

Many pretty identifications have been offered for these figures: stars, the Hyades and Pleiades; Aurai (Breezes); Nephelai (Clouds); but nothing on those lines accounts for the dancers on earth and their male director. That dance is just forming up, and the third woman, without himation, might one feels have just alighted from the sky. Similarly the last figure on the top, swathed in her himation, looks as though she had just taken off and not yet accustomed herself to the new element. Perhaps such a two-way movement is intended: the mortal dancers reach a point of intensity when they become ethereal; later the ecstasy fades and they return to the human condition. Hoffmann suggests that the man is a shaman who can induce such a condition in his followers.[206] I have flirted with an alternative idea. Hephaistos, the divine artificer, and his mortal disciple in the heroic age, Daidalos, are both shown in such workman's garb. Both were credited with the creation of sculptures which had the power of coming to life, and dancers by Daidalos were shown in Crete.[207] Might this picture show him, having released his creatures into life, calling them back again? But Hoffmann's idea is probably nearer the mark.

This work, whatever the meaning, displays the same combination as the white cups: drawing that is both delicate and strong; and a poetic imagination. The black background, which in the Niobid Painter's masterpiece worryingly conflicts with the new intimations of space, is a much more easily accepted ambience for this world of faery.

6

High classical

I. Intoductory

The painters we shall be considering in this chapter follow straight on from those in the last, and there must have been much overlap of careers between the two groups; but the division corresponds to a real change of spirit. It is the change we feel between the sculptures of the temple of Zeus at Olympia, finished by 456 B.C, and those of the Parthenon, created within two decades after 449. Certainly the sculptors of the Olympia temple, like the vase-painters treated in the last chapter, were already classical. Certainly too, many of those who worked on the Parthenon, like many of the vase-painters we are coming to, were formed in the earlier phase before going on to form the later. Still, the spirit which perhaps finds its purest expression in the Parthenon frieze and the white lekythoi of the mature Achilles Painter, does more or less clearly inform most of the vase-painting we shall be looking at here. Its character seems to be given by a perfect technical command of the means to express what they want to express, which allows these artists to imbue the stillness that is characteristic of much early classical art with a tenderness which does not detract from its strength.

If we cannot establish a strict chronological and stylistic divide between these high classical vase-painters and their immediate predecessors, it is equally true that they merge with their successors. Again, though, there is a real different of spirit; and the more evident contrast between the work treated in the last chapter and that which we shall meet in the one after this may help us to realise the peculiar character of this high classical moment. In the age that follows, in sculpture as well as in vase-painting, technical mastery seems to become an end in itself, virtuosity, rather than a necessary foundation for the expression of something new. With these thoughts in mind we may turn to the consideration of the works themselves.

II. Pot-painters

a. The Chicago Painter

The difference effected by the new tenderness is very clear when one looks from a work by the Villa Giulia Painter, his name-vase for instance,[1] to one by his pupil the Chicago Painter.[2] This artist's own name-vase, a stamnos in Chicago with women preparing a feast of Dionysos (fig. 203), is not his greatest work but the quality is high. The drawing of the faces, the angles of the heads, the gestures, all make one feel that these are real people engaged on something serious to them. The Villa Giulia Painter in his dancers (and the context of

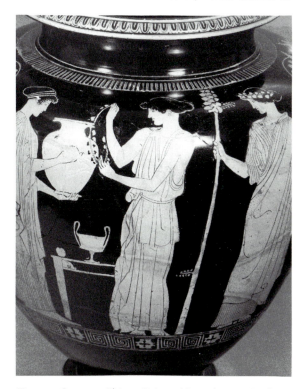

Fig. 203. Stamnos; Chicago Painter. Maenads preparing feast of Dionysos. H. of picture *c*. 0.20.

191

their dance too is no doubt religious) shows the grace of physical movement almost uninformed by feeling. Beazley once wrote on the subject of attribution: 'It was hard at first, I remember, to distinguish the Syriskos Painter from the Painter of the Copenhagen amphora, or even the Villa Giulia Painter from the Painter of the Chicago stamnos. But now it is quite easy.'[3] This case is a good example of the way Beazley's distinction of artists helps us to gain a better understanding of the development of style in a wider sense.

The stamnos is the Chicago Painter's favourite form, most often with pictures like that on the name-vase, or showing the women at a later moment, already maenads; but there are other scenes: mortal revels, warriors arming, pursuit. These stamnoi have attractive palmette-complexes, but confined to the immediate area of the handle; they do not reach out to make the 'four-sided' decoration some artists like for this shape. The painter's finest work, however, is on vases of other forms. There are several pelikai, of which one in London has an impressive picture of Apollo with *kithara* and phiale, Artemis with jug to fill it and bow.[4] The dignified figures are very like those on the Villa Giulia Painter's stand in Cambridge (fig. 181).[5]

More interesting are the two figures on a vase of the same shape in Lecce (fig. 204).[6] A bearded man in conical helmet and short chiton, an amulet round his ankle, leans on his stick. In his left hand he holds a box and from his right dangles a necklace he has taken out of it. A woman stands frontal but turns her head towards the man, looking down at the necklace. She has her right hand open below it, waiting for it to drop. Their names are written: Polyneikes and Eriphyle. He is bribing her to send her seer-spouse Amphiaraos to join the champions her brother Adrastos is gathering to help Polyneikes seize the kingdom of Thebes from his brother Eteokles. Amphiaraos foresees his own death before Thebes; but he and Adrastos have agreed to put any disagreement between them to arbitration by Eriphyle and to abide by her decision. She accepts the bribe and sends him to his death; but the necklace, an heirloom in the Theban royal family, bears a curse which she will feel in her turn. One could not of course read this story from the picture, but to one who knows it the effect of the confrontation is powerful. The long-legged water-bird between the figures is there for the design, but it is not an intrusion. Such creatures often appear in pictures of life in the *gynaikeion*, the women's quarters, pets I suppose; and its presence here suggests the privacy of the meeting.

We saw a picture of Amphiaraos's death on a not much earlier volute-krater in Ferrara.[7] Another, one of the biggest of the large vases of that shape found at Spina,[8] was decorated by the Chicago Painter himself, and is his most ambitious surviving work (fig. 205).

The bottom border is set low, making the picture-field higher than usual, and the fourteen figures which ring the vase without interruption are some 35 cm high. One is seated; all the rest stand quietly, linked only by look and gesture. The painter likes tall, slender figures, and the effect on this scale is impressive.

Columns on both sides indicate that the scenes are interiors. A figure under one handle moves from one to the other, looking back, and the two pictures seem closely connected. In the centre of one stands a bearded warrior, wearing an elaborate corslet and holding spear and sheathed sword. Among those about him are a woman, a naked youth and a young warrior fully armed. The others are bearded men in civil dress, as are all those on the other side. At the left end of that picture an old man sits in a high-backed chair, his hand resting on his stick. Beside him stands a younger man gesturing with his right hand and holding a sceptre in his left. Two bearded men come next, and seem to be arguing; and after them another old man who seems to be confronting the seated figure and the man with the sceptre. He is bent over his stick and muffles his face in his mantle in evident distress. More bearded men in conversation close the scene.

Here there are no names, but the artist clearly had a particular story in mind. Alfieri has an attractive idea which may well be right.[9] The hero is Hector, putting on the armour which had been lent by Achilles to Patroklos. Hector had stripped it from the body when he killed Patroklos, and he is about to go out and meet his own death at Achilles's hands. The picture on the other side looks back to an earlier moment, when old Antenor proposes that the Trojans shall give back Helen to the Greeks to gain peace. Paris rejects the idea, but offers to give up the plunder he had brought home with her if that will satisfy the Greeks; and old Priam backs Paris against Antenor.

One cup with picture inside only is ascribed to the Chicago Painter, and a few small pots including several oinochoai. One of these has the inscription *Alkimachos kalos*, which is found also on a fragment of a bell-krater by the painter. These pieces, and vases from the Polygnotan Group which have the same name, are decidedly later than those of the Alkimachos Painter and his contemporaries on which Alkimachos son of Epichares is praised, so this is probably a different man.[10]

Nothing on a white ground is attributed to this artist; but we noticed beautiful fragments of a white calyx-krater associated with the Methyse Painter who stands close to the Chicago.[11]

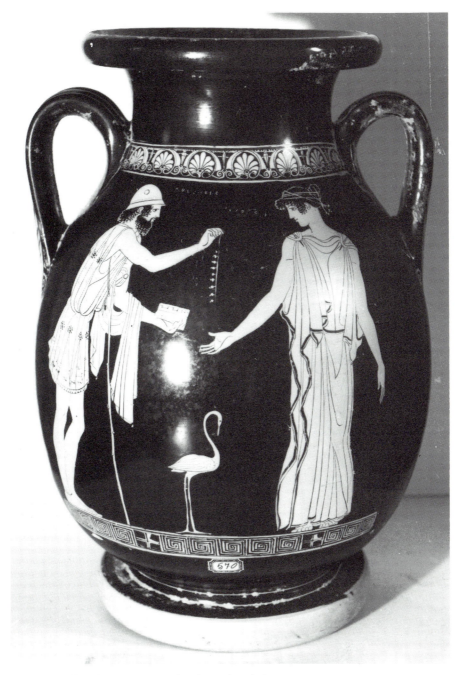

Fig. 204. Pelike; Chicago Painter. Polyneikes and Eriphyle. H. *c.* 0.41.

b. The Achilles Painter and his circle; black-figure panathenaics; white lekythoi; the Phiale Painter

The Achilles Painter is the last pupil of the Berlin Painter[12] and, like his master, one of the finest draughtsmen of his day. His work is important in red-figure, black-figure and especially white ground; but, before we consider it, we may glance at his use of *kalos*-names. He uses a good many, especially in his youth, but we need not bother with those which occur in no other artist's work. On vases by or near him in his early period the names of Alkimachos son of Epichares and Lichas son of Samieus are found (he often adds the patronymic); and these occur also on vases by the

193

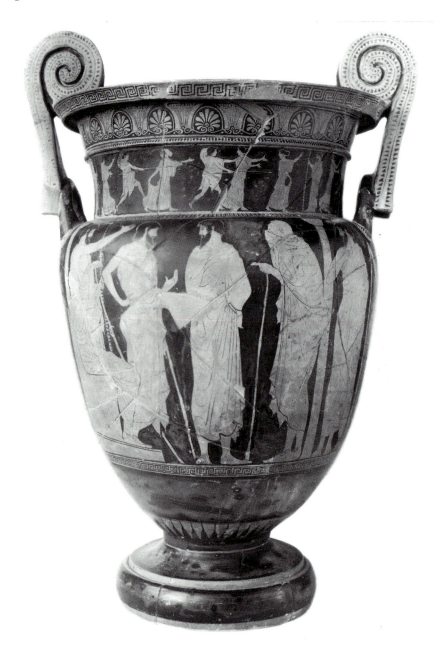

Fig. 205. Volute-krater; Chicago Painter. Heroic debate. H. without handles *c.* 0.80.

Alkimachos Painter and white lekythoi from the circle of the Timokrates and Vouni Painters; Lichas also on cups by the Telephos Painter.[13] On the Achilles Painter's mature work appear Axiopeithes son of Alkimachos (no doubt the son of Epichares) and Euaion son of Aeschylus. Both are also praised by the Lykaon Painter, a member of the Polygnotan Group; Euaion also by the Euaion Painter and on an early piece by

the Achilles Painter's own great follower, the Phiale Painter.[14]

The Achilles Painter takes his name from a red-figured amphora Type B in the Vatican.[15] The one-piece amphora was no longer a fashionable form. The Kleophrades and Berlin Painters were the last to use Type A for masterpieces and it did not long survive them. By the Achilles Painter's time Type B too was on

the way out. This example is decorated in the Berlin Painter's favourite way: a single figure on each side (something no longer common on large pots); no ornament but an ULFA[16] maeander-strip under the feet. Much of the Morellian detail too is directly derived from the Berlin Painter. The drawing is of its time, the purest and finest classical, but the whole piece looks like a tribute to the older artist. The exquisite elaboration of detail on the principal figure is likewise rather in the archaic tradition, and hardly recurs in the artist's work.

The figure on the front is a young warrior, bare-headed but with an elaborate corslet over his short chiton. He stands frontal, weight on the left foot and on the immense spear which slopes over his left shoulder high up to the rim of the vase. His right hand rests on his hip, and his level gaze is turned the other way. His limbs are exceptionally massy, and his hair dressed with an elaboration rare in this period. A name is written beside him: Achilles; and the artist has not simply drawn a young warrior and given him a heroic name. The whole character of the figure is Achillean, and the exceptional spear is the famous ash inherited by the hero from his father Peleus. The gorgoneion on the corslet-breast may also be significant. It is really Athena's emblem and rare among mortals. (Interestingly there is one on the breast of the corslet worn by the bearded hero on the Chicago Painter's volute-krater, who may be Hector wearing the armour of Achilles.[17]) The woman on the reverse of the Achilles vase, beautifully but more simply drawn, is surely, on the analogy of Oltos's amphora, Briseis.[18]

The bulk of the artist's red-figure carries on another side of the Berlin Painter's work, and the Providence Painter's:[19] Nolans and other small neck-amphorae, and lekythoi. The Nolans have one or two figures on the front, a single figure wrapped in a mantle on the back. These 'mantle-figures', introduced by the Berlin Painter, become universal reverse-decoration as the century wears on. Youths are most common, but the Achilles Painter has a liking for bearded men. Later such figures (always youths), one on smaller, two or three on larger vases, are mere daubs. The Achilles Painter dashes them in quickly, to a formula, but always with decent care.[20] He also decorates squat lekythoi (some with just a head), oinochoai, and small versions of normally large shapes: pelike, hydria, calyx and bell-krater.

These smaller vessels are unpretentious, but with a high standard of craftsmanship and often much charm. There are also other large, careful vases in red-figure. A beautiful neck-amphora with twisted handles in the Cabinet des Médailles[21] follows naturally on the series by the Berlin and Providence Painters. The back has a bearded 'mantle-figure' like those on the Nolans but more finely drawn; the front a rare subject. A young man dressed as a traveller, a spear in his hand, is carrying a small child. The child is named Oidipodas,

the man Euphorbos. The latter name does not appear in any version we have of the story of Oedipus, so we cannot tell whether this is the slave given the child by Laios and Jocasta to kill or expose on Mt Cithaeron, or the slave of the king of Corinth to whom the first in pity handed the baby over. The tenderness which we noticed as characteristic of the art of this time is not so marked a feature of the Achilles Painter's style as of the Chicago Painter's, but it is present here. Euphorbos bends his head, and the child lays his on the man's shoulder, his hand on his breast.

Oedipus's face is in three-quarter view, and there are other examples of this, on a larger scale, in the painter's work. Two are of Amazons, on the calyx-krater from Spina[22] mentioned earlier. In the construction of this fine picture, though not in the drawing, the artist is working less evidently in the Berlin Painter's tradition, aligns himself rather with the followers of the Niobid Painter. We noticed that the handle-florals on two stamnoi by the Achilles Painter are like those used in the Niobid Group; that oinochoai decorated by the Berlin and Niobid Painters share potting characteristics;[23] and that the *kalos*-name Axiopeithes is used only by the Achilles Painter and the Lykaon Painter, who belongs to the Group of Polygnotos, the direct succession of the Niobid Group.[24] It is not clear what is the significance of these links between two traditions which are stylistically so disparate.

The most successful three-quarter face in the Achilles Painter's work is a maenad's on a pointed amphora, again in the Cabinet des Médailles,[25] the artist's masterpiece in red-figure (fig. 206). The vase is egg-shaped, like the Oreithyia Painter's pieces[26] and, like those, probably influenced by the panathenaic amphora. There are florals on the shoulder, an ULFA band below, and the eleven figures ring the vase: a Dionysiac revel at night. First goes a maenad with a torch. Dionysos follows, looking back at three maenads and a satyr who follow in good order. One maenad plays a tambourine, another pipes. In the six remaining figures (satyr, three maenads, satyr, maenad) the procession is more broken; and it is among these that the three-quarter face appears. Two maenads are drawn in a close group; one, her arm over the other's shoulder, looks back and down at her with great tenderness, the three-quartering well realised at last. The maenad in front of this pair, tearing a fawn, moves forward but turns in almost full back view. Her face is drawn in *profil perdu*, something which, as we shall see in a later chapter, seems to have interested a major painter of this time.[27]

We do not know where the vase was found, but it is no doubt from Etruria and we happen to have copies of two of the groups from this vase or a replica (the piping maenad and the satyr following her; the last satyr and maenad) on the two sides of a red-figure stamnos

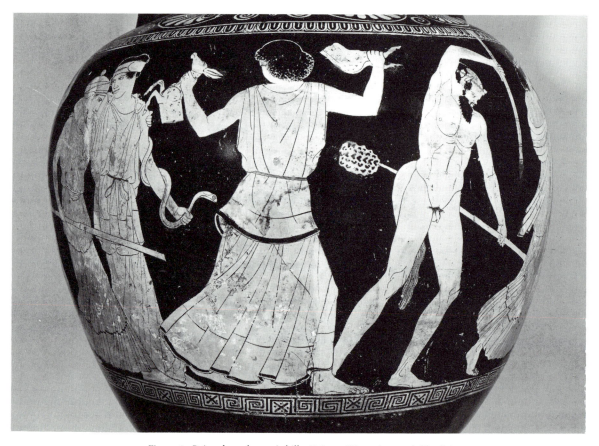

Fig. 206. Pointed amphora; Achilles Painter. Dionysiac revel. H. of picture *c.* 0.25.

decorated by an Etruscan painter probably some forty or fifty years later.[28] There is one such case earlier: the exterior of the Dourian Oedipus Painter's name-cup and an Etruscan version;[29] but it is extremely rare. On the stamnos the postures and details down to the swing of the drapery are clumsily but industriously imitated; but there is one divergence. On the Etruscan vase the last maenad has castanets; on the Greek she is holding up a bowl in both hands. The motif is unusual, and this area of the vase has a lot of restoration. It seems likely that the original action is preserved for us by the Etruscan copyist.

Two other big red-figure vases need a mention. One, a bell-krater in New York,[30] is the only major piece in a group which Beazley early associated with the Achilles Painter, though long uncertain whether they were his own work. I have little doubt that he was right in coming to the conclusion that they are his from an early phase. One side of the New York krater has Nike approaching a youth; the other (the front) a man or youth (his face is missing) with himation and staff approached by a bare-headed man in short chiton and corslet, girt with a sword, who seems to support his

steps on a spear in his left hand. The right is stretched out towards the other figure, who stands frontal, hand on hip, and turns his head towards the warrior but makes no response. The warrior is uncouth in proportion and movement. His hair and beard seem rather thick and rough, and his face is like nothing else in contemporary vase-painting, though one is reminded of some of the things said about the style of the wall-painter Polygnotos. Some of the Centaurs of the Parthenon metopes also come to mind. The face is strangely profiled (very long nose with a deep indentation below the jutting and knotted brow) and furrowed, with an expression of deep suffering. A suggestion that he is Tereus, based on an emendation in an inscription incised in the clay between the figures and then covered in the background black I do not find very convincing.[31] I think it might be Philoktetes on Lemnos, meeting Neoptolemos or Odysseus come to take him to Troy; a story we shall touch on later in this section.[32]

The other red-figure piece by the Achilles Painter we need to look at is a funeral loutrophoros in Philadelphia;[33] a form of vessel which we discussed in an earlier chapter.[34] This one is of the amphora

196

type (fig. 207), and is for a man's funeral. Many such loutrophoros-amphorae, like the loutrophoros-hydria in Athens by the Painter of Bologna 228, for a woman's funeral, bear pictures of the prothesis. Such is a splendid piece in the Louvre[35] by the Kleophrades Painter, where the figure laid out is a young man. The Achilles Painter's is different. It belongs to a relatively small group with battle-scenes, presumably for men killed in war.[36] There is a fragment of one by Hermonax, and of an earlier by the Berlin Painter.[37] On that the fight is mythologised: Greeks at Troy against Memnon's Ethiopians. The nearest thing in the Achilles Painter's work to the battle on the Philadelphia vase is the Spina Amazonomachy. On the loutrophoros all figures are male, including two on horseback; and, though some are shown in heroic nudity, I do not think this necessarily means that the battle is thought of in mythological terms.

This picture is worth attention for its quality, but there is another reason for our noticing the vase. Loutrophoroi with prothesis sometimes have a subordinate picture below (sometimes in black-figure or black silhouette) with horsemen: the convoy to the tomb. On this vase the prothesis itself is put in this position, in red-figure, slight, uninteresting work. Its importance is that it is not by the painter himself but an assistant, who also added the hasty figures of a warrior on either side of the neck. We saw such warriors on the neck-fragment in New York by the Painter of Bologna 228,[38] and one may wonder if that vase too may not have had a battle on the body. These subordinate pictures are attributed to the Sabouroff Painter.

We met this artist in an earlier chapter as a hack producer of red-figure cups who also painted a lovely white tondo (fig. 176).[39] In this later phase of his career he decorates red-figure pots, large and small, including loutrophoroi and many lekythoi. These are generally of little worth, but he also paints white-ground lekythoi of much higher quality. He and the Achilles Painter appear as the two artists who formed the character of the classical white lekythos. Before we come on, though, to the complicated and difficult question of the relation of these two to one another and to other early masters in this important field, we must glance at another aspect of the Achilles Painter's work, black-figured panathenaic amphorae.

We saw that in the generation after the Pioneers, when the production of the black-figure prize-vases for the Panathenaic games came into the hands of pot-painters who now worked largely in red-figure, it became the practice for each painter to put always the same device on Athena's shield: the Kleophrades Painter a Pegasos, the Berlin a gorgoneion, the Eucharides (or Nikoxenos) a snake. We noticed also that the same device recurs on vases of this type which are not by the painter himself but only in his manner, or occasionally

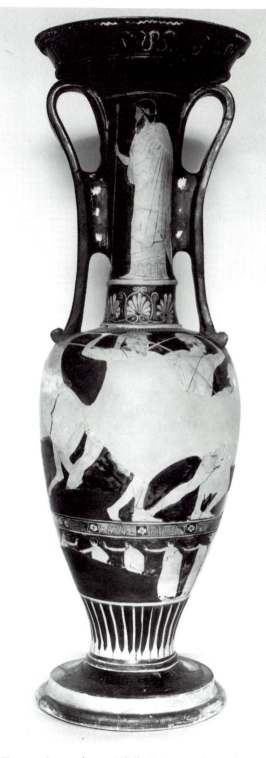

Fig. 207. Loutrophoros: Achilles Painter. Battle. Prothesis below and figures on neck by Sabouroff Painter. H. *c.* 0.93.

not closely connected with his style at all: so the Pegasos on the vase signed by Sikelos, who may be the Syleus Painter.[40] The device is often thought of as the painter's choice; but I would suggest a different picture.

Suppose that some time in the early decades of the democracy a law was passed, by which, every four years, the state official responsible (probably one of the ten *athlothetai*) picked a workshop to supply the prize-vases for the games at the Greater Panathenaia, and at the same time allotted a device. It is clear that the archon-name which appears on prize-vases over a part of the fourth century was that for the 'vintage' year of the oil·to be put in the pots;[41] and it seems possible that the shield-device was a logo serving the same purpose. Cases like Sikelos's Pegasos would then be due to a workshop calling in help from outside to complete an order; something we have envisaged in other cir-cumstances. To test this idea one would have to group as many fifth-century panathenaics as possible by the device on Athena's shield and see the pattern of dating and attribution in each group. In the very limited material I am aware of, Pegasos and snake fit the picture well enough but the gorgoneion presents a problem.

Two sets of vases bear this device: a dozen ascribed to the Berlin Painter or his school, half a dozen to the Achilles Painter.[42] When Beazley originally associated four of the first set he did not attribute them but dated them, rather hesitantly, about 480. He noted the re-semblance to the Athena on these of one on a vase in Naples dated by the style of its reverse to 'the later part of the fifth century, perhaps about 420'.[43] When he had grouped more vases with these he realised that the first set was from the Berlin Painter's school (later, doubtfully, perhaps from his hand),[44] the other by the Achilles Painter; and that the gap in time between the two was smaller.[45] He must, I think, still have envisaged an interval of decades, since he thought the reverses not in the Achilles Painter's earliest style. One might conjecture that, when after a period, the commission came back to the same workshop, the old logo was revived; but, though difficult, I do not think it wholly impossible that the two sets were made for the same festival, say one of those in the 450s. I believe that there is evidence that Epiktetos's last works are some twenty years later than a glance at their style suggests;[46] and I see no reason to think that old-fashioned members of the Berlin Painter's workshop may not have con-tinued to work in his manner long into the time when the Achilles Painter had taken over.

The Athena of the obverse, the archaic Promachos, already old-fashioned in the Kleophrades Painter's day, is now becoming a stereotype. On the reverses, drawn in the style of the day, the old technique hardly allows the Achilles Painter to show his full quality, but the pictures (mostly foot-races) are drawn with vigour as well as

care, and have life. The same is true of the earlier, or earlier-seeming, set; indeed they are among the more attractive works issuing from the Berlin Painter's school. Particularly pleasing are, from that set, a foot-race of men on a vase formerly in Castle Ashby (fig. 208); among the Achilles Painter's a picture on a vase in Bologna[47] which combines two scenes: two boys racing; and the victor with his palm who stands looking up at a man (fig. 209). This has been called the trainer; but Beazley points out that he does not carry the distinctive attribute, the forked wand. Perhaps it is the boy's father.

We saw, in the early classical work of the Timokrates, Vouni and Lupoli Painters,[48] the large white-ground lekythos with careful outline drawing emerging as a specialised type of vase for funeral use. In the high classical it becomes the vehicle for some of the best drawing of the time;[49] and the two artists who set its character are the Achilles Painter and the Sabouroff Painter. The Achilles Painter is consistently the finer draughtsman, but the Sabouroff Painter has quality and he is both more innovative in technique and more varied in iconography. He never uses the 'second white' which we saw used for woman's skin and other things on early examples of the genre. All early pieces by the Achilles Painter have it; and it is an unsubtle medium which inhibits the artist's fine drawing. None of these early pieces show him at his best, except one, not known to Beazley, which has only male figures,[50] one of whom has a realistic face which recalls, though less extreme, the red-figure 'Philoktetes'.

In his mature work the Achilles Painter abandons 'second white', but he is more resistant to another technical change. In all earlier work the outlines are drawn in the thinned black long in use in red-figure. In the next generation of white lekythos painters this 'glazed outline' (as it is called) gives way to 'matt outline'. The new matt colour, black or red, is unlike anything previously found in vase-painting, and lends itself to a freer style of drawing. The Achilles Painter uses this only on a small group of lekythoi from the very end of his career. The Sabouroff Painter goes over to it much earlier, and it would appear to have been he who introduced it.

As regards iconography, both use a scheme which is common to all painters of classic funeral lekythoi: a tomb flanked by two figures (later often other figures added). The Achilles Painter's favourite theme, however, is domestic: mistress and maid, in various avocations. Of more than a hundred white lekythoi ascribed to the painter, barely a dozen show the tomb. All were intended for the grave, but any funerary association in the domestic scenes is metaphorical or implied. The Sabouroff Painter seldom if ever employs this type of scene, but has a considerable repertory of subjects connected with death ignored by the Achilles Painter:

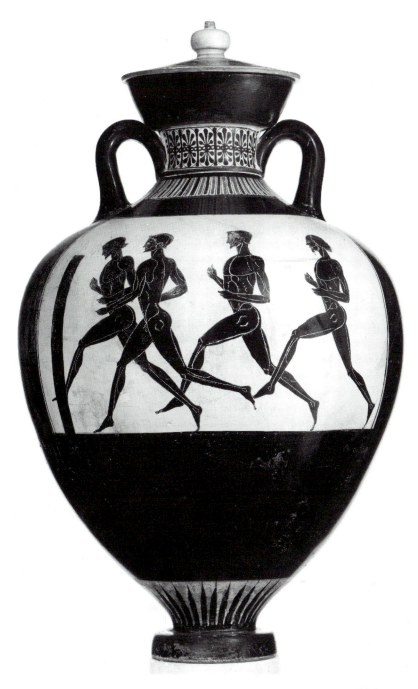

Fig. 208. Panathenaic prize-amphora; Berlin Painter's workshop. Foot-race. H. with lid *c.* 0.81.

the prothesis; Sleep and Death with the body of a young warrior; Charon in his boat waiting to take the dead aboard.[51] One beautiful lekythos by the Achilles Painter, in Munich,[52] has a unique picture (figs. 210a and b) a woman seated on a rock playing the lyre; another standing looking at her; a bird between; on the rock the word Helikon: so, Muses, or a mortal poet inspired by a Muse. Here again there is no evident direct connection with the idea of death, though the picture may have carried some implication of that kind to a

199

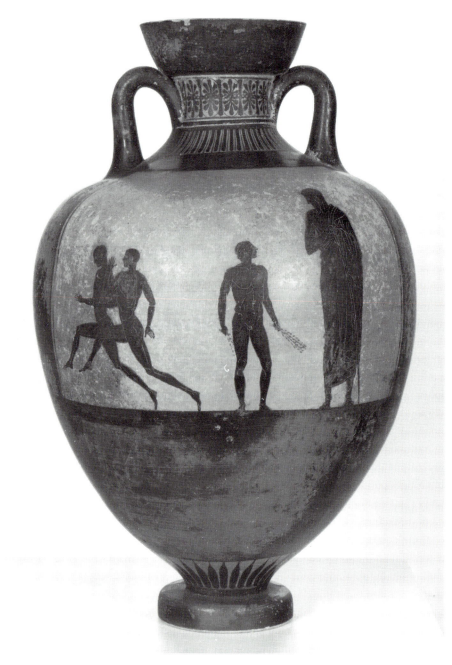

Fig. 209. Panathenaic prize-amphora; Achilles Painter. Boy runners. H. *c*. 0.62.

contemporary. That the domestic scenes may have conveyed that implication too is suggested by one where the feeling is scarcely avoidable. One of the Achilles Painter's loveliest pieces of drawing is on an exceptionally big lekythos in Athens from Eretria (figs. 211a and b).[53] A young woman sits, relaxed, one elbow on the back of her chair, the other hand lying in her lap, and looks up at a young man who stands looking down at her, bare-headed, shield on arm and holding helmet

and spear. The serenity is filled with a sense of endless parting.

The Sabouroff Painter's drawing is freer, less perfect, but vivid, and he presents such thoughts more directly: by the bier of a dead boy a girl tears her hair (fig. 212).[54] Such expressionism, here still very restrained, looks forward to a later mood.[55]

The interpretation of the scenes at the tomb is disputed. It is often said that, while one of the figures is a

200

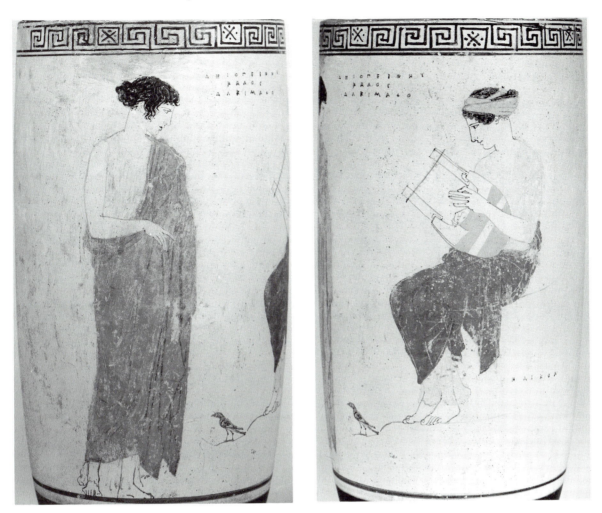

Fig. 210. Lekythos; Achilles Painter. Muses on Mt Helikon. H. of picture *c.* 0.16.

mourner, the other is the dead person, the two worlds united by the tombstone. Lately it has been cogently argued that this idea is hard to justify; that it is safer to assume that when the dead are shown they are shown dead (laid on the bier; lifted by Sleep and Death), and any figure shown living by the tomb must be a mourner.[56] This may often be the case, but not always. On a vase we shall look at later Hermes, the god who guides the dead to Hades, is shown with a woman who stands adjusting the stephane on her hair, the tomb behind her. She can only be the dead. In the pictures of Charon's boat, too, the dead are shown approaching it in living form. True, in both these cases the second figure is not a living mourner but an immortal, into whose world the dead person has already passed. Nevertheless, a favourite composition shows one of the figures at the tomb carrying offerings, so certainly

a living mourner, the other standing still and detached in what seems an intended contrast. I still incline to the old interpretation for these.

The relation of the Sabouroff and Achilles Painters is a difficult question. A valuable recent study by van de Put[57] suggests that the Sabouroff Painter sat, at this period, in the Achilles Painter's workshop. Indeed he believes that in this crucial time, when the white funeral lekythos was already becoming a major line in the Kerameikos, but white lekythoi were still largely, perhaps entirely, the work of red-figure painters, the Achilles Painter's workshop was the only centre of their production. He paints a coherent and plausible picture which may well be right. It suggests a workshop-structure rather different from anything we have seen, but that is not against it. In the case of the Sabouroff Painter the collaboration on the red-figure loutrophoros

201

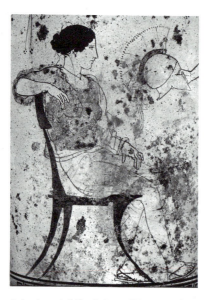

Fig. 211. Lekythos; Achilles Painter. Woman and warrior. H. of picture *c*. 0.21.

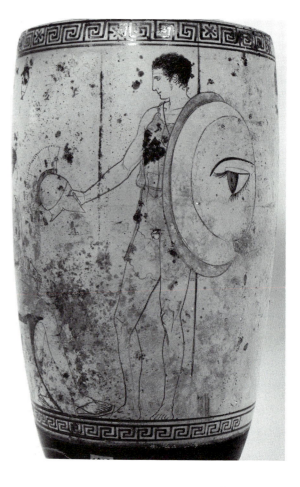

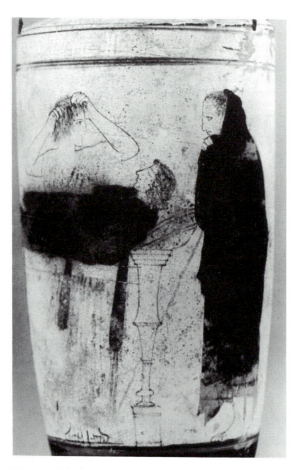

Fig. 212. Lekythos; Sabouroff Painter. Prothesis. H. of picture *c*. 0.12.

shows that he sometimes sat with the Achilles Painter. There is also the case of the Trophy Painter.[58] He decorates small pelikai and uses patternwork (including a neat ULFA) which connects him with the Achilles Painter. His fussy style has nothing in common with the Achilles Painter's, but he has several links with the Sabouroff.[59] The potting of the Sabouroff Painter's lekythoi is consistently different from that of the Achilles Painter's, but a large workshop must have contained several potters as well as several painters. One might have expected more technical and stylistic interaction between the two sets of white lekythoi, but we shall see that both act on younger painters who may be supposed to have joined the shop.

Early, and very fine, is a small group attributed to a Bosanquet Painter,[60] named after the scholar who first put some of the vases together. The major piece is a very large lekythos in Athens from Eretria. In the centre is a big tomb, its steps covered with wreaths and vases (something this artist likes to show). On the right a woman puts her foot on the lowest step and stoops to set down a tray of further offerings; a living mourner certainly. The youth on the other side, though, could to my eyes well belong to another world. He stands quite still, frontal, in a short cloak, travelling hat on shoulder,

right hand on hip, left on the spear which leans on his shoulder, and looks across at the woman.

This youth stands like the much larger and more elaborate Achilles in red-figure who gives his name to the Achilles Painter. The Bosanquet Painter has much in common with the Achilles Painter, but also stands apart from him. There is no correspondence in Morellian details or in pattern-work. Each of these white-lekythos painters has his own way of drawing the palmette-complex on the vase-shoulder, but most of the designs conform to a general common character. The Bosanquet Painter's is entirely his own. He never uses 'second white', and always draws in 'glaze outline'.

In the Athens lekythos, and in a splendid fragment in London[61] of the same scale and character, (fig. 213) I feel a likeness to two great red-figure pieces. The first, a good deal earlier than the lekythoi, is the Erichthonios stamnos once given to Hermonax (figs. 186 and 187).[62] There are likenesses of detail. In the youth's hand on his hip the forefinger is raised, separate from the others, as we noticed Hephaistos and an Eros on the stamnos hold it (the Achilles Painter's hero does not); and the hooks on the woman's drapery recall the drapery-treatment on the stamnos. On the London fragment a slave holds a baby who reaches his hands out to his seated mother, and I think the likeness to the Erichthonios is more than one of motif. Mainly, though, it is the feeling, the restrained mixture of grandeur and charm, which unites the red-figure pot

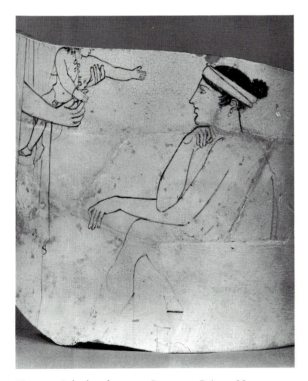

Fig. 213. Lekythos-fragment; Bosanquet Painter. Nurse handing baby to seated woman. Preserved H. *c.* 0.12.

and the white lekythoi, and I could very easily see the lekythoi as later work of the artist of the stamnos.

I find the same character in a red-figure bell-krater in New York (fig. 214), the name-vase of a Persephone Painter, whom Beazley describes as 'akin to the Achilles Painter in spirit'.[63] Persephone steps up from a cleft in the ground, on the other side of which Hermes stands. Hekate precedes her with torches, and Demeter stands waiting, frontal but looking towards her returning daughter. Much of the other work (all in red-figure) ascribed to this artist is relatively weak, but the drawing on the name-vase is strong and the construction daring. The dark cleft is sharply foreshortened, and this, with the way Hermes stands beyond it, face as well as body completely frontal, gives quite a new sense of depth. I feel a real likeness of feeling between this picture and the considerably earlier Erichthonios. If both the Persephone Painter's red-figure and the Bosanquet Painter's lekythoi are works of the painter of the stamnos I would suppose that the lekythos series was in general a little earlier than the Persephone group, in which the influence of the Achilles Painter has become more marked.

A larger series of white lekythoi was assembled by Buschor under the name of the Thanatos Painter.[64] He thought the pieces we have just looked at were an early phase of this artist. There is certainly a connection, but I feel sure Beazley was right to detach the Bosanquet Painter as a separate personality. The Thanatos Painter is named after a vase in the British Museum with the two *daimones* carrying a dead warrior. In this, and in pictures of Charon, he looks towards the Sabouroff Painter, but in style he is closer to the Achilles Painter. Far the greater number of his vases show two figures confronted over a tomb; very quiet and simple, and at best extremely moving (fig. 215). Once he adds a third figure, seated, which looks forward to a later fashion.[65] On two we see, unexpectedly, two youths coursing a hare over broken ground on which stands a tomb:[66] life in shadow of death; and this surely is how we should read the domestic scenes beloved of the Achilles Painter.

An attempt has been made to identify this painter with a great red-figure artist, the Kleophon Painter, a late member of the Group of Polygnotos which, with that of the Achilles Painter, dominates pot-painting in this time.[67] I am sure this identification is a mistake, but it is very likely that the Thanatos Painter had a red-figure side. Once, in the twenties, Beazley made the suggestion that Buschor's Thanatos Painter was probably in the main his own Dwarf Painter,[68] but he never repeated this. The Dwarf Painter is a follower in red-figure of the Achilles Painter who worked mainly on Nolans and small pelikai or hydriai. A large hydria in Boston with the departure of Amphiaraos shows him a more considerable artist that one would otherwise have guessed. He is lively, with rather a coarse touch, and I do not see him as the same personality as the Thanatos

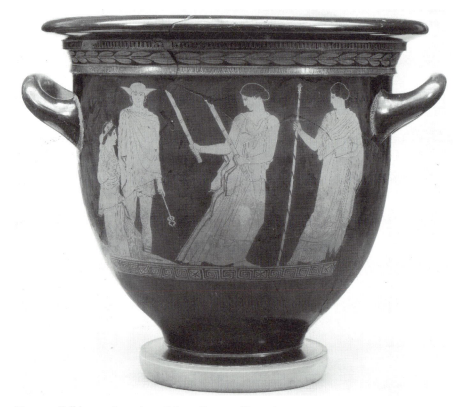

Fig. 214. Bell-krater; Persephone Painter. Return of Persephone. H. *c.* 0.41.

Painter. Van de Put[69] remarks that one should look into the possibility that the Thanatos Painter is to be identified with the Persephone Painter; and this should certainly be considered as an alternative to the suggestion made above.

One should look also, in this connection, at the Painter of London E 494.[70] This vase is a magnificent fragment of bell-krater with which Beazley associated a few other pieces. He calls the artist 'a fine painter, in spirit akin to the Achilles Painter and the Persephone Painter', but does not list him in the same chapter. The krater shows Herakles sacrificing to Chryse, Athena present. He is assisted by two boys, Lichas and Philoktetes. Philoktetes later inherited Herakles's bow. Hermonax, a little earlier than this, drew on a stamnos the hero bitten by a snake at a sacrifice on Lemnos, when the Greeks were on their way to Troy.[71] They abandoned him there because they could not bear his shrieks of pain and the stench of his wound; but Troy could not be taken without him and his bow. We noticed the possibility that a picture by the young Achilles Painter may show the embittered man meeting the ambassadors sent to make peace with him;[72] the subject, later in the century, of Sophocles's most moving play.

Two other significant painters of white lekythoi have been associated with the Achilles Painter's workshop: the Painter of Munich 2335 and the Bird Painter. The first,[73] like the Sabouroff Painter, produces also quantities of red-figure of a quality generally inferior to his white-ground. Oakley has shown that his Nolans and small pelikai and hydriai are by the same potters as the Achilles and Phiale Painter's; and van de Put that these are his earliest work and that most of his white lekythoi belong to the same time.[74] He has a liking for Charon scenes, and these seem to show influence from the Sabouroff Painter, but the composition of the most charming of them is all his own (fig. 216).[75] Charon in his boat is on the right; on the left a woman hurries up, head bent, arms and hands muffled in her himation. Between them, on a mound, stands a very small boy, his baby-forms well realised, holding a go-cart. His feet are half turned towards the barque, but he looks back at his mother and waves. The painter uses only matt outline, and his latest white lekythoi lead on to those of one of the major painters of a later generation, the Woman Painter.[76] His later red-figure also connects with other workshops. We shall touch on him again.[77]

The Bird Painter[78] is closely connected with the Painter of Munich 2335. He is mainly a producer of

Fig. 215. Lekythos; Thanatos Painter. Woman and girl at tomb. H. *c.* 0.35.

hasty, small lekythoi, but there are better pieces which suggest that he was a pupil of the Thanatos Painter and began work in the Achilles Painter's workshop. He too leads on to later painters. He was perhaps one of the first to ignore red-figure and specialise entirely in white lekythoi.

The Phiale Painter[79] decorated some of the finest white lekythoi we have, but he is primarily a painter of

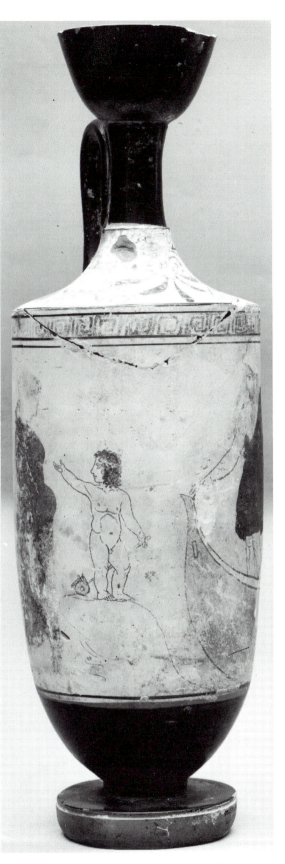

Fig. 216. Lekythos; Painter of Munich 2335. Child between mother and Charon. H. *c.* 0.32.

red-figure. He is a pupil and close follower of the Achilles Painter, just as the Achilles Painter is of the Berlin and Providence Painters. He was probably no older than some painters we shall treat in the next chapter: the Washing Painter, for instance; or the Kleophon Painter, whose relation to the Polygnotans is very like the Phiale Painter's to the Achilles Painter's circle.[80] There are factors, however, which lead me to prefer to discuss him here. The Washing Painter is among the early formulators of a new and important tendency in Attic vase-painting. The Kleophon Painter has a pupil and close follower, the Dinos Painter,[81] who works till late in the century and is a formative influence on early fourth-century red-figure. To the Phiale Painter no pupils have been traced. Van de Put suggests,[82] and he is surely right, that it was the end of the Achilles–Phiale Painter workshop which brought about the departure of the Painter of Munich 2335, and the beginning of the divorce between white-lekythos and red-figure painters. The great line which starts from the Pioneers with the Berlin Painter ends here. Happily it does not end in decline. The Phiale Painter not only has

exceptional charm, expressed mainly in work on a rather small scale; he can also achieve grandeur, and shows himself as true an artist as any of his predecessors.

The phiale in Boston[83] from which he takes his name is one of the rather few red-figure examples of this shape. We saw an outsize one by Douris, with pictures inside and out round the black omphalos.[84] The Boston vase is of a size to fit the human hand. It is black outside and has a little picture on the omphalos as well as the main one round it (fig. 217). This shows a visit to hetairai. A bearded man listens with bent head to a woman piping. A young man is in talk with a woman muffled in her himation. Another applauds a little girl dancing with castanets. She wears a short chiton, and her himation lies on a chair. On her other side her instructress leans on her *narthex* (teacher's cane) and beats time. Another woman holds a jug and a pile of three phialai.

A scene from ordinary life? Not quite. The phialai can hardly be, as has been suggested, simply for the men to drink from. It is a ritual vessel; and that this vase and its pictures have a religious association is shown by

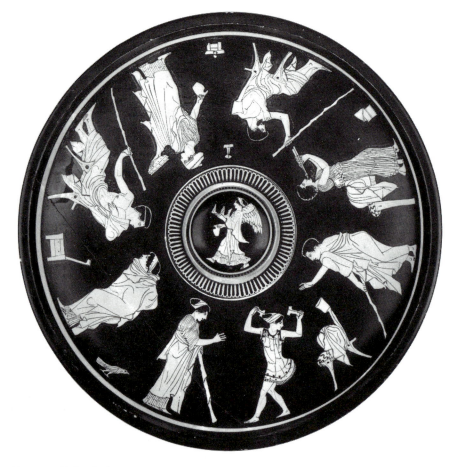

Fig. 217. Phiale; Phiale Painter. Visit to courtesans, with religious overtones. D. *c.* 0.34.

the decoration of the omphalos. A winged goddess (Nike or Iris) hastens along, a jug in one hand, in the other a basket-tray of a type constantly shown in pictures of religious ceremonies. The vase was found in Attica (near Sunium), presumably in a grave; and I would hazard that it was the grave of a priestess of Aphrodite and that the pictures have allusion to the goddess's worship.

The painter was particularly fond of this kind of subject.[85] Dancing girls, most not fully grown, appear on lekythoi, Nolans, hydriai, a two-row calyx-krater and at least one oinochoe by him, in various forms of short chiton, muffled in the himation, or naked; so he would have been a natural choice for the decoration of the phiale. The dancers are almost always accompanied by the woman with the *narthex*, and in several of the pictures there are men looking on. From where we stand, of course, these pictures are a typical reminder of the macho character of classical Athens: the exploitation of women and children by totally dominant man. The painter, however, and his public could not see it that way. The subject gives scope to his quick observation and deft rendering of movement, and he imbues it with great charm.

For the most part the Phiale Painter carries on the line in small vases, begun by the Berlin Painter and continued by the Providence and Achilles Painters: Nolans and lekythoi and small versions of large shapes, especially the pelike. Many have traditional subjects, from daily life or mythological, but often there is a special touch in the treatment. A Nolan in Woburn[86] with satyr and maenad has the maenad perform an unusually carefully observed dance to the satyr's pipes; and on the back another woman, wrapped in her himation, throws back her head and sings: a reverse 'mantle-figure' with a difference. On another in Naples,[87] where the front has an athlete preparing for the race in armour with his trainer, on the back is a rare glimpse of relaxation in the palaistra. A naked youth leans both elbows on a pillar and just looks. Sometimes the subject itself is more uncommon. A small pelike in Boston[88] shows two young actors getting ready to perform in a tragic chorus of women (all parts in Greek drama were taken by men). One is pulling on his second boot (*kothornos*) and his mask lies on the ground. The other, dressed and masked, practises movement and gesture, but holds his man's himation in one hand.

The artist did work on a larger scale. Some of the most interesting pieces are fragments, but there is one complete masterpiece. On a stamnos in Warsaw[89] he treats the subject we have met already, on the same shape, in the work of the Chicago Painter:[90] women preparing a festival of Dionysos. The image of the god is not shown, and the centre of the front is occupied by a woman, evidently the principal organiser. She has her

back to another, who lifts a big stamnos on to or off a table, in front of a column which defines the scene as an interior. The central figure holds a *barbitos* in her left hand, and extends her right to a baby, carried by a third woman, and he reaches out to her. The picture has the charm and life of the artist's small-scale work, with a grandeur for which that does not prepare us.

These scenes of preparation are taken from real life. Maenadism was was also part of real life, and these women would take to the hills in the god's ecstasy. When painters represent them so they habitually show with them not only the god himself manifest but his elfin company of half-animal satyrs: the women are translated into another world. Pictures of the preparation are not normally like that; but here the painter has given the baby the snub nose and horse's ears of a satyr. This casual crossing of the boundary between the worlds helps us to appreciate the ambiguity of the pictures on the funeral lekythoi.

The Phiale Painter worked in white-ground too. To his youth are ascribed two beautiful little white-ground calyx-kraters. One of them, in Agrigento,[91] has the *kalos*-name of Euaion son of Aeschylus, which appears also on red-figure works by this painter, the Achilles Painter, the Polygnotan Lykaon Painter and the Euaion Painter. The Agrigento vase has Andromeda staked out for the monster (not shown), and Perseus. He has come to the rescue, but he stands quite still, foot up on a rock, elbow on knee, hand to chin, rapt in contemplation of her beauty, his spears idle in the other hand. The *kalos*-name is written by him, and two of the other appearances of Euaion's name are placed close to figures who are known to have been central in Attic tragedies: Actaeon and Thamyras. Euaion is described as *tragikos*, and was probably a tragic poet like his father, but the word can also mean tragic actor, and the same man was sometimes both. These pictures are thought to have been inspired by productions in which Euaion took part.[92] Whether that is so or not, in this picture there is surely another influence, that of wall-painting, visible especially in the Perseus, so like something in Pausanias's description of the Underworld at Delphi. On the back also are two quiet figures: a woman with a sceptre (no doubt Andromeda's mother Cassiopeia) and an attendant.

The other white calyx-krater by the painter, in the Vatican,[93] has more figures (fig. 218). Hermes brings the infant Dionysos to a white-haired old Silenos, a nymph to either side; on the back three Muses. Ivy-covered rocks add an attractive element of landscape, but the figures are arranged in the traditional frieze-like manner. The impression of influence from large painting is much less strong here. On both vases 'second white' is freely used. It is possible that when they were painted the artist's master, the Achilles Painter, was still using

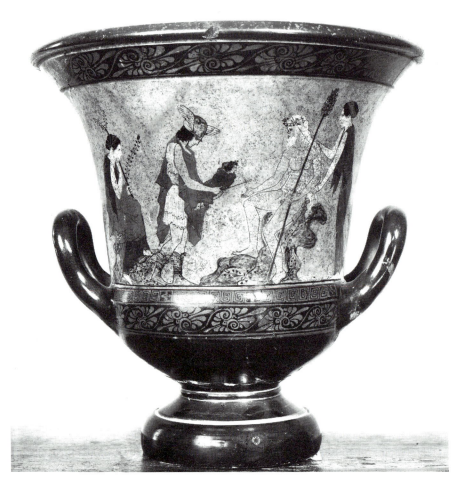

Fig. 218. Calyx-krater; Phiale Painter. Hermes bringing baby Dionysos to the nymphs of Nysa. H. *c.* 0.35.

this on his lekythoi, but it is not necessary to suppose so. Certainly when, at a much more advanced phase of his career, the Phiale Painter himself decorated white lekythoi, he abjured not only 'second white' but 'glaze outlines' too.

Only half a dozen white lekythoi are attributed to him, but they are of wonderful quality. On one in Athens[94] a woman has flung herself on her knees, head back, one hand up to it, the other reached high: an action of ritual lament, which does not mean that it could not also express true grief. On the other side of the tomb stands a woman, quite still, a leveret in her arms: a second mourner in different mood? the dead? Two other lekythoi by the painter, in Munich, have a bearing on this question. They were found together, and were evidently made as a pair. Buschor attributed them to one hand. Beazley at first gave only one to the Phiale Painter, the other to a Clio Painter, a minor artist we shall touch on in another section.[95] He was surely right, however, later to renege on that and see them both as the Phiale Painter's. One[96] we have already noticed for its picture

of the dead woman standing, decking herself for the journey to the Underworld, and Hermes, seated on a rock, waiting to guide her (fig. 219). The composition of the other[97] is extremely similar. Again there is a rock on the left, on which a figure sits, an upright figure before her. This time, however, both are women, and the one on the right is certainly a living mourner, approaching with a fillet to add to others already bound on the tomb. The other sits, her bowed head on her hand; a grieving posture, certainly, but appropriate also to the dead, and as such I see her (fig. 220).

Another difference in composition might be significant. On the vase with the two women the tomb is, in the usual way, between them, though much closer to the seated one, overlapped by her and by the rocky outcrop on which she sits but which does not reach to the other woman's feet. On the other both seated god and standing woman are supported by the rock, and the tomb is at the woman's back, much overlapped by her but leaving both figures on the same side of it. This might support the idea that, in the common composition

208

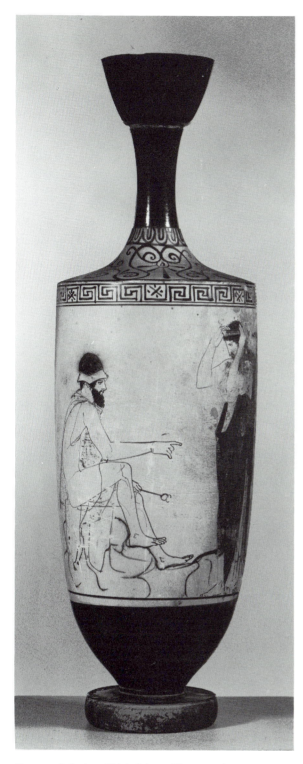

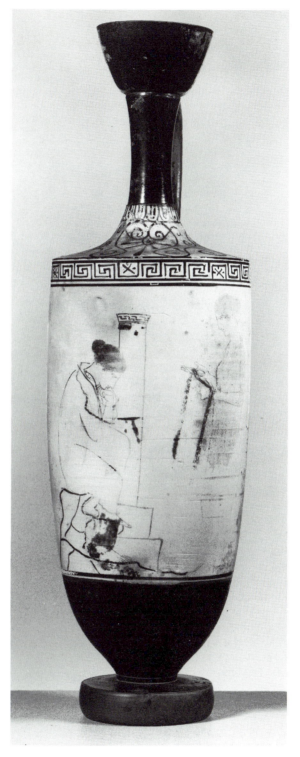

Fig. 219. Lekythos; Phiale Painter. Hermes and woman at tomb. H. *c.* 0.37.

Fig. 220. Lekythos; Phiale Painter. Woman seated at tomb, another approaching. H. *c.* 0.36.

of a tombstone between two figures, the stele can mark the boundary of the two worlds.

On both the Munich lekythoi the main outline of the figures is in matt red, while a thicker matt black line is used for the configuration of the rocks. For other features the two colours are variously used. Early developers of the matt outline, the Sabouroff Painter for instance, employ mainly black. Later in the century red takes over all but entirely.

But the first and last thing about these two pictures relates neither to technique nor to iconography. It is simply their great beauty as works of art.

c. The Group of Polygnotos

The high classical style in vase-painting is represented perhaps at its purest, certainly to me at its most appealing, in the art of the Achilles Painter and his companions. The group, however, to which we now turn produces work of no less high quality and is of greater historical importance. That is to say, by its links both backwards and forwards it takes a more significant place in the development of Attic red-figure. These artists derive their style (and surely also their workshop) from the Niobid Painter and his circle;[98] and a great artist who issues from the Polygnotan circle, the Kleophon Painter, carries the tradition into the next phase, while his pupil the Dinos Painter works down to near the end of the fifth century and is a formative influence on developments in the early fourth.[99]

It is true that these artists play no part in the creation of the white funeral lekythos, perhaps the single most important artistic achievement of the classical Kerameikos. There the Achilles Painter and his workshop must have the credit. However, it is also true that outline drawing on a white ground remains a specialised sideline which does not outlast the fifth century, and the history of Attic vase-painting has to be traced primarily through black-figure and red-figure.

The involvement of the Achilles Painter and his companions in the creation of the white lekythos is linked to the fact that the principal business of the shop in red-figure was the production of small pots, Nolans and lekythoi in particular. Their large-scale work is superb, but there is little of it; almost every example a special piece. The situation in the Polygnotan workshop could not be more different. Among well over four hundred vases listed by Beazley in his chapter 'Polygnotos and his Group' there is not one lekythos and fewer than twenty Nolans. Almost all Polygnotan pots are large; and this has the incidental effect of making less clear-cut the distinction between everyday work and special pieces.

We noticed that Polygnotos was the name of the Lewis Painter, or at least the name by which he wished to be known, and that the signature is found also on a vase ascribed to the Nausicaa Painter whom we shall meet in the next section.[100] Apart from these, *Polygnotos egrapsen* is found on five vases clearly by one hand.[101] The suggestion that the name Polygnotos was assumed by vase-painters in homage to the great wall-painter from Thasos we found perhaps plausible in the case of the Lewis and Nausicaa Painters. In this other case I prefer a variation on that idea. The Polygnotan workshop takes over that of the Niobid Painter. Crafts and trades commonly ran in families. The Niobideans show in their work their admiration for wall-painting, and I would suppose that one of them called his son Polygnotos.

The signed vases are two stamnoi, a neck-amphora, a pelike and a krater-fragment (calyx or bell). Some seventy vases are assigned to the painter, a dozen more to his manner; about 170 to a dozen named companions or close to one or other of them; and about the same number classed simply as 'Group of Polygnotos: undetermined'. In the chapter on the Niobid Painter eight companions are named and the total of pots listed is considerably under three hundred. It looks as though the workshop had undergone an enlargement analogous to, though less marked than, the earlier change from the Pistoxenos to the Penthesilea workshop. Stamnos and bell-krater are the commonest shapes, calyx-krater and neck-amphora also popular; a fair number of pelikai and hydriai; not many volute-kraters, but several of those special pieces; dinoi, loutrophoroi, nuptial lebetes and a few other shapes in small numbers.

Beazley noted that the signed vases are not Polygnotos's best. He also isolated 'within the Group of Polygnotos...a great group that may be named after the chief artist in it – the Peleus Painter'.[102] These artists produced much of the best work in the Group, and one might wonder if the Peleus Painter rather than Polygnotos should not be regarded as the true central figure. However, Matheson's study of the Group in depth has convinced me that the traditional view is better.[103]

A signed stamnos in London[104] shows Herakles attacking a Centaur, a woman running away, a man standing by (fig. 221). It is not, as at a glance one would think, the story of Nessos and Deianira, for the Centaur is named Eurytion; and there is a tale of Herakles rescuing the daughter of one Dexamenos from a Centaur of that name. The woman's dress, chiton and diagonal himation, is old-fashioned, and it is drawn in an oddly archaic way. Matheson has pointed out the likeness of the central group (hero and Centaur) to a Parthenon metope. One of the lost metopes recorded in Carrey's drawing has two women costumed in just this puzzling way.[105] The vase-painter had surely been looking at the building.

The artist's quality tells better in a fragment of a bell-

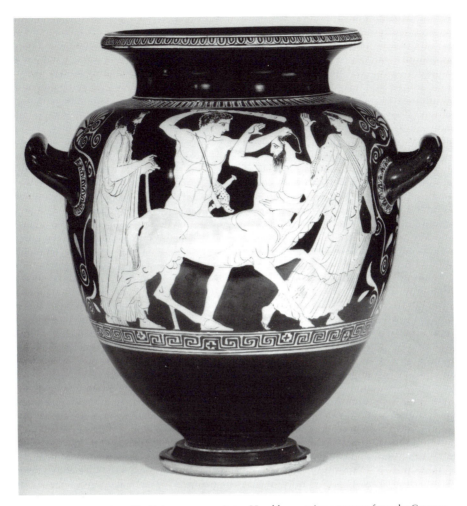

Fig. 221. Stamnos; signed by Polygnotos as painter. Herakles rescuing a woman from the Centaur Eurytion. H. *c.* 0.45.

krater from Adria (fig. 222)[106] with another rare subject: the meeting of Oedipus and Laios in the narrow way. Neither of the principals is preserved, but we have Oedipus's name and part of the club he is swinging against Laios's groom, in cap and skin cloak, who raises a stick to strike back. Behind him are the heads of two mules drawing Laios's cart, and behind them the head and raised hand of a female figure, her himation drawn up over her loose hair. She is named *Kalliopa*, the Muse Calliope, and her presence marks the locale of the tragic event, Helikon or Parnassos where the Muses wander. The mules wear sun-hats, carefully observed and rendered with a hint of shading. The drawing is vivid, and one wishes one had the whole picture.

Polygnotos, in his surviving work, shows little interest in the spatial effects which the Niobid Painter and some of his companions sometimes took over from wall-painting. Another leading member of the Group, the

Lykaon Painter,[107] has more taste for them. On a bell-krater in Boston he draws the death of Actaeon. Artemis stands by with a torch, and on the other side Zeus looks on. Both these framing figures stand on the base-line of the picture, but Zeus has one foot up on a rock, and in the centre, where Actaeon struggles against his attacking hounds, broken ground is indicated with plants growing on it. Running towards him is a strangely clad figure, a tiny wolf-head rising from her scalp, her name written above, *Lyssa*, Madness. In the Pan Painter's great version in the same collection there is no hint of Actaeon's transformation into a stag, though in his earlier rendering from the Acropolis he had shown the victim clad in a deerskin.[108] The Lykaon Painter shows the metamorphosis unequivocally. The ears are already animal, antlers begin to sprout from the brow, and fur is appearing on the thickening face. This is the Actaeon picture which has the name Euaion written above the victim.[109] Here the name (without patronymic) stands

Fig. 222. Bell-krater fragment; Polygnotos. The meeting of Laios and Oedipus. L. of fragment *c.* 0.30.

by itself, not followed by *kalos*. This strengthens the idea that it may name an actor in a tragedy on the theme; but though it may allude to a production it cannot illustrate action on the stage. By the conventions of Attic drama Actaeon's terrible end must have happened off, and been recounted to chorus and audience in a speech. The artist painted a near-replica of this picture on a calyx-krater of which a fragment in Oxford survives, with parts of Actaeon and Artemis.[110] In neither did the artist show his best drawing. Far finer is a pelike, in Boston like the bell-krater, which again demonstrates his interest in setting.[111]

It illustrates Homer's story of Odysseus's visit to the Underworld to consult the dead seer Teiresias (fig. 223). Instructed by Circe, the hero has sailed to the ends of the earth. There he digs a trench, sacrifices into it two black rams, and sits by it, waiting for the ghosts to smell the blood and come; they cannot speak until they have drunk blood. Odysseus sits well up in the picture, on broken ground, his cloak under him, right foot raised on a rock, elbow on knee, chin on hand. He wears boots, and a travelling-hat is slung on his back. His scabbard hangs at his side, and he holds his sword low, strangely in his left hand. The dead rams (not black, which is awkward to render in red-figure) bleed in the trench in front of him, and beyond them rises the first ghost, visible from the knees up, the young helmsman Elpenor. His right hand presses down heavily on a ledge of ground and his left is raised on another, as though he is

climbing painfully up from the depth. The ground-contours and a clump of flowering reeds behind the ghost are added in white which has faded and can only be seen now in certain lights. Behind Odysseus, still on the broken ground but nearer the base-line, Hermes moves towards the hero with a protective gesture. The god does not figure in the account of this episode in the *Odyssey*, but he is a natural presence when a mortal comes to the Underworld.

This is a picture directly in the tradition of the earlier Underworld by the Niobid Painter.[112] It is evidently closely dependent on wall-painting, and takes over from that more than the older painter did of landscape detail. Like that picture, though, this too is well adapted by the vase-painter. The composition sits effectively on the vase; and both wayworn hero and lost ghost are finely characterised.

The reverse of this vase has a picture of Poseidon in pursuit of Amymone, another woman fleeing; a traditional composition decently but conventionally drawn. The backs of the same artist's Actaeon krater and Polygnotos's Eurytion stamnos have mantle-figures: on the first a youth between women, on the other three youths. The women show some variety and movement, but the central youth is already a stereotype, as are the three on the stamnos; and so these reverse-figures tend more and more to become.

The Lykaon Painter takes his name from the hero whose departure is shown on a pelike in London.

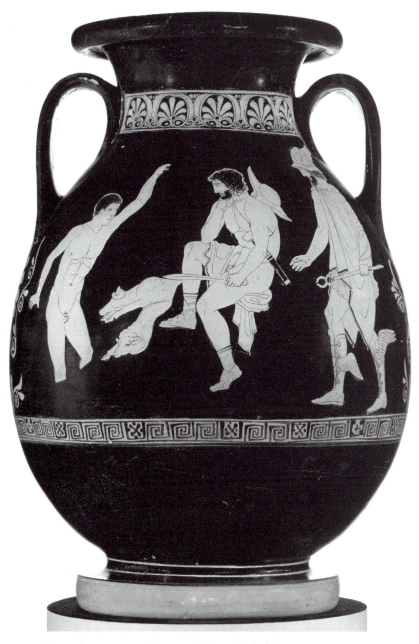

Fig. 223. Pelike; Lykaon Painter. Odysseus and Elpenor's shade. H. *c.* 0.47.

Closely similar but finer is Neoptolemos in a similar scene by the same painter on a neck-amphora in New York.[113] Big neck-amphorae like this are decorated by most of the major painters in the Group and are one of the areas where they stand closest to one another.[114] One signed by Polygnotos in Moscow[115] has Eos in a biga on one side, on the other Achilles sulking. Of half a dozen others by him several show an Amazonomachy, and of one of these it has been noted that the florals are by the same hand as those on the Lykaon Painter's

Odysseus pelike and a neck-amphora by the Kleophon Painter.[116]

A very fine neck-amphora in the Vatican shows another warrior's departure, and gives his name to the Hector Painter.[117] He and the Peleus and Coghill Painters form the Peleus Group;[118] but, in his final lists, Beazley adds that there are 'many vases not certainly by the Peleus Painter himself but close to him and sometimes of very high quality. The separating lines are often hard to draw';[119] and the difficulty appears in

comments in the lists. There are fifteen vases in the Hector Painter's list, twice as many in the Peleus Painter's. Three vases are described as 'near the Hector Painter', three others as 'near the Peleus Painter as well as the Hector'. The Peleus Painter is said to be 'near the Hector Painter and hard to tell from him'. Eleven vases 'in the Manner of the Peleus Painter (i)' are rubricked 'these are all close to the Painter and may be from his hand. Excellent pieces are among them'; while (ii) is the Coghill Painter, to whom only three vases are given, and 'these also are very close to the Peleus Painter'. Beazley further notes that the Curti Painter and the Guglielmi Painter are connected with the Peleus Group.[120] Four vases are ascribed to the Guglielmi; two to the Curti, and a third is said to be 'near these and also near the Peleus Painter'.

That these distinctions represent genuine perceptions of stylistic difference is not in question; but I do not think it follows that these seventy interlocked vases were necessarily painted by five or more artists, several of very high quality. I think it much more likely that they represent different aspects of one or two. Korshak has perceptively analysed the difference between the Hector Painter, more backward looking, and the Peleus, more forward;[121] but even this might be a distinction not of personality but of phase or mood. This seems to me a good example of how, while it is always a mistake to neglect Beazley's observation of stylistic distinction, one should keep an open mind about the exact interpretation to be put on the observations.

The Peleus Painter, whether one sees him as Beazley's core or as embracing a wider range, is a very fine artist. The masterpiece from which he takes his name is a calyx-krater from Spina[122] with the wedding of Peleus and Thetis, the figures named. The divine bride stands in a chariot, wreathed by a small flying Eros (he alone has no name by him). Her mortal groom is mounting behind her, but turns to receive a wreath from Aphrodite. Facing Thetis stands Apollo, playing his *kithara*, and Hermes minds the horses' heads. Between the two gods, behind the team, a goddess stands holding two torches. In an Athenian wedding this is the part of the bride's mother. The mother of the Nereids was Doris, but this figure is named, rather surprisingly, Hekate. We have seen Hekate with her torches lighting Persephone from the Underworld; she is sometimes seen with Persephone and Demeter sending Triptolemos out on his mission; and there is other evidence, from Hesiod[123] on, for a more kindly aspect of the goddess than one would guess from her common image as queen of night, mistress of witches and black magic. The composition of this picture is noble, the drawing sensitive. On the reverse is a less elaborate and less interesting picture but still of decent quality. A young warrior and his squire stand ready to depart, between the sceptred father and a Nike with jug and bowl for libation.

As exquisite as in the wedding picture is the drawing on the front of a neck-amphora in London (fig. 224).[124] In the middle a woman sits and plays the harp; a Muse, rather – above her is a name, Terpsichore. Behind her stands another, holding pipes; a Muse too, one would have said, but though her name Melousa (miswritten Melelousa) connects her with music it does not belong to one of the nine. Between them on the wall a small *kithara* is hanging. In front of Terpsichore stands a young male, looking down at her. He wears a himation with no chiton beneath and a laurel-wreath, and leans on a laurel-branch, a lyre in his other hand. If he were not named we should have no hesitation in calling him Apollo, but he is Mousaios. This is not the only place in classical vase-painting in which the bard is made indistinguishable from his god.[125] The reverse-picture, a woman between youths, is conventional.

Terpsichore's face is as attractively three-quartered as the maenad's by the Achilles Painter (fig. 206), and the practice is more popular in this circle than in his. A Nike on a stamnos by the Hector Painter[126] is exceedingly like Terpsichore. Other examples are the Lykaon Painter's Elpenor and Actaeon,[127] and a boxer on a very fine fragmentary volute-krater from Spina[128] by the Peleus Painter with the funeral games of Pelias. There are impressive complete volute-kraters ascribed to the Group of Polygnotos only. One, from Spina,[129] has a god and goddess enthroned side by side in a temple. The god is snake-wreathed, the diademed goddess has a lion on her arm: Dionysos with Semele or Ariadne?, Sabazios with Kybele? There is an altar in front and a priestess with a covered basket on her head; and dancing all around, to the piping of two women and a bearded man, women and young girls, snake-wreathed and wild.

One other piece deserves mention here, not primarily for its quality (though it is a big, elaborate piece of distinctive character) but because it seems another interesting example of an artist working beyond his time, as I believe we can see Epiktetos doing.[130] This is a calyx-krater from Spina.[131] On the front, and extending over the handles, is a Gigantomachy; on the back the abduction by the Dioskouroi of the daughters of Leukippos. In both pictures the figures are set up and down the field. Beazley remarks: 'A puzzling vase belongs to the period of Polygnotos, but can hardly be assigned to the Polygnotan Group: one is sometimes inclined to wonder if it might not be extremely belated work by the Painter of the Woolly Satyrs.'[132]

Fig. 224. Neck-amphora; Peleus Painter. Mousaios with Muses. H. *c.* 0.58.

d. Other painters of large pots; the column-krater

In the chapter of *ARV*², 'Polygnotos and his Group', Beazley evidently lists only painters whom he sees as forming a close circle; indeed, surely a workshop. This 'house style', however, had a pervasive influence, and most pot-painters of the time who appear in the two following chapters, 'Other classic pot-painters' and 'Painters of column-kraters', can be counted Polygnotan in a very loose sense. It is the dominant style of the age. In many cases (the Naples Painter for instance, and the Painter of the Louvre Centauromachy)[133] Beazley ac-

knowledges this in earlier publications though he does not repeat the observation in the final lists. Thus the related Clio and Cassel Painters[134] appear in *AV* (1925) in the Polygnotan chapter, though the Clio Painter's connection with the Phiale Painter is already noted. In *ARV*[1] (1942) the Polygnotan connection is still mentioned, and next year there is a reference to 'artists who stand on the outskirts of the Polygnotan group or just outside it, for instance the Cassel Painter'.[135] The omission of any such reference in *ARV*[2] surely reflects a tightening in Beazley's concept of the Group, not a rejection of all stylistic affinity.

The allusion to the Cassel Painter in 1943 comes in an article 'Panathenaica' à propos the style of a 'Robinson Group' of black-figure prize-vases. We shall have much to say of the series of prize-vases in later chapters. Meanwhile we should not forget that throughout the period they were issuing from red-figure workshops.[136]

Few of the painters listed in these chapters of *ARV*[2] need much attention for their quality; but there are exceptions, and there are also points arising of more general interest. Such is the incidence of column-krater painting. Already in the late archaic period, when the shape first becomes popular in red-figure, it tends to be a second-class vase in which second-class painters specialise; and it remains so, though there are exceptions at all periods. It is of interest that among the many hundreds of vases listed in *ARV*[2] in the chapters devoted to the Kleophrades Painter, the Niobid Group, Hermonax, the Achilles and Phiale Painters and the Group of Polygnotos, not a single column-krater appears. It is a very popular shape, but not in most of the workshops in which the main lines of red-figure pot-painting develop.

Among early classical painters of column-kraters we noticed the Boreas Painter[137] for his power of rising sometimes above his usual level on a volute-krater. His companion the Florence Painter[138] more rarely shows such flashes, but there is real quality in the Centauromachy on his name-vase. His style is continued in this period by a Naples Painter of consistently undistinguished achievement. The Painter of the Louvre Centauromachy[139] is no better, but his range of shapes is slightly different. All these craftsmen sometimes decorate other shapes, but this painter is unusual in having almost as many bell-kraters as column-kraters. This anticipates a trend. Later in the century the column-krater virtually dies out, and the bell-krater takes over its position as the krater for bulk production, while continuing to be used also for better work.

There exist column-kraters in the high classical time which display really fine work, notably the famous vase in Berlin with Orpheus (fig. 225).[140] The bard, half-wrapped in his himation and wearing a laurel-wreath, is an Apolline figure. He sits on a rock in the centre and strikes his lyre, head thrown back to sing. Around him stand four Thracians. All wear native caps and cloaks and hold a pair of spears, but each is different. Immediately in front of Orpheus a youth has his foot up on the rock and leans forward on his spears, gazing into the singer's face. Behind him a bearded man turns his look the same way but stands frontal, clutching his cloak round him and gripping his spears. At Orpheus's back are two more youths, their cloaks, like the first youth's, hanging behind and revealing their bodies. One stands frontal, face as well as body, and leans on his spears, head tilted, eyes closed, rapt. The last, his cap hanging on his back and revealing a wreath on his hair, rests his cheek on his friend's shoulder. The composition, without being crowded, gives an impression of a listening multitude, and the bewitching nature of the music is beautifully conveyed.

Polygnotan influence is strong in the style; indeed in *ARV*[1] the Orpheus Painter is classed as a Polygnotan.[141] As often, one wonders if there is not a wall-painting behind the composition; and the badly confused drawing of the frontal youth's shoulder suggests that the executant was not the creator of this figure. Nevertheless, the vase-painter has done well.

Another interesting picture on a column-krater of this time shows the death of Talos, and we shall come back to it in connection with important renderings of that subject from the end of the century.[142] The vase is unattributed. Beazley did not know it, and I have seen only rather poor reproductions of the main picture. One might seek to place it near the Orpheus krater. Certainly it has no connection with the largest group of classical column-kraters, those from the later phases of the Mannerist workshop.

We noticed that of the earlier generation the Agrigento, Perseus and Oinanthe Painters[143] lead on to the later, in particular to the Nausicaa Painter who seems to be the dominant figure. He and the Hephaistos Painter[144] seem sometimes to make some effort at decent drawing, but even their standard is deplorable. Interesting subjects, however, are sometimes chosen.

The Nausicaa Painter takes his name from the picture on a neck-amphora in Munich.[145] Nausicaa and her women are surprised by Odysseus, cast naked on the shore where they have brought their washing: the first appearance of a rare subject. We know that Polygnotos of Thasos depicted it in a picture which centuries later Pausanias[146] saw in the *pinakotheke* of the Propylaea at Athens. On the vase there are elements of natural setting: rocks; a piece of water from which a girl is drawing a garment; a tree with garments hung to dry; the sprays with which the hero tries to cover his nakedness. One would guess that the craftsman had looked at a painting, but the frieze-like arrangement of

Fig. 225. Column-krater; Orpheus Painter. Orpheus enchanting the Thracians. H. of picture *c.* 0.22.

the figures round the vase is conventional, the drawing clumsy and weak. Hardly a hint of a fine original comes through.

The inscription *Polygnotos egrapsen* on an amphora Type B ascribed to this artist[147] may, as suggested, show the vase-painter borrowing the wall-painter's name. The oddly composed picture, two women back to back, each decking an ox for sacrifice, a big tripod behind each beast, might again be a borrowing from wall-painting. It has elements in common with a design (Nike and a woman preparing an ox by a tripod) on a much better drawn stamnos-picture by the Hector Painter;[148] but, if there is a common inspiration, one artist at least has treated the original very freely. It is curious that a poor kalpis in Warsaw was associated by Beazley, when he knew it only in a bad drawing, with the Nausicaa Painter; when he had seen the original he ascribed it to the vase-painter Polygnotos or a close imitator.[149]

A big column-krater by the Hephaistos Painter from Spina[150] with a young warrior arming is well composed. The youth sits on a rock and turns, leaning on his spear, to listen to a man who rests his foot on a rock and gestures; while a woman holding the youth's helmet is in conversation with another man. Even the reverse-figures are arranged in two conversational pairs with differences of posture and movement; and the drawing is quite competent. It is instructive to compare it with the same painter's smaller and much more typical piece from the same site with the same theme: three figures on each side mechanically daubed in.[151]

Two painters show this workshop continuing into the last quarter of the century. To one of them only a few pelikai and a hydria are given,[152] but the Academy Painter[153] has also column-kraters and bell-kraters; and his column-kraters have still the distinctive form given the shape by the earliest Mannerists.[154]

e. Smaller pots (oinochoai, skyphoi); the Penelope Painter

The shop in which the Achilles and Phiale Painters worked was a major producer of smaller pots: Nolans and lekythoi; and small versions of large pots (pelikai, hydriai, calyx and bell-kraters). The Polygnotans avoid both classes; nor are any oinochoai ascribed to them, whereas there are several from the Achilles Painter's

circle, and a fine set of four in Boston is ascribed to the Chicago Painter.[155] Earlier, in late black-figure, and again in red-figure from soon after this time, one finds workshops which specialise in one or more of the many forms of oinochoe. In earlier red-figure they seem mainly decorated as a sideline by painters whose main interest is in other shapes. There are exceptions. The few early and eccentric pieces given to the Goluchow Painter must be by-blows from a black-figure workshop; but the many coarse cups of the Painter of Berlin 2268 are accompanied by almost as many equally worthless examples of the 'oinochoe shape 8A (mug)'.[156] Still in the archaic period, eight of the pretty little vases given to the Dutuit Painter[157] are oinochoai, more than any other shape in his repertory; and so are four of the five by the Terpaulos Painter.[158] The Harrow Painter[159] has left us only a few, but he kept his best work for them. In the early classical phase there are five jugs of quality of a rather uncommon form (shape 7) by one hand, the Painter of the Brussels Oinochoai. Beazley originally thought that this good artist decorated also a number of large vases, which he later detached. We have already considered these under the name of the Painter of Bologna 228.[160]

In the time we are now concerned with a Mannheim Painter[161] decorates a dozen oinochoai, some of shape 7, more of shape 5A which is also not common. He is a talented and careful draughtsman who chooses some unusual subjects: a warrior with his unharnessed chariot; Persian royalty.

We considered the skyphos in the last chapter, noting that it is a specialism of some late black-figure workshops but that in early red-figure it appears only as a sideline of workshops and painters with other principal interests. At the beginning of the early classical, however, some red-figure specialisation in it does begin, with the *poietes* Pistoxenos and the Lewis Painter, whether or not there is any association between the two.[162] In the high classical the situation is much the same. There is one specialist, the Lewis Painter's pupil the Penelope Painter, whom we shall consider in a moment, and occasional examples in many other circles. None is attributed to the Achilles Painter or any of his circle, or to the Chicago Painter, but there are three in Beazley's chapter on Polygnotos and his Group.

One of these appears in the Undetermined list,[163] but the other two are put together as the work of a Pantoxena Painter.[164] One bears the unusual inscription: *Pantoxena kala Korinthoi*, 'Pantoxena is beautiful at Corinth'; the other, still more oddly, *Pantoxena Korinthoi ho[ra]ia kalais*. Corinth was a Dorian city, and *kala* is the Doric form of *kale*. The word *horaia* means 'in season', and by extension 'in the bloom of youth'; and *kalais* is reported as a Doric word meaning 'hen'. Corinth was famous for its prostitutes, and the Pantoxena Painter had perhaps been visiting there. Artistically he is a shadowy figure, with only two other

pieces to his name. The representations on the vases have no evident relation to the inscriptions. The first, which was found in Etruria at Vulci, has Eos pursuing Tithonos, the boy's brothers on the reverse running to their father. The other, a fragment, was found in Piraeus and shows the death of Orpheus at the hands of the Thracian women. Aspects of predatory woman, perhaps?

It is clear that the Penelope Painter[165] was a pupil of the Lewis Painter and succeeded to his master's position in the workshop. He carries on the interest in subjects outside the usual vase-painters' range; and he is a more considerable artist than the Lewis Painter, capable of making his pictures more interesting. He takes his name from a famous skyphos in Chiusi.[166] Odysseus is home at last, but his kingdom is in hostile hands, and he has entered his palace disguised as a beggar. On one side his feet are being washed by the old slave Eurykleia, who recognises him by a scar. On the other his wife Penelope sits sadly by her loom, their son Telemachos standing by, unaware that deliverance is at hand. On a second skyphos, in Berlin,[167] the artist has put an extract from the sequel, the slaughter of the suitors at the feast. On one side Odysseus draws the famous bow; on the other three suitors are shown, one already stricken, one kneeling up on a couch lifting his mantle in front of him, the other improvising a shield from a table. The two short-haired women behind Odysseus, who show signs of distress, must be the slave-girls who had slept with the suitors and who with reason fear the fate of collaborators. The two vases (found at Chiusi and Vulci) are not a pair: their rims are differently treated. That of the Penelope skyphos is plain, the rule hitherto; the other bears a narrow border of ovolo. We shall meet the same distinction in cups by the Euaion Painter.[168] There those with ovolo are in general later than the others; and the same may be true in the case of the Penelope Painter's skyphoi.

The painter's style is the purest classical. The figure of Penelope, however, faithfully reproduces a sculptural type created in the generation before. It is known in Roman copies in the round and in relief, in a fragment of one original marble statue, and in small terracotta reliefs from Melos.[169] Very probably it appeared also in wall-painting; and the Penelope Painter is another vase-painter in whom one suspects influence from the great art. Polygnotos of Thasos is known to have painted the slaughter of the suitors in a temple at Plataea, but he chose a different moment: 'Odysseus having already made an end of the suitors'.[170] The slaughter was represented on a late archaic phiale,[171] but apart from that these are among the earliest representations of any of these subjects, and they never become common.

Another very interesting skyphos by the painter, again in Berlin,[172] shows on one side a satyr walking behind a woman and holding a parasol over her head; on the other a satyr pushing a woman on a swing. There was a

swinging ritual at the Attic festival of Anthesteria; and these pictures surely illustrate the festival, lifted to another plane by the presence of *daimones*.

Yet another exceptional subject is on a skyphos in the Louvre:[173] apparently the building of the walls of the Acropolis. On one side Athena directs a Giant, inscribed *gigas*, who carries a boulder; on the other are two men, seemingly architect and overseer. The latter is named Philyas, and an attractive theory sees an allusion here to Pheidias who at this time was Pericles's overseer of building works on the Acropolis.

Among the more ordinary scenes a much restored vase in Oxford[174] deserves mention. It is one of those with ovolo at the rim. On one side a young trainer stands, trailing his wand, and beside him a Nike, wings and arms spread wide. Both look in one direction, certainly at the figures on the other side, two wrestlers in a grip. Behind one of these, at the far end from the figures on the other side if one follows the direction of their look, is a pillar, and on top of this sits a small Nike, frontal, face three-quartered, looking down at the wrestlers. Her hand is to her chin, in a gesture of troubled thought (compare Penelope, and one of the apprehensive girls at the killing of the suitors). It is strange in a Victory, though paralleled on one of the enchanting series of coins struck at Olympia. Set there it surely had some special meaning.[175] On the skyphos one wonders if the winged women may not represent the spirits of the two wrestlers; potential Victories both, but one stands proud, sure of her man's triumph, while the other foreknows defeat: 'Thy lustre thickens/When he shines by.' The mothers Thetis and Eos are often similarly distinguished in pictures of the combat in which Achilles is to kill Memnon.

III. Cup-painters: the Euaion Painter; the Codrus Painter

The relation of the Euaion Painter to Douris seems much like that of the Achilles Painter to the Berlin Painter. He carries on the earlier artist's workshop, and one would guess that he had had personal contact with him, but only at the end of the master's career.

The Euaion Painter[176] certainly begins in the early classical phase, but his work has always the calm that one associates rather with the high classic. One understands why Beazley connected him, among his early classical contemporaries, with the Villa Giulia Painter, but it seems a likeness of temperament rather than a workshop link.

Through the early classical years the Euaion Painter's production runs parallel to that of the Penthesilea Painter. They are the two principal cup-producers of the time. The Penthesilean workshop, if not the painter himself, continued production deep into the high classical age, but it is not really at home there; its spirit is

that of the earlier phase. The Euaion Painter on the other hand comes to his own in his maturity, though he rarely if ever displays the warmth and tenderness of the best classical work. He is an accomplished draughtsman and maintains a high standard of care. A cup-skyphos in Warsaw,[177] which Beazley ascribed to him, after hesitation, as an early work, has scenes of sacrifice drawn with some of the life and charm which marks the work of the Akestorides Painter, but this is exceptional.

For the most part the Euaion Painter's figures, whether athletes, komasts, men and women or satyrs and maenads, are arranged around his cup-exteriors with little overlap or interaction. In the tondo there is often a pair of figures, and he likes to set them upright on an exergue which sometimes cuts off quite a large segment, so that the composition requires the least possible adjustment to the curve of the frame (fig. 226).

We noticed in the last section that, while most of the Penelope Painter's skyphoi have the traditional undecorated rim, a few show a strip of ovolo along it. The Euaion Painter regularly introduces this feature on his later cups, and it is found on cups by several artists of the period; not, however, on those of the other painter we shall consider in this section, the Codrus Painter.[178]

I do not know if it could be demonstrated that the Codrus Painter learned his craft from the Euaion Painter, but I should think it probable. He is, however, a far more interesting artist; a sensitive draughtsman whose work is informed to a high degree with that tenderness and grace which is one of the glories of classical art in Athens. In this he reminds me rather of the Phiale Painter; and it has been observed that pyxides and a cup by the Phiale Painter show potter-links to late work of the Euaion.[179]

Fig. 226. Cup; Euaion Painter. Youth and man preparing for party. D. *c.* 0.20.

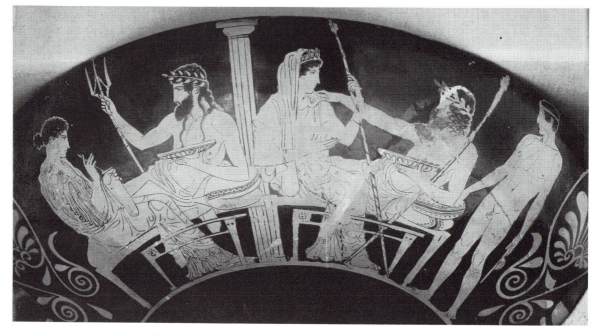

Fig. 227. Cup; Codrus Painter. Divine symposium: Amphitrite and Poseidon; Hera and Zeus, with Ganymede. H. of picture *c*. o.11.

The Codrus Painter in his tondos uses the exergue more discreetly than the Euaion Painter, but one would not call him one of the great composers for the circle. His exteriors, however, are often of striking beauty, and there is interest in his choice of subject-matter.

A divine symposium on a cup in London[180] has pairs of gods and goddesses reclining (fig. 227): Plouton and Persephone within; on one side Poseidon and Amphitrite, Zeus and Hera, Ganymede serving; on the other Ares and Aphrodite, Dionysos and Ariadne, served by a satyr, Komos. Often, however, the themes have a strongly Athenian slant. Another London cup[181] has the deeds of Theseus, and that in Bologna,[182] from which he takes his name, shows six Attic heroes. On one in Berlin[183] the exterior has the Calydonian boar-hunt and Peleus hunting a stag; but we are back to an Athenian theme in the tondo: Aigeus, Theseus's father, consulting the oracle at Delphi. Another in the same collection[184] has in the tondo Eos carrying off the Attic hunter Kephalos, and round the outside a beautiful composition of the birth of Erichthonios. Ge, rising from her element, hands the baby to Athena who stoops to receive him, and he reaches out his hands to her. Behind Ge snake-lengged Kekrops waits, holding a garment to wrap the child; and other figures, with names from the legendary royal house of Athens, hurry up to view the miracle. The scene has not the mystery and power of the rendering on the great early classical stamnos. It is more personal, intimate, charming. The preoccupation with Athenian legend reflects one mood of Periclean Athens.

The London Theseus cup has a peculiarity we have not met before. The pairs of Theseus and monster or brigand circling the exterior are repeated in a zone round the interior tondo, in corresponding positions but seen from the other side; as it were, two views of a three-dimensional group. The subject is treated in the same way on an evidently related cup in Harrow,[185] much smaller and with hastier but lively drawing (fig. 228). This Beazley first ascribed to the Codrus Painter; later he detached it and noted that it resembled the work of the Phiale Painter; he omitted it from *ARV*[2]. A pleasing puzzle to which I should like to know the answer. We shall return to the London Theseus cup in connection with an important painter of the following phase, Aison.[186]

Fig. 228. Cup; reminiscent of Codrus and Phiale Painters. Deeds of Theseus (detail). H. of picture *c*. o.05.

7

Developments from the high classical

I. The Kleophon Painter

The painters treated in the last chapter and those in this all belong to the Periclean age. The Achilles Painter, however, and the Polygnotans, must have got their training before Pericles established himself and were already reaching their maturity during the earlier part of his ascendancy: the time when the treasury of the Delian League was moved to Athens and the great building programme on the Acropolis began. The Kleophon Painter and the Washing Painter will rather have come to their prime when work on the Parthenon and its sculptures was drawing to a close; and they worked on into the time of the Peloponnesian War, the prolonged, disastrous conflict between Athens and Sparta which broke out in 431.

The Kleophon Painter[1] issues from the Group of Polygnotos; is indeed a younger member of it. He takes his name from the inscription *Kleophon kalos* on one of his stamnoi. No other painter uses the name; but Megakles, who is praised on the same vase, appears also on a bell-krater by one of the later Mannerists, the Orestes Painter[2] (who worked mainly on column-kraters) and on a fragment of another from the Group of Polygnotos.[3] The Kleophon Painter works on the same range of shapes as the older members of the Group: stamnoi, pelikai, calyx and bell-kraters (one with lugs,[4] a dinos, a volute-krater. A surprise is a fragment of a column-krater.[5] Another fragment is from a stand,[6] perhaps of a nuptial lebes, and there are a number, some very fine, from loutrophoroi.

All the Kleophon Painter's loutrophoroi are funeral vases, two of them (fragments in Oxford)[7] having battle-scenes with cavalry. On one of these a stele is shown, as quite often on battle-loutrophoroi; not, surely, that the fight is thought of as taking place near a tomb, but a reminder that the vase is meant for a soldier's funeral. The stele is white, bound with a red sash, and a horseman has a red petasos with a ribbon of a lighter red. This unusual polychromy looks on to developments later in the century. It is found again

on another of the Kleophon Painter's fragmentary loutrophoroi, in Athens.[8] This is not a battle-scene. Three stelai are shown and four figures (fig. 229). Three are warriors, one leading a horse, the fourth an old man (white hair and beard), in a himation. I do not take them all for mourners in a cemetery. The young men, I suppose, are shown by the three tombstones to be dead, and by their accoutrements to be dead in battle. The old man will be the father of all or one, or perhaps he just stands for bereaved fatherhood. These vases probably belong to the ten-year first phase of the conflict, known as the Archidamian war, from king Archidamos of Sparta who annually invaded Attica.

This last vase has the peculiarity of being very small. The painter, in the Polygnotan tradition, normally works on big vases and draws with an ample sweep. It is pleasing to see that he can on occasion produce the

Fig. 229. Loutrophoros; Kleophon Painter. Warriors and old man at tombs. H. of fragment as restored *c*. 0.10.

same gracious effect on a near-miniature scale. A pretty fragment (from an oinochoe?) in Bucharest,[9] with a citharode at a shrine of Herakles, seems to me a possible attribution to the painter in the same rare mood, but Beazley could not accept this.

To turn to more typical work, several of the Kleophon Painter's stamnoi show a young warrior leaving home. The finest is in Munich (fig. 230),[10] but a near-replica in Leningrad[11] comes close. A young warrior stands frontal, shield on arm, and raises a phiale on his right hand. Facing him a woman, his wife, bows her head and lifts the chiton from her shoulder. Behind her stands an old man with a stick, behind the warrior another woman: the warrior's parents. Warrior and mother, wife and father, overlap each other slightly, but there is a clear space between the two principals. The composition fits well on the tall, slender vase, and the picture has a gentle gravity. It is interesting to compare it with

a variation of the scene on another stamnos by the painter, in Cambridge.[12] That vase is of a different, wider model and the figures are more evenly distributed. The warrior is all but identical, but the figure behind him is his squire. The father seems more actively involved, leaning forward and gesturing, and the woman, whose hair is on her neck instead of fastened up, holds a jug to fill the bowl.

Both types of stamnos were in use among the Polygnotans, but the slenderer seems to suit the Kleophon Painter's style and he shows a preference for it. Of five vases with his other favourite stamnos-subject, the *komos*, three are of that type. A fine *komos* is shown, too, on the reverse of the Munich vase. The Leningrad and Cambridge vases have more conventional, though decently drawn, groups: boy between youths; man between women.

In the *komos* on the back of the Munich vase two

Fig. 230. Stamnos; Kleophon Painter. Young warrior leaving home. H. *c.* 0.43.

men, a youth and a girl piper dance along. In a similar four-figure composition on the front of another slender stamnos, the name-vase in Leningrad,[13] the movement is more complex. The man at the right-hand end, who plays the *barbitos* and throws his head back to sing, dances to the left, the rest to the right, but the way the figures overlap suggests that he is at the head of the procession and has just wheeled round. Two dancing youths come next, the second turning back to a third who is piping; while on the back two bearded men and a youth between them complete the party.

A pelike in Munich,[14] which has a man between women on the back, shows for its main picture the return of Hephaistos to Olympus; a much quieter affair than the archaic versions we have seen. In the centre walks Dionysos, a stout thyrsos for staff, and looks back at Hephaistos whose wandering steps are supported by a small satyr. The rest of the rout is reduced to a maenad who walks in front, striking a tambourine, and looks back and down at another undersized satyr who, seeming to forget the torch he is carrying to light the procession, tries to embrace her.

Another subject the painter likes is sacrifice, or the procession to sacrifice. On a calyx-krater in Leningrad[15] a sheep is being led up and is already near the altar where a priest and two acolytes are making preparations. The painter has enlivened the reverse-figures here by making them a maenad between satyrs wearing himatia.

One of the artist's masterpieces is on a krater, the only volute-krater known from his hand, a very big vase from Spina.[16] Below the ornaments of a deep stepped lip the shallow neck is black, but a frieze of small figures, such as is commonly found on volute-krater necks, here runs round the vase below the main pictures. It consists in satyrs and maenads, and is an adjunct to the big picture on the back: the return of Hephaistos. This is on the older model, the god on a donkey. Dionysos again walks before, looking back at Hephaistos, a piping satyr between them. The tambourine-playing maenad in front moves unmolested here, though the satyr in front of her looks round, and at the rear a running maenad is pursued by a satyr. This is an attractive *mouvementé* composition, but the still picture on the front of the vase (fig. 231) is more unusual and more impressive.

On the right two pairs of Doric columns support an architrave beneath which, on a throne, sits Apollo, in himation, laurel-wreathed, a laurel-bough leaning on his right knee and shoulder. He sits relaxed, his left elbow on the back of the throne, and his bow and quiver hang on the wall. Outside the temple, at back and front, are tripods, the base and lower part of the one in front masked by the omphalos. The god is looking out across this; and looking the same way a laurel-wreathed priest stands beyond the tripod. They are watching a pro-

cession which is just arriving. In front is a girl, a knee-length patterned garment over her chiton, holding an elaborate sacrificial basket (*kanoun*) balanced on her head. Behind her a boy stands frontal and looks back, past a tall incense-burner which stands on the ground, at two other boys who walk, the second carrying a phiale at his side, and two young men leading a sacrificial bull. All the males are laurel-wreathed.

The deity is Apollo, and the omphalos suggests Delphi; but the artist has looked at and appreciated the frieze of the Parthenon in his own city, with its procession in honour of Athena. In his small-scale brief picture on a pot he has come wonderfully close to its feeling.

Dionysos shared Delphi with Apollo, and it can be no chance that the painter has combined the two deities here. In the work of the Kleophon Painter's great follower the Dinos Painter[17] we shall meet more of Dionysos than of Apollo; and the mood changes from that of the Parthenon. In the pictures on this vase the Kleophon Painter is still Periclean in the happiest sense. On his loutrophoroi he is already caught in a new world.

II. The Washing Painter: woman's world

Production, mainly second-rate, of column-kraters and other large vases, such as we noticed in a section of the last chapter, continues of course unbroken. We shall revert to it in the next chapter, but none of the painters involved is of importance in the transition from the high classical to the style of the later fifth century. The Kleophon Painter is so for the way he links the Polygnotans to the Dinos Painter. The painters mainly of smaller pots and cups, whom we shall treat in the remaining sections of this chapter, have no such clear origins, but they represent a quite distinct first phase in a tendency which becomes of major importance in the later part of the century.

In the late archaic and early classical periods, 'painters of small pots' tends to mean specialists in Nolans and lekythoi or (generally at a lower level) in lekythoi and other oil or perfume pots (squat lekythoi, alabastra). Other smaller pots are decorated occasionally by painters who work on other shapes. We have glanced at the oinochoe and the pyxis. In the high classical a new type of small vase appears, apparently initiated by the Achilles Painter: little versions of common large shapes, especially the pelike and the hydria. The first artist to specialise in these seems to be the Washing Painter.[18] His origins are not clear. I could imagine him learning his craft alongside the Phiale Painter in the Achilles Painter's workshop, but leaving it soon.

The most notable characteristic of the Washing

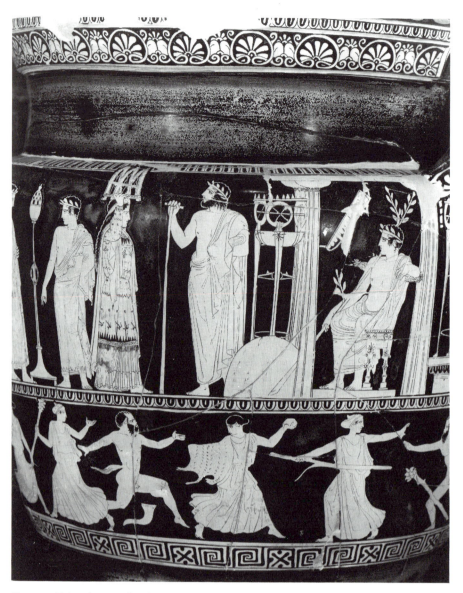

Fig. 231. Volute-krater; Kleophon Painter. Detail: Apollo in his temple. H. of main picture *c*. 0.18.

Painter's work is his emphasis on life in the women's quarters. The genre was often treated before, but in a much less concentrated way. The slight lekythoi, squat lekythoi and alabastra which straggle through the latest archaic and early classical periods often have such subjects, but not exclusively. Pyxides are regularly so adorned, but their painters more often treat other subject on other shapes.

The Washing Painter takes his name from a favourite theme of his little hydriai: two naked women at a laver (fig. 232). On others women sometimes appear naked in other contexts, more often clothed; but of twenty-two such pieces in Beazley's list only one, with Eos pursuing

Kephalos,[19] moves outside the *gynaikeion* and shows a male figure other than Eros. Eros appears now with increasing frequency in the company of mortal women. The drawing on the painter's small hydriai is generally careful and fine, and the same goes for half a dozen larger hydriai. Most of these too show only women, and the exception, Helen receiving Paris,[20] is still laid in the women's rooms. The painter treats this subject again on a plate,[21] and it becomes popular in succeeding generations.

More than fifty small pelikai are ascribed to the Washing Painter, others to his manner or to various companions. These little pots differ from the hydriai in

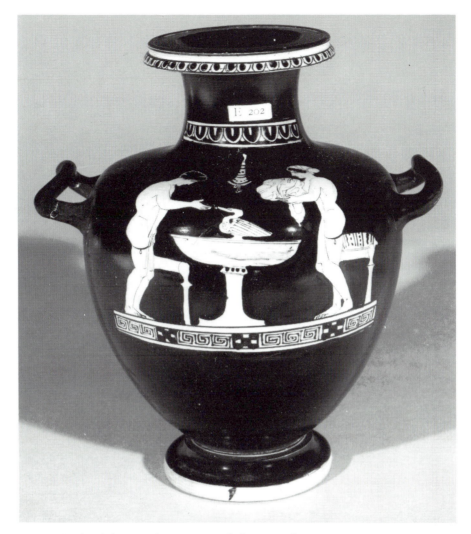

Fig. 232. Hydria (kalpis); Washing Painter. Naked women at laver. H. *c.* 0.18.

two respects: they are in general hasty, careless work; and they have a much wider range of subject. It seems that for work which interested him, into which he put his best, this painter chose woman's world. That idea is borne out by another most important side of his production: lebetes and loutrophoroi, decorated on a relatively large scale with wedding-scenes.

Hitherto we have come across the loutrophoros only as a funeral vase.[22] The Washing Painter has left only wedding pieces. The *lebes gamikos* (nuptial lebes) is, as its name implies, another special wedding shape. It is a round bowl, lidded, with either a low ring-foot or, more often, a high stand (which also has figure-decoration) in one with the bowl (fig. 233). Ten or a dozen standed lebetes, whole or fragments, are ascribed to the Washing Painter. For long he had much the same allotment of loutrophoroi; but some forty years ago the situation was dramatically changed. A vast deposit came to light on

the south slope of the Acropolis, including fragments of hundreds of wedding-loutrophoroi, black-figure and red-figure. The shrine is identified by a graffito as *nymphes*: 'of the nymph' (Kallirrhoe?), or 'of the bride'.[23] From this deposit come seventy-three fragments or groups of fragments of loutrophoroi by the Washing Painter, 'from many vases, large and small, splendid and slight'.[24]

All the painter's other loutrophoroi show the wedding procession; all his lebetes the bride and her women preparing; but many of the Acropolis fragments show the preparation and other painters do not always keep the distinction, so we cannot argue from it to the presumably different function of the two shapes. It is true, though, that while vessels of both types are regularly shown standing on the ground in scenes of preparation, a loutrophoros appears far more often than a lebes carried in the procession. It is noticeable that the

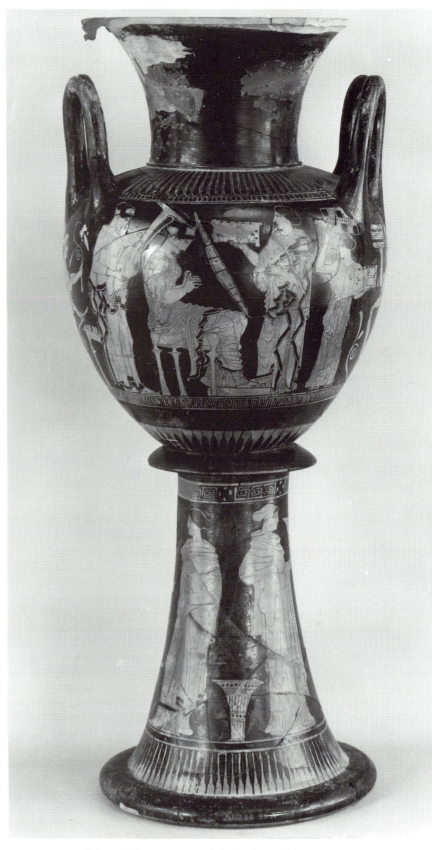

Fig. 233. Nuptial lebes; Washing Painter. Bride before the wedding. H. *c.* 0.51.

procession is treated very much as an extension of the preparation of the bride, the groom being generally the only male represented among the women.

We noticed that the loutrophoros takes two forms, loutrophoros-amphora and loutrophoros-hydria, and that the 'amphora' was often, perhaps regularly, used at men's funerals, the 'hydria' sometimes at least at women's. Vessels of both forms are decorated with, and represented in, wedding scenes (fig. 234). All complete examples which survive by the Washing Painter are amphorae, but he depicts both forms.[25]

Many of these pieces are of great beauty, and in his capacity to range from the lively charm of the little hydriai to the grace and grandeur of these larger works the Washing Painter reminds one of the Phiale Painter. Apart from these wedding-vases, the few larger hydriai and the plate, all his work is on small pots: two little neck-amphorae, a few oinochoai, more squat lekythoi, one cup and one stemless; also one pyxis, a masterpiece.

On this vase, in Würzburg,[26] we have again the preparations for a wedding. The figures circle the handle-less vase but seem to make two pictures. In the centre of one the bride sits on an elaborate couch, decking herself with help from a little Eros (fig. 235). At one end of the couch a woman stands, holding a loutrophoros-hydria. At the other, behind Eros, stands Aphrodite, lifting her mantle from both shoulders. At her back a wreath on the wall and a wool-basket on the floor seem to mark a break, and the next figure, a woman seated playing the harp, faces the other way. The focus of this second picture is a wrestling match between two Erotes (or Eros and Anteros) (fig. 236); a lovely group repeated on a larger scale on a fragment of one of the painter's lebetes.[27] On the pyxis they are flanked by two sceptred goddesses. One stands on the left (back to back with the loutrophoros-carrier of the other picture). This is probably Peitho, the one seated on the other side of

the wrestlers probably Aphrodite. Between her and the harp-player another woman stands by a stool and takes something out of a box she holds. Whatever the precise symbolism of the wrestling Erotes, the group is an enchanting addition to the wedding imagery.

One of the little pelikai ascribed to the painter's manner is worth a mention because the picture of a boy standing by his horse, though an incompetent piece of drawing, is clearly inspired by a group on the Parthenon frieze.[28] The Hasselmann Painter[29] and other companions of the Washing Painter are of no significance, but one piece placed in his neighbourhood is more interesting. This is a stemless cup in Boston[30] with the name of a *poietes* Xenotimos, not otherwise known. In the tondo a man in travelling gear sits with his staff held vertically as if he were about to stand up with its help; but his name is by him: Perithoos. He is bound to his seat in the Underworld for ever. On the outside Leda and her father Tyndareos stand to either side of an altar on which Zeus's eagle sits by the egg from which Helen will issue. The version in the artist's mind was no doubt one shown by other representations to have been current in Athens at this time. In this it was not Leda whom Zeus took in the form of a swan but Nemesis; and, after the goddess had laid the egg, it was given to Leda to hatch.[31]

III. Oinochoai: the Shuvalov Painter; choes

In archaic red-figure, we saw, oinochoai were produced as a sideline by many painters of large or small pots, but none seems to have specialised in the shape. Even later, with such artists as the Painter of the Brussels Oinochoai, or even the Mannheim Painter,[32] the numbers are so small that we may guess that other shapes had at least as large a place in the painters' repertory though they have not been recognised. We saw, indeed, that the Brussels oinochoai were originally given to the Painter of Bologna 228, whose substantial *oeuvre* consists mainly in column-kraters and other large pots.[33] Now things change; and among painters of small pots of the same kind as the Washing Painter there are several who have a special line in small oinochoai. Many of these jugs, especially later in the century, are of small worth, and some of the best painters have only a few pieces grouped together; but one of the earlier, whose drawing is consistently good, has many: the Shuvalov Painter.[34]

This artist's name-piece (after a former owner) is a small neck-amphora, and more of these are given him, as well as a few small hydriai and pelikai and other things; but of nearly eighty pieces in Beazley's list fifty are oinochoai, of seven different varieties. His favourite forms numerically are Beazley's Shape 2 and Shape 4, both with strong shoulder, the first with trefoil

Fig. 234. Fragment of lebes or loutrophoros; Washing Painter. Wedding: woman carrying loutrophoros-hydria. L. of fragment *c.* 0.07.

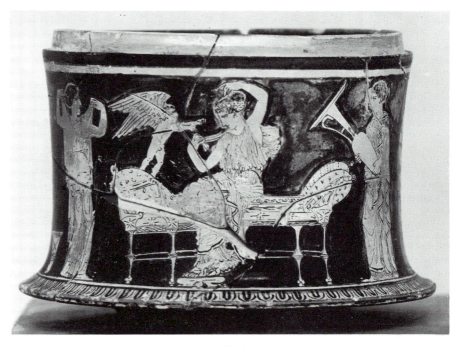

Fig. 235. Pyxis; Washing Painter. Preparation of bride. H. *c.* 0.09.

Fig. 236. As 235: Loves wrestling.

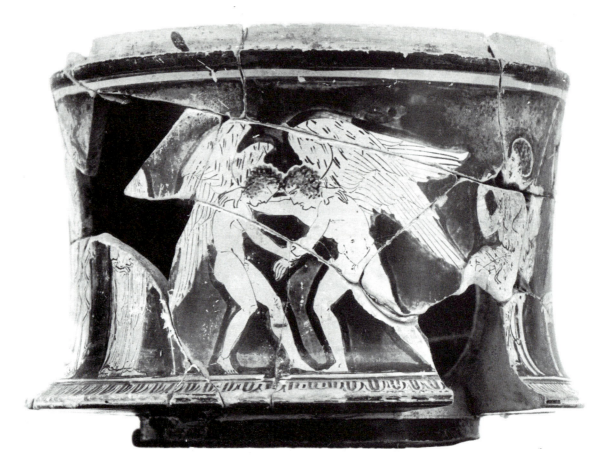

mouth and low ring-foot, the other with stronger foot and round mouth. His drawing is neat and pretty even when not very careful. The figures tend to have a head rather large for the body and an eye rather large for the face, giving a child-like effect.

The painter quite often illustrates mythological stories. When it is Perseus chased by Gorgons, or Apollo with laurel-wreath and branch pursuing a girl,[35] one is in no doubt; but when it is a youth with two spears in pursuit of a woman, though very likely Theseus is meant, the figure has nothing heroic about it.[36] Similarly, pictures which no doubt represent Polyneikes and Eriphyle[37] have none of the tension and power felt in the Chicago Painter's version; this is just a lady getting a nice present. The potting and the black are admirable, and the drawing at the best not unworthy of the technique; and there is among the painter's surviving vases one masterpiece.

This is a jug in Berlin[38] of the rather rare Shape 9, round-bodied with narrow neck and round mouth, the picture on the shoulder. It is a scene of love-making (fig. 237). A naked girl climbs on the ready lap of a youth who leans back in his chair. Their faces are close together, and their eyes meet, with an effect of tenderness extremely rare in the erotic art of this time, and very charming.

This artist is the subject of a study in depth of the greatest importance by Lezzi-Hafter.[39] She has shown how the painter worked over a considerable period with different potters and different assistants who put in the ornament, and has established an extremely precise relative chronology which she relates closely to actual years. We will come back to this when we look at dating in the next chapter. I remain unsure about the validity of the very precise chronology, relative as well as actual,

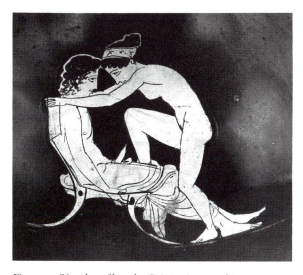

Fig. 237. Oinochoe; Shuvalov Painter. Love-making. H. of picture *c.* 0.06.

but the exercise has added a great deal to our knowledge and understanding. A very interesting observation is that some oinochoai of Shape 5A, with picture on the shoulder produced in the Shuvalov Painter's workshop, were decorated by the Painter of Munich 2335.[40] This must be after that craftsman left the workshop of the Achilles Painter (perhaps on its closure) and before he went on to his final phase as a decorator of column-kraters.

Some half-dozen of the Shuvalov Painter's oinochoai are of Shape 3, choes. *Chous* was originally a measure, which gave its name to a pot-bellied, trefoil-mouthed jug. The shape seems to have been created, or at least introduced into Attic fine ware, soon after the middle of the sixth century, and was popular in plain black throughout the fifth. There are red-figure examples as early as the Berlin Painter, but many more from this time on. There will be more to say about these jugs, and about their association with the festival of Anthesteria, in the next chapter. One of the Shuvalov Painter's, in London, has an excerpt from a school-scene: one boy standing with a lyre, one seated with an inscribed scroll; another, in Berlin,[41] three boys out of school, playing *ephedrismos*. This is a kind of blindman's buff in which one sits on another's back, covers the steed's eyes with his hands, and tries to direct him to catch another. We shall meet finer choes from this phase in the Eretria Painter's work, and a few others may be mentioned here.

Two, of exceptional quality, go together. One, in Oxford, Beazley describes in *ARV*[2] as 'more or less akin to the work of the Eretria Painter'.[42] The second, in Boston, he listed in *ARV*[1] as showing the influence of the Dinos Painter,[43] but omitted it from *ARV*[2]. In an earlier discussion he had spoken of the two as 'based on a similar model . . . of equal beauty, and yet . . . not by the same artist'.[44] Each shows a maenad asleep in the countryside, approached in Oxford by one, in Boston by two satyrs (fig. 238). The positions of the maenad and of the satyr approaching from in front, and the relation of the two figures, is similar in both though differing in detail. On the Oxford vase the maenad sleeps on an ivy-covered rock drawn with care. In Boston it is only her position that indicates the ground she lies on. The drawing in both is masterly, but in Boston there is a more nervous and broken line, which looks forward to a development most manifest in the latest white lekythoi.[45]

The satyr on the Oxford vase is named Kissos (Ivy), the maenad, rather oddly, Tragodia (Tragedy). The same two names appear on fragments of another chous (divided between Florence and Leipzig),[46] which Beazley put with the Oxford vase though unable to say if it were by the same hand. On another chous in Boston[47] of similar character a maenad named Kraipale (Hangover) is brought a hot drink by Thymedia (Heart's

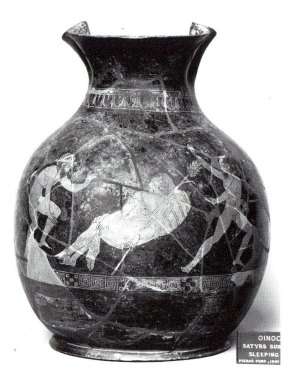

Fig. 238. Chous; not attributed. Satyrs and sleeping maenad. H. *c*. 0.22.

Delight). A satyr in their company is named Sikinnos. There was a satyr-dance Sikinnis, presumably performed in satyr-plays; and the close link between satyr-play and tragedy might account for the maenad's name on the Oxford chous and the fragments.

A chous in the Vlasto Collection in Athens[48] shows a dance on stage, not a satyr but a grotesque actor, seemingly a dwarf, dressed as a mock-Perseus. A youth and an older man sit watching and discussing the act. The representation of the actual stage is very rare in Attic vase-painting, but it becomes regular on the 'phlyax-vases' of fourth-century south Italy. The drawing on the Vlasto vase is less refined than on the others we have been looking at, but lively.

IV. The Eretria Painter; cup-painting

Beazley lists the Eretria Painter among cup-painters because more than half of the hundred-odd pieces assigned to him are cups, but remarks that 'his most exquisite work is on small vases of other shapes'. The same chapter includes the Codrus Painter.[49] That artist has fewer than fifty vases, but all of them are some form of cup, and he clearly belongs in the great line of cup-painters that starts in the generation after the Pioneers. In the later fifth century, though cups continue to be produced in some quantity, they lose their central position in the art of vase-painting; and a distinction among the better artists of 'pot-painter and cup-painter' seems less useful than one of 'painter of large pots and painter of small pots'. The Eretria Painter marks the transition to this phase. His cups are numerous and uniformly excellent but never as interesting as his best work on other shapes.

Of the two painters of small pots we have considered already, the Shuvalov Painter decorates neither larger pots nor cups. The Washing Painter scarcely ever touches a cup but puts some of his best work on larger pots of special character. The figures on the Eretria Painter's cups are larger than those on most of his small pots, but only slightly. He has no larger style, like the Washing Painter's, but his best drawing on a small scale is finer than anything the other two achieve. His level, too, is remarkably high. There are quick, slight pieces but seldom or never mechanical or dull ones.

On a kantharos in the Cabinet des Médailles[50] he puts the name of a *poietes* Epigenes, not otherwise known. On each side of this vase is shown a warrior leaving home, one named Patroklos, the other Achilles. The artist likes to give names from legend to his figures, and does so on the piece from which he takes his name, an *epinetron* in Athens, found at Eretria. The *epinetron* was a thigh-guard with a roughened upper surface for the carding of wool. There are coarse-ware examples for everyday use[51] and a number of imitations in black-figure and red-figure of which this is the finest. The roughening of the upper surface in these takes the form of a scale-pattern in relief. The end over the knee has often, as here, a moulded head; occasionally a red-figure tondo. The principal pictures are along the sides, but this piece has also a picture curving over the knee-end behind the head (which is painted white), and a palmette-band at the other, open end.

The extra picture here shows Peleus seizing Thetis, a sea-monster indicating her transformations, her father Nereus standing by, five sister-Nereids hithering and thithering. This action led to a famous wedding; and the main pictures here show brides and their women making preparation. On one side it is a divine bride given by the gods to a mortal man, as Thetis was to Peleus: Harmonia, daughter of Aphrodite and Ares, who married Kadmos, founder of Thebes. Harmonia sits in the centre, turning to talk to a little girl who leans on her shoulder. In front of her stands Peitho with a mirror. At one end sits Aphrodite, the bride's mother, Eros before her; at the other end Himeros, Hebe standing by him, adjusting her hair. He holds a perfume-flask and Eros a box. Peitho, Hebe, Eros and Himeros are minor deities who are also personifications (Persuasion, Youth, Love and Desire). The little girl with the bride is

inscribed *kore* (maiden). This too can be a goddess's name: Persephone is so called in certain connections. This figure, though, cannot be meant for the queen of the Underworld; this is just 'one of Harmonia's maidens'.

A Doric column behind Aphrodite indicates an interior. In the other picture an Ionic column cuts the bride off from the other figures. She leans against a bed, double doors open behind. The open door is a common symbol in wedding-scenes. Its rendering here is an early example of an interest in perspective of which we shall have more to say. Here there are no Erotes or divine personifications. It is a picture of wedding preparations as they were made in contemporary Athens, and one could imagine it meant for the wedding for which the object was no doubt made; only this scene too is mythologised by a name. The bride is Alcestis, the most famous of all good mortal wives in legend. Beyond the column Hippolyte is seated, playing with a bird, Asterope leaning on her shoulder. Alcestis and Asterope were daughters of Pelias. The names Anaxibia and Phylomache are given to Pelias's wife by different authors, but one wonders if the vase-painter did not think of Hippolyte as the bride's mother. Behind Asterope a woman prepares to lift a big loutrophoros-hydria with leafy sprays in its mouth. Behind her another adjusts her mantle, and at the end is one arranging twigs or sticks in two nuptial lebetes.

These vessels are reserved in the colour of the clay, and figures are drawn on them in black silhouette; not because they are thought of as black-figure, but because of the limitations of the red-figure technique on this scale. On a larger and more elaborate wedding-scene on a fragmentary loutrophoros by the Persephone Painter from the sanctuary of the Nymph,[52] the vases are so disposed as to be drawn in black, the pictures on them carefully rendered in red-figure.

The *epinetron*, though attractive, does not show the artist's drawing at its most sensitive. I have described it in detail because it has so much that becomes regular later in the century: the extension of bridal imagery beyond the shapes particularly associated with weddings; the mythologising of domestic scenes; the taste for personification; the prettiness.

Some of the Eretria Painter's finest work is on choes and squat lekythoi. One chous with a man putting a child on a swing is certainly connected with the Anthesteria. So also, surely, is another with women preparing for a festival of Dionysos.[53] They have a mask of the god, lying in a liknon, a kind of sacred basket. A third, fragmentary, had a picture of bridal preparations;[54] and there are a number of others.

The squat lekythos was a creation of the early classical period but becomes more important at this time. A beautiful one by the Eretria Painter in Berlin[55] has the figures set up and down the field, broken ground-lines and a few flowers added in white. There is no real attempt to suggest space, however. The figures are prettily interwoven in a purely surface pattern; none overlaps another or is partly concealed by a ground-line. The wall-painters' innovation has become an alternative convention for the vase-painter. Young Dionysos sits surrounded by his followers, two satyrs and ten maenads. They stand or lean, sit or lie. One holds pipes and one strikes a tambourine. One dances, and one collapses in a friend's arms.

Variations on this shape are made: a very low version, generally small, slight pieces; and a tall one, relatively big vases, often very carefully decorated. There are two tall pieces by the Eretria Painter; one, in New York, a masterpiece.[56] The decoration is in three zones (fig. 239). That on the shoulder, mostly lost, and the lowest, an Amazonomachy with eighteen figures, are in red-figure, the figures set up and down the field. The central zone is in outline on a white ground. Most of the circuit is occupied by Nereids riding dolphins and carrying armour for Achilles; but the centre front, framed by two columns, makes a picture on its own (fig. 240). The young hero sits naked on a chair, hands crossed on his lap, head bent, beside the bed on which lies the body of his friend Patroklos, also shown as young. It is a very still scene, and the most touching picture of grief on a vase; nothing on a lekythos comes up to it. No white lekythos has been attributed to the Eretria Painter, but his other tall squat lekythos, in Kansas City, is in white-ground, a single picture.[57]

One other shape decorated by the Eretria Painter should be mentioned: the amphoriskos, a scent-bottle made in the shape of the big coarse-ware pointed amphora used for the transport of wine. We have noticed the shape adapted from time to time for big pots in black-figure or red-figure. Now it becomes very popular for little scent-bottles, mostly black with stamped decoration,[58] occasionally with pictures in red-figure. A very pretty one by the Eretria Painter in Oxford[59] has a woman on either side: one seated, with loose hair, holding a mirror, perhaps a bride; the other standing with a sash and a box. This attendant is named Theano, as is the woman with the loutrophoros in attendance on Alcestis on the *epinetron*. The scent-bottle held by Himeros in the picture of Harmonia on that piece is an amphoriskos.

Black ware with stamped decoration, often of fine make and attractive design, is an important element of ceramic production in Athens at this time. It lies outside the scope of this book, but such vases were certainly produced in the same workshops as red-figure, and the two kinds of decoration are sometimes combined on one

pot. In particular stemless cups often have stamped decoration within, red-figure pictures on the exterior.

More than fifty cups and a fair number of small pots, in particular pelikai, are given to a less interesting companion of the Eretria Painter, the Calliope Painter.[60] Smaller groups are given other names, and some are just placed 'near the Eretria Painter'. Among these are two little pieces the shape and size of a hen's egg. In one, in a private collection in America,[61] the big end was cut off as a lid (now lost). In the other, in Athens,[62] the lid, which bears a female head, is the small end. Both have a wheel on the bottom. The main picture on the Athens vase is of two women playing morra; on the other a youth carrying off a woman in a chariot. Morra is the timeless Mediterranean game in which one player flashes one hand up and down again and the other has to say how many fingers were raised. The two eggs are rumoured to have been found in one grave, but Beazley thought them by different hands, the Athens one less close to the Eretria Painter than the other. I mention them as an example of the unexplained oddities that crop up from time to time.

Parallel to the fine cups from this circle is a generally coarse series, the Marlay Group.[63] The principal craftsman of the Group, the Marlay Painter, works also on pots, large (kraters, wedding-vases) and small (choes, pyxides, skyphoi). Many of his cups, like those of his companions, are stemless. The exteriors of some, both stemless and stemmed, are covered with an overall lozenge-pattern, sometimes with an animal or human figure in silhouette at the handle.[64] This scheme has been thought to derive from textiles.

Some of the painter's more careful pieces have charm, a pyxis from Spina,[65] for instance, with an unusual scene: Apollo with his sister and mother and Hermes; a palm-tree; and a nymph seated on a rock, her name by her, Delos, the personification of the holy island. A small cup from the same site,[66] again among the artist's better works, has in the tondo a very odd picture of the death of Cassandra. Clytemnestra attacks her with an axe in a sanctuary of Apollo (altar, laurel-tree, over-turned tripod). Cassandra's rape by the lesser Ajax at the sack of Troy is shown in one of the outside pictures, and the double axe is Clytemnestra's regular weapon in pictures of the death of Aegisthus; so the interpretation seems sure, but it is a version quite at variance with that familiar to us from Aeschylus.

The painter's facial type recalls the Eretria Painter and still more the Shuvalov Painter. The childlike effect we noticed in that artist's work is at least as marked here. We shall come back to this phenomenon in connection with work from later in the century.

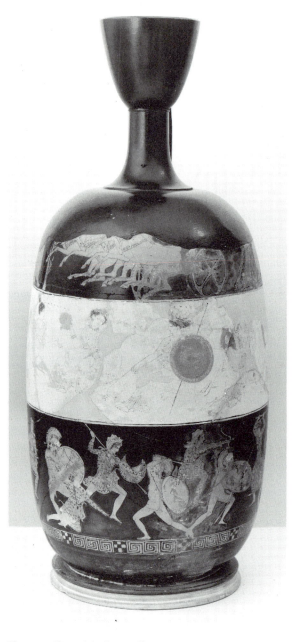

Fig. 239. 'Squat lekythos' (tall variety); Eretria Painter. Three-tier decoration: chariots; Nereids with arms of Achilles; Amazonomachy. H. *c.* 0.49.

Fig. 240. Detail of 239: Achilles mourning Patroklos.

V. Aison

The signature of the painter Aison is found only once, on a cup, but Beazley lists him as a pot-painter.[67] Indeed the great majority of the fifty pieces or so ascribed to him are small pots of just the same character as those we have discussed in the last three sections. There are a very few larger pots and a very few cups and stemlesses. The signed cup, in Madrid,[68] shows the deeds of Theseus: in the tondo, the Minotaur; outside, Skiron, the sow of Krommyon, Sinis; the bull of Marathon, Procrustes, Kerkyon. There is a marked resemblance to the Codrus Painter's London cup,[69] only Aison does not repeat the exterior scenes in a zone round the interior. The tondos are especially close, though with interesting points of difference besides that of personal style. In both Theseus moves sharply to the left, sword in right hand, looking back and down at the dead Minotaur whom he is dragging out of the Labyrinth. The pose of the hero is almost identical, but Aison's picture is larger and more elaborate. The entry to the Labyrinth in the Codrus Painter's is marked by a single Doric column supporting entablature. Aison has two Ionic columns with entablature and the lower corner of a pediment with a palmette akroterion; and steps below, across which the Minotaur's arms and hands are stretched. In both pictures the nature of the building is schematically

indicated by a vertical strip of maeander-pattern with intercalated chequer-squares. This forms a vertical chord and cuts the Minotaur off, at the waist in the Codrus Painter's picture, much higher up in Aison's. Aison has added an onlooker omitted by the other painter: Athena, in very Pheidian guise.

In style Aison is more dramatic, for instance in the way Theseus throws out his manly chest, a habit of the artist's male figures in action. The same character is emphasised by the lunging diagonals such figures tend to make. Both features are marked in an athlete launching his javelin in the tondo of a stemless cup in Berlin.[70] This belongs to a small group of cups and stemlesses which Beazley places between the Codrus Painter and Aison, isolating this and two others with the note that 'one might think of early Aison under the influence of the Codrus Painter'; and surely this is what they are. The outside pictures of the javelin-thrower stemless are quieter, nearer the Codrus Painter (figs. 241 and 242): exceptionally charming studies of young athletes relaxing in the palaistra, lounging and chatting.

The characteristic poses are very strong in a fine Amazonomachy on a squat lekythos in Naples.[71] This is close in character to the Eretria Painter's on the lowest zone of his New York vase of the same shape. Both have been thought to show influence from the battle on the shield of Pheidias's Athena Parthenos, and this must

Figs. 241 and 242. Stemless cup; influence of the Codrus Painter; probably early Aison. Athletes relaxing. H. of picture *c.* 0.08.

be right. Violent diagonal poses are a feature of that Pheidian style, and no doubt this was the source from which Aison took the idea. There is certainly, however, also direct contact between him and the Eretria Painter. A squat lekythos in New York[72] with a seated woman and Eros was attributed by Beazley first to Aison and later to the Eretria Painter.

Another disputed piece is a fine chous found in the Kerameikos[73] after Beazley's time. It shows Amymone with her pitcher beset by four satyrs (fig. 243). This has been given both to Aison and to the Meidias Painter, a leading artist of the next period. There is certainly much of the Meidias Painter in the figure of the Nymph; but her strongly diagonal pose, repeated in three of the satyrs, and the staccato spacing, are quite out of his manner and typical of Aison. Knigge thinks that this vase shows that Aison was the young Meidias Painter, but this very interesting idea has met with little acceptance. I find it difficult, and incline rather to think the chous a late work of Aison's, whom I see as an artist very sensitive to influence, first from the Codrus Painter, then the Eretria Painter, then the Meidias Painter.

Other shapes decorated by Aison include oinochoai of

several forms and a new type of squat lekythos, the acorn-lekythos.[74] This is popular in the next generation in the circle of the Meidias Painter; Aison's is not quite canonical in form. There are also a few larger pots (fragments of loutrophoroi from the sanctuary of the Nymph; one neck-amphora; one pelike); as well as a considerable number of small, slight pelikai, some of them of the same make as those of the Washing Painter.

It is evident that the four painters treated in these sections had close links with one another. That at least the Shuvalov and Eretria Painters sat in one workshop is suggested by Lezzi-Hafter's fascinating demonstration that much of the pattern-work on their vases was put in by a few specialist hands. She has further shown that some of these continued to work with painters of the Meidian circle in the next phase. It appears to me that the two central figures in this tradition (perhaps initiated by the Washing Painter) are the Eretria Painter and the Meidias Painter. The Shuvalov Painter and Aison I see as more peripheral figures. The Meidias Painter surely followed on in the Eretria Painter's workshop, and it looks as though the Shuvalov Painter sat in it too. Whether one should postulate a single workshop including also the Washing Painter and Aison seems more doubtful, though a close relationship is certain.

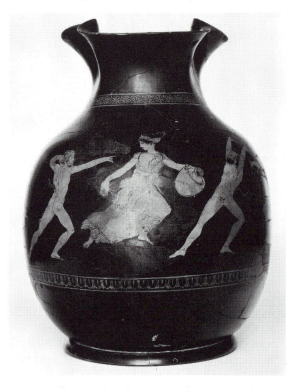

Fig. 243. Chous; perhaps late Aison under influence of Meidias Painter. Amymone beset by satyrs. H. *c.* 025.

8

The later fifth century; developments into the fourth

I. Introductory

a. *The historical background*

The high classical in Athens belongs to a period of peace. We are now entering on the time of the Peloponnesian War. War and peace are relative terms. War was endemic among the Greeks, but they could speak of peace, as we do today, when great powers are not in active and open conflict. The great powers in fifth-century Greece were Sparta and Athens, and they had been spoiling for a fight (and sometimes fighting) since the formation of the Delian League in 477, still more since its conversion into an Athenian empire was made manifest by the transfer of the treasury from Delos to Athens in 454. The change to open war, however, in 431, did make a profound difference to life in Athens and Attica. Athens controlled the sea but could not challenge Sparta by land; and in five of the first seven years of the ten-year 'Archidamian' war a Spartan army invaded Attica in the summer and burned the crops. Very many of the country people moved into Athens or into the space between the long walls which joined Athens to Piraeus. The effect must have been tremendous, even apart from the devastation of the plague, which struck in the second and third years and in which Pericles himself died.

A stalemate was recognised in the 'Peace of Nikias' (421), which lasted uneasily until in 415 the Athenians attempted to double their empire by seizing a new one in the west. The principal architect of the attempt to conquer Syracuse was Alcibiades, Pericles's brilliant and irresponsible nephew; but the armada had not reached its destination before he was recalled to face charges of involvement in an outrage which had delayed its departure: the mutilation of the Herms which stood at the street-corners of Athens. The expedition went on, but after besieging Syracuse fleet and army were destroyed in 413. Meanwhile Alcibiades had fled to Sparta, and in the same year, on his advice, the Spartans established a permanent post at Decelea in Attica near the Boeotian border, from which they could harass much of the Attic countryside.

This was the beginning of the last phase of the Peloponnesian War, the 'Decelean', but the final defeat of Athens took another nine years. A briefly successful attempt to subvert the democracy and establish an oligarchic constitution took place in 411, when some cities revolted and left the empire. The fleet and army, based on Samos, stuck by the democracy. Alcibiades joined them there, was given command and won significant victories which allowed him to return to Athens; but he was again in exile when in 405 the Spartans destroyed the Athenian fleet at Aigospotamoi. The next year Athens surrendered. The long walls and the fortifications of Piraeus were destroyed, the fleet reduced to twelve triremes, and an oligarchic government imposed. Yet within a year exiled democrats had returned with an army and overthrown the 'Thirty Tyrants', and within ten the long walls were rebuilt and the city had begun to recover some of its prosperity.

b. *Pointers towards absolute dates*

It is, in my view, misguided to try to define any precise correlation between changes in art and changes in social and political conditions. In a period like this, however, when in both fields change is marked, it is at least desirable, when trying to trace the course of art-historical development, to be aware of the wider historical background. Besides this general point there are a few specific occasions with which vase-finds can be associated and so be precisely dated; and reference to these would be meaningless without some knowledge of the course of events of which they form part. Several of these cases come late in the period, and we will treat them as we come to them,[1] but one may be considered now.

In 426/5 the Athenians purified the island of Delos and dedicated it wholly to Apollo, god of the ancient sanctuary there founded on his birth-place. He was god of health and sickness, and plague was something sent

by him, as Homer tells so dramatically at the start of the Iliad. The Athenian action was probably in hope of averting recurrence of the terrible visitation of a few years before, in which Pericles had perished. It was performed by one of the new statesmen, Nikias, an immensely wealthy man (silver-mines and slaves) and obsessively religious. It was he who achieved the Peace of Nikias five years later, and ten years after that was an unwilling commander of the expedition against Syracuse, where he was captured and executed. The purification of Delos involved a ban on giving birth or dying on the island, and the removal of all previous burials. The contents of the graves were reburied on the islet of Rheneia, and the trench containing them has been excavated. Among the pottery were pieces by artists treated in the last chapter (the Shuvalov Painter, the Marlay Painter), but nothing later. The latest products of the Kerameikos may not have found their way into graves on Delos, but the time-lag is not likely to have been great. This at least is a *terminus ante quem* for activity by these artists, and by extension for others closely associated with them.

We may also consider here a different question, the development of red-figure production outside Athens. This phenomenon was not entirely the result of war conditions, but it was surely encouraged by them. Etruscans had produced black-figure on the Greek model, and during the fifth century they also made red-figure and pseudo-red-figure, occasionally as we have seen directly copying Attic models. The emergence of a school of red-figure painting at Falerii closely modelled on Attic work of late fifth- or early fourth-century style has been thought with great probability the result of emigration from Athens in the bad years after the end of the war.[2]

Among Greek cities from the late sixth century on fine figured pottery had been virtually a monopoly of Athens. Production of red-figure in Greek cities of South Italy begins before the war and is almost certainly to be associated with the foundation of Thurii in 443; a Panhellenic colony proposed by Pericles and in which many Athenians took part. The first South Italian red-figure painters were certainly trained in Attic workshops of the Periclean age. The name-piece of the Painter of the Berlin Dancing Girl, a calyx-krater on which a little girl in a short chiton dances to the piping of a seated woman, derives from such scenes by the Phiale Painter and has much of their charm. Thurii, however, seems never to have become an important centre of production. The Painter of the Berlin Dancing Girl and his followers established themselves in Apulia, probably at Taras (Taranto); the Pisticci Painter and his in Lucania, probably at Herakleia; and the growth of workshops there during the war years was surely encouraged by problems in trading with Athens. In the fourth century

many other centres develop in South Italy and Sicily; and their production becomes more important than Attic and outlasts it. They lie outside the scope of this book, but we need to be aware of their existence.[3]

There are also small-scale productions of red-figure in old Greece: in Boeotia[4] in some quantity; in the Peloponnese at Corinth, Olympia and a site in Laconia;[5] at Eretria in Euboea;[6] at more than one site in Crete.[7] Some of these may have started before the war, but were surely encouraged by war conditions. These fabrics are without significance in the history of art but their existence is of interest.

c. *Developments in wall and panel painting*

A further step in the realisation of pictorial space, a systematised perspective, is ascribed by ancient writers to Agatharchos of Samos, active in Athens; but the invention is placed in a highly particularised context. Agatharchos is said to have designed a set for a production by Aeschylus (who died in 456), and to have written a treatise on it which influenced the optical theories of Anaxagoras and Democritus. The question of the nature, and even the existence, of a perspective system in ancient painting is disputed. I am convinced by the monumental and literary evidence that Greek artists, beginning with Agatharchos, did work out a system of foreshortening on a single, central vanishing-point; but that this was confined to architectural designs for stage-sets. The surviving examples are on walls of Roman houses of the later first century B.C., and these are certainly directly derived from Hellenistic stage-painting. There is no evidence for the interest, which so impassioned the painters of quattrocento Italy, in constructing by means of vanishing-point perspective a 'real' space around the figures in a figure-painting. The method was used only to create a real-looking background against which living actors might stand and move.[8]

This development in the mid-fifth century, then, is less marked a step than one might have thought in the alienation of vase-painting from major painting, though it is one. Examples of architectural foreshortening are found on a good many Attic and South Italian vases from later in the century. The notion was in the air, and no doubt similar essays were found in wall- and panel-painting, probably as empirical and without system as those on the vases; only less unsuited to their setting than those are to the curved surface and black background of the pot.

Agatharchos is further said to have decorated a house for Alcibiades (under *force majeure*; an amusing story there is no room for here). Alcibiades also commissioned a pair of pictures from Aristophon, Polygnotos of Thasos's brother, or more probably from Polygnotos's

son Aglaophon (the sources are in disagreement). One showed him crowned by Pythias and Olympias, the spirits of the Olympian and Pythian (Delphic) games; personifications again. In the other he was depicted sitting on the knees of the Nymph Nemea, who personifies the other great games, held at Nemea at the temple of Zeus. We shall find the motif of one figure holding another on her knees in contemporary vase-painting; also, later, another figure of Olympias.[9]

Pliny records a tradition that Pheidias himself started as a painter and painted a shield at Athens; or more probably 'the shield', that is the interior of Athena's shield, in the Parthenon. We shall come back to this in connection with some late fifth-century vase-paintings.[10] His brother or nephew Panainos was a famous painter, and collaborated with him on the Zeus at Olympia. This is now proved to be later than the Athena in the Parthenon, that is, to belong to the early years of the war, by the excavation of the workshop at Olympia in which it was made. Pottery found there includes a good fragment by the Kleophon Painter.[11] Panainos's principal contribution was nine panels on 'barriers' round the statue, each with two figures. Some were action-scenes, but more showed quietly standing couples. These must surely have been very like the figures on white lekythoi; I think particularly of the great pair by the Phiale Painter, which must be close to the Olympia panels in date.[12]

Another native Athenian painter was Apollodoros, known as *skiagraphos*, shadow-painter. A good deal of rather confused literary evidence seems to allow some safe deductions: that Apollodoros made serious advances in the use of shading; that a younger artist, Zeuxis of Herakleia, learned from and surpassed him; and that some others, notably Parrhasios of Ephesus, resisted the innovation, developing the use of a nervous contour-line to suggest modelling of forms. The Herakleia from which Zeuxis came was probably the one in Lucania which was about this time becoming a centre of red-figure production. Zeuxis was in Athens about the time of the Peace of Nikias, and later worked for Archelaos of Macedon, who reigned from 409 to 397. Parrhasios was also in Athens during the Peloponnesian War. We shall find it possible to suggest influence from both the rival traditions of Parrhasios and Zeuxis on different groups of late white lekythoi.[13]

II. Woman's world in its divine dimension: the Meidias Painter and his circle

In the Meidian circle[14] the tradition of the Washing Painter, the Eretria Painter and their associates is not only continued (we have considered the nature of the connection)[15] but takes on a new importance in the overall production of the Kerameikos. The change has two aspects: scale, and content. The Eretria Painter, so far as the evidence goes, draws only smallish figures. The Washing Painter has a larger style, but he confines it to his wedding-vases, which stand a little apart from his norm. Aison's occasional larger works seem part of his eclecticism. The Meidias Painter continues the production of choes, squat lekythoi and other small pots. He also, however, decorates large pots, especially hydriai, not occasionally but as a major part of his output; and the drawing on these is of precisely the same elegant elaboration as on the smaller pieces.

The other change is rather one of emphasis, but it is real and significant. The Eretria Painter's wedding-pictures[16] read as contemporary but are raised to the legendary sphere by the addition of names. In those scenes the names are carefully chosen; but in other cases he seems to put them casually, simply to give a general effect of being in the world of legend. On an oinochoe in Palermo,[17] for instance, a youth Pandion is welcomed by women, Procne, Theo and Chryseis. Pandion and Procne are indeed related, but not in a way compatible with this representation. Theo appears otherwise only as one of Alcestis's attendants on the *epinetron*. Chryseis is of course a famous name in quite another legendary context: the mistress Agamemnon has to give up at the beginning of the Iliad; but we shall meet it constantly in the Meidian circle for one of Aphrodite's attendants, no doubt because of its meaning ('Goldie').

There are true mythological scenes in the Eretria Painter's work (the Amazonomachy for instance, or Nereids on dolphins with arms for Achilles),[18] which are treated as such in a more or less traditional way. The special character of Meidian work seems to be most perfectly displayed in a favourite type of scene: a kind of inversion of the domestic picture raised to mythological status by added names. In these Meidian pictures the setting is the open air – a 'paradise garden' as Burn well calls it[19] – and the participants are manifestly divine, yet the informal, relaxed character of the gatherings makes them seem a glorified, ideal form of the scenes from the *gynaikeion* popularised in the generation before. Aphrodite and her women are the most constant theme. Subjects involving violence and distress are avoided; and apparent exceptions seem by their treatment to validate the rule.

This can be seen on the not entirely typical vase which gives the painter and circle their traditional appellation: the famous hydria in London with the name of a *poietes* Meidias.[20] As on many of the large hydriai (kalpides; all hydriai now are of that form) in this group there are here two pictures: one on the shoulder reaching over the side-handles to meet a floral under the handle at the back; the other, with smaller figures, circling the vase below. The upper picture shows one of the most violent

episodes in the painter's work, but the word seems ill-chosen when one looks at the treatment.

The Dioskouroi, Kastor and Polydeukes, are reiving the daughters of Leukippos. The venue is a sanctuary, marked by an altar in the foreground and further back a female statue of archaic stiffness and frontality. A goddess lolls against the altar, her name beside her: Aphrodite. The action is in her service, but the implication surely is also that this is her sanctuary and primitive image. Aphrodite's head takes the centre of the picture, the altar a little to the right, and the statue is further right still, dividing the upper part into two unequal areas which are occupied by the heroes' chariots. In the narrower space to the right a charioteer Chrysippos stands in the profile car and holds the team still above the handle, while his master Polydeukes seizes his bride, here called Eriphyle. This group occupies middle ground, below the statue-base, above and to the right of the altar. In the wide space on the other side of the statue Kastor has already secured his girl, inscribed Elera (Hilaeira). She stands upright with bent head in the three-quartered car, while he leans back and urges the wheeling team out above the other handle. Other figures occupy the foreground. Between the feet of Polydeukes and Eriphyle and the right handle Peitho runs away, looking back. At the other handle sits Zeus, quietly surveying the scene, and between him and Aphrodite are two of her women. Agave runs towards the god, while Chryseis, facing her mistress, is kneeling to pick flowers. She looks up with a mild gesture of surprise, echoing Aphrodite's, who looks up too. There are indications of uneven ground with some plants, and a sapling grows at each handle and in the middle by the altar.

The only figures who show any agitation are Peitho, Agave and Eriphyle, who seems to struggle a little against her fate. Agave's movement resembles that of the young running goddess in the east pediment of the Parthenon. Peitho, perhaps uniquely in the painter's work, picks up the sharp-kneed violent diagonal favoured by Aison.[21] She has much in common with the Amymone of the Kerameikos chous. The choice of subject is unusual, but in most other respects this picture represents the painter well. Typical are the careful and effective design for its place on the pot, the skilful elaboration of drawing, the liking for youth. Zeus is the only bearded figure, and two of the men and two of the women have their young faces drawn in a now well-mastered three-quarter view, their heads expressively bent.

The lower picture is more simply designed, a frieze-like composition being imposed by the narrow field. In other respects it is as typical of the artist's best work as the upper one, more so in its total quietude. It separates into three parts, but there is no division and they are probably conceived as merging. On the front we see Herakles in the Garden of the Hesperides: seven still figures of whom the outermost, youths each holding a pair of spears, look towards the centre and frame the scene. Each stands below the tree by the handle in the upper picture. The one on the left is inscribed Klytios, 'famous', a name (like Agave, 'noble') often given to minor characters in story. Here he is introduced as a pair to Herakles's loyal companion Iolaos who stands at the other end behind the hero. Herakles, beardless, sits on his lion-skin on a mound, hand resting on his club. He looks up at a Hesperid, Lipara, who stands towards the apple-tree but turns her face back in three-quarter view to talk to him. A sapling grows between them, and beyond Lipara is the apple-tree, the snake winding about it. Another Hesperid, Chrysothemis, lifts her hand to pick an apple (Lipara already has one). A third, Asterope, leans on Chrysothemis's shoulder and reaches her hand forward, perhaps for an apple. Behind her a larger, more spread figure sits, her knees towards Klytios. He leans forward on his spears, one foot up, and gestures to draw her attention to the scene by the tree, and she turns her face in three-quarter view that way. She has a sceptre, and is named Hygieia.

A sapling grows behind Klytios, and a woman sitting with her back to it, Chryseis, is probably to be thought of as a fourth Hesperid, linking the front picture to that on the back. This gives seven of the ten tribal heroes of Attica. Next to Chryseis stand Demophon and Oineus in conversation, naked youths with cloak, travelling-hat and a pair of spears. Like these, except for the hats, are Klymenos and Hippotho(o)n, on either side of Antiochos, who sits on his cloak and is empty-handed. Last come Akamas and Philoktetes, the latter a standing youth like the others. Akamas is bearded, and sits wrapped in his himation which is brought up over his hair. He also wears shoes (half the youths are barefoot, half booted) and holds not spears but a sceptre. The special treatment given to Akamas is perhaps because he was eldest son of Theseus, the greatest figure in Athenian legend and the unifier of Attica but not himself hero of a tribe. The other seated figure, Antiochos, was son to Herakles.

Under the handle, between Iolaos and Philoktetes, is a group of three: Medea, in oriental costume, holding her box of simples, between Elera (Hilaeira) and Arniope, seemingly names of no significance here given to her attendants.

Number, parentage and names of the Hesperids vary in various accounts. The names given here are of the kind which recur constantly in the work of these painters, especially for the companions of Aphrodite: Asterope, a star-name; Chrysothemis and Chryseis (which we have met already), gold-names; Lipara, 'Glistening'.

Hygieia, 'Health', is not out of place in this context, and she reappears among Aphrodite's women on two other hydriai by the Meidias Painter; but her case is different. Here her placing and her sceptre set her apart. She is not one of the garden Nymphs but an independent goddess. She was worshipped with her father Asklepios, Apollo's mortal son whom Zeus slew because, as a healer, he passed permitted bounds and revived a dead man. Later he was raised to godhead as the divine patron of healers. His worship was officially brought to Athens in 420/19 from his Peloponnesian home, Epidauros. On a beautiful fragmentary plate[22] by the Meidias Painter, the Nymph Epidauros holds the baby Asklepios in her arms beside a tripod on a column. Eudaimonia (Good Luck, another Meidian favourite) sits loking up at them, and there was another female figure. Hygieia has no traditional place in the Hesperides's garden, any more than in the entourage of Aphrodite, but the Meidians do not go by that kind of criterion. The image they offer is the paradise garden, and there all that is sweet and good is at home.

Pictures of the tribal heroes become rather popular at this time; we saw a beginning of this concern in the Codrus Painter's cups.[23] The heroes' association with a paradise garden is typically Meidian. Much more difficult is the presence of Medea. In Greek legend, and especially in Athens, Medea is the bad queen of the fairy-story, cruel stepmother and wicked witch. Her presence here cannot be free of that association; must be a hint of Nemesis, of the insecurity of things, even in a paradise garden. So I read the creation of the *femme fatale* Pandora on the base of Pheidias's Athena in the Parthenon; and we shall find other possible hints like this in other Meidian paradises.

Nothing of the kind can be detected on two other masterly hydriai by the Meidias Painter, a pair in Florence.[24] Each shows Aphrodite and one of her mortal favourites, Adonis and Phaon, and on each Hygieia appears among the attendants. These hydriai have only one picture, and the figures are larger. On one Aphrodite sits high in the centre, Adonis reclining in her lap, flowers growing around. A litle Himeros beguiles Adonis with a toy, and three other Erotes play around, one (again named Himeros) dancing to a tambourine struck by Pannychis (Night-festival). Other figures seated or standing around are all women. Hygieia sits with Paidia (Play) on her lap; one thinks of Alcibiades on Nemea's knees.[25] The others are Chrysothemis, Pandaisia (Banquet; *pan*, 'all', in these compounds signifies completeness, perfection), Eudaimonia and Eutychia (Good Luck both) and Eurynome (Breadth of Knowledge, from *eurys*, 'broad', but the painter perhaps associated it with *eu*, 'good').

On the second vase (fig. 244), Phaon, the erstwhile old ferryman of Lesbos whom Aphrodite rewarded for

his kindness to her in disguise by turning him into an irresistible youth, sits in the centre with a woman named Demonassa. The laurel-branches which surround them are here shaped into a more formal bower. On one side are Chrysope (another gold-name) and Leura (Smooth); on the other, less predictably, Apollo seated, his mother Leto standing by him; deities of light, and so welcome in a paradise garden. Above, Aphrodite departs in a chariot drawn by two winged boys, Himeros and Pothos (another word for desire). To left and right appear Hygieia with Eudaimonia, and Pannychis with Herosora (Springtime). Demonassa, Lady of the People, is an unexpected name. She is found again in a cup-tondo by the painter in Malibu,[26] where she sits between a woman and Eros. She is probably a bride for Phaon provided by Aphrodite. An interesting idea that she is Aphrodite herself, a variant of the well-known Aphrodite Pandemos, is perhaps not quite ruled out by the second appearance of Aphrodite on the hydria, but the other interpretation fits that much more easily and I prefer it.[27]

These three hydriai give the tone typical of Meidian art and show it at its best, but its range is much wider. Often the character is the same even if the cast is different. The Thracian bard Mousaios, seated Apollo-like among Muses on a big pelike by the Meidias Painter in New York,[28] is in a paradise garden; and, as well as his wife and child, Aphrodite is present with Peitho and an Eros, much as Apollo and Leto are present on the Phaon hydria. In a very similar picture on a squat lekythos in Ruvo[29] the singer is another Thracian, Thamyras. He overreached himself and challenged the Muses, for which insolence he was blinded and deprived of his gift. There are problems in the interpretation of this picture, but it certainly contains no hint of the bard's horrific end as there is in some earlier pictures. It is a peaceful garden-scene like the others; but the artist and his clients knew the story and it throws a shadow on the garden, as Medea does on the London hydria.

Many of the pictures on squat lekythoi and acorn-lekythoi (which now have a 'realistic' rough cup instead of Aison's black one[30]) have the air of extracts from, or briefer versions of, the scenes on the big vases. The choes in general seem more closely in the tradition of the Eretria Painter. A charming one in New York[31] balances the earlier painter's with the man putting a child on a swing.[32] On the Meidias Painter's a little boy stands by while a woman takes clothes from a chair and puts them on a swing. Beneath it is a small smoking fire, on which another woman is sprinkling liquid from a little jug, perhaps to perfume the garments for the festival.

The Malibu kylix, which Beazley did not know, is the only one ascribed to the Meidias Painter himself, and even of that the exterior is thought to be rather in his

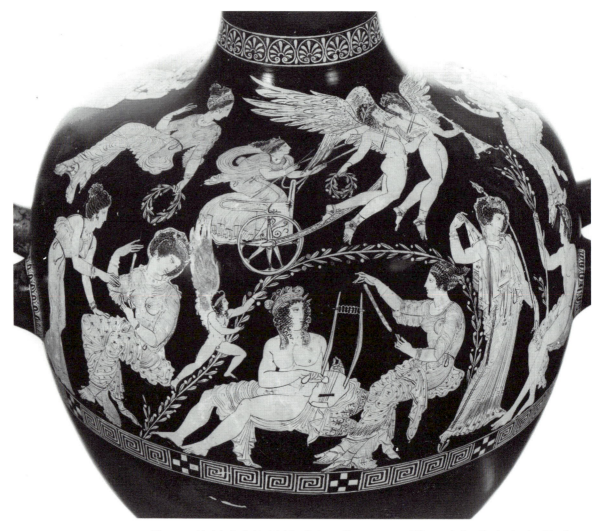

Fig. 244. Hydria (kalpis); Meidias Painter. Demonassa and Phaon; Aphrodite in chariot. H. of vase *c.* 0.47.

manner. It has the ovolo at the rim which is found on the later cups of the Euaion Painter (as well as on some of the Penelope Painter's skyphoi), but not on those of the Codrus or Eretria Painters. A number of stemlesses are ascribed to the Meidias Painter or his manner, and there is a large 'Sub-Meidian Cup-group' which we will touch on in the next chapter;[33] but the only other careful cups from the inner Meidian circle are those of the only painter in it to have left his name, Aristophanes.

The name is found on two cups, in Berlin[34] and Boston[35] (as well as on a bell-krater fragment in Agrigento[36] with almost no figured remains), together with that of a *poietes* Erginos. Two more cups are assigned to him (one, in Boston,[37] a replica of one of those with a signature and found with it), and an acorn-lekythos, once in Berlin[38] but now lost. The last shows Phaon with Eros and women; a thoroughly Meidian design, but the style is harsher than the Meidias

Painter's, and three of the cups have un-Meidian themes of battle, Centauromachy and Amazonomachy. The fourth, a fine piece on the market,[39] not known to Beazley, has Dionysiac compositions. The style is not far from that of the exterior of the Malibu cup, and one might think of Aristophanes for that, though he does not elsewhere put ovolo at the rim.

Harshness of style is relative, and it is something hardly found even in this mild form in other work of this circle, except as a chance effect of clumsiness; but not all scenes are sweetness and light. In the small lower frieze of a fragmentary hydria from the Kerameikos[40] by the Meidias Painter, maenads are tearing Pentheus. This vase is in other respects unusual. The pictures are separated by a broad band of palmette and lotus, and the large figures in the upper picture are not set up and down the field. Helen is seated among her sisters (fig. 245). Her head is bent towards a little Eros who sits

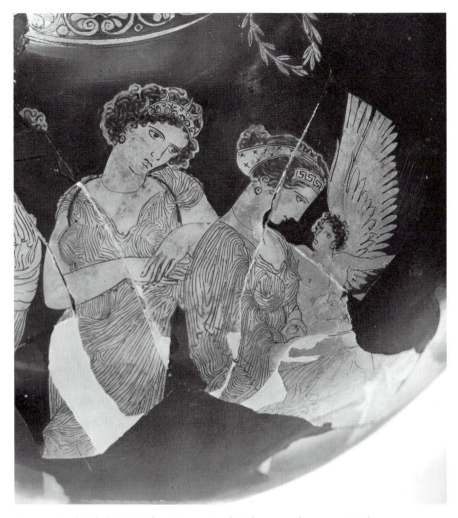

Fig. 245. Hydria (kalpis); Meidias Painter. Detail: Helen among her sisters. H. of picture *c*. 0.17.

on her lap. Her expression is grave, as is Phylonoe's, who leans on her shoulder. Phylonoe's three-quarter face is perfectly realised, and the drawing throughout is the finest and most sensitive in the artist's surviving work. Helen seems to be brooding on the fatal action to which Eros is leading her.

A similar character informs Agamemnon on a fragment of a lekanis-lid from Taranto,[41] though the drawing is less fine. Artemis and Apollo are present, and Agamemnon is surely, as Burn says, meditating the dreadful decision to sacrifice his daughter Iphigeneia. This allusive approach seems more typical of the artist and his circle than the direct action of the rape of the Leucippids or the death of Pentheus. It is probably right to associate it with the conventions of contemporary tragedy; though curiously, a scene of brutal action on a skyphos-fragment in private hands,[42] ascribed to the artist's manner, is paralleled in a surviving play. At the beginning of the Aeschylean Prometheus, Hephaistos is

compelled by Kratos (Power), who is accompanied by his sister Bia (Force), to carry out Zeus's command and nail the Titan to a rock. On the fragment Hephaistos is working on the wheel to which Ixion will be bound for eternity and, as well as the victim, Kratos and Bia are present and named. No paradise garden here.

We have not had occasion to notice the lekanis, the shape on which Agamemnon appears. It is a wide shallow bowl of many uses, which goes back to the earliest black-figure and has a continuous history in plain black.[43] In the developed form in which we meet it now it has a low foot, ribbon handles on the rim, and a nearly flat lid with a central knob on a low stem. The top of the knob is flat, so that the lid can stand as a bowl. If red-figure decoration is applied the picture is confined to the lid, the figures' feet resting on the rim. There is a fragment by the Berlin Painter in his middle to late period from Locri,[44] with Poseidon pursuing a woman; and a finer by Hermonax from Spina[45] with a

Gigantomachy, but it is only in the later fifth and fourth century that it becomes a popular shape with red-figure painters. Some have scenes of weddings or women's life, and were certainly wedding dedications; and it seems that the popularity of the shape in later red-figure is almost exclusively as a wedding-vase. Loutrophoros and nuptial lebes attest the strength of tradition in shapes made specially for use at funerals and weddings. Fashions also change, however; and the *red-figure* lekanis as a wedding-vase comes in now, just as about the same time or very little later the white lekythos goes out of fashion for funerals after half a century or so of popularity.

Two lekanis-lids of unknown provenance, by or very near the Meidias Painter,[46] show men in oriental dress, probably Persians, pursuing women in a sanctuary. The subject, not attested elsewhere, is unexplained, though there are possible theories. Probably in any case it has a bridal connotation. As in the rape of the Leucippids, there is little sense here of stress or distress. The feeling seems more that of a masque, or perhaps rather of ritual play.

The pyxis is a shape early adapted to scenes from the *gynaikeion*, and there are predictably many from the Meidian circle. Some of the pictures on these have a character which informs also some on squat lekythoi and other shapes: a tendency to make the figures chubby and childlike. This is not a feature of the Meidias Painter's own style, but we noticed something analogous earlier in the work of the Shuvalov Painter and the Marlay Group.[47] It could well be that some of these painters were engaged also in production of the little festal choes with pictures of children at play which we shall notice in the last section of this chapter.[48]

III. The broader tradition: the Dinos Painter; Polion

The Meidias Painter is in some ways the most interesting and original artist active in the Kerameikos in the later fifth century, but there are other draughtsmen of no less quality who seem to belong to a more central tradition. The Meidias Painter makes something monumental out of a fine miniature style of relatively recent development; and though the influence of his work can be traced in the following period he does not seem to have clear direct successors. The Dinos Painter, a very fine artist, derives his style from the Polygnotans through his master the Kleophon Painter,[49] and transmits that tradition to vase-painters of the latest fifth century and the early fourth. The Kleophon Painter is roughly a contemporary of the Eretria Painter; the Dinos Painter, who, Beazley says, 'continues the style of his master . . . in a less solemn and sweeter form', roughly of the Meidias Painter.

Of towards fifty vases in the Dinos Painter's list,[50]

Beazley isolates four which 'show him in a grander mood than usual, but are not to be separated, I think, from the rest'. I feel no doubt that they are his. The range of quality is great. Some pieces, especially among the bell and calyx-kraters, are poor stuff; but the best of the others seem to me to merge imperceptibly into the 'grander' style.

The artist's most famous vase (one of the four) is not the name-piece (a dinos in Berlin[51] with Dionysos at feast) but a stamnos in Naples:[52] one of the last with women preparing for a festival round an image of the god in the form of a mask on a dressed post (fig. 246). Four on the front are so engaged, four on the back already possessed (fig. 247): three dancing with thyrsos, torch and tambourine behind the fourth who plays the pipes. They stand or move on the base-line, not set up and down the field, and are more massive than Meidian figures; and the detail though fine is not so pernickety.

The Dinos Painter did not always eschew the broken groundline, though the other way of composing is his norm. Another of the four, a calyx-krater in Bologna[53] has on the front broken ground with plants as a setting for Atalanta and Hippomenes preparing for their race, Aphrodite and Eros encouraging the man. The main figures are near the front, but others are set up and back, one partly concealed. The landscape is carried round to the back of the vase, but the three large figures which occupy it are set very near the front and reach most of the picture-height. They are all bearded men in himatia with sticks: in fact conventional reverse 'mantle-figures', for once carefully drawn and characterised and brought to life in a natural setting. We saw that such conventional reverses were becoming the rule in the time of the Polygnotans, and many of the Dinos Painter's vases have them; especially on the bell-kraters a boy between youths, done summarily to a pattern. The rejection of this convention by the Meidians is one of their distinguishing marks.

The Dinos Painter used the landscape setting once more on the only volute-krater known by him, a damaged vase likewise in Bologna.[54] Beazley did not put it in his 'grander' group, but I do not see how it can be separated. On the front, high in the field at one side, Dionysos and Ariadne sit side by side, looking in each other's eyes. She holds small cymbals and strikes them in a rather desultory way, and the theme is music and the dance. Near the other edge a satyr sits piping and a maenad, below him, stands with her foot on a rock and looks round at another satyr who dances in from under the handle. Another maenad and satyr appear above broken ground at the top, and the centre is occupied by four dancing maenads. One swings her thyrsos, one beats a tambourine, one rather surprisingly carries a child on her shoulder. We saw a small child held by a maenad in a preparation scene on the Phiale Painter's

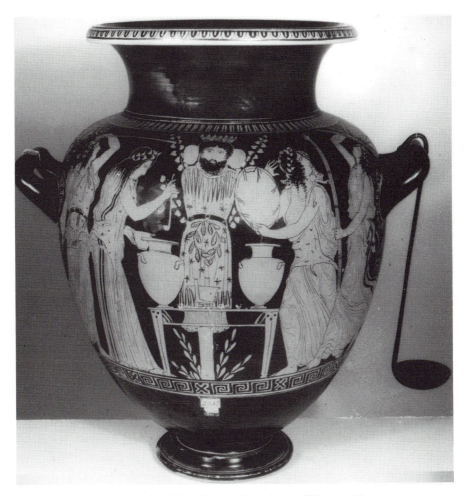

Fig. 246. Stamnos; Dinos Painter. Maenads preparing at image of Dionysos. H. *c.* 0.49.

Fig. 247. Detail from reverse of 246: maenads.

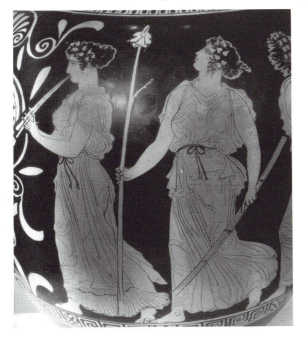

great stamnos.[55] He is reaching out to his mother; and the Dinos Painter's, with a no less natural gesture, holds on to his mother's forehead while turning to look back and up at the piping satyr. I suppose a mother who felt the call of the god to the mountain but had a small child might take it along with her. The Dinos Painter did not, like the Phiale Painter, assimilate the child to a satyr, but I doubt there is much significance in the difference.

On a coarse Meidian pyxis-lid (of the style in which all figures look rather like children) a maenad swings a real child over her shoulder by the ankle.[56] This is clearly another matter. The motif is repeated elsewhere, notably on the great bronze krater from Derveni[57] of nearly a century later, where the maenad is dancing opposite a wild man, not a satyr, who carries a hunting-spear. This may be the Thracian King Lycurgus, who offended Dionysos and, maddened by him, killed his own son. There are other repetitions of Dionysiac motifs in the art of the late fifth century and after. It is possible that the ultimate source is wall-paintings in the temple of Dionysos at Athens; but this is highly conjectural.[58]

We saw that the Kleophon Painter could do delicate work on a small scale. There is no evidence of this in the Dinos Painter. The figures on a two-tier calyx-krater in Oxford[59] are quite small, but it is hasty, rather rough work. It is as if he had taken up a position against the extreme elegance and elaboration of the Meidians. One puzzling vase, however, cannot be fitted into such neat generalisations. This is a neck-amphora in Arezzo.[60] The black neck is decorated in white, a sphinx on the front, a heron on the back. On the back of the body two women run to a bearded man, a common reverse type. On the front (figs. 248 and 249) is an elaborate picture of Pelops driving his chariot at speed, looking back for the expected pursuer, his bride Hippodameia (they are named) still and upright in the car in front of him,

untouched by the wind of flight which blows her lover's hair and cloak out as he leans back holding the reins. There are landscape-lines over the background, with trees and two birds mating; and in front of the horses a dolphin leaping over indications of sea.

Beazley lists this vase under Manner of the Dinos Painter. He compares the reverse to two other reverses in the list, but says of the principal picture that it 'approximates to the Meidian style'. Burn accepts that the 'three-quarter faces, features, and drapery' are Meidian, but points rightly to the 'single ground line, and the serious, statuesque qualities of the scene' as producing a very un-Meidian effect, while such reverse figures 'would certainly never appear on a Meidian vase'. This strange and rather beautiful piece must

Figs. 248 and 249. Neck-amphora; manner of the Dinos Painter, but under Meidian influence. Pelops with Hippodameia in his chariot. H. *c.* 0.54.

Fig. 250. Volute-krater; signed by Polion as painter. Apollo with his chariot, and other deities. H. *c.* 0.59.

surely have issued from the Dinos Painter's workshop. Perhaps it was painted by some talented pupil who had been impressed by the Meidias Painter. We seem to be able to trace such a late pupil of the Dinos Painter in the Pronomos Painter,[61] though I am not suggesting that this could be his work. Before we come to that interesting artist and his companions there are other contemporaries of the Meidias and Dinos Painters to be considered. Most of these are relatively minor figures and we will look at them together in the next section. One, however, who has left his name, Polion, is of comparable quality to the Dinos Painter and of not dissimilar character.

The signed vase (fig. 250) is a volute-krater in New York.[62] A frieze of big figures, feet on the base-line, surrounds the pot. On the front is a four-horse chariot, standing quietly. Behind the horses Athena stands, fully accoutred, and looks in the direction of Artemis who stands by the car holding the reins. She too looks back over her shoulder in the same direction. Behind her stands another goddess, laurel-wreathed and richly clad, and she too looks the same way: Leto, mother of Artemis, and of Apollo who closes the picture. He stands, robed and playing the *kithara*. His head is lost, but he was surely looking before him and was the focus of the others' gaze and the goal of a little Nike who

is shown in flight between Athena and Artemis. The picture continues round the back with deities in pairs. This noble composition has much the feeling of that on the Berlin Painter's dinos painted more than half a century before.[63] Busy as we are mapping change we do well to be reminded sometimes of how much continuity of spirit and tradition there is.

In conception and design the picture on this vase is in the same tradition as the work of the Kleophon and Dinos Painters. One other volute-krater is attributed to Polion, from Spina;[64] an equally large and splendid vase, but here the figures are set up and down the field. Their disposition, however, is not like what one finds on Meidian vases. There is little overlap, and they are arranged roughly in two tiers, an old tradition going back to the time of the Niobid Painter. One may compare the volute-krater we looked at earlier from the same site, with the seven against Thebes and the unexplained picture on the other side.[65]

On both sides of Polion's Spina vase (the surface of which has unhappily suffered much damage in some areas) are elaborate compositions. On what may be taken as the back (there are fewer figures; the picture on the other side occupies more of the space under the handles; the torch-race on the neck culminates at an altar on the other side) we have the fullest surviving picture of the contest of Thamyras with the Muses. Thamyras stands to right in the upper register, left of centre. He is playing the *kithara*, with bent head, so not singing to it. A rapt hare crouches at his feet, and a Muse stands, lyre in hand, foot up on rock, elbow on knee, leaning forward and gazing earnestly in the arrogant mortal's face. Behind him is a tripod, and beyond that are Apollo standing with laurel-branch and a seated Muse holding a *barbitos*, both looking towards Thamyras. The other seven Muses occupy the lower register, standing or seated, with *kithara*, lyres, pipes, a scroll, a fillet. One of those seated clasps her knee. On the right of the upper register, next to the Muse confronting Thamyras, a woman stands frontal, hands raised in prayer, looking down at an altar against which a lyre is leaning. Above it is a row of nine little objects, posts with human heads: primitive images of the Muses whose sanctuary, with Apollo, this is. The woman is Thamyras's mother, who is shown, maddened by grief, in earlier pictures of his punishment. To right of these, above the last Muse in the lower register, grows a little tree which marks the change to the other picture.

That represents the old story of the return of Hephaistos to Olympos, but in an unprecedented, a unique, form. At the top left sits Hera on the fettering throne. No bonds are shown, but she is drawn in an odd combination of front and side view which gives a cramped and awkward effect that is certainly deliberate. She looks very cross. Behind her, backing on the tree

which separates the pictures, a little siren perches and fans the goddess, in front of whom stands a waiting woman with a box. All three look to the right, and the woman raises one hand in a gesture of surprise. Approaching them at a run is a satyr, who holds a flaming torch before him, and in his other hand carries Hephaistos's tongs. Immediately behind him Hephaistos himself, evidently very drunk, is being heaved to his feet by a little satyr from a big mattress on which Dionysos still reclines with kantharos and thyrsos. Beyond the couch a maenad sits playing a *barbitos* and looks over her shoulder at a satyr with a thyrsos. He too sits on the ground, one knee drawn up, his hand lying idly on the ankle – a nicely observed pose. Four more satyrs and two maenads form similar conversational groups in the lower register. Particularly charming are two satyrs in back view, one leaning back, a leg tucked under him, and reaching out to lay a hand on the shoulder of his friend, who sits hunched and looks back over his shoulder. At the right-hand end a maenad stands with another lit torch.

The mattress with its fringed rug and cushion is such as is normally laid on a couch, but no couch is drawn. One gets a momentary impression that Hephaistos, instead of being got to Olympos on donkey-back or his own two feet has been wafted there on a magic carpet. In fact, I suppose, the artist has combined two moments distinct in space and time. Hera and her companions in Olympos have glimpsed the satyric torch-bearer leading the procession towards them through the night. The rest of the picture shows the earlier moment down below when, the smith-god sufficiently happy, the party begins to break up to form the procession to take him home. There are other examples of such picnic-symposia laid out on the open ground. Both the overall conception and the interest in unusual postures makes one wonder about a possible model in wall-painting.

Nothing else of the scale, or the quality, of these two vases is ascribed to Polion. The score of pieces given him includes fragments of a loutrophoros and a nuptial lebes as well as of a calyx-krater, and several bell-kraters. These, however, are small and most of them slight. The most interesting are one in Bonn[66] with Leda, Tyndareos and the Dioskouroi at an altar, a column with a statue of Zeus beside it, the egg lying on it; and one in New York[67] which shows a chorus of old satyrs with lyres, accompanied by a piper. The artist has not put much into the little pictures of athletes on the necks of the two volute-kraters, but on smaller vases he shows a pretty touch which suggests contact with the Eretrian–Meidian tradition. A squat lekythos in Oxford (fig. 251) has an enchanting picture of Eros riding a fawn, repeated on an oinochoe in New York.[68]

We should look here at a pretty pointed amphoriskos in Berlin[69] with Aphrodite holding Helen on her knees

Fig. 251. Squat lekythos; Polion. Eros riding fawn. Preserved H. *c.* 0.16.

Fig. 252. Pointed amphoriskos; Heimarmene Painter. Attendants on Helen. H. of picture *c.* 0.09.

Fig. 253. As 252: Paris and Eros.

(that motif again), while Eros brings Paris to her (figs. 252 and 253); Erotes also on the shoulder. Beazley ascribed one squat lekythos to the same hand, the 'Heimarmene Painter' after one of Helen's women named on the amphoriskos, and remarked on 'a certain resemblance to Polion'. One must wonder if further finds might not show this to be another aspect of Polion's own work.

IV. Some minor figures: the Kadmos and Pothos Painters; the Kekrops Painter; the Nikias Painter

Beazley describes the Kadmos and Pothos Painters as 'brothers', a word he uses to express a particularly close relation between two contemporary painters: the Antimenes Painter and Psiax, the Copenhagen and Syriskos, the Boreas and Florence Painters. He qualifies the Kadmos Painter as superior to the Pothos. Indeed the Pothos Painter is a consistently poor artist, and nothing in his work need detain us.[70] Both are mainly producers of bell-kraters, and on these there is not much to choose between them, but the Kadmos has a wider range both of shapes and of quality. A few hasty pieces (two column-kraters, a skyphos) are at least as bad as anything of the other's, but he is more careful in more ambitious compositions on other shapes (a volute-krater, calyx-kraters, pelikai, hydriai). Never a fine draughtsman, he sometimes chooses unusual subjects

and makes something interesting of them. In these works the figures are set up and down a landscaped field, rarely overlapping, in often rather formally symmetrical compositions.

On a pair of hydriai in Berlin[71] the Kadmos Painter set the Judgement of Paris and the picture of Kadmos and the dragon from which he takes his name. That subject is found on an occasional Attic vase from early classical times, but this is the most elaborate rendering. High up to right of centre the dragon rears, and the bearded hero, dressed as a traveller, approaches with

drawn sword. Between them stands Athena holding a wreath, and another is in the hands of a little Nike above Kadmos's head. His bride Harmonia sits behind him; and all round, sitting or standing, are named deities watching the action: Thebe (Nymph of Thebes) with Eros laying a wreath at her feet; Demeter and Kore; Apollo and Artemis; Poseidon; Hermes. By Hermes is a seated woman, arms and hands muffled in her mantle. No name is written by her, nor by a naked boy with a hoop near her under the left handle. He looks like Ganymede, but it is hard to find a reason for his presence. The corresponding position under the other handle, near Apollo and Artemis, is filled by their creature, a griffin. A deer, which should also belong to them, the painter has placed near Harmonia and Kadmos, balancing Thebe's little Eros. We shall return to the identity of the muffled woman.[72] Besides plants there are two tripods on columns, something the painter likes.

Many of the names on this vase are written in their Doric forms: Theba, Damater, Kora, Apellon, Artamis, Hermas. One wonders if the vase-painter may not have based his composition on a wall-painting at Thebes. Thebes and Athens were generally hostile and Thebes was an active ally of Sparta during the war. One would think this vase most likely to have been painted between the Peace of Nikias in 421 and the fortification of Decelea in 413.

On a calyx-krater in Bologna[73] the Kadmos Painter puts a picture of Theseus at the bottom of the sea (fig. 254). In the centre foreground Poseidon reclines on a couch and looks up at the scene above. Amphitrite, seated on broken ground, holds the shining wreath for which the boy Theseus, in Triton's arms, reaches out his hands. Triton, wreathed and richly clad, ends in a nicely curled sea-monster's tail. Behind him the stern of the ship, with the steering oar, marks the end of the picture. Above an irregular ground-line running from the ship, part of the rising sun with his chariot-team appears. Behind the couch stands a calyx-krater which an Eros is filling from a hydria. His high-curling wings separate a group of two standing Nymphs just above Poseidon, one leaning on the other's shoulder, from another couple, one with a tambourine.

Fig. 254. Calyx-krater; Kadmos Painter. Theseus at the bottom of the sea. H. *c.* 0.52.

This picture too looks like something borrowed from a wall-painting. It was long ago suggested that it reflects the famous picture by Mikon in the Cimonian Theseum of more than half a century earlier.[74] For many years scholars have rejected the idea and seen the vase-painting as a creation of its own time, but this does not convince me. Certainly it is handled in a late fifth-century manner, and some elements must be of that time: Eros, and the seated Nymphs behind him, as well as the painter's favourite tripods on columns (one in front of the couch, one between Amphitrite and the standing Nymphs). The main composition, however, from the ship and Helios to Poseidon and the standing Nymphs, seems to me perfectly compatible with an early classical design. To close a picture with the stern of a ship is a convention. We shall meet one on an only slightly later vase treated in another section,[75] and it recurs on the Ficoroni cista,[76] which copies a fourth-century wall-painting; and it is almost certainly an early classical invention. One end of Polygnotos's picture at Delphi of Troy Taken showed Menelaos's ship, a ladder to the shore with a man on it as there is in the two pictures just cited; and there too the ship was surely cut off in front of the stern.

In the picture on the back of this vase, Herakles and the hind, a figure of Athena is certainly inspired by the early classical relief on the Acropolis known as the 'mourning Athena';[77] and we shall come in a moment to another figure in vase-painting similarly derived from a work of early classical sculpture.

One of the Kadmos Painter's better drawings is on a pelike in Munich.[78] In the upper part Athena drives Herakles in a chariot, taking him to Olympus. Herakles's ascension in a chariot, the charioteer generally Nike, the horses often winged, becomes a favourite subject in early fourth-century red-figure. Here the scene is extended. Below is seen the pyre on Mt Oeta where Herakles, tortured by the poisoned robe, burned himself. A corslet lies on it, a satyr rushes up to look close while another starts back, and two Nymphs come with water to pour on the flames. The satyrs do not have the costume of satyr-play, and the picture cannot illustrate a performance, but must have been suggested by one. We shall look in a moment at the slight picture of satyrs and women on the back.

The reverses of the Kadmos and Pothos Painters' bell-kraters have normally a boy between two youths, all wrapped in their himatia. So do many of the Dinos Painter's, and indeed most such vases in this period. They are not yet the almost unrecognisable ciphers they become a little later, but they are daubed in almost mechanically and each craftsman has his own preferred formulae.

Two calyx-kraters and a bell-krater are grouped by Beazley as works of a Kekrops Painter, a bell-krater and two pelikai as works of a Kiev Painter,[79] both described as followers of the Kadmos Painter. The first is said to be very close to him, but while 'the Kadmos Painter has a certain dignity ... in the Kekrops all is trivial and tawdry'. The judgement is hard to dispute, but there are points of interest in the two large calyx-kraters in Adolphseck[80] one of which gives the painter his name. Many figures are scattered up and down the surface. On the front of the name-vase they are grouped round Athena and Kekrops at an altar. On the back Herakles subdues the Cretan bull in the presence of Apollo, Athena, two Nikai and a still, upright figure muffled in her mantle which is brought up over her head. Apart from the fact that her right hand just issues from the wraps near her face this figure is almost identical in design with a famous early classical statue, 'Amelung's goddess', known in many Roman copies, one of which is inscribed with the name of Europa. The bull Herakles had to capture in Crete was the same Zeus had sent to Phoenicia to swim with Europa to the island, so her presence is entirely suitable. The same type is used for the same heroine in other contexts too.[81] As Kadmos's sister, in search of whom he had set out from Phoenicia, she would also be an appropriate presence among those gathered round his fight with the dragon. In fact the upper part of the seated woman without a name in the Kadmos Painter's picture[82] is again all but identical, only nearer the statue in having her right hand under the cloak. I have no doubt she too is Europa.

Nearer still to the statue (standing, with hands concealed) is a woman on the reverse of the Kadmos Painter's Herakles pelike,[83] but this figure cannot represent the heroine. On the left a woman sits making a wreath while a satyr with a thyrsos stands quietly by. Both these are on wavy ground-lines some way above the lower border. So is a satyr on the right who starts back with outstretched arm, beneath which the muffled woman stands on the base-line. This has been called 'satyrs and maenads', and the seated woman may be a maenad; but it is hardly possible to interpret the muffled one so. Lullies suggested that she is Kore rising. Her position in relation to the others, and the silen's movement fit this idea well, and I have no doubt it is right. It is interesting to find the Europa type adapted to Kore.

I have gone into this at some length for two reasons. First, it is a good example of the transmission and adaptation of types in a vase-painter's workshop. Secondly, it is a clear case of late fifth-century vase-painters borrowing from earlier work.

Several names are known from the Kerameikos at this time. In the Meidian circle we noticed, besides the *poietes* Meidias, another *poietes* Erginos and the painter Aristophanes.[84] Two fragmentary lekanis-lids, one from the Acropolis with the rare subject of the strife of Athena and Poseidon for Attica (the theme of the west gable of the Parthenon), the other from the Pnyx, have inscriptions in white with the name of Mikion.[85] On the

Pnyx fragment he certainly appears as *poietes*, on the other probably the same; and that bears also the name of Euemporos, probably as painter. A plaque-fragment from the Acropolis,[86] of early or high classical style, has a signature, likewise in white, of a painter Mikion who may or may not be the same man.

An inscription in monumental white lettering round the foot of a bell-krater of Greek provenance in London[87] gives the name of a *poietes* Nikias son of Hermokles of the deme Anaphlystos. The picture on the front (the back has three mantle-youths) shows torch-racers at an altar with an old man and Nike. It perhaps celebrates a deme victory. We noticed a torch-race to an altar on the neck of Polion's volute-krater from Spina.[88] At the beginning of the *Republic*, Plato speaks of torch-races on horseback at the introduction of the worship of the Thracian goddess Bendis to Piraeus, which took place in 430/29. A cup from Spina,[89] which Beazley connects with the Fauvel Painter, a late member of the Marlay Group, has on the outside torch-racers with similar head-dresses to those on the Nikias krater, and in the tondo a female in short chiton, cloak and boots, with a strange hair-do, seated on the ground playing the lyre, Eros standing before her holding pipes. This must be Bendis.

The Nikias Painter, named after the London bell-krater, is a hack who decorates mainly though not exclusively this shape. More interesting than most of his work is a chous in the Louvre[90] with a burlesque (fig. 255): Herakles driven by Nike in a chariot drawn by

Fig. 255. Chous; Nikias Painter. Burlesque: Nike driving Herakles in a Centaur-chariot. H. *c.* 0.11.

250

four Centaurs, a man with torches capering in front. The grotesque faces are evidently theatre-masks, and the torch-bearer has the phallic tights of comedy. The so-called phlyax vases of fourth-century South Italy seem mainly to illustrate Attic Old and Middle Comedy,[91] but such representations are rare in Attic vase-painting. There is, however, one other most interesting example.

A small calyx-krater in Malibu,[92] not known to Beazley, has three-figure pictures on either side. On one a young warrior, holding helmet and spear, stands between father and mother. On the other (fig. 256), two actors in phallic costume with wings and bird-heads dance to the music of a piper, in long figured robe, who stands frontal in the centre. This is almost certainly an illustration to the *Birds* of Aristophanes, produced in 414.

The harsh but lively style has been convincingly associated with the Painter of Munich 2335.[93] We noticed his early work, slight red-figure and good white lekythoi, in the workshop of the Achilles Painter, and his subsequent brief sojourn decorating oinochoai with the Shuvalov Painter. In his last phase he joins the hack krater-painters, and stands near to the Pothos Painter. There are several small calyx-kraters in his late *oeuvre*, but the majority are bell or column-kraters. The latter shape falls sharply in popularity in this period, but the late Mannerists continue to produce them,[94] and probably some of the other column-krater workshops active in the high classical drag on. Half a dozen little stemless kantharoi attributed to the Painter of Munich 2335 belong to a class which seems to date from the turn of the fifth and fourth centuries.[95] We shall touch again on the question of how late this painter worked, both in the next section, on white lekythoi, and in the next chapter, when we consider the development of one line in early fourth-century red-figure.

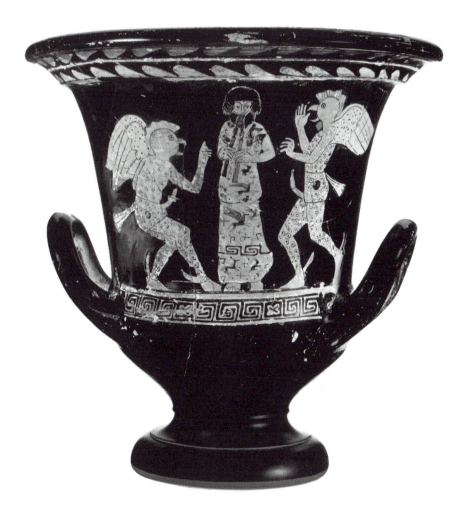

Fig. 256. Calyx-krater; probably by or near the Painter of Munich 2335. Scene from comedy: piper, and two chorus-men dressed as cocks. H. without modern foot *c.* 0.19.

V. The last white lekythoi

We saw that when the white funeral lekythos first becomes of major importance, with the work of the Sabouroff Painter and the Achilles Painter, most of the artists who decorate it seem to have sat in the same workshop with these, or at least to have been closely associated with it. Most of them, too, worked also in red-figure, though this cannot be demonstrated with certainty for such important figures as the Bosanquet and Thanatos Painters.[96] With the disappearance of the Achilles/Phiale workshop things change. None of the artists we shall be concerned with in this section can be seen to have worked in red-figure. The styles of the two arts diverge, and it is probable that all the white lekythos painters of this time were specialists.

The change is not sudden. Two painters who began in close association in the Achilles Painter's circle lead on to the new generation: the Painter of Munich 2335 and the Bird Painter.[97] We have seen that the first worked on in red-figure for a long time. It has been thought that most of his white lekythoi are early, but this is not sure and he certainly was the teacher of one of the finest artists of the new generation, the Woman Painter. The Bird Painter was perhaps one of the first who had no red-figure side. He is, as we saw, mainly a producer of quick slight pieces, and his follower in the next generation, the Reed Painter, carries on that tradition in a debased form.

Another artist who straddles the periods is the Quadrate Painter,[98] a name devised by Buschor, from his liking for chequer-squares in the maeander, and taken over by Beazley. (Many of the white-lekythos painters were first recognised by Buschor.) This painter Beazley cruelly but not unfairly characterises as one who 'with his mannered, mincing style ... comes nearest to the modern forger's idea of a white lekythos'. No red-figure is associated with him, though he is one of the last painters occasionally to use glaze outlines. The great majority of his pieces are, like everything else of this time, in matt. Beazley admitted some improvement in his later work, which is contemporary with the Woman and Reed Painters and influenced by the latter and his more interesting offshoot Group R.

The Woman Painter[99] clearly learnt from the Painter of Munich 2335, but the character of his style is different (fig. 257), graver and grander. His favoured but by no means exclusive theme is three women at a tomb, one standing to either side, the third sometimes sitting on the steps, sometimes kneeling with arms flung out in mourning. The red-figure painter with whose spirit his has most in common seems the Dinos Painter, but this is not to suggest any connection.

The Reed Painter[100] was a prolific hack. Nearly 150 lekythoi are ascribed to him, mostly small and the few larger ones no better. He takes his name from the reeds which he puts in profusely, not only round Charon's boat (a theme he likes) but less appropriately around tombstones or in scenes of combat. His work is of less interest for itself (except in so far as it demonstrates a continued demand for white lekythoi at a humble level) than for its relation to the lekythoi of Group R.[101]

There are more than twenty of these, all large. Potting, pattern-work and the quality of the matt red pigment make it certain that they were produced in the same workshop as the Reed Painter's lekythoi; but the quality, though it varies, is uniformly much higher, and it does not seem possible that any of them (it is not clear that they are all from one hand) can be his work. Most, including the best, show three figures at a tomb, the central one, normally a youth, seated (fig. 258). There is thus a resemblance in design to some of the Woman Painter's pieces, but the effect is very different. There is great serenity in the Woman Painter's quiet figures, a passionate abandon in his mourners. The figures in

Fig. 257. Lekythos; Woman Painter. Prothesis. H. of picture *c.* 0.16.

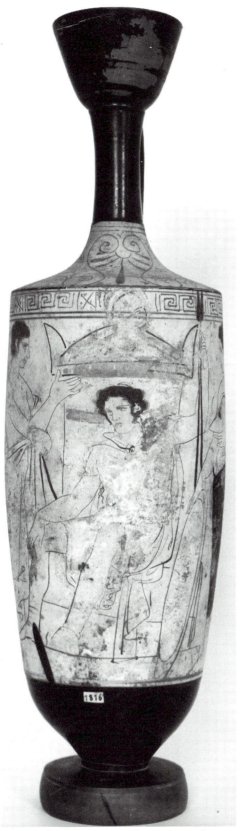

Fig. 258. Lekythos; Group R. Youth seated at tomb between youth and woman. H. *c.* 0.48.

Group R are still; but they seem to smoulder, brooding, turned in on themselves. They also give a great sense of physical mass, which is a remarkable achievement by purely linear means. Line indeed is used here not to contour forms but, in its nervous, broken handling, to suggest their bulk and weight. We saw that in the literary record there seems a suggestion that Parrhasios opposed the experiments in modelling by shadow of Apollodoros and Zeuxis and developed an alternative modelling by a new use of line.[102] Rumpf argued convincingly that what we see on the lekythoi of Group R is a reflection of Parrhasios's ideas.[103] The typical posture of the seated youths is three-quartered towards us with one thigh foreshortened. Johansen pointed out that Philoktetes is so shown in several Roman works which look derived in style from Greek work of this period; and that there was a famous Philoktetes by Parrhasios which may lie behind them.[104]

Beazley noted among the late works of the Quadrate Painter some large pieces, one of which he describes as 'emulating the great lekythoi of Group R'.[105] There are two further series among these latest white lekythoi. One, the Group of the Huge Lekythoi, stands apart and we will consider it in a moment. The principal craftsman in the other was named by Buschor the Triglyph Painter[106] after three vertical lines with which he often adorns the stele in the tomb-scenes which predominate in his work. Beazley places him, apart from a few oddments and the Huge Lekythoi, last in the chapter, after the Woman Painter, the Reed Painter and Group R, and calls his style 'overblown'. His pieces are often large, but he is a weak draughtsman and his work is of little intrinsic interest, but it has importance for us.

An observation has been made by van de Put which is of great significance for the dating of these vases.[107] The funeral white lekythos was made by Attic ceramists for use in Attic rites and the vast majority were found in Athens or Attica. The occasional piece found elsewhere can be explained as from the grave of an Athenian dead abroad, or an Atticising fancy by a foreigner. There is, however, one important exception to this rule: Eretria in Euboea. A high proportion of the red-figure from Eretria is lekythoi, and white lekythoi are found there from the time of the Timokrates, Inscription and Tymbos Painters on. There are several by the Sabouroff Painter and nearly thirty by the Achilles Painter, including some of his best. From that time until the time of the Woman and Reed Painters there is not a painter of white lekythoi with a dozen pieces to his name who does not show Eretria among his provenances. Whether they are from the graves of Attic residents or of Eretrians who had adopted this Attic burial custom we cannot say. Four from Group R, including the two most celebrated, come from Eretria, but not one of the fifty vases listed as by the Triglyph Painter is known to have been found there.

In 411, Athenians, defeated in a sea-battle by the Spartans, took refuge in Eretria. The Eretrians put them to death and joined the revolt. It is extremely improbable that any of the white lekythoi found there reached the city after that date. It therefore seems safe to say that the Woman and Reed Painters, with the artists of Group R, were in production before 411 (though not of course that they ceased production then), but the Triglyph Painter was not.

How long after this white lekythoi continued to be produced it is hard to say. The Triglyph Painter must have learnt in one of the older workshops which was carrying on after 411, and been active in the last decade of the fifth century. A passage in a play of Aristophanes produced in 393 was long taken to show that they were still being painted then, but it is doubtful if it really does so. In an unappealing exchange between an old woman and a young man whom she wants for a lover he offers her instead 'the best of painters', then defined as 'the one who paints the lekythoi for the dead'. The joke would be compatible with, but does not require, the existence of one old man (the Triglyph Painter as it were) still producing an outmoded vase for an old-fashioned and vanishing clientele; but, as Kurtz has stressed, another explanation is at least as likely.[108]

Gravestones with scenes in relief (occasionally with scenes simply painted, not on a relief basis; the reliefs themselves were of course coloured) became popular in Athens soon after the time of the Parthenon. Later in the century a fashion arose for marble tomb-monuments in the form of lekythoi. There are others in the form of loutrophoroi, presumably for the graves of those who died before marriage; and one in the form of a chous, to which we shall return in a later section.[109] The lekythoi often had scenes carved in relief, but others were simply painted, and it may very well be to these that Aristophanes is referring. The paint has perished from the marble vases, but traces remain and patterns can sometimes be made out. It is in this context that we must look at the last of the clay white lekythoi.

The Group of the Huge Lekythoi[110] consists of five pieces, one of them fragmentary. They differ from all others not only in size (they range in height from 68 to 110 cm) but in their construction and in the way they are decorated. The lekythos has no floor and no inserted container; that is, it could not have held oil or anything else; it is not a vessel. The mouth is thrown separately and held in place by a pierced 'stalk', which passes a short way down inside the neck. As to decoration: the normal white lekythos has the white slip only on the areas to be decorated, the cylindrical body for figures, the shoulder for palmettes. Mouth, neck and handle, lower part of body, upper surface of foot are black, edge of foot reserved, all as in red-figure or black lekythoi.

The lekythoi of the Huge Group have the white slip over the whole visible surface.

The separate making of the mouth is because of the great size. All the other peculiarities point to the reason of the size. These are not vessels for use in rites; they are monuments to stand on tombs, imitations in fact of the painted marble tomb-lekythoi. Two in Berlin were found at Ambelokepoi, ancient Alopeke, then a few miles from Athens. The provenance of the others is not known though one, in Madrid, came from Greece. They were all on the market between the 1870s and 1890s, and it is extremely likely that they were one find: a country grave-plot with a poor man's version of a type of marble monument fashionable in the city.[111]

The decoration is remote from normal vase-painting tradition. If it is the work of regular vase-painters they have adapted their style to that of the painters of marble vases, evidently closer to major painting. Blue, green and violet are used in the patterns and in the palmettes and acanthus which adorn some of the tombstones represented, as well as in the draperies. Nor are the figures drawn in outline on the white ground. A colour is added: 'second white' for women, brown for men; and on brown skin and coloured garments shading is put in, but not on white skin. Thus, while the special use of line on the lekythoi of Group R seems to reflect something in the style of Parrhasios, the technique of the Huge Lekythoi certainly gives us a glimpse of the innovation of Apollodoros and Zeuxis.

The absence of shading on women's skin also fits with indications in the literary tradition that this came in later than on men's: a reversion to the age-old distinction (exceptionally ignored in red-figure) between sun-burnt man and woman whose place is in the shady house. It is interesting that just at this time it begins to be the rule in red-figure to add white for the skin of women and Erotes. The shading on the men's skin on the lekythoi makes a heavy effect because it is unaccompanied by highlighting. We shall have more to say of these developments in the next chapter.[112]

Shading is found also on one other white lekythos. This, in Berlin,[113] was acquired at the same time as the two Huge Lekythoi and with the same provenance. It is extremely large, bigger than the smaller of the Huge Lekythoi, but apart from these two peculiarities is a 'normal' vase. With them was also a normal piece by the Triglyph Painter,[114] not much smaller than the smallest of the Huge Group. Several others of his are on this scale. Another equally large piece in Copenhagen[115] is not attributed but is of analogous style. This has peculiar proportions, near those of some stone lekythoi and some of those of the Huge Group, and has a band of leaf and dart pattern at the top of the body. This is

found also on one of the Huge Lekythoi and on stone examples. The conclusion from all this must be that the Huge Lekythoi are contemporary with the latest 'normal' white lekythoi, those of the Triglyph Painter and some others, in the last decade of the fifth century or very little later.

VI. After the Dinos and Meidias Painters: the Pronomos Painter; the Talos Painter; the Semele and Suessula Painters; the Painter of the New York Centauromachy

The Pronomos Painter takes his name from a volute-krater in Naples;[116] on the back is a fine and careful picture: Dionysos and Ariadne in a night-revel (torches), with satyrs and maenads, a panther, Eros clashing cymbals as he flies behind the couple. Dionysos carries a lyre; unusual, though we saw him playing a *barbitos* on a cup by the Brygos Painter.[117] The figures, some partly hidden by folds in the ground, are set up and down the field, as they are also in the picture on the front; and in both they are irregularly disposed in two tiers.

In the centre of the upper register of the main picture the divine couple appears again, embracing on a couch, both naked to the waist, elaborate draperies spread over their knees. They are here as patrons of drama. All round them are the actors and chorus of a satyr-play, costumed but mostly carrying their masks. The actors and chorus-leader are in the upper row, with two chorus-men, the actor who took the principal woman's part sitting on the couch-end. In the lower register, besides more chorus-men, one masked and dancing, are a standing youth with a lyre and two seated figures. One, named Demetrios, is probably the author of the play; the other, richly clad and playing the pipes, is named Pronomos. A Pronomos of Thebes is known as a composer for and performer on the pipes. He is mentioned by Aristophanes in the *Ecclesiazusae* of 392, but if a story that he taught Alcibiades the pipes is true he must have been active long before that. It seems likely that the vase was commissioned for a party to celebrate a dramatic victory. If so, the fact that it was found at Ruvo in South Italy is one of several pieces of evidence which suggest that, besides the regular trade from the workshops, there was also a market in secondhand vases.[118]

The patterned and figured cloth of the stage-costumes is rendered in great detail, and the elaborate effect is enhanced by the free use of white for wreaths and actors' masks (satyr-masks are red), and for the skin of Ariadne and little Himeros who crouches at her side, making much of the actor seated on the couch. It is

interesting that in the picture on the back, which is not in 'reverse-style' but carefully, even elaborately, drawn, white is used far more discreetly: not for the skin of Ariadne or Eros, or for any broad area. I said that though minor and sub-Meidians use white for skin the master himself does not. A possible exception to this rule is a vase in Vienna[119] which many have thought a late work of his. Beazley, though recognising it as close to him, separated it and thought it might be an elaborate piece by a companion, the Painter of the Athens Wedding.[120] It is a bell-krater of unique form, with horizontal lug-handles set directly under the moulded rim. On one side the Judgement of Paris is framed by Helios in his chariot rising above a hill and Selene on horseback departing. On the other the three goddesses of the Judgement are seen with Artemis and Apollo. Here white for skin is used selectively, apparently largely for decorative balance. In the Judgement, Aphrodite and Hera are white, Athena and Selene not; an Eros attending white Aphrodite is not, but one with Paris is. In the other picture (fig. 259), white skin is confined to Artemis and to two Erotes attendant on Aphrodite who herself is not.

This vase, whether or not the Meidias Painter's, is certainly a late product of the Meidian workshop. At the same time it is clearly close in character to the Pronomos vase and others which we shall look at in a moment. The Pronomos Painter, and others who go with him, develop aspects already present in Meidian painting: elaboration of detail, rejection of 'reverse-style'. In Beazley's list of the Pronomos Painter's work there is one thoroughly Meidian vase: a squat lekythos with Aphrodite, Helen and Paris;[121] but in general, in the shapes chosen for decoration, in compositions, and in choice and treatment of subject, he and his companions look another way. They were surely not trained in the Meidian workshop; and the Pronomos Painter himself, at least, I believe to have been a pupil of the Dinos Painter.

A disputed attribution is of interest here. In publishing the red-figure from the Phoenician sanctuary at Kition on Cyprus I gave a bell-krater without hesitation to the Dinos Painter.[122] The youths on the back follow his regular pattern precisely, though they are unusually slovenly in drawing; and the beautiful symposium on the front I find inseparable from good work by the painter, notably a dinos-fragment in Palermo[123] of higher quality than the name-piece in Berlin.[124] I then found that a fragment of the front had been published already, and on the basis of the published photograph McPhee had ascribed it to the Pronomos Painter.[125] This first drew my attention to the fact that the faces in the work of the two painters are extraordinarily alike. The Kition vase was certainly painted in the Dinos Painter's workshop. If it is the Pronomos Painter's he

255

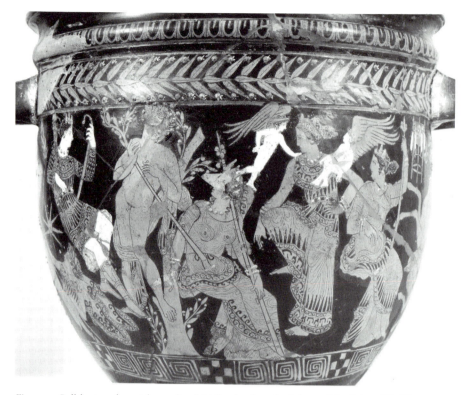

Fig. 259. Bell-krater of special type; late Meidian (perhaps by Painter of the Athens Wedding), approximating to the manner of the Pronomos Painter. Apollo and Artemis, with the goddesses from the Judgement of Paris, which is shown on the other side. H. of picture *c.* 0.16.

was sitting there; if, as I still believe, it is the Dinos Painter's, the resemblance still remains such as to suggest that they were master and pupil.

Besides the name-vase and the squat lekythos, Beazley ascribes to the Pronomos Painter himself only a bell-krater and a fragment of another. McPhee has convincingly added a third, and also a calyx-krater and some fragments.[126] Beazley further lists ten pieces, all large, 'some . . . important', as near the Pronomos Painter.[127] One is a large plate-fragment, in Boston, with a maenad riding a lion. From about this time the god himself is sometimes shown riding a lion or panther, astride or, like the woman here (who might be Ariadne), sideways. The drawing of the mount's head here and its shaggy mane are hard to parallel in vase-painting, and the rider's balancing act, arms outspread, is very striking. Curiously similar in design, though not in detail, is a mosaic floor, some 300 years later, from a house on Delos.[128] Once again one wonders if the two do not reflect one original, perhaps in the wall-paintings of the temple of Dionysos at Athens.[129]

Another piece listed as near the Pronomos Painter is a bell-krater with Atalanta from the sanctuary of Hera at Perachora.[130] It exists only in fragments, but the rim-diameter has been estimated at about 80 cm. This is a quite exceptional size; but two others of similar dimensions, one not known to Beazley, the other not listed by him, have been shown to be products of the same circle. The second is from Olynthos, and shows Nereids bringing Achilles his arms.[131] The other, the least ill-preserved of the three, comes from a tumulus at Baksy in South Russia.[132] It has on the back a Dionysiac scene, on the front an assembly of deities apparently welcoming both Herakles and the Dioskouroi to Olympos. What particularly concerns us in this impressive piece as a document in the history of art is its richness in echoes from high classical works. The figures identified as the Dioskouroi are reminiscent of horsemen on the Parthenon frieze, and the disposition and character of Zeus, Athena and Nike align them with other works which have been thought to reflect the central group in the east pediment. Much more precise than these are allusions in the Athena and the Zeus to Pheidias's gold and ivory statues at Athens and Olympia. The clinching factor is the presence on the arm of Zeus's throne of little figures which correspond closely with Apollo and a Niobid in Roman marble reliefs, long recognised as copies from the representation of the slaughter of the Niobids set by Pheidias at a lower level on the throne of Zeus at Olympia.

The Talos Painter[133] takes his name from a volute-krater in Ruvo. Talos was a man of brass who guarded

Crete, running forever round its shores. The Argonauts, returning from Colchis, wanted to land on the island, and Medea told them how the creature could be destroyed by extracting a nail from his heel and letting the life-giving ichor flow out. We noticed an earler column-krater with the subject.[134] On that two heroes are holding Talos and a third (perhaps Jason) is performing the operation. On the volute-Krater an earlier moment is shown, Talos seized by the Dioskouroi (which perhaps identifies the two youths holding him on the column-krater). Polydeukes on the Ruvo vase has already leaped from his horse but Kastor is still mounted. On the right a Nymph runs away, and Poseidon and Amphitrite recline above. On the left Medea stands, in oriental dress, a box of simples in her hand. Behind her is the stern of the Argo, with more heroes and a ladder to shore; a scheme we have already noticed.[135] The brazen man is painted white. The figures are set on broken ground with plants and a tree behind Talos, but there is very little recession. On the back of the vase Jason is shown with Hera, the Dioskouroi with Athena.

Polydeukes and white Talos are virtually repeated on a calyx-krater fragment from Spina (fig. 260),[136] but here Kastor too is dismounted and the horses are not shown. A sceptred goddess stood on the right, and on the left was Medea, seated down near Talos's feet. She held her box and also a knife, perhaps to prise out the nail. Opposite her a tiny winged figure gestures: an Eros in type, and I once wondered if the witch had put a love-spell on the ogre; but the earlier column-krater proves that wrong. On that a similar winged manikin appears near the feet of Talos, but he is bearded and can only be Thanatos, Death; and so must the youthful figure on the Spina fragment. Beazley thought this by a different hand from the Ruvo vase, but it is certainly close. In any case one would guess that a wall-painting, differently adapted, lay behind both renderings.

A small fine krater-fragment in Würzburg,[137] not attributed by Beazley but surely very close to the Talos Painter, has a very rare subject: a hero issuing from the back of the Wooden Horse in Troy. Above is seen the corner of a temple, drawn in an attempt at recession. It is in white with dark details which include pediment-sculptures. Another unattributed calyx-krater fragment in Jena,[138] from the same circle but cruder, has a more serious attempt at perspective. Dionysos, seated in a posture reminiscent of the youths on Group R lekythoi, is flanked by Ariadne and Eros, both painted white. Behind them is a shrine: four white columns supporting an entablature with a pediment, and between these the painter has tried to render a receding view of a coffered

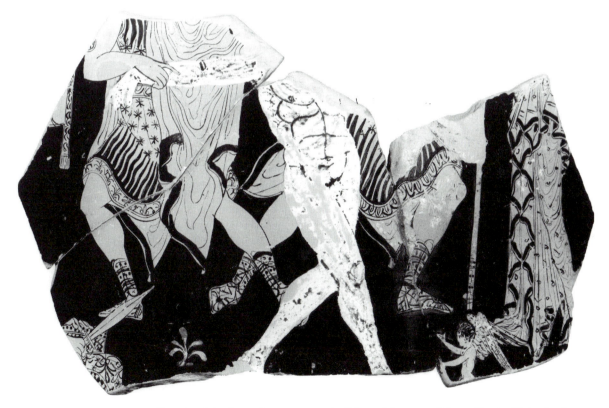

Fig. 260. Calyx-krater fragment; near the Talos and Pronomos Painters. Death of Talos. L. of fragment *c*. 0.25.

257

ceiling. The attempt is rudimentary, but shows that such ideas were in the air. It looks forward to more accomplished (though never systematic) drawings of such shrines on later vases from south Italy.

A fragmentary calyx-crater in Naples[139] from Ruvo has one of the most remarkable pictures of the Gigantomachy. This vase has been in the past associated with both the Pronomos Painter and the Talos Painter. Beazley inclined to a stronger connection with the first; but the two painters belong in any case to the same circle and movement. So does a weaker artist, the Suessula Painter,[140] and he painted another Gigantomachy which has much in common with that on the calyx-krater. A third is on a pelike in Athens,[141] near the Pronomos Painter, and a fourth on fragments of a volute-krater in Würzburg.[142] On this Beazley first accepted the opinion of von Salis, who studied these scenes, that its style somewhat resembled that of the Suessula Painter's vase but was superior. He later learned that these fragments came from the back of a vase in the same collection,[143] the front of which (Dionysos seated with the cast of a tragedy) he had spoken of as 'akin to the work of the Pronomos Painter'.[144] In fact all these, with the Semele Painter,[145] form a closely connected group.

The Suessula Painter's Gigantomachy is on a neck-amphora in the Louvre (fig. 261), long believed to have been found on Melos but in fact probably from Italy like his other five neck-amphorae (four found at Suessula, in the Province of Naples, one at Cumae). Von Salis,[146] noting the repetition of figures and groups, variously arranged, in these Gigantomachies, showed reason for thinking that the original source was a Gigantomachy on the interior of the shield of the chryselephantine statue of Athena in the Parthenon, which may have been painted by Pheidias himself. Others have doubted this conclusion, but von Salis's argument seems to me soundly based. The common features include more than the repetitions: a principle of composition. In earlier battles the opposing forces approach each other from left and right. Here, in a bold departure, the main thrust of the Olympians is from the upper part of the picture down towards us, and the Giants fight back at them from below, some with their backs to us. There are Giants' faces in *profil perdu*, and we have lucky confirmation that this idea was exercising painters in Pheidias's time in the maenad's head on the Achilles Painter's pointed amphora (fig. 206).[147]

To the Semele Painter[148] Beazley gives only two pieces, a hydria and a bell-krater. Of three more bell-kraters, which he places as 'connected both with the Semele and (less closely) with the Suessula Painter', one (a fragment)[149] was found in the grave of the Lacedemonians who died in Athens during the fighting

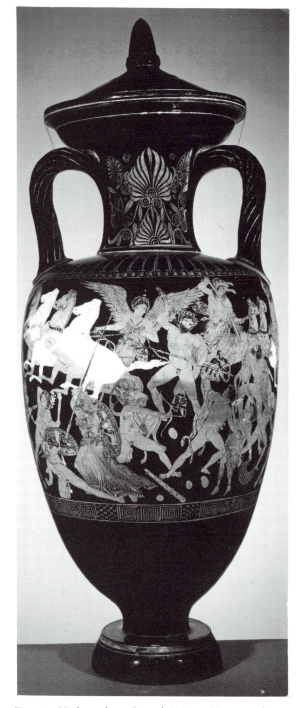

Fig. 261. Neck-amphora; Suessula Painter. Gigantomachy. H. *c.* 0.68.

in 403 which led to the restoration of the democracy. This is of great significance for chronology, and perhaps for more than that. It shows that the distinctive style of this circle of painters was established by that date; and, since the grave is that of a foreigner who, by the

circumstances of the case cannot have been in the city as much as a year, the vase must have been new, probably purchased for the funeral. This style, then, was current in the time of the Thirty Tyrants; and the iconography of some of the pieces is worth notice in this connection.

The fragment from the grave has a youth who closely resembles one of the Dioskouroi on a complete bell-krater in the same list with Leda and the egg.[150] We noticed examples of this Laconian subject earlier (perhaps from the years after the Peace of Nikias).[151] It is no surprise to find it again in the time when conquered Athens was governed by a pro-Spartan clique; and most probably it was represented on the vase from the grave. The role of the Dioskouroi on the Baksy krater points the same way, and perhaps the prominence given to them in the Talos pictures. The name-picture of the Semele Painter,[152] the birth of Dionysos from the dead Semele, is a Theban myth extremely rare in Attic art; and one may wonder if the Theban musician Pronomos would have been in Athens during the war. The appearance of an exceptional Attic red-figure vase at the Corinthian sanctuary of Perachora fits into the same picture.

The vases by and around the Pronomos and Talos Painters which we have looked at have all been exceptionally elaborated pieces, many of them outsize. These artists cannot always have painted like that; indeed the bell-kraters given to the Pronomos Painter are much more everyday pieces, with 'reverse-style' daubs on the backs. Similar pieces are ascribed to the Suessula Painter (whose elaborate work trails behind that of the Pronomos and Talos Painters); and there are a few other small groupings. All this, with a good deal that has never been attributed, belongs in a continuous tradition of everyday work that runs from the Dinos Painter and weaker figures like the Pothos and Nikias Painters through to the pot-painters of the early fourth century. Some of the earlier generation will no doubt still have been working in this time and some of the later already beginning. The overwrought elaboration of the big pots does not seem to form part of such a continuum. Its origins are clear, in the Dinos Painter and the Meidias Painter; but it is different in character even from their work, and nothing follows on it. It seems possible that it is a fashion which developed under the patronage of the Thirty Tyrants and their circle; and that a period of retrenchment and austerity followed the overthrow of the régime.

It is true that fragments of two elaborate and very fine volute-kraters by one hand, the Painter of the New York Centauromachy (fig. 262)[153] (the second, in Leningrad, has Herakles sacrificing to Chryse), are generally placed in the fourth century, but I see them as going closely with the works we have been considering. I find great affinity to the style of the Pronomos Painter himself, and a particular likeness to the bell-krater from Perachora (fig. 263), classed by Beazley as 'near the Pronomos Painter'. I have no difficulty in dating them as early as 403. It is worth reminding oneself sometimes that fifth and fourth century is not a distinction a Greek could have made. The development of Beazley's views on the two volute-krater fragments is of interest. In the American book (1918)[154] he quotes Hauser as putting the two pieces together with the famous maenad stamnos in Naples (which Beazley only later ascribed to the Dinos Painter).[155] In the German lists (1925)[156] he puts the painter at the end of the chapter which contains the Dinos and Kadmos Painters, and calls him follower of the art of the Dinos Painter and his maenad stamnos. In both these books the Meidians are treated in the following chapter. It is first in *ARV*[1] (1942)[157] and afterwards in *ARV*[2] that the Painter of the New York Centauromachy appears at the beginning of the first fourth-century chapter, before the Meleager Painter.

VII. Black-figured panathenaics; red-figured choes; other vases of festal or ritual use

Throughout the later fifth and earlier fourth century the production of black-figured prize-vases for the Panathenaic games continued on the old lines. The Athena becomes more and more elongated and conventional; the athlete-pictures continue to be drawn in the style of their time. No doubt the workshops which produced them were among those which produced large red-figured pots, but not very much work has been done on grouping them and associating them with red-figure painters. Still relatively early is Beazley's Robinson Group, already briefly mentioned.[158] The vases are few and undistinguished (there is little fine work on these vases in this period), but the history of their study has points of general interest. Three prize-vases in the Robinson Collection were attributed by the owner to one hand and associated with Aison.[159] Peters considered this too late, and thought of the Euaion Painter.[160] Beazley, unaware of Peters's work (both were publishing during the war; later he spoke highly of it) also dated the vases earlier than Robinson. He added two more pieces to the Group (a designation he preferred here to Painter), and remarked that these vases 'recall artists who stand on the outskirts of the Polygnotan Group or just outside it, for instance the Cassel Painter'[161] (who appears in the lists as follower of the Clio Painter). There is a question of general probability here. I find it most improbable that a painter with the red-figure range of the Euaion Painter (almost exclusively cups and skyphoi) or even of Aison (small pots and a cup; but it is true that two larger vases are

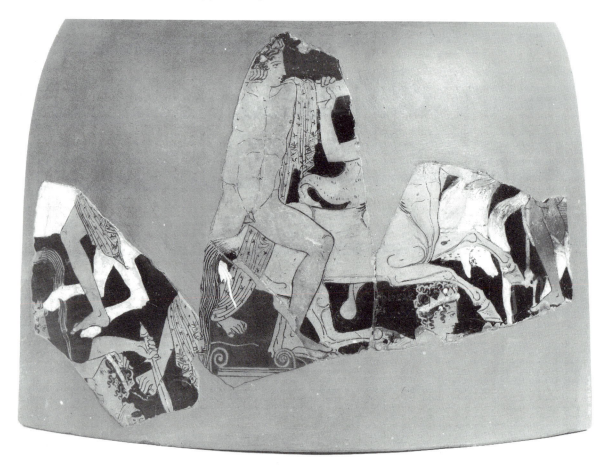

Fig. 262. Volute-krater fragment; Painter of the New York Centauromachy. Centauromachy. L. of combined fragments *c.* 0.30.

given him) would have had workshop affiliations that would have led him to decorate panathenaic prize-vases. The Cassel Painter works exclusively on large pots, and it is among such that one would normally look. This is not to lay down a rule; only to suggest that one would need very compelling stylistic evidence to make one of the other attributions plausible.

Fig. 263. Bell-krater fragment; near Pronomos Painter. (Atalanta). Youth. H. *c.* 0.05.

The shield-device on vases of the Robinson Group is Nike proffering a wreath. Beazley noted that two later vases[162] (device an olive-wreath), which he saw as connected with the Group, also look forward to the Kuban Group.[163] This is important, because the Kuban Group seems to provide us with a date. The shield-device on a vase in London[164] shows the statues of the Tyrannicides by Kritios and Nesiotes set up in 477 to replace those by Antenor which Xerxes had carried off (fig. 264). It has been convincingly argued that its appearance on a prize panathenaic of this period is most likely at the games of 402, the first celebrated after the expulsion of the Thirty Tyrants and the death of their leader Kritias the year before.[165] Two other vases with the same device, in Hildesheim, must be from the same year. They are separated from the Kuban Group by Beazley and assigned to a 'different and less competent hand'.[166] They were found at Ptolemais in Cyrenaica; the London vase at Teucheira in the same region. A second vase in London, found with it, is by the same hand but bears a different device, a star with a gorgoneion at the centre, and this is found also on a

third assigned to the same hand, in Leningrad,[167] from Kuban in South Russia. If the idea that the device marks the year is right, these should be from another festival, probably that immediately before or after (406 or 398). A smaller vase in London[168] (device, Nike carrying a victor's fillet) is placed in the Group by Beazley but not given to the same hand and said to be earlier. Beazley suggested that the Robinson Group belongs to the thirties, the vases with the olive-wreath device 'a little later, between 430 and 425'.[169] The anticipations of the Kuban style in these makes me think a later date for them more likely, and I see no difficulty in lowering the Robinson Group to the twenties.

The elaborately patterned and figured stuff of Athena's garment on the Kuban Group amphorae is

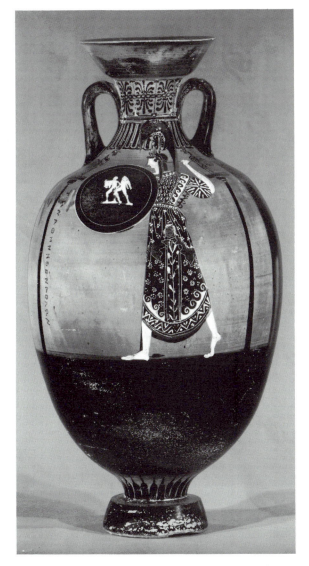

Fig. 264. Panathenaic prize-amphora; Kuban Group. Athena with Tyrannicide shield-device. H. *c.* 0.72.

exactly in the taste of the Pronomos and Talos vases, which we saw probably belong to the years immediately before. Very likely the prize-amphorae issued from one of those workshops, the Hildesheim pair perhaps from the Suessula or Semele Painter's, or some minor contemporary's, the Kekrops Painter for example, or the Nikias Painter.

The Tyrannicide group reappears on a red-figured vase which probably gives us another fixed date. Five fragmentary choes in Boston were found in the grave-precinct of Dexileos in the Kerameikos.[170] Dexileos himself, who fell in battle at Corinth in 394, was not buried in the precinct but with the other war-dead in a public grave. Members of his family were laid in the precinct evidently over a good many years; but the arguments for associating the choes with Dexileos himself are cogent. The conspicuous corner plot is laid out to display the fine relief, which shows the young knight in victorious action on horseback and bears an inscription in terms which suggest that he won special distinction. The interments recorded are of siblings and in-laws of his own generation who outlived him considerably, and it is clear that the first use of the plot was as Dexileos's cenotaph.[171] The five choes, though works of little quality, can be stylistically placed in the Meidian or sub-Meidian circle. One might have accepted an earlier date by a decade or so (vaguely Meidian fragments of still poorer quality were found in the grave of the Lacedaemonians of 403[172]), but not a substantially later one.

The subject of the Tyrannicides[173] is a suitable offering for a young warrior killed in action in these years. Dexileos died in his twentieth year, so was ten when the other tyrants were expelled. The other four vases have subjects suited to the Anthesteria, a feast of Dionysos at the turn of winter and spring (late February) in which choes had a special place, and to the participation in it of a youth like Dexileos. One shows a particular feature of the festival: a *komos* in which young men on horseback took part.[174] Here one rides with a torch, another runs behind playing the lyre, and a third dances ahead. There was also a chariot-race at the Anthesteria, and another of these choes[175] has a chariot at the starting post (or drawn up having passed the winning post), a youth running in front, another standing behind, a Nike flying above. Of the remaining two one has Dionysos between a maenad with a torch and a satyr,[176] the other a male pursuing a female between seated figures of either sex, apparently (though much is lost I think this is sure) not maenads and satyrs.[177]

The second day of the Anthesteria was given over to drinking and was named *choes*. On that day boys in their third year were admitted to take part or initiated. Drinking must have formed part of this *rite de passage*, and there is a large series of undersize choes from the

later fifth and earlier fourth centuries which are certainly connected with it.[178] They are decorated with pictures of children, sometimes playing with toys, sometimes aping their elders at their revels. Many of them are known to come from children's graves. Such a vase could have been given to a child on the occasion of his first Anthesteria and put in his grave as a treasured possession if he died in later childhood. Alternatively they may have been designed for the graves of children who died before they reached the year of initiation. The existence of a marble tombstone in the form of a chous, like those in the form of a loutrophoros for those who died unwed, suggests that the second hypothesis is at least sometimes correct.[179]

The pictures on these little pots are seldom careful, often slight or coarse, but many have great charm (figs. 265 and 266). The very few that Beazley lists he puts in his Meidian chapter,[180] and they are often and reasonably called 'sub-Meidian'. Several choes by the Shuvalov Painter and one by the Marlay Painter have pictures of boys which look forward to these.[181] We noticed that the Marlay Painter's and even the Shuvalov Painter's figures often have a childish look, and that this tendency is intensified in much Meidian and sub-Meidian work. These pictures of actual children come easily out of that tradition.

A set of five large choes may be mentioned here.[182] They stand quite apart, indeed outside the normal traditions of Attic vase-painting, rather as the Huge Lekythoi do, with which they must be roughly contemporary. Four were found in a well in the Agora. The fifth, of exactly the same character, had been for more than half a century in the British Museum. In make they are like the normally undecorated kitchen-ware, and the pictures are laid on the clay, presumably after firing, in colours (pink for skin) which have largely flaked or faded. Each has a few grotesque figures crudely drawn (on the London vase a man rows a huge blue fish as if it were a boat) and are thought to illustrate comedy.

Scenes from child-life of a special kind are found on two of three red-figured krateriskoi (small kraters)[183] painted in a hasty style analogous to that of the child-choes; but these seem earlier than the run of those, hardly later than the third quarter of the century. Their find-spot is not known, but they are very closely related to a long series of black-figured krateriskoi found in great quantities at the temple of Artemis at Brauron in eastern Attica, and a few at other Attic sanctuaries of Artemis linked to that: Mounychia (Piraeus), Halai and the Acropolis of Athens where Artemis Brauronia had a shrine.[184] At Brauron the goddess was served by little Athenian girls of good family between the ages of five

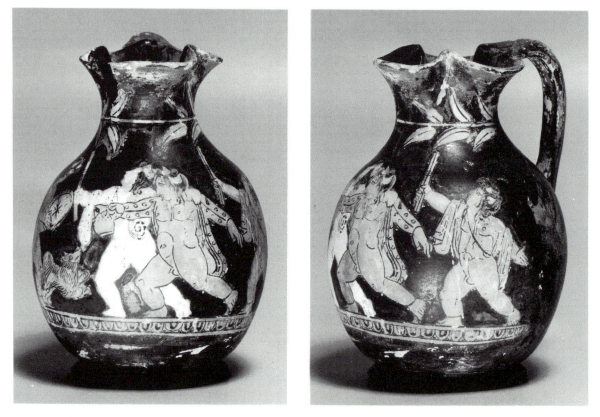

Figs. 265 and 266. Chous; not attributed. Revelling toddlers. H. *c.* 0.08.

and ten, known in this connection as *arktoi*, bears. The site has yielded statues of little girls, evidently *arktoi*, but these only begin well into the fourth century. The black-figured krateriskoi are mainly decorated with pictures of *arktoi*, either dancing in short chitons, or running races in short chitons, or naked. Sometimes the sacred site is indicated by a palm-tree or an altar with a flame. Sometimes a woman is present, presumably a priestess.[185]

Both fabric and style of these black-figured pieces is unlike standard Attic, and they may have been made at Brauron. 'Black-figure', indeed, is stretching a point for most of them: they are without incision, and the white of the girls' skin is laid directly on the clay, not over a black base. The series begins before the end of the sixth century, and the shape, with double handles and often a high foot, looks derived from still earlier models; but they were certainly still being produced in the second half of the fifth century when the red-figure pieces were made.

A fragment found at Brauron of a larger and more careful red-figured vase of the third quarter of the century[186] shows an altar and, tipped over beside it, a krateriskos adorned with running figures. The fact that the pictured vessel is reserved, the figures silhouetted on it in black, does not prove that a black-figured vase is meant. However, it does look exactly like the regular black-figure type; whereas the three red-figured krateriskoi we have all show peculiarities of shape or decoration.

The black-figured pieces have normally only clothed or only naked girls on one pot. On one of those in red-figure[187] they are all naked, but the shape is peculiar: a higher bowl with straight sides; and in front of one of the palm-trees which stand over the handles is a bear. Also, below the main picture and separated from it by palmettes, is a second: hounds chasing a hare. This ancient theme is rare at this time, except that on askoi (a shape we shall consider in a moment) a single hound on one side often chases a hare on the other. The second red-figured krateriskos[188] shows both naked and clothed girls running, and one naked, standing still, apparently receiving instruction from a woman (priestess). Other women are present, holding a box and a branch, and again there are palm-trees over the handles. The fragments of the third[189] show no children. On one side the goddess herself appears, in company with her brother and mother. Over the handles are fawns, and Artemis is drawing her bow on one of them. On the other side are a woman and a man in bear-masks.

In these tantalising glimpses we seem to have to do with a *rite de passage* for girls analogous to that suggested by the choes for boys.

The askos has been strongly argued to have served a

ritual purpose at funerals; but the evidence for this has been no less forcibly challenged.[190] Askoi are most often found in graves, but appear also as dedications in sanctuaries, as well as on dwelling sites. The commonest type has already been described.[191] The great majority of this basic type have two balancing pictures, most often a single figure on each side. The shape came into use in the late archaic period (we noticed beautiful examples by Makron, two with Erotes flying, one with reclining maenads), but is far commonest in the second half of the fifth and fourth centuries. Another early one is the only known example with a single picture passing under the handle: a tomb-mound occupying one field, and rising from it in the other a warrior's ghost.[192] There is a large range of representation in the paired designs: Nikai as well as Erotes, satyrs as well as maenads, human beings in various actions; but by far the commonest theme is pairs of animals, either confronting each other across the spout (or occasionally the other way), or one pursuing the other. One of the earlier, in Oxford,[193] with a hound pursuing a hare, is surely the Pan Painter's; but later, though there is decent work, the general level is low, and in the late fifth century and the fourth they are daubed bulk-production. These were certainly produced by the same craftsmen who over the same period put out quantities of small squat lekythoi with similar decoration.

A technical peculiarity: broken askoi often show a wash or streaks of black or red on the interior. These could not have got there after the vase was complete, and show that the top and bottom halves were thrown separately and then joined.[194]

We may end this chapter with a more interesting group. In the American excavations on the north slope of the Acropolis were found, in a fill of mixed material apparently washed down the slope, fragments of at least sixteen red-figured oinochoai, evidently a set.[195] Of two which can be restored to give their full height, one measures just over 31 cm, the other just over 26 cm;[196] and probably none of them was far outside those limits. Elements in the potting and in the elaborate florals connect them with the Shuvalov Painter's workshop,[197] but at a very late stage indeed. The ornaments include a foreshortened and shaded bell-flower, a type which seems to be created only towards the end of the century. Green thought that all, except one fragment, might be by one hand.[198] Beazley placed them 'not very far from the Jena Painter',[199] who worked mainly in the early fourth century but must have begun, as we shall see, in the fifth.[200]

The basic form of the jug is that of 'oinochoe Shape 1', but instead of the usual trefoil mouth these have a wide heavy round mouth of a kind more usually found on neck-amphora or hydria. There is great variety in the treatment of this mouth. Of the five preserved, one is a

simple convex curve;[201] two more the same with a narrow everted lip, a berried laurel-wreath on one for ornament;[202] the other two have complex mouldings, one with ovolo on the everted lip, as is common on hydriai.[203] On the front of the shoulder, wherever it is preserved, is a pair of plastic *mastoi* (nipples), sometimes reserved, sometimes painted white.

Each of these vases in which the relevant part is preserved has a floral under the handle and a chariot on the front of the body; but again there is great variety in the treatment, and the necks differ even more markedly. Some are black with, below the mid-point, a wreath in added clay, the leaves sometimes filled in with white; some have red-figure palmette or palmette and lotus designs; two have figures of Athena. These, in red-figure, are the striding Athena Promachos of the black-figured panathenaics, and like them drawn archaically. One of them faces, like the Panathenaic goddesses, to the left, showing a shield with a rosette for device and a patterned rim, and her drapery too, like theirs, is patterned. The other (fig. 267) faces to the right, showing the inside of her shield, and her drapery is drawn in folds, some of which hang in anticipation of the 'swallow-tail' motif which is the hallmark of the Hellenistic and Roman archaising style. We shall meet it again when, in the mid-fourth century, the Athena on the black-figure prize-vases too is turned that way.[204]

There is some evidence for cautious archaism in late fifth-century sculpture, in the Caryatids of the Erechtheum and perhaps in the work of Alkamenes; but this is the most unambiguous surviving example. It is surely another case of the nostalgia evidenced in the copying we have several times noticed of high classical and early classical models.[205]

The chariots on the body are drawn in contemporary idiom. Some are in profile, some three-quartered, some facing right, some left. Some are still, the charioteer mounting, some already in motion. The charioteer is

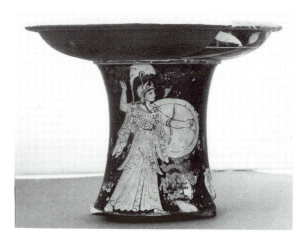

Fig. 267. Oinochoe-neck; perhaps related to the Jena Painter. Athena. H. *c.* 0.10.

always, where it can be defined, female, and Hermes is sometimes shown at the horses' heads, so she is surely Athena. In one case the hair and flying cloak of Hermes are rendered archaistically; and it does not appear that this body-fragment can belong to either of the necks with Athena, both apparently from smaller vases. Mostly wheels and horse-hooves are on the base-line, but once they have taken off over the sea (dolphins and a pebbled shore).

That these vessels were for some ritual or festal use cannot be doubted. The archaisms in the drawing and still more the throw-back in the nipples on the vases (something not infrequently found on Geometric pots, but at this period most surprising) are hardly explicable otherwise. The Promachoi of course make one think of the Panathenaia; a festival of Athena Hippia (Athena of Horses) has been suggested as an alternative; we do not know. This is one of those fascinating finds the chief effect of which is perhaps to remind us of the breadth of our ignorance.

9

The fourth century

I. Introductory

a. The historical background

We can only (and need only) here give the simplest outline of the complicated history of the Greek states during this period. After the defeat of Athens in 404 the Spartans more or less dominated the empire they had fought to free and rapidly became at least as unpopular as Athens had been. Agesilaos of Sparta campaigned against the Persians in Asia Minor and planned a united Greek assault on the Persian empire such as was carried out sixty years later by Alexander, but unrest in Greece brought him home. The battle at Corinth in 394 where Dexileos fell[1] was part of a war in which Athens joined with her old enemy Thebes to challenge Spartan dominion. Athens was reviving: the rebuilding of the long walls, begun the year before the battle at Corinth, was completed the year after. Both sides played with Persia, and in 386 the cities of old Greece accepted a peace arbitrated by the king of Persia in a treaty which allowed him to keep possession of the Greek cities in Asia Minor and Cyprus.

In Greece the cities were soon fighting again. During the seventies a leader came into power in Thebes, Epaminondas, who made her for the first time a major contender for overall dominion. He decisively defeated the Spartans at Leuctra in Boeotia in 371, and during the sixties several times invaded the Peloponnese and fomented disaffection with Sparta there. Athens meanwhile was regaining some of her old importance. In 378/7 she had entered into a confederacy with many of her old imperial vassals but on a more equal footing. This worked with some success to contain and reduce Sparta's power. Athens, however, was also jealous of rising Thebes, and just before Leuctra had concluded peace with Sparta. In 362 an Athenian contingent was fighting alongside the Spartans in the Peloponnese when Epaminondas defeated them in a battle at Mantinea[2] in which he himself was killed. After his death Thebes rapidly lost her dominant position.

The bickering coexistence of the independent city-states of Greece continued for another twenty or thirty years; but during that time a new power was gradually exerting more and more influence over their affairs, and at the end of it subdued them, and after them the Persian empire, establishing a new world order in which they had little independence or political importance. The large kingdom of Macedon in the north had from the first developed politically and culturally in quite a different way from the city-states. How far the Macedonians could claim to be 'Greek' was a matter of dispute in antiquity and is so still. However, at least from the time of Archelaos who, in the late fifth century, built a new capital at Pella where he invited Greek poets and artists,[3] the Macedonian court adopted Greek culture for its own. Three years after the battle of Mantinea a royal Macedonian who had been a hostage in Epaminondas's Thebes assumed power in Macedon, first as regent, then as King Philip II. He systematically exploited the gold-mines and manpower of his country to make it the most powerful in the Aegean area.

The politics and policies of Athens, as of most Greek cities in the middle decades of the century, were determined largely by the struggles of a pro-Macedonian and an anti-Macedonian party, the latter led by Demosthenes, much of whose oratory against Philip survives. Sometimes this persuaded his fellow-citizens and those of other states, sometimes not; but Philip was a master of diversion and division (to which the Greeks were addicted by nature), and resistance was never united or sustained enough. Key moments in Macedon's take-over were the sack of Olynthos, federal capital of the Chalcidic League, in 348,[4] and the destruction ten years later of the combined armies of Thebes and Athens at Chaeronea. An invasion of the Peloponnese followed, and though Sparta remained undefeated she was reduced in effect to a cipher.

Philip called a meeting of all Greek cities (only Sparta refused) at Corinth, and they accepted the status of members of a confederacy headed by Macedon. At a second meeting the following year (337), Philip declared

his intention of invading Asia Minor to free the Greek cities from Persia. He was elected general, and the contributions in money and kind of each city were laid down; but the following year Philip was assassinated. Any idea that this was a chance for Greek cities to throw off the yoke of Macedon was rapidly dissipated by his son Alexander, who descended on Greece, destroyed Thebes by way of example, and at Corinth had himself elected general. Athens was spared, allowed to retain her constitution, and not given a Macedonian garrison. It was only in 322, when news came that Alexander, after conquering the east, had died at Babylon, that another insurrection led to the reversal of this policy. A garrison was established, the constitution modified, and in 317 a puppet dictator, Demetrios of Phaleron installed. By this time at latest red-figure had ceased to be produced in Athens, and the city's Hellenistic history does not concern us.

b. Developments in painting on wall and panel; vase-painters' reactions to these

After the first innovations of Polygnotos and Mikon the ideas of organising the representation of spatial setting and of modelling forms by shading were forwarded by Agatharchos, Apollodoros and Zeuxis. Their fourth-century successors pushed further down the same roads, with the result that, at least by the time of Alexander, painting in Greece had entirely left behind its origins in Egypt and the east and become recognisably 'European painting' as that was understood from the Renaissance until quite recent times: not simply decoration of a surface but an illusion of a window on the three-dimensional world. That this stage had been reached by the later fourth century had long been pretty clear, from the literary tradition taken with echoes on the one hand in later Roman house-decoration, and on the other in contemporary vase-painting. The truth of this conclusion is now demonstrated in actual Greek wall-paintings unearthed in Macedonian royal and noble tombs.[5] The acknowledged masters of this art were Apelles and Protogenes, who worked in the time of Alexander and his successors, from the fourth into the third century. Most of the illusionistic advances had certainly been mastered, however, a generation or two before, by such painters as Nikomachos and Aristides of Thebes and Philoxenos of Eretria. The earliest of the Macedonian tomb-paintings are contemporary with these, in the third quarter of the century, that is at the end of the time with which we are now engaged. For the stages between Zeuxis and Nikomachos we are still dependent on deduction from literary references in the light of echoes in the minor arts. Such echoes are frequent in the vase-painting of South Italy, almost totally absent from that of Athens. We are concerned

only with the latter; but the very fact of Attic vase-painters' rejection of this development is significant. We may also find points of contact with major painters of the day, even though vase-decorators abjure the new direction those are giving their art.

We saw that on the 'Huge Lekythoi' modelling with shading is shown on man's skin and some inanimate objects, but not on woman's and not accompanied by highlighting (nor are there cast shadows).[6] Highlights do appear already on some South Italian vases of this period, but only on objects of burnished metal where they draw attention to themselves.[7] Words of Pliny about Nikias, a famous Athenian painter who can hardly have been active much before the mid-century, suggest that he initiated shading on women's skin. General use of shading and highlights, and cast shadows too, are found in the Macedonian tomb-paintings, one of which is identified as that of Philip II and so dated to 336.

A significant figure between the generation of Zeuxis and that of Nikias was evidently Euphranor, who was also a sculptor. He is given a date in the 104th Olympiad, probably because the battle of Mantinea was in 362[8] and he painted a famous picture of it in Athens. What is said about him does not help us to determine his position in the movement towards illusionism, and we can make no contact through vase-painting with his colouring for which he was particularly praised; but we shall find that there are possible points of contact.[9]

One more painter needs a mention here, Pausias of Sicyon, a city which in this period became famous for its school of painting. We hear of Pausias as an architectural decorator (ceiling-coffers and vaults), and most often as an innovative flower-painter. Accounts of his work, with its complex garlands of mixed flowers, make it clear that it was closely related to a new style of floral decoration which appears in a great many fields of Greek art in the middle and later fourth century. A particularly attractive form is found on South Italian vases and on pebble mosaic floors, identical in artistic character in spite of the very different techniques. The most sophisticated and finest floors are from late in the century at Pella, the Macedonian capital, but they occur also in old Greece and there are beautiful examples from Sicyon from before the mid-century. There is a good deal of evidence for close cultural contact between the court of Macedon and the city of Taras (Taranto), where the best of the South Italian vases in this style were produced. Sicyon at this time was ruled by a tyrant Aristratos who is pilloried by Demosthenes as a lackey first of Philip, then of Alexander.[10]

The significance for our study lies in the fact that this floral style is wholly absent from Attic vase-painting. We noticed foreshortened and shaded bell-flowers

introduced into the florals on some Attic vases of the end of the fifth century.[11] At the same period acanthus-leaves are sometimes introduced.[12] Both these features are regular elements in the developed 'Pausian' style, but Attic vase-painting gets no nearer that. This is a further example of the way Athenian vase-painters of the fourth century turn their backs on the movement of major painters (Athenian artists among them) towards illusionism. The character of late archaic red-figure seemed to be given by the way painters kept up with change in free painting while never sacrificing the traditional sense of what was appropriate in the decoration of a vase. This balance was maintained with growing difficulty through the early and high classical phases, and the attempt is now abandoned. In Attica, that is; the red-figure painters of South Italy, without the weight of tradition at their back, take a more liberal view of what pot-decorators may allow themselves. This makes Attic vase-painting of this time often less interesting than South Italian. The best of the Attic craftsmen maintain the great tradition of linear drawing in a purer form than is often found elsewhere, and adapt it interestingly to new ideals of the human figure and new ideas in composition. This is, however, a tradition which serves less and less well the mood of the time, and it is not surprising that the Kerameikos ceased to produce figured pottery some time before it comes to an end in South Italy and Sicily.

In this connection it is interesting also that fourth-century Attic vase-painters are more traditional in the techniques they employ than their contemporaries beyond the Ionian Sea. In many of the Italian fabrics much use is made of a new technique (with a future beyond red-figure) known as Gnathia, after a site in Apulia where examples were first noticed.[13] Here, as in 'Six's technique' in late archaic Attic, the vase is blacked and the figurework and ornament applied on top in a number of colours with sometimes some incision. In this, or in a mixture of this and red-figure, some of the most effective and interesting adaptations of painterly illusionism are found, including 'Pausian' florals. It is all but unknown in Attic; though later, after the demise of red-figure, a version of it is adapted to a quite different, largely geometric style of decoration on the early Hellenistic West Slope Ware.[14]

Attic vase-painters had abandoned white-ground about the end of the fifth century. It had always been kept a sideline, presumably because it lacked the strong decorative basis that silhouette gave to black-figure and red-figure, and so stood closer to free-painting. Now that Attic vase-painting was moving away from free-painting there was no longer a place in it for white-ground. Figurework is now exclusively in red-figure or black-figure; and the relation of the two undergoes a change.

In the time of the Pioneers and their successors a century before, with the revolution that was breaking the archaic mould and bringing about the classical style, red-figure we saw offered far better opportunities than black-figure for the kind of experiments that were then exercising all artists, vase-painters among them. In the conditions we are now considering that superiority no longer holds. Black-figure is as good a medium as red-figure for the effects the craftsmen are aiming for now; and in fact some of the best fourth-century Attic vase-painting is on black-figure prize-vases for the Panathenaic games.

c. Distribution and dating

From early in the sixth century the great sites of Etruria dominate the list of find-spots for Attic vases, but now that changes. The change indeed begins before the end of the fifth century: very few pieces ascribed to the Meidias Painter and his circle or to the Pronomos Painter and those around him come from Etruria proper. In the fourth century very little Attic is found there. It almost ceases to appear in Sicily also, where it had been very popular, and in the sites of southern-most Italy. Two areas of the peninsula continue to yield a certain amount: the Greek and native cities of Campania (Cumae, Naples, Nola, Capua and others), with some of northern Apulia, notably Ruvo; and the Greek-Etruscan sites of the Po delta, Adria, Bologna and especially Spina.

Further west, more than before is found on a number of Spanish sites, and at the Gallic stronghold of Ensérune in southern France. More than before, too, comes from Cyrenaica in North Africa; also from the trading-post at Al Mina near Antioch in Syria and from the Phoenician sanctuary at Kition on Cyprus. Much comes from Athens itself and Attica, and a good deal from other areas of old Greece, especially Boeotia, and from Rhodes and other of the Dodecanesian islands; but the most interesting change is the wealth of material from south Russia. The Athenians had long had contact with this area, from which they imported grain; and vases, black-figure and red-figure, from late archaic on, are found there. The import, however, increases in the late fifth century, and in the fourth a high proportion of the best red-figure is found there. The principal area is Kerch in the Crimea. This is the site of a Greek city, Pantikapaion, but much of the best material is from Scythian tumuli in the neighbourhood. Such is the huge krater we noticed from the circle of the Pronomos Painter found in a tumulus at Baksy, and there is much more later material. Indeed the fine style of full fourth-century Attic red-figure used to be known as 'Kerch', but the boundaries of the term were always ill-defined and I think it serves no useful purpose.

The reasons for these changes are not easy to pin-point. The Etruscans, who had produced some red-figure during the fifth century, put out much more in the fourth. The early phase of an important production at Falerii is so like Attic of the turn of the fifth and fourth centuries that it has been reasonably conjectured that some ceramists may have emigrated there from Athens in the aftermath of the war.[15] Whether increased local production is a cause or a consequence of a falling off in trade, or both are rather symptoms of a larger change is hard to say. The fine Attic pottery from princely tombs in South Russia reflects an increasing interest in Greek culture which is marked in other ways too in this and the following centuries. The growth of imports by Phoenicians and in Spain and Gaul may be a related phenomenon.

Migration of potters is interestingly documented in a case we shall consider in the final section.[16] There is another likely case at the beginning of this phase. Two squat lekythoi found in Kerch and now in Leningrad bear a conspicuous inscription naming a *poietes* Xenophantos who describes himself as *athenaios*, 'of Athens'.[17] The decoration of the smaller is entirely in relief, that of the larger in great part also, but on this some minor figures are in red-figure. Beazley lists it at the beginning of his fourth-century section, 'because of a resemblance to the earlier works of the Meleager Painter',[18] whose beginnings must lie around the turn of the century. Relief-decoration is occasionally combined with red-figure earlier, for instance on a late sixth-century cup from the Acropolis where men and horses are applied in relief, elaborate handle-florals and some details of the figures drawn in red-figure, probably by the Euergides Painter.[19] A series of askoi, on a different design from those we have looked at, has a spout moulded as a lion's head, the animal's body supplied in red-figure. These begin about 400 and continue through the middle of the fourth century;[20] and we shall meet a large vase of that late period in which elaborate figure-work is so divided.[21] Decoration of vases entirely in relief becomes quite common in the fourth century and regular in the Hellenistic age. What primarily concerns us on the Xenophantos vases, however, is the inscription.

We noticed in the generation before that the Nikias Painter's name-vase bore the inscription *Nikias Hermokleous Anaphlystios epoiesen*, 'Nikias son of Hermokles of the deme Anaphlystos made'.[22] Name with father's name and deme is the correct description for an Athenian citizen in Athens; when abroad he drops the deme and calls himself Athenian. On his cenotaph in the Kerameikos, Dexileos is described as son of Lysanias, of Thorikos;[23] but when Aeschylus, dying in Sicily, wrote his own epitaph he called himself son of Euphorion, of Athens, not of Eleusis.

Xenophantos does not put his father's name, possibly because of the convention we have thought to observe that a craftsman names his father only when the father had also been a craftsman. That he names his city not his deme strongly suggests that he was not working in Athens. In the later sixth century some vases found and almost certainly made in Boeotia bear the name of a *poietes* Teisias, who describes himself as *athenaios*.[24] He was surely an immigrant; and I feel it very nearly sure that the vases with Xenophantos's name were made in Pantikapaion by an immigrant Athenian *poietes*.

One of the sites in Greece itself which has yielded much fourth-century Attic red-figure is Olynthos. It was sacked by Philip in 348[25] and thereafter deserted, so it is important for dating. The finds include examples of the most debased bulk production, including one skyphos-fragment of the very large F.B. Group and other pieces in its periphery. This shows that the Group was already in production about the middle of the century. The very small numbers might suggest that it was near its start then, but we shall see that we cannot be sure that this is a safe deduction. There is nothing from the latest fine wares, such as the L.C. Group. This could be because there is very little fine red-figure from the site; but other evidence suggests that the L.C. Group was not yet in production. There are a good many pieces from Group G, a very large late group of pelikai and kraters with repetitive designs of little quality, but that must have continued in production over a long period.[26]

Alexandria in Egypt, founded in 331, seventeen years after the sack of Olynthos, has produced very little. This might be partly due to the lack of systematic excavation (the ancient city lies under the modern), but such Attic red-figure pieces as are reported from there look very late indeed.[27]

The most important source for absolute dating of Attic vases in this time is of a different kind. Over most of the fourth century it was the practice to put on the prize-vases for the Panathenaic games the name of the archon for the year. The number of surviving vases so documented is limited, and the relation of black-figure to red-figure style is not always easy to establish; but it is a real line, and we shall revert to it constantly in later sections of this chapter.

II. Cup-painting: the Jena Painter and others; the decline

The red-figure cup is not a major feature of production in the fourth-century Kerameikos. I begin with it because it stands a little apart and presents a relatively simple development. This covers a great range of quality from the very fine to the lowest hackwork. The fine work is all early, which is not the situation in pot-painting; and it is not possible to establish whether the

miserable late cups continue in production in the latest phase of red-figure in Athens.

Our knowledge of the work of the Jena Painter[28] is of an unusual kind, and reminds one of how chance finds can affect our perception of pottery production in Athens. Of over eighty numbers listed by Beazley the vast majority are fragments of cups and stemlesses (and one plate) now in the University of Jena. This is what remains of a larger find made in Athens (Hermes Street) in 1853, evidently from a potter's shop. The other works attributed to the painter are a fine pelike of unknown provenance, a hydria found in Rhodes, a cup-fragment from the Pnyx in Athens and ten more cups. One of these comes from the Crimea, one from Spina, two (unusually for this period) from Vulci, four from Ensérune and two from Spain.

The painter's style is thin-lined and delicate. This is almost invariable in his cup-interiors. The same style is occasionally found also on the exteriors, but the great majority of those are daubed in various versions of a mechanical 'reverse-style' in thick, coarse lines with no pretensions to art. This is found also in the reverse youths of the pelike (where the front is in the artist's finest delicate style), as well as on the interiors of a few slight cups and stemlesses. The variations in this coarse style suggest a number of assistants, but it may well be that some of it is the painter's own work.

The front of the pelike (in Exeter)[29] shows Orestes and Electra at Agamemnon's tomb. The artist has named Electra, and also a second girl; but by a fascinating slip he has written the name not of Chrysothemis but of another strong woman's gentle sister, Ismene. He must have been familiar with Sophocles's *Electra* and his *Antigone*.

The cup-tondos usually have (or originally had) two figures, the exteriors three on each side. A particularly pretty tondo-fragment (fig. 268) with Aphrodite seated, Eros on her lap playing the harp,[30] had probably another figure standing by. Few of the stemlesses are of comparable quality. Some are of a heavy variety with offset lip which approximates to the cup-skyphos. These have only impressed decoration on the black inside, two figures on either side of the exterior. Others are thin-walled, lipless or lipped on the interior only. Many of these, very slight, have no decoration on the outside; others have the same distinction of style between interior and exterior as the cups.

A very pretty stemless without lip in Oxford is the name-piece of a 'Diomed Painter',[31] to whom Beazley assigned only one other stemless and a squat lekythos. The interior has Diomedes running with the palladion. An equally charming piece (fig. 269), once in Castle Ashby, has Eros crouching with a trap.[32] Beazley does not list this, but it is surely by the same hand. He later thought that the Diomed Painter might be the same

as the Jena Painter,[33] and this seems to me highly probable.

The principal cup-workshop in the outgoing fifth century seems to have been the sub-Meidian. Of two cups (one from Spina) Beazley remarks that they are 'related to the Jena Painter, although the floral decoration is not that of the Jena Workshop but sub-Meidian'.[34] One might conjecture that the Jena workshop took over from the sub-Meidian, and see these two

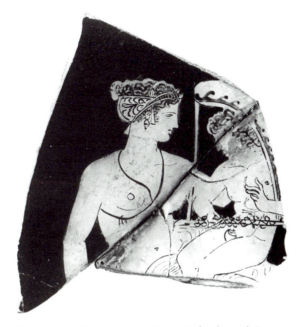

Fig. 268. Cup-fragment; Jena Painter. Aphrodite with Eros on her lap playing harp. Gr. d. *c.* 0.10.

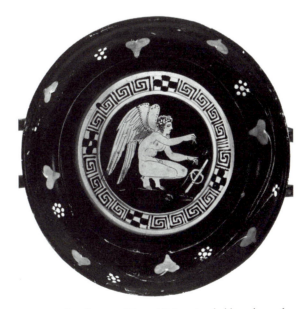

Fig. 269. Stemless cup; Diomed Painter (probably a phase of the Jena Painter). Eros setting trap. D. *c.* 0.15.

cups as forming a link; but I do not think so. The Jena Painter's style is much closer to that of the Pronomos Painter and his circle, in particular the Painter of the New York Centauromachy, with whom a few cups and stemlesses are associated.[35] Especially close to the Centauromachy Painter's style is one of the Jena fragments (fig. 270), a tondo with Achilles in combat, which Beazley detaches from the Jena Painter's work and places in his manner.[36] It is in no way inferior but the drawing is rather stronger, less delicate. It much resembles the 'Diomed Painter' group. A cup in Boston,[37] which Beazley describes as akin to the Diomed Painter's stemlesses and near the Jena Painter, has in the tondo a female figure named Sparte: the Nymph of Sparta. The year 404/3 would be a likely time for such a representation. I could believe that the Achilles fragment, the 'Diomed Painter' stemlesses and the Sparte cup are all early work of the Jena Painter when his style was being formed in the workshop of the Pronomos Painter, alongside the Painter of the New York Centauromachy. Indeed I do not think it is beyond possibility that the Painter of the New York Centauromachy is himself an aspect of the young Jena Painter. The Acropolis oinochoai, too, whatever their precise relation to the Jena Painter and to the workshop of the Shuvalov Painter, must belong to this phase.[38]

I imagine that the sub-Meidian cup-workshop continued into the early fourth century, overlapping the Jena workshop by some years; and that the two cups which combine figurework related to the Jena Painter with sub-Meidian florals are evidence of interaction between the two.

The Jena fragments are evidently from a workshop. We cannot be certain of the nature of the deposit: stock in hand at the moment of a disaster; or a dump where broken vessels were thrown over a period. The absence of spoiled or trial pieces, however, strongly suggests the first. If that is right, and if the hypothesis is accepted that the cup with Achilles is early work, then it will have been on the shelves for a while. How long we cannot say; but whatever the accident which the deposit witnesses it was not the end of the workshop. The painter's style was already mature, but there is reason, as we shall see in a moment, for thinking that the workshop at least, if not the painter, continued for some time after this.

Many of the Jena Painter's pictures are mythological, often with a slant (which becomes more marked in the work of others as the century progresses) towards the mystical side of religion, especially in relation to Aphrodite, Dionysos and the Eleusinians.[39] One of the cup-tondos has a goddess rising, a satyr swinging a hammer with which he has broken the ground for her;[40] an old theme we have noticed before but especially popular now. She is probably Aphrodite, whom we have seen already with the harping Eros on her lap. For the Eleusinians this painter gives only the old theme of Triptolemos;[41] but some of his Dionysiac tondos are unusual, in particular a lost piece from the Athens find in which Herakles carries Dionysos on his back.[42]

A closely similar design on a cup in the Cabinet des Médailles has Plouton in place of Dionysos, a subject which is found elsewhere in this period.[43] Beazley was inclined to attribute this not to the Jena Painter but to a craftsman to whom he gave the conventional name of Q Painter.[44] The fifty-odd pieces ascribed to this painter represent a continuation of the Jena Painter's style in a weaker and less interesting form. I think it not impossible that they are the last phase of the Jena Painter himself. In any case they are later products of the same workshop; and it is interesting that this phase is not represented in the Athens find, showing that the accident does not mark the workshop's end. The pattern of find-spots is otherwise much as before, with rather more from Crimea and from Spina. About half of the attributions are stemlesses of the heavy kind; the rest cups, a few thin-walled stemlesses, and one skyphos.

One of the better drawn is also the most interesting in subject. The interior of a thin-walled stemless from Corinth[45] shows a unique scene (fig. 271). Dionysos sits on a chair, holding a thyrsos, watching a young woman dance. She is not a maenad, at least has none of the normal equipment of a maenad, and she dances bare-breasted, naked but for a pair of satyr-play drawers equipped with a tail and an erect phallos. One wonders if the hetairai of Corinth had a Dionysiac cult peculiar to themselves.

The Jena Workshop was certainly the principal cup-workshop of the early fourth century. Parallel to it, and close but greatly inferior, run cups and stemlesses from the hand and circle of the Meleager Painter, whom we shall treat in the next section as he is principally a painter of pots.[46] In this connection we should note a

Fig. 270. Cup-fragment; probably Jena Painter. Achilles in combat. Gr. D. *c.* 0.10.

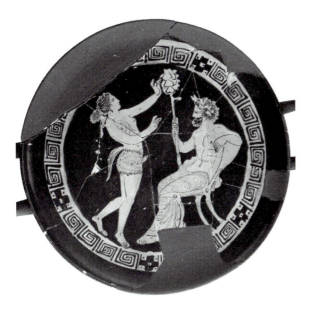

Fig. 271. Cup; Q Painter. Dionysos and dancing-girl. D. *c.* 0.15.

dozen stemlesses of the heavy kind without internal picture put together in 1960 by Peredolskaya as by 'the Painter of the Kerch fragments found on Mt Mithridates', and accepted by Beazley in *Paralipomena* (Mithridates Painter).[47] They are inferior work of the same order as the Meleager Painter's. Almost all come from Crimea, and one is tempted to think of an immigrant craftsman; but one, in Oxford, is from Al Mina. Beazley, publishing it in 1939,[48] had been unable to point to other works by the same hand. This is another reminder of how patchy and easily altered our picture of the field is.

It is noteworthy that nothing in Beazley's chapters dealing with the Meleager Painter and his circle and with the Jena Workshop was found at Olynthos. This can have nothing to do with date, and warns us not to attach too definite a significance to the absence of later material from the site.[49]

There are no later cup-painters of any quality, and the dating of the decline is impossible to establish with precision. The Jena and Meleager workshops evidently began in the last years of the fifth century, and I suppose the latest work we have glanced at, the 'Q Painter' phase of the former, is unlikely to run far into the second quarter of the fourth. The last cups and stemlesses seem to follow on from it. Beazley groups most of these in a loose 'YZ Group'[50] (a fancy name like 'Q Painter'). Early in this group comes a Painter of Vienna 202 whose name-piece, Apollo riding a griffin in the tondo, and a pair to that with Artemis on a fawn, are in a relatively tolerable style of drawing evidently derived from the Q Painter.[51] Beazley's last list of stemlesses, the Group of

Vienna 116, he describes as 'related to the F.B. Group and the YZ Group'. He also remarks that some of the skyphoi and oinochoai of the F.B. Group 'must be by the same hands as some of the cups'. The F.B. Group[52] (for Fat Boy) consists of some two hundred oinochoai, more than fifty skyphoi and a few other shapes, daubed for the most part with figures of youths, some marked as athletes by a strigil or the like. With the cups of the YZ Group these pieces mark the nadir of Attic red-figure. One skyphos of the F.B. Group and one stemless of the Group of Vienna 116 were found at Olynthos, so these hacks were already at work by 348. We have seen that the very small numbers imported do not give safe grounds for supposing that they had not then been long in production; and the link back in the cups to the Jena Workshop suggests that this phase began some time before the mid-century. We shall meet evidence that large, often fine red-figure pots continued in production at least till around 330 and probably longer; but it is possible that the demand for bulk-produced small pots and cups ceased before that.

III. Pot-painting

a. *Everyday work; bulk production*

The Jena Painter is the best artist working in the Kerameikos in the early years of the fourth century. Among the pot-painters the one most closely connected with him is the Meleager Painter, but the nature of the connection needs definition. Both evidently owe much to the group of artists around the Pronomos and Talos Painters who produced peculiarly elaborate fine work on a large scale, perhaps for a limited clientèle in the time of the Thirty Tyrants. The Jena Painter was surely trained among these. Working mainly on cups, he sustains the quality of their drawing in the following period. The Meleager Painter's work makes the effect, rather, of imitation by a poorly trained hack. In general the products of this time show little evidence of a demand for fine work; not surprisingly perhaps in a post-war atmosphere of defeat and seeming ruin. There are better draughtsmen than the Meleager Painter, who work in a simpler tradition, Beazley's Plainer Group. We shall glance at them in a moment, but their claims are modest. One is a little reminded of the situation of black-figure in the early sixth century. We know much less about the historical and social background then; but the periods have in common at least that they were times of changing markets.

The Meleager Painter[53] (Atalanta and Meleager are shown on several of his vases) is a sloppy draughtsman with an unusually weak grasp of the proportions of the human figure. We have noticed his cups and stemlesses (fig. 272) as running parallel to those of the Jena Painter

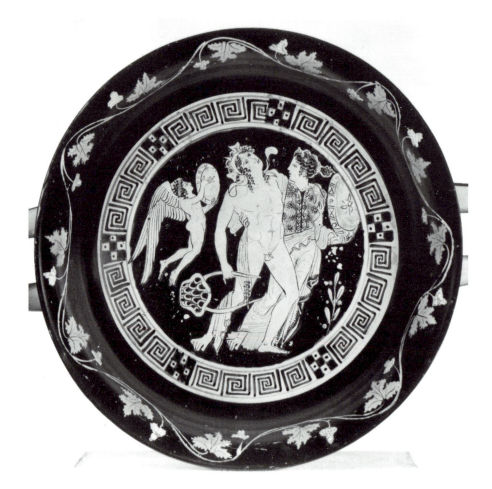

Fig. 272. Stemless cup; Meleager Painter. Dionysos and Ariadne with Eros. D. *c.* 0.25.

at a lower level; an imitator rather than a colleague. His pots include two neck-amphorae and several hydriai and pelikai but the greater number are kraters. A single volute-krater, in Vienna,[54] with Meleager and Atalanta on the back, a dance before an oriental king on the front, imitates the elaboration of the Pronomos/Talos style but is wretchedly drawn. His favourite shape (inevitably at this time) is the bell-krater: more than twenty against half a dozen calyx-kraters. Most unusually, however, there are also nine or ten column-kraters, among the last in Attic. Perhaps this points to the craftsman having got his first training in some old-fashioned workshop of the late fifth century which continued to produce cheap column-kraters in the tradition of the Painter of Munich 2335.[55]

One of the Meleager Painter's better pieces, an early hydria in New York, has a rare subject: Poseidon seated among the daughters of Danaos.[56] The god is often shown in pursuit of one of them, Amymone, seldom seated among the sisters. The subject, however, is repeated in a varied form on a hydria in the same

collection,[57] of different proportions, ascribed to the Erbach Painter, who heads Beazley's next chapter, 'The Plainer Group'. These artists (the principal other one is the Painter of London F 64)[58] carry on the tradition of the Dinos and Pronomos Painters as exemplified in their everyday work. Again bell-kraters are their staple production. Dionysiac subjects are the Erbach Painter's favourites. The Painter of London F 64 prefers Herakles driven in a chariot by Nike (fig. 273).

All the craftsmen we have so far looked at in these sections must have got their training in the fifth century. Those of Beazley's next chapter, the Telos Group, seem to be a little younger; at least the fifth-century tradition is less evident in their work; but, before we glance at them, a word about the way I present the material.

A much higher proportion of fourth-century red-figure, especially among the everyday bulk-production treated in this section, was left unattributed by Beazley, and much of what he includes in his lists is placed in looser groupings than earlier. Work has been done on attribution by other scholars, notably Hahland and

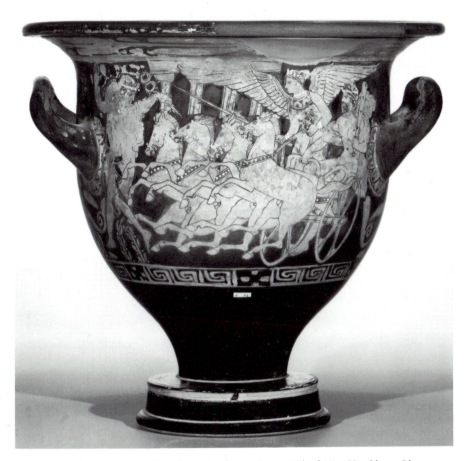

Fig. 273. Bell-krater; Painter of London F 64 (Plainer Group). Nike driving Herakles to Olympus. H. *c.* 0.40.

Schefold, and more recently McPhee;[59] but for the purposes of this book the mapping by Beazley is in general a sufficient guide, though I do not follow his order. He groups his painters under their favourite shape, beginning with six chapters on krater-painters, which cover the whole period in roughly chronological order. These chapters form the basis of my discussion in this section. Two chapters on pelike-painters follow, the first being the huge Group G, which comprises also many bell-kraters, and to which we shall return in a moment. The second pelike chapter includes both earlier and later material, and Beazley writes: 'The few really good fourth-century vases, which are nearly all by the Marsyas Painter, find a place here, although they are not, of course, all pelikai'.[60] This material I treat in the next section. Of the remaining chapters a very short one on hydria-painters contains nothing to interest us. We have already discussed the F.B. Group, and shall glance in a moment at things from 'Painters of lekanides' and 'Odds and ends'. The cup-painters, placed by Beazley in his last chapters, we have already treated.

The painters of the Telos Group[61] (the name-vase was found on the island of Telos, near Rhodes) never show the relative care which can sometimes be seen on better pieces of the Plainer Group, but their coarse drawing is often lively. The free use of white and abundant patterning on dresses makes for a pleasantly gaudy effect (fig. 274). Their work seems to have been more popular in the eastern market; at least they are better represented than the Plainer Group at Al Mina and the Kition sanctuary.[62] There is a similar coarse liveliness and fun in bell-krater fragments from Al Mina which Beazley could not attribute:[63] Pan and a satyr reclining on the ground at a picnic. Fragments from Kition,[64] not known to Beazley but surely from the Telos Group, seem to be from a rather similar scene and have a similar quality. There was an empty couch in the picture; and one appears, two satyrs reclining by it, a male and female figure standing by, on a complete vase by the Telos Painter.[65] There is perhaps allusion to some unidentified Dionysiac ritual in all these.

The Telos Painter and some of his companions sometimes replace the central youth on the reverse by a Nike.[66] Reverse-youths in general are often identified as

273

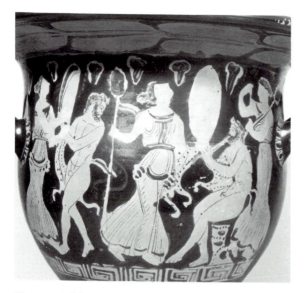

Fig. 274. Bell-krater; Black-thyrsos Painter (Telos Group). Maenads and satyrs. H. of picture *c.* 0.15.

athletes by a strigil or an aryballos, and Nike here has the same significance. We shall meet her on several prize panathenaics.[67]

I suppose the painters of the Plainer Group worked mainly in the first quarter, those of the Telos Group from the first into the second. The majority of those in Beazley's next krater-chapter, described as 'still early', have the same general character and are no doubt roughly contemporary. They call for no particular comment, but among them are listed two (the Iphigeneia and Oinomaos Painters)[68] of better quality whom we shall glance at in the next section. Beazley's next chapter is called 'Other krater-painters: later'. Here too there are painters of quality whom we shall touch on, but most carry on the same traditions in even more debased forms, no doubt across the mid-century. Such are the Toya and Filottrano Painters[69] and those around them. The Filottrano Painter seems the more degenerate of the two; and it may not be chance that the circle of the Toya Painter is represented at Olynthos, of the Filottrano Painter not.

Beazley places his chapter on the large Group G (G for griffin) in the section on painters of pelikai; but remarks that it might quite well have been inserted in the krater series near the beginning of Chapter 81 ('Other krater-painters: later'). Just before the Filottrano Painter he puts three vases as a 'Painter of London F 6' who, he says, 'continues the manner of Group G'.[70] There are a dozen pieces of Group G from Olynthos, so it was in production by the mid-century, but the exaggerated shapes of some pieces suggest that it went on a good deal later. In late bell-kraters the stem is drawn out long and thin and the lip leans far out, giving quite a new look to the shape. The calyx-krater undergoes an

analogous transformation in the L.C. Group (Group of the Late Calyx-kraters),[71] the subject of Beazley's last krater-chapter, which we shall treat in the next section. Pelike and hydria evolve similarly. The lip spreads very wide (in late pelikai beyond the vertical of the handles) and the neck is stretched out narrow and tall like the bell-krater stem. Hardly a hint of these changes is visible in the Jena Painter's Exeter pelike.[72] Group G pelikai show a considerable range of development and some of the bell-kraters are also far advanced. The incidence of late features, however, is not consistent. One cannot arrange bell-kraters or pelikai in a single chronological development; only note a tendency.

The drawing in Group G shows links with that found on vases of the F.B. Group,[73] and the general level is not a great deal better than that suggests. The favourite subject, repeated over and over, especially on the pelikai, is the Grypomachy: griffins in combat with orientals (Arimasps) or occasionally Greeks. The theme is popular in other circles also in this time, perhaps because the venue is Scythia, the seat of the new market for Attic vases. Relatively well-drawn examples are on a small number of pelikai, of a shape not yet extremely developed, ascribed to a 'Painter of Munich 2365'.[74] In Group G there are other repeated themes: for instance a battle, almost always with a rider usually characterised as an oriental, sometimes as an Amazon. A few pelikai have more individualised subjects, and the kraters are slightly less stereotyped. There is a series of pelikai decorated with large heads: griffin, Amazon, horse; griffin, Amazon, griffin; sometimes just griffin and Amazon or Amazon and horse; a type of decoration found also on smaller vases in and out of the Group.

Among later pelike-painters the Amazon Painter[75] carries on the themes of Group G in a slightly less mechanical way. We shall have occasion to refer to his battle-compositions in the next section.

We noticed the lekanis as a shape which, with red-figure decoration, becomes a regular piece of wedding equipment at the end of the fifth century.[76] There are fine fourth-century examples by major artists,[77] but in general in this period they are bulk-produced according to fixed formulae of decoration which emphasise the nuptial character. In the most elaborate type wedding-vases are shown (loutrophoros-hydria, nuptial lebes), and the figures include a seated woman naked to the waist (the bride), Eros, a seated naked youth (the groom) and one or two women (slaves) running with box and sash. Slighter pieces have elements picked from these. Many are put together by Beazley in an Otchët Group,[78] and probably many more are from the same workshop, which seems to develop from sub-Meidian origins and probably goes on into the second quarter of the century. There are pyxides, and vases of other shapes, of similar character, some collected by Beazley

in his chapter 'Odds and ends'.[79] The Otchët lekanides are well represented at Olynthos, and there is at least one example from that site of a seemingly in general later type, decorated with large heads, female or of Arimasp and griffin or sometimes panther. Beazley puts some of these in groups, and has also groups of askoi with similar decoration.[80] One of these too comes from Olynthos. As with the F.B. Group, one wonders how late the demand for this material continued. There are also large numbers, omitted by Beazley, of askoi and small squat lekythoi decorated with animals, carrying on the tradition from the late fifth century to some ill-defined point after the middle of the fourth.

A shape which Beazley does not treat is the fish-plate.[81] This wide plate, floor sloping slightly to a depression in the centre, with hanging vertical rim and a low foot, is found in Attic black from the beginning of the fourth century into the Hellenistic period. That it was intended for eating fish is demonstrated by the red-figure examples which show, in various combinations, certain favourite table-fishes. These figured fish-plates were produced in great quantity over a long period in many centres of South Italian red-figure, but there is also a good number of Attic pieces of superior quality (fig. 275). Most of these (Spina is a rich source) show, like the Italian examples, only the swimming fish. On four from Kerch, however, one still there, the others in Leningrad, the fish are subordinated to a picture of Europa, brought by the bull over the sea from Phoenicia to Crete.[82] On the best of them (the others have minor variations, and Zeus is omitted from one) the nicely drawn squid rears up in front of the bull's hooves and

separates it from two Erotes. One looks back at Europa as he flies. The other has already alighted in front of Zeus, who sits enthroned, with bowed head. Eros seems to be offering him something from an open chest on the ground, perhaps a present for the bride. Europa floats naked beside the bull, and a third Eros flies behind with tambourine and sash. This figure is strongly reminiscent of the Eros regularly found on the nuptial lekanis, which offers a field of similar shape, and the bridal allusion must be deliberate. Behind this Eros, Poseidon is shown sitting on a rock, and between Poseidon and Zeus the cortege concludes (opposite Europa) with a Nereid riding a large hippocamp. The pretty, delicate style of these plates seems related to that of some krater-painters we shall look at in the next section: the Iphigeneia, Oinomaos and Pourtalés Painters and the Painter of Athens 12592.[83] This tradition perhaps begins in the first quarter of the century and flourishes in the second.

We hear of an artist, Androkydes of Kyzikos, who was renowned as a fish-painter[84] and seems to have flourished early in the fourth century. An anecdote has him working on a battle-picture in Thebes around 370, but in another passage he is called a contemporary of Parrhasios, who was certainly active before the end of the fifth. Some attractive Roman mosaics[85] show selections of fish on a dark ground disposed in a not dissimilar way (*mutatis mutandis*) to those on the plates. These may derive from Greek paintings. At the least Androkydes's reputation and the plates witness a common contemporary interest, similar to the interest in flower-painting evidenced a little later by what we hear of Pausias of Sicyon and see in the floral scrolls on Macedonian mosaics and South Italian vases.

b. Black-figure panathenaics and the fine style in red-figure

Early in the fourth century two changes are made in the old picture on the front of the panathenaic amphora. Athena retains the traditional *promachos* stance, facing left so that the outside of her shield is seen, and she is still flanked by two columns. Beside the one in front of her still runs the inscription *ton athenethen athlon*, 'one of the prizes from Athens'; but now a second inscription is set by the other column: *[ho deina] archontos*, '(so-and-so) being archon'. The other change is that the columns no longer bear the traditional cocks but figures which often, perhaps always, represent pieces of sculpture. It is not demonstrable that the two changes were made at the same time, but it is most likely. There certainly cannot be much difference in time.

We have a list of the Athenian archons who gave their name to their year of office, and we can equate these years with dates in the scheme of reckoning we use; can

Fig. 275. Fish-plate. Fish. D. *c*. 0.34.

therefore put a fixed date on each archon-name written on a vase. At first surprising is the fact that the years so reached seldom or never correspond to the years of the four-yearly Greater Panathenaia, at which the full vases were given as prizes. The explanation is given by a passage in Aristotle, who was writing during the period in which these vases were inscribed with the archon-name. He says that the archon of each year was responsible for collecting the oil from the sacred olives and making it over to the *tamiai* (treasurers). He adds that the organisation of the procession and contests at the Greater Panathenaia, including the making of the *peplos* (the robe for the ancient image of the goddess) and of the amphorae, and the giving of the prize-oil, was the charge of ten *athlothetai* (stewards of the games), who held office for four years. The name on the vase, then, will be the archon's for the year in which the olives were harvested and crushed for oil, and the vase will have been made either in that year or between that and the year of the next festival. One may wonder if the consistent shield-device on fifth-century panathenaics may not have been a logo with the same significance: the 'vintage' of the oil. The figures on the columns seem likewise associated with the archon-name, not the year of the festival.[86] At least on a vase with the name of Nikokrates (333/2) both are Athena; on one with the name of Niketes (332/1) both are Nikai;[87] and these two vases must both have been prizes at the games of summer, 330. Often, as in these two cases, the same figure tops both columns, occasionally viewed from two angles; but often they are different.

The first archon-name which can be restored with certainty on a panathenaic is Hippodamas (375/4), but that is on a fragment (in Istanbul) without preserved figurework (though it has another feature of interest which will bring it to our attention again).[88] Asteios (373/2) appears on a vase in Oxford[89] of which the athletic scene (wrestlers) is largely lost but the Athena relatively well preserved. There is, however, a vase in Berlin,[90] complete but with much of the surface, especially on Athena's side, corroded, and this corrosion has removed all the archon's name but the final sigma. It is said that just seven letters must have preceded that. Beazley thought the style distinctively earlier than that of the Asteios vase; and if that is so there is only one name in the relevant range of years which would fit: Philokles (392/1). Some have thought the style of the reverse (quintain: javelin-throwing from horse-back) too late. I do not feel this, and Athena's gaudy drapery seems to me directly derived from that on the two vases of the Hildesheim Group, discussed in the last chapter. These have the Tyrannicide shield-device which we believe dates them to the games of summer, 402. The third vase with that device belongs to the Kuban

Group;[91] and of a fragmentary vase from Olynthos Beazley remarks that it 'is akin to the Kuban Group, but later, and extraordinarily deboshed'.[92] On the Olythos vase the columns, which on the Tyrannicide vases still bore cocks, have Nikai; the area where there might be an archon-inscription is unfortunately missing. The columns on the vase in Berlin which seems to have borne the name of Philokles (392/1) support spirits of good fortune, male and female: Agathos Daimon and Agathe Tyche.

It seems to me a reasonable hypothesis, though no more, that a law providing for the inscription on prize-vases of the archon's name came into effect in a four-year period after that leading up to the festival of 402 and not later than that leading up to 390 (the festival at which an amphora with Philokles's name would have been a prize); and that the change was accompanied by the replacement of the cocks on the columns by other symbols.

We saw reason to connect the style of the Kuban Group with that of the Pronomos/Talos circle in red-figure. All probably issued from a single workshop. The Suessula and Semele Painters may have sat in the same or in a related one, and it is likely that the Hildesheim pair of panathenaics go with those. Peters thought they were by Aristophanes, but that seems to me unlikely.[93] The reverse of one has a chariot, of the other a foot-race of marked conventionality and dullness. The figures are strung out in an identical pose: left leg forward, left arm forward and up, right arm back and down; a minimum of inner detail mechanically repeated on each. The style of the Berlin vase which probably bore the name of Philokles seems to me to follow naturally on these, and I think it not unlikely that it comes from the workshop of the Meleager Painter, whose red-figure stands in a similar relation to that of the Pronomos circle.[94]

The reverse of the Asteios vase (373/2) is largely lost, and those of two vases connected with it by the style of the Athena are not much help. One of these, in Alexandria, has the name of Phrasikleides (371/0), the other, in Detroit,[95] is without an archon-name. This phenomenon we will touch on in the next section. The figures on the columns on the Detroit amphora are different from those of either Asteios or Phrasikleides. The foot-race on the reverse is almost a repeat of that on the Hildesheim vase of probably some thirty years before. The victor with his trainer and another on the Phrasikleides vase are disposed in a slightly more imaginative manner, but the drawing is summary. I cannot attach these three panathenaics with any conviction to any red-figure work.

The Asteios and Phrasikleides amphorae must have been prizes at the games of 370, those with the name of Polyzelos (367/6) at the next festival (366). This name is

found on vases in Brussels and New York with foot-race and one in London with wrestlers (figs. 276 and 277).[96] The foot-races are as conventional and dull as those on the vases in Hildesheim and Detroit, though the re-

Figs. 276 and 277. Panathenaic prize-amphora with name of archon Polyzelos (367/6); Kittos Group. Athena; wrestlers. H. c. 0.64.

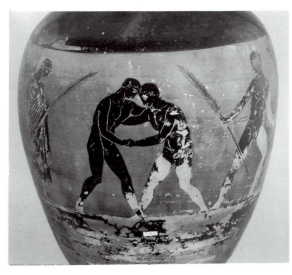

peated pose and the proportions are different. We shall meet a no less conventional one a quarter of a century on. It seems to be a subject which no longer challenges. The wrestling match has more character. The Athenas on the three vases with the name of Polyzelos are all but identical and I suppose the vases come from one workshop. A precisely similar Athena is found on another in London (figs. 278 and 279),[97] which bears no archon-name but in its place that of a *poietes* Kittos, a matter we shall return to in the next section. On the reverse of the Kittos vase is a *pankration*, a rough mixture of wrestling and boxing. The design of the wrestling picture on the Polyzelos vase in London is exceedingly like that of the *pankration* on the Kittos amphora, though the drawing is different. The Kittos vase too must, I think, come from the same workshop, but evidently several craftsmen were employed.

The delicate style of the Kittos reverse was associated by Peters with that of the Jena Painter, by Karouzon[98] with a beautiful red-figure calyx-krater in Athens which Beazley gives to the Oinomaos Painter. It appears to me that a cluster of a dozen kraters, which Beazley divides among the Iphigeneia and Oinomaos Painters, the Pourtalés Painter and the Painter of Athens 12592,[99] stands very close to the Jena Painter. The first pair he places in his 'still early' krater chapter, the second at the beginning of the 'later' chapter, and links the two in each pair as 'akin'. It seems to me that all must be from one workshop, though probably more than one hand. I doubt if the workshop was actually the Jena Painter's, but his influence is paramount in the delicate style. The panathenaic with the name of Kittos as *poietes* must issue from the same shop and be by one of these artists. It brings with it those with the name of the archon Polyzelos (367/6), and their reverses show that other draughtsmen were employed in the workshop. A pretty fragment from Kition is, I believe, by the Painter of Athens 12592 (fig. 280).

Most of the red-figure vases of this group have figures set up and down the field in more or less elaborate designs. The calyx-krater from Spina[100] which gives the Iphigeneia Painter his name (fig. 281) is clearly an illustration to Euripides's *Iphigeneia in Tauris*, though it concentrates figures and actions from divers scenes and speeches. In the centre is the temple, two drain-pipe columns at the top of steps supporting entablature and pediment over a primitive image of Artemis and an offering-table. There is no trace of an attempt at perspective such as one regularly finds in the *aediculae* which often occupy the same position on South Italian vases. On each side of this are an attendant with a tray and Iphigeneia, who holds a temple-key (the badge of a priestess) and the letter. Pylades, seated below her, raises his hand to take the letter and pass it to Orestes,

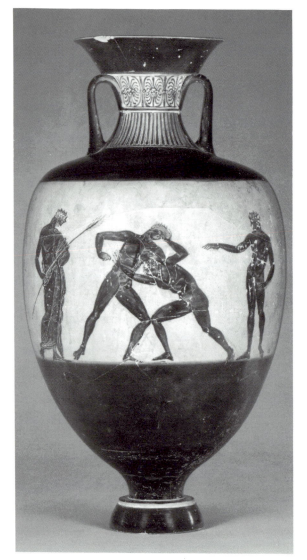

Figs. 278 and 279. Panathenaic specimen(?) amphora, without archon-name but with name of *poietes* Kittos; Kittos Group. Athena: *pankration*. H. *c.* 0.71.

reclining at bottom centre. Below the attendant sits King Thoas, a slave with a big fan behind his chair. A female seated beyond Iphigeneia and Pylades is probably the goddess herself.

The Oinomaos Painter's name-piece, a bell-krater, in Naples,[101] is a more ambitious and crowded composition. The subject (that of the east gable at Olympia) is the oath before Pelops's race against Oinomaos for the hand of his daughter Hippodameia. In the centre is an altar with a tall column supporting an image; again of Artemis, who seems out of place here. Probably the vase-painter knew what he was doing, but we should rather have expected Zeus. He is indeed shown in person, sitting at the top right with Ganymede and

Fig. 280. Bell-krater fragment; Painter of Athens 12592. Dionysos and Ariadne with Eros. L. *c.* 0.11.

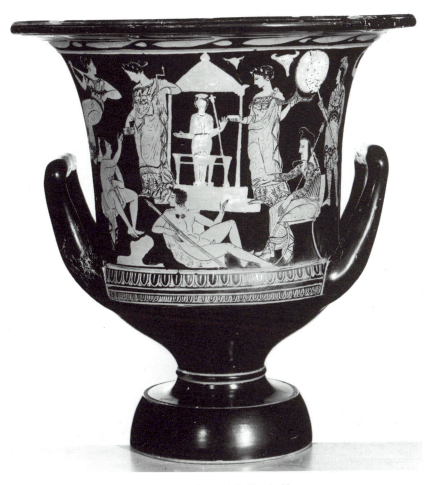

Fig. 281. Calyx-krater; Iphigeneia Painter. Iphigeneia in Tauris. H. *c.* 0.42.

Aphrodite. Oinomaos stands at the altar between two attendants, one bringing up a sacrificial ram behind which sits an unidentified youth with spears. Above these Myrtilos, Oinomaos's charioteer, holds the team ready, and at the bottom on the other side, below Zeus and his companions, Pelops is setting off in his chariot with Hippodameia.

These two vases are more or less ambitious mythologies. The masterpiece of the group is a fragmentary calyx-krater from Hermione in Athens[102] ascribed to the Oinomaos Painter, the piece Karouzou associated with the Kittos panathenaic. One side is virtually lost, and of the upper register of the other only the lower parts of a male between two females survive. The lower register is almost complete, but the subject is obscure and disputed (fig. 282). From the left a female figure approaches a seated youth of Apolline character. He has long hair, a laurel-wreath on it, and holds a laurel-branch in his left hand against his shoulder. He lifts his right in greeting to the woman, and she holds out a big

laurel-wreath as though to place it on his head. Another laurel grows at the youth's feet. A closely similar pair follows, differing chiefly in the youth's having no laurel, except the wreath on his long hair. He holds a kid on his knees. He is seated to the right but looks up and back at the approaching woman. A crescent moon is shown between the branches of the first youth's laurel. It is not far from the back of the second woman's head; and not far from her face, the other side of the big wreath she holds up, is another, decrescent. One cannot be quite sure that they belong to her. The second is directly above the second youth's head and near a third woman who sits above and beyond him to the right, both arms raised. Head and hands are lost and we do not know which way she was turning or whether she held a wreath. A young man, however, beyond and below her, stands the other way but looks back and up at her and begins to raise his hand, and it is natural to suppose that she too was offering him a wreath. Most of his hair is lost and we do not know if it was wreathed but it is

279

Fig. 282. Calyx-krater; Oinomaos Painter. Uncertain subject: bards and their brides? Preserved H. of picture *c.* 0.20.

shorter than the others. Beyond him another woman stands frontal, left hand low and empty, head and raised right hand lost. The scene is closed by two male figures. A youth stands holding a loutropohoros. His hair is lost, and the top of the vase, so we cannot be sure if it was amphora or hydria. At the end a man sits. His head is missing with something he was holding on his right shoulder; what remains looks like the foot of another vessel. All figures, male and female, wear only a himation, leaving most of the upper body bare. The artist's delicate drawing, though not very careful, is at its best here, and the idyll, whatever it means, has great charm.

Karouzou and Metzger have debated most interestingly about it, but I do not feel that either of them, or Simon, has found a satisfactory answer.[103] The loutrophoros *must* imply either a hymeneal or a funerary context, and the pairing of female and male figures makes the hymeneal all but certain. We have seen that Mousaios sometimes carries the laurel and is indistinguishable from Apollo. I have wondered if these might be the bards and their brides: Mousaios with Deiope or Antiope; Orpheus (the kid suggesting his bewitching of animals with his music) and Eurydike;

and a third pair, the bard perhaps Linos. However, this would leave a great deal unaccounted for, and in the loss of the upper register conjecture is probably vain.

To return to the panathenaic series, the next archon-name preserved (apart from some on scraps without figurework) is that of Charikleides (363/2) on a very fragmentary vase from Eleusis.[104] The reverse had horsemen, perhaps at quintain. Two or three other Athena-fragments from the same site,[105] one with boxers on the reverse, have been associated with it, and there will be something more to say of these later. The Charikleides vase will have been a prize in 362; and at the next festival in 358 will have been given a group of vases found at Eretria with the name of Kallimedes (360/59), already known on a fragment from the Agora of Athens.[106] The Eretria vases have pictures in a style far superior to anything we have looked at in this kind. Indeed they are among the best drawings on any fourth-century vase, and it is important if we can to associate them with red-figure.

Far the best work in Attic red-figure of the fourth century is on vases attributed to a Marsyas Painter and a few associates. Many of the best pieces in this distinctive

style are in Leningrad and were found in Crimea, and it is to this style that the word 'Kerch' was originally applied. Schefold[107] studied them in a wider context of fourth-century Attic red-figure, and isolated a number of artists. Not all of these were recognised by Beazley, but he agreed on the key figure of the Marsyas Painter,[108] though noting that the Marsyas pelike (from

Kerch, in Leningrad) is a poor specimen of the artist's style. A much finer pelike, in London,[109] from Kameiros on Rhodes, has a slight Dionysiac picture on the back, on the front Peleus seizing Thetis (fig. 283). Naked Thetis, crouching to wash, is in white, as is Eros who hovers above her, but no other figure. There is light blue on Eros's wings, and green on a garment by Thetis's

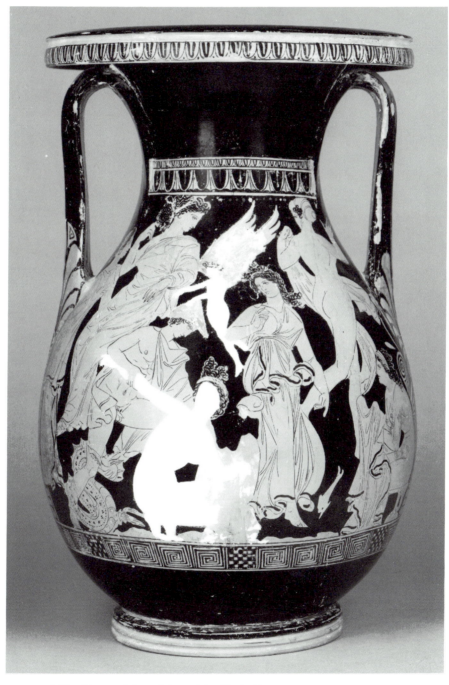

Fig. 283. Pelike; Marsyas Painter. Peleus seizing Thetis. H. *c.* 0.43.

281

side. The young lover, in travelling-hat and cloak, bends to seize Thetis, and a dragon (one of her transformations) winds about his leg. Behind him Aphrodite sits, an attendant, no doubt Peitho, standing by. A sister Nereid sits holding a garment for Thetis and another starts back in alarm. These are both clothed, and a third, naked, runs away in contrapposto back view, her face in *profil perdu*.

The drawing is more sensitive than anything we have met in this chapter. In the artist's best work, exemplified in a nuptial lebes from Kerch in Leningrad,[110] this is combined with a grandeur which looks back to such masters as the Dinos and Kleophon Painters. The lebes has a single picture all round: a bride enthroned, and twelve of her women; besides a very small girl who stands by the throne-leg lifting a lekanis to the bride, who nurses a tiny Eros. Six other Erotes, larger, flutter around. The skin of the bride and of the Erotes is white, as are other details, and another colour was applied for the bride's dress and for a cloth being taken from a chest by two women. Some ornaments are in gilded relief. The drawing of a young and beautiful face in three-quarter view, which took so long to master, now presents no problem. Two of the women have it, one carrying a heavy burden on her shoulders, the other stooping in a beautifully caught action to lift something. A third, standing quietly, is so muffled in her draperies that only her eyes show. One woman's chiton is elaborately patterned, but most of the voluminous draperies, in

which the artist seems to take special pleasure, are drawn with close and varied 'realistic' folds.

It has been usual to date this splendid and distinctive style in the middle and third quarter of the century, but the discovery of the panathenaics at Eretria with the name of Kallimedes, archon in 360/59, seems to me to make a revision necessary. The two best of those, at least, stand apart in their quality from all that come before in precisely the way that the Marsyas Painter's best work stands out from all earlier fourth-century red-figure, and the drawing seems to me unquestionably the work of the same fine artist.

One shows two wrestlers at the end of the bout (fig. 284a–c). One, locked in his opponent's grip, is pressed down on knees and right arm, and beats the ground with his left hand to acknowledge defeat. His face is in *profil perdu*. The victor's face is hidden behind the other's shoulder, and the curve of his back and buttocks, echoed by the victim's below, makes a powerful and beautiful silhouette. It is strikingly like the line of the crouching Thetis's body on the Kameiros pelike; and the naked back-view Nereid there, with her face in *profil perdu*, is likewise near akin to the wrestlers and to a third naked athlete who stands by looking down at the bout. On the other side a stately Nike[111] looks down too. She holds a trainer's wand out, as though to intervene with it if the victor does not respond to the other's signal. She wears a himation which leaves her right shoulder and most of her upper body bare. Over ankles

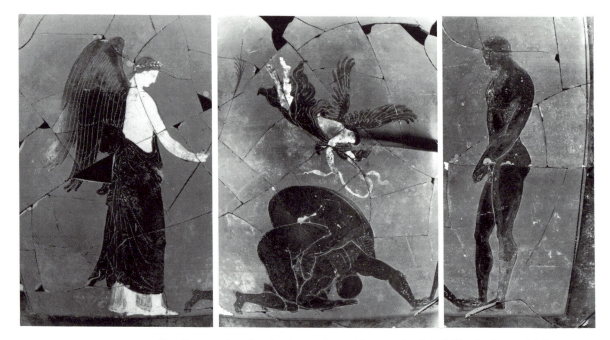

Fig. 284, a–c. Panathenaic prize-amphora with name of archon Kallimedes (360/59); Marsyas Painter. Wrestlers between Nike and athlete; small Nike above. H. of picture *c*. 0.25.

and feet the painter has indicated a transparent chiton, but there is no sign of it above; and a second, smaller Nike, who occupies the centre of the picture, descending in an amazing pounce on the wrestlers, arms extended down with a fillet for the victor, certainly wears nothing but the himation which flies wildly round her naked body. The big Nike's profile head is very like those of the painter's red-figure women, but the folds of her himation are more traditional. Those of her little sister, in her wind-blown rush, approximate much more nearly to the painter's norm.

The central group on the second panathenaic (flanked by another athlete and a trainer) is again a pair of wrestlers (fig. 285a–c). Indeed one might think it the same bout at an earlier stage. The victor-to-be has already locked his arms round the other's rib-cage. They stand almost frontal to us, straining with bent knees, most of the aggressor's head and much of his body concealed behind the other, who bends his head, in three-quarter face, and struggles with both hands to break the grip. The woman on the lebes bending to lift something is analogously posed.

It seems to me proven by these vases that the Marsyas Painter had reached his full powers ten years before the fall of Olynthos. That nothing of his, or his companions, has been recognised there must be attributable to the fact that the Olynthian demand for Attic pottery was almost exclusively for cheap lines. Beazley does indeed compare a satyr on a small fragment from the site with Marsyas on a bell-krater in San Simeon which he attributes to a Painter of Athens 1472,[112] of whom he says 'some figures recall the Marsyas Painter'; but nobody would wish to build on that. The shape of the

Kameiros pelike is interesting. The spreading lip is a 'late' feature, while the proportion of belly and neck is much more traditional.

The best male nude in Attic red-figure of this time is Marsyas (fig. 286) on a big calyx-krater from Al Mina, very fragmentary, in Oxford.[113] He sits on the ground, twisted towards us, arms bound behind his back, one leg doubled under him. This figure strongly recalls the wrestlers on the second panathenaic, but the contour is less harmonious, more nervous. In the original publication of the vase Beazley wrote of it as 'the finest, I think, of all late Attic vases, although I do not forget the beauty of the lebes in Leningrad'.[114] He never ascribed it and it does not appear in his lists, but at the end of the original article he wrote: 'The only vase that bears much resemblance to the Mina krater in style ... [is] ... the Eleusinian pelike in Leningrad; but the Mina vase is superior, and I cannot say that the two are by the same hand.'[115] The Eleusinian pelike was grouped by Furtwängler with a pair to it in the same collection. Both come from Kerch and are large, elaborate vases with assemblies of deities. Schefold added a lekanis with wedding-preparations, likewise from Kerch in Leningrad, and called the artist the Eleusinian Painter. Beazley lists him in *ARV*² and characterises him as 'connected with the Marsyas Painter, but his work is laboured and weak – all the difference'.[116] Certainly this painter does not appear an artist of the Marsyas Painter's calibre, but the judgement is harsh. The Mina vase, though I cannot place it above the lebes, is a work of the highest quality, but I wonder if it might not after all be the Eleusinian Painter's, perhaps an early work when he was closest to the Marsyas Painter.

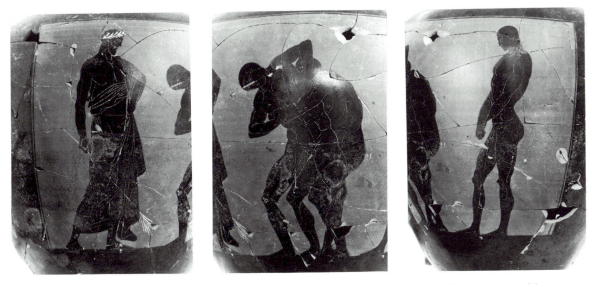

Fig. 285, a–c. Panathenaic prize-amphora with name of archon Kallimedes (360/59); Marsyas Painter. Wrestlers between trainer and athlete. H. of picture *c.* 0.25.

A marked feature of the Eleusinian Painter's compositions is the way the figures ignore each other and look out at us. This tendency is found in a good deal of work of this time: Etruscan engraved mirrors, Attic tomb-reliefs, and other late red-figure vases. It is marked in the Mina krater and hinted at in the Marsyas Painter's Thetis pelike. It was no doubt present in major painting too, and indeed there are clear traces of it in Roman wall-paintings, many of which are certainly of fourth-century Greek derivation. We do not know how Euphranor[117] presented his twelve Olympians in a famous painting in a stoa in Athens, but I find it natural to suppose that it was in this manner.

In the same stoa Euphranor painted the battle of Mantinea (362), which no doubt led Pliny to date him in the hundred and fourth Olympiad (363–360). It is possible that this celebrated battle-piece has left traces in contemporary vase-painting. The fights (mainly Amazonomachai) on pelikai of Group G and the Amazon Painter, often show a pyramidal group, a fallen figure between two fighters. This is a favourite also in relief-sculpture of the time, recurring constantly in the Amazon-frieze of the Mausoleum. More interesting are variations on the composition, by the Amazon Painter,[118] in which a figure on horse-back rides out of the picture three-quartered towards us and a figure on foot starts back on either side. This looks like a pictorial invention. Euphranor's Battle of Mantinea centred on a cavalry engagement and is a likely source for the vase-painters. Of similar character and far higher quality is a foreshortened chariot team (Athena's driven by Nike) on the reverse of the Mina krater. The drawing has suffered much, but two almost frontal horses' heads are preserved (fig. 287), one of them complete and very beautiful.[119]

In other respects Euphranor's work will have been entirely unlike the vase-paintings. He is said to have remarked that his Theseus was fed on beef, Parrhasios's on roses. Parrhasios, as we saw, seems to have refined and developed a tradition of linear modelling against the steady progress of chiaroscuro. Euphranor's comment surely reflects, besides a changed ideal, the etiolated impression made on an artist of the new school by works of the old. So, one thinks, Titian might have felt about a Venus of his compared with Botticelli's. The Marsyas Painter and the draughtsman of the Mina krater are great late masters of linearity; and even colleagues of less skill eschew like them the interest in

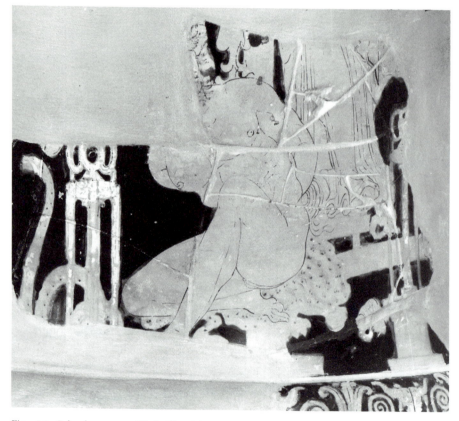

Fig. 286. Calyx-krater; possibly by Eleusinian Painter. Detail: Marsyas punished. H. of detail *c.* 0.14.

shading and highlights admitted by some vase-painters in South Italy.

After the Kallimedes group of 360/59 there is a large gap in the series of dated panathenaics. Fragments exist with the names of Aristodemos (352/1), Theophilos (348/7) and Themistokles (347/6),[120] but it is not till Nikomachos (341/0) that we get a complete vase. At some point in the interval one general change took place: Athena is turned to face right, her extended shield in foreshortened view from within. Shs is given a wrap over her shoulders with deliberately archaising 'swallow-tail' ends. The overfall of her drapery on the thighs is in three points, treated like the swallow-tail of the wrap. The skirt, which in the old type revealed the ankles, now comes down to the feet, and the stride is shorter, the rear heel only just off the ground. On two vases with the archon name Pythodelos (336/5) the feet are almost together (Beazley's Hobble Group,[121] from the effect the stance makes of a 'hobble skirt', a fashion of Beazley's youth). Otherwise there is very little variation in the type.

The old Athena was *retardataire*, the repetition of an outdated model. The new is archaistic, displaying mannerisms deliberately used to suggest an archaic style. We saw a hesitant anticipation of this on a red-figured oinochoe of the end of the fifth century from the Acropolis (fig. 267).[122] The date of the change on the panathenaics cannot be fixed exactly. The swallow-tail wrap appears already on the fragment from Eleusis with the name of Charikleides (363/2),[123] but Athena there still faces left, as she does on the Kallimedes vases (360/59),[124] where she does not have a wrap. She faces right on the Theophilos fragment (348/7). On one of the fragments with the name Themistokles of the next year, she wears a wrap and seems to have faced right.[125] Oil from these two archon years served for the games

of 346. She faces right on all subsequent surviving vases, beginning with those which bear the archon names of Nikomachos (341/0) and Theophrastos (340/39).[126]

We do not know how long the practice continued of writing the archon's name on prize-vases. The last we have is Polemon (312/11) on a small fragment.[127] At some times in the Hellenistic age names of other magistrates, *agonothetai* or *tamiai*, were written, but these can seldom or never be dated. That development in any case lies outside the scope of this book; but we may note that black-figure panathenaic amphorae are represented on second-century mosaics, that examples from that period exist, and that fragments from Athens seem to document their continuance into Roman imperial times.[128]

The latest complete panathenaic to survive with an archon name bears that of Neaichmos (320/19), so for the games of 318; and virtually all we have between the archonships of Nikomachos (341/0) and Neaichmos are grouped by Beazley in or around one long 'Nikomachos Series'.[129] The unity is given by the homogeneity of the Athena; there is great variety in the drawing of the reverses. It seems most likely that all issued from one large workshop which employed a good many painters.

The difficulty of stylistic dating of these late black-figure works is illustrated by a dispute over a vase with the archon-name Theophrastos. Two men of this name held the office, one in 340/39, one in 313/12. The name is found on two vases. One, in Harvard from Capua (fig. 288), is like in shape and the general character of the drawing to the one vase which survives with the name of Nikomachos (341/0), and no one questions that this is the first Theophrastos.[130] This and the Nikomachos vase will both have been prizes in 338 (the year of the disaster at Chaeronea). The second vase with the name of Theophrastos (in the Louvre from Benghazi)[131] has a reverse in a totally dissimilar style, and good scholars have placed it in the archonship of the younger man. Beazley has discussed the matter in detail and to my mind conclusively refuted this position; but the dispute reminds one how tricky these questions are. There is a similar though less significant dispute over a vase with the name of Archippos.[132] One man of this name held office in 321/0, another in 318/17. The vase will have been a prize either in 318 or 314. One scholar opted for the later date on stylistic grounds; but to attempt a stylistic dating within four years is, to my mind, a ludicrous misapplication of method. An argument on the other side, though not conclusive, has weight until it is proved wrong. Among all archon-names we have on other panathenaics none is for the third year of an Olympiad; that is a year in the summer of which the Greater Panathenaia falls: 318/17 is such a year. The sacred olives must have yielded oil in those years too,

Fig. 287. Detail from reverse of 286: Nike and Athena with their foreshortened chariot-team.

but perhaps it was all devoted to some other special purpose.

The reverse of the Theophrastos vase in Harvard (figs. 288 and 289) has a picture unusual in several respects. Two boxers stand side by side, facing us, their bodies turned very slightly towards each other, both faces three-quartered towards a bearded man in himation. He addresses them with a gesture, one might think of admonition but perhaps rather of encouragement; for on their other side stands a female figure named Olympias, the spirit of the Olympian games.[133] Her presence can only be intended to suggest that the winner may go on to win at that much more prestigious festival. The point is underlined by the symbols on the columns flanking Athena. One has the Athenian goddess herself; the other the Olympian Zeus with Nike on his hand. The prize-vases must have been made before the Panathenaic games took place, so there can be no personal reference, and it is interesting that the same symbols are found on the second Theophrastos vase, which we shall come back to later.[134] This is one of the many reasons for attributing the two to the same archonship.

Olympias is an interesting figure. She stands leaning on a pillar away from the athletes, but turns her face three-quartered towards them. Her arms are muffled in her mantle and it is drawn up like a yashmak over chin and mouth. The style is close to that of the Marsyas Painter; looser and fussier than the Kallimedes vases, made for the games of twenty years before. I could still imagine it a just possible late work of the master's own, but it seems even closer to the Eleusinian Painter. Much

Figs. 288 and 289. Panathenaic prize-amphora with name of archon Theophrastos (340/39); Nikomachos Series. Athena; boxers. H. *c.* 0.80.

286

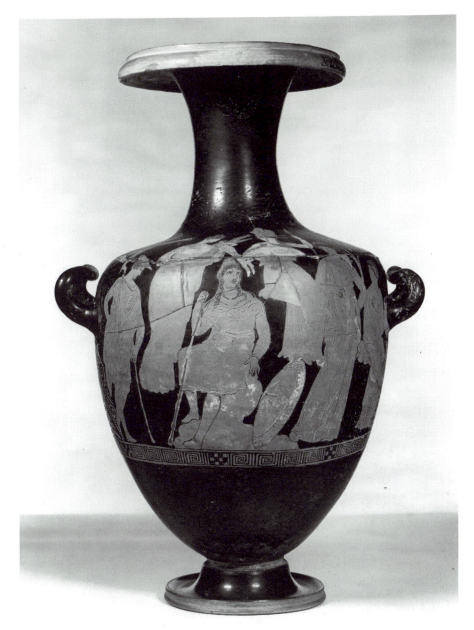

Fig. 290. Hydria (kalpis); possibly very late work of Eleusinian Painter. Judgement of Paris. H. *c.* 0.60.

less interesting is the vase for the same games with the name of Nikomachos, in Alexandria from Cyrenaica. The figures are of similar build and general character, but they are mechanically repeated in a foot-race which has the wholly conventional character we have noticed in other renderings of the subject.[135] I cannot attribute it, and it certainly has none of the marked frontality which the Theophrastos vase shares with the Eleusinian Painter's red-figure pelikai.

Another striking example of this compositional character is the Judgement of Paris (fig. 290) on a red-figured hydria from Alexandria (founded in 331).[136] Beazley did not ascribe it, but it certainly stands in the Marsyas Painter's tradition; this time surely not his own work, but possibly still the Eleusinian Painter's. One figure, probably a local personification, has mantle wrapped over mouth like Olympias. Another, reclining above one handle, finds a close parallel on another

hydria of this latest phase from Kerch in Leningrad.[137] On the Alexandria vase there is much more added colour for clothes than usual earlier. On the Kerch vase only the subordinate figures are in red-figure. The principals, Athena and Poseidon quarrelling over the land of Attica (a composition influenced by the west pediment of the Parthenon), are in gilded relief. We saw a similar combination much earlier in the squat lekythos with the name of the *poietes* Xenophantos, whose characterisation of himself as 'Athenian' probably means that he was working in Crimea.[138] One may wonder if the later vase too was not made there. The same seems even more likely for one of the very few 'Attic' pieces decorated in the Gnathia technique. This is a pelike from Pantikapaion with a combat in elaborate polychromy applied over the black ground, with shading and highlights.[139]

Another vase, basically red-figure but with a great deal of polychromy, is a large chous in New York (fig. 291).[140] In the centre stands a goddess, her skin white, her dress added in pink. On one side of her a white Eros adjusts his sandal. Between them is a sacrificial basket in gilded relief, and on the goddess's other side sits Dionysos, in red-figure. One would have thought the goddess Aphrodite, but she is named Pompe, 'Procession', personification of a vital element in Athenian religious life. There can be no question of

Fig. 291. Chous; not attributed. Pompe between Eros and Dionysos. H. *c.* 0.23.

this vase having been made elsewhere than in Athens. Schefold gave this to a Helena Painter, but Beazley did not accept the grouping and left this vase unattributed. The delicate drawing is reminiscent of the Oinomaos–Pourtalés Painter sequence, and one might think it a late work of one of those painters. A pretty fragment of a red-figure bell-krater from Kition,[141] which I have attributed to the Painter of Athens 12592 (fig. 280), has something in common with it.

The second panathenaic with the name of Theophrastos[142] has a subject (figs. 292 and 293) not unlike the first. Of two athletes holding palms one runs off while the other stands in much the attitude of those on the other Theophrastos vase, half turning to a judge or trainer who seems to address him, an official standing by. The style, however, is quite different, etiolated and elegant in a way that recalls the Kittos vase of nearly thirty years earlier.[143] That we saw associated with the red-figure of the Oinomaos Painter; and for this panathenaic, as for the polychrome chous, one might seek a painter in the later phases of that circle.

The next archon-name recorded on panathenaics is Pythodelos (336/5). Of three vases which bear it, and which were thus made for the games of 334, two are those in which Athena wears the 'hobble skirt' (fig. 294). The third, in London,[144] unexpectedly from Caere, has boxers in action; but whereas those on the Theophrastos Harvard vase, made for the games of 338, have the old soft thongs bound round the hands, these wear the new armoured glove (fig. 295). This, then, was introduced at Athens at the games of 334, and no doubt around the same time at the other games. One might argue, since the vases must have been made before the games at which they were given, that the new glove was used at Athens in 338; but I think it more likely that vase-painters were aware of athletes in training for the games to come. The change to the bruiser's glove seems part of a shift in athletic ideal clearly indicated by this artist in the type of the boxers. They have small heads and very heavy bodies with gross muscles.

The composition is traditional, looking right back past the Theophrastos boxer-vase to the Kallimedes wrestling-bouts. The group is flanked by a third boxer (also wearing the gloves) and a Nike with a trainer's wand.[145] Some trace, perhaps, still shows in the drawing of the Marsyas/Eleusinian Painter tradition, but there is much more that is new. The fussy drawing of the over-muscled back of one boxer is very well paralleled in a Herakles on a red-figure fragment from Kition[146] of an exceptionally large bell-krater. The hero is accompanied by Athena but the subject is hard to make out. On the back of the vase a male is seated on a rock modelled with shading. The coarse, not ineffective style finds close parallels in the L.C. Group[147] (Group of the Late Calyx-kraters, the last important series in Attic

Figs. 292 and 293. Panathenaic prize-amphora with name of archon Theophrastos (340/39);
Nikomachos Series. Foot-racers and judges. H. *c.* 0.77.

red-figure) and that is certainly where the Kition fragments belong.

A very few bell-kraters, standed dinoi, lebetes and pelikai are assigned to the L.C. Group, but, out of fewer than eighty pieces listed, more than sixty are calyx-kraters of a distinctive shape: tall and narrow, the walls almost vertical below spreading to a wide rim, handles sharply incurved, a tall, narrow stem. This form, the end of a general tendency, is already almost reached, so far as the fragmentary state allows one to say, not only in the beautiful piece with Marsyas from Al Mina but in one from Olynthos which cannot be later than the mid-century.[148] Neither of these, however, belongs stylistically to the L.C. Group, and it seems likely that that

does not begin before the forties. It is interesting that recorded provenances for this Group are exclusively in Greece and, where more particularised, in Boeotia. The Group was isolated in Hahland's admirable book.[149] He noted the existence within it of three painters, and these were accepted both by Schefold and Beazley. None of them is a master: there is no fine drawing, but a certain standard is maintained. The Erotostasia Painter's name-picture (fig. 296: Aphrodite weighing two Erotes in scales, with Hermes) has charm.[150] There are action-scenes; but typically the tall, narrow field is occupied by big, quiet figures, many of them draped women, with a good deal of white and some other colours, and these decorate the tall shape effectively.

289

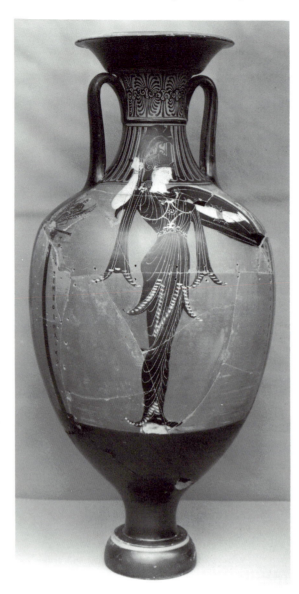

Fig. 294. Panathenaic prize-amphora with name of archon Pythodelos (336/5); Hobble Group. Athena. H. *c.* 0.82.

Remarkable are two vases in Munich,[151] calyx-kraters of L.C. type, but not in red-figure. The vase is completely blacked and decorated with figures in added colour: Gnathia technique, but these are unquestionably Attic work. The best preserved picture (fig. 297) has a single figure. Draped Aphrodite stands facing us, resting an elbow on an acanthus-column, a bird on her hand, a long sceptre leaning across her shoulder, and inclines her head towards a little Eros who hovers at her side. She has all the air of a figure on a krater of the L.C. Group, and I have little doubt that these are a late experiment by one of those painters.

Of much the same character as this and the red-figure women of the L.C. Group is the Nike on the Pythodelos panathenaic of 336/5; and I believe that this too is a product of the same workshop. Two other vases from the same archonship are listed by Beazley as the Hobble Group,[152] related to the Nikomachos Series. He regards the reverse of one at least of these as being not far from the vase we have just mentioned, but not by the same hand.[153] I suppose that these also come from the L.C. workshop, and that further research would reveal more links between the two series, in red-figure and black-figure. This might help us to get nearer defining the moment at which red-figure in Athens comes to an end.

Among twenty pieces listed in the Nikomachos Series Beazley assigned fourteen to four stylistic groups,[154] and one might see if any of these could be related to any of the L.C. Group painters. The first of the Nikomachos sub-groups comprises two of the three vases painted for the games of 338, one at least of which I have suggested is connected with the Eleusinian Painter.[155] The second has two vases for the games of 330 and two for those of 326. The archons are Nikokrates (333/2), Niketes (332/1) and Euthykritos (328/7). A second vase from the archonship of Niketes, in London,[156] which Beazley lists only as showing connections with the Nikomachos Series, has been associated by Peters with the L.C. Group (figs. 298 and 299). The third of Beazley's stylistic sub-groups has four vases for the games of 322 (archons Hegesias, 324/3, and Kephisodoros, 323/2), and one for those of 318; the fourth, one for 318 and two on which the archon-name is lost. These games of 318 are the last from which complete vases with archon-names survive: Archippos (321/0), Neaichmos (320/19). We know from a fragment that the practice continued at least until Polemon (312/11, games of 310)[157] but it is very unlikely that any red-figure was still being produced in Athens then.

Why did figured vase-painting now, after such long dominance, cease in Athens, while beyond the Ionian Sea red-figure went on for a considerable time, with Gnathia and other developments in polychromy deep into the Hellenistic age? (The continued production in Athens of prize-panathenaics in black-figure was motivated by the traditional conservatism of ritual.) This question must come to mind but probably cannot be answered. The *coup de grace* was possibly given, directly or indirectly, by the laws limiting expenditure introduced in 317 by Demetrios of Phaleron, but it is possible that the process was over before that, certain that contraction in production was by then far advanced. The cessation is consonant with the way Attic vase-painting from the later fifth century on had turned its back on developments in panel- and wall-painting, but that does not provide a reason why; it is a phase in

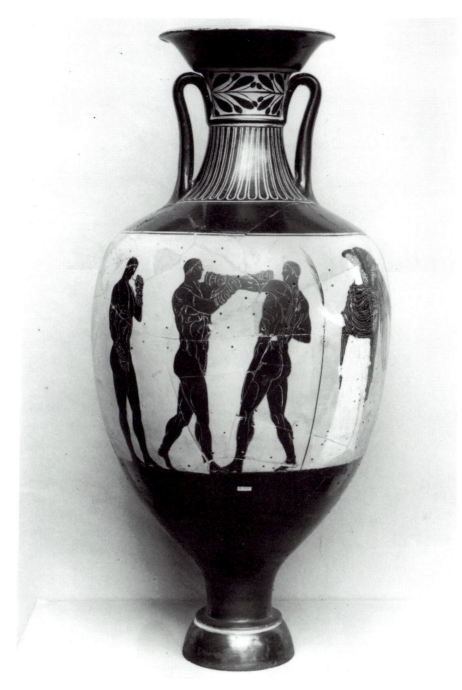

Fig. 295. Panathenaic prize-amphora with name of archon Pythodelos (336/5); Nikomachos Series. Boxers. H. *c.* 0.82.

the passing of the craft and its attendant art, not a cause of it. The process of cessation is also something we cannot trace with any precision. Did the bulk production of artistically worthless small stuff (the F.B. Group, the YZ Group) outlast the fine ware or, as I rather suspect, fail before it, or did they go out together?

None of these questions seem answerable in the present state of our knowledge; but on one aspect of the process of dissolution we do have some unexpected and enlightening evidence. This we will consider in the next section.

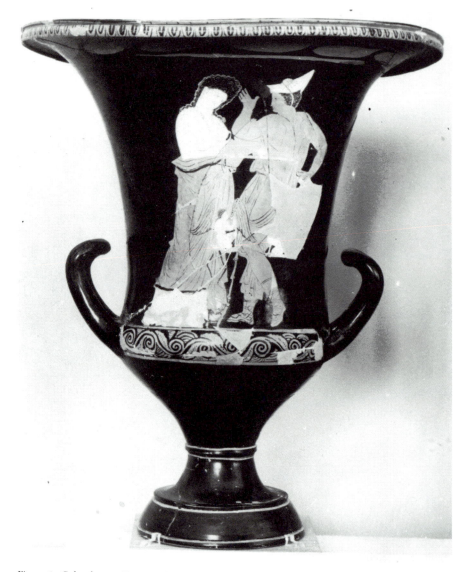

Fig. 296. Calyx-krater; Erotostasia Painter (L.C. Group).
Aphrodite weighing two Erotes, Hermes. H. *c.* 0.47.

IV. Kittos and Bakchios, sons of Bakchios

We noticed a panathenaic in London, canonical in most respects, which can be dated to the archonship of Polyzelos (367/6), not only because the Athena closely resembles that on four which bear this name, but because the columns carry the same symbol as those, Triptolemos.[158] This vase, however, carries no archon-name but a *poietes* inscription with the name Kittos. There are several other panathenaics of this period which are without an archon-name, and it has been suggested that these are not prize-vases but specimens submitted to obtain the order. This seems very probable.

One might think the idea supported by the addition of the *poietes*-inscription, but what other evidence there is makes this doubtful. Several of the not numerous panathenaics of the period which lack the archon's name do not have the *poietes* inscription either; and, more tellingly, one of the few other *poietes*-inscriptions is combined with the name of an archon. However, there will be more to say about this in a moment.

A fragment from Lindos (Rhodes) in Istanbul[159] has part of a column, on one side *Hippo...*, on the other *Bakch...* The first is Hippodamas, archon 375/4. The second can safely be restored *Bakchios epoiesen*, since that is found along a column on a fragment of a

292

Fig. 297. Calyx-krater; not attributed. Aphrodite. H. *c.* 0.48.

panathenaic from the Kerameikos.[160] There was no archon-name on that; and other fragments from the same vase show that Athena faced left and that the reverse had a horse-race. The only other *poietes*-inscription on a fourth-century panathenaic, a fragment from Eleusis, preserves only the last two letters of the name, . . . *os epoese*.[161] Here again there is no archon-inscription, but the piece is associated by two very unusual features with the fragment from the same site which has the name of Charikleides (363/2) and two others which go with it.[162] On all four, Athena, though still facing left, has the wrap typical of the later right-facing type; and the column is an acanthus-column.

Bakchios and Kittos are of peculiar interest to us

because both names are found in two inscriptions on stone, which unquestionably refer to ceramists active in Athens in this period. The first[163] is a tombstone from Athens of one Bakchios son of [A]mphis [tratos]? of the deme Kerameis, which is dated by the letter forms to the second half of the fourth century, perhaps around 330. It is the stepped base of a lost monument, so certainly antedates Demetrios of Phaleron's laws of 317. On the upper step are name, patronymic and deme, so Bakchios was an Athenian citizen; on the lower an elegiac verse: 'Of those craftsmen who blend earth, water, fire into one by skill (*techne*) Bakchios was judged by all Hellas first for natural gifts; and in every contest appointed by this city he won the crown.' The periphrasis at the

293

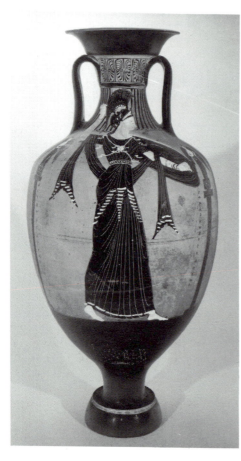

Figs. 298 and 299. Panathenaic prize-amphora with name of archon Niketes (332/1); related to Nikomachos Series. Athena; *pankration*. H. *c.* 0.78.

beginning is poetic usage for a potter. The reference to competitions is interesting in view of the idea that panathenaics without archon-name were specimens of work. The evidence is compatible with a modification of that theory; that vases were so submitted; and that such specimens might, though they need not, bear the name of either archon or *poietes*.

The second inscription is from Ephesos.[164] It is not dated, but has been shown to be before 321 but not much before. It records a decree of the senate (*boule*) and people of Ephesos, and says that Kittos and Bakchios, sons of Bakchios, Athenians, who have undertaken to provide, at the price established by law, black pottery for the city and the hydria for the goddess, shall, so long as they remain in the city, be citizens of Ephesos, and their descendants also.

We cannot, I suppose, say with absolute certainty that the Bakchios of the tombstone is identical with the father of the emigrants, but it is far more likely than not; probable too that it is he whose name appears as *poietes* on the fragments of panathenaics from Lindos and the Kerameikos. We can in any case be quite sure, given the regular Greek practices of keeping a craft in a

family and repeating family names, that the people named in these two inscriptions and the Bakchios and Kittos who have left their names as *poietai* on panathenaics were all members of one family of Athenian ceramists. The Kittos whose name appears on a vase of 367/6 cannot be the emigrant of the name; uncle perhaps, or cousin. The names, it is worth noting, suggest a family devotion to Dionysos, appropriate among potters: Bakchios, 'of Bacchus'; Kittos, the Attic form of *kissos*, ivy.

This happy cluster of finds throws real light on the Kerameikos in the fourth century. We see citizens running a flourishing family business, supplying prize-vases for the Panathenaic games and no doubt also producing red-figure and plain black. Familiarity with this last is implied in the Ephesian decree, and in any case it was, I am sure, a main line of production in all Athenian pottery-workshops over the period covered in this book. It also helps to clarify our picture of the character and status of a *poietes*. The Kittos and Bakchios who were given citizenship in Ephesos much have been workshop-owners, but they must also have been respected for their expertise as craftsmen, as the epitaph of the Athenian citizen Bakchios the elder shows that he was. All this confirms an impression we have already registered, that the head of a pottery was often at least someone who had worked his way to that position through practice of the craft.

The decision of the younger Bakchios and Kittos to

emigrate to Ephesos is also extremely interesting. A severe economic crisis in Athens is implied in Demetrios of Phaleron's laws of 317, with their drastic curbs on spending. In the aftermath of the Macedonian conquest, Athens had to adjust to becoming a minor power, with all that that implies; and it need not have been economic pressure alone that made many unhappy to go on living in the once-great city. We saw that around 400, in the shadow of an earlier defeat and at a time of crisis over markets for pottery, at least one *poietes*, Xenophantos, seems to have emigrated to Crimea, others possibly to Etruria.[165] We have traced a recovery in the Kerameikos from that trough. This time the crisis proved terminal for fine decorated pottery in Athens. Our only documented emigrants are Kittos and Bakchios, but we have seen reason to wonder if others may not have followed Xenophantos's northern road.[166] Yet others may have gone west again, probably not this time to Etruria but to Campania. Some of the really bad Attic red-figure in the fourth century is hard to distinguish from Campanian;[167] and there is a case involving black pottery which is of particular interest in light of the Ephesian inscription.

Black ware is outside the scope of this book, but we have had occasion more than once to refer to it, and it is important not to forget its large role in Attic production. There is a wide range of quality, but the standard is in general high and the best is very fine indeed. Most of it is smaller pots: drinking vessels of all types, plates, jugs, oil- and scent-bottles, pyxides, lekanides and so on; but there are also, scattered over the fifth and fourth centuries, many larger pieces: amphorae, pelikai, stamnoi, hydriai and kraters of all kinds. In the fourth century there is one distinctive class which merits our consideration.

Quite a large number of big black vases of various shapes share a consistent principle of decoration and are surely the product of one workshop. The shapes are pelike, hydria, oinochoe and calyx-krater. The whole vase is black, the lower part ribbed, the upper smooth and adorned with a 'necklace' in applied clay carrying gilding. The quality throughout is superb, and some pieces are very large. The shapes of pelike, hydria and calyx-krater are analogous to red-figure pieces of

around the mid-century and later, the calyx-krater less elongated than in the L.C. Group. Kopcke in his study of these vessels isolated a group, evidently designed to look like the others, but the technique in various points and degrees coarser and less careful. The clay too could only with difficulty be accepted as Attic, and he showed reason to think that these vases were produced in Campania. He went on to suggest, very convincingly, that they are productions of an immigrant Attic workshop.[168]

Most of the black ware which Kittos and Bakchios undertook to supply for their new city will have been for everyday use, mainly no doubt the smaller pots and cups that make up the bulk of Attic black pottery. There will, however, have been occasions for more elaborate productions, and the most prestigious is specified in the decree: 'the hydria for the goddess'. The goddess is Artemis, 'Diana of the Ephesians', who from time immemorial had stood to Ephesos as Athena to Athens. The hydria must have been something required for a major recurrent festival, like the *peplos* (robe) for Athena at the four-yearly Greater Panathenaia. It is not specified, perhaps not even implied, that the hydria shall be black; but the unrivalled quality of the black slip was one of the things which gave Attic pottery its particular cachet and was evidently one of the reasons why the Ephesian *boule* wanted to acquire the services of these Athenian potters. The 'hydria for the goddess' was presumably a ritual vessel of traditional importance. Remembering religious conservatism (illustrated by the persistent use of black-figure for the prize-vases in the Panathenaic games) one cannot suppose that the Ephesians would have contemplated having it decorated in an alien Attic style, red-figure or black-figure. A black slip is common in all local Greek wares; only Attic potters had learned to produce it superlatively well.

There is nothing to connect the family of Kittos and Bakchios with the workshop from which came the superb black pots we have just been considering; but if we envisage the vessel they undertook to make for Artemis in the form of such a great black hydria, with fluted body and a gilded garland round the neck (fig. 300),[169] I doubt if we shall be much wrong.

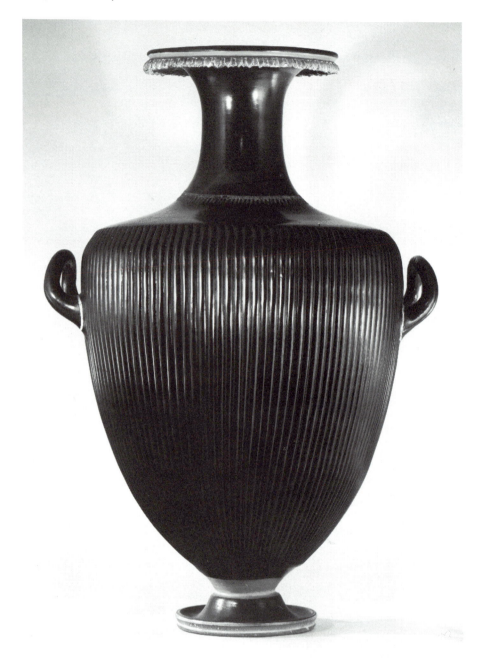

Fig. 300. Hydria (kalpis). Black; ribbed below; necklace above in applied clay, gilded. H. *c.* 0.54.

NOTES

Introduction

[1] Conspectus of the Greek Bronze Age: Vermeule (1964). Mycenaean pottery of Attica: Stubbings (1947).

[2] The 'dark age': Desborough (1964, 1972); Snodgrass (1971).

[3] Protogeometric: Desborough (1952). Geometric: Coldstream (1968).

[4] Surveys of painted pottery, Geometric to red-figure and beyond: Arias, Hirmer and Shefton (1962); Cook (1960). In general surveys of Greek art: Boardman, Dörig, Fuchs and Hirmer (1966); Robertson (1975, 1981).

[5] Bronze tripod-cauldrons: Benton (1938); Willemsen (1957).

[6] Attic orientalising ('Protoattic'): Cook (1938); Hampe (1960); Kübler (1950). 'Black-and-white style' and Aigina: Morris (1984).

[7] Corinthian Geometric and orientalising ('Protocorinthian' and 'Corinthian'): Amyx (1988); Johansen (1923); Payne (1931, 1933). Corinthian and Attic black-figure: Beazley (1951), 13–25 (= 1986, 12–23); Payne (1931), 190–202.

[8] Technique: Noble (1966); below, p. 7 with Chapter 1 n. 5.

[9] Attic black-figure: Beazley (1927, 1928a, 1932b, 1951 (= 1986) and 1956); Boardman (1974). Kleitias: Maetzke (1981). Lydos: Rumpf (1937); Tiverios (1976). Exekias: Technau (1936). Amasis Painter: Beazley (1931a); Karouzou (1956); Bothmer (1985); True (1987). Pictures in Boardman: Kleitias, figs. 46.1–7; Nearchos, figs. 49f; p. of Acrop. 606, figs. 47f; Lydos, figs. 64–71; Exekias, figs. 97–106; Amasis Painter, figs. 77–91.

[10] See Bothmer (1987).

[11] Klein (1886); Hartwig (1893); F. Hauser in Furtwängler and Reichold (1904–1932); Furtwängler, ibid. and (1885).

[12] Meaning of epoiesen: Beazley (1944); Cook (1971); Robertson (1972); Eisman (1974). Fragments with autos poi[esas]: Athens Acr. 2134; Graef (1901–14) pl. 94; ABV 347; below, p. 18 with Chapter 1 n. 42. Nikosthenes and Pamphaios: below, p. 16 with Chapter 1 n. 32.

[13] Stähler (1967).

[14] E.g. Francis and Vickers (1981, 1983); Vickers (1985a, 1988).

[15] E.g. Vickers (1985); Gill and Vickers (1989, 1990). (In the last, the extreme position slightly modified.)

[16] Examples: Vickers (1985) pl. 4(c); Gill and Vickers (1990) figs. 1, 3, 4 and 5.

[17] Cook (1987); Robertson (1985, 1987).

[18] Corbett (1965).

[19] See below, p. 292, with notes 158–69.

[20] See below, p. 50, with n. 45; p. 97 with n. 308.

[21] See below, p. 78 with notes 205–9; p. 140, with notes 36–43.

1 The beginning of red-figure

[1] Beazley (1931a), 258f.

[2] E.g. Beazley (1986) pls. 50.2, 54.1 (= 1951, pl. 23.1), 55.1, 56.2; Bothmer (1985) 49 fig. 7, 109 fig. 67, 110f no. 18bis, 126 no. 23, 152 fig. 92, 164 no. 37, 199 fig. 104.

[3] See Robertson (1973).

[4] Levi (1929), 338–41 fig. 443a–d; 359f fig. 472a–b.

[5] Technique: Noble (1966); cf. above, p. 9 with n. 8. Preliminary sketch: Corbett (1965).

[6] See below, p. 254, with notes 12f; p. 266 with notes 6–7.

[7] Homer Thompson in a lecture; see below, p. 11 with notes 14f.

[8] See Introduction, with notes 15f.

[9] Six's technique: Six (1888); Beazley (1928) 8; Grossmann (1991); see also below, p. 131 with n. 597. Etruscan: Beazley (1947) 3 and Chapter 12.

[10] See below, p. 33 with n. 81.

[11] Bilinguals: Cohen (1978). Andokides and the Andokides Painter: ARV² 1–6; Lysippides Painter (called after a kalos-name) and his group: ABV 252–65; and see following notes. Pictures (all called Andokides Painter) in Boardman (1974) figs. 160–6, (1975) figs. 2–10.

[12] Cerberus: Andokides Painter, ARV² 4.9; Lysippides Painter, ABV 255.8; Boardman (1974) figs. 162f. Bilingual cup: ARV² 5.14; ABV 256.21; Boardman (1974) fig. 160. Eye-cups: below, p. 16 with n. 28.

[13] Beazley's views: VA 3–5 implied they are the same; AV 7, some of black-figure certainly not by same hand as red-figure (following Langlotz (1920) 23–31); (1928a) 40, might be the same; ARV¹ 1, the same; (1951) 75–8, the same; ABV 254, different; this opinion maintained thereafter. See also Rumpf (1953) 60–1, the same; Marwitz (1963), the same (the fullest statement of the case); Knauer (1965); Bothmer (1966), different.

[14] See in particular Bothmer (1966). Sculptor-painter on Siphnian Treasury: Robertson (1975) 157.

[15] Above, p. 9 with n. 7.

[16] See below, p. 32 with notes 72–7.

[17] Francis and Vickers (1983) 54–9.

18 Andokides bilingual: Madrid 11008; *ABV* 294.24; *ARV²* 7.2. Menon amphora: Philadelphia 5399; *ARV²* 7.3. Hilinos/Psiax alabastra: *ARV²* 7.4, 5.

19 Psiax: *ABV* 292–5; *ARV²* 6–9; Smith (1929); Richter (1934); Boardman (1974) figs. 167–70; (1975) figs. 11–15.

20 Antimenes Painter and his circle: *ABV* 266–97; Beazley (1927); Boardman (1974) 186–90; Burow (1989).

21 Andokides neck-amphora: London, 1980. 10–29.1; *ABV* 293.7; Beazley (1986) pl. 81.2–4. White slip: below, p. 51, with notes 50–5. This decorative scheme on metal vessels: see below, p. 35, with n. 95.

22 New York 14.146.1; *ARV²* 8.9.

23 New York 63.11.6; *ARV²* 1617 (*Para* 321), 2*bis*; Bothmer (1966) figs. 1, 2, 4, 5, 8, 10 and 11. Dionysiac scene: Boardman (1975) fig. 6.

24 Berlin 2159; *ARV²* 3.1; Boardman (1975) fig. 3.1–3; Knauer (1965).

25 Neck-amphora: see below, p. 15 with n. 27, and p. 34 with n. 88.

26 *ARV²* 6.

27 Early red-figure neck-amphora: *ARV²* 11.2; hydriai, *ibid.* 12.7–9. See also above, p. 13 with n. 25; below, p. 16 with n. 33 and p. 34 with n. 88, p. 35 with notes 98–104, p. 36 notes 112–19.

28 Andokides eye-cup: above, p. 11 with n. 12. Eye-cups: *ARV²* 37–52; Cohen (1978), 246–9, pls. 1.1, 46.3, 47, 49.1, 2. Pictures: Boardman (1974) figs. 173, 176–8, 183; (1975) figs. 14, 61, 66–8, 79 and 83. See also below, p. 107 with notes 371–3.

29 London E 3; *ARV²* 70.3.

30 Syringe: Noble (1966) 56–8; hair: Seiterle (1976) 34. Now, in support of Seiterle, see Hemelrijk (1991) 239–41.

31 Hischylos: *ABV* 166–7; *ARV²* 161–2.

32 Nikosthenes: *ABV* 216–35; *ARV²* 122–3. Pamphaios: *ABV* 235–6; *ARV²* 127–32.

33 *ARV²* 53.1–2; *Para* 327.1*bis*; Boardman (1975) fig. 56.

34 See below, p. 22 with notes 7–16.

35 London E 347; *ARV²* 54.5; Boardman (1975) fig. 54.

36 See below, p. 33 with notes 79–81.

37 Villa Giulia: *ARV²* 77.90; Cohen (1978) pl. 91. Foot dissociated by Cohen (1991) 89 n. 68.

38 Below, p. 107 with notes 371–3.

39 Below, p. 44 with notes 12–16.

40 Below, p. 89 with notes 277–81; p. 138 with notes 23–9.

41 Athens Acr. 6; Graef and Langlotz (1929) pl. 2; *ARV²* 78.102. Late character: Callipolitis-Feytmans (1974), 216–17.

42 Above, p. 4 with n. 12.

43 Athens Arc. 806; *ARV²* 240.42; Boardman (1975) fig. 168.

44 Below, p. 124 and p. 127 with notes 527, 549.

2 A time of ferment

1 See, e.g., Robertson (1981) 45–50.

2 *Ibid.* 40–2.

3 *Kalos*-inscriptions: Klein (1898); Robinson and Fluck (1937); Webster (1972). Euaion son of Aeschylus: below, pp. 207 and 211 with notes 91f and 109.

4 Langlotz (1920). Against this line of argument: Francis and Vickers (1981).

5 Munich 2590; *ARV²* 24.12; Boardman (1975) fig. 42.

6 Munich 2620; *ARV²* 16.17; *Capolavori* (1990) 180–3.40; *Euphronios* (1990) 184–8.41; Boardman (1975) figs. 26.1 and 2.

7 *ARV²* 59.54–7 and 60; on 58.51 see below with notes 11f.

8 Formerly in the Bunker Hunt Collection; Robertson (1981a) 23–5; Bothmer (1981) 57; Tompkins (1983) 54–57; *Capolavori* (1990) 58–61.1; *Euphronios* (1990) 168f.34.

9 See below, with n. 24.

10 J. Paul Getty Museum 77.AE.20; Robertson (1981a) 25f; *Capolavori* (1990) 62f.2; *Euphronios* (1990) 170f.35.

11 London E 41; *ARV²* 58.51 (Oltos); *Capolavori* (1990) 64–7; *Euphronios* (1990) 174–6.36. Many other cup-fragments, early and mature, are now assigned to Euphronios: see *Euphronios* (1990) 178–211.38–40, 42–3, 44–6, 48–50. There is also a small signed cup, Munich inv. 8953, *ibid.* 198f.47. An important signed cup is discussed below, with Chapter 3 n. 9.

12 Robertson (1981a) 26.

13 *ARV²* 60.64 (Berlin 2264) and 66 (Tarquinia RC 6848). Pictures: Berlin, *LIMC* 1, Antilochos 6; Tarquinia: Arias *et al.* (1962) pls. 100–4. An analogous cup, London E 8, *ARV²* 63.88; Boardman (1975) fig. 65.

14 Vienna, Univ. 631a and Boston 10.219; *ARV²* 54.3 and 6; *Para* 326; Robertson (1965). For amphorae Types A–C, see p. 71.

15 London E 258; *ARV²* 54.4; Boardman (1975) figs. 57.1 and 2.

16 Kachrylion: *ARV²* 107–14; Euxitheos/Euphronios kraters: see below, p. 24 with notes 23f.

17 *ABV* 145.19 (picture, Boardman (1974) fig. 103), and 148.9; *Para* 62.9*bis*.

18 *ABV* 275.134, 135; 280.56; 284.10; 289.27. See also Robertson in True (1987) 18.

19 Below, with n. 122.

20 Louvre G 103; *ARV²* 14.2; *Capolavori* (1990) 82–5.8; *Euphronios* (1990) 60–6.2; Boardman (1975) fig. 23.

21 Louvre G 110; *ARV²* 14.3; *Capolavori* (1990) 76–81.7.

22 London B 193; *ARV²* 4.8. Picture: Boardman (1975) fig. 10.

23 Louvre G 33; *ARV²* 14.4; *Capolavori* (1990) 148–51.28; *Euphronios* (1990) 108–13.11. See also below, p. 81 with n. 224.

24 New York 1972.11.10; Bothmer (1976, 1981); *Euphronios* (1990) 77–88.4; Boardman (1975) fig. 22.

25 Above, with n. 8.

26 Robertson (1981a) 23–4.

27 Above, p. 10 with n. 11; below, p. 100 with notes 335f.

28 Below, p. 119 with n. 473.

29 Herakles: Milan 06.590; *ARV²* 14.5; *Capolavori* (1990) 94f.10; *Euphronios* (1990) 104f.8, Athena: J. Paul Getty Museum 77.AE.86; Robertson (1981a) 27–8; *Capolavori* (1990) 114f.17; *Euphronios* (1990) 102f.7. Another: New York 11.140.6; *Euphronios* (1990) 114.12.

30 New York, Shelby White and Leon Levy (ex Hunt); Robertson (1981a) 29–34; Tompkins (1983) 58–61.6; *Capolavori* (1990) 86–93.9; *Euphronios* (1990) 96–101.6.

31 Berlin 2180; *ARV²* 13.1; *Capolavori* (1990) 163–7.33; *Euphronios* (1990) 53–59.1; Boardman (1975) figs. 24.1–3.

32 Below, p. 26 with n. 36.

33 Chalcidian psykter–neck-amphorae: Rumpf (1927) 26–7, nos. 109–12; 121–2; 181 fig. 11; pls. 116–23. Chalcidian psykter-amphora: Trendall (1958) 5–8, pls. 1–4. Attic black-figure psykter-amphora: London B 148; *ABV* 109.29, Lydos. Attic red-figure psykter-column-krater: New York 1986.11.12; Christie (1986) 38f. no. 141; early fifth century.

34 Psykters: Drougou (1975). Euphronios's signed piece: below, p. 27 with n. 42; Euthymides's: below, p. 30 with n. 67; later pieces: below, p. 92 with n. 285, p. 144 with n. 62.

35 Brussels A 717; *ARV*² 20.1; Boardman (1975) fig. 32.1 and 2.

36 Munich 8935; *ARV*² 1619 and 1705.3*bis*; *Para* 322; *Euphronios* (1990) 89–95.5; Vierneisel (1967); Ohly (1971); Boardman (1975) fig. 25.

37 Below, p. 22 with n. 48; p. 32 with n. 71.

38 Below, p. 30 with n. 66.

39 Below, p. 27 with n. 42.

40 J. Paul Getty Museum 82.AE.53; Frel (1983) 147–50; Keuls (1988).

41 By Frel (see n. 40) and Bothmer (1989) 26; *Capolavori* (1990) 192f.43; *Euphronios* (1990) 234–7.60.

42 Leningrad 644; *ARV*² 16.15; Peredolskaya (1967) pls. 14 and 15; *Capolavori* (1990) 146f.27; *Euphronios* 164–7.33; Boardman (1975) fig. 27.

43 I cannot find where I read this suggestion.

44 Frontal faces: Korshak (1987).

45 Robertson (1975) 44–5, 58–9; Bonfante (1989) 558–62.

46 Below, p. 48 with n. 41; p. 51 with n. 48; p. 64 with n. 127.

47 Kottabos: Sparkes (1960); Phintias's vase: next note.

48 Munich 2421; *ARV*² 23.7; Boardman (1975) fig. 38.1 and 2. Development of hydria: below, p. 35 with notes 98–100.

49 Below, p. 89 with n. 277; p. 167 with notes 39–41.

50 London E 159; *ARV*² 24.9.

51 Robertson (1967) 6 with n. 10.

52 Atheus, Agora P 24106; Sparkes and Talcott (1958) 32.

53 Slab N. VI.

54 Louvre G 42; *ARV*² 23.1; *Euphronios* 243–7.62; Boardman (1975) fig. 41.1 and 2. Tarquinia RC 6843; *ARV*² 23.2; Boardman fig. 40.1 and 2.

55 Below, p. 157 with n. 159.

56 Berlin inv. 3210; *ABV* 151.21; Beazley (1986) pl. 55.1.

57 Beazley (1951) 58 (= 1986, 54); Bothmer (1985) 53.

58 Below, p. 39 with n. 139; p. 44 with n. 9.

59 J. Paul Getty Museum 80.AE.31; *ARV*² 1620.12*bis*; Frel (1983) 150.

60 Psykter: below, p. 30 with n. 67; cup: below, p. 39 with n. 139.

61 Above, p. 26 with n. 35.

62 Munich 2307; *ARV*² 26.1; Boardman (1975) fig. 33.1 and 2.

63 Munich 2308; *ARV*² 26.2; *CVA* pls. 169–71.

64 Pinney (1983).

65 Vos (1963).

66 Above, p. 26 with n. 38.

67 Turin 4123; *ARV*² 28.11; Boardman (1975) fig. 36.

68 Munich 2309; *ARV*² 27.4; Boardman (1975) fig. 34.1 and 2.

69 Louvre G 44; *ARV*² 27.3.

70 Below, p. 92 with notes 278–280.

71 Neumann (1977); Engelmann (1987).

72 Black-figure families: Beazley (1932b), *ABV* 162–3, 178. Kleophrades son of Amasis: Bothmer (1981a) 1–4, (1985) 230–1; below, p. 56 with n. 87.

73 Robert, C. in *RE* s.v. Euthymides; Robertson (1975) 130 (with n. 124), 227.

74 Raubitschek (1949) 522f.

75 Boardman (1956) 20–3; Robertson (1975) 226.

76 Above, p. 11 with n. 15.

77 Jeffery (1962), 127 no. 19; Deyhle (1969) 12–39.

78 Above, p. 11 with n. 15.

79 Above, p. 17 with n. 35.

80 Euphronios: Louvre Cp. 11070 and Leipzig T 523; *ARV*² 15.9 and 10; *Euphronios* (1990) 123–7.14, 15. Signed by Smikros: Brussels A 717 (above, n. 35); London E 438, *ARV*² 20.3; a third attributed, Louvre G 33, *ARV*² 20.2.

81 The stamnos: Philippaki (1967); Pamphaios/Oltos, 2–4; black-figure, 9–24; pseudo red-figure, 25–9, pls. 15.4 and 19; Euphronios and Smikros, 4–8. Other pictures of pseudo red-figure stamnoi: Jacobsthal (1927) pls. 87, 89 and 90. See also Grossmann (1991).

82 The pelike: Becker (1977); and see notes 83, 84 and 86.

83 Alabastron: below, p. 52 with n. 57.

84 Black-figured pelikai: Bothmer (1951); Becker (1977).

85 Neck-pelikai: Becker (1977) 11; and see below, p. 78 with n. 203. Neck-pelikai by Euphronios: Rome, Villa Giulia, *ARV*² 15.11, *Euphronios* (1990) 154–6.29; Villa Giulia and Chicago University, *ARV*² 16.12, *Euphronios* (1990) 150–3.27/28. Pelike by Euthymides: Louvre G 31, *ARV*² 27.9.

86 E.g. *Para* 1–2.1–3 (Chimaera and Nettos Painter).

87 Leningrad 615; *ARV*² 1594.48. Boston 1973.88: not known to Beazley; Robertson (1977).

88 Above, p. 13 with n. 25.

89 Euphronios: Louvre G 10 and C 11071, *ARV*² 15.9 and 10; Manner, Louvre G 106 and 107, Leningrad 610; *ARV*² 18.1–3; these and others, *Euphronios* (1990) 128–49, 16–26. Smikros: Berlin 1966.19; *Para* 323.3*bis*. Euthymides: Syracuse 49305, Louvre C 11072, Warsaw 142332; *ARV*² 27.6–8; and one, not known to Beazley, in Malibu (the piece with a maeander-band on the neck).

90 Beazley (1928) 13–15, pls. 4–6; satyr: Boardman (1975) fig. 37.

91 Above, p. 22 with n. 15.

92 Psiax's plates: London B 588–93 (B 590, Boardman (1974) fig. 169), Berlin 2099; *ABV* 294.17–20; 21 is different: see below, p. 51 with n. 51. Paseas's: *ARV*² 163.1–9 (6 and 8, Boardman (1975) figs. 16 and 17). On Paseas (Cerberus Painter) see *ARV*² 164; also below, p. 51 with n. 54.

93 Below, p. 85 with notes 254–6 (phiale); p. 99 with n. 321 (kantharos).

94 François vase: above, with n. 9. Antimenean volute-kraters: *ABV* 280.55, 289.26. Nicosthenic: *ABV* 229, London B 364.

95 Vix krater: Joffroy (1954); Robertson (1975) 144–5, pls. 45 and 46a.

96 Hackwork in red-figure: *ARV*² 221.13–16, 223 (above).2, (below).1–4, 224.1–3, Nikoxenos Painter and his circle. No doubt some of the black-figure examples come from the same shop. Euthymides: Serra Orlando; *ARV*² 28.10; *AJA* 63 (1959) pl. 43, figs. 24 and 44.

97 See below, p. 44 with n. 11.

[98] Antimenean: *ABV* 266–9.1–35; 276f.1–14; 280f.1–12; 282.1–2; 287.13–14. Lysippidean: 256.18; 260.30–41; 263.6, (below) 1–2; 264.1.

[99] Below, p. 36 with notes 113–19 and 121.

[100] *ARV*² 12.7–9.

[101] Above, p. 28 with notes 48 and 50. Munich 2422; *ARV*² 24.8.

[102] Hypsis: Munich 2423; *ARV*² 30.1; Boardman (1975) fig. 43. Pioneer Group: *ARV*² 33f.8–12.

[103] Below, p. 80 with notes 216–18.

[104] Euphronios: Dresden cv 295; *ARV*² 16.13; *Euphronios* (1990) 137f.30 (see also 31). Phintias: *ARV*² 24.10. Euthymides: *ARV*² 28.12–16 (14, Boardman (1975) fig. 35); his manner: *ARV*² 29.1. Hypsis: *ARV*² 30.2 (Boardman (1975) fig. 44. Dikaios Painter (imitator of Euthymides): *ARV*² 31.7 (Boardman (1975) fig. 46). Pioneer Group: *ARV*² 34.13–17. See also below, p. 61 with notes 123f.

[105] E.g. the lekythos, oinochoe and eye-cup grouped as the Painter of Oxford 1949, *ARV*² 9–10.

[106] *ARV*² 10.1–4 (1–2, Beazley (1928) pl. 3; 3, Boardman (1975) fig. 21). See Beazley *ARV*² 10 and (1928) 11–13; Peters (1941) 59 (identification with Euphiletos Painter); Bruckner (1954) 52–3 and 67.

[107] *ABV* 357–91; Beazley (1928a) 26–8, pls. 13–15; (1951) 81–5, pls. 39–43 (1986, 74–80, pls. 84–8).

[108] Naples inv. 128933; *ABV* 367.93; Beazley (1928a) pl. 13.

[109] Touloupa (1983). An interesting discussion in Francis (1990) 8–16.

[110] Oxford 1927.4065; *ARV*² 62.77; *CVA* pls. 53.3 and 4.

[111] Above, p. 22 with notes 11 and 12.

[112] *ABV* 361f.24–8 (27, Boardman (1974) fig. 201; Beazley (1986) pl. 86; 28, *ibid.* pl. 85.3); 363.39; 379.271, 272.

[113] *ABV* 362.30, 35; 365.70; 367.86, 96; 368.97–9.

[114] *ABV* 361.13; 362.31; 371.147; 378.257–9; 380.290. *Para* 164.31*bis* (Boardman (1974) fig. 203).

[115] *ABV* 362.33 (Boardman (1974) fig. 204).

[116] *ABV* 362.34 (Beazley (1986) pl. 87.4); 367.95; 378.261; 379.281.

[117] *ABV* 362.35 (Beazley (1986) pl. 85.4 (= 1951 pl. 41)); 373.175.

[118] *ABV* 363.37 (Beazley (1986) pl. 87).

[119] *ABV* 362.36 (Beazley (1986) pl. 87.2); 371f.150–4.

[120] *ABV* 330–4; *Para* 146f; Boardman (1972) 64, 67f; Moon (1983) 97–118.

[121] Fountain-hydriai. Priam Painter: *ABV* 333.27; 334.1–5 ('A.D. Painter', subsumed in Priam Painter, *Para* 147f, adding 5*bis* to *quater*; 1, Boardman (1974) fig. 224); 335.1 (Painter of Madrid Fountain). Leagros Group: *ABV* 365f.70–4. Antimenean: *ABV* 266.1–3; 276.1; 280.1–2. See also below, p. 80 with n. 216.

[122] Priam Painter's calyx: *ABV* 332.16. Rycroft Painter: *ABV* 335–7; calyx-kraters: *Para* 149.23*bis* and *ter* (wrongly '22*ter*'; 23*bis*, Boardman (1974) fig. 227).

[123] Below, p. 130 with n. 589.

[124] *ABV* 51–62 (C Painter and related), 63–7 (Heidelberg Painter and manner), 68–75 (others); Brijder (1983); Boardman (1974) figs. 34–45.

[125] Above, p. 32 with n. 72.

[126] *ABV* 629–54; Boardman (1974) figs. 290f.

[127] Cups of this period: *ARV*² 37–180; Pheidippos, 164–6; Boardman (1975) figs. 79f.

[128] Euergides Painter and related: *ARV*² 87–106; Boardman

[129] *ARV*² 82–6, with a note on the confusion in which this distinct artistic personality has left us about his name; Boardman (1975) figs. 88–91.

[130] *ARV*² 175; Boardman (1975) fig. 126; Bothmer in Farnsworth and Wisely (1958). Hegesiboulos: below, p. 186 with n. 183.

[131] Pyxis-lid: Boston 10.216; *ARV*² 81, bottom; Pfuhl (1923) fig. 387. Disc: Athens Acr. 1073; Graef and Langlotz (1931) pl. 83. See Robertson (1978) 129 n. 30; Keuls (1988).

[132] Robertson (1978) pl. 43a. The Kleophrades Painter: below, Chapter 3 section IIc.

[133] *ARV*² 122–35; Boardman (1975) figs. 93–7; and see following notes.

[134] *ARV*² 125.20; Boardman (1975) fig. 95.

[135] *ARV*² 126.24. Painter of London Sleep and Death: *VA* 23–4; omitted from lists in *AV* and *ARV*¹; Robertson (1975) pl. 43a.

[136] Euphronios's Sarpedon cup: above, p. 22 with n. 8; krater: p. 24 with n. 24.

[137] *ARV*² 126, on 24.

[138] *ARV*² 122–58.

[139] Poseidon Painter: *ARV*² 136.1–10 (1, Birth of Athena; 10, Boardman (1975) fig. 127). Euthymides's Birth of Athena: *ARV*² 29.19; Beazley in CB (1963) 13–15.

[140] Pithos Painter: *ARV*² 139–41 (symposion-cups nos. 23–63; more in *Para*; Boardman (1975) fig. 128.

[141] Below, p. 109 with notes 391–396.

[142] Above, p. 22 with notes 7, 8, 11 and 16.

[143] Kachrylion: *ARV*² 107–15. Hermaios and Hermaios Painter: *ibid.* 107, 109–11. Chelis and Chelis Painter: *ibid.* 109, 112. Thalia Painter: *ARV*² 112–14 (Berlin cup no. 7); Boardman (1975) figs. 108–12.

[144] 'Coral red', 'intentional red': Farnsworth and Wisely (1958). Hegesiboulos cup: above, p. 38 with n. 130. See also below, p. 186 with n. 183.

[145] Above, p. 39 with n. 139.

[146] Beazley (1933) 14.

[147] *ARV*² 115f.

[148] Below, p. 87 with notes 267–72, p. 138 notes 24–9.

[149] Above, p. 21 with n. 4.

[150] The Marathon material is published in *CVA* Athens 1. Williams (1991) 4f with fig. 5 and notes 25–7.

[151] Berlin Painter: *ARV*² 196–219 (Oreithyia vase, Berlin 2186, 208.150); and see below, Chapter 3 section IId. Pictures of Boreas and Oreithyia: below, pp. 140 and 142 with notes 38 and 47.

[152] Below, p. 42 with n. 40.

3 After the Pioneers: red-figure mastery; the beginning of white-ground

[1] Kleophrades Painter: below, section IIc; Berlin Painter: below, section IId.

[2] Onesimos (Panaitios Painter): below, section IIIa; Douris: below, section IIIa; Brygos Painter: below, section IIIb; Makron: below, section IIIc.

[3] Foundry Painter: below, section IVb; Antiphon Painter: below section IVa; Triptolemos Painter: below, section Va.

[4] Below, p. 85 with notes 247f.

5 Below, section ivc.

6 Below, p. 44 with notes 12–14.

7 Below, p. 44 with n. 15.

8 Below, p. 56 with notes 87–104; p. 80 with notes 220–6.

9 Athens Acr. 176; *ARV²* 17.18; Graef and Langlotz (1929) pl. 8; *Euphronios* (1990) 191–4.44.

10 Above, p. 40 with notes 144 and 145.

11 Above, p. 35 with n. 97; Arezzo 1465; *ARV²* 15.6; Boardman (1975) fig. 29; *Capolavori* (1990) 100–7.13.

12 Boston 10.221; *ARV²* 16.14; Boardman (1975) fig. 28; *Capolavori* (1990) 72–5.6.

13 *AV* 166.1–19 and some others.

14 *ARV¹* 210–11; *ARV²* 314f; Boardman (1975) figs. 217 and 219; see below, p. 55 with notes 69f.

15 *ARV¹* 210–13; *ARV²* 315–18; Boardman (1975) 220f.

16 Below, p. 42 with notes 42–4.

17 *ARV¹* 19f.1.2; *ARV²* 19.1,2; Williams (1976).

18 Below, p. 46 with n. 31.

19 Below, p. 55 with notes 69–71.

20 Mingazzini (1969) ascribed the neck-pictures to Smikros. I am attracted by a recent modification of that suggestion by Williams: that the komasts on the front are Euphronios's own, those on the back Smikros's imitations of the front.

21 Below, p. 50 with n. 46; p. 156 with n. 152.

22 Phintias: below, p. 81 with n. 234. Euthymides: below, p. 57 with n. 93. Smikros: below, p. 84 with n. 240.

23 Eisman (1974) and (1988) on Phintias.

24 Bloesch (1940) and (1951).

25 See further in the last section of this book.

26 Above, p. 44 with n. 17.

27 Basel, Cahn 116 (ex Ferrari); *ARV²* 316.3; Boardman (1975) fig. 221; Williams (1976) 18–21 with figs. 11–14, associating it with the Berlin/Vatican fragments as very early work of Panaetian Onesimos.

28 Below, p. 48 with n. 42.

29 E.g. below, p. 160 with notes 2f.

30 Below, section b *passim*; p. 156 with notes 152–4; p. 167 with n. 46.

31 J. Paul Getty Museum, 86.AE.161; not known to Beazley; Williams (1991).

32 London B 426; *ABV* 256.20; *CVA* pl. 21.

33 London E 65; *ARV²* 370.13 (Brygos Painter); Boardman (1975) fig. 252.1 and 2; see below, p. 96 with n. 306.

34 Sarpedon cup: above, p. 22 with n. 8; Geryon cup: above, p. 21 with n. 6. Others: below, p. 84 with notes 242f (Kleophrades, Python).

35 Above, p. 39 with n. 118.

36 Below, p. 62 with n. 125, p. 94 with notes 291–4.

37 This was an important feature in Polygnotos's Troy Taken at Delphi; most recently Stansbury-O'Donnell (1989) 211–14.

38 Below, p. 62 with n. 125.

39 Cf. below, p. 104 with notes 348f; p. 114 with notes 437–44.

40 An example of the difficulties in using iconography for dating (above, p. 41 with n. 152).

41 Cf. above, p. 27 with notes 44–8.

42 Louvre G 104; *ARV²* 318.1; Boardman (1975) fig. 223.1 and 2; *Capolavori* (1990) 186–9, 42a; *Euphronios* (1990) 214–18.55.

43 Below, p. 182 with notes 137–142; p. 249 with notes 74–6.

44 On this wreath see Hampe (1936) 78; Kunze (1950) 131f; Schefold (1968) 70f.

45 See above, p. 5 with n. 19. Euphronios's Acropolis cup: above, p. 44 with n. 9. Brygos cup: below, p. 96 with note 308.

46 Louvre G 105; *ARV²* 324.60; Boardman (1975) fig. 228.

47 Brussels A 889; *ARV²* 329.130; Boardman (1975) fig. 224. Cophenhagen, Thorvaldsen Museum 105; *ARV²* 329.131; Langlotz (1922) pl. 20.

48 Bowdoin 30.1; *ARV²* 328.114; Boardman (1975) fig. 225.

49 Below, p. 99 with notes 318–20; p. 105 notes 354–7; p. 114 with n. 438; p. 136–8 with notes 17–29; also Chapter 5 section II, Chapter 6 section IIe.

50 On the material treated in this section see Mertens (1974, 1977); Wehgartner (1983).

51 White oinochoai, perhaps Nicosthenic: *ABV* 425 top and 434.1–5 (Painter of London B 620; 3, Boardman (1974) fig. 230). Psiax's white kyathos; *ABV* 294.16; Boardman (1975) fig. 171.1f; others near him, *ABV* 295.3–5. White plate: Basel 421; *ABV* 294.21; Mertens (1977) pl. 4.1. White lekythoi in this period: below, p. 86 with notes 260–2; p. 96 with n. 310.

52 Above, p. 13 with n. 23.

53 Louvre F 203; *ARV²* 4.13; Boardman (1975) fig. 4. See Bothmer (1957) 153f.

54 Oxford 1984.131,132; Greifenhagen (1976) 43–8. Paseas (the 'Cerberus Painter'): *ARV²* 163f.

55 Orlandos (1965).

56 Signed lekythos-fragment: Athens, Agora NS AP 422; *ARV²* 102.1 (top); *Hesp.* (1935) 4, 291; and see below, n. 58.

57 Pelike: above, p. 33 with n. 82. Early history of the alabastron: Payne (1931) 269–71. Alabaster examples from a tomb at Spina with Etruscan bronzes and Attic red-figure of the third quarter of the fifth century: Aurigemma (1960) pl. 48.

58 *ARV²* 90–104.

59 Athens 15002; *ARV²* 98.2; *BCH* 45 (1921) 519. London B 668, *ARV²* 98.1; Mertens (1977) pl. 18.3.

60 Below, p. 103 with notes 345f.

61 Below, p. 86 with notes 260–2.

62 Taranto and Oxford; *ARV²* 33.7; White calyx-kraters: below, p. 172 with n. 87; p. 207 with notes 91–3.

63 Pamphaios cup: New York, Mitchell; *ABV* 236.7 (*Para* 102, 107); Mertens (1974) 84 with figs. 8 and 9. Exekias cup: Munich 2044; *ABV* 146.21; Boardman (1974) fig. 104.1–3.

64 Early Panaetian cups: above, p. 44 with n. 17; p. 46 with notes 25 and 26. Ashby Painter: *ARV²* 454f (Apollo cup, London E 64, *ARV²* 455.9; Schefold (1981) 206 fig. 278).

65 Below, p. 160 with notes 2 and 3.

66 J. Paul Getty Museum 86.AE.313. See also note 68.

67 Below, p. 60 with n. 114.

68 Mertens (1974) 96 and 97, fig. 12; (1977) 271ff; Williams (1991) believes that all three are vey early works of Onesimos; and this may after all be right.

69 Eleusis Painter: *ARV²* 314f. Triton: 314.3 (Boardman (1975) fig. 217). Athena: 315.4. See also next note.

70 Papaspyridi (1925) 13–18 with fig. 14 and pl. 1a. Beazley *AV* 166.1, 2; *ARV¹* 209.3 and 5. Williams (1976) 20. Cahn (Ferrari) cup: above, with n. 27.

71 Gotha: *ARV²* 20, top; Mertens (1974) 96 and 98, figs. 13

and 14, pointing to the black-figure associations of the white exterior and noting a possible stylistic relation to the Proto-Panaetion Group; Boardman (1975) figs. 51.1–2. Sosias Painter: below, p. 58 with n. 103.

72 London D 1; *ARV²* 429.20 and 1652; Mertens (1974) 10f, figs. 21 and 22; *LIMC* IV, Europe, 1 37.

73 *Para* 349, bottom.

74 Myson: below, section VIC. Epiktetos: above, p. 18 with notes 37–41; below, p. 87 with notes 267–71; pp. 138 with notes 25–9.

75 Athens Acr. 429, 431, 438, 439, 441.

76 Below, p. 156 with n. 154.

77 Athens Acr. 441; Langlotz (1920) pl. 37; *ARV²* 333, bottom.

78 One, Florence PD 2653; *ARV²* 322.29; Mertens (1974) 98, fig. 15.

79 Athens Acr. 432, *ARV²* 332.27; Graef and Langlotz (1929) pl. 33 (letters in the interior may be from Euphronios's name); Athens Acr. 434, *ARV²* 330.5; Graef and Langlotz (1929) pls. 33 and 35. On these two see Mertens (1974) 98f with figs. 16–18; Berlin inv. 3376, *ARV²* 330.4; *CVA* pls. 51.5–7; see below, p. 98 with n. 315.

80 Louvre G 109; Waiblinger (1972). Mertens (1974) associates this with Euphronios and with the cup from Delphi, below n. 82.

81 Below, p. 156 with n. 152.

82 Konstantinou (1972); Karouzos (1974) 172–5; Mertens (1974) 106ff, fig. 28.

83 Below, p. 157 with n. 155.

84 Below, p. 186 with notes 193–9.

85 Athens, Acropolis: above, p. 56 with notes 75–7, 79. Eleusis: above, p. 55 with n. 69. Aigina, Aphaia: see next note. Aigina, Apollo: fr. lost, ex Rhousopoulos, and fr. Oxford, ex Woodward (Philippart (1936) nos. 30 and 31). Naucratis: above, p. 55 with n. 72, and there are others.

86 Aphaia cup: below, p. 156 with n. 154. Athens Acr. 434: above, p. 56 with n. 79. The same scheme is found in the red-figure exteriors of the Villa Giulia Painter's white cup in New York (fig. 178) and the white covered cup in Boston (fig. 183).

87 Above, p. 32 with n. 72.

88 Hartwig (1893) 400–20.

89 Six (1888a) 233.

90 Hauser (1909) 228.

91 Beazley (1910).

92 Below, p. 59 with n. 105.

93 Below, p. 59 with n. 109.

94 Bloesch (1951) 31–5.

95 Early amphorae Type A by the Kleophrades Painter: Würzburg 507, Vatican, Munich 2305; *ARV²* 181f.1 (Boardman (1975) fig. 129.1 and 2), 3, 4 (2, Leipzig T 666, is only a fragment).

96 Louvre G 57, *CVA* pls. 58f; Compiègne 1068, *CVA* pls. 13, 15, 16; *ARV²* 188.66 and 67.

97 AV 64.7, 8 (Euthymides); Richter (1936); *ARV²* 20, 125.57 and 58 (Kleophrades Painter). See below, p. 60 with n. 116.

98 Below, p. 61 with n. 121.

99 Munich and Würzburg, above n. 95.

100 *ABV* 404–6.

101 *ARV²* 32.1–4, 114 (where the group is called 'Pezzino Painter') and 1621.3*bis*; *Para* 324 ('Group'); 2 (name-piece after a former owner), calyx-krater in Agrigento; Schefold (1978) fig. 309. See also Ohly-Dumm (1984) 168.

102 Private collection, unpublished.

103 *ARV²* 21.1; Boardman (1975) figs. 50.1 and 2. See also following notes.

104 Athens Acr. 556; Graef and Langlotz (1929) pl. 42; *ARV²* 21.2.

105 Ohly-Dumm (1984). I much regret that in Robertson (1978) 128 with n. 21 I misleadingly asserted that she gives this cup to the Kleophrades Painter.

106 Ohly-Dumm (1984) 171 n. 54.

107 Berlin 2315; *ARV²* 21, bottom; Ohly-Dumm (1984) 171 with n. 53.

108 Euthymides: amphora, Louvre G 44, *ARV²* 27.3; volute-krater, Serra Orlando, *ARV²* 28.10. Phintias: amphora, Louvre G 42, *ARV²* 23.1. Also on a calyx-krater, largely lost, *ARV²* 33 (Pioneer Group, Sundry); Ohly-Dumm believes this a late work of Euthymides: (1984) 165 with n. 11.

109 New York 1981.119; not known to Beazley; Bothmer in Kurtz and Sparkes (1982) 46; Immerwahr (1990) 72 n. 41. Williams (1991) n. 19 groups this with other pieces which he attributes to Beazley's Pythokles Painter (*ARV²* 36). See now Cohen (1991) 63–5, figs. 24–5.

110 Paris, Cabinet des Medailles 535, 699 *et al.*; *ARV²* 191.103. See next note.

111 Paris, Cabinet des Médailles 536 (part), 647, part of 535 *et al.*; *ARV²* 191.104. On these two cups see Beazley (1933) 17–22 (= (1974) 9–13), pls. 8–15.

112 Below, p. 140 with notes 36–43.

113 Munich 2344; *ARV²* 182.6; Boardman (1975) fig. 132.1 and 2.

114 Paris, Cabinet des Médailles 385 (and Bonn 143b); *ARV²* 186.50; Boardman (1975) fig. 134.

115 Now J. Paul Getty Museum 77.AE.11; *ARV²* 186.51 (part, then Louvre G 166); Greifenhagen (1972) 24–41 (Louvre frr. and more then in Geneva; Frel (1977) 63–70.

116 Harvard 1960.236; *ARV²* 185.31; Boardman (1975) fig. 130.

117 Above, p. 58 with n. 101; below, p. 81 with notes 222–5.

118 Louvre G 48; *ARV²* 185.33; Greifenhagen (1972) pl. 13.

119 Copenhagen inv. 13365; *ARV²* 15.32; Boardman (1975) fig. 131.1 and 2.

120 Above, p. 26 with n. 36.

121 Tarquinia RC 4196; Boardman (1975) fig. 133; Beazley (1933) pls. 16–18. New York 08.258.58; *ARV²* 185.35, 36; Beazley (1933) pl. 19. See also above, p. 58 with n. 98.

122 Louvre G 162; *ARV²* 186.47; Beazley (1933) pl. 26.

123 Naples 2422; *ARV²* 189.74; Boardman (1975) fig. 135.

124 Early hydria: Salerno inv. 1371; *ARV²* 188.67; Greifenhagen (1972) pl. 26.2. Early kalpis: Rouen 25; *ARV²* 188.68; *AJA* 40 (1936). Later kalpides: *ARV²* 188f.68–73.

125 Above, p. 46 with n. 31.

126 Below, p. 94 with n. 291.

127 Three-quarter faces in the work of the Kleophrades Painter and his contemporaries: Beazley (1910) 58, n. 69. *Di sotto in su* and *profil perdu*, see below, p. 134 with n. 4.

128 Amphora Type B, Boulogne 558; *ABV* 145.18; Boardman (1974) fig. 101.

129 Vienna 3723; *ARV²* 193; middle; *CVA* pl. 53. See also below, p. 66 with n. 140.

130 Harrow 55; *ARV²* 183.11; Boardman (1975) fig. 140.

131 Above, p. 5 with n. 17. Harrow *pentimenti*: Corbett (1965).

132 London E 201; *ARV²* 189.77; Munich 2426; *ARV²* 189.76; *CVA* pls. 227f.

133 Munich 2424; *ARV¹* 129.4; omitted from *ARV²* (see p. 193, middle); *CVA* pl. 227f. See Robertson (1978) 127 with n. 16; Ohly-Dumm (1984) 171 with n. 54.

134 Below, p. 75 with notes 195–200.

135 *ARV²* 183.7–10.

136 Panathenaics: Brauchitsch (1910); Gardiner (1912); Peters (1941); Beazley (1943) and *ABV* 403–17; Amyx (1958); Frel (1969); Brandt (1978). See also following notes, and below, Chapter 9 sections IIIb and IV *passim*.

137 Above, p. 58 with n. 100 (Panathenaics *ABV* 404.1–16; others in the painter's manner, 404f.1–8).

138 Below, p. 198 with notes 40–7; p. 259 with notes 158–73; p. 276 with notes 86–92.

139 Stamnoi: *ARV²* 187f.55–63; Theseus vase 187.58; Boardman (1975) fig. 137. Three-quarter face: above, p. 64 with n. 127.

140 Pelikai: *ARV²* 184f.23–30; 'signed' vase, Berlin 2170, 185.8; Boardman (1975) fig. 142; signatures rejected: Boardman and Gehrig (1981). Vienna neck-amphora: above, p. 64 with n. 129. Late activity of Epiktetos: below, p. 87 with notes 267–71; p. 138 with notes 23–9.

141 Below, p. 67 with n. 148.

142 Beazley (1911).

143 Euphronios: Winter (1900). 'Kleophrades': Furtwängler (1894); he had previously (1885, 2, 485) thought of 'Brygos'.

144 Sokrates: *ARV²* 198.12 and 207.134. Nikostratos: *ARV²* 207.139 and 1635.185bis. Alkmeon: *ARV²* 1635.185bis. Brygos Painter: below, section IIIb; Antiphon Painter: below, section IVa; Triptolemos Painter: below, section Va; Hephaisteion Painter: below, p. 129 with n. 575.

145 Below, p. 84 with notes 240f.

146 See Robertson (1982).

147 Below, Chapter 5 section IIIb (Providence Painter, Hermonax); Chapter 6 section IIb (Achilles Painter).

148 Würzburg 508; *ARV²* 182.5; Beazley (1933) pl. 28.2.

149 Cf. the Pioneer pelike with jumpers, above, p. 34 with n. 87. Pollaiuolo's St Sebastian: London, National Gallery no. 292; Davies (1953) pl. 359.

150 Berlin 2160; *ARV²* 196.1; Boardman (1975) fig. 144.

151 Below, p. 68 with notes 255–8.

152 See Robertson (1950) 25 with n. 9; Beazley (1951) 114 (= 1986, 104) n. 15.

153 Beazley (1922) 88–90.

154 *ARV²* 197f.6–19.

155 Munich 2311; Würzburg 500; *ARV²* 197.9 and 8; Beazley (1930) pls. 6 and 9.2; Boardman (1975) fig. 145.

156 Basel BS 456; *ARV²* 1634.1bis; Boardman (1975) fig. 148.1 and 2; Beazley (1961).

157 New York 1985.11.5; not known to Beazley; Bothmer (1986); Louvre CA 2981; *ARV²* 196.2; Beazley (1936).

158 *ARV²* 198–200.20–44.

159 Above, n. 147.

160 New York, Bothmer; *Para* 520 (to 341–5).2bis; Cardon (1979), 137 fig. 12.

161 Bloesch (1972).

162 Below, p. 119 with n. 475.

163 New York 56.171.38; *ARV²* 197.3; Boardman (1975) fig. 152.1 and 2; Beazley (1922).

164 Beazley (1922) 75–83.

165 Cf. below, p. 249 with n. 78.

166 Volute-kraters: *ARV²* 206, 127–32, 1634.132bis; *Para* 344.131bis. Calyx-kraters: *ARV²* 205.115–22; *Para* 344.115bis-quater, 116bis.

167 Beazley (1964) 7; also (1914) 186 (Achilles Painter). Below, p. 174 with n. 93; p. 202 with n. 59.

168 Cambridge 5.1952;, *ARV²* 206.127; *JHS* 70 (1950) pls. 6–9; Louvre C 10799 and part of G 166, 206, 129 and 130, now shown to belong together: see Giroux (1972); Villa Giulia: *ARV²* 206, 131; Moretti (1980) fig. 77.

169 Carlsruhe 68.101; *Para* 344.131bis; Boardman (1975) fig. 154.

170 Vatican (Astarita 703); *ARV²* 1634 132bis; Beazley (1964) pl. 7a.

171 London E 408; *ARV²* 206.132; Beazley (1930) pls. 29–31.

172 London E 408; *ARV²* 206.132; Beazley (1930) pls. 29–31.

173 Louvre C 10799 + G 166 (part); Carlsruhe 68.101; above, notes 168 and 169.

174 Athens Acr. 742 + London E 459; Graef and Langlotz (1929) pls. 59f; *ARV²* 205.117; Beazley (1930) pl. 32. See also below, p. 75 with n. 190.

175 Calyx-kraters: Corinth CP 436; *ARV²* 205.115 (*Para* 342; and see below, p. 81 with n. 221); *Hesp.* 35 (1966) pls. 73f. Basel amphora: above, p. 71 with n. 166.

176 Above, n. 168; Cardon (1979) 136 fig. 10.

177 Vatican fr., above n. 170; see Beazley (1964) 11; Robertson (1966).

178 *ARV²* 200–3.46–99 (doubleens and Nolans), 210.184–7 (oinochoai), 211f.188–213 (lekythoi).

179 Nolan: Oxford 273; *ARV²* 184.21. Lekythos: Munich inv. 7157; *ARV²* 189.78.

180 Gela Painter: *ABV* 473–5. Edinburgh Painter: *ABV* 476–80. On both, and on black-figure of this phase in general, see Haspels (1936): Gela Painter, 78–86 and 205–15; Edinburgh Painter, 86–9 and 215–21.

181 Below, p. 198 with notes 41–7.

182 Boulogne 656; *ARV²* 200.48; Beazley (1930) pl. 16.

183 Corinth CP 884; *ARV²* 211.191; Boulter (1966) 316f; Benz (1980) 307f.

184 Below, p. 75 with n. 188.

185 E.g. Athens Acr. 587, *ABV* 39.15, and London 1971.11-1.1 (both signed by Sophilos); Athens Acr. 606, *ABV* 81.1; Athens Acr. 607, *ABV* 107.1 (signed by Lydos).

186 See Lullies (1971).

187 J. Paul Getty Museum 76.AE.132.1B, 81.AE.148 and other frr.; not known to Beazley; Robetson (1983).

188 Basel, Antiken Museum und Sammlung Ludwig Lu 39; not known to Beazley; Lullies (1971).

189 I think Margot Schmidt first pointed this out to me. A named Herakles, without attributes but with the same eye (though young and beardless), below, p. 158 with n. 160.

190 Above, n. 174.

191 Below, p. 81 with notes 221, 222, 224.

192 Winchester 44.4; *ARV²* 205.118; Beazley (1930) pl. 13.4.

193 Athens Acr. 8732, Graef and Langlotz (1931) pl. 58; Syracuse 15205; Beazley (1936) 72; *ARV²* 205.119, 121.

194 Oxford 291; *ARV²* 205.122; *CVA* pls. 21.3 and 12.6.

195 *ARV²* 205f.123–6. Europa: Tarquinia RC 7456, *ARV²* 205f.126; Simon and Hirmer (1976) pl. xxxv.

196 Euergides Painter: above, p. 38 with n. 128; youth in vat:

197 *ARV*² 89.14 (Oxford 1929.465, *CVA* pl. 51.3), 90.29, 91.54, 92.61, 95.126. On 91.50 (ex Castle Ashby, *CVA* pl. 34) and 95.127 he is standing beside the tub with his hands in it.

197 Paris, Cabinet des Médailles 387; *ARV*² 31.5.

198 Rome, Villa Giulia 50590; *ARV*² 162.5; Boardman (1975) fig. 87.

199 Complete vase: Basel; *ARV*² 1632.49*bis*; Greifenhagen (1972) pls. 19–20. Fr.: Basel, Cahn; *Para* 341.49*bis* (wrongly, for *ter*).

200 Louvre G 175; *ARV*² 206.124; Boardman (1975) fig. 150; Boardman *et al.* (1966) pls. 136f.

201 *ARV*² 11.5 (bilingual; Boardman (1975) fig. 20) and 6.

202 *ARV*² 106f.133–6. Lion-fr.: 133, Brunswick 544; *CVA* pl. 22.1.

203 Lekythoi: Munich 2475; *ARV*² 211.199; Adria B 180 and 404; *ARV*² 211.200; Beazley (1930) pl. 12.1 and 2. Neck-pelikai: Ferrara T. 867 (Alfieri (1979) 18) and (finer but unpublished) T. 41 D VP; *ARV*² 205.114, 114*bis*.

204 *ARV*² 207–9.137–61.

205 New York, Bastis; *ARV*² 207.141; *CVA* Castle Ashby pls. 46f, 49.3 and 4.

206 Oxford 1912.1165; *ARV*² 208.144; *CVA* pls. 25.1 and 2, 20.10–12, 30.5–6.

207 Above, p. 42 with n. 151.

208 Boston 1978.45; not known to Beazley.

209 Graz inv. G 30; *ARV*² 1634.183*bis*; *ÖJh* 50 (1972–5) 125–33 figs. 1–4, 6–7. J. Paul Getty Museum S.80.AE.185 (ex Bareiss); *Para* 345.183*ter*; Robertson (1983a) 65 fig. 17.

210 *ARV*² 209f.169–83.

211 New York 65.11.12: *ARV*² 1634.175*bis* (wrongly, 75; *Para* 343); *LIMC* I Achilleus 425.

212 Boulogne 449; *ARV*² 210.175.

213 Vienna 3739; *ARV*² 210.173; *CVA* pl. 140.1–3.

214 Leningrad 628; *ARV*² 210.174; Beazley (1930) pl. 24.1.

215 *ARV*² 209.171.

216 *ARV*² 209.162–8.

217 Madrid 11117; *ARV*² 209.167; *CVA* pl. 13.1. Women at the fountain: above, p. 37 with n. 121.

218 Vatican: *ARV*² 209.166; Boardman (1975) fig. 157; Beazley (1930) pls. 25f.

219 New York 10.210.19; *ARV*² 209.169; Beazley (1930) pl. 22.1.

220 Munich 2310; *ARV*² 197.6; Beazley (1930) pl. 7.2.

221 Corinth CP 436, 1671, 1675, 1716 and 2617; *ARV*² 205.115, 116; *Para* 344.115*bis-quater*; Boulter (1966) 310–19.

222 Robertson (1983) 55–61; superseded by Moore (forthcoming).

223 Above, p. 24 with n. 24. See Bothmer (1989) 41 with fig. 31.

224 Part Basel, Cahn; *Para* 34.16*bis*. Other frr.: Louvre G 193; J. Paul Getty Museum 77.AE.105. Robertson (1983) 61–5.

225 Above, p. 24 with n. 23.

226 Above, p. 29 with n. 54.

227 Munich 2312; *ARV*² 197.11; Beazley (1930) pl. 9.1. Basel amphora: above, p. 71 with n. 166.

228 London E 180; *ARV*² 218, near top; Robertson (1958) 64–6.

229 Vienna 1725; *ARV*² 204.109; Boardman (1975) fig. 143; *CVA* pls. 68f. Florence 3985; *ARV*² 204.110; *CVA* pls. 31f. See also following notes.

230 FR 2, 79–81.

231 Beazley (1917) 236; *VA* 33.6 and 7 (Euthymides); *AV* 65.1 and 2 below, and 76 (detached from Euthymides and relation to the Berlin Painter mentioned); *ARV*¹ 27f.1 and 2 (Vienna Painter, 'Related to Euthymides. Forerunner, perhaps, of the Berlin Painter'). Robertson (1950), 28–32.

232 Madrid 11200; *ARV*² 204.112. Vienna 3726; *ARV*² 113; *CVA* pl. 71.

233 Rome, Villa Giulia 50755; *ARV*² 204.111; Stefani (1934) 54.

234 Athens 1628; *ARV*² 25.1 (middle); *CVA* pl. 2.1, 3 and 5; Hoppin (1917), Robertson (1958), 62–6.

235 Athens, Agora P 24113; *ARV*² 213.242; Boardman (1975) fig. 48.1–3; Robertson (1958); Pinney (1981); Kurtz (1983).

236 Athens, Agora P 26245; *ARV*² 214.243; *Hesp.* 28 (1959) pl. 22a and c.

237 Athens Acr. 427 (w-g), Graef and Langlotz (1929) pl. 32, *ARV*² 214.244; Mertens (1977) pl. 11,2; Athens Acr. 23 (red-figure), Graef and Langlotz pl. 1, *ARV*² 214.245.

238 *ARV*² 456–7.

239 Athens Acr. 428; Graef and Langlotz (1929) pl. 32; *ARV*² 1635, towards bottom.

240 Kantharos: Brussels A 718; *ARV*² 445.256; Boardman (1975) fig. 298. Phiale: J. Paul Getty Museum 81.AE.213 and other numbers; not known to Beazley; Robertson (1991). Aryballos: Athens T.E. 556; *Para* 376.273*bis* and 524; Boardman (1975) fig. 282. Psykter: London E 768; *ARV*² 446.262; Boardman (1975) fig. 299.1–2.

241 Athens 15375; *ARV*² 447.274; Greifenhagen (1957) 59.

242 Kalliades: Louvre G 115; *ARV*² 434.74. Kleophrades: Berlin 2283 or 2284; *ARV*² 429.21 and 22.

243 Vienna 3694 and 3695, Louvre G 121; *ARV*² 427.3. 429.26, 434.78.

244 Below, p. 87 with n. 268.

245 Bloesch (1940) 70.2; 71.9; 77.33 (*ARV*² 427.1,2; 428.13).

246 *VA* 97.

247 Berlin 2286; *ARV*² 365.59; Pfuhl (1923) fig. 465. A second cup has now appeared, said to be attributable to the Triptolemos Painter and signed by Douris: Immerwahr (1990) 86. Immerwahr believes that these signatures are written by the same hand as those on vases painted by Douris, and concludes that Douris wrote them on cups painted by another man working in the same shop.

248 Buschor (1916); *VA* 98f n. 1, *AV* 151f, *ARV*¹ 239, *ARV*² 360. Below, p. 112 with n. 416.

249 Vienna 3694; above, n. 243.

250 Above, n. 240.

251 Above, n. 240.

252 Vienna 3695; above, n. 243.

253 Beazley (1911) 277, bottom and 291.

254 Luschey (1939); Dunbabin (1951); Simon (1953); Bothmer (1962); Robertson (1979). Caere vase: Baglione (1988); Williams (1991) 44 with n. 32 ascribes this phiale to Onesimos.

255 J. Paul Getty Museum 76.AE.16.1 and 2; Cardon (1979).

256 Above, p. 60 with n. 115 (the handles recovered after the publications there cited). Bronze volute-krater with spiral on handles: e.g. the Vix krater, above, p. 35 with n. 95.

257 Berlin 2160; above, p. 67 with notes 148 and 149. New York, Bothmer; above, p. 71 with n. 160.

258 Naples 2422; above, p. 60 with n. 113.

259 Europa cup: above, p. 55 with n. 72. White zone: Louvre G 276; *ARV*² 428.11.

260 Palermo; *ARV*² 446.266; Kurtz (1975) pl. 10.1.

261 Cleveland 66.144; *Para* 376.266*bis*; Boardman (1975) fig. 294; Kurtz (1975) pls. 10.2 and 11.

262 J. Paul Getty Museum; not known to Beazley.

263 Cabinet des Médailles 537 and 598; *ARV²* 429.19; *LIMC* I Achilleus 889; head, Boardman (1975) 138.

264 Louvre G 115; *ARV²* 434.74; Boardman (1975) fig. 292.

265 Louvre G 123; *ARV²* 435.94; Schefold (1981) 215.

266 Vatican; *ARV²* 437.116; Boardman (1975) fig. 288.

267 London E 54; *ARV²* 436.96; Robertson (1975) pl. 78d.

268 London E 38; *ARV²* 72.16; Robertson (1975) pl. 78a and b; Boardman (1975) fig. 75.1 and 2.

269 London E 49; *ARV²* 432.52; Robertson (1975) pl. 78c; Boardman (1975) fig. 290.

270 Furtwängler in FR (1909), 82f.

271 Below, p. 138 with notes 24–9.

272 Bloesch (1940) 28f; *ABV* 204f. Chalcidian cups: Rumpf (1927) 35–9, 104–15, 125f.

273 Antiphon Painter: below, section IVa.

274 Above, p. 84 with notes 243 and 252.

275 Douris: (i) Cabinet des Médailles 675 and others; *ARV²* 433.71; correct interpretation by R. Guy in Williams (1980) 139; (ii) Vienna 3695; (iii) and (iv) Vatican, Astarita 133 and 132 (part); *ARV²* 433.71,72. Brygos Painter: (i) London E 69; *ARV²* 369.2; (ii) Malibu 86.AE.26; *Para* 367.1*bis*. Makron: (i) Louvre C 11271; *ARV²* 460.12; (ii) Athens Acr. 315; *ARV²* 459.11. See Williams (1980).

276 Berlin 2285; *ARV²* 431.48; Boardman (1975) fig. 289.

277 Onesimos: Oxford 138.3, 5 and 11; *ARV²* 326.93; *CVA* pl. 14.27–31. Other scrolls, below, p. 167 with notes 39–41.

278 Above, n. 240.

279 Munich 2648; *ARV²* 441.185 ('school-piece?'); ascribed to the Oedipus Painter by Guy; *JHS* 59 (1939) 109.

280 Above, p. 70 with n. 156.

281 Boardman (1979).

282 Above, p. 84 with n. 240.

283 Above, p. 86 with n. 261.

284 Leningrad inv. 5576; *ARV²* 446.263; Peredolskaya (1967) pls. 42f. Vienna Univ. 526a; *ARV²* 447.272; Greifenhagen (1957) 65.

285 Above, p. 85 with n. 251.

286 Below, p. 100 with notes 325–7.

287 Brygos: *ARV²* 368 and 398f; Bloesch (1940) 81–90.

288 Below, p. 96 with n. 306.

289 Cabinet des Médailles 570 and other frr.; *ARV²* 399, middle.

290 *ARV²* 368. Brygos Painter: *ibid.* 368–85; Cambitoglou (1968).

291 Louvre G 152; *ARV²* 369.1; Boardman (1975) fig. 245.1 and 2.

292 Kleophrades Painter's kalpis: above, p. 62 with n. 123. Proto-Panaetian Iliupersis: above, p. 44 with n. 17; Panaetian: above, p. 46 with n. 31.

293 Cambitoglou (1968) 33.

294 Above, p. 47 with n. 36.

295 Above, p. 46 with n. 35.

296 Above, pp. 47 and 63.

297 Above, p. 88 with n. 275.

298 Getty (above, n. 275).

299 London (above n. 275).

300 Tarquinia RC 6846; *ARV²* 369.4; Wegner (1973) pls. 16a and 32a.

301 Berlin 2293; *ARV²* 370.10; *CVA* pls. 67f.

302 Athens Acr. 293; *ARV²* 369.5; Graef and Langlotz (1929) pls. 17f.

303 Würzburg 479; *ARV²* 372.32; Boardman (1975) fig. 254; Arias, Hirmer and Shefton (1962) pls. 138 and xxxiii.

304 Cabinet des Médailles 576; *ARV²* 371.14; Boardman (1975) fig. 255.

305 Above, p. 73 with n. 177.

306 London E 65; *ARV²* 370.13; Boardman (1975) fig. 252.1 and 2; Cambitoglou (1968) pls. 8f; Simon (1982) 125–9.

307 Oltos: amphora, Vienna Univ. 631a; *ARV²* 54.3; *CVA* pls. 7f. Douris: phiale, Getty; above, p. 84 with n. 240; another warrior so dressed on the cup, Vatican (Astarita 132) above, p. 88 with n. 275.

308 Above, p. 5 with n. 19.

309 Munich 2645; *ARV²* 371.15; Boardman (1975) figs. 218 and 256.

310 Gela; *ARV²* 385.223; Williams (1982) 32f.

311 London D13; *ARV²* 403.38; Boardman (1975) fig. 267; Mertens (1977) pl. 18.1; Williams (1982) 18–21.

312 Below, section IVb.

313 Williams (1982).

314 Athens Acr. 435; Graef and Langlotz (1929) pl. 32; not in Beazley; Williams (1982) 31–4.

315 Above, p. 56 with n. 79; Williams (1982) 35f.

316 *ARV²* 383f.198–201 (Nolans), 202–22 (lekythoi).

317 Athens Acr. 20; Graef and Langlotz (1929) pl. 1; *ARV²* 385.229.

318 Louvre G 156; *ARV²* 386.172; Arias, Hirmer and Shefton (1962) pls. 135–7.

319 Vienna inv. 3710; *ARV²* 366.171; Boardman (1975) fig. 248; *CVA* pls. 35–7.

320 Below, p. 105 with notes 354–7.

321 Boston 95.36; *ARV²* 381.182; Schefold (1981) 12–13.

322 Beazley in CB (1954), 68–9; Schefold, l. c. last note.

323 Calyx-krater, Boston 95.23; *ARV²* 510.3 (below; Fröhner Painter, related to Altamura Painter, on whom see below, p. 182 with notes 139–146); Beazley in CB (1954) 68f.

324 Beazley (1929); *ARV²* 1528–52.

325 Rhyta: Hoffmann (1962) and (1985).

326 *ARV²* 445f. 257–61.

327 *ARV²* 382f. 185–95.

328 Once Goluchow, Czartoryski; *ARV²* 382.185; Boardman (1975) fig. 257; Beazley (1928), 24f.

329 Below, p. 185 with notes 186–192.

330 Below, section IVb.

331 Below, section Vb.

332 Paestum; *ARV²* 384.212; *AJA* 58 (1954) pl. 68.5.

333 Munich 2416; *ARV²* 385.228; Boardman (1975) fig. 261.

334 Below, p. 118 with n. 456.

335 Hieron: *ARV²* 458, 481f, 816f, 832.

336 Below, p. 152 with notes 133f. On these inscriptions see Bothmer (1982), 45–7, Cohen (1991) 66–75.

337 Below, p. 104 with n. 348.

338 *ARV²* 458–80.

339 Athens Acr. 560; *ARV²* 479.336; Graef and Langlotz (1931) pl. 43.

340 Below, p. 152 with notes 128–30.

341 Below, p. 152 with notes 133–7.

342 London E 44; *ARV²* 318.2 (Panaetian Onesimos). On Makron see Beazley (1989) 74–87; Bothmer (1982).

343 Palermo V 659; *ARV²* 480.2 (no. 1, Munich 2617, is Hieronian).

344 Below, p. 105 with notes 357–9.

345 Berlin 2290; *ARV*² 462.48; Boardman (1975) fig. 311; *CVA* pls. 87–9.

346 Below, p. 191 with n. 1; p. 207 with notes 89f.

347 Berlin 2291; *ARV*² 459.4; Boardman (1975) fig. 310; *CVA* pls. 84–6.

348 Boston 13.186; *ARV*² 458.1; Boardman (1975) fig. 308.1 and 2; Robertson (1975) pl. 79.

349 Beazley (1957); Robertson (forthcoming).

350 Leningrad 649; *ARV*² 460.13; Peredolskaya (1967) pl. 56.

351 Sourvinou-Inwood (1979).

352 Louvre G 146; *ARV*² 458.2; *AJA* 25 (1921) pl. 14.

353 London E 140; *ARV*² 459.3; Boardman (1975) fig. 309; Robertson (1986) 80.

354 Skyphoi: below, p. 105 with n. 357; also Chapters 5 section II, 6 section IIE.

355 Florence 4218; *ARV*² 191.102; Boardman (1975) fig. 139.

356 Below, p. 114 with n. 438.

357 Haspels (1936) 141–4, 249–51; *ABV* 518–21, 617; Boardman (1974) figs. 245 and 246. See below, p. 132 with n. 600.

358 Above, Chapter 2 section II.

359 Athens Acr. 325, 319; *ARV*² 460.20, 21; Graef and Langlotz (1929) pls. 20–2. 'Pictorial' character of late black-figure: below, p. 180 with n. 131.

360 Bowdoin 23.30; *ARV*² 480.339; Boardman (1975) fig. 316. Aleria L. 67.200; *Para* 379.339*bis*.

361 Below, p. 263 with notes 191–5.

362 Providence 25.074; *ARV*² 480.338; *CVA* pl. 17.4.

363 Below, p. 152 with n. 131.

364 Oxford 1929.175; *ARV*² 480.337; Boardman (1975) fig. 318.1 and 2.

365 *ARV*² 335–41; stand, Berlin 2325, 335.1; Boardman (1975) fig. 239; fr. of mug(?), Bowdoin 30.34, *ARV*² 341.90.

366 *ARV*² 341–50; skyphos, Athens, Agora P 2787, *ARV*² 347.115; pyxis, Liverpool 49.50.7, 348, near bottom.

367 *ARV*² 335.

368 Williams (forthcoming).

369 Below, p. 155 with n. 150.

370 Below, Chapter 5 section IA.

371 Above, p. 18 with n. 38. Example: Boardman (1975) fig. 242.

372 Below, p. 109 with notes 391–6.

373 Williams (1988).

374 *ARV*² 297f. See also below, with n. 577.

375 Foundry Painter: below, section IVb; Tripolemos Painter: below, section VA; Dokimasia Painter: below, section Vb; Diogenes Painter: below, section VIb. Pistoxenos and Tarquinia Painters: below, Chapter 4 section IVb; Copenhagen and Syriskos Painters: below, Chapter 4 sections II and IIIA.

376 Louvre C 10892; *ARV*² 320.13.

377 *ARV*² 386–424.

378 Below, section Vb.

379 *ARV*² 400–4; Beazley (1966, in Italian; translated 1989, 78–83).

380 Rome, Villa Giulia 50407; *ARV*² 402.23; Bloesch (1940) 84.17.

381 *ARV*² 400–2.1–3, 12, 21, 22; Bloesch (1940) 71.13, 73.18–20, 74.22, 79.51.

382 See *ARV*² 403.27, and on the Triptolemos Painter, below, section VA.

383 Berlin 2294; *ARV*² 400.1; Bloesch (1940) 73.19; Boardman (1975) fig. 262.1–3; *kalos*-name Diogenes.

384 London E 44; *ARV*² 318.2; Bloesch (1940) 70.4; Boardman (1975) fig. 222.

385 For example: Boardman (1975) fig. 263; Beazley (1966) pls. 4 and 11 (= 1989 pls. 51 and 57).

386 Above, p. 98 with n. 311.

387 *ARV*² 405. Tarquinia RC 5291; *ARV*² 405; Boardman (1975) fig. 269.

388 Above, p. 95 with n. 299.

389 London 95.5–13.1; *ARV*² 405.2; Hartwig (1893) 350f.

390 Above, p. 101 with n. 344.

391 Above, p. 107 with n. 372. *ARV*² 352–7.

392 Oxford 300; *ARV*² 357.69; Boardman (1975) fig. 236.

393 *ARV*² 353.4 and 11, 354.24, 355.44–6 and 48, 356,.56, 357.69; Bloesch (1940) 70–9.3, 16, 17, 26–8, 31, 36, 37, 44.

394 Naples 2633; *ARV*² 366.63; Bloesch (1940) 45.8.

395 *ARV*² 351f.

396 Above, p. 39 with notes 133–40.

397 Above, p. 40 with n. 143–7.

398 *ARV*² 119–21; examples: Boardman (1975) figs. 116–18.

399 *ARV*² 117–19.

400 Euryptolemos: Louvre G 139–40 (signed), *ARV*² 120.1; Florence 73131 (ascribed), *ARV*² 120.5. Pammachos: Paris market, *ARV*² 120.12; Tessin, private, *Para* 333*bis*; Schefold (1974) 137.1 and 2, pl. 37.2.

401 Tessin, private, Schefold (1974) 137.3; pl. 38.1.

402 Basel BS 465; Schefold (1974) 137.4; pl. 39.

403 Bloesch (1940) 127f.

404 Berlin inv. 3232; *ARV*² 117.2; Bloesch (1940) 94.25.

405 Proto-Panaetian ('probably early Onesimos'): Boston 01.8018; *ARV*² 317.9. With Leagros: Baltimore; *ARV*² 177.3.

406 New York 18.145.28; *ARV*² 120.10.

407 Adria Bd 2; *ARV*² 1565.

408 Below, n. 413.

409 Stemmed plate: Maplewood, Noble; *Para* 332 (Elpinikos Painter). Aryballoi: Corinth C 31.77, *ARV*² 118.15 (Epidromos Painter); Naples RC 177, *ARV*² 119.3 (Kleomelos Painter).

410 Athens Acr. 703; Graef and Langlotz (1931) pl. 185; *ARV*² 118.2.

411 J. Paul Getty Museum; not known to Beazley; below, p. 135 with n. 8.

412 Bonn 63; *ARV*² 119.1; *CVA* pls. 3.5 and 4.5.

413 Munich inv. 8771; not known to Beazley; Boardman (1975) fig. 115; Ohly-Dumm (1971).

414 Robertson (1975) 229 and 276.

415 Below, Chapter 4 section IIIb.

416 Above, p. 85 with n. 247, where a second such cup is mentioned and Immerwahr's opinion quoted.

417 *ARV*² 360–7.

418 Berlin 2286; *ARV*² 365.59; Bloesch (1940) 97.12; Pfuhl (1923) fig. 465.

419 Louvre G 138; *ARV*² 365,61; Bloesch (1940) 99.24.

420 Leipzig T 504, *ARV*² 363.35; Leipzig T 513, *ARV*² 364.43; Berlin 2295, *ARV*² 364.45; Vienna 3692, *ARV*² 364.50; Leipzig, Kunstgewerbemuseum inv. 781.03. G, *ARV*² 364.51; Bloesch (1940) 73–8. 14, 39, 41, 42, and 43.

421 Vatican; *ARV*² 364.49; Bloesch (1940) 85.21.

422 *ARV*² 360.

423 Fr.: above, p. 108 with n. 382. Calyx-krater: *VA* 94; *AV* 152; below, p. 114 with n. 436.

424 *ARV*² 360.

[425] Example: Edinburgh 1887.213; *ARV*² 364.46; Boardman (1975) fig. 303.1 and 2.

[426] Mykonos; *ARV*² 362.21 and 280.18; Dugas (1952) pl. 3.7.

[427] See below, p. 128 with notes 565–7.

[428] Beazley (1957) 138.

[429] Louvre C 10834; *ARV*² 361.3; Beazley (1957).

[430] Louvre C 10822; *ARV*² 352.22. More of this vase is now in Geneva. I am very grateful to Elfriede Knauer for this information.

[431] Beazley (1957).

[432] Below, p. 143 with notes 57–61.

[433] Copenhagen, Ny Carlsberg inv. 2695; *ARV*² 362.19; *LIMC* I Amphitrite 78a.

[434] Below, p. 144 with n. 62.

[435] Louvre G 187; *ARV*² 361.2; *Enc. Phot.* iii 21.

[436] Leningrad 637; *ARV*² 360.1; Boardman (1975) fig. 306.

[437] Above, p. 99 with n. 319; p. 104 with n. 348; p. 105 with notes 354–6.

[438] Berlin inv. 1970.9; not known to Beazley; Knauer (1973); Hampe (1975).

[439] See last note.

[440] Fr. 21: West (1972) 89.

[441] Louvre E 640; Payne (1931) 327.1437.

[442] Louvre G 109; not listed by Beazley; Waiblinger (1972).

[443] Robertson (forthcoming).

[444] *ARV*² 400, 405–17.

[445] Briseis Painter: *ARV*² 406–12. Cups with name of Brygos: Louvre G 151, *ARV*² 406.8, and J. Paul Getty Museum (Bareiss), *Para* 372.8*bis*. Theseus cup: New York 53.11.4; *ARV*² 405.7; *Bull. Met.* 13 (1954) 62f.

[446] Above, p. 42 with n. 42.

[447] *ARV*² 412–15.

[448] Berlin 2309 *ARV*² 373.46 (Boardman (1975) fig. 275.1 and 2); Copenhagen inv. 3880, *ARV*² 373.36 (Rumpf (1953) pl. 25.5); ex Castle Ashby, *ARV*² 371.16 (*CVA* pl. 41.63.); all there given to the Brygos Painter; *ARV*² 1649, tentatively transferred to the Dokimasia Painter; *Para* 372, Dokimasia Painter 11*bis* and *ter* and 25*bis*.

[449] Berlin 2296; *ARV*² 412.1. Subject: Cahn (1973) and (1986).

[450] *ARV*² 409f. 47–59.

[451] Stamnoi: Oxford 1965.121, *ARV*² 414.34; Zurich Univ., *ARV*² 1652 top (tentative ascription), *Para* 373.34*bis* (Boardman (1975) fig. 277); Lugano, Bolla, *Para* 373.34*ter*. Calyx-krater: see next note.

[452] Boston 63.1246; *ARV*² 1652 (tentative ascription); *Para* 373.34*quater*; Boardman (1975) fig. 274.1 and 2; Vermeule (1966).

[453] Below, Chapter 6 section IIb.

[454] Zurich and Lugano, above, n. 451.

[455] Boston 91.227; *ARV*² 208.151. Class of Berlin Painter's Late Stamnoi: Philippaki (1967) 36–46.

[456] Above, p. 100 with n. 334.

[457] *ARV* 354, 392f.

[458] *ARV*² 220–2.

[459] Eucharides: Beazley (1913), Nikoxenos: Beazley (1914).

[460] Beazley (1913) 232f, (1914) 245f.

[461] *ARV* 395.

[462] Robertson (1962).

[463] Mississippi; *ARV*² 221.6.

[464] Boston 95.19; *ARV*² 220.5; Boardman (1975) fig. 162.

[465] Louvre G 60 and 61; *ARV*² 221.9, 10.

[466] Zurich, private; *ARV*² 221.8*bis*.

[467] *ARV* 395.1–3; 397, middle (*Para* 174.3*bis*, near top).

[468] Oxford 563; *ABV* 396.21; Boardman (1974) fig. 229.

[469] Neck-amphora, Boston 01.8035; *CVA* pl. 37; not listed by Beazley; see Beazley (1908).

[470] Copenhagen 124; *ARV*² 229.35; *CVA* pl. 134.

[471] Louvre G 163; *ARV*² 227.12; Boardman (1975) fig. 166; Bothmer (1981) fig. 74.

[472] Eucharides: part of Naples 2201, *ARV*² 227.13. Nikoxenos: Athens Acr. 727, *ARV*² 221.17; Graef and Langlotz (1931) pls. 56f.

[473] Above, p. 37 with n. 122.

[474] See Robertson (1975a).

[475] Hamburg 1966.34; *Para* 147.8*ter*; Boardman (1975) fig. 165. See also above, p. 71 with notes 160–2.

[476] Basel Antikenmuseum und Sammlung Ludwig BS 453; *ARV*² 1634.30*bis*; Boardman (1975) fig. 149.

[477] Above, p. 44 with n. 11. See Schmidt (1980).

[478] London E 279; *ARV*² 226.1; Beazley (1913) pls. 11f.

[479] London E 278; *ARV*² 226.2; *BSA* 18 (1913) pls. 13f.

[480] Vatican; *ARV*² 197.5; Beazley (1930) pl. 11.

[481] *ARV*² 218f.

[482] Below, p. 129 with n. 579.

[483] *VA* 69.

[484] *ARV*² 226.

[485] Above, n. 475.

[486] Below, p. 145 with notes 65–70.

[487] Nikoxenos and Eucharides Painters: above, section VIa. Apollodoros: above, section IVc.

[488] *VA* 66f, 52.

[489] *AV* 160–2, 473.

[490] *AV* 111f, 470.

[491] *AV* 108f, 470. Name-piece: amphora, Munich 2303; Boardman (1975) fig. 191. Danae hydria: Boston 13.200; Boardman (1975) fig. 192.

[492] *AV* 112f.

[493] Below, Chapter 4 sections II and IIIa.

[494] *ARV*¹ 161f.

[495] *ARV*¹ 163.

[496] *ARV*¹ 163f.

[497] *ARV*¹ 164–8.

[498] *ARV*² 245–55.

[499] *ARV*² 245.

[500] *Para* 350, middle; attributed in *ARV*² to the Tyskiewicz Painter (below, p. 128 with n. 563).

[501] *ARV*² 248.1; Boardman (1975) fig. 193; Beazley in *VA* 52; Robertson (1970).

[502] London E 261; *ARV*² 248.2; Boardman (1975) fig. 194.

[503] Above, p. 107 with n. 375.

[504] Below, Chapter 4 sections II and IIIa.

[505] *AV* 160.

[506] Below, p. 140 with n. 37.

[507] Below, section VIc.

[508] *ARV*² 254. Above, p. 113 with notes 432 and 433; and next note.

[509] Below, p. 143 with notes 57–61.

[510] Leningrad, St. 1637; *ARV*² 244.3; Peredolskaya (1967) pl. 19.

[511] *AV* 160; below, p. 140 with n. 38.

[512] Berlin 2179; *ARV*² 252.52; Neugebauer (1932) pl. 45.

[513] Louvre G 232; *ARV*² 250.24; *VA* 66.

[514] Antioch; *ARV*² 251.28; *JHS* 59 (1939) pl. 1 and pp. 4–6.

[515] *ABV* 395–7 (Eucharides Painter and near); 404–6 (Kleophradean); 407–9 (Berlin Painter).

[516] See further below, p. 144 with notes 58–62.

517 Naples inv. 112848; *ABV* 403.1, bottom.

518 Robertson (1970).

519 *ARV*² 68.13.

520 Below, p. 137 with notes 19f.

521 *ARV*² 233–7.

522 Above, p. 119 with n. 468.

523 Beazley (1908) 318. Oxford 561; *ARV*² 241.52; *CVA* pls. 23.1, 22.5.

524 *VA* 48–52; amphora and calyx-krater (52.29 and 30), below with notes 528 and 529; signed column-krater (49.5), Athens Acr. 806, *ARV*² 240.42; Graef and Langlotz (1931) pl. 72; Boardman (1975) fig. 168.

525 Pottier (1928) rejects both, and argues against much in Beazley's method and results. Analysis of 'Beazley's Myson': Berge (1992).

526 Above, p. 18 with n. 41. Myson's signed vase: above, n. 524.

527 Below, p. 127 with n. 549.

528 London E 458; *ARV*² 239.16; Boardman (1975) fig. 172.1 and 2.

529 Louvre G 197; *ARV*² 238.1; Boardman (1975) fig. 171.

530 *ARV*² 238, top.

531 Florence 3982; *ARV*² 238.2; *CVA* pl. 25.1. Pan Painter: Beazley (1912) 358.17; *AV* 101.17. Myson: *ARV*¹ 172.48.

532 Below, p. 143 with notes 55f.

533 Above, p. 36 with notes 108–11.

534 New York 59.11.20; *ARV*² 224.1.

535 Oxford 1966.471 (ex Beazley); *ARV*² 319.4*bis*; *Para* 359.

536 Vatican (Astarita 428); *ARV*² 242.77; Follmann (1968) pl. 15.2 and 5.

537 Florence 3 B 15; *ARV*² 242.83; Follmann (1968) pl. 15.3.

538 Above, p. 55 with notes 73 and 74.

539 *ARV*² 336.

540 Below, with notes 545–7; Chapter 4 section IIIb.

541 Adria B 515 and B 1412; *ARV*² 242.81.

542 Naples 2410; *ARV*² 239.18; Boardman (1975) fig. 170. Rome, Villa Giulia 984; *ARV*² 239.21; *CVA* pl. 15.

543 Above, p. 124 with n. 523.

544 Munich inv. 8762; *ARV* 1638.2*bis*; *AA* 1962, 615–18.

545 Boston 03.786; *ARV*² 242.80. Athens, Agora P 25965; *ARV*² 242.79; Sparkes and Talcott (1958) fig. 16. Salonica A 799; *ARV*² 242.78; *BCH* 94 (1970) 412–15.

546 Berlin 1966.14; *Para* 349.77*bis*.

547 *ARV*² 238.

548 Beazley ap. Dohan, in *Mus. J.* 23 (1932) 33.

549 Berge (1991).

550 *ARV*² 296f.

551 Vatican (Astarita 735); *ARV*² 1632, 58*bis*; Greifenhagen (1972, pl. 27.2), Williamstown (Mass.), Williams College Museum of Art 1964.9; *ARV*² 1643, 10*bis*; Buitron (1972) no. 41.

552 *ARV*² 1643.

553 Copenhagen 126; *ARV*² 297.11; *VA* 60.

554 *ABV* 400.

555 *ARV*² 272–8.

556 *ARV*² 1635f.

557 *ARV*² 1705, 78*bis* and *ter*; Robertson (1976) 33f, figs. 5–7.

558 *ARV*² 276.76; Beazley (1916) 128.

559 Vienna 1103; *ARV*² 277, middle; *CVA* pl. 87.3 and 4, with Eichler's remarks.

560 Berlin inv. 3163; *ARV*² 275.59; *AA* 1890, 89 (below).

561 Caltanisetta; *Para* 354.39*bis*; Boardman (1975) fig. 174.

562 Below, p. 134 with n. 5.

563 *ARV*² 289–96; name-vase, Boston 97.368; *ARV*² 290.1; Boardman (1975) fig. 186.

564 Above, p. 113 with notes 426 and 427.

565 *ARV*² 279–82; name-vase, Boston 98.882; *ARV*² 279.7; Boardman (1975) fig. 177.

566 Leningrad G 212; *ARV*² 279.6; *VA* 59. Petit Palais, 307; *ARV*² 279.2; Boardman (1975) fig. 176. Rome, Villa Giulia; *ARV*² 279.3.

567 *ARV*² 282.40, 41 and bottom; 283.1–4, top.

568 *ARV*² 283.

569 Geras Painter: *ARV*² 285–7; Boardman (1975) figs. 179–81. Argos Painter: *ARV*² 288f; Boardman (1975) fig. 183. Class of small pelikai: Becker (1977) 1, 54f, Class XX, nos. 190–7. See also below, p. 145 with n. 77.

570 *ARV*² 289.

571 Above, p. 113 with notes 432 and 433; below, p. 143 with notes 57–61.

572 Syleus: *ARV*² 251.29–31. Tyskiewicz: *ARV*² 291.14–24.

573 London E 440; *ARV*² 289.1; Boardman (1975) fig. 184.1 and 2; below p. 135 with n. 12.

574 J. Paul Getty Museum (ex Hunt Collection); not known to Beazley; Isler-Kerenyi (1977), Causey-Frel (1980) no. 15; Greifenhagen (1982).

575 *ARV*² 297f.

576 Above, p. 107 with n. 375.

577 Calyx-krater: Athens, Agora P 9462; *ARV*² 298.4; Dinsmoor (1941) 133.60. Stamnoi: Great Neck (Long Island), Pomerance *ARV*² 298.3; *Man in the Ancient World* 59 figs. 169; London E 439; *ARV*² 298, middle. Cf. above, p. 75 with n. 194.

578 Painter of Palermo 1108: *ARV*² 298f. Syracuse Painter: p. 152 below, with n. 132.

579 *ARV*² 306–8; Boardman (1975) figs. 207 and 212; below, p. 129 with notes 582 and 583.

580 Diosphos painter and workshop: Haspels (1936) 94–130 and 228–31; *ABV* 508–17; *ARV*² 300–4; Boardman (1974) figs. 268–72. See also below, p. 130 with n. 591.

581 *ARV*² 309f; Boardman (1975) fig. 213.

582 *VA* 69.

583 Above, p. 121 with notes 481–3.

584 *ARV*² 309.

585 Providence Painter and Hermonax; below, Chapter 5 section IIIb. Achilles Painter: below, Chapter 6 section IIb.

586 Above, p. 72 with n. 167.

587 Above, p. 127 with notes 556–9.

588 Red-line Painter: *ABV* 600–8; Boardman (1974) figs. 281f. Leafless Group: *ABV* 632–53; Boardman (1974) figs. 290f. Haimon Painter and Group: Haspels (1936) 130–41 and 241–7; *ABV* 538–83; Boardman (1974) figs. 273–6. Class of Athens 581: *ABV* 487 (with refs. to Haspels) -506. Much on all these also in *Para*.

589 Gela and Edinburgh Painters: above, p. 73 with n. 180; Boardman (1974) figs. 234–236. 239–244.

590 Theseus and Athena Painters: Haspels (1936) 141–65 and 249–62; *ABV* 518–37; Boardman (1974) figs. 245–9, 250–5.

591 Diosphos and Sappho Painters: above, n. 580.

592 Bowdoin Painter: *ARV*² 677–95; Kurtz (1975) pls. 15f, 63 (Workshop, pls. 12–14).

593 See Haspels 157–60, *ARV*² 677, bottom.

594 Above, p. 52 with notes 66 and 68.

595 Side-palmette lekythoi: *ARV*² 301–5; one from Diosphos

workshop, Boardman (1975) fig. 210. Emporion Painter: *ABV* 584–6.

596 *ARV²* 35f.1 (Boston 13.195; Boardman (1975) fig. 211) and 2 (Syracuse 26967).

597 *ARV²* 332f; Kurtz (1975) pl. 6.3.

598 Marathon Painter: Haspels (1936) 89–94 and 221–5; subsumed by Beazley in Class of Athens 581 (above, n. 588); Boardman (1974) figs. 256f.

599 Warsaw 142333; Haspels (1936) 228.56; *CVA* Goluchow pl. 16.3. Six's technique: above p. 9 with n. 9.

600 Above, p. 105 with notes 356 and 357; p. 114 with n. 438.

601 Below, Chapter 5 section IIIc.

4 Archaic into classical

1 Above, p. 42 with n. 150.

2 Above, p. 23 with n. 20.

3 Above, p. 68 with n. 150.

4 Three-quarter faces: above p. 64 with n. 127. Kleophrades Painter satyr *di sotto in su*: kalpis-fragments, J. Paul Getty Museum 85.AE.188; attributed by True (1986) 192 no. 52; Kossatz-Deissmann (1991) 139 (inscription) and 141 fig. 5 (with third fr.). Panaetian *profil perdu*: alabastron-fragment, Würzburg 545, Langlotz (1932) pl. 219; not in *ARV²*.

5 Rome, Villa Giulia: not in *ARV²*; FR pl. 15; Pfuhl (1923) fig. 491.

6 *AV* 471, middle. Harrow Painter: above, p. 127 with notes 556–62.

7 Below, p. 254 with n. 112.

8 Above, p. 111 with notes 399, 411. Siege-cup: J. Paul Getty Museum 84.AE.38; not known to Beazley; Childs (1991), a wide ranging and most important discussion.

9 See Robertson (1975) 227.

10 Polygnotos and Mikon: Robertson (1975) 248–70, with refs.; more recently, Stansbury-O'Donnell (1989) and (1990).

11 Tomba del Tuffatore: Napoli (1970).

12 Siren Painter's name-vase: above, p. 129 with n. 573. Priam Painter: above, p. 37 with notes 120–2. Amphora with bathing women: Rome, Villa Giulia; *Para* 146.8*ter*; Moon (1983) 110–13.

13 *ARV²* 257.

14 Robertson (1976) 40–4.

15 *ARV²* 264.67; Boardman (1975) fig. 204.

16 Below, p. 188 with n. 202.

17 Calyx-krater in a private collection with signature of Syriskos as painter: by the courtesy of Robert Guy I have now seen his notes on this piece and pictures, and am sure that his attribution to the 'Copenhagen Painter' is correct. Skyphos and cup-skyphos in English private collection: *Para* 352f.1 and 2; Boardman (1975) figs. 205f; Robertson (1976) figs. 12–15.

18 *Para* 353.

19 *ABV* 107 (Lydos), 178 (Thrax), 403 (Sikelos); *ARV²* 68f (Sikanos), 82 (Skythes), 663f (Mys). Sikelos and Sikanos: above, p. 123 with notes 518–20. Mys: below, p. 178 with n. 114.

20 Kyathos (ladle), Rome, Villa Giulia; not known to Beazley; Canciani (1978).

21 Robertson (1976) 42f.

22 Below, section IVb.

23 Florence 2 B 2; *ARV²* 1554.2.

24 London E 139; *ARV²* 77.86; Robertson (1976) 42f.

25 Above, p. 87 with notes 267–71.

26 Oxford 520, *ARV²* 76.84; Boardman (1975) fig. 76. Naples Racc. Porn. 1, *ARV²* 77.85.

27 Bologna 470; *ARV²* 445.253.

28 Above, p. 55 with notes 73 and 74.

29 Not known to Beazley; *MM* 60 (1982) no. 27, pl. 11.

30 Copenhagen Painter: *ARV²* 256–9; Boardman (1975) figs. 199–201. Copenhagen 125: *ARV²* 256.1; *CVA* pl. 130.

31 Swiss private: *ARV²* 257 and 1640.11; Philippaki (1967) pl. 33.

32 Athens Acr. 780; *ARV²* 258.28; Graef and Langlotz (1931) pl. 69.

33 Syriskos Painter: *ARV²* 259–67; Boardman (1975) figs. 203f. Lebes: Mykonos; *ARV²* 261.19; Dugas (1952) pls. 5–7 and 57.

34 Above, p. 136 with n. 17.

35 Dutuit Painter: above, p. 129 with n. 579. Painter of the Yale Lekythos: *ARV²* 657–62; Zurich cup-skyphos, 661.94; *JdI* 59 (1944) 75.

36 Above, p. 60 with n. 113.

37 Copenhagen Painter: London E 350; *ARV²* 256.2; *CVA* pl. 18. Syleus Painter: Brussels R 303; *ARV²* 249.6; Boardman (1975) fig. 196.

38 Oreithyia Painter: *ARV²* 496f; Berlin 2165, *ARV²* 496.1; Munich 2345, *ARV²* 496.2; Boardman (1989) fig. 30.

39 Zurich; *ARV²* 1636.2*bis*; Isler-Kerenyi (1977); Boardman (1989) fig. 31.

40 E.g. Grace (1961) fig. 35, left.

41 Acheloos Painter: *ABV* 382f; pointed amphorae: Florence 3871; *ABV* 383.2 (see *Para* 168); Toledo (Ohio) 1958.69; *Para* 168.2*bis*; Boardman (1974) fig. 209.

42 Chian: Grace (1961) fig. 44; other, *ibid.* fig. 35, front row left.

43 Germany, private; Cahn (1988).

44 Below, Chapter 5 section IIId.

45 Bologna PU 283; *ARV²* 260.8; Boardman (1975) fig. 203.

46 Louvre, G 194; *ARV²* 260.7; *CVA* pl. 22.4.

47 Boreas Painter: *ARV²* 536–40; name-vase: Bologna 273, *ARV²* 536.2; *CVA* pls. 51f.

48 Painter of Bologna 228: *ARV²* 511–14. Name vase, Bologna 228: *ARV²* 551.3; *CVA* pls. 41–3. Good Spina column-krater, Ferrara T 308, *ARV²* 511.5; Alfieri (1979) fig. 50. Poor Spina volute-krater: Ferrara T 346, *ARV²* 511.2; Alfieri (1979) figs. 48f. Loutrophoros: Athens 1170, *ARV²* 512.13; *AM* 53 (1928) Beil.16f.96. Neck-fragment: New York 07.286.70, *ARV²* 12.15; Richter and Hall (1936) pl. 83. Painter of the Brussels Oinochoai: below, p. 218 with n. 160.

49 History of shape and distinction in use of two types: Boardman (1988). Wedding-loutrophoroi: below, p. 227 with n. 25; see also p. 196, with n. 33.

50 Above, p. 126 with notes 531 and 532.

51 Beazley (1912a) 354.

52 *VA* 113.

53 Beazley (1931) 18 (= 1974, 8f).

54 Beazley (1931) 17 (English text, 1974, 8).

55 Follmann (1968) 70–2; Berge (1992) 122–8.

56 Above, p. 113 with notes 419–24. Cf. also p. 107 with notes 377–82 (Foundry Painter).

57 J. Paul Getty Museum 81.AE.62; not known to Beazley;

58 Siren Painter: above, p. 129 with notes 570 and 571. Argos Painter: above, p. 129 with n. 569.

59 Athens Acr. 620; Graef and Langlotz (1931) pl. 48; *ARV²* 254, near top.

60 Above, p. 113 with n. 433.

61 Becker (1977) 1, 48–50 and nos. 142–50.

62 Munich 2417; *ARV²* 556.101; Boardman (1975) fig. 338.1 and 2; Beazley (1931) pl. 12.1. See also above, p. 114 with n. 434.

63 Above, p. 113 with n. 430.

64 Above, p. 99 with n. 319.

65 Boston 10.185; *ARV²* 550.1; Boardman (1975) fig. 335.1 and 2; Beazley (1931) pls. 1–4. A marvellous acount of this vase: Beazley in CB (1954).

66 Above, p. 76 with notes 195–9.

67 Oreithyia Painter: above, p. 140 with n. 38; bell-krater, *ARV²* 496.5; CVA pls. 35f. See also below, p. 255 with n. 120.

68 Black-figure Siana Cup tondo lost; Hoffmann (1967) 20, fig. 13. Red-figure amphora by Eucharides painter (early): above, p. 119 with notes 475 and 486. Red-figure examples by the Geras Painter (see below, p. 145 with n. 77) and black-figure on late lekythoi (*ABV* 500.51 and 586.1) are probably no earlier than the Pan Painter's.

69 Below, p. 311 with n. 108.

70 Athens Acr. 760; *ARV²* 552.20; Boardman (1975) fig. 337.1 and 2; Beazley (1931) pl. 12.2.

71 Boston 95.58; *ARV²* 552.21; Beazley (1931) pl. 13.3.

72 Cambridge GR 3.1971; *ARV²* 550.3; Beazley (1931) pl. 25.2.

73 Palermo v 778; *ARV²* 550.2; Boardman (1975) fig. 343; Beazley (1931) pls. 31f.

74 London E 512; *ARV²* 557.125; Boardman (1975) fig. 341; Beazley (1931) pl. 5.2.

75 Vienna 3727; *ARV²* 55.88; Boardman (1975) fig. 344; Beazley (1931) pl. 23.1–3.

76 *ARV²* 555.88–93 and 1659.91*bis*, 92*bis*, 93*bis*; another, not known to Beazley, J. Paul Getty Museum 76.AE.102.29 and 30; Robertson (1986) 88 (frr.; Bothmer's attribution).

77 Becker (1977) 1, 54f and nos. 190–7.

78 Ferrara inv. 1499; *ARV²* 554.83; Alfieri (1979) figs. 69f.

79 Athens 9683; *ARV²* 554.82; Boardman (1975) fig. 336; Beazley (1931) pls. 7–10.

80 Leipzig T 3365; *ARV²* 559.151; Mertens (1977).

81 Athens, Vlasto; *ARV²* 552.28; Boardman (1975) fig. 346; Follmann (1968) pls. 3 and 11.5.

82 Sourvinou-Inwood (1975).

83 London E 579; *ARV²* 557.117; Beazley (1931) pl. 25.1.

84 Adolphseck 51; *ARV²* 557.119; CVA pl. 38.

85 Boston 13.198; *ARV²* 557.113; Boardman (1975) fig. 347; Beazley (1931) pls. 24.1 and 13.2.

86 Athens Acr. 469a; *ARV²* 559.144; Beazley (1931) pl. 24.2.

87 Leningrad 670; *ARV²* 557.121; Beazley (1931) pl. 14.1. 'Second white' on lekythoi: p. 198 below, with n. 49; see also above, p. 98 with notes 310–5.

88 Bari 4402; *ARV²* 550.4; Follmann (1968) pl. 12.1.

89 Three representations on red-figure fragments of this time from the Acropolis, all dated by Langlotz about 460: skyphos 516, Graef and Langlotz (1931) pl. 40, not in Beazley; votive shields, 1071 and 1072, Graef and Langlotz pl. 83, *ARV²* 535.6 (recalls the Alkimachos Painter) and 1072. *ARV²* 539.48 (Boreas Painter).

90 Syracuse 19900; *ARV²* 557.122; Kurtz (1975) pl. 24.3.

91 Above, p. 127 with n. 549.

92 *ARV²* 562.

93 *ARV²* 567.

94 *VA* 118–20.

95 See-saw fr. removed from renamed Pig Painter and noted as like Leningrad Painter, *AV* 239; recognised as column-krater and attributed to Leningrad Painter, CB (1963); *ARV²* 569.49; Boardman (1975) fig. 322.

96 Cambridge 9.17; *ARV²* 564.27; CVA pls. 33.2 and 34.4.

97 Milan, Torno; *ARV²* 571.73; Boardman (1975) fig. 323.

98 Metal-working: Green (1961); against, Noble (1966). Woman in pottery: Scheibler (1986) 801 with n. 31.

99 Boston 03.788; *ARV²* 571.75; Boardman (1975) fig. 325; Simon (1982) 135.

100 Agrigento Painter: *ARV²* 574–9; Boardman (1975) figs. 327f.

101 Perseus Painter: *ARV²* 581f.

102 Berlin 2172; *ARV²* 581.4; Boardman (1975) fig. 330.

103 Oinanthe Painter: *ARV²* 579f; Boardman (1975) fig. 329.

104 Below, p. 216 with notes 143–9.

105 Chicago 11.456; *ARV²* 572.88; Moon and Berge (1979) no. 97.

106 Chicago 89.16; *ARV²* 585.29; Moon and Berge (1979) no. 98.

107 Basel BS 415; not in Beazley's lists; Boardman (1975) fig. 333; Schmidt (1967).

108 Leningrad 627; *ARV²* 555.95; Follmann (1968) pl. 5.1.

109 Palermo; phots. in Beazley Archive.

110 Cleveland Painter: *ARV²* 516f.

111 Copenhagen, Ny Carlsberg inv. 2697; *ARV²* 517.11.

112 Orchard Painter: *ARV²* 522–8; Boardman (1989) figs. 41–3; oinochoe, New York 21.88.148; *ARV²* 527.74.

113 Above, p. 142 with n. 47.

114 Cleveland 30, 104; *ARV²* 516.1; CVA pls. 23f.

115 Vienna inv. 683; *ARV²* 517.8; *AV* 470, 'Art des Panmalers'; CVA pls. 88.4f.

116 Harrow 516, *ARV²* 516.5; Boardman (1989) fig. 37. Ferrara (sequestro Venezia), *ARV²* 517.6; Alfieri (1979) fig. 52. London E 473, *ARV²* 551.13; Beazley (1931) pl. 27.1. See *ibid.* 19 with n. 47 and 21 no. 11 (= 1974, 9 and 11 no. 12).

117 Alkimachos Painter: *ARV²* 529–32.

118 Above, p. 127 with notes 556–62.

119 Leningrad 611; *ARV²* 530.26; Peredolskaya (1967) pls. 66f.

120 London 1928.1–17.57; *ARV²* 529.12; CVA pls. 46.2 and 51.3.

121 Above, p. 149 with n. 106.

122 Berlin inv. 30035, Boston 95.39; *ARV²* 533.57, 58; Boardman (1989) figs. 47 and 46. Swiss private, on loan to Basel, Antikenmuseum und Sammlung Ludwig, not known to Beazley; Schefold (1976).

123 Taranto; *ARV²* 560.5; *ÖJh* 38 (1956) 1f; Boardman (1975) 181.5.

124 *ARV²* 1659, middle; *Para* 388, bottom.

125 Oedipus Painter: *ARV²* 451f; 1, Vatican, Boardman (1975) figs. 301.1 and 2.

126 Above, p. 139 with notes 30–3.

127 Akestorides Painter: below, Chapter 5 section 1b.

128 Euaion Painter: below, Chapter 6 section III.

129 Telephos Painter: *ARV*² 816–20.

130 Eos and Telephos cups: Boston 95.28 and 98.931, *ARV*² 817.1 and 2; Boardman (1975) figs. 379.1 and 2, 378; Beazley in CB (1963).

131 Clinic Painter and his circle: *ARV*² 807–14; name-vase: Louvre CA 2183; *ARV*² 813.96; Boardman (1975) fig. 377.

132 Syracuse Painter: *ARV*² 517–22; Boardman (1989) figs. 38f. Stamnos: Boston 10.177; *ARV*² 518.1; Philippaki (1967) pl. 64.

133 Amphitrite Painter: *ARV*² 830–4; Hieron Kantharos: Boston 98.932; *ARV*² 833.46; CB iii pl. 85.152.

134 Above, p. 101 with n. 336.

135 Vienna 1847 and Bryn Mawr P 218; *ARV*² 830.1 (CVA pl. 17.1–4) and 2 (Bothmer (1957) pl. 80.5).

136 Athens 1708; *ARV*² 833.46; CVA pls. 18–20. See Beazley in CB (1954) 92f.

137 London E 155; *ARV*² 832.37; CVA pls. 33.2, 35.2.

138 Below, p. 170 with notes 73–6.

139 Above, p. 96 with n. 301.

140 Athens, Agora P 5113; not listed by Beazley; Robertson (1959) 110f; Mertens (1977) 142; *Hesp.* (1948) 334, fig. 1.

141 Below, p. 158 with n. 161; p. 164 with n. 30.

142 Athens, Agora P 43; *ARV*² 1578, bottom (not attributed); Diepolder (1936) pl. 2.1. Mertens (1974, 101–3 with fig. 23) attributes the cup to Douris, which I find difficult. In 1977 (186, pl. 34.1) she is less sure. See also below, p. 170 with n. 77.

143 Athens, Agora P 42; *ARV*² 415.1; *Hesp.* (1933) 2, 217.

144 Brauron; *ARV*² 827.1; Kahil (1963) pl. 9.

145 Stieglitz Painter: Beazley (1933a) 25; *ARV*¹ 546; *ARV*² 827–30.

146 Lyandros Painter: *ARV*² 835; Aphrodite cup, no. 1; Florence 75409; CVA J pl. 1; Mertens (1977) pl. 31.2.

147 Boot Painter: *ARV*² 821–3; Boardman (1975) fig. 382. White interior, *ARV*² 821.1.

148 Warsaw 142317 (ex Czartoryski 80): *ARV*² 821.4 (Boot Painter); CVA pl. 36; in Beazley (1928) 38f noted as closely resembling a cup in the Vatican: *ARV*² 819.41 (Telephos Painter).

149 *ARV*² 821.

150 Above, p. 106 with notes 369f.

151 Above, p. 137 with notes 21f.

152 Pistoxenos Painter: *ARV*² 859–63; Berlin 2282, *ARV*² 859.1; CVA pl. 102f.

153 Payne (1936) 45 with n. 4, pls. 113–15.

154 Athens Acr. 439; Taranto; *ARV*² 860.2 and 3; Boardman (1989) figs. 64f.

155 Above, p. 55 with notes 72–77.

156 Above, p. 54 with notes 66–8.

157 Schwerin; *ARV*² 862.30; Boardman (1989) fig. 68.

158 Above, p. 89 with notes 276f.

159 Munich 2646; *ARV*² 437.128; Boardman (1975) fig. 296.

160 Above, p. 75 with n. 189.

161 Bobbin: Athens 2192; *ARV*² 863.32; Diepolder (1954) pl. 7; on the form see above, p. 154 with notes 140f. Pyxis: Brussels, Bibliotheque Royale 9; *ARV*² 863.31; Diepolder (1954) 11.

162 Above, p. 101 with n. 339.

163 Tarquinia Painter: *ARV*² 866–71; London D 43, *ARV*² 869, 55; Boardman (1989) fig. 73.1 and 2.

164 Samos; *ARV*² 865.1, middle; AM 54 pls. 5f. Boston 03.847; *ARV*² 865.2; AJA 19 (1915) 410.

165 Munich 2686; not listed by Beazley; Schefold (1981) 235; Williams (1987) 674f. See also p. 56 above, with n. 86.

166 London D 2; *ARV*² 862.22; Bloesch (1940) 103.2; Mertens (1974) 106, fig. 27; Boardman (1989) fig. 67.

167 Corbett (1965) 18f.

168 Providence Painter: below, Chapter 5 section IIIb; Nikon Painter: below, p. 174 with notes 92f; Timokrates Painter: below, p. 178 with notes 123–5.

169 Above, p. 21 with n. 4.

5 Early classical

1 Hartwig (1893) 490f; Furtwängler in FR (1904) 281–5; Beazley VA 129–32; Diepolder (1936) and (1954).

2 Penthesilea Painter: *ARV*² 879–90; name-piece, Munich 2688, 879.1; Boardman (1989) fig. 80.1 and 2.

3 Munich 2689; *ARV*² 879.2; Diepolder (1936) pls. 16–18.

4 See above, p. 106 with notes 369 and 370, p. 155 with n. 150; below, p. 178 with n. 120.

5 Penthesilean workshop: *ARV*² 877–971; collaboration, 877f. Wider study of collaboration in Attic potteries: Scheibler (1986).

6 Ferrara T.5 B VP; *ARV*² 880.12 and 891.3; Boardman (1989) fig. 82 (interior only); Alfieri (1979) figs. 118f.

7 Splanchnopt Painter: *ARV*² 891–9.

8 Painter of Brussels R 330: *ARV*² 925–31; Painter of Bologna 417:907–18.

9 Curtius Painter: *ARV*² 931–5; Boardman (1989) fig. 90.

10 Athens, Agora P 10206; *ARV*² 908.14 and 940.8. Painter of London E 777: *ARV*² 939–44.

11 Above, p. 46 with n. 31. See also below, p. 220 with n. 185.

12 Ferrara T.18 C VP; *ARV*² 882.35; Boardman (1989) fig. 81; Alfieri (1979) figs. 120–4.

13 Above, p. 88 with notes 274f.

14 Above, p. 67 with n. 149.

15 *Profil perdu*: Above, p. 64 with n. 127; below, p. 195 with n. 27; p. 258 with n. 147.

16 Above, p. 87 with n. 264.

17 'Class of the Seven Lobster-claws': *ARV*² 970f.

18 Boston 01.8032; *ARV*² 888.155; Boardman (1989) fig. 86; Bérard (1974) pl. 12.42.

19 Rhodes 12454; *ARV*² 1218.2 (Erichthonios Painter); CVA pls. 1.2–3 and 2.1; Bérard (1974) pl. 18.63. Bérard collects and studies these scenes.

20 Volute-krater, Oxford 525; *ARV*² 1562.4 (not attributed); CVA pls. 21.1–2 and 32.6. Bérard (1974) pl. 19.71. Ge: see below, p. 177 with notes 100–4; p. 220 with note 184.

21 Ancona 3130; *ARV*² 899.144; *JdI* 65/6 (1950/1) 169.

22 Wedding Painter: *ARV*² 922–4; pyxis, New York 39.11.8, *ARV*² 924.34; AJA 44 (1940) 182 fig. 7, and 183; Bérard (1974) pl. 14.48; another, Boardman (1989) fig. 89.

23 Several by the Painter of London D 12; *ARV*² 959–64; Boardman (1989) fig. 91.

24 New York 07.286.36; *ARV*² 890.173; Diepolder (1936) pls. 11.2 and 12.1.

25 Swindler (1915) no. 16. VA 130.

26 VA 128. Wedding pyxis: London D 11; *ARV*² 899.146; AM 32 (1907) 80–3; see also following notes. Sotades Painter: below, section IV.

27 AV 261; Acropolis fr. 589, from a covered cup; *ARV*² 898.136; Graef and Langlotz (1929) pl. 45 (in AV

numbered F 46 and thought to be from a pyxis-lid). Anesidora cup: above, p. 158 with n. 163.

28 *ARV*¹ 589–92.

29 Above, p. 103 with n. 347.

30 Bobbins: New York 28.167; *ARV*² 890, 175; Diepolder (1936) pl. 19; Mertens (1977) pl. 21.1; Athens, Ceramicus Museum; *ARV*² 890.176; *AA* 1940, 335. Splanchnopt Painter's covered cup: above, p. 164 with n. 27. Other covered cups: below, p. 172 with notes 88ff.

31 Athens Acr. 396; Graef and Langlotz (1929) pl. 29; not in *ARV*² (see Robertson (1979) 134 n. 29); *ARV*¹ 628.1, top.

32 See Kardara (1964) 22–4.

33 Bologna 289; *ARV*² 891, middle; *JHS* 92 (1972) pl. 6a; Furtwängler in FR 2, 88; Bothmer (1957) 165.

34 Below, p. 181, with notes 136–41; p. 195 with n. 22.

35 Above, p. 166 with notes 125–7.

36 Below, Chapter 6 section III.

37 Akestorides Painter: *ARV*² 781f; Boardman (1975) fig. 368.

38 New York 22.139.72; *ARV*² 781.1. Richter and Hall (1936) pl. 107. Akestorides *kalos*: *ARV*² 1560; on two Nolan amphorae by the Oionokles Painter (below, p. 177 with notes 106f); white lekythos by the Timokrates Painter (below, p. 178 with notes 124f).

39 Douris's scroll: above, p. 89 with notes 276f. Lekythos with hymn to Hermes: Neuchâtel (formerly Paris, Seyrig); *ARV*² 452, bottom; Beazley (1948) with pl. 34.

40 Washington 136673; *ARV*² 781.4; Beazley (1948a) pls. 36–8.

41 J. Paul Getty Museum (ex Bareiss 63); *ARV*² 1670.4*bis*; *AK* 16, 1973, pl. 31.1 and 3.

42 Below, section II.

43 Amphitrite Painter: above, p. 152 with notes 133–7. Stieglitz, Lyandros and Boot Painters: above, p. 155 with notes 144–9.

44 Painter of Würzburg 487: *ARV*² 836. Colmar Painter: above, p. 109 with notes 391–6.

45 Painter of Louvre G 456: *ARV*² 824–6. Eretria Painter: below, Chapter 7 section IV.

46 Munich 2685; *ARV*² 837.9; Boardman (1989) fig. 51.

47 See below, p. 249 with notes 80–3.

48 Sabouroff Painter: *ARV*² 837–51.

49 Below, p. 198 with notes 39 and 49–59.

50 Bloesch (1940) 87.1. White cups: below, p. 170 with notes 73–7, 88–90.

51 Above, p. 99 with notes 318–20 (Brygos Painter); 348f; 352–7 (Hieron/Makron); 437–41 (Triptolemos Painter).

52 Komast Group: *ABV* 23–37; others, *ibid.* 616–28; Heron Class: above, p. 105 with n. 357.

53 Sparkes and Talcott (1970) 81–7 and 256–61 nos. 303–77 (skyphoi); 109–12 and 275–80, nos. 562–623 (cup-skyphos).

54 Above, p. 136 with notes 17–23.

55 Owl-skyphoi: *ARV*² 982–4; Boardman (1989) fig. 96; fig. 97 is a rare careful piece.

56 Penelope Painter: below, Chapter 6 section IIe.

57 Euaion Painter: below, Chapter 6 section III. Euaichme Painter: *ARV*² 785–7.

58 Group of Ferrara T. 981; *ARV*² 978f.

59 Lewis Painter: *ARV*² 972–5; Boardman (1989) figs. 92–5; signed vases, 974.26 and 27. Smith (1939).

60 Below, Chapter 6 section IIc.

61 Below, p. 216 with notes 145–9.

62 Below, p. 210 with n. 101.

63 Above, p. 157 with n. 157.

64 Berlin 2317; *ARV*² 972.1; Smith (1939) pl. 1.

65 Vienna 1773; *ARV*² 272.2; Smith (1939) pl. 2.

66 Schwerin 731; *ARV*² 974.23; Smith (1939) pl. 13a–b.

67 Naples inv. 126057; *ARV*² 974.24; Smith (1939) pl. 13c–d.

68 Schefold (1981) 326.

69 Zephyros Painter: *ARV*² 976; Vienna 191, 976.2; Smith (1939) pl. 27.

70 Agathon Painter: *ARV*² 977f; Agathon pyxis, Berlin inv. 3308, 977.1; Rutherford Roberts (1978) pls. 61, 68.1.

71 Villa Giulia Painter: *ARV*² 618–26; Rome, Villa Giulia 909, 618.1; Boardman (1989) fig. 21; Beazley (1912b).

72 Above, p. 140 with n. 33.

73 I am grateful to Robert Guy for information on this.

74 New York 1979.11.15, Fletcher and Rogers Funds; *Metropolitan Museum of Art* (1980) 14.

75 *ARV*² 625f.101–9.

76 Athens Acr. 443; *ARV*² 625.100; Graef and Langlotz (1929) pl. 37.

77 Above, p. 155 with n. 142.

78 Below, p. 172 with n. 88.

79 Above, p. 142 with n. 46.

80 *ARV*² 619f.18–20; 18, London E 493, Beazley (1912b) pl. 11.

81 *ARV*² 621.33–42; 34, Boston 90.155, Boardman (1989) fig. 24. Cf. above, p. 103 with notes 345f; below, p. 191 with n. 2, p. 207 with notes 89f.

82 Cambridge 12.17; *ARV*² 623.66; *CVA* pls. 35.1 and 40.8.

83 Cambridge X 13; *ARV*² 623.73; *CVA* pl. 38.

84 Below, Chapter 6 section IIa.

85 Eupolis and Danae Painters: *ARV*² 1072–6; see also p. 216 below, n. 134.

86 Methyse Painter: *ARV*² 632–4.

87 Cincinnati 1962, 38; *ARV*² 634.5; Berge in Moon and Berge (1979) 204f no. 114; Mertens (1977) pl. 17.

88 Above, with n. 78; Boston 00.356; *ARV*² 741, near bottom; *AJA* 19 (1915) pl. 28.

89 Splanchnopt Painter's: above, p. 165 with n. 30. Pistoxenos Painter's: Nicosia 1934.iv-23, 1; *ARV*² 862.26; Beazley (1948) pl. 6.1 and 44–6 with discussion of shape and list.

90 Carlsruhe Painter: *ARV*² 730–9. See also below, p. 178 with n. 119.

91 Below, Chapter 6 section IIb.

92 Providence Painter: *ARV*² 635–44; Providence 15.005, 635.1; *CVA* pl. 18. Monograph: Serbeti (1983).

93 Above, p. 72 with n. 167.

94 Hermonax: *ARV*² 483–92.

95 Athens, from Brauron; *ARV*² 491.132. *Praktika* 1949, 87 fig. 16a, 2 (above).

96 Above, p. 105 with n. 358.

97 Pfuhl (1923) II, 521, bottom; Beazley AV 299.

98 Above, p. 152 with notes 134–6.

99 Siren cup: Louvre G 268; *ARV*² 492.161. Owl cup: Stockholm G 2334; *ARV*² 1655f.

100 Painter of the Birth of Athena: *ARV*² 494f; 1 (name-vase), London E 410, Boardman (1975) fig. 355.

101 Munich 2413; *ARV*² 495.1; Boardman (1975) fig. 350.1 and 2; *CVA* pls. 252–5.

102 Pallottino (1940); Beazley *ARV*² 495. Stamnos-fragment: Heidelberg 169; *ARV*² 495.2.

103 Louvre G 192 and Munich inv. 8738; *ARV²* 208f.160, 161; Philippaki (1967) pl. 63.1 and 2.

104 Harrison (1977).

105 Below, p. 202 with notes 60–3.

106 Oionokles Painter: *ARV²* 646–9; Nikon Painter: 650–2; Charmides Painter: 653f; Boardman (1975) figs. 360–7.

107 Dresden Painter; *ARV²* 655f.

108 Above, p. 166 with n. 38; p. 178 below with n. 124.

109 Villa Giulia Painter: above p. 169 with n. 71; *kalos Nikon* on lekythos, Oxford 1947.25, *ARV²* 624.78; Alkimachos Painter: above, p. 151 with n. 117; Nolan amphora with Nikon said to recall him: Boston 95.20, *ARV²* 535.4.

110 Pan Painter: above, p. 143 with n. 51; lekythos with Hippon said to be near him: Oxford 321, *ARV²* 561.9.

111 Following of Douris: above, p. 152 with n. 125; Nolan with Charmides: Madrid 11121; *ARV²* 805.81. Cat-and-Dog Painter: *ARV²* 866; name-vase with Charmides, Switzerland, private, 866.1.

112 Painter of the Yale Lekythos: *ARV²* 657–62; cup-skyphos, above, p. 140 with n. 35.

113 Above, p. 130 with notes 592f.

114 Mys: Athens 1626; *ARV²* 663f.

115 Athena Painter: above, p. 130 with n. 590; Haimon Workshop: above, p. 130 with n. 588.

116 Beldam Painter and his workshop: Haspels (1936), 170–91, 266–71; *ABV* 586f. Name-vase: Athens 1129; Haspels 266.1, pl. 49. Kurtz (1975) 84–7.

117 Athens 487; Haspels (1936) 267.11, pl. 50.1.

118 Outline or part-outline lekythoi: Athens 12801, 1982 and 1983; Haspels (1936) 266.2, 12 and 13. Red-figure: Copenhagen 1941; Haspels 266.8.

119 Above, p. 173 with n. 90. Association with Beldam Workshop: Haspels (1936) 180f.

120 See above, p. 106 with notes 369f; p. 150 with n. 150; p. 161 with n. 4.

121 Chimney lekythos: Haspels (1936) 165f, 178f; Kurtz (1975) 87. Emporion Painter: above, p. 131 with n. 595.

122 False interiors: Haspels (1936) 176f; Kurtz (1975) 86f.

123 Tymbos Painter and Group: *ARV²* 753–62; Boardman (1989) figs. 258–60.

124 Timokrates Painter: *ARV²* 743–4; Boardman (1989) fig. 252; relation to the Pistoxenos Painter, *ARV¹* 578.

125 Vouni and Lupoli Pointers: *ARV²* 744–5.

126 Painter of Athens 1826: *ARV²* 745–8; Boardman (1989) fig. 253. Inscription Painter: *ARV²* 748f; Boardman (1989) fig. 257. Buschor (1925) 16–18.

127 Above, p. 96 with n. 310; p. 146 with n. 87.

128 Methyse Painter's white calyx: above, p. 172 with n. 87. Examples of the shape using second white: below, p. 207 with notes 91–3.

129 Below, section IV.

130 Hesiod Painter: *ARV²* 774. 1, Boston 98.887, CB i pl. 15.37; 2 and 3, Louvre CA 482 and 483, *Enc. Phot.* iii 42a and b.

131 Haspels (1936) 190. Cf. above, p. 105 with n. 359.

132 Above, p. 135 with notes 11, 12.

133 Above, p. 135 with notes 8 and 12.

134 Niobid Painter: *ARV²* 598–608; name-vase, Louvre G 341; *ARV²* 601.22; Boardman (1989) fig. 4.1 and 2; Webster (1935) pls. 2–5.

135 Barron (1972). A different interpretation recently put forward with interesting arguments: McNiven (1989).

136 Painter of the Woolly Satyrs: *ARV²* 613f. Volute-krater:

137 New York 07.286.84; *ARV²* 613.1; Richter and Hall pls. 97f; Boardman (1989) fig. 15.

137 Pausanias I.17.

138 So on amphorae by the Andokides and Lysippides painters, above, p. 10 with n. 12. See also Sourvinou-Inwood (1974).

139 Pausanias X. 28–31.

140 See below, p. 248 with n. 74.

141 Painter of the Berlin Hydria: *ARV²* 615–17; calyx-krater, New York 07.286.86, *ARV²* 616.3; Richter and Hall (1936) pl. 99; Bothmer (1957) pl. 74.2.

142 Berlin 2403; *ARV²* 599.9; Webster (1935) pl. 24b and c.

143 Pausanias I.25–7.

144 Pausanias I.15.

145 Pausanias IX.4.

146 Information from J.R. Green; cf. Green (1978).

147 *ARV²* 1661, bottom.

148 Above, p. 141 with n. 44.

149 Altamura Painter: *ARV²* 589–97; 1 (name-vase), London E 469, Boardman (1989) fig. 10; 11 (Iliupersis vase), Boston 59.176, CB iii pls. 92–5.

150 Volute-krater: Ferrara T.381; *ARV²* 589.3; Alfiei (1979) figs. 77 and 78. Bell-krater: Ferrara T.311; *ARV²* 593.41; Alfieri (1979) figs. 74–6.

151 Copenhagen, Thorwaldsen Museum 96, and Erbach; *ARV²* 592.37.

152 *ARV²* 592.32–6; 32, Palermo V 780, Boardman (1989) fig. 11.

153 Palermo V 779; *ARV²* 496.5; *CVA* pls. 35f.

154 Louvre C 10846; *ARV²* 602.28.

155 Niobid Painter: *ARV²* 602f.30, 34–6, 38, 41. His manner: *ARV²* 609f.12, 15, 19–21. Other fragments in both lists may be from either form.

156 Bologna 313; *ARV²* 602.30; Webster (1935) pl. 19b.

157 *ARV²* 619f.14–26.

158 *ARV²* 599f.2, 13, 14; 2, Palermo G 1283, Boardman (1989) fig. 2.

159 *ARV²* 598f.1, 8.

160 Bologna: above, p. 165 with n. 33. Ferrara: below, p. 195 with n. 22.

161 London E 467, Ferrara T.313; *ARV²* 601f.23, 24; Webster (1935) pls. 14–16; 24, Boardman (1989) fig. 6.

162 Geneva MF 238; *ARV²* 615.1 above; Boardman (1989) fig. 17.

163 Palermo (1817); *ARV²* 619.13. Villa Giulia Painter: above, p. 169 with n. 71. Double-register calyx-kraters listed and discussed by Oakley (1984). He observes that they feature regularly in two workshops only: the Niobid Painter's and the Phiale Painter's (below, Chapter 6, section IIb).

164 Above, p. 183 with n. 141.

165 *ARV²* 612f, Mertens (1977) pl. 18.1.

166 Ferrara T.579; *ARV²* 612.1; Boardman (1989) fig. 15.1–2 (3, Bologna 279, *ibid.* fig. 16).

167 Above, p. 181 with n. 136.

168 Syracuse 23508; *ARV²* 613.6; *CVA* pl. 14; Simon (1982) 133.

169 Palermo; *ARV²* 613.4; Boardman (1989) fig. 14.

170 An archaic example, above, p. 98 with n. 311; A later London D 14, *ARV²* 1213.2.

171 Sotades: *ARV²* 772f; *Para* 416, top; Hoffmann (forthcoming). Amazon-vase: Boston 21.228; *ARV²* 772; Bothmer (1957) pl. 90.1a–c.

172 Horse: Louvre CA 1526. Sphinx: Rome, Villa Giulia; *ARV*² 772.

173 Louvre CA 3825; *Para* 416; Boardman (1989) fig. 101.

174 London D 8; Boston 98.886; *ARV*² 772; Boardman (1989) fig. 100; Burn (1985) pl. 26. Cicada: Hoffmann (1988).

175 London D 5; *ARV*² 763.2 and 772; Mertens (1974) 104f, fig. 26; Burn (1985) pls. 23.1, 24.2, 27.1 and 2; Hoffmann (1989) 77–82, figs. 6 and 7. See below, p. 187 with n. 196.

176 London D 6: *ARV*² 763.1 and 772; Boardman (1989) fig. 102; Burn (1985) pls. 23.2, 27.3–4. Hoffmann (1989) 70–4, fig. 1. See below, p. 188 with n. 198.

177 Once Goluchow, Czartoryski 76; *ARV*² 764.7 and 772; Beazley (1928) pls. 15f.

178 London D 9, D 10; *ARV*² 773.1 and 2, middle; Burn (1985) pl. 26.

179 London D 7; *ARV*² 763.3; Boardman (1989) fig. 103; Burn (1985) pls. 24.1 and 3–4, 27.5 and 6. Hoffmann (1989) 74–7, fig. 3. See below, p. 186 with n. 193.

180 Brussels A 891; *ARV*² 771.2, middle; Burn (1985) pls. 25.2, 27.8.

181 Brussels A 890; *ARV*² 771.1, middle; Burn (1985) pls. 25.1, 27.7.

182 Burn (1985) 100–2.

183 Above, p. 38 with n. 130.

184 London E 788; *ARV*² 764.8; Boardman (1989) fig. 106.

185 London E 789; Paris, Petit Palais 349; Dresden 364; *ARV*² 764.9–11; 10, Boardman (1989) fig. 104. Others decorated in the painter's manner: *ARV*² 765f.1, 2.

186 In the painter's manner: *ARV*² 766.3, 4.

187 Ferrara T.18 C VP; *ARV*² 766.5 (painter's manner); Hoffmann (1984).

188 Decorated by the painter: *ARV*² 764.12–19; in his manner: *ibid.* 766–8.6–31; 16, Compiègne 898, Boardman (1989) fig. 107.

189 Above, p. 100 with n. 325.

190 New York, Katz; *ARV*² 767.25 (manner).

191 Boston 26.15; *ARV*² 767.21 (manner, might be by the painter himself).

192 The painter: Louvre SB 4143 and 4154; *ARV*² 765.19. His manner: Louvre SB 4136, SB 4135, unnumbered, SB 4145; *ARV*² 767f.23 and 29–31; Louvre SB 4138 and 4151; *ARV*² 773, middle.

193 Above, p. 185 with n. 179.

194 Burn (1985) 95–100.

195 Above, p. 135 with n. 7.

196 Above, p. 185 with n. 175.

197 Above, p. 180 with n. 134.

198 Above, p. 185 with n. 176.

199 Burn (1985) 94 with notes 8 and 9 (references).

200 Above, p. 185 with notes 180 and 181.

201 Hoffmann (1989).

202 London E 804; *ARV*² 765.20; Boardman (1989) fig. 105; Robertson (1975) pl. 91a–d.

203 Above, p. 136 with n. 15.

204 Above, p. 185 with n. 179.

205 Above, p. 185 with n. 177.

206 Hoffmann (1985).

207 See Robertson (1984) 207.

6 High classical

1 Above, p. 169 with n. 71.

2 Chicago Painter: *ARV*² 628–31; 4 (name-vase), Chicago 1889.22; Moon and Berge (1979) no. 111; 9, St Louis 20.15.51, *ibid.* no. 113. See also below, p. 218 with n. 155.

3 *VA* vi.

4 London E 383; *ARV*² 630.25; *VA* 156.

5 Above, p. 171 with n. 83.

6 Lecce 570; *ARV*² 529.23; Boardman (1989) fig. 28.

7 Above, p. 185 with n. 166.

8 Ferrara T.19 C VP; *ARV*² 628.1; Alfieri (1979) figs. 95–8.

9 Alfieri (1979) 44.

10 See *ARV*² 1562.

11 Above, p. 172 with n. 87.

12 Berlin Painter: above, Chapter 3 section IId.

13 Alkimachos Painter: above, p. 151 with n. 117. Timokrates and Vouni Painters: above, p. 179 with notes 124f. Telephos Painter: above, p. 152 with n. 129.

14 Lykaon Painter: below, with notes 107–17. Euaion Painter: below, section III. Phiale Painter: below, p. 000 with notes 79–97.

15 Achilles Painter: Beazley (1914a); *ABV* 408–9, *ARV*² 986–1001; 1 (name-amphora), Vatican; Boardman (1989) fig. 109.

16 Above, p. 72 with n. 167.

17 Above, p. 192 with n. 9.

18 Above, p. 34 with n. 91.

19 Above, p. 174 with n. 92.

20 Beazley (1914a) 179–85. Nolans: Boardman (1989) figs. 111f.

21 Cabinet des Médailles 372; *ARV*² 987.4; Boardman (1989) fig. 110.

22 Above, p. 184 with n. 160; Ferrara T.1052; *ARV*² 991.53; Alfieri (1979) figs. 139–41.

23 Above, p. 183 with notes 146 and 147.

24 Above, p. 194 with n. 14.

25 Cabinet des Médailles 357; *ARV*² 987.2; detail, Beazley (1914a) 192; Robertson (1975) pl. 106b; full publication, Shefton (1967).

26 Above, p. 141 with n. 42.

27 Below, p. 258 with n. 147.

28 Vich (Barcelona); Shefton (1967), with a fine account of the Achilles Painter's vase.

29 Oedipus Painter's: Vatican; *ARV*² 451.1: Boardman (1975) fig. 301.1 and 2. Etruscan: Musée Rodin 980; Plaoutine (1937). Oedipus Painter: above, p. 152 with n. 125.

30 New York 07.286.81; *ARV*² 991.61; Boardman (1989) fig. 114.

31 Beazley and Bothmer, *ARV*² 1677.

32 Below, p. 205 with n. 72.

33 Philadelphia 30.4.1; *ARV*² 990.45 and 841.112; Boardman (1989) fig. 113; Beazley (1932a).

34 Above, p. 143 with n. 49.

35 Painter of Bologna 228: see n. 38; Louvre CA 453; *ARV*² 184.22; Boardman (1975) fig. 141; *Enc. Phot.* 6–7.

36 Beazley (1932a) 15.

37 Hermonax: Tübingen E 90; *ARV*² 488.81; Beazley (1932a) 22. Berlin Painter: Erlangen 526; *AJA* 39 (1935) pl. 9.

38 Painter of Bologna 228: above, p. 142 with n. 48.

39 Above, p. 167 with n. 48.

40 Above, p. 123 with notes 515–9.

41 Below, p. 276 with n. 86.

42 Berlin Painter, *ABV* 407–9; New York, G. Callimanopulos, on loan to Metropolitan Museum

L.1982.102.3, *CVA* Castle Ashby pls. 17 and 18.1; 4, Berlin 1832, Boardman (1974) fig. 302. Achilles Painter, *ABV* 409; 1, Bologna 11, Boardman (1974) fig. 303 (detail), Rumpf (1953) pl. 32.8.
43 Beazley (1928) 7–8.
44 Beazley (1929) 12f, where he notes that Rumpf had also seen the connection; (1951) 94f (= 1986, 87f); *ABV* 407f.
45 Beazley (1943) 448–50.
46 Above, p. 138 with notes 25–9.
47 Above, n. 42.
48 Above, p. 178 with notes 124f.
49 See especially Kurtz (1975), Wehgartner (1983).
50 Wehgartner (1985).
51 Prothesis: *ARV²* 846.190, 851, 273f; 273, London D 62, Boardman (1989) fig. 256. Hypnos and Thanatos: *ARV²* 51.272; London D 59, Robertson (1959) 150f. Charon: *ARV²* 846f.193–9; 193, Athens 1926, Boardman (1989) fig. 255.
52 Munich; *ARV²* 997.155; Boardman (1989) fig. 262.
53 Athens 1818; *ARV²* 998.161; Boardman (1989) fig. 264.
54 New York 07.286.40; *ARV²* 846.190; Robertson (1959) 147.
55 See below, Chapter 8, section v.
56 Kurtz and Boardman (1971) 104f.
57 Unpublished thesis. I am most grateful to Mr van de Put for letting me see this.
58 Trophy Painter: *ARV²* 857f; Boardman (1989) figs. 54f.
59 See *ARV²* 853f, 857.
60 Bosanquet Painter: *ARV²* 1226f; Eretria lekythos, 1227.1; Boardman (1989) fig. 269.
61 London 1907.7–10.10; *ARV²* 1227.10; Kurtz (1975) pl. 30.3.
62 Above, p. 197 with n. 101.
63 Persephone Painter: *ARV²* 1012f; 1 (name-vase), New York 28.57.23; Boardman (1989) fig. 121; Bérard (1974) pl. 2.5.
64 Thanatos Painter: *ARV²* 1228–31; 12 (name-vase), London D 58; Boardman (1989) fig. 271; Kurtz (1975) pl. 32.4.
65 Athens 1942; *ARV²* 1229.27. See below, p. 252 with notes 101–4.
66 London D 60, Bonn 1011; *ARV²* 1230.37 and 38; 37, Boardman (1989) fig. 272; Kurtz (1975) pl. 32.3.
67 Felten (1971). Kleophon Painter: below, Chapter 7 section I.
68 Beazley (1928) 66 n. 5. Dwarf Painter: *ARV²* 1010f; Boardman (1989) figs. 119–20. Amphiaraos hydria, Boston 76.45, *ARV²* 1011.16; CB i pl. 27.58.
69 Above, p. 201 with n. 57.
70 Painter of London E 494: *ARV²* 1079f; 3 (name-piece), *JHS* 70 (1950) 36, fig. 1.
71 Louvre G 413; *ARV²* 484.22; *LIMC* I, Agamemnon 43. Hermonax: above, p. 174 with n. 94.
72 Above, p. 196 with notes 30–2.
73 Painter of Munich 2335: *ARV²* 1161–70.
74 Oakley (1990). Van de Put, above, p. 201 with n. 57. Nolan and pelike, Boardman (1989) figs. 205f.
75 New York 09.221.44; *ARV²* 168.128; Boardman (1989) fig. 268.
76 Below, p. 252 with n. 99.
77 Below, p. 219 with n. 40; and p. 251 with notes 95 and 99; p. 272 with n. 55.
78 Bird Painter: *ARV²* 1231–6, 1687f; *Para* 467; Boardman (1989) fig. 274.
79 Phiale Painter: *ARV²* 1014–24; Oakley (1990).
80 Washing Painter: below, Chapter 7 section II. Kleophon Painter: below, Chapter 7 section I.
81 Dinos Painter: below, Chapter 8 section III.
82 Above, p. 201 with n. 57.
83 Boston 97.371; *ARV²* 1023.146; Boardman (1989) fig. 128.
84 Above, p. 84 with n. 240.
85 Robertson (1979).
86 Woburn Abbey, Bedford; *ARV²* 1015.19; Beazley (1932) pl. 17.
87 Naples 3083; *ARV²* 1016.33; Beazley (1932) 112, fig. 2.
88 Boston 98.883; *ARV²* 1017.46; Boardman (1989) fig. 124.
89 Warsaw 142465; *ARV²* 1019.82; *CVA* pl. 26.
90 Above, p. 191 with n. 2.
91 Agrigento; *ARV²* 1017.53; Boardman (1989) fig. 123.
92 Trendall and Webster (1971) 4f.
93 Vatican; *ARV²* 1017.54; Arias, Hirmer and Shefton (1962) pls. xliiif.
94 Athens 19355; *ARV²* 1022.139*bis*; Boardman (1989) fig. 267.
95 Below, p. 216 with n. 134; p. 218 with n. 161.
96 Munich 2797; *ARV²* 1022.138; Boardman (1989) fig. 266.
97 Munich 2798; *ARV²* 1022.139; Arias, Hirmer and Shefton (1962) pl. 189.
98 Above, p. 180 with n. 134.
99 Kleophon Painter: below, Chapter 7 section I; Dinos Painter: below, Chapter 8 section III.
100 Lewis Painter: above, p. 168 with n. 59; Nausicaa Painter: below, p. 216 with notes 145–9.
101 Polygnotos: *ARV²* 1027–31; the Group, 1027–64; Boardman (1989) figs. 129–66.
102 *ARV²* 1035. Below, p. 213 with notes 117–27.
103 Matheson (forthcoming).
104 London 96.7-16.5; *ARV²* 1027.2; *CVA* pl. 25.2.
105 See Robertson (1984) 207.
106 Adria BC 104; *ARV²* 1029.19; *CVA* pl. 42.1.
107 Lykaon Painter: *ARV²* 1044–6; Boston bell-krater, *ibid.* 1045.7; Boardman (1989) fig. 152.
108 Above, p. 145 with notes 65–70.
109 See above, p. 207 with n. 92.
110 Oxford, 289; *ARV²* 1046.11; *CVA* pl. 25.6.
111 Boston 34.79; *ARV²* 1045.2; Boardman (1989) fig. 150.
112 Above, p. 151 with notes 135–9.
113 Pelike: London E 379; *ARV²* 1045.3. Neck-amphora: New York 06.21.116; *ibid.* 1044.1; Richter and Hall (1936) pls. 128–30.
114 See Beazley in *VA* 172f.
115 Moscow, Hist. Mus. inv. 73; *ARV²* 1030.34; *AA* 1927 Beil. 3–4.
116 Polygnotos: Berlin 2353; *ARV²* 1031.39; Neugebauer (1932) pl. 61. Lykaon Painter: above, n. 111. Kleophon Painter: Munich, Haniel; *ARV²* 1146.44; Neugebauer (1938) pl. 77.
117 Hector Painter: *ARV²* 1035–7; 1 (name-vase): Boardman (1989) fig. 140; Korshak (1980) pls. 27.2 and 4, 32.6.
118 Peleus Group: *ARV²* 1035–42.
119 *ARV²* 1035.

315

[120] Curti and Guglielmi Painters: *ARV*² 1042f; Boardman (1989) figs. 146f.

[121] Korshak (1980).

[122] Ferrara T.617; *ARV*² 1038.1; Boardman (1989) fig. 142; Alfieri (1979) fig. 148.

[123] Hesiod, Theogony 440–52.

[124] London E 271; *ARV*² 1039.13; Boardman (1989) fig. 144.

[125] E.g. the Meidias Painter's Mousaios, below, p. 239 with n. 28.

[126] Munich 2412; *ARV*² 1036.5; Boardman (1989) fig. 141.

[127] Above, notes 107, 111.

[128] Ferrara T.404; *ARV*² 1039.9; Boardman (1989) fig. 143.

[129] Ferrara T.128; *ARV*² 1052.25; Boardman (1989) fig. 157.1 and 2; Bérard (1974) pl. 3.7. On the subject see *ARV*² 1052.25 and Simon (1953) 79–87.

[130] Above, p. 138 with notes 24–6.

[131] Ferrara (sequestro Guardia Finanze di Comacchio); *ARV*² 1680f; Boardman (1989) fig. 167; Alfieri (1979) figs. 152–6.

[132] Painter of the Woolly Satyrs: above, p. 151 with notes 136, 167–9.

[133] Painter of the Louvre Centauromachy: *ARV*² 1088–94; Boardman (1989) figs. 186–8. Naples Painter, *ARV*² 1096–100; Boardman (1989) figs. 189–90. Cf. *ARV*¹ 705 and 709, 'approximates to the Group of Polygnotos'.

[134] Clio Painter: *ARV*² 1080–2. Cassel Painter: *ARV*² 1083–6. AV 402–4 (Kleiomaler; Cassel Painter, not yet named, bottom of 404); *ARV*¹ 668 (of the Eupolis Painter): 'His early work is early classical: in his late, like the Clio and Cassel Painters, he approximates to the group of Polygnotos.' Eupolis Painter: *ARV*² 1072–4, 'related to the Group of the Villa Giulia Painter'; above, p. 172 with n. 85.

[135] Beazley (1943) 453.

[136] Robinson Group: *ABV* 410. Panathenaics: below, p. 259 with notes 159–65; Chapter 9, *passim*.

[137] Boreas Painter: above, p. 142 with n. 47.

[138] Florence Painter: *ARV*² 540–4; 1 (name-vase), Florence 3997; Boardman (1989) fig. 50.

[139] Naples Painter and Painter of Louvre Centauromachy: above, n. 133.

[140] Orpheus Painter: *ARV*² 1103–5; 1 (name-vase), Berlin 3172; Simon and Hirmer (1976) pl. 203; others, Boardman (1989) figs. 192f.

[141] *ARV*¹ 703f.

[142] Salerno, from Montesarchio (near Benevento); not known to Beazley; Gourevitch (1972); Lesky (1973) figs 1f; d'Henry (1974); Robertson (1977a). See further below, p. 256 with notes 133–6.

[143] Agrigento, Perseus and Oinanthe Painters: above, p. 149 with notes 100–4.

[144] Nausicaa Painter: *ARV*² 1106–10. Hephaistos Painter: *ibid.* 1113–16.

[145] Munich 2322; *ARV*² 1107.2; Boardman (1989) fig. 194.

[146] 1 22 6.

[147] London E 284; *ARV*² 1107.7; CVA pl. 17.3.

[148] Above, p. 214 with n. 126.

[149] Warsaw 142261; CVA pl. 34.1; *ARV*² 1033.6 (Group of Brussels A 3096); AV 255.4 (Manner of Nausicaa Painter); see Beazley (1928) 53f.

[150] Ferrara T.614; *ARV*² 1114.11; Alfieri (1979) fig. 167.

[151] Ferrara T.394; *ARV*² 1114.13; Alfieri (1979) fig. 168.

[152] *ARV*² 1123f (Painter of Athens 1183).

[153] Academy Painter: *ARV*² 1124f; 6, column-krater, Ferrara T.200; Alfieri (1979) fig. 171.

[154] Above, Chapter 3 section VIC; Chapter 4 section IIIb.

[155] Chicago Painter: above, p. 191 with n. 1. Oinochai shape 4: Boston 13.197, 196, 191, 192; *ARV*² 630f.37–40; 38, Boardman (1989) fig. 29.

[156] Goluchow Painter: above, p. 36 with n. 106. Painter of Berlin 2268: *ARV*² 153–7.

[157] Dutuit Painter: above, p. 121 with notes 482f, p. 129 with notes 579f.

[158] Terpaulos Painter: *ARV*² 308; 4, St Louis, Washington Univ. 3283; Kurtz (1975) pl. 55.4.

[159] Harrow Painter: above, p. 127 with notes 555–8.

[160] Painter of the Brussels Oinochoai: *ARV*² 775.2 and 3 (name-vases), Brussels A 719, 720; CVA d p. 5. 1 and 2. Painter of Bologna 228 separated: *ARV*¹ 335. See above, p. 142 with n. 48.

[161] Mannheim Painter: *ARV*² 1065f; 1, London E 555, Boardman (1989) fig. 219; 8, Vatican, Boardman (1989) fig. 220.

[162] Pistoxenos: above, p. 138 with n. 23. Lewis Painter: above, p. 168 with n. 59.

[163] Florence 12221–5; *ARV*² 1061.165.

[164] Pantoxena Painter: *ARV*² 1050. 1, Cabinet des Médailles 846; *EAA* v 941. 2, Boston 10.224; FR iii 358. 4, calyx-krater, Syracuse 22934; Boardman (1989) fig. 155.

[165] Penelope Painter: *ARV*² 1300–2.

[166] Name-piece: Chiusi 1831; *ARV*² 1300.2; Boardman (1989) fig. 247.

[167] Berlin 2588; *ARV*² 1300.1; Boardman (1989) fig. 246.

[168] Below, p. 219 with n. 176.

[169] Refs. in Robertson (1975) 209f with notes 95f. Add (very important) Gauer (1990).

[170] Above, p. 183 with n. 145.

[171] Above, p. 86 with n. 254.

[172] Berlin 2589; *ARV*² 1301.7; Boardman (1985) fig. 249.

[173] Louvre G 372; *ARV*² 1300.4; Boardman (1989) fig. 248.

[174] Oxford 288; *ARV*² 1301.14; CVA pl. 46.8–9.

[175] Robertson (1975) 212 with n. 99.

[176] Euaion Painter: *ARV*² 789–98; Boardman (1989) figs. 369f and 374.

[177] Warsaw 142464; *ARV*² 797.142; CVA pl. 34.3.

[178] Codrus Painter: *ARV*² 1268–72.

[179] See Rutherford Roberts (1978) 229–31; Oakley (1984) 122 with n. 23. Cf. also below, with n. 185.

[180] London E 82; *ARV*² 1269.3; Boardman (1989) fig. 239.

[181] London E 84; *ARV*² 1269.4; Boardman (1989) fig. 240.

[182] Bologna PU 273; *ARV*² 1268.1; CVA pls. 19–22.

[183] Berlin 2538; *ARV*² 1269.5; LIMC I, Aigeus 1.

[184] Berlin 2537; *ARV*² 1268.2; Boardman (1989) fig. 238; Bérard (1974) pl. 2.4.

[185] Harrow 52; not in *ARV*²; AV 426.8; *ARV*¹ 660, bottom; Burl. Cat. (1904) pl. 97 1 60.

[186] Below, p. 233 with notes 67–9.

7 Developments from the high classical

[1] Kleophon Painter: *ARV*² 1143–7; 7 (name-stamnos), Leningrad 810; Peredolskaya (1967) pls. 140f.

[2] Orestes Painter: *ARV*² 1112f; 5 (name-vase), London 1923.10–16.10; Boardman (1989) fig. 198; 10 (Megakles vase, his only bell-krater), London A 258; CVA pl. 27.1–3.

3 *ARV*² 1054.58.

4 Copenhagen inv. 13817; *ARV*² 1145.35; Boardman (1989) fig. 174.

5 Oxford 281; *ARV*² 1144.13; *CVA* pl. 29.

6 Amsterdam inv. 2354; *ARV*² 1144.12; *CVA* Scheurleer d pl. 4.4.

7 Oxford 1929.11 (with the stele) and 1966.708, 708a; *ARV*² 1146.51 and 52; *CVA* pl. 66.27–9 and *Beazley Gifts* pl. 40.268.

8 Athens 1700; *ARV*² 1146.50; Boardman (1989) 176; Kurtz (1975) pl. 45.1a–c.

9 Bucharest inv. 03207; *CVA* 1 pl. 32.1; not listed by Beazley.

10 Munich 2415; *ARV*² 1143.2 (reverse wrongly described); Boardman (1989) fig. 172.

11 Leningrad 809; *ARV*² 1143.3; Peredolskaya (1967) pl. 142.

12 Cambridge 28.8; *ARV*² 1143.5; *CVA* pls. 25.2, 28.7, 39.4.

13 Above, n. 1.

14 Munich 2361; *ARV*² 1145.36; *CVA* pls. 74 and 75.2, 6, 7.

15 Leningrad 774; *ARV*² 1144.14; Peredolskaya (1967) pl. 143.

16 Ferrara t.57 c vp; *ARV*² 1143.1; Boardman (1989) fig. 171; Alfieri (1979) figs. 174–7.

17 Below, Chapter 8 section iii.

18 Washing Painter: *ARV*² 1126–33. Typical small hydria: Boardman (1989) fig. 209; small pelike, fig. 208.

19 Dresden; *ARV*² 1132.176.

20 New York 22.139.25; *ARV*² 1130.151; Richter and Hall (1936) pl. 149.147.

21 Athens 14792; *ARV*² 1133.197; *AM* 71, Beil. 116, above. A squat lekythos with the same: London, Victoria and Albert Museum C2500.1910; Boardman (1989) fig. 211.

22 Above, p. 142 with n. 49; also p. 196 with notes 33–7.

23 *Praktika* 1955, 51; 1957, 25f; *BCH* 1956, 234; 1958, 660–6; *AR* 1955 (1956) 7; 1957 (1958) 5; *ARV*² viii and xlv.

24 Athens, Acr.; *ARV*² 1128.20–92.

25 Distinction: above, p. 145 with n. 49. Complete loutrophoros by Washing Painter: Athens 1453; Buschor (1940) 215; fine fragment: London 96.12.–17.11; *JHS* 41 (1921) pl. 7. Complete lebes: New York 16.73; Richter and Hall (1936) pls. 147 and 174.144; Boardman (1989) fig. 207.

26 Wurzburg 541; *ARV*² 1133.196; Greifenhagen (1957) 42–5.

27 Munich 8926 (ex Breitbrunn, Buschor); *ARV*² 1127.6*bis*; Greifenhagen (1957) 46.

28 Berlin 2357; *ARV*² 1134.8; Pfuhl (1923) fig. 577.

29 Hasselmann Painter and manner: *ARV*² 1135–40; Boardman (1989) fig. 213. Painter of London E 395 and related: *ARV*² 1140f.

30 Xenotimos cup: Boston 99.539; *ARV*² 1142; Boardman (1989) fig. 214.

31 See also below, pp. 246 and 259 with notes 66 and 150–2.

32 Painter of the Brussels Oinochoai and Mannheim Painter: above, p. 218 with notes 160 and 161.

33 Painter of Bologna 228: Above, p. 142 with n. 48.

34 Shuvalov Painter: *ARV*² 1206–13; Lezzi-Hafter (1976).

35 Perseus: Ferrara (sequestro Venezia); *ARV*² 1206.2; Alfieri (1979) fig. 195. Apollo pursuing woman: Bari inv. 1402;

36 'Theseus' pursuing woman: Ferrara t.857; Bologna 346; *ARV*² 20 and 21; 20, Alfieri (1979) fig. 193. On the subject see Sourvinou-Inwood (1987) and (1987a).

37 Eriphyle: Ferrara t.512 and t.40 a vp; *ARV*² 1206.4 and 12; Alfieri (1979) figs. 197 and 198. Chicago Painter: above, p. 191 with n. 6.

38 Berlin 2414; *ARV*² 1208.41; Boardman (1989) fig. 224.

39 Above, n. 34.

40 *ARV*² 1167.110–14; Painter of Munich 2335: above, p. 204 with notes 73–77; below, pp. 251 and 252 with notes 95 and 99; p. 272 with n. 55.

41 Choes: Sparkes and Talcott (1970) 60–3 and 244f nos. 105–38; van Hoorn (1951). School-scene: London E 525; *ARV*² 1208.38; van Hoorn (1951) fig. 196. *Ephedrismos*: Berlin 2417; *ARV*² 1208.35; van Hoorn (1951) fig. 283.

42 Oxford 534; *ARV*² 1258.1, bottom; *CVA* pls. 43.2 and 39.3–4.

43 Boston 01.8085; *ARV*¹ 704, middle (not in *ARV*²); see also Beazley in CB ii 95f (pl. 64, below); van Hoorn (1951) fig. 501.

44 *VA* 178.

45 Below, p. 253 with notes 102–4.

46 Florence 22 B 324 and Leipzig T 527; *ARV*² 1258.2, bottom; van Hoorn (1951) fig. 365.

47 Boston 00.352; *ARV*² 1214.1, below; CB ii pl. 64, above.

48 Athens, Vlasto; *ARV*² 1215.1; Boardman (1989) fig. 228. Phlyax vases: below, p. 251 with n. 91.

49 Codrus Painter: above, p. 219 with n. 178. Eretria Painter: *ARV*² 1247–55; cups, nos. 50–104; 50, Naples 2613, 80, Louvre G 457; Boardman (1989) figs. 236f.

50 Cabinet des Médailles 851; *ARV*² 1251.41; *LIMC* I Achilleus 204, Antiochos I 3.

51 Athens 1629; *ARV*² 1250.34; Boardman (1989) fig. 235. Coarse ware examples: Sparkes and Talcott (1970) 280 and 357f.1995–9.

52 Above, p. 225 with n. 23.

53 Both Athens, Vlasto; *ARV*² 1249.13 and 14; van Hoorn (1951) figs. 38 and 10; 13, Boardman (1989) fig. 233.

54 Athens; *ARV*² 1249.15.

55 Berlin 2471; *ARV*² 1247.1; Boardman (1989) fig. 229.

56 New York 31.1.13; *ARV*² 1248.9; Boardman (1989) fig. 231.1 and 2.

57 Kansas City 31.80; *ARV*² 1248.8; *LIMC* I, Aglauros 36.

58 Sparkes and Talcott (1970) 156 and 316f nos. 1149–61.

59 Oxford 537; *ARV*² 1248.1; Boardman (1989) fig. 232.

60 Calliope Painter: *ARV*² 1259–63.

61 Oon: Guennol (Long Island), Martin; *ARV*² 1256.1; Bothmer (1961) pls. 91.246 and 92.246.

62 Oon: Athens (ex Stathatou); *ARV*² 1257.2, top; *Mon.Piot.* 40 pl. 7 and pp. 70–4 and 86.

63 Marlay Group: *ARV*² 1276–86; Marlay Painter: 1267–81; calyx-krater by him, Oxford 1942.3, Boardman (1989) fig. 242. Pyxis by Marlay Painter with lid by his companion the Lid Painter: London 1920.12–21.1, *ARV*² 1277.23 and 1282.1; Boardman (1989) fig. 243.

64 'Lozengy' stemlesses: *ARV*² 1279.48–51*bis* (Marlay Painter: 51*bis*, Laon 7.1064, *CVA* pl. 50); 1282.3,4,10–13 (Lid Painter; 11, Vienna 149, *CVA* pl. 25). 'Lozengy' cup: *ARV*² 1280.67 (Marlay Painter).

65 Ferrara t.27 c vp; *ARV*² 1277.22; Alfieri (1979) figs. 214f.

66 Ferrara t.264; *ARV*² 1280.64; Alfieri (1979) fig. 213.

67 Aison: *ARV²* 1174–7.
68 Madrid 11265; *ARV²* 1171.1, below; Boardman (1989) fig. 292.1–4.
69 Above, p. 220 with n. 180.
70 Berlin 2728; *ARV²* 1275.4; interior, *JHS* 96 (1976) pl. 2a.
71 Naples RC 239; *ARV²* 1174.6; Arias, Hirmer and Shefton (1962) pl. 205.
72 New York 75,2.8 (x.22.42); *ARV²* 1248.6.
73 Athens, Ceramicus Museum 4290; Knigge (1975); Burn (1987) pl. 33, and see 12f and 98.M 15.
74 Athens Acr.; *ARV²* 1175.11; *AM* 90 (1975) pl. 51.

8 The later fifth century; developments into the fourth

1 See below, p. 253 with n. 107, p. 258 with notes 149–52, p. 260 with n. 165, p. 261 with n. 171.
2 Etruscan copies: above, p. 196 with notes 28, 29; Attic ceramists at Falerii?: Beazley (1947) 70.
3 South Italian vase-painting: Trendall's books (see Bibliography).
4 Boeotian red-figure: Lullies (1940); Ure (1953) and (1958).
5 Corinthian red-figure: Luce (1930); Trendall (1959); Corbett (1962). Elean (Olympian) red-figure: Schiering (1964); Trendall and McPhee (1982). Laconian red-figure, from Vourvoura: *Ergon* (1956) 83ff; *Praktika* (1956) 181f, (1957) 110f, (1961) 167f; S. Karouzou in *Eph*. 1985, 33–44 (pictures in *AR* 1987–8, 24f); see also Robertson (1988) 109 with n. 9 (McPhee).
6 Eretrian red-figure: Gex-Morgenthaler (1986).
7 Cretan red-figure: Cook (1990) with n. 6 (McPhee). McPhee is planning a survey of the non-Attic red-figure of Greece.
8 A summary of my views on this disputed question, with refs.: Robertson (1981) 149f.
9 Figure holding another on knees: below, p. 239 with n. 25, 246 with n. 69. Olympias: below, p. 286 with n. 133.
10 Below, p. 258 with notes 145–7.
11 *Ol.Forsch.* v. Calyx-krater frr. by Kleophon Painter: *ibid*. 250.5, pls. 82f; *ARV²* 1144.17.
12 Above, p. 208 with notes 96 and 97.
13 Below, pp. 253 and 254 with notes 103, 111–13. Apollodoros, Zeuxis, Parrhasios: Robertson (1981) 147–9.
14 Meidias Painter: *ARV²* 1312–14; his circle, 1315–32; Burn (1987).
15 Above, p. 234 with notes 72 and 73.
16 Above, p. 220 with n. 51.
17 Palermo 12480 (or 1280?); *ARV²* 1249.21.
18 Above, p. 231 with notes 55 and 56.
19 Burn (1987) 18f and *passim*. My treatment of this circle owes a great deal to Burn's book.
20 London E 224; *ARV²* 1313.5; Burn (1987) pls. 1–9, and see 15–25 and 97.M 5; Boardman (1989) fig. 287.
21 Above, p. 233 with n. 71.
22 Once Leyden, Cramers G 36; not known to Beazley; Burn (1987) pl. 46, and see 71 and 100.M 33; Boardman (1989) fig. 305.
23 Above, p. 220 with notes 180–3.
24 Florence 81948 and 81947; *ARV²* 1322.1 and 2; Burn (1987) pls. 22–5a and 27–9; and see 40–4 and 97.M 1, M 2; Boardman (1989) figs. 285f.

25 Above, p. 238 with n. 9.
26 J. Paul Getty Museum 82.AE.38; not known to Beazley; True (1985); Burn (1987) pls. 30, 31a, and see 43 and 100.M 32.
27 True, who attributed the cup, suggests that Demonassa is Phaon's bride; Simon (and Hirmer, 1976: 148), who did not then know the cup, suggests that on the hydria she is Aphrodite, an idea favoured by Burn.
28 New York 37.11.23; *ARV²* 1313.7; Burn (1987) pls. 33–7, and see 54f and 98.M 7. Cf. above, p. 214 with n. 125.
29 Ruvo, Jatta 1538; *ARV²* 1314.18; Burn (1987) pl. 38a–c, and see 55–7 and 99.M 18.
30 Above, p. 234 with n. 74.
31 New York 75.2.11; *ARV²* 1313.11; Burn (1987) pl. 52b, and see 89–93 and 98.M 12; Boardman (1989) fig. 288.
32 Above, p. 231 with n. 53.
33 Below, p. 269 with notes 33–8.
34 Berlin 2531; *ARV²* 1318.1, bottom; Burn (1987) 45f and 102.A 1; Boardman (1989) fig. 289.1 and 2.
35 Boston 00.344; *ARV²* 1319.2, top; Burn (1987) 45 and 103.A 2; Boardman (1989) fig. 290; CB iii pls. 103.171 and 104.
36 Agrigento; *ARV²* 1319.4; Burn (1987) 103.A 5.
37 Boston 00.345; *ARV²* 1319.3; Burn (1987) 45 and 103.A 3; Boardman (1989) fig. 291; CB iii pls. 103, 172 and 105.
38 Once Berlin 2706; *ARV²* 1319.5; Burn (1987) 43, 45 and 103.A 6; Hahland (1930) pl. 21c.
39 Once Basel market; not known to Beazley; Burn (1987) 79 and 103.A 4; 109.MM 56 no. 109, pls. 50f.
40 Athens, Ceramicus Museum 2712; *ARV²* 1313.6; Burn (1987) pls. 44f and see 69f, 76f and 97.M 6.
41 Taranto 4529; *ARV²* 1326.77; Burn (1987) pl. 38d, and see 60–2 and 99.M 23.
42 Basel, Cahn 541; not known to Beazley; Burn (1987) pl. 34, and see 53–4 and 100.MM 17.
43 Sparkes and Talcott (1970) 164–73 and 320–6 nos. 1206–84.
44 Taranto and Reggio; *ARV²* 212.215; *AK* 14 (1971) pl. 22.
45 Ferrara T.0; *ARV²* 490.125; Alfieri (1979) fig. 44.
46 Louvre CA 3068; *ARV²* 1314, below; North German, private, not known to Beazley; Burn (1987) pls. 31b and c, and see 48–50 and 99.M 24 and 25.
47 Above, p. 232 with notes 63–5.
48 Below, p. 262 with notes 179–81.
49 Above, p. 221 with n. 1.
50 Dinos Painter: *ARV²* 1151–5.
51 Berlin 2402; *ARV²* 1152.3; Boardman (1989) fig. 178.
52 Naples 2419; *ARV²* 1151.2; Boardman (1989) fig. 177; Arias, Hirmer and Shefton (1962) pls. 206–11. On the subject, see above, p. 171 with n. 81, below, p. 243 with n. 55.
53 Bologna 300; *ARV²* 1152.7; Boardman (1989) fig. 179; CVA pls. 86f.
54 Bologna 283; *ARV²* 1151.1; CVA pls. 68.3–5, 69 and 70.9.
55 Above, p. 207 with n. 89.
56 London E 775; *ARV²* 1328.92; Burn (1987) 79 and 116.MM 136.
57 Derveni krater: Yuri (1978).
58 Robertson (1972a).
59 Oxford 1937.983; *ARV²* 1153.13; Boardman (1989) fig. 181.

[60] Arezzo 1460; ARV^2 1157.25; Arias, Hirmer and Shefton (1962) pls. 212f; Pfuhl (1923) fig. 583.

[61] Below, p. 255 with notes 122–5.

[62] Polion: ARV^2 1171–3. Signed krater: New York 27.122.8; ARV^2 1171.2; Richter and Hall (1936) pls. 153f and 171.154.

[63] Above, p. 75 with notes 188f.

[64] Ferrara T.127; ARV^2 1171.1; Boardman (1989) fig. 306.1 and 2; Alfieri (1979) figs. 182–5.

[65] Above, p. 185 with n. 166.

[66] Bonn 78; ARV^2 1171.4 ; CVA pl. 19.1 and 2.

[67] New York 25.78.66; ARV^2 1172.8; Richter and Hall (1936) pls. 155 and 171.135.

[68] Oxford 1957.31; New York 56.171.57; ARV^2 1172.19 and 16; 19, Boardman (1989) fig. 307.

[69] Berlin inv. 30036; ARV^2 1173.1, below; Boardman (1989) fig. 308. Figure on another's knees: above, p. 237 with n. 9; p. 239 with n. 25.

[70] ARV^2 1184–8 (Kadmos Painter and manner); 1188–91 (Pothos Painter and manner). 'Brother': see Robertson (1982) xii.

[71] Berlin 2633, 2634; ARV^2 1187, 32 and 33; ML 14 (1903) pl. 2 and pp. 19, 40, 42 (32), pl. 3 and p. 15 (33).

[72] Below, p. 249 with n. 82.

[73] Bologna 303; ARV^2 1184.6; CVA pls. 79.3–4, 82 and 83.1–2; Pfuhl (1923) fig. 590.

[74] Above, p. 182 with n. 140.

[75] Below, p. 257 with n. 135.

[76] Ficoroni cista: Dohrn (1972).

[77] Robertson (1975) 178, pl. 56d.

[78] Munich 2360; ARV^2 1186.30; Boardman (1989) fig. 311; CVA pls. 80.11, 81, 82.

[79] Kiev and Kekrops Painters: ARV^2 1346f.

[80] Adolphseck, Landgraf Philipp of Hesse 77, 78; ARV^2 1346, 1 and 2, below; CVA pls. 46–51; Boardman (1989) fig. 334 (2, detail).

[81] See LIMC s.v. Europe I nos. 1, 218 and 225.

[82] Above, p. 247 with n. 71; Robertson (forthcoming).

[83] Above, with n. 78 (Lullies's remarks in CVA).

[84] Above, p. 237 with n. 20; p. 240 with notes 34 and 35.

[85] Athens Acr. 594, Graef and Langlotz (1931) pl. 45, Boardman (1989) fig. 331; Athens Pnyx 124; Talcott and Philippaki (1956); ARV^2 1341.1 and middle.

[86] Athens Acr. 1051; Graef and Langlotz (1931) pl. 81; ARV^2 1341, below middle.

[87] London 98.7–16.6; ARV^2 1332.1; Boardman (1989) fig. 319.

[88] Above, p. 246 with n. 64.

[89] Ferrara T.563; ARV^2 1286, middle; Alfieri (1979) fig. 216.

[90] Nikias Painter: ARV^2 1333–5; chous, Louvre N 3408; ARV^2 1335.34; Boardman (1989) fig. 321.

[91] Trendall (1959). See also above, p. 230 with n. 48.

[92] J. Paul Getty Museum 82.AE.83; not known to Beazley; Green (1986); Boardman (1989) fig. 314.

[93] Above, p. 204 with n. 73; p. 229 with n. 40; below, p. 252 with n. 99; p. 272 with n. 55.

[94] Above, p. 217 with notes 152 and 153.

[95] ARV^2 1167f.119–25 (120, Vienna 399; CVA pl. 46.1–3); 1360f.1–29.

[96] Above, p. 203 with notes 68–9.

[97] Above, p. 204 with notes 73–8.

[98] Quadrate Painter: ARV^2 1236–40; Buschor (1925) 19; Boardman (1989) fig. 275.

[99] Woman Painter: ARV^2 1371–3; Buschor (1925) 21; Kurtz (1975) 57, pls. 43.2 and 44.1–4; Boardman (1989) figs. 276, 277 (Manner).

[100] Reed Painter: ARV^2 1376–82; Buschor (1925) 20; and see next note.

[101] Group R: ARV^2 1383f; Reed Workshop (Reed Painter and Group R): Kurtz (1975) 58–68, pls. 46.2, 47f, 51.1 (Reed Painter and workshop), 49f (group R); Boardman (1989) figs. 278 and 279 (Reed Painter), 280–3 (Group R).

[102] Above, p. 237 with n. 13.

[103] Rumpf (1951).

[104] Johansen (1923a) 123–6 (French summary, 160); Rumpf (1953) 115f.

[105] ARV^2 1240.61–4.

[106] Triglyph Painter: ARV^2 1384–7; Buschor (1925) 19f; Kurtz (1975) 66f, pl. 51.3 and 4.

[107] Van de Put; see also Green and Sinclair (1970).

[108] Aristophanes Ecclesiazusae 994–7; Kurtz (1975) 73f.

[109] Below, p. 262 with n. 179.

[110] ARV^2 1390; Kurtz (1975) 68–73, pl. 54.1 and 2; Boardman (1989) fig. 284.

[111] Kurtz, l.c. last note.

[112] Below, pp. 266 and 288 with notes 6f, 139.

[113] Berlin 2683; not listed by Beazley; Kurtz (1975) 69 with n. 9.

[114] Berlin 2862; ARV^2 1385.13; Kurtz (1975) 69 with n. 8.

[115] Copenhagen NM 4986; ARV^2 1389.1, bottom; Kurtz (1975) 67, pl. 52.1.

[116] Pronomos Painter: ARV^2 1335f; 1 (name-vase) Naples 3240; Boardman (1989) fig. 323.

[117] Above, p. 96 with n. 304.

[118] See Webster (1972), an overstated case; Robertson (1991a).

[119] Vienna 1771; ARV^2 1318, near top; Boardman (1989) fig. 296; CVA pls. 120f.

[120] Painter of the Athens Wedding: ARV^2 1317f; 1, calyx-krater, Athens 138 (name-vase), Boardman (1989) fig. 295.

[121] Berlin inv. 4906; ARV^2 1336.4; Hahland (1930) pl. 11.

[122] Robertson (1981b) 59f no. 52, pl. 43.

[123] Palermo; ARV^2 1152.6; Hahland (1930) pl. 5.

[124] Above, p. 292 with n. 51.

[125] McPhee (1978) 553.

[126] McPhee (1978) 551–3. Bell-krater: Turin 4122; ARV^2 1190f 'might be by the Pothos Painter' (on basis of old drawing); McPhee (1978) figs. 1 and 2. Calyx-krater: Vienna Univ. 551c; ARV^2 1156.18 (Manner of the Dinos Painter); CVA pl. 25.4–6. Fragments: Oxford 1954.254; ARV^2 1156.14 (Manner of the Dinos Painter; same hand as last); Beazley (1939) 19.47.

[127] ARV^2 1336f; 10, plate, Boston 10.187, Boardman (1989) fig. 328.

[128] Rumpf (1953) pl. 56.3; see Robertson (1975) 579.

[129] See above, p. 243 with n. 58.

[130] Athens; ARV^2 1337.7; Corbett (1962) 354–7 no. 3852, pls. 148f. See also below, p. 259 with n. 154.

[131] Salonica 131; not listed by Beazley; Robinson (1933) pls. 78 and 79; 109–15, no. 131, pls. 78–9; Shefton (1982) 156.

[132] Leningrad, Baksy 8; not known to Beazley; Shefton (1982) 149f, figs. 3 and 4, pls. 41–4.

[133] Talos Painter: ARV^2 1338f; 1 (name-vase) Ruvo, Jatta 1501; Boardman (1989) fig. 324.1 and 2.

134 Above, p. 216 with n. 142.

135 Above, p. 249 with notes 75 and 76.

136 Ferrara (erratico presso т.312); *ARV*² 1340, middle; Alfieri (1979) fig. 240.

137 Würzburg н 4695; not listed by Beazley; Walter (1962).

138 Jena inv. 362; not listed by Beazley; Hahland (1930) 8f, pl. 16a.

139 Naples 2883; *ARV*² 1338, middle; Boardman (1989) fig. 327; Bérard (1974) pl. 1.1.

140 Suessula Painter: *ARV*² 1344f; 1, Gigantomachy neck-amphora, Louvre s 1677; Boardman (1989) fig. 329.1 and 2.

141 Athens 1333; *ARV*² 1337.8; Boardman (1989) fig. 326.

142 Würzburg inv. 4729; *ARV*² 1345f.; Boardman (1989) fig. 330. See also next note.

143 Würzburg inv. 4781; *ARV*² 1337f; 1690, bottom; *CVA* 2 pl. 41.1–5.

144 See *Para* 482, middle.

145 Semele Painter: *ARV*² 1343f; 1 (name-hydria) Berkeley 8.3316, Boardman (1989) fig. 333.

146 Von Salis (1940).

147 Above, p. 195 with n. 27.

148 See above, n. 145; below, with n. 152.

149 Athens, Ceramicus Museum; *ARV*² 1344.3, top; *AA* 1937 194, fig. 13.3.

150 S. Agata dei Goti, Mustilli; *ARV*² 1344.1, top; *Annuario* NS 8–10, 125–7.

151 Above, p. 227 with n. 31; p. 246 with n. 66; and cf. p. 248 with n. 72.

152 Above, n. 145.

153 Painter of the New York Centauromachy: *ARV*² 1408; 1, Leningrad 33a, Hahland (1930) pl. 17a; 2 (name-vase), New York 06.1021.140; Boardman (1989) fig. 339. See further below, p. 270 with notes 35–8.

154 *VA* 184.

155 Above, p. 242 with n. 52.

156 *AV* 456.

157 *ARV*¹ 870.

158 Above, p. 216 with n. 136; *ABV* 410.1–5, middle.

159 *CVA Baltimore*, Robinson 1 pls. 31–3.

160 Peters (1941) 91f.

161 Beazley (1943) 451f.

162 Beazley (1943) 452f; Berne 23725; Leningrad inv. 17295; *ABV* 410.1 and 2, bottom.

163 Beazley (1943) 453f; *ABV* 411.

164 London в 605; *ABV* 411.4; Beazley (1943) 453.5; *CVA* f pls. 2. 3 and 6, and pl. 6.

165 Süsserott (1938) 69–78, 205–6.

166 Beazley (1943) 454f; *ABV* 412.1–2, middle.

167 London в 606; Leningrad inv. 17553; *ABV* 411 and Beazley (1943) 453.3 and 2; *CVA* f pl. 1.2.

168 London 1903.2–17.1; *ABV* 411 and Beazley (1943) 453.1; *CVA* f pl. 1.1; Boardman (1974) fig. 304.1 and 2.

169 Beazley (1943) 453.

170 Boston 98.934, 935, 936; 01.8254, 8255; not listed by Beazley; Vermeule (1970) figs. 2–11, with earlier refs.

171 Vermeule (1970) 97f with n. 6. See below, p. 265 with n. 1.

172 Burn (1987) 7 with n. 32.

173 On Boston 98.936; Vermeule (1970) no. 3, fig. 7.

174 Boston 01.8255; Vermeule (1970) no. 5, figs. 10–11.

175 Boston 98.935; Vermeule (1970) no. 2, figs. 4–6.

176 Boston 98.934; Vermeule (1970) no. 1, fig. 3.

177 Boston 01.8254; Vermeule (1970) no. 4, figs. 8–9.

178 Choes collected and discussed by van Hoorn (1951). See also Green (1971).

179 Marble chous-tombstone: van Hoorn (1951).

180 *ARV*² 1318.1–3 (Group of Boston 10.190) (1, Berlin 2658, van Hoorn (1951) fig. 503; 2, Boston 10.190, *ibid.* fig. 85); 1320f.1–3 (Group of Athens 12144 (1, London 1929.10–16.2, *ibid.* fig. 300; 3, Berlin 2661, *ibid.* fig. 20), with another in which 'the drawing is not Meidian' (Athens 1560, *ibid.* fig. 1560).

181 Shuvalov Painter: *ARV*² 1208.35, 38, 39 (above, p. 229 with n. 41). Marlay Painter: *ARV*² 1277.20.

182 Crosby (1955); Trendall (1959) 20; Webster (1960) 261f, pl. 65 в2, 3, 4, 5; Boardman (1989) 240 fig. 429; Trendall and Webster (1971) 120 iv 5 and 6 (London).

183 Kahil (1977).

184 Kahil (1981).

185 Kahil (1963, 1965, 1977, 1979, 1981, 1983).

186 Kahil (1965) 24.

187 Kahil (1977) krater i, pl. 8, 8.

188 Kahil (1977) krater ii.

189 Kahil (1977) krater iii.

190 Hoffmann (1977); Boardman (1979a); Burkert and Hoffmann (1980); Boardman (1981); Hoffmann (1982).

191 Above, p. 106 with notes 360–2.

192 Boston 13, 169; not in *ARV*²; given to the Tyskiewicz Painter in Beazley (1916), *VA*, *AV* and *ARV*¹; Hoffmann (1977) 11.R1 (139), pl. x 4.

193 Vickers (1979).

194 Robertson (1981b) 64.

195 P 15840–53, with 14793, 16301 and 2, 26341; Green (1962) nos. 1–18, pls. 28–32; not listed by Beazley, but see below with n. 199.

196 Green (1962) nos. 2 (P 15841) and 1 (P 15840).

197 Green (1962) n. 196, 91. Shuvalov Painter: above, p. 227 with notes 34–41.

198 Green (1962) 89 (the odd piece, P 15851, his no. 6, pl. 29).

199 *ARV*² 1697 (to 1518).

200 Below, p. 269 with notes 28–38.

201 Green (1962) no. 13, pl. 31 (P 15853).

202 Green (1962) no. 2, pls. 28, 29 (P 15841), and no. 15, pl. 31 (P 14793, with wreath).

203 Green (1962) no. 1, pl. 28 (P 15840, with ovolo), and no. 14, pl. 31 (P 15847).

204 Below, p. 285 with n. 122.

205 Above, p. 248 with notes 74–7; p. 249 with notes 81–3; p. 256 with n. 132; p. 258 with n. 147.

9 The fourth century

1 See above, p. 261 with notes 170 and 171.

2 See below, p. 266 with n. 8.

3 Above, p. 237 with n. 13.

4 Below, p. 268 with n. 25.

5 See especially Petsas (1966) and Andronikos (1984).

6 Above, p. 254 with notes 110–15.

7 E.g. Robertson (1981) 149 with fig. 205.

8 Above, p. 265 with n. 2.

9 Below, p. 284 with notes 118f.

10 On all this see Robertson (1982a).

11 Above, p. 263 with n. 197.

12 See Beazley (1947) 45.

13 Gnathia: Cook (1960) 206–7.

[14] West Slope: Cook (1960) 204–6. Rare examples of 'Attic Gnathia': below p. 288 with n. 139; p. 290 with n. 151.

[15] Above, p. 265 with n. 2; below, p. 295 with n. 165.

[16] Below, section IV.

[17] Leningrad (St 1790) and unnumbered; ARV^2 1407; Boardman (1989) fig. 340.

[18] Meleager Painter: below, pp. 270 and 272 with notes 46 and 48f, 53–56.

[19] Athens Acr. 102; Graef and Langlotz (1929) pl. 5; ARV^2 1625, near bottom; Boardman (1975) fig. 100.

[20] Schauenburg (1976).

[21] Below, p. 288 with notes 137f.

[22] Above, p. 250 with n. 87.

[23] Above, p. 261 with notes 170 and 171.

[24] See ABV 177.

[25] Above, p. 265 with n. 4.

[26] F.B. Group: below, p. 271 with n. 52; L.C. Group: below, p. 288 with notes 147–56; Group G: below, p. 274 with notes 70–3. Significance of non-representation at Olynthos: below, p. 271 with n. 49.

[27] Below, p. 287 with n. 136.

[28] Jena Painter and workshop: ARV^2 1510–21.

[29] Exeter Univ.; ARV^2 1516.80; Shefton (1982) 177f; Boardman (1989) fig. 361.

[30] Jena 390; ARV^2 1511.1; Boardman (1989) fig. 358; Hahland (1930) pl. 22c.

[31] Oxford 1931.39; ARV^2 1516.1; Boardman (1989) fig. 363.

[32] Texas, McCoy Collection (ex Castle Ashby); not listed by Beazley; Boardman (1989) fig. 364; CVA Castle Ashby pl. 40.

[33] Para 500.

[34] ARV^2 1517.1 and 2, bottom; 1, Aurigemma (1965) pls. 45 and 47. Sub-Meidian Cup-group: ARV^2 1391–9; above, p. 240 with n. 33.

[35] Painter of New York Centauromachy: above, p. 259 with notes 153–7. Cups and stemlesses ascribed to or associated with him: ARV^2 1408 (4, Bryn Mawr P 208, CVA 1 pl. 28.1–6).

[36] Jena 813; ARV^2 1517.1; Hahland (1930) pl. 22b.

[37] Boston 00.354; ARV^2 1516, near bottom; Boardman (1989) fig. 365.

[38] Acropolis oinochoai: above, p. 259 with notes 195–205.

[39] On this aspect of fourth-century Attic vase-painting see Metzger (1951) and (1965).

[40] Jena 393; ARV^2 1512.12; Brommer (1959) 48 fig. 48. On the subject see above, p. 164 with notes 18 and 19.

[41] Vatican; ARV^2 1513.24.

[42] Once Weimar, Preller; ARV^2 1511.3; Metzger (1951) pl. 26.3.

[43] Cabinet des Médailles 822; ARV^2 1521, bottom. On the subject, see Metzger (1951), with pl. 26.2.

[44] Q Painter: ARV^2 1518–21.

[45] Corinth; ARV^2 1519.13; AJA 35 (1931) 51f.

[46] Below, with notes 53–6.

[47] Para 489.

[48] Oxford 1954.7; Para 489.1; Beazley (1939) 26.63.

[49] Above, p. 268 with n. 25.

[50] Group YZ: ARV^2 1522–5.

[51] Painter of Vienna 202: ARV^2 1523f (Vienna 202 and 204, ARV^2 1523.1 and 2; CVA pls. 30.1–4, 31.1–3; 202, Boardman (1989) fig. 425). Further decline illustrated ibid. pls. 32–3, the depths (Group of Vienna 116) pl. 34.

[52] F.B. Group: ARV^2 1484–95; Boardman (1989) figs. 423f.

[53] Meleager Painter: ARV^2 1408–15; 89, London E 129 (the best of his stemlesses), Boardman (1989) fig. 337.1 and 2; another, fig. 338.

[54] Vienna 158; ARV^2 1408.1; CVA 3 pl. 139.

[55] Above, p. 204 with notes 73–7; p. 229 with n. 40; p. 251 with notes 95, 97 and 99.

[56] New York 56.171.56; ARV^2 1412.46; Milne (1962) pl. 82.5; see next note.

[57] New York 56.171.55; ARV^2 1419.12; Milne (1962) pl. 82.6. On these two pictures see Milne (1962).

[58] Erbach Painter: ARV^2 1418f; Boardman (1989) fig. 353. Painter of London F 64: ARV^2 1419f; Boardman (1989) figs. 354 and 355.

[59] Hahland (1930); Schefold (1930) and (1934); McPhee, work in progress.

[60] ARV^2 1406.

[61] ARV^2 1425–34.

[62] Al Mina: the preference is not evident in Beazley's publication (1939), but in ARV^2 two pieces from the site are listed in the Plainer Group, eleven in the Telos Group. Kition: Robertson (1981b), especially Comment, 67–73.

[63] Beazley (1939) 33f.84; not in ARV^2.

[64] Robertson (1981b) 57f.43, pl. 41; not known to Beazley.

[65] Los Angeles A. 593.50.33; ARV^2 1426.23; CVA 1 pl. 32.4–6.

[66] Found in the work of the Telos Painter, the Painter of the Oxford Grypomachy, who is particularly fond of the motif (e.g., ARV^2 1428.1, Oxford 1917.61, CVA pls. 24.4, 25.9) and of the Retorted Painter; none in list of the Black-thyrsos Painter. See Talcott and Philippaki (1956) 59.272; Robertson (1981b) 63f.80.

[67] Below, p. 282 and p. 288 with notes 111 and 145.

[68] Below, p. 277 with notes 99–103.

[69] Toya Painter: ARV^2 1448f; Boardman (1989) fig. 374. Filottrano Painter: ARV^2 1453f; Boardman (1989) figs. 416–17.

[70] Group G: ARV^2 1462–71; Boardman (1989) figs. 408–15. Painter of London F 6: ARV^2 1452f.

[71] Below, p. 288 with n. 147.

[72] Above, p. 269 with n. 29.

[73] ARV^2 1470.170 and 1485.36.

[74] ARV^2 1473, top; Boardman (1989) fig. 380; CVA Castle Ashby pl. 44.1–3.

[75] Amazon Painter: ARV^2 1478–80; Boardman (1989) figs. 406f. See further below, p. 284 with n. 118.

[76] Above, p. 241 with notes 41–6.

[77] Below, p. 283 with n. 116 (Eleusinian Painter); there is one, too, by the Marsyas Painter (ARV^2 1475.7).

[78] Otchët Group: ARV^2 1496–9; Boardman (1989) figs. 397f.

[79] ARV^2 1503–9.

[80] Lekanides: Painter of Reading Lekanis and Group of Vienna Lekanis, ARV^2 1501f; Boardman (1989) figs. 401 and 402. Askoi: Painter of Ferrara T.408 and Group of Cambridge Askos, ARV^2 1504f; Boardman (1989) fig. 426.

[81] McPhee and Trendall (1987); Art Institute of Chicago 1889.98, Boardman (1989) fig. 371; Ferrara T.369 B VP, Alfieri (1979) figs. 306f.

[82] Leningrad B 3292, St 1915 and two others; Kerch; see LIMC IV, Europe I, 59, 60.

[83] Below, p. 277 with notes 99–103.

84 Overbeck (1868) 1731–3.

85 Robertson (1975) 437, pl. 186b.

86 See Peters (1941) 7–9; Beazley (1951) 96f (= 1986, 89) with n. 62. Statues on columns: Eschbach (1986).

87 Nikokrates: London B 609; *ABV* 415.5; Pfuhl (1923) fig. 308; *CVA* f pl. 4.2. Niketes: Sèvres 7230; *ABV* 415.6; *CVA* pl. 17.19–22.

88 Hippo[damas]: Istanbul *L.3149; ABV* 413.2, top; Beazley (1986) pl. 99.6. See below, p. 292 with n. 159.

89 Asteios: Oxford 572; *ABV* 412.1, bottom; *CVA* 3 pl. 28.4–7.

90 Berlin inv. 3980; not in *ABV*; Beazley (1951) 96f. (= 1986, 89, pl. 100.1–2) with n. 61.

91 Hildesheim and Kuban Groups: above, p. 260 with notes 163–9.

92 Beazley (1943) 454; Salonica inv. 8.29 (R 100); *ABV* 412, near top; Robinson (1950) pl. 17.13i.

93 Peters (1942). Cf. above, p. 259 with n. 161.

94 Meleager Painter: above, p. 271 with n. 53.

95 Alexandria 18239. Detroit 50,193; *ABV* 412.2 (Schefold (1934) figs. 46 and 47) and 3 (Moon and Berge (1979) 222f).

96 Brussels A 1703 (*CVA* pl. 14.3); New York 56.171.6 (*CVA* iii pl. 45.1–4, ex San Simeon, Hearst); London B 603 (Beazley (1986) pl. 101.1–2); *ABV* 413f.2–3.

97 London B 604; *ABV* 413, middle and bottom 1; Beazley (1986) pl. 100.3–4.

98 Peters (1941) 99–105; Karouzou (1964), below with n. 103.

99 Iphigeneia and Oinomaos Painters: *ARV²* 1440; Pourtalès Painter and Painter of Athens 12592: *ibid.* 1446f; Nicosia inv. 3552, from Kition, Robertson (1981b) 57 no. 40a, pl. 40.

100 Ferrara *T.*1145; *ARV²* 1440.1, above; Boardman (1989) fig. 350; Alfieri (1979) figs. 276 and 277.

101 Naples 2200; *ARV²* 1440.1, middle; Boardman (1989) fig. 351.

102 Athens 1435; *ARV²* 1440.4; and see next note.

103 Karouzou (1964) pls. 1–3; Metzger (1965) 102, pl. 46; Simon (1965) figs. 1–4 and 11.

104 Eleusis; *ABV* 414.1, middle; Schmidt (1922) pl. 7.1. See next note and below, p. 285 with n. 123.

105 Eleusis; *ABV* 414.2–3, middle, and note; Schmidt (1922) pl. 7.2 and 3.

106 Eretria: Themelis (1969) 412–15, figs. 2–5; Robertson (1975) 384 and 436, pl. 137a and c–d. Athens, Agora P 31: Beazley (1943) 457, bottom.

107 Schefold (1930) and especially (1934); see *ARV²* 1406.

108 Marsyas Painter: *ARV²* 1474–6; 3 (name-vase), Leningrad St 1795; Boardman (1989) fig. 389.

109 London E 424; *ARV²* 1475.4; Boardman (1989) fig. 390; Arias, Hirmer and Shefton (1962) pl. xlvii.

110 Leningrad inv. 15592; *ARV²* 1475.1; Boardman (1989) fig. 388; Arias, Hirmer and Shefton (1962) pls. 225–8.

111 Cf. above, p. 273 with notes 66 and 67.

112 *ARV²* 1477.

113 Oxford 1939.599; not in *ARV²*; Beazley (1939) 35–44.86 with pls. 2–6; Boardman (1989) fig. 387.

114 Beazley (1939) 35.

115 Beazley (1939) 44.

116 *ARV²* 1476.1–3; Boardman (1989) figs. 392–3.

117 Above, p. 266 with notes 8 and 9.

118 Amazon Painter, above with n. 75. The composition well

119 seen on Leningrad NB 2230; *ARV²* 1478.6; Rumpf (1953) 150–2, pl. 50, 7. 1, Amsterdam inv. 937, Boardman (1989) fig. 406, shows a similar design flattened out in a more conventional vase-painter's manner.

119 Above, n. 113; Beazley (1939) pl. 6; the surviving horse's head better seen in Boardman (1989) fig. 387.

120 Aristodemos: Chicago; Beazley (1943) 457, bottom. Theophilos: Athens, Ceramicus Museum; Beazley, *ibid.* Themistokles (two fragments): Athens; Beazley, *ibid.* See also below, with n. 125.

121 Hobble Group: London B 608, Munich inv. 7767; *ARV²* 417.1 and 2; 1, Beazley (1986) pls. 102.3 and 103.2; 2, *ibid.* pl. 102.4, Boardman (1974) fig. 307.

122 Above, p. 264 with n. 204.

123 Above, p. 280 with notes 104 and 105; below, p. 293 with n. 161.

124 Above, p. 280 with n. 106.

125 Theophilos and Themistokles: above, with n. 120.

126 Nikomachos: Alexandria 18238; Theophrastos: Cambridge, Mass., Fogg 1925.30.124 and Louvre MN 706; *ARV²* 414f.1–3 (Nikomachos Series); 1; Schefold (1934) figs. 48f; 2, Beazley (1951) pl. 48, (1989) pl. 101.3 and 4; 3, *CVA* g pls. 5.8–14, 6.1. See further below, with notes 129–35.

127 Polemon: Chalkis Museum (?), from Eretria: Beazley (1951) 100 (= 1986, 92) with n. 84; *AJA* 11 (1896) 332.

128 Hellenistic panathenaics: Beazley (1951) 100 (= 1986, 92) with notes 85f. Roman: Edwards (1957).

129 *ABV* 414–17; 14, Neaichmos: Leningrad inv. 1768; *AA* 1913, 183.

130 Above, with n. 126.

131 Louvre MN 706; above, n. 126; Beazley (1943) 462–5.

132 Louvre MN 705; *ARV²* 416.13; *CVA* g pl. 6.4–7 and 11; Beazley (1943) 461.

133 See above, p. 237 with n. 9.

134 Below, with n. 142.

135 Above, with notes 94, 96.

136 Munich 2439; not in Beazley; Boardman (1989) fig. 428. Schefold (1934) 188.

137 Leningrad KAB 6a; not in Beazley; Pfuhl (1923) fig. 604; Schefold (1934) no. 161, pl. 28.

138 Above, p. 268 with n. 17.

139 Leningrad; not in Beazley; Rumpf (1953) 145, pl. 47.4.

140 New York 25.190; not in Beazley; Boardman (1989) fig. 494; Schefold (1934) no. 327.

141 Robertson (1981b) 57.40; these painters, above, p. 277 with n. 98.

142 Above, p. 286 with n. 131.

143 Above, p. 277 with notes 97f.

144 London B 607; *ABV* 415.4; Boardman (1974) fig. 305; Beazley (1989) pl. 102, 1–2 (detail (1951) pl. 47.2).

145 Cf. above, p. 273 with notes 66f, p. 282 with n. 111.

146 Not known to Beazley; Robertson (1981b) 56.37.

147 L.C. Group: *ARV²* 1456–61; Boardman (1989) figs. 418–22.

148 Al Mina vase: above, p. 283 with n. 113. Olynthos vase: Salonica 130; not in Beazley; Robinson (1933) pl. 73.

149 Hahland (1930) 18f, n. 18.

150 Athens 12544; *ARV²* 1456.1 and 1461, top; Boardman (1989) fig. 418.

151 Munich 2754 and 2755 (illustrated). See FR on pl. 100.; not in Beazley; Rumpf (1953) 150, pl. 50.6.

152 Above, p. 285 with n. 121.

[153] London B 608; above, p. 285 with n. 121.

[154] *ABV* 416.

[155] Harvard 1925, 30.124; above, p. 286 with n. 133.

[156] London B 610, from Capua; *ABV* 416f; Peters (1941) 157; Beazley (1951) 99 (= 1986, 92, with pls. 103.1 and 3).

[157] Archippos: above, p. 285 with n. 132; Neaichmos: above, p. 285 with n. 129; Polemon: above, p. 285 with n. 127.

[158] Above, p. 277 with notes 96–8.

[159] Above, p. 276 with n. 88.

[160] Athens, Ceramicus Museum; *ABV* 413.1, top.

[161] Eleusis; *ABV* 414, middle; *BSA* 3 (1896) pl. 16c; and see next note.

[162] Charikleides Group: above, p. 280 with notes 104f, p. 285 with n. 124.

[163] Preuner (1920); Kern (1913) pl. 27.5; and see next note.

[164] Preuner (1920) 71f; on this and last, Beazley (1943) 456f.

[165] Above, p. 268 with notes 15–17.

[166] Above, p. 288 with notes 137–9.

[167] See Robertson (1987) 44 on no. 50 (pls. 56 and 57), quoting Trendall and McPhee. Trendall now agrees with McPhee that the piece is probably Attic, like no. 41 (pls. 40 and 41b); see Jenkins (1990). This may well be right.

[168] Kopcke (1964); see also Robertson (1987) 50f.62–5 (remarks on 65).

[169] Winterthur; Lane (1948) pl. 96; *CVA* Ostschweiz Ticino (Switzerland 5) pl. 19.1, 2.

AA *Archäologischer Anzeiger*, Berlin from 1880; until 1963 part of *JdI*

AAA *Athens Annals of Archaeology*, Athens from 1968

ABV See Beazley 1956

AJA *American Journal of Archaeology*. Princeton, Norwood, Concorde from 1885

AK *Antike Kunst*, Basel from 1958

Alfieri, N. (1979) *Spina: Museo archeologico nazionale di Ferrara I*, Bologna

AM *Mitteilungen des Deutschen Archäologischen Instituts: Athenische Abteilung*, Athens from 1876

Amsterdam symposium *Ancient Greek and Related Pottery*, Proceedings of the International Vase Symposium, ed. H.A.G. Brijder, Amsterdam 1984

Amyx, D.A. (1958) 'The Attic stelai III', *Hesp.* 27: 178–86
 (1988) *Corinthian Vase-painting of the Archaic Period*, Berkeley

Andronikos, M. (1984) *Vergina; the Royal Tombs*, Athens

Annuario See *ASAtene*

Antike Welt, Zurich from 1970

Antiquity, Gloucester etc. from 1927

Aparchai: Nuove ricerche e studi sulla Magna Grecia e la Sicilia antica in onore di P.E. Arias, Pisa 1982

AR *Archaeological Reports*, London from 1955

Arezzo, Euphronios exhibition, see *Capolavori*

Arias, P.E., Hirmer, M. and Shefton, B.B. (1962) *A History of Greek Vase-painting*, London

Arias Festschrift: see *Aparchai*

ARV[1] and *ARV*[2] See Beazley 1942 and 1963

ASAtene *Annuario della Scuola Archeologica di Atene*, Bergamo, from 1914

Aurigemma, S. *La Necropoli di Spina in Valle Trebba*, Rome, I 1 1960, I 2 1965

AV See Beazley 1925

Baglione, M.P. (1988) 'Quelques données sur les plus récentes fouilles de Pyrgi', in Copenhagen symposium 17–24

Barron, J.P. (1972) 'New light on old walls: the murals of the Theseion', *JHS* 92: 20–45

Barr-Sharrar, B. and E.N. Borza, eds. (1982) *Macedonia and Greece in Late Classical and Early Hellenistic Times* (National Gallery of Art, Washington, *Studies in the History of Art* 10, Symposium Series 1), Washington

Basel, Münzen und Medaillen A.G. See MM

BCH *Bulletin de correspondance hellénique*, Paris from 1877

Beazley, J.D. (1908) 'Three new vases in the Ashmolean Museum', *JHS* 28: 313–16
 (1910) 'Kleophrades', *JHS* 30: 38–68
 (1911) 'The Master of the Berlin amphora', *JHS* 31: 276–95
 (1912) 'The Master of the Troilus-hydria in the British Museum', *JHS* 32: 171–3
 (1912a) 'The Master of the Boston pan-krater', *JHS* 32: 354–69
 (1912b) 'The Master of the Villa Giulia calyx-krater', *RM*: 27, 286–97
 (1913) 'The Master of the Eucharides-stamnos in Copenhagen', *BSA* 18: 217–33
 (1913a) 'The Master of the Dutuit Oinochoe', *JHS* 33: 106–10
 (1913b) 'A note on the painter of the vases signed Euergides', *JHS* 33: 347–55
 (1914) 'The Master of the Stroganoff Nikoxenos vase', *BSA* 19: 229–47
 (1914a) 'The Master of the Achilles amphora in the Vatican', *JHS* 34: 179–226
 (1916) 'Fragment of a vase in Oxford and the Painter of the Tyszkiewicz crater in Boston', *AJA* 20: 144–53
 (1916a) 'Two vases in Harrow', *JHS* 36: 123–33
 (1917) Review of J.C. Hoppin, *Euthymides and his Fellows*, in *JHS* 37: 233–7
 (1918) (*VA*) *Attic Red-figured Vases in American Museums*, Cambridge, Mass.
 (1922) 'Citharoedus', *JHS* 42: 70–98
 (1925) (*AV*) *Attische Vasenmaler des rotfigurigen Stils*, Tübingen
 (1927) 'The Antimenes Painter', *JHS* 47: 63–92
 (1928) *Greek Vases in Poland*, Oxford
 (1928a) *Attic Black-figure: a Sketch* (Henriette Herz Lecture to the British Academy), London (=*Proceedings of the British Academy* 14: 217–63)
 (1929) 'Notes on the vases in Castle Ashby', *Papers of the British School at Rome*, 11: 1–29
 (1929a) Charinos, *JHS* 49: 38–78
 (1930) *Der Berliner Maler* (*Bilder griechischer Vasen* 2), Berlin; English version, Mainz, 1974
 (1931) *Der Pan-Maler* (*Bilder griechischer Vasen* 4), Berlin; English version, Mainz, 1974
 (1931a) 'Amasea', *JHS* 51: 257–84
 (1932) 'A dancing maenad', *BSA* 30: 109–12
 (1932a) 'Battle-loutrophoros', *Mus. J.* 23: 4–22

(1932b) 'Little Master cups', *JHS* 52: 167–204

(1933) *Der Kleophrades-Maler* (*Bilder griechischer Vasen* 6), Berlin; English version, Mainz, 1974

(1933a) *Campana Fragments in Florence*, Oxford

(1936) (with A. Merlin) 'Une nouvelle amphore du "Peintre de Berlin"' (Musée du Louvre), *Mon. Piot*. 35: 49–72

(1938) *Attic White Lekythoi* (William Henry Charlton Memorial Lecture, Newcastle, 1 November, 1937), Oxford

(1939) 'The excavations at Al Mina, Suedia, 3: the red-figured vases', *JHS* 59: 1–44

(1942) (*ARV*[1]) *Attic Red-figure Vase-painters*, Oxford

(1943) 'Panathenaica', *AJA* 47: 441–65

(1944) *Potter and Painter in Ancient Athens*, London (from *Proceedings of the British Academy* 30)

(1947) *Etruscan Vase-painting*, Oxford

(1948) *Some Attic Vases in the Cyprus Museum*, London (from *Proceedings of the British Academy* 33)

(1948a) 'Hymn to Hermes', *AJA* 52: 336–40

(1951) *The Development of Attic Black-figure*, Berkeley, Cal. See also (1986)

(1956) (*ABV*) *Attic Black-figure Vase-painters*, Oxford

(1957) 'Marpessa', *Charites* (Festschrift, Ernst Langlotz), Bonn: 136–9

(1961) 'An amphora by the Berlin Painter', *AK* 4: 49–67

(1963) (*ARV*[2]) *Attic Red-figure Vase-painters*, 2nd edn, Oxford

(1964) *The Berlin Painter*, Australian Humanities Research Council, Occasional Paper 6, Melbourne

(1966) *Un realista greco* (*Adunanze Straordinarie per il conferimento dei premi della Fondazione A. Feltrinelli* 1, 3, 53–60)

(1971) (*Para*) *Paralipomena*: additions to *ABV* and *ARV*[2], Oxford 1971

(1986) New edition of (1951) with additional plates

(1989) *Greek Vases*: lectures by J.D. Beazley, ed. D.C. Kurtz, Oxford

See also CB

Beazley Addenda, additional references to *ABV*, *ARV*[2] and *Paralipomena*, compiled by L. Burn and R. Glynn at the Beazley Archive, Oxford, 1982. Second edition, compiled by T.H. Carpenter with T. Mannack and M. Mendonca, 1990

Beazley Gifts Ashmolean Museum, Department of Antiquities. *Sir John and Lady Beazley, Gifts 1912–1966* (Exhibition catalogue), Oxford 1967

Becker, R.-M. (1977) *Formen attischer Peliken von der Pionier-Gruppe bis zum Beginn der Frühklassik*, Böblingen

Benton, S. (1938) 'The evolution of the tripod-lebes', *BSA* 35: 56–130

Benz, J.L. (1980) 'New fragments of the Berlin Painter lekythos' (addendum to C.J. Boulter, 'Fifth-century Attic red-figure at Corinth'), *Hesp*. 49: 307f.

Bérard, C. (1974) *Anodoi: essai sur l'imagerie des passages chthoniens*, Neuchatel

Bérard, C., C. Bron and A. Pomari, eds. (1987) *Images et société en Grèce ancienne*, Lausanne

Berge, L. (1992) *Myson: a Craftsman of Athenian Red-figured Vases*, Chicago

See also Moon

Berger, E., ed. (1984) *Parthenon-Kongress Basel*, Mainz

Berl. Mus. See *Jahrbuch*

Betts, J.H., J.T. Hooker and J.R. Green, eds. (1988) *Studies in Honour of T.B.L. Webster* 2, Bristol

BICS *Bulletin of the Institute of Classical Studies*, London, from 1970

Bloesch, H. (1940) *Formen attischer Schalen*, Berlin

(1951) 'Stout and slender in the late archaic period', *JHS* 71: 29–39

(1972) 'Ein Meisterwerk der Töpferei', *AK* 5: 18–29

Boardman, J. (1956) 'Some Attic fragments: pot, plaque and dithyramb', *JHS* 76: 18–25

(1972) 'Herakles, Peisistratos and sons', *RA* 1972: 57–72

(1974) *Athenian Black-figure Vases*, London

(1975) *Athenian Red-figure Vases: the Archaic Period*, London

(1979) 'The karchesion of Herakles', *JHS* 99: 149–51

(1979a) Review of Hoffmann (1977), *CR* 29, 118–20

(1981) '"Askoi"', *Hephaistos*: 23–5

(1983) 'Atalanta', *Art Institute of Chicago, Centenary Lectures* 3–19

(1988) 'Sex differentiation in grave vases', *Istituto Universitario Orientale: Annali* (*Archeologia e Storia Antica*) 171–8, Naples

(1989) *Athenian Red-figure Vases: the Classical Period*, London

Boardman, J., J. Dörig, W. Fuchs and M. Hirmer (1966) *The Art and Architecture of Ancient Greece*, London

Boardman, J. and U. Gehrig (1981) 'Epiktetos II R.I.P.', *AA* 329–32

Böhr, E. and W. Martini, eds. (1986) *Studien zur Mythologie und Vasenmalerei* (Festschrift, K. Schauenburg), Mainz

Bonfante, L. (1989) 'Nudity as a costume in classical art', *AJA* 93: 543–56

Bothmer, D.v. (1951) 'Attic black-figured pelikai', *JHS* 71, 40–7

(1957) *Amazons in Greek Art*, Oxford

(1958) Appendix on the New York Hegesiboulos cup, in Farnsworth and Wisely

(1961) *Ancient Art from New York Collections*, New York

(1962) 'A gold libation bowl', *Bull. Met*. 21: 154–66

(1966) 'Andokides the potter and the Andokides Painter', *Bull. Met*. 24 (1965–6): 201–12, figs. 1–5, 9–11, 14

(1976) 'Der Euphronioskrater in New York', *AA* 1976: 485–512

(1981) 'The Death of Sarpedon', in Hyatt, 63–80

(1981a) 'Ἄμασις, Ἀμασιδος', *JPGMJ* 9: 1–4

(1982) 'Notes on Makron', in Kurtz and Sparkes, 29–52

(1985) *The Amasis Painter and his World* (Exhibition catalogue), Malibu

(1986) 'Attributed to the Berlin Painter: red-figured amphora (Type A)', in *Metropolitan Museum of Art: Recent Acquisitions 1985–1986*: 9

(1987) 'Greek vase-painting: two hundred years of connoisseurship', in True (1987) 184–204

(1989) 'Euphronios: an Attic vase-painter's view of the human body', Goulandris Foundation *Dialexeis 1986–1989*: 26–42

Boulter, C.G. (1966) 'The Berlin Painter at Corinth', *Hesp*. 35: 310–19

(1971) *CVA, Cleveland Museum of Art*, Fasc. 1, Princeton
See also Benz

Brandt, J.R. (1978) 'Archaeologia Panathenaica 1', *Inst. Rom. Norv. Acta* 8: 1–23

Brauchitsch, G. von (1910) *Die Panathenäischen Preis-amphoren*, Leipzig/Berlin

Brendel, O.J. See *Essays*

Brijder, H.A.G. (1983) *Siana Cups I and Komast Cups* (Allard Pierson series 4), Amsterdam
See also Amsterdam symposium

Brommer, F. (1959) *Satyrspiele*, 2nd edn, Berlin

Bruckner, A. (1954) *Pälastradarstellungen auf frührot-figurigen attische Vasen*, Basel

BSA *Annual of the British School at Athens*, London from 1894

Buitron, D.M. (1972) *Attic Vase Painting in New England Collections*, Harvard

Buitron-Oliver, D. (1991) 'A cup for a hero', *Greek Vases* V, 65–71

Bulletin See *BCH, BICS, Bull. Met.*

Bull. Met. *Bulletin of the Metropolitan Museum of Art*, New York from 1905

Burkert, W. and H. Hoffmann (1980) 'La cuisine des morts', *Hephaistos* 2: 107–11

Burl. Cat. Burlington Fine Arts Club, *Exhibition of Ancient Greek Art, 1903*, London 1904

Burl. M. *The Burlington Magazine*, London from 1903

Burn, L. (1985) 'Honey-pots: three white-ground cups by the Sotades Painter', *AK* 28: 93–105
(1987) *The Meidias Painter*, Oxford
See also *Beazley Addenda*

Burow, J. (1989) *Der Antimenesmaler* (Kerameus 7), Mainz

Buschor, E. (1916) 'Neue Duris-Gefässe', *JdI* 31: 74–6
(1925) *Attische Lekythen der Parthenonzeit* (from *MüJb* n.s. 2)
(1940) *Griechische Vasen*, Munich
(1941) *Grab eines Attischen Mädchens*, 2nd edn, Munich

Cahn, H.A. (1973) 'Dokimasia', *RA* 1973: 3–22
(1986) 'Dokimasia II', in Böhr and Martini, 91–3
(1988) 'Okeanos, Strymon und Atlas auf einer rotfigurigen Spitzamphora', in Copenhagen symposium 107–16

Cahn, H.A. and E. Simon, eds. See *Tainia*

Callipolitis-Feytmans, D. (1974) *Les plats attiques à figures noires*, Paris

Cambitoglou, A. (1968) *The Brygos Painter*, Sydney
(1979) ed. *Studies in Honour of Arthur Dale Trendall*, Sydney
See also Trendall

Canciani, F. (with a note by G. Neumann) (1978) 'Lydos, der Sklave?', *AK* 21: 17–21

Capolavori di Euphronios, un pionere della ceramografia Attica, Arezzo, 1990

Cardon, C. (1979) 'Two omphalos phialai', *JPGMJ* 6/7: 131–8

Causey-Frel, F. (1980) *Stamnoi* (Exhibition catalogue, J. Paul Getty Museum, Malibu)

CB Caskey, L.D. and J.D. Beazley *Attic Vase-paintings in the Museum of Fine Arts, Boston*, Oxford, I 1937, II 1954, III 1963

Charisterion eis A.K. Orlandon II, Athens, 1964

Charites (Festschrift, Ernst Langlotz, ed. K. Schauenburg), Bonn, 1957

Childs, W.A.P. (1991) 'A new representation of a city on an Attic red-figured Kylix', *Greek Vases* 5, 27–40

Christiansen, J. and T. Melander, eds. See Copenhagen symposium

Christie, sale catalogue, 16 July 1986

Clio Medica: acta Academiae Internationalis Historiae Medicinae, Oxford from 1966

Cohen, B. (1978) *Attic Bilingual Vases*, New York
(1991) 'The literate potter: a tradition of incised signatures on Attic vases', *MMJ* 26, 49–95

Coldstream, J.N. (1968) *Greek Geometric Pottery: a Survey of Ten Local Styles and their Chronology*, London

Cook, B.F. (1990) 'Cretan red-figured lekythoi', *BSA* 85: 69f

Cook, J.M. (1938) 'Protoattic pottery', *BSA* 35: 165–219

Cook, R.M. (1960) *Greek Painted Pottery*, London
(1971) ' "Epoiesen" on Greek vases', *JHS* 91: 137–8
(1987) ' "Artful crafts": a commentary', *JHS* 107: 169–71

Copenhagen symposium *Proceedings of the 3rd Symposium on Ancient Greek and Related Pottery Copenhagen, 1987*, ed. J. Christiansen and T. Melander, Copenhagen, 1988

Corbett, P.E. (1962) in *Perachora* II: 'Late Corinthian vases, red-figure', 286–9; 'Attic red-figure; Attic and Corinthian black glaze', 350–63
(1965) 'Preliminary sketch in Greek vase-painting', *JHS* 85: 16–28

Crosby, M. (1955) 'Five comic scenes from Athens', *Hesp.* 24: 76–84

CVA *Corpus Vasorum Antiquorum*, Paris and elsewhere from 1922

Davies, M. (1953) *Early Italian Schools* (National Gallery Catalogues), Plates, London

Délos See Dugas

Desborough, V.R.d'A. (1952) *Protogeometric Pottery*, Oxford
(1964) *The Last Mycenaeans and their Successors*, London
(1972) *The Greek Dark Ages*, London

Deyhle, W. (1969) 'Meisterfragen der archaischen Plastik Athens', *AM* 84: 1–64

Diepolder, H. (1936) *Der Penthesilea-Maler* (Bilder griechischer Vasen 10), Leipzig
(1954) *Der Pistoxenos-Maler* (110 Winckelmanns-programm), Berlin

Dinsmoor, W.B. (1941) *Observations on the Hephaisteion* (*Hesp. Suppl.* 5), Athens

Dohan, R.H. (1932) 'Four vases from the Henry C. Lea Collection', *Mus. J.* 23: 23–44

Dohrn, T. (1972) *Die Ficoronische Ciste in der Villa Giulia in Rom* (*Monumenta Artis Romanae* XI), Berlin

Drougou, S. (1975) *Die attische Psykter*, Würzburg

Dugas, C. (1952) *Délos* xxi, Paris

Dunbabin, T.J. (1951) 'The oracle of Hera Akraia at Perachora', *BSA* 46: 61–71
See also *Perachora* II

EAA *Enciclopedia dell'Arte Antica*, Rome, 1938–66

Edwards, G.R. (1957) 'Panathenaics of Hellenistic and Roman times', *Hesp.* 26: 120–349

Eisman, M.M. (1974) 'A further note on EPOIESEN signatures', *JHS* 94: 178
(1988) 'With Phintias' (Lecture at 90th General meeting of AIA), summary in *AJA* 92: 236f.

Enciclopedia see *EAA*

Enc. Phot. *Encyclopédie photographique de l'art: le Museé du Louvre*, Paris, 1937

Engelmann, H. (1987) '"Wie nie Euphronios"', *ZPE* 68: 129–33

Eph. *Ephemeris Arkhaiologike*, Athens from 1883

Ergon *To ergon tes Arkhaiologikes Etairias*, Athens from 1956

Eschbach, R. (1986) *Statuen auf Panathenäischen Preisamphoren des 4. Jhs. v. Chr.*, Mainz

Essays in Archaeology and the Humanities, in Memoriam Otto J. Brendel, Mainz, 1976

Euphronios, peintre a Athènes au VI Siècle avant J.-C. (Exhibition catalogue), Paris 1990

Farnsworth, M. and H. Wisely (1958) 'Fifth century intentional red glaze' *AJA* 62: 165–73

Felten, K.F. (1971) *Thanatos und Kleophon*, Munich

Follmann, B.-A. (1968) *Der Pan-Maler*, Bonn

FR (i 1904, ii 1909, iii 1932) A. Furtwängler and K. Reichold, *Griechische Vasenmalerei*, Munich

Francis, E.D. (1990) *Image and Idea in Fifth-Century Greece*, London

Francis, E.D. and M. Vickers (1981) '"Leagros kalos"', *PCPhS* 207 (n.s. 27): 97–136

(1983) '*Signa priscae artis*: Eretria and Siphnos', *JHS* 103: 49–67

Frel, J. (1969) 'Arx Atheniensium: Panathenaica', *AAA* 2: 377–86

(1977) 'The Kleophrades Painter in Malibu', *JPGMJ* 4: 63–76

(1983) 'Euphronios and his fellows', in Moon (1983) 147–58

Freyer-Schauenburg, B. (1986) 'Eine attisch rotfigurige Phiale in Kiel', in Böhr and Martini, 117–20

Furtwängler, A. (1885) *Beschreibung der Vasensammlung im Antiquarium*, Berlin

(1894) Review of P. Hartwig, *Berliner Philologische Wochenschrift*, 114

See also FR

Gardiner, N. (1912) 'Panathenaic amphorae', *JHS* 32: 179–93

Gauer, W. (1990) 'Penelope, Hellas und der Perserkönig', *JdI* 105: 31–65

Gaz. arch. *Gazette archéologique*, Paris, 1875–87

Gex-Morgenthaler, K. (1986) 'Der Berner Maler', *AK* 29: 115–25

Ghali-Kahil, L. (1955) *Les enlèvements et le retour d'Hélène*, Paris

See also Kahil

Gill, D.W.J. and M. Vickers (1989) 'Pots and kettles', *RA* 1989: 297–303

(1990) 'Reflected glory: pottery and precious metal in Classical Greece', *JdI* 105: 1–30

Giroux, H, (1972) 'Trois images de l'éducation grecque', in *Mélanges ... Lebel* 92f, figs. 2 and 3.

Glynn, R. See *Beazley Addenda*

Goulandris Foundation. *Dialexeis 1986–1989*, Athens, 1989

Gourevitch, D. (1972) 'Les soins donnés a Philoctète', *Clio Medica* 7: 1ff

Grace, V.R. (1961) *Amphoras and the Ancient Wine Trade* (Agora Picture Books 6), Princeton

Graef, B. and E. Langlotz (1925–33) *Die antiken Vasen von der Akropolis zu Athen* I iv and II i-iii, Berlin

Graef, B. and others (1901–14 *Die antiken Vasen von der Akropolis zu Athen* I i-iii, Berlin

GRBS *Greek, Roman and Byzantine Studies*, San Antonio etc., from 1958

Greek Vases *Greek Vases in the J. Paul Getty Museum* 1, 1983, 3, 1986, 5, 1991

Green, J. R. (1961) 'The Caputi hydria', *JHS* 81: 73–5

(1962) 'A new oinochoe series from the Acropolis', *Hesp.* 31: 82–94

(1971) 'Choes of the later fifth century', *BSA* 66: 189–228

(1978) 'Some classes of oinochoe of the first half of the fifth century B.C.', *AA* 1978: 262–72

(1986) 'A representation of the Birds of Aristophanes', in *Greek Vases* 3

Green, J.R. and R.K. Sinclair (1970) 'Athenians in Eretria', *Historia* 19: 515–27

Greifenhagen, A. (1957) *Griechische Eroten*, Berlin

(1972) *Neue Fragmente des Kleophradesmalers*, Heidelberg

(1976) 'Fragmente eines rotfigurigen Pinax', in *Essays ... Brendel* 43–8

(1982) 'Odysseus in Malibu', *Pantheon* 40: 211–17

Grossmann, J.B. (1991) 'Six's technique at the Getty', *Greek Vases* 5, 13–26.

Hahland, W. (1930) *Vasen um Meidias (Bilder griechischer Vasen* 1), Berlin

Hampe, R. (1936) *Frühe griechische Sagenbilder in Böotien* Athens

(1960) *Ein frühattisches Grabfund*, Mainz

(1975) *Tydeus und Ismene*, *AK* 18: 10–6

Festschrift See *Tainia*

Harrison, E.B. (1977) 'Alkamenes' sculptures for the Hephaisteion: Part II, the base' *AJA* 81: 411–26

Hartwig, P. (1893) *Die griechischen Meisterschalen*, Stuttgart

Haspels, C.H.E. (1936) *Attic Black-figured Lekythoi*, Paris

Hauser, F. (1909) in FR ii:228

Hemelrijk, J.M. (1991) 'A closer look at the potter', in Rasmussen and Spivey, 233–56

d'Henry, G. (1974) 'Scavi e scoperte 508', *SE* 42: 5–8

Hephaistos, Bad Bramstedt from 1979, Bremen from 1981

Hesp. *Hesperia*, Cambridge, Mass., from 1932

Historia, Wiesbaden from 1952

Hoffmann, H. (1962) *Attic Red-figured Rhyta*, Mainz

(1967) 'Eine neue Amphora des Eucharidesmalers', *Jahrbuch der Hamburger Kunstsammlungen* 12, 9–34

(1977) *Sexual and Asexual Pursuit: a Structuralist Approach to Greek Vase-painting* (Royal Anthropological Institute of Great Britain and Ireland, Occasional Paper 340), London

(1982) 'J. Boardman "Askoi": a rejoinder', *Hephaistos* 4: 177f

(1984) 'Charos, Charun, Charon', *OJA* 3: 65–9

(1985) 'From Charos to Charon; some notes on the human encounter with death in Attic red-figure vase-painting', in *Visible Religion* 4/5 (*Approaches to iconology*) 173ff

(1988) 'The cicada on the omphalos: an iconological excursion', *Antiquity* 62: 744–9

(1989) 'Aletheia: the iconography of death/rebirth in three cups by the Sotades Painter', *Res* 17/18: 67–88

(1990) 'Rhyta and kantharoi in Greek ritual', in *Greek Vases* IV: 131–66

van Hoorn, C. (1951) *Choes and Anthesteria*, Leyden

Hoppin, J.C. (1917) *Euthymides and his Fellows*, Cambridge, Mass.

Hyatt, S., ed. (1981) *The Greek Vase*, Latham, New York

Immerwahr, H.R. (1990) *Attic Script: a Survey*, Oxford

Inst. Rom. Norv. Acta Institutum Romanum Norvegiae, *Acta ad archaeologiam et artium historian pertinentia*, Rome from 1971

Isler-Kerenyi, C. (1977) *Lieblinge der Meermädchen*, Zurich

(1977a) *Stamnoi*, Lugano

Jacobsthal, P. (1927) *Ornamente griechischer Vasen*, Berlin

Jahrbuch der Berliner Museen (*Berl. Mus.*), Berlin from 1959

JdI *Jahrbuch des Deutschen Archäologisches Instituts*, Berlin from 1886

Jahreshefte See *ÖJh*

Jeffery, L.H. (1962) 'The inscribed gravestones of Attica', *BSA* 57: 115–53

Jenkins, I. (1990) Review of Robertson (1987) in *Burl. Mag.* 132:

JHS *Journal of Hellenic Studies*, London from 1881

Joffroy, R. (1954) *Le Trésor de Vix* (*Mon. Piot.* 48, 1), Paris

Johansen, K.F. (1923) *Les Vases Sicyoniens*, Paris and Copenhagen

(1923a) *Hoby-fundet* (*Nordiske Fortidsminder* II 3; summary in French), Copenhagen

JPGMJ *The J. Paul Getty Museum Journal*, Malibu, from 1974

Kahil, L. (1963) *Quelques vases du sanctuaire d'Artémis a Brauron* (*AK* Beiheft 1)

(1965) 'Autour de 1'Artémis attique', *AK* 8: 20–3

(1977) 'L'Artémis de Brauron, rites et Mystères', *AK* 20: 86–98

(1979) 'La déesse Artémis: mythologie et iconographie', in *Greece and Italy in the Classical World*, London

(1981) 'Le "cratérisque" d'Artémis et le Brauronion de l'Acropole', *Hesp.* 50: 253–63

(1983) 'Mythological répertoire of Brauron', in Moon, ed. (1983) 231–44

See also Ghali-Kahil

Karageorghis, V. and others (1981) *The Excavations at Kition* IV: *the non-Cypriote Pottery*, Nicosia

Kardara, C. (1964) 'Erichthonios spendon', in *Charisterion eis A.K. Orlandon* II 22–4

Karouzos, C. (1974) *Delphoi*, Athens

Karouzou, S. (1956) *The Amasis Painter*, Oxford

(1964) '"Eroes Agnoi" s'enan Attikon kratera', *Arkhaiologikon Deltion* 19: 1–16

See also Papaspyridi

Kern, O. (1913) *Inscriptiones Graecae*, Bonn

Keuls, E.C. (1988) 'The social position of Attic vase-painters and the birth of caricature', in Copenhagen symposium 1988: 310–13

Klein, W. (1886) *Euphronios*, 2nd edn, Vienna

(1898) *Die griechischen Vasen mit Lieblingsinschriften*, 2nd edn, Leipzing

Knauer, E.R. (1965) *Die Berliner Andokidesvase*, Berlin

(1973) *Ein Skyphos des Triptolemosmalers* (125 Berliner Winckelmannsprogramm)

Knigge, U. (1975) 'Aison der Meidiasmaler?', *AM* 90: 123–62

Konstantinou, I.K. (1972) *Leuke Delphike kylix*, *Eph.* 1970: 27–46

Kopcke, G.M. (1964) 'Golddekorierte attische Schwartzfirniskeramik des vierten Jhdts. v. Chr.', *AM* 79, 22–84

Korshak, Y. (1980) 'Der Peleusmaler und seine Gefährte der Hektormaler', *AK* 23: 125–36

(1987) *Frontal Faces in Attic Vase-painting of the Archaic Period*, Chicago

Kossatz-Deissmann, A. (1991) 'Satyr- und mänadennamen auf Vasenbildern des Getty Museums', *Greek Vases* 5, 131–99

Kübler, K. (1950) *Altattische Malerei*, Tübingen

Kunze, E. (1950) *Archaische Schildbänder* (*Olympische Forschungen* 2), Berlin

Kurtz, D. (1975) *Athenian White Lekythoi: Patterns and Painters*, Oxford

(1983) 'Gorgos' cup: an essay in connoisseurship', *JHS* 103: 68–86

ed. (1985) *Beazley and Oxford*, Oxford

Kurtz, D. and J. Boardman (1971) *Greek Burial Customs*, London

Kurtz, D. and B.A. Sparkes, eds. (1982) *The Eye of Greece*, Cambridge

See also Beazley (1988)

Lane, A. (1948) *Greek Pottery*, London

Langlotz, E. (1920) *Zur Zeitbestimmung der strengrotfigurigen Vasenmalerei und der gleichzeitigen Plastik*, Leipzig

(1922) *Griechische Vasenbilder*, Heidelberg

(1932) *Griechische Vasen in Würzburg*, Munich

See also Graef

Langlotz Festschrift See *Charites*

Lauffer, S., Festschrift for. See *Studien*

Lesky, A. (1973) 'Eine neue Talosvase', *AA* 1973: 1115–19

Levi, D. (1929) *Arkades* (*ASAtene* 10–12, 1927–9)

Lezzi-Hafter, A. (1976) *Der Schuvalow-Maler: eine Kannenwerkstatt der Parthenonzeit* (*Kerameus* 2), Mainz

(1988) *Der Eretria-Maler und sein Kreis: Werke und Weggefährten* (*Kerameus* 6), Mainz

LIMC *Lexicon iconographicum mythologiae classicae*, ed. H.C. Ackermann, J.R. Gisler and others, Zurich and Munich, I, 1981; II, 1984; III i-ii, 1986; IV i-ii, 1988.

Luce, S.B. (1930) 'Attic red-figure vases at Corinth' *AJA* 34: 334–42

Lullies, R. (1940) 'Zur boiotischen rotfigurigen Vasenmalerei', *AM* 65: 1–27

(1971) 'Dinos des Berliner Malers', *AK* 14: 49–53

Luschey, H. (1939) *Die Phiale*, Bleichenrode

McNiven, T.J. (1989) 'Odysseus on the Niobid krater', *JHS* 109: 191–8

McPhee, I. (1978) 'Turin 4122 and the Pronomos Painter', *AJA* 82: 551–3

(1981) 'Laconian red-figure from the British excavations in Sparta', *BSA* 81: 153–65

McPhee, I. and A.D. Trendall (1987) *Greek Red-figured Fish-plates* (*AK* Beiheft 14), Basel

Maetzke, G., M. Cristofani and others (1981) *Materiali per servire alla Storia del Vaso François* (*Bollettino d'Arte*, Serie speciale 1), Rome

Man in the Ancient World (Exhibition catalogue), New York, 1958

Marwitz, H. (1963) 'Zur Einheit des Andokidesmalers', *ÖJh* 46 (1961–3): 73–104, figs. 39–69

Mélanges d'études anciennes offerts à Maurice Lebel, Paris, 1972

Mertens, J.R. (1972) 'A white-ground cup by Euphronios', *Harvard Studies* 76: 271–81

 (1974) 'Attic white-ground cups: a special class of vases', *MMJ* 9: 91–108

 (1977) *Attic White-ground: its Development on Shapes other than the Lekythos*, New York

Metropolitan Museum Journal, New York from 1966

Metropolitan Museum of Art: Notable Acquisitions 1979–1980, New York, 1980

Metropolitan Museum of Art: Recent Acquisitions, a Selection, 1985–1986, New York, 1986

 See also *Bulletin*

Metzger, H. (1951) *Les représentations dans la céramique attique du IVe siècle*, Paris

 (1965) *Recherches sur l'imagerie athénienne*, Paris

Milne, M.J. (1962) 'Three Attic red-figured vases in New York', *AJA* 66: 165ff

Mingazzini, P. (1969) 'Spigolature vascolari', *ASAtene* 45–6, 1967–8: 327–53

ML *Monumenti antichi pubblicati per cura della Reale Accademia dei Lincei*, Milan and Rome from 1889

MM Basel, *Münzen und Medaillen A.G.*, catalogues, 56 (1980) and 60 (1982)

MMJ See *Metropolitan Museum Journal*

Mon. Piot. *Monuments et Mémoires publiés par l'Académie des Inscriptions et Belles-Lettres*, Paris from 1884

Moon, W.G. (1983) 'The Priam Painter': some iconographic and stylistic considerations', in next: 97–118

 (1983a) ed. *Ancient Greek Art and Iconography*, Madison, Wisconsin

Moon, W.G. and L. Berge (1979) *Greek Vase-painting in Midwestern Collections*, Chicago

Moretti, M. (1980) *Museo di Villa Giulia*, Rome

Morris, S.P. (1984) *The Black and White Style: Athens and Aigina in the Orientalizing Period* (Yale Classical Monographs 6), New Haven and London

MüJb *Münchner Jahrbuch der bildenden Kunst*, Munich from 1906

Mus. J. *The Museum Journal*, Philadelphia 1910–33

Napoli, M. (1970) *La Tomba del Tuffatore*, Bari

Neugebauer, K.A. (1932) *Staatliche Museen zu Berlin. Führer durch das Antiquarium*, II. *Vasen*, Berlin

 (1938) *Antiken in deutschem Privatbesitz*, Berlin

Neumann, G. (1977) 'Zu einige Beischriften auf Münchner Vasen', *AA* 1977: 38–43

 See also Canciani

Noble, J.V. (1966) *The Techniques of Painted Attic Pottery*, London

Num. Chron. *Numismatic Chronicle*, London from 1838

Oakley, J.H. (1984) 'Double-register calyx-kraters: a study in workshop tradition', in Amsterdam symposium 119–27

 (1990) *The Phiale Painter* (Kerameus 8), Mainz

Ohly, D. (1971) 'Staatliche Antikensammlung und Glyptotek: Neuerwerbungen', *MüJb* 22: 229–36

Ohly-Dumm, M. (1971) 'Schale mit Theseus und Sinis', *MüJb* 22: 7–22

 (1984) 'Sosias und Euthymides', in Amsterdam symposium 165–72

OJA *Oxford Journal of Archaeology*, Oxford from 1982

ÖJh *Jahreshefte des Oesterreichischen Archäologischen Institutes*, Vienna from 1898

Ol. Forsch. (1964) *Olympische Forschungen* v: A. Mallwitz and W. Schiering, *Die Werkstadt des Pheidias in Olympia*, Berlin

Olshausen, E., ed. (1979) *Vasenforschung nach Beazley, Tübingen, 24–5.11.1978* (Schriften des deutschen Archäologen-Verbandes iv), Mainz

Orlandos, A.K. (1965) 'Pitsa', in *EAA* v: 201–6

Orlandos Festschrift See *Charisterion*

Overbeck, J. (1868) *Die antiken Schriftquellen zur Geschichte der bildenden Künste bei den Griechen*, Leipzig

Oxford See also *OJA*

Oxford Art Journal, Oxford from 1977

Pallottino, M. (1940) *Studi sull'arte di Hermonax* (Memorie della R. Accademia d'Italia vii.1.1.), Rome

Pantheon, Munich, from 1928

Papaspyridi, S. (1925) 'Eleusiniaka angeia', *Arkhaiologikon Deltion* 9: 1–52

 See also Karouzou

Para See Beazley 1971

Parthenon-Kongress See Berger

Payne, H. (1931) *Necrocorinthia: a Study of Corinthian Art in the Archaic Period*, Oxford

 (1933) *Protokorinthische Vasenmalerei* (Bilder griechischer Vasen 7), Berlin

 (1936) *Archaic Marble Sculpture from the Acropolis*, London

PCPhS *Proceedings of the Cambridge Philological Society*, Cambridge from 1882

Perachora II, ed. T.J. Dunbabin, Oxford, 1962

Peredolskaya, A.A. (1967) *Krasnofigurnye attischeskie vazy*, Leningrad

Peters, K. (1941) *Studien zu den panathenäischen Preisamphoren*, Berlin

 (1942) 'Zwei panathenäischen Preisamphoren des Aristophanes', *JdI* 57: 143–57

Petsas, Ph.M. (1966) *O taphos ton Lefkadion*, Athens

Pfuhl, E. (1923) *Malerei und Zeichnung der Griechen*, Munich

Philadelphia See *Mus. J.*

Philippaki, B. (1967) *The Attic Stamnos*, Oxford

Philippart, H. (1936) *Les coupes attiques à fond blanc*, Brussels

Pinney, G.F. (1981) 'The nonage of the Berlin Painter', *AJA* 85: 145–58

 (1983) 'Achilles lord of Scythia', in Moon, ed. (1983)

Plaoutine, N. (1937) 'An Etruscan imitation of an Attic cup', *JHS* 57: 22–7

Pottier, E. (1928) 'Deux silènes démolissant un tertre funéraire', *Mon. Piot.* 29: 149–92

Praktika, Athens, from 1871

Preuner, E. (1920) 'Archäologisch-Epigraphisches', *JdI* 3: 69–72

Proceedings See Amsterdam symposium; Copenhagen symposium

RA *Revue archéologique*, Paris from 1844

Rasmussen, T. and N. Spivey, eds. (1991) *Looking at Greek Vases*, Cambridge

Raubitschek, A.E. (1949) with L.H. Jeffery, *Dedications from the Athenian Acropolis*, Cambridge, Mass

RE *Paulys Real-Encyclopedie der klassischen Altertum-*

swissenschaft. Neue Bearb. herausg. von G. Wissowa. Stuttgart, 1894–1972

Res, Cambridge from 1976

Richter, G.M.A. (1934) 'The Menon Painter = Psiax', *AJA* 38: 547–54

(1936) 'The Kleophrades Painter', *AJA* 40: 100–15

Richter, G.M.A. and L.F. Hall (1936) *Red-figured Athenian Vases in the Metropolitan Museum of Art*, New Haven

RM *Mitteilungen des Deutsches Archäologischen Instituts: Römische Abteilung*, Rome from 1886

Robert, C. s.v. Euthymides in *RE*

Robertson, M. (1950) 'Origins of the Berlin Painter', *JHS* 70: 23–34

(1958) 'The Gorgos cup', *AJA* 62: 55–66

(1959) *Greek Painting*, Geneva

(1962) 'A fragment by the Nikoxenos Painter', *AJA* 66, 311f

(1965) 'Oltos's amphora', *ÖJh* 48 (1964/5): 107–17

(1966) Review of J.D. Beazley, *The Berlin Painter* (1964) in *JHS* 86: 289

(1967) 'Conjectures in Polygnotus' Troy', *BSA* 62: 5–12

(1970) 'The Diogenes Painter's masterpiece', *AK* 13: 13–16

(1972) '"Epoiesen" on Greek vases: other considerations', *JHS* 92: 137–8

(1972a) 'Monocrepis', *GRBS* 13: 39–48

(1973) 'A vignette by the Amasis Painter', *AK* 9: 81–4

(1975) *A History of Greek Art*, Cambridge

(1975a) 'A red-figured lekythos', *JPGMJ* 2: 57–60

(1976) 'Beazley and after', *MüJb* 27: 29–46

(1977) 'Jumpers', *Burl. M.* 119: 78–86

(1977a) 'The death of Talos', *JHS* 97: 158–60

(1978) 'An unrecognised cup by the Kleophrades Painter?', *Stele* 125–9

(1979) 'A muffled dancer and others', in Cambitoglou, ed. (1979) 129–34

(1981) *A Shorter History of Greek Art*, Cambridge

(1981a) 'Euphronios at the Getty', *JPGMJ* 9: 23–34

(1981b) 'Kition: the Attic black-figure and red-figure pottery', in Karageorghis (1981) 51–74

(1982) 'Beazley's use of terms', in *Beazley Addenda* xi–xviii

(1982a) 'Early Greek mosaic', in Barr-Sharrar and Borza, 240–9

(1983) 'Fragments of a dinos and a cup-fragment by the Kleophrades Painter', in *Greek Vases* 1, 51–4

(1983a) 'The Berlin Painter at the Getty Museum, and some others', in *Greek Vases* 1, 55–72

(1984) 'The South Metopes: Theseus and Daidalos', in Berger, 206–8

(1985) 'Beazley and Attic vase-painting', in Kurtz (1985) 19–20

(1986) 'Two pelikai by the Pan Painter', in *Greek Vases* 3, 71–90

(1987) *Greek, Etruscan and Roman Vases in the Lady Lever Art Gallery, Port Sunlight*, Liverpool

(1987a) 'The state of Attic vase-painting in the mid sixth century, in True (1987) 13–28

(1988) 'Sarpedon brought home', in Betts, Hooker and Green, 109–20

(1991) 'A fragmentary phiale by Douris', *Greek Vases* 5, 75–91

(1991a) 'Adopting an approach, 1', in Rasmussen and Spivey eds.

(forthcoming) 'Menelaos and Helen at Troy'

Robinson, D.M. (1933) *Excavations at Olynthus* 5, Baltimore

(1950) *Excavations at Olynthus* 13, Baltimore

Robinson, D.M. and E.J. Fluck (1937) *A Study of the Greek Love-names*, Baltimore (reprinted New York, 1979)

Rumpf, A. (1927) *Chalkidische Vasen*, Berlin

(1937) *Sakonides (Bilder griechischer Vasen* 11), Leipzig

(1951) 'Parrhasios', *AJA* 55: 1–12

(1953) *Malerei und Zeichnung (Handbuch der Archäologie* 4,1), Munich

Rutherford Roberts, S. (1978) *The Attic Pyxis*, Chicago

von Salis, A. (1940) 'Die Gigantomachie am Schild der Athena Parthenos', *JdI* 55: 90–169

Schauenburg, K. (1976) 'Askoi mit plastischen Löwenkopf', *RM* 83: 261–71

Schauenburg Festschrift: see Böhr and Martini

Schefold, K. (1930) *Kertscher Vasen (Bilder griechischer Vasen* 3), Berlin

(1934) *Untersuchungen zu den Kertscher Vasen*, Berlin

(1968) *Myth and Legend in Early Greek Art*, London (translated from *Frühgriechische Sagenbilder*, Munich, 1964)

(1974) 'Pammachos', *AK* 17: 137–42

(1976) 'Sophokles' Aias auf einer Lekythos', *AK* 19: 71–8

(1978) *Götter und Heldensagen der Griechen in der spätarchaischen Kunst*, Munich

(1981) *Die Göttersage in der klassischen und hellenistischen Kunst*, Munich

Scheibler, I. (1986) 'Formen der Zusammenarbeit in attischen Töpfereien des 6 und 5 Jahrhunderts v. Chr.', *Studien zur alten Geschichte*, 787–804

Schiering, W. (1964) '(Archäologische Befund) Rotfigurig bemalte Keramik', in *Ol. Forsch.* v, *Die Werkstatt des Pheidias in Olympia*, 248–66, pls. 80–91

Schmidt, E. (1922) *Archaistische Kunst in Griechenland und Rom*, Munich

Schmidt, M. (1967) 'Dionysien', *AK* 10: 70–81

(1980) 'Zu Amazonomachiedarstellungen des Berliner Malers und des Euphronios', in *Tainia* 153–69

SE See *Studi Etruschi*

Seiterle, G. (1976) 'Die Zeichentechnik in der rotfigurigen Vasenmalerei', *Antike Welt* 7: 3ff

Serbeti, E.P. (1983) *O Zografos tis Providence*, Athens

Shefton, B.B. (1967) 'Attisches Meisterwerk und etruskische Kopie', *WZUR* 16: 529–37

(1982) 'The krater from Baksy', in Kurtz and Sparkes, 149–81

See also Arias

Simon, E. (1953) *Opfernde Götter*, Berlin

(1965) 'Attische Monatsbilder', *JdI* 80: 105–23

(1982) 'Satyr-plays on vases in the time of Aeschylus', in Kurtz and Sparkes, 123–48

Simon, E. and M. Hirmer (1976) *Die griechischen Vasen*, Munich

Six, J. (1888) 'Vases polychromes sur fond noir de la période archaique', *Gaz. arch* 13: 193–210, 281–94

(1888a) 'Kleophrades sohn des Amasis', *RM* 1888: 233–4

Smith, H.R.W. (1929) *New Aspects of the Menon Painter*, Berkeley

(1939) *Der Lewismaler (Bilder griechischer Vasen* 13), Leipzig

Snodgrass, A.M. (1971) *The Dark Age of Greece*, Edinburgh

Sourvinou-Inwood, C. (1974) 'Three related Cerberi', *AK* 17: 20–45

(1975) 'Who was the teacher of the Pan Painter?', *JHS* 95: 107–21

(1979) *Theseus as Son and Stepson* (BICS Suppl. 40), London

(1987) 'A series of erotic pursuits: images and meanings', *JHS* 107: 131–53

(1987a) 'Menace and pursuit: differentiation and the creation of meaning', in Bérard, Bron and Pomari

Sparkes, B.A. (1960) 'Kottabos: an Athenian after-dinner game', *Archaeology* 13: 201–7

Sparkes, B.A. and Talcott, L. (1958) *Pots and Pans of Classical Athens* (Excavations of the Athenian Agora, Picture Book no. 1), Princeton

(1970) *Black and Plain Pottery* (*The Athenian Agora* XII), Princeton

Stähler, K.P. (1967) *Eine unbekannte Pelike des Eucharidesmalers*, Köln/Graz

Stansbury-O'Donnell, M. (1989) 'Polygnotos's *Iliupersis*: a new reconstruction', *AJA* 93: 203–15

(1990) 'Polygnotos's *Nekyia*: a reconstruction and analysis', *AJA* 94: 213–35

Stefani, E. (1934) *Il Museo Nazionale de Villa Giulia in Roma*, Rome

Stele (volume in memory of N. Kondoleon), Athens, 1978

Stubbings, F.H. (1947) 'The Mycenaean pottery of Attica', *BSA* 42: 1–75

Studi Etruschi, Florence from 1927

Studien zur alten Geschichte, Siegried Lauffer zum 70. Geburtstag, eds. H. Kalcyk, B. Gullath, A. Graeber, III, Rome, 1986

Süsserott, H.K. (1938) *Griechische Plastik des IV. Jahrhunderts v. Chr. Untersuchungen zur Zeitbestimmung*, Frankfurt

Swindler, M.H. (1915) 'The Penthesilea Master', *AJA* 19: 398–417

Tainia (Festschrift, R. Hampe), ed. H.A. Cahn and E. Simon, Mainz am Rhein, 1980

Talcott, L. and B. Philippaki (1956) *Small Objects from the Pnyx* II, Part 1, *Figured Pottery* (*Hesp.* Suppl. x), Princeton

Technau, W. (1936) *Exekias* (Bilder griechischer Vasen 9), Leipzig

Themelis, P.G. (1969) 'Eretria: Pompike Odos kai Panathenaikoi Amphoreis', *AAA* 2: 409–15

Tiverios, M. (1976) *O Lydos kai to ergon tou*, Athens

Tompkins, J.F., ed. (1983) *Wealth of the Ancient World*, Fort Worth (Exhibition catalogue: the Nelson Bunker Hunt and William Herbert Hunt Collections, Fort Worth)

Touloupa, E. (1983) *Ta enaetia glypta tes naou tou Apollonos Daphnephorou stin Eretria*, Joannina

Trendall, A.D. (1938) *Frühitaliotischer Vasen* (Bilder griechischer Vasen 12), Leipzig

(1958) *The Felton Greek Vases in the National Gallery of Victoria*, Canberra

(1959) *Phlyax Vases* (BICS Suppl.), London

(1966) *South Italian Vase-painting*, London

(1967) *The Red-figure Vases of Lucania, Campania and Sicily*, Oxford (and Supplements)

(1987) *The Red-figured Vases of Paestum*, London

Trendall, A.D. and A. Cambitoglou (1978) *The Red-figured Vases of Apulia*, Oxford (and Supplements)

Trendall, A.D. and I. McPhee (1982) 'An Elean red-figured pelike in Liverpool and an early South Italian vase-painting', in *Aparchai*, 471–2

Trendall, A.D. and T.B.L. Webster (1971) *Illustrations of Greek Drama*, London
See also McPhee

Trendall Festschrift. See Cambitoglou (1979)

True, M. (1985) 'A new Meidian kylix', *Greek Vases* III, 79–88

(1986) 'Acquisitions in 1985', *JPGMJ* 14

(1987) ed. *Papers on the Amasis Painter and his World*, Malibu

Ure, A.D. (1953) 'Boeotian vases with women's heads', *AJA* 57: 245–9

(1958) 'The Argos Painter and the Painter of the Dancing Pan', *AJA* 62: 382–95

VA See Beazley 1918

van de Put, W.D.J. (1988) 'The development of the white-ground lekythos in the later fifth century and its relation to red-figure vase-painting' (Amsterdam dissertation)

Vermeule, E.T. (1964) *Greece in the Bronze Age*, Chicago

(1966) 'The Boston Oresteia krater', *AJA* 70: 1–22

(1970) 'Five vases from the grave precinct of Dexileos', *JdI* 85: 94–111

Vickers, M. (1979) 'A new vase by the Pan Painter in Oxford', *Oxford Art Journal*, 1979: 61–3

(1984) 'The influence of exotic materials on Attic white-ground pottery', *Amsterdam Symposium* 88–96

(1985) 'Artful crafts: the influence of metalwork on Athenian painted pottery', *JHS* 105: 108–28

(1985a) 'Early Greek coinage, a reassessment', *Num. Chron.* 145: 1–44

(1988) 'The Agora revisited: Athenian chronology, c.500–450 B.C.', *BSA* 83: 143–67
See also Francis, Gill

Vierneisel, K. (1967) 'Berichte der Staatlichen Kunstsammlungen; Neuerwerbungen der Antikensammlungen' *MüJb* 18: 241ff

Visible Religion, Groningen, from 1982

Vos, M.F. (1963) *Scythian Archers in Archaic Attic Vase-painting*, Groningen

Waiblinger, A. (1972) 'Remarques sur une coupe à fond blanc du Musée du Louvre', *RA* 1972: 233–42

Walter, H. (1962) 'Amazonen oder Achäer', *AM* 77: 193–8

Webster, T.B.L. (1935) *Der Niobidenmaler* (Bilder griechischer Vasen 8), Leipzig

(1960) 'Greek dramatic monuments from the Athenian Agora and Pnyx', *Hesp.* 29: 234–84

(1972) *Potter and Patron in Classical Athens*, London
See also Trendall

Wegner, M. (1968) *Duris*, Münster

(1973) *Der Brygosmaler*, Berlin

Wehgartner, I. (1983) *Attische Weissgründige Keramik*, Berlin

(1985) *Ein Grabbild des Achilleusmalers* (129 Berliner Winckelsmannprogramm)

West, M.L. (1972) *Iambi et Elegi Graeci*, Oxford

Willemsen, F. (1957) *Dreifusskessel von Olympia: alte und neue Funde* (Olympische Forschungen iii), Berlin

Williams, D.J.R. (1976) 'The Ilioupersis cup in Berlin and the Vatican', *Berl. Mus.*, 80: 9–23

(1980) 'Ajax, Odysseus and the arms of Achilles', *AK* 23: 137–45

(1982) 'An oinochoe in the British Museum and the Brygos Painter's work on a white ground', *Berl. Mus.* 24: 17–40

(1987) 'Aigina. Aphaia-Tempel xi', *AA* 1987: 629–80

(1988) 'The late archaic class of eye-cups', in Copenhagen symposium 675–83

(1990) Euphronios: du peintre au potier, in *Euphronios* 33–7

(1991) 'Onesimos and the Getty Iliupersis', *Greek Vases* 5, 41–64

Winter, C. (1900) 'Zu Euphronios', *ÖJh*, 3, 128

WZUR Wissenschaftliche Zeitschrift der Universität Rostock, Rostock from 1952

Yuri, E. (1978) *O krateras tou Derveniou*, Athens

ZPE Zeitschrift für Papyrologie und Epigraphik, Bonn from 1967

ILLUSTRATIONS

Frontispiece Red-figure calyx-krater, from Vulci? Paris, Musée du Louvre G 162. *ARV²* 186.47. Phot. Chuzeville, courtesy of the Museum.

1 and 2 Black-figure neck-amphora, from Vulci. Paris, Bibliothèque Nationale, Cabinet des Médailles 222. *ABV* 152.25. Museum phots.

3 Black-figure oinochoe, from Italy. London, British Museum B 524. *ABV* 154.47. Museum phot.

4 and 5 Black-figure and red-figure amphora. Boston, Museum of Fine Arts 99.538. *ABV* 253.6; *ARV²* 4.12. Museum phots.

6 Black-figure and red-figure cup, from Chiusi. Palermo, Museo Nazionale V 650. *ABV* 256.21; *ARV²* 5.14. Museum phot.

7 Black-figure hydria from Vulci. London, British Museum B 336. *ABV* 266.3. Museum phot.

8 Red-figure cup. New York, Metropolitan Museum of Art 14.146. *ARV²* 8.9. Museum phot.

9 Red-figure amphora. New York, Metropolitan Museum of Art 63.11.6, Joseph Pulitzer Bequest. *ARV²* 1617 and *Para* 320.2*bis*. Museum phot.

10 Red-figure amphora, from Vulci. Berlin, Staatliche Museen 2159. *ARV²* 3.1. Museum phot.

11 Black-figure and red-figure cup. London, British Museum E 3. *ARV²* 70.3. Museum phot.

12 Red-figure stamnos, from Cerveteri. London, British Museum E 437. *ARV²* 52.7. Museum phot.

13 Red-figure plate, from Vulci. London, British Museum E 136. *ARV²* 78.94. Museum phot.

14 Red-figure cup, from Vulci. Munich, Staatliche Antikensammlungen und Glyptotek 2590. *ARV²* 24.12. Museum phot.

15 and 16 Red-figure cup. Market (ex Hunt Collection). Not known to Beazley. Phots. J. Paul Getty Museum, Malibu.

17 Red-figure cup, from Vulci. London, British Museum E 41. *ARV²* 28.51. Museum phot.

18 Red-figure calyx-krater, from Cerveteri. Paris, Musée du Louvre G 103. *ARV²* 14.2. Phot. Chuzeville, courtesy of the Museum

19 Red-figure calyx-krater. New York, Shelby White and Leon Levy. Not known to Beazley. Phot. J. Paul Getty Museum, Malibu, courtesy of owners.

20 Red-figure hydria, from Vulci. Munich, Staatliche Antikensammlungen und Glyptotek 2421. *ARV²* 23.7. Museum phot.

21 Red-figure hydria, from Vulci. London, British Museum E 159. *ARV²* 24.9. Museum phot.

22 Red-figure amphora, from Vulci. Munich, Staatliche Antikensammlungen und Glyptotek 2309. *ARV²* 27.4. Museum phot.

23 Red-figure amphora, from Vulci. Munich, Staatliche Antikensammlungen und Glyptotek 2307. *ARV²* 26.1. Museum phot.

24 Red-figure pelike. Boston, Museum of Fine Arts 1973.88, Robert J. Edwards Fund. Not known to Beazley. Museum phot.

25 Red-figure neck-amphora. Warsaw, National Museum 142332. *ARV²* 27.8. Phot. Marie Beazley.

26 Black-figure plate, from Vulci. London, British Museum B 591. *ABV* 294.19. Museum phot.

27 Black-figure hydria, from Vulci. London, British Museum B 323. *ABV* 362.33. Museum phot.

28 Black-figure hydria, from Vulci. London, British Museum B 332. *ABV* 333.27. Museum phot.

29 Red-figure cup, from Tanagra. Paris, Musée du Louvre CA 1527. *ARV²* 83.12. Phot. Marie Beazley, courtesy of the Museum.

30 Red-figure cup. New York, Metropolitan Museum of Art 07.286.47. *ARV²* 175, bottom. Museum phot.

31 Red-figure cup, from Vulci. London, British Museum E 12. *ARV²* 126.4. Museum phot.

32 Red-figure cup, from Cerveteri. London, British Museum E 46. *ARV²* 315.1. Museum phot.

33 Red-figure cup. Malibu, J. Paul Getty Museum 86.AE.161. Not known to Beazley. Museum phot.

34 and 35 Red-figure cup, from Cerveteri. Paris, Musée du Louvre G 104. *ARV²* 318.1. Phots. Chuzeville, courtesy of the Museum.

36 Red-figure cup, from Chiusi. Brussels, Musées Royaux A 889. *ARV²* 329.130. Museum phot.

37 Red-figure cup, from Cerveteri, Brunswick (Maine), Bowdoin College 30.1. *ARV²* 328.114. Museum phot.

38 Red-figure and white-figure plaque. Oxford, Ashmolean Museum 1984.131, 132. Not known to Beazley. Museum phot.

39 and 40 White-ground alabastron, from Marion. London, British Museum B 668. *ARV²* 98.1. Museum phots.

41 White-ground cup. Malibu, J. Paul Getty Museum 86.AE.313. Not known to Beazley. Museum phot.

42 White-ground cup, from Eleusis. Eleusis Museum 618. *ARV²* 314.3. Museum phot.

43 White-ground cup-fragment. Cambridge, Museum of Classical Archaeology UP 29. *Para* 349, bottom. Phot. R.M. Cook, courtesy of the Museum.

44 White-ground cup. Paris, Musée du Louvre G 109. Not listed by Beazley. Phot. Chuzeville, courtesy of the Museum.

45 Red-figure amphora, from Vulci. Würzburg, University, Martin von Wagner-Museum 507. *ARV²* 181.1. Museum phot.

46 Red-figure cup, from Vulci. Berlin, Staatliche Museen 2278. *ARV²* 21.1. Museum phot.

47 Red-figure cup, from Tarquinia. Paris, Bibliothèque Nationale, Cabinet des Médailles 536 (part). *ARV²* 191.104. Phot. Marie Beazley, courtesy of the Museum.

48 Red-figure calyx-krater. Harvard, Arthur M. Sackler Museum 1960.236 *ARV²* 185.31. Museum phot.

49 Red-figure calyx-krater, from Vulci? Paris, Musée du Louvre G 162. *ARV²* 186.47. Phot. Chuzeville, courtesy of the Museum.

50 Red-figure hydria (kalpis), from Nola. Naples, Museo Nazionale 2422. *ARV²* 189.74. Museum phot.

51 Red-figure neck-amphora. Harrow on the Hill, Harrow School Museum 55. *ARV²* 183.11. Museum phot.

52 Red-figure hydria (kalpis), from Sicily. Munich, Staatliche Antikensammlungen und Glyptotek 2424. Not in *ARV²*; *ARV¹* 129.4. Museum phot.

53 and 54 Black-figure panathenaic amphora, from Vulci. New York, Metropolitan Museum of Art 16.71. *ABV* 404.2. Museum phot.

55 Red-figure amphora, from Vulci. Würzburg, University, Martin von Wagner-Museum 508. *ARV²* 182.5. Museum phot.

56 Red-figure amphora, from Vulci. Berlin, Staatliche Museen 2160. *ARV²* 196.1 Museum phot.

57 Red-figure amphora of panathenaic shape, from Vulci. Würzburg, University, Martin von Wagner-Museum 500. *ARV²* 197.8. Museum phot.

58 Red-figure amphora. Basel, Antikenmuseum und Sammlung Ludwig BS 456. *ARV²* 1634 and *Para* 342.1*bis* Museum phot.

59 Red-figure amphora Type C. New York, Metropolitan Museum of Art 56.171.38. *ARV²* 197.3. Museum phot.

60 and 61 Red-figure volute-krater from Cerveteri. London, British Museum E 468. *ARV²* 206.132. Museum phots.

62 and 63 Red-figure dinos. Basel, Antikenmuseum und Sammlung Ludwig Lu 39. Not known to Beazley. Museum phots.

64 Red-figure bell-krater. Paris. Musée du Louvre G 175. *ARV²* 206.124. Museum phot.

65 Red-figure lekythos. Munich, Staatliche Antikensammlungen und Glyptotek 2475. *ARV²* 211.190. Museum phot.

66 Red-figure stamnos, from Cerveteri. Oxford, Ashmolean Museum 1912.1165. *ARV²* 208.144. Museum phot.

67 Red-figure hydria (kalpis). New York, Metropolitan Museum of Art 65.11.12. Not known to Beazley. Museum phot.

68 Red-figure calyx-krater fragments. Malibu, J. Paul Getty Museum 81.AE.213. Not known to Beazley. Museum phot.

69 Red-figure calyx-krater. New York, Metropolitan Museum of Art 1972.11.10, bequest of J.H. Durkee, gifts of D.O. Mills and J.R. Love by exchange. Not known to Beazley. Museum phot.

70 Red-figure pelike, from Cerveteri. Vienna, Kunsthistorisches Museum 3725. *ARV²* 204.109. Museum phot.

71 Red-figure cup, from Tanagra. Athens, National Museum 1628. *ARV²* 25, middle. Museum phot.

72 Red-figure cup, from Athens. Athens, Agora Museum P 24113. *ARV²* 213.242. Museum phot.

73 Red-figure aryballos, from Athens. Athens, Third Ephoria T.E. 356. *Para* 376.273*bis* and 524. Museum phot.

74 Red-figure phiale fragment. Malibu, J. Paul Getty Museum 81.AE.213. Not known to Beazley. Museum phot.

75 Red-figure cup, from Cerveteri. Rome, Museo Vaticano. *ARV²* 437.116. Museum phot.

76 Red-figure cup, from Vulci. London, British Museum E 54. *ARV²* 436.96. Museum phot.

77 and 78 Red-figure cup, from Vulci. London, British Museum E 38. *ARV²* 72.16. Museum phots.

79 Red-figure cup, from Vulci. London, British Museum E 49. *ARV²* 432.52. Museum phot.

80 and 81 Red-figure cup, from Cerveteri. Vienna, Kunsthistorisches Museum 3695. *ARV²* 429.26. Museum phots.

82 Red-figure cup, from Vulci. London, British Museum E 69. *ARV²* 369.2. Museum phot.

83 Red-figure cup, from Cerveteri. Berlin, Staatliche Museen 2285. *ARV²* 431.48. Museum phot.

84 Red-figure kantharos. Brussels, Musées Royaux A 718. *ARV²* 445.256. Museum phot.

85 Red-figure aryballos, from Athens. Athens, National Museum 15375. *ARV²* 447.274. Museum phot.

86 Red-figure psykter, from Cerveteri. London, British Museum E 768. *ARV²* 446.262. Museum phot.

87 Red-figure cup, from Vulci. Paris, Musée du Louvre G 152. *ARV²* 369.1. Museum phot.

88 Red-figure cup. Malibu, J. Paul Getty Museum 81.AE.26. *Para* 367.1*bis*. Museum phot.

89 Red-figure cup, from Vulci. Würzburg, University, Martin von Wagner-Museum 479. *ARV²* 372.32. Museum phot.

90 Red-figure cup, from Capua. London, British Museum E 65. *ARV²* 370.13. Museum phot.

91 Red-figure cup, from Vulci. London, British Museum E 68. *ARV²* 373.24. Museum phot.

92 White-ground (and red-figure) cup, from Vulci. Munich, Staatliche Antikensammlungen und Glyptotek 2645. *ARV²* 371.15. Museum phot.

93 White-ground oinochoe, from Locri? London, British Museum D 13. *ARV²* 403.38. Museum phot.

94 Red-figure skyphos, from Nola. Paris, Musée du Louvre G 156. *ARV²* 380.172. Museum phot.

95 Red-figure cylinder, from Agrigento. Munich, Staatliche Antikensammlungen und Glyptotek 2416. *ARV²* 385.228. Museum phot.

96 Red-figure cup, from Vulci. London, British Museum E 61. *ARV²* 468.145. Museum phot.

97 and 98 Red-figure cup, from Vulci. Berlin, Staatliche Museen 2290. *ARV²* 462.48. Museum phots.

99 Red-figure cup, from Vulci. Berlin, Staatliche Museen 2291. *ARV²* 459.4. Museum phot.

100 Red-figure skyphos, from Suessula. Boston, Museum of Fine Arts 13.186. ARV^2 458.1 Museum phot.

101 Black-figure skyphos. London, British Museum 1920.2–16.3 Haspels (1936) 250.27. Museum phot.

102 Red-figure askos. Brunswick (Maine). Bowdoin College 23.30. ARV^2 480.339. Museum phot.

103 Red-figure cup, from Spina. Ferrara, Museo Nazionale di Spina T.41 D VP. ARV^2 337.30*bis*. Museum phot.

104 Red-figure cup, from Vulci. Berlin, Staatliche Museen 2294. ARV^2 400.1. Museum phot.

105 Red-figure cup, from Vulci. London, British Museum E 78. ARV^2 401.3 Museum phot.

106 and 107 Red-figure cup. London, British Museum 95.5–13.3. ARV^2 405.2. Museum phots.

108 Red-figure cup, from Chiusi. Oxford, Ashmolean Museum 300. ARV^2 357.69. Museum phot.

109 Red-figure cup. Basel, Antikenmuseum und Sammlung Ludwig BS 465. Not known to Beazley. Museum phot.

110 Red-figure cup. Munich, Staatliche Antikensammlungen und Glyptotek inv. 8771. Not known to Beazley. Museum phot.

111 Red-figure cup. Florence, Museo Archeologico Etrusco 4211. ARV^2 121.22. Phot. Marie Beazley, courtesy of the Museum.

112 Red-figure cup, from Italy. Edinburgh, Royal Scottish Museum 1887.213. ARV^2 464.46. Phot. Marie Beazley, courtesy of the Museum.

113 Red-figure pelike, from Orvieto. Copenhagen, Ny Carlsberg Glyptotek 2695. ARV^2 364.19. Museum phot.

114 Red-figure skyphos. Berlin, Staatliche Museen inv. 1970.9. Not known to Beazley. Museum phot.

115 Red-figure cup. New York, Metropolitan Museum of Art 53.11.4. ARV^2 406.7. Museum phot.

116 Red-figure cup, from Orvieto. Berlin, Staatliche Museen 2296. ARV^2 412.1. Museum phot.

117 Red-figure stamnos. Oxford, Ashmolean Museum 1965.121 (ex Spencer-Churchill). ARV^2 414.34; *Para* 372. Museum phot.

118 Red-figure calyx-krater. Boston, Museum of Fine Arts 63.1246. ARV^2 1652, near top, and *Para* 373.34*quater*. Museum phot.

119 Red-figure hydria (kalpis)-fragment, from Greece. English private collection. ARV^2 222.24. Phot. Robertson.

120 Black-figure pelike, from Rhodes. Oxford, Ashmolean Museum 563. ABV 396.21. Museum phot.

121 Red-figure amphora Type A. Hamburg, Museum für Kunst und Gewerbe 1966.34. *Para* 147.8*ter*. Museum phot.

122 Red-figure neck-amphora. Basel, Antikenmuseum und Sammlung Ludwig BS 453. ARV^2 1634.30*bis*. Museum phot.

123 Red-figure neck-amphora. London, British Museum E 279. ARV^2 226.1. Museum phot.

124 Red-figure column-krater, from Kerch. Leningrad, Museum of the Hermitage. ARV^2 248.1. Museum phot.

125 Red-figure amphora Type B, from Vulci. London, British Museum E 261. ARV^2 248.2. Museum phot.

126 Red-figure hydria (kalpis), from Vulci. Berlin (Staatliche Museen 2179. ARV^2 252.52. Museum phot.

127 Red-figure column-krater, from Athens. Athens, National Museum Acr. 806. ARV^2 240.42. Phot. Berge, courtesy of the Museum.

128 Red-figure calyx-krater. London, British Museum E 458. ARV^2 239.16 Museum phot.

129 Red-figure column-krater. Oxford, Ashmolean Museum 561. ARV^2 241.52. Museum phot.

130 Red-figure pelike. Munich, Staatliche Antikensammlungen und Glyptotek inv. 8672. ARV^2 1638.2*bis*. Museum phot.

131 Red-figure oinochoe. Maplewood (New Jersey), Joseph V. Noble. ARV^2 1635f and 1705 bottom. 78*bis*. Phot. courtesy of owner.

132 Red-figure amphora Type C, from Capua. Boston, Museum of Fine Arts 98.882. ARV^2 279.7. Museum phot.

133 Red-figure oinochoe, from Vulci. London, British Museum E 511. ARV^2 307.9. Museum phot.

134 White-ground 'semi-outline' lekythos. New York, Metropolitan Museum of Art 06.1070. ARV^2 301.3. Museum phot.

135 Red-figure lekythos, from Gela. Boston 13.195. ARV^2 35, bottom. 1. Museum phot.

136 Red-figure hydria (kalpis)-fragments. Malibu, J. Paul Getty Museum 85.AE.188. Not known to Beazley. Museum phot.

137 Red-figure cup. Malibu. J. Paul Getty Museum 84.AE.38. Not known to Beazley. Museum phot.

138 Red-figure stamnos, from Vulci. London, British Museum E 440. ARV^2 289.1. Museum phot.

139 Red-figure skyphos. English private collection. *Para* 353.1. Phot. courtesy of owner.

140 and 141 Red-figure skyphos, from Capua. London, British Museum E 139. ARV^2 77.86. Museum phot.

142 Red-figure amphora Type B, from Vulci. Copenhagen, National Museum 125. ARV^2 256.1 Museum phot.

143 Red-figure pointed amphora, from Vulci. Munich, Staatliche Antikensammlungen und Glyptotek 2345. ARV^2 496.2. Museum phot.

144 Red-figure pointed amphora, from Vulci. Brussels, Musées Royaux R 303. ARV^2 249.6. Museum phot.

145 Red-figure pointed amphora. Zurich, University. ARV^2 1656. Museum phot.

146 and 147 Red-figure pelike-fragments. Malibu, J. Paul Getty Museum 81.AE.62. Two fragments (then Louvre C 10833) ARV^2 358.130. Museum phots.

148 and 149 Red-figure bell-krater, from Cumae. Boston, Museum of Fine Arts 10.185. ARV^2 550.1. Museum phots.

150 Red-figure pelike, from Cerveteri. Vienna, Kunsthistorisches Museum 3727. ARV^2 555.88. Museum phot.

151 Red-figure lekythos. Adolphseck, Landgraf Philipp of Hesse 53. ARV^2 556.109. Museum phot.

152 and 153. Red-figure pelike. Cambridge, Fitzwilliam Museum 9.17. ARV^2 564.27. 152, Museum phot; 153, phot. Berge, courtesy of the Museum.

154 Red-figure hydria (kalpis). Boston, Museum of Fine Arts 03.788. ARV^2 571.75. Museum phot.

155 Red-figure column-krater. Chicago, Art Institute 89.16. ARV^2 585.29. Museum phot.

156 Red-figure lekythos. Swiss private collection, on loan to Basel, Antikenmuseum und Sammlung Ludwig. Not known to Beazley. Museum phot., courtesy of owner.

157 and 158 Red-figure cup, from Vulci. Boston, Museum of Fine Arts 95.28. ARV^2 816.1. Museum phot.

159 Red-figure cup, from Vulci. Berlin, Staatliche Museen 2293. ARV^2 370.10. Museum phot.

160 White-ground bobbin, from Athens. Athens, Agora Museum. Not listed by Beazley. Museum phot.

161 White-ground cup, from Athens. Athens, Agora Museum. P 43. ARV^2 1578. Museum phot.

162 White-ground and red-figure cup, from Vulci. Berlin, Staatliche Museen 2282. ARV^2 859.1. Museum phot.

163 White-ground and red-figure cup, from Locri. Taranto, Museo Nazionale. ARV^2 860.3. Museum phot.

164 Red-figure skyphos, from Cerveteri. Schwerin, Staatliches Museum. ARV^2 862.30. Museum phot.

165 White-ground cup-fragment, from Attica. Boston, Museum of Fine Arts 03.847. ARV^2 865, middle. 2. Museum phot.

166 White-ground cup, from Camiros. London, British Museum D 2. ARV^2 862.22. Museum phot.

167 Red-figure cup, from Vulci. Munich, Staatliche Antikensammlungen und Glyptotek 2688. ARV^2 879.1. Museum phot.

168 and 169 Red-figure cup, from Spina. Ferrara, Museo Nazionale di Spina T.18 C VP. ARV^2 882.35. Museum phots.

170 Red-figure skyphos, from Vico Equense (near Naples). Boston, Museum of Fine Arts 01.8032. ARV^2 868.155. Museum phot.

171 White-ground pyxis, from Cumae. New York, Metropolitan Museum of Art 07.286.36, Rogers Fund 1907. ARV^2 890.173. Museum phot.

172 White-ground bobbin, from near Athens. New York, Metropolitan Museum of Art 28.167, Fletcher Fund 1928. ARV^2 890.175. Museum phot.

173 and 174 Red-figure calyx-krater, from Bologna. Bologna 289. ARV^2 891, middle. Museum phots.

175 Red-figure cup, from Aegina. New York, Metropolitan Museum of Art 22.139.72, Rogers Fund 1922. ARV^2 781.1 Museum phot.

176 White-ground (and red-figure) cup, from Vulci. Munich, Staatliche Antikensammlungen und Glyptotek 2685. ARV^2 837.6. Museum phot.

177 Red-figure skyphos, from Orvieto, Vienna, Kunsthistorisches Museum 1773. ARV^2 972.2. Museum phot.

178 White-ground (and red-figure) cup. New York, Metropolitan Museum of Art 1979.11.15. Not known to Beazley. Museum phot.

179 Red-figure bell-krater, from Nola. London, British Museum E 492. ARV^2 619.16. Museum phot.

180 Red-figure hydria (kalpis). Cambridge, Fitzwilliam Museum 12.17. ARV^2 623.66. Museum phot.

181 Red-figure stand, from Naucratis. Cambridge, Fitzwilliam Museum x.13. ARV^2 623.73. Museum phot.

182 White-ground calyx-krater fragments. Cincinnati, Art Museum 1962.386–388. ARV^2 634.3. Museum phot.

183 White-ground and red-figure covered cup, from Vari (Attica). Boston, Museum of Fine Arts 00.356. ARV^2 741, below. Museum phot.

184 Red-figure neck-amphora, from Vulci. Providence, Rhode Island School of Design 15.005, gift of Mrs Gustav Radeke. ARV^2 635.1. Museum phot.

185 Red-figure pelike, from Cerveteri. Vienna, Kunsthistorisches Museum 3728. ARV^2 485.24. Museum phot.

186 and 187 Red-figure stamnos, from Vulci. Munich, Staatliche Antikensammlungen und Glyptotek 2413. ARV^2 495.1. Museum phots.

188 White-ground lekythos, from Eretria. Athens, National Museum 12771. ARV^2 743, 1. Museum phot.

189 White-ground cup, from Attica? Paris, Musée du Louvre CA 482, ARV^2 774.2. Phot. Chuzeville, courtesy of the Museum.

190 White-ground cup, from Attica? Paris, Musée du Louvre CA 483. ARV^2 774.3. Phot. Chuzeville, courtesy of the Museum.

191 and 192 Red-figure calyx-krater, from Orvieto. Paris, Musée du Louvre G 341. ARV^2 601.22. Phots. Chuzeville, courtesy of the Museum.

193 and 194 Red-figure volute-krater, from Numana, New York, Metropolitan Museum of Art 07.286.84, Rogers Fund 1907. ARV^2 613.1. Museum phots.

195 Red-figure bell-krater, from Spina. Ferrara, Museo Nazionale di Spina T.311. ARV^2 593.41. Museum phot.

196 White-ground stemless cup, from Athens. London, British Museum D 7. ARV^2 763.3. Museum phot.

197 White-ground cup, from Athens. London, British Museum D 5. ARV^2 763.2. Museum phot.

198 White-ground cup, from Athens. London, British Museum D 6. ARV^2 763.1. Museum phot.

199–202 Red-figure *astragalos*-vase, from Aegina. London, British Museum E 804. ARV^2 765.20. Museum phots.

203 Red-figure stamnos, from Capua. Chicago, Art Institute 89.22. ARV^2 628.4. Museum phot.

204 Red-figure pelike, from Rugge (near Lecce). Lecce, Museo Provinciale Sigismondo Castromediano 570. ARV^2 629.33. Museum phot.

205 Red-figure volute-krater, from Spina. Ferrara, Museo Nazionale di Spina T.10 C VP. ARV^2 628.1. Museum phot.

206 Red-figure pointed amphora. Paris, Bibliothèque Nationale, Cabinet des Médailles 357. ARV^2 987.2. Museum phot.

207 Red-figure loutrophoros. Philadelphia, University Museum 30.4.1. ARV^2 990.45. Museum phot.

208 Black-figure panathenaic amphora from Vulci. New York. Mr G. Callimanopulos (ex Castle Ashby), on loan to Metropolitan Museum of Art L.1982.102.3. ABV 408.1. Museum phot., courtesy of Mr Callimanopulos.

209 Black-figure panathenaic amphora, from Bologna. Bologna, Museo Civico 11. ABV 409.1. Museum phot.

210 White-ground lekythos, from Greece. Munich, Staatliche Antikensammlungen und Glyptotek. ARV^2 997.155. Museum phots.

211 White-ground lekythos, from Eretria. Athens, National Museum 1818. ARV^2 998.161. Museum phots.

212 White-ground lekythos, from Athens. New York, Metropolitan Museum of Art 07.286.40. Rogers Fund 1907. ARV^2 846.190. Museum phot.

213 White-ground lekythos-fragment. London, British Museum 1907.7–7.10. ARV^2 1227.10. Museum phot.

214 Red-figure bell-krater. New York, Metropolitan Museum of Art 28.57.23, Fletcher Fund 1928. ARV^2 1012.1. Museum phot.

215 White-ground lekythos, from Eretria. Athens, National Museum 12792. ARV^2 1229.28 Museum phot.

216 White-ground lekythos. New York, Metropolitan Museum of Art 09.221.44, Rogers Fund 1909. *ARV²* 1168.128. Museum phot.

217 Red-figure phiale, from near Sunium. Boston, Museum of Fine Arts 97.371. *ARV²* 1023.146. Museum phot.

218 White-ground calyx-krater, from Vulci. Rome, Museo Vaticano. *ARV²* 1017.54. Museum phot.

219 White-ground lekythos, from Oropos. Munich, Staatliche Antikensammlungen und Glyptotek 2797. *ARV²* 1022.138. Museum phot.

220 White-ground lekythos, from Oropos. Munich, Staatliche Antikensammlungen und Glyptotek 2798. *ARV²* 1022.139. Museum phot.

221 Red-figure stamnos, from Sorrento. London, British Museum 96.7–16.5. *ARV²* 1027.2. Museum phot.

222 Red-figure bell-krater fragment, from Adria. Adria, Museo Civico BC 104. *ARV²* 1029.19. Museum phot.

223 Red-figure pelike. Boston, Museum of Fine Arts 34.79 *ARV²* 1045.3 Museum phot.

224 Red-figure neck-amphora. London, British Museum E 271. *ARV²* 1039.13. Museum phot.

225 Red-figure column-krater, from Gela. Berlin, Staatliche Museen inv. 3172. *ARV²* 1103.1. Museum phot.

226 Red-figure cup. Malibu, J. Paul Getty Museum 86.AE.682. Not known to Beazley. Museum phot.

227 Red-figure cup, from Vulci. London, British Museum E 82. *ARV²* 1269.3. Museum phot.

228 Red-figure cup, from Vulci? Harrow on the Hill, Harrow School Museum 52. Not in *ARV²*; *ARV¹* 660. Phot. A. Cambitoglou, courtesy of the School.

229 Red-figure loutrophoros. Athens, National Museum 1700. *ARV²* 1145.50. Museum phot.

230 Red-figure stamnos, from Vulci. Munich, Staatliche Antikensammlungen und Glyptotek 2415. *ARV²* 1143.2. Museum phot.

231 Red-figure volute-krater, from Spina. Ferrara, Museo Nazionale di Spina T.57 C VP. *ARV²* 1143.1. Museum phot.

232 Red-figure hydria (kalpis), from Nola. London, British Museum E 202. *ARV²* 1131.155. Museum phot.

233 Red-figure nuptial lebes, from Greece. New York, Metropolitan Museum of Art 07.286.35. *ARV²* 1126.1. Museum phot.

234 Red-figure lebes or loutrophoros (fragment). London, British Museum 1931.1–14.3. *ARV²* 1127.9. Museum phot.

235 and 236 Red-figure pyxis, from Attica. Würzburg, University, Martin von Wagner-Museum 541. *ARV²* 1133.196. Museum phot.

237 Red-figure oinochoe, from Locri. Berlin, Staatliche Museen 2414. *ARV²* 1208.41. Museum phot.

238 Red-figure chous, from Athens. Boston, Museum of Fine Arts 01.8085. Not in *ARV²*; *ARV¹* 794, middle. Museum phot.

239 and 240 White-ground and red-figure squat lekythos, from Athens. New York, Metropolitan Museum of Art 31.11.13, Fletcher Fund 1931. *ARV²* 1248.9. Museum phots.

241 and 242 Red figure stemless cup, from Vulci. Berlin, Staatliche Museen 2728. *ARV²* 1275.4. Phots. Marie Beazley, courtesy of the Museum.

243 Red-figure chous, from Athens. Athens, Ceramicus Museum 4290. Not known to Beazley. Museum phot.

244 Red-figure hydria, from Populonia. Florence, Museo Archeologico 81947. *ARV²* 1312.2 Museum phot.

245 Red-figure hydria, from Athens. Athens, Ceramicus Museum 2712. *ARV²* 1313.6. Museum phot.

246 and 247 Red-figure stamnos, fom Nocera dei Pagani (near Salerno). Naples, Museo Nazionale 2419. *ARV²* 1151.2. Museum phots.

248 and 249 Red-figure neck-amphora, from Casalta near Lucignano di Val di Chiana. Arezzo, Museo Civico 1460. *ARV²* 1157.25. Museum phots.

250 Red-figure volute-krater. New York, Metropolitan Museum of Art 27.122.8. *ARV²* 1171.2. Museum phot.

251 Red-figure squat lekythos. Oxford, Ashmolean Museum 1957.31. *ARV²* 1172.19. Museum phot.

252 and 253 Red-figure pointed amphoriskos, from Greece. Berlin, Staatliche Museen 30036. *ARV²* 1173.1. Museum phots.

254 Red-figure calyx-krater, from Bologna. Bologna, Museo Civico 303. *ARV²* 1185.6. Museum phot.

255 Red-figure chous, from Cyrenaica. Paris, Musée du Louvre N 3408. *ARV²* 1335.34. Phot. Chuzeville, courtesy of the Museum.

256 Red-figure calyx-krater. Malibu, J. Paul Getty Museum 82.AE.83. Not known to Beazley. Museum phot.

257 White-ground lekythos, from Athens. Vienna, Kunsthistorisches Museum 3748. *ARV²* 1372.16. Museum phot.

258 White-ground lekythos, from Eretria. Athens, National Museum 1816. *ARV²* 1383.12. Museum phot.

259 Red-figure bell-krater, from Orvieto, Vienna, Kunsthistorisches Museum 1771. *ARV²* 1318, top. Museum phot.

260 Red-figure calyx-krater fragment, from Spina. Ferrara, Museo Nazionale di Spina (erratico presso) T.312. *ARV²* 1340, middle. Museum phot.

261 Red-figure neck-amphora, probably from Italy. Paris, Musée du Louvre S 1677. *ARV²* 1344.1. Museum phot.

262 Red-figure volute-krater fragment, from Capua. New York, Metropolitan Museum of Art 06.1021.140. *ARV²* 1408.2. Museum phot.

263 Red-figure bell-krater fragment, from Perachora. Athens, National Museum. *ARV²* 1337.7. Phot. British School at Athens.

264 Black-figure panathenaic amphora, from Teucheira (Cyrenaica). London, British Museum B 605. *ABV* 411.4. Museum phot.

265 and 266 Red-figure chous. New York, Metropolitan Museum of Art 06.1021.196. Not listed by Beazley. Museum phots.

267 Red-figure oinochoe, from Athens. Athens, Agora Museum P 14763 *ARV²* 1697. Museum phot.

268 Red-figure cup-fragment, from Athens. Jena, University. *ARV²* 1511.1. University phot.

269 Red-figure cup. Formerly Castle Ashby, Marquess of Northampton. Not listed by Beazley. Phot. R.L. Wilkins.

270 Red-figure cup-fragment, from Athens. Jena, University. *ARV²* 1317.1. University phot.

271 Red-figure cup, from Corinth. Corinth, Museum. *ARV²* 1519.13. Museum phot.

272 Red-figure stemless cup, from Nola. London, British Museum E 129. *ARV²* 1414.89. Museum phot.

273 Red-figure bell-krater. London, British Museum F 64. *ARV²* 1419.1. Museum phot.

274 Red-figure bell-krater. Vienna, Kunsthistorisches Museum 801. *ARV*² 1431.7. Museum phot.

275 Red-figure fish-plate. Chicago, Art Institute 1889.95. Not listed by Beazley. Museum phot.

276 and 277 Black-figure panathenaic amphora, from Teucheira (Cyrenaica). London, British Museum B 603. *ABV* 414.4. Museum phots.

278 and 279 Black-figure panathenaic amphora, from Teucheira (Cyrenaica). London, British Museum B 604. *ABV* 413, middle, and below 1. Museum phots.

280 Red-figure bell-krater fragments, from Kition. Nicosia, Cyprus Museum KIT.1974 II 1552. Not known to Beazley. Museum phot.

281 Red-figure calyx-krater, from Spina. Ferrara, Museo Nazionale di Spina T.1145. *ARV*² 1440, above 1. Museum phot.

282 Red-figure calyx-krater, from Hermione (Argolid). Athens, National Museum 1435. *ARV*² 1440.4. Museum phot.

283 Red-figure pelike, from Camiros. London, British Museum E 424. *ARV*² 1475.4. Museum phot.

284 Black-figure panathenaic amphora, from Eretria. Chalkis, Museum. Not known to Beazley. Phots. G. Themelis.

285 Black-figure panathenaic amphora, from Eretria. Chalkis, Museum. Not known to Beazley. Phots. G. Themelis.

286 and 287 Red-figure calyx-krater, from Al Mina. Oxford, Ashmolean Museum 1939.599. Not listed by Beazley. Museum phots.

288 and 289 Black-figure panathenaic amphora, from Capua. Harvard, Arthur M. Sackler Museum 1925.10.134. *ABV* 414, bottom. 2. Museum phots.

290 Red-figure hydria, from Alexandria. Munich, Staatliche Antikensammlungen und Glyptotek 2439. Not listed by Beazley. Museum phot.

291 Red-figure and polychrome chous. New York, Metropolitan Museum of Art 25.190, Fletcher Fund 1925. Not listed by Beazley. Museum phot.

292 and 293 Black-figure panathenaic amphora, from Benghazi. Paris, Musée du Louvre MN 706. *ABV* 415.3. Museum phot.

294 Black-figure panathenaic amphora, from Cerveteri. London, British Museum B 608. *ABV* 417.1. Museum phot.

295 Black-figure panathenaic amphora, from Cerveteri. London, British Museum B 607. *ABV* 415.4. Museum phot.

296 Red-figure calyx-krater. Athens, National Museum 12544. *ARV*² 1456.1. Museum phot.

297 Black calyx-krater with figures in applied white. Munich, Staatliche Kunstsammlungen und Glyptotek 2755. Not listed by Beazley. Museum phot.

298 and 299 Black-figure panathenaic amphora, from Capua. London, British Museum B 610. *ABV* 417, top. Museum phots.

300 Black hydria with relief and gilded decoration. Winterthur, Kunstmuseum. Not listed by Beazley. Phot. H. Bloesch, courtesy of the Museum.

Index

347